Prague, Capital of the Twentieth Century

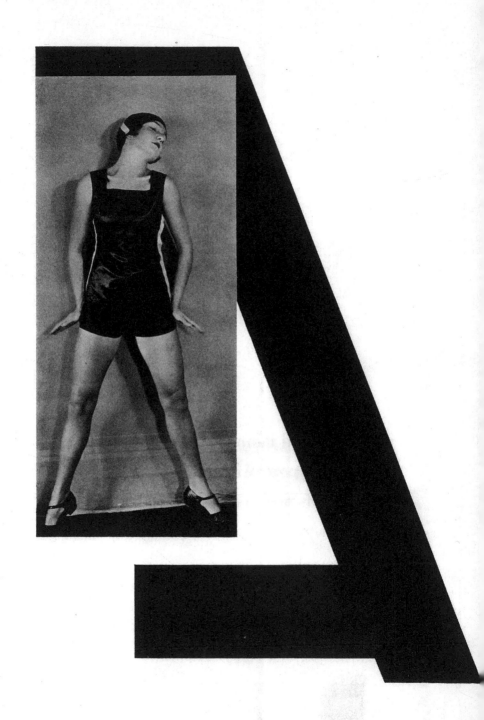

Derek Sayer

Prague, Capital of the Twentieth Century

A Surrealist History

PRINCETON UNIVERSITY PRESS PRINCETON AND OXFORD

Frontispiece. The letter *A* from Vítězslav Nezval, *Abeceda* (*Alphabet*). Dance composition
 Milča Mayerová; typographic design Karel Teige. Prague: Otto, 1926. Archive of Jindřich
 Toman. Courtsey of Olga Hilmerová, © Karel Teige - heirs c/o DILIA.

press.princeton.edu

Library of Congress Cataloging-in-Publication Data

Sayer, Derek.
Prague, capital of the twentieth century : a surrealist history / Derek Sayer.
 pages cm
Includes bibliographical references and index.
ISBN 978-0-691-04380-7 (hardcover : alk. paper) 1. Surrealism—Czech Republic—
Prague.
2. Prague (Czech Republic)—Civilization—20th century. I. Title.
NX571.C92P777 2013
700.94371´20904—dc23 2012023215

British Library Cataloging-in-Publication Data is available

This book has been composed in Garamond Premier Pro and Clarendon

Printed on acid-free paper. ∞

Printed in the United States of America

10 9 8 7 6 5 4 3 2 1

To Jindra Toman

All the past we leave behind,
We debouch upon a newer mightier world, varied world,
Fresh and strong the world we seize, world of labor and the march,
Pioneers! O pioneers!

> —WALT WHITMAN, "PIONEERS! O PIONEERS!"
> FROM *Leaves of Grass*, 1900

Ah, love, let us be true
To one another! for the world, which seems
To lie before us like a land of dreams,
So various, so beautiful, so new,
Hath really neither joy, nor love, nor light,
Nor certitude, nor peace, nor help for pain;
And we are here as on a darkling plain
Swept with confused alarms of struggle and flight,
Where ignorant armies clash by night.

> —MATTHEW ARNOLD, "DOVER BEACH," 1867

Contents

Illustrations

Acknowledgments

This book has been long in the making and I have accumulated many debts along the way. I can acknowledge only the most outstanding of them here. I would ask anyone I have inadvertently left out to forgive me; my memory is not all it once was. The Social Sciences and Humanities Research Council of Canada funded the initial research for the book in Prague and elsewhere in 2000–2003. I also benefited from the generous research support provisions of the Canada Research Chairs (CRC) program during my time as a CRC at the University of Alberta from 2000 to 2006. A period of two terms of research leave from Lancaster University in 2008–9, funded by the Arts and Humanities Research Council of Great Britain, gave me a much-needed break from teaching and administration and the time once again to focus on writing. Without such external research funding—which is getting increasingly rare, on both sides of the Atlantic, for the "lone scholar" in the humanities doing work that has no immediately measurable "impact"—it is unlikely that this book would have seen the light of day at all. I would also like to express my gratitude to the History Department at Lancaster University for helping defray the considerable cost of the illustrations.

Some passages in the book rework parts of articles previously published in *Past and Present*, *Common Knowledge*, *Bohemia*, and *The Grey Room* and of essays published in Timothy O. Benson, editor, *Central European Avant-Gardes*, and Mark Décimo, editor, *Marcel Duchamp and Eroticism*. Full details can be found in the bibliography. Preferring wherever possible to let my protagonists speak in their own words, I quote extensively from primary

sources, but such quotations are in my view covered by the provisions of fair use. Sources and copyrights for illustrations are provided in the captions. I am grateful for help with permissions and reproductions to Alena Bártová of the Museum of Decorative Arts (UPM, Prague); Magda Němcová of the National Gallery (NG, Prague); Jana Štursová of the Museum of National Literature (PNP, Prague); Karel Srp and Eva Štěpánková of the Prague City Gallery (GHMP); Tomáš Pavlíček of the National Technical Museum (NTM, Prague); Markéta Janotová of the Institute of Art History of the Czech Academy of Sciences (ÚDU AVČR, Prague); Alena Beránková of the Severočeská galerie in Litoměřice; Pavla Obrovská of the Moravian Gallery in Brno; Zuzana Štěpanovičová of the Oblastní galerie in Liberec; Veronica Keyes of the Museum of Fine Arts, Houston (MFAH); Tracey Schuster of the Getty Research Institute, Los Angeles; Kerry Negahban of the Lee Miller Archive, England; Philip Hunt of the National Gallery of Scotland; Ivana Simonová of DILIA, Prague; and Elizabeth Walley at the Design and Artist Copyright Society (DACS, London).

At Princeton I have been fortunate to have the support of Mary Murrell, my editor from *The Coasts of Bohemia* who originally commissioned this book; Hanne Winarsky, who inherited the project when Mary left the press and who steered the final manuscript through the review process; Brigitta van Rheinberg, who reassured me of Princeton's commitment to producing "a beautiful book" after Hanne's departure in the summer of 2011; and Alison MacKeen, my present editor. Kelly Malloy, Larissa Klein, and Sara Lerner, who oversaw the nuts and bolts of putting the book into production, have been great to work with. The press's illustration specialist, Dimitri Karetnikov, was both patient and very helpful in advising on questions of image quality, and Jennifer Harris did a sensitive as well as a scrupulous job of copyediting. I would also like to take the opportunity here to thank participants in Czech Cultural Studies Workshop meetings in Ann Arbor, Michigan, and at lectures and papers I have presented at McGill University, the University of Toronto, the Université d'Orléans, Universität Regensburg, the University of Texas at Austin, UCLA, and Lancaster University. It is not just their direct comments on my presentations but the conversations in the bars and restaurants afterward that left their mark. Jonathan Bolton, Peter Zusi, and Kimberly Elman Zarecor in particular gave me much to think about, some of which has no doubt crept into these pages. I got as much stimulation from viewing Mary and Roy Cullen's magnificent collection of Czech avant-garde and surrealist art in Houston, Texas. I cannot overstate my appreciation to

Mary for both her kindness in inviting me into her home and the way she gave so generously of her time.

Among those I am fortunate to count as personal friends, Lucie Zídková (*née* Bartošová) kindly supplied me with transcripts of interviews she did as a journalist for *Lidové noviny*. Jiří Lukas surprised me one day with a gift of hard-to-obtain Devětsil and Skupina Ra exhibition catalogues. Jindřich Toman has been characteristically generous in giving me access to rare books and magazines in his personal collection and taking the time to provide me with superb scans of covers and illustrations. He has also read the entire manuscript at various stages in its evolution, offering valued advice and correcting not a few errors, orthographical and otherwise, along the way. I dedicate this book to him as an expression of gratitude on the part of all of us in Czech cultural studies whom he has helped and inspired over the years. Others who were kind enough to read the manuscript in full or in part include Michael Beckerman, Craig Campbell, Karen Engle, Dariusz Gafijczuk, Colin Richmond, Tereza Valny, and Alex Wilkinson. They will probably never know how important their encouragement was in times when I doubted the wisdom of the whole enterprise. Yoke-Sum Wong, on the other hand, knows exactly how much she has contributed to this book—up to and including a holiday in Paris where we spent our days wandering Batignolles and Père Lachaise cemeteries in search of surrealist graves and she devoted large chunks of her evenings to reading a typescript that was then even longer than it is now. For good or ill this book is my resolution of what we have for years laughingly referred to as the problem of form. Sum can have her dining room back now.

DEREK SAYER
Garstang, England, 15 May 2012

Translation and Pronunciation

CZECH NAMES

With the exception of Saint Wenceslas (in Czech, Svatý Václav) and kings of Bohemia who simultaneously ruled over other territories and are better known under English or German names (like the Holy Roman Emperors Charles IV and Rudolf II or the Austrian Emperors Maria Theresa and Franz-Josef), I have left Czech personal names in their Czech form (Jan Hus rather than John Huss, Alfons Mucha rather than Alphonse Mucha). I have also used Czech rather than German or English versions of Czech place names (Mariánské Lázně not Marienbad, River Vltava instead of River Moldau) other than in the case of Prague itself. Czechs call their capital city Praha, but to do so here would simply have been pretentious. I have rendered *ulice* as street, *ulička* as lane, *třída* as avenue, *náměstí* as square, and *nábřeží* as embankment. Street names are anglicized where they are familiar from travel guides in an English form (Old Town Square rather than Staroměstské náměstí, Wenceslas Square rather than Václavské náměstí) or where translation brings out significant connotations of the name that would otherwise be lost on the English reader (Národní třída, for instance, is translated as National Avenue). Where the Czech language derives possessive adjectives from proper names (Karlův most, Neklanova ulice), I have made the connection obvious (Charles Bridge, Neklanov Street). I have also translated the names of artistic groups, organizations, and movements (Osma becomes The Eight, Spolek výtvarných umělců "Mánes" becomes the Mánes Artists' Society) unless the Czech name has connotations that would be lost in translation (for

example, Devětsil, which is the name of a flower, the butterbur, also puns on the Czech for "nine powers," *devět sil*). These associations are always explained in my text or notes. Titles of Czech books, plays, operas, paintings, and so on, are given in the original with an English translation on their first occurrence but in English thereafter.

CZECH EXPRESSIONS

Some words and phrases used in the text are characteristically Czech—they say something about the place and the people—and are also often difficult to translate into English in ways that preserve their full range of meaning and nuance. They are all explained in the text, but for convenience I list the main examples here together with the pages on which they are first discussed.

asanace slum clearance (99–100)

babička granny (126)

bílá místa blanks left by censors in text (literally: white places) (166)

českost Czechness (194)

chalupa cottage (152)

Já nic, já muzikant I'm just a song-and-dance man (meaning: It's nothing to do with me) (349)

kupředu, zpátky ani krok forward, backward not a step (communist slogan) (121–22)

lid people (194–96)

lidovost popular or folk quality (194–96)

lidový (f. *lidová*, n. *lidové*) popular, ordinary, folk (194–96)

lidový člověk a regular guy (194–96)

malé lidé ordinary folk (literally: little people) (197)

malý (f. *malá*, n. *malé*), *ale naše* little but ours (83)

malý český člověk little Czech guy (188)

matička (diminutive of *matka*) mother (45)

obložené chlebíčky open-face sandwiches (237)

panelák (plural *paneláky*) prefabricated apartment-block housing (167)

pasáž (plural *pasáže*) arcade (168)

pomlázka (plural *pomlázky*) a willow switch used in Easter Monday festivities (19)

práce work, labor (153)

samizdat clandestine publication (literally: self-published) (188)

špalíček stick, log; chapbook (345)

studentka (plural *studentky*) female student (43, 454 note 34)

ú nás our place, among us, at home (185)

vepřo-knedlo-zelí roast pork, dumplings, and sauerkraut—the Czech Sunday roast (185)

všecky krásy světa all the beauties of the world (210–11)

závist envy (98)

zpátky do Evropy back into Europe (Civic Forum slogan) (439, 465 note 85)

CZECH PRONUNCIATION

Czech is for the most part written phonetically. Diacritical marks either lengthen a vowel (as in *a, á*) or change the sound altogether (as in *s, š*). Stress usually falls on the first syllable of a word (thus KUNdera, *not* KunDERa).

a is somewhere between the *a* in *bat* and the *u* in *but*.

á is like the *a* in *car*.

c is like the *ts* in *bats*.

č is like the *ch* in *church*.

ď is like the *d* in *dune*.

e is like the *e* in *end*.

é is like the *ea* in *pear*.

ě is like the *ye* in *yet*.

ch is like the *ch* in the Scottish *loch*.

i is like the *i* in *bit*.

í is like the *ee* in *beet*.

j is like the *y* in *yet* (never like the *j* in *jet*).

ň is like the *ni* in *onion*.

q is pronounced *kv*.

r is rolled.

ř has no direct English equivalent; it sounds like a combination of a rolled *r* and the Czech sound *ž*.

š is like the *sh* in *ship*.

ť is like the *t* in *tune*.

u is like the *oo* in *foot*.

ú and *ů* are like the *oo* in *moon*.

w is pronounced like the English *v*.

y is pronounced the same as *i*.

ý is pronounced the same as *í*.

ž is like the *s* in *leisure*.

When followed by *i* or *í*, the letters *d, n,* and *t* are pronounced like *ď, ň,* and *ť*.

The dipthong *ou* combines the Czech sounds *o* and *u*, sounding something like the *oa* combination in *boat*, not the *ou* in *round* or *ounce*.

Other letters are sounded more or less as they are in English.

Prague, Capital of the Twentieth Century

Introduction

Il faut confronter des idées vagues avec des images claires.

—JEAN-LUC GODARD, *LA CHINOISE*[1]

Walter Benjamin's essay "Paris, Capital of the Nineteenth Century" exists in two versions, the first written in May 1935, the second in March 1939. Neither text was published until long after his death—at his own hand, by a morphine overdose, in the little Catalan border town of Port Bou on the night of 25 September 1940. The German-Jewish critic had fled France, where he had been living as a refugee since Adolf Hitler's rise to power in 1933, only to be informed on his arrival in Spain that he would be returned the next day to almost certain deportation to a Nazi concentration camp. Both versions of the exposé (as Benjamin called it) were written to solicit support from American sources—the German émigrés who had reestablished the Frankfurt Institute of Social Research at Columbia University in 1934, and the New York banker Frank Altschul—for the monumental project upon which he had been engaged since 1927. The aim of that project was nothing less than to recover the "prehistory of modernity" through an excavation of the "dreamworlds" incarnated in the material fabric and cultural artifacts of nineteenth-century Paris. "Paris, Capital of the Nineteenth Century" was Benjamin's working title for the project as a whole, not just the exposé. The manuscript of the larger work, which Walter entrusted to his friend Georges Bataille before fleeing Paris on

13 June 1940—the day before the Wehrmacht entered the city—survived the war hidden in a vault of the Bibliothèque nationale de France. The mammoth, rambling, and terminally unfinished torso would be published for the first time only in 1982 under the title *Passagen-Werk*. It finally appeared in English in 1999 as *The Arcades Project*, just in time to illuminate the turn of a new century.

The delay in publication may have been a blessing in disguise, for there is much in *The Arcades Project* that seems closer to the spirit of our times than to Benjamin's own. What above all distinguishes a "postmodern" sensibility, according to Jean-François Lyotard, is "incredulity toward metanarratives"—the various "grand narratives" of modernity that confer a progressive and singular sense on the course of human history.[2] Like many European intellectuals of his day Walter Benjamin considered himself a Marxist, and his interest in nineteenth-century Paris was not just antiquarian but (as he would have seen it) emancipatory. At the same time (and less usually) he emphatically rejected any identification of history with the forward march of progress, and his distaste for totalizing narratives, whether Marxist or otherwise, is evident in the very form of *The Arcades Project*. The apparent incompleteness of the work is not just the result of its being unfinished; its montage style was foreshadowed in earlier texts like "One-Way Street" (1928), whose coherence emerges—insofar as it emerges at all—only out of the accumulation and juxtaposition of a multitude of fragments.[3] *The Arcades Project* is made up of hundreds of verbatim quotations garnered from the most heterogeneous of sources, interlaced with Benjamin's own difficult, poetic, and often aphoristic reflections. His object, he says at one point, was "to develop to the highest degree the art of citing without quotation marks."[4]

Benjamin organized these "Notes and Materials" into thirty-six convolutes (from the German *Konvolut*, which literally means a "sheaf" or "bundle"), each composed of numbered and cross-referenced passages. Foremost among their subjects were the new technologies (iron construction, artificial lighting, railroads, photography), urban milieus (arcades, boulevards, interiors), cultural artifacts (fashion, advertising, exhibitions, museums), social types (the collector, the *flâneur*), and modes of experience (boredom, idleness) brought into being by nineteenth-century capitalism. Benjamin's self-proclaimed materialism did not prevent him from attending equally closely to the dreams and desires fostered by modernity: Convolute K is titled "Dream City and Dream House, Dreams of the Future, Anthropological Nihilism, Jung," Convolute L "Dream House, Museum, Spa." Other folders are

given over to prostitution and gambling, painting and Jugendstil, mirrors, conspiracies, the Paris Commune, the stock exchange, the École Polytechnique, and automatons and dolls. Benjamin reserved individual convolutes for Saint-Simon, Fourier, Marx, Hugo, and Daumier, but by far the largest "sheaf" in the book is devoted to Charles Baudelaire, who first popularized the term *modernity* in his 1863 essay "The Painter of Modern Life." "By modernity," the French poet wrote, "I mean the ephemeral, the fleeting, the contingent, the half of art whose other half is the eternal and the immutable." Forgetting that for Baudelaire "every old master had his own modernity," social theorists would before long appropriate this endless mutability as the feature that supposedly distinguishes "the modern world" from everything that came before it.[5]

"One can read the real like a text,"[6] Benjamin maintains. He has in mind a reading that is both close and symptomatic, whose protocols are closer to those of psychoanalysis than positivist historiography. "The nineteenth century [is] a spacetime [*Zeitraum*] (a dreamtime [*Zeit-traum*])," he writes, "in which . . . the collective consciousness sinks into ever deeper sleep." He advises historians to follow "the dreaming collective" in order "to expound the nineteenth century—in fashion and advertising, in buildings and in politics—as the outcome of its dream visions."[7] Committed to bringing these nocturnal visions to the light of day, he conceived *The Arcades Project* as "an experiment in the technique of awakening" whose aim was to transform "not-yet-conscious knowledge of *what has been*" into "something that just now first happened to us, first struck us." He wished to illuminate "the darkness of the lived moment" with "the flash of awakened consciousness." The material residues the nineteenth century left behind it, he believed, "preserve this unconscious, amorphous dream configuration," appearing to "stand in the cycle of the eternally selfsame, until the collective seizes upon them in politics and history emerges."[8] "Remembering and awakening are most intimately related,"[9] he argues. "It's not that what is past casts its light on what is present, or what is present its light on what is past; rather . . . what has been comes together in a flash with the now to form a constellation . . . the relation of what-has-been to the now is dialectical: is not progression but *image*, suddenly emergent."[10]

From Benjamin's perspective it is only by being made newly present as image that the past becomes *history* at all. "The dialectical image is an image that emerges suddenly," he asserts, "in a flash. What has been is to be held fast—as an image flashing up in the *now of its recognizability*."[11] It might help

us make sense of these gnostic formulations if we remember the pivotal scene in Marcel Proust's *À la recherche du temps perdu* (*In Search of Lost Time*) in which a chance encounter with the most everyday of objects—a cookie dunked in tea—triggers an unanticipated flood of childhood recollections. "As soon as I had recognized the taste of the piece of madeleine dipped in lime-blossom tea that my aunt used to give me," Proust's narrator relates, "all the flowers in our garden and in M. Swann's park, and the water-lilies on the Vivonne, and the good people of the village and their little dwellings and the church and all of Combray and its surroundings, all of this which is assuming form and substance, emerged, town and gardens alike, from my cup of tea."[12] "Just as Proust begins the story of his life with an awakening," says Benjamin, "so must every presentation of history begin with an awakening; in fact, it should treat of nothing else. This one, accordingly, deals with awakening from the nineteenth century."[13] He extends the childhood analogy to provide a striking metaphor for what *The Arcades Project* is all about: "What the child (and, through faint reminiscence, the man) discovers in the pleats of the old material to which it clings while trailing at its mother's skirts—that's what these pages should contain."[14]

Though *The Arcades Project* is extraordinarily rich in detail—in the convolute devoted to "Modes of Lighting," for instance, we learn that "When, on February 12, 1790, the Marquis de Favras was executed for plotting against the Revolution, the Place de Grève and the scaffold were adorned with Chinese lanterns"[15]—Benjamin neither mobilizes such minutiae to advance a chronological narrative nor marshals them to exemplify a theoretical argument. The fragments out of which the book is woven instead seem to communicate directly with one another within and across his convolutes, speaking a difficult language of association and allusion that the reader can learn only through total immersion. Benjamin provides no roadmap for navigating these thickets. Readers might take a multitude of crisscrossing paths through the maze, none of which are clearly signposted. Before long one suspects that the point is not the destination so much as what is encountered along the way. Insofar as there is a discernible Ariadne's thread running through the labyrinth it is Karl Marx's doctrine of the fetishism of the commodity, but the text constantly slips out of the confines of any frame we might wish to impose upon it, including a Marxist one. It is not just that the devil is in the detail. The devil *is* the detail.

A passage from Convolute C, which sports the cryptic title "Ancient Paris, Catacombs, Demolitions, Decline of Paris," gives a flavor of Benjamin's style:

> One knew of places in ancient Greece where the way led down into the underworld. . . . But another system of galleries runs underground through Paris: the Métro, where at dusk glowing red lights point the way into the underworld of names. Combat, Elysée, Georges V, Etienne Marcel, Solférino, Invalides, Vaugirard—they have all thrown off the fetters of street or square, and here in the lightning-scored, whistle-resounding darkness are transformed into misshapen sewer gods, catacomb fairies. This labyrinth harbors in its interior not one but a dozen raging bulls, into whose jaws not one Theban virgin once a year but thousands of anemic dressmakers and drowsy clerks every morning must hurl themselves. . . . Here, underground, nothing more of the collision, the intersection of names—that which aboveground forms the linguistic network of the city. Here each name dwells alone; hell is its demesne. Amer, Picon, Dubonnet are guardians on the threshold.[16]

The Paris Métro recalls a mythical Minoan labyrinth even as it remains its unmistakably modern self; the everyday sights and sounds of the metropolis become a palimpsest of dream-images that it is the task of the historian to decode. Freud irresistibly comes to mind, patiently listening to his patients' ramblings on that famous couch in Vienna, ever on the alert for those slips of the tongue that reveal repressed childhood traumas—except that the unconscious Benjamin hopes to tap into is collective, and the infancy that of modernity itself.

A more immediate point of comparison, in the context of this book, is the surrealist poet Louis Aragon, whose excursions through the fading glories of the Passage de l'Opéra in his *Le Paysan de Paris* (*Paris Peasant*, 1926) triggered Benjamin's own engagement with the arcades. Though Benjamin had his differences with the surrealists ("whereas Aragon persists within the realm of dream, here the concern is to find the constellation of awakening," he sniffs),[17] he was happy to acknowledge his considerable debt to the movement that André Breton founded in 1924. "Balzac was the first to speak of the ruins of the bourgeoisie," he writes in the first (1935) version of "Paris, Capital of the Nineteenth Century," "but it was Surrealism that first opened our eyes to them."[18] *The Arcades Project* has much in common with the surrealist *dérive*, a meandering stroll through the highways and byways of the city that is *necessarily* directionless because it is driven by the hope of chancing

upon the marvels hidden in the mundane. "To construct the city topograph-
ically—tenfold and a hundredfold—from out of its arcades and its gateways,
its cemeteries and bordellos, its railroad stations," Benjamin muses in what
reads like one of many methodological notes to self, "and the more secret,
more deeply embedded figures of the city: murders and rebellions, the
bloody knots in the network of the streets, lairs of love, and conflagrations."[19]
This is an exploration that could begin anywhere and has no terminus—not
out of intellectual sloppiness, but on principle.

Benjamin's attempt to grasp his subject matter through a seemingly ran-
dom proliferation of fragments was systematic, a *methodology*. He was seek-
ing a mode of historical inquiry that would allow the Chinese lanterns light-
ing the Marquis de Favras's scaffold and the aperitif advertisements beckoning
commuters into the Métro to signify in all their concrete particularity, rather
than being reduced to mere examples of (supposedly) more general processes
like "commodification" or "consumption." "In what way is it possible to con-
join a heightened graphicness [*Anschaulichkeit*] to the realization of the
Marxist method?" he asks. His answer, which goes against the grain of most
academic historiography as well as most Marxism then and since, is to elevate
one of the most revolutionary inventions in twentieth-century art, the pho-
tomontage pioneered by the Berlin Dadaists and the Russian constructivists
in the years following World War I, into an epistemological principle. "The
first stage in this undertaking," he writes, "will be to carry over the principle
of montage into history. That is, to assemble large-scale constructions out of
the smallest and most precisely cut components. Indeed, to discover in the
analysis of the small individual moment the crystal of the total event."[20]

In the words of its English translators, the aim of *The Arcades Project* was
less to produce an analysis or explanation of an epoch than to fashion "an
image of that epoch . . . a historical 'mirror-world'" in which the era could
recognize itself and wake from its dreams.[21] "I needn't *say* anything," Benja-
min observes, echoing Ludwig Wittgenstein's *Tractatus Logico-Philosophi-
cus*.[22] "Merely *show*. I shall purloin no valuables, appropriate no ingenious
formulations. But the rags, the refuse—these I will not inventory but allow,
in the only way possible, *to come into their own*: by making use of them."[23] He
considered his "Copernican revolution" in historical method "comparable
. . . to the process of splitting the atom."[24] An equally salient comparison
might be drawn with the analytic cubism of Picasso and Braque, which shat-
tered the illusionistic conventions of post-Renaissance painting with an ex-
plosion of simultaneous angles of vision and went so far as to collage bits and
pieces of cloth, newsprint, and other *objets trouvés* directly onto the canvas,

blurring the boundaries between the real and its representation. Whether in the writing of history or the visual arts, such a twist of perspective does not produce an immediately legible surface. There is work for the reader to do. But the fragmentation of the field of vision may in the end give us a much firmer grip on what Milan Kundera, following the surrealists, has called "the density of unexpected encounters."[25] I have not attempted to emulate the architecture of *The Arcades Project* here—I tell a story, albeit a story that is woven from of a multitude of *petites narratives*—but such has been my intention too. I am not interested in the grand narratives that discipline so much as the details that derail.

"Every epoch," wrote Benjamin in his conclusion to the first (1935) version of "Paris, Capital of the Nineteenth Century," "not only dreams the one to follow but, in dreaming, precipitates its awakening. It bears its end within itself and unfolds it—as Hegel had already noticed—by cunning."[26] The era in which Benjamin lived and died is now as distant, and as close, to us as the Paris of Louis Philippe, the Second Empire, and the Third Republic were to him: the "recent past," a time hovering uncertainly on the boundaries between memory and history. Its monuments litter the landscapes we inhabit without quite belonging to *our* world any more. This book tries to do for our recent past—which is to say, for Walter Benjamin's present—what *The Arcades Project* did for his: to rummage amid the rags and refuse of yesterday's modernity in the hope of uncovering the dreamworlds that continue to haunt what we fondly believe to be today's waking state. The epoch from whose dreams I wish to awaken is the twentieth century, and more particularly what Eric Hobsbawm has called "the short twentieth century" between the outbreak of World War I on 1 August 1914 and the collapse of the Soviet Union on 31 December 1991[27]—a period that was incidentally, and probably not coincidentally, the bloodiest in recorded human history. The nature as well as the magnitude of that carnage is one of the reasons why I have less confidence than Benjamin did in humanity's capacity to live by "the whetted axe of reason" alone.[28] I do not identify a postmodern awakening with a Hegelian "end of history" in which the real and the rational finally coincide.[29] The postmodern era will no doubt dream up phantasmagorias of its own, of which the conviction of its own postmodernity may well turn out to be one.

Hobsbawm's age of extremes was dominated politically by the conflict between liberal-democratic, fascist, and communist visions of modernity, set against a backcloth of the disintegration of the great European empires that

still ruled much of the world in 1900—a process that begun with the collapse
of Romanov Russia, Hohenzollern Germany, and Habsburg Austria-Hun-
gary on the battlefields of World War I and continued with the decoloniza-
tion of Africa and Asia after World War II. In architecture and the arts *mod-
ernism* was the watchword of the day, even if what it meant to be modern was
much disputed and seldom a question that could be severed from the ideo-
logical struggles of the age. My main concentration will be on the first half of
the century, when the struggles were at their peak and the visions fresh and
new, although there are plentiful diversions into the Cold War years that
came after and occasional glances back to the *fin de siècle*. Like Benjamin I
choose a single city as a setting for this excavation. Prague is a less glittering
capital for a century, to be sure, than *la ville-lumière*, but then it was a very
much darker century. At first sight this nomination may strike many as ab-
surd—at one with the black humor beloved of both surrealists and Czechs,
perhaps, but scarcely a fitting homage to Benjamin's magnum opus. But con-
sider: in what other city, apart perhaps from Berlin, can we witness, in the
course of less than one hundred years, such a variety of ways of being mod-
ern? Certainly not London or Paris, and still less Los Angeles or New York.

Prague entered the twentieth century as the capital of a restive province of
Austria-Hungary, energized by a recent Czech "national revival" that trans-
formed Bohemia's German-speaking inhabitants—who then made up
around one-third of its population—into an "ethnic" minority. In the course
of the next hundred years the city on the Vltava successively served as the
capital of the most easterly democracy on the continent (1918–38), a Nazi-
occupied Protectorate (1939–45), a westerly outpost of the Soviet gulag
(1946–89), and a reborn post-communist republic (1990–). The borders of
these polities have shifted as frequently as their regimes. The historic Czech
Lands of Bohemia, Moravia, and Czech Silesia were joined with Slovakia
and Sub-Carpathian Ruthenia to form an independent Czechoslovak Re-
public in October 1918. Twenty years later a third of the country's territory
and inhabitants were lost to Germany (and Hungary) as a consequence of
the Munich Agreement of September 1938 at which Neville Chamberlain
and Edouard Daladier tore up the guarantees given to Czechoslovakia by
Britain and France at the Treaty of Versailles in the name of "peace in our
time." Six months after that Slovakia became a nominally independent state
under German tutelage and the Czech Lands disappeared into the Third
Reich. Prague was occupied for longer during World War II than any other
European capital. After the war Czechoslovakia's former territory was re-
stored, with the exception of Sub-Carpathian Ruthenia, which was summar-

ily annexed by the Soviet Union (and is now part of an independent Ukraine). For the next four decades Prague found itself in "Eastern Europe," even though the city lies to the west of Vienna (which is one of the reasons why most of the artists discussed in this book will be unfamiliar to most Anglophone readers). With the fall of communism in the Velvet Revolution of November 1989 Prague took itself "back into Europe," but within two years tensions between Czechs and Slovaks came out into the open again[30] and the country split into separate Czech and Slovak Republics at the stroke of midnight on 31 December 1992.

At least the Velvet Divorce, as the separation became jokingly known, was amicable; the same cannot be said of Bohemia's earlier changes of borders and populations. Czechs constituted a bare majority of the population of interwar Czechoslovakia, a ramshackle creation in which Bohemian Germans—who were incorporated into the new state at gunpoint—outnumbered Slovaks and there were substantial minorities of Hungarians, Jews, and others. The resultant conflicts between "nationalities" provided the justification, if not necessarily the reason, for the events that led to Czechoslovakia's destruction in 1938–39. Prague's Jewish community, one of the oldest and largest in Europe, was largely eradicated during the Nazi occupation; most of those who survived the Holocaust emigrated after the war. The Czechs in turn expelled the three-million-strong German population in 1945–46. They were calling the action *čištění vlasti* (cleansing of the homeland) half a century before the term "ethnic cleansing" entered the political vocabulary of the English language by way of the former Yugoslavia.[31] There was abundant brutality and thousands of deaths. Add to this the waves of political emigration caused by the Munich crisis of 1938, the communist coup of "Victorious February" 1948, and the Soviet invasion of 21 August 1968, and it becomes evident that we are talking of a part of the world in which modernity has been exactly what Baudelaire said it was: *le transitoire, le fugitif, le contingent.*

It should already be evident that Prague offers slim pickings for grand narratives, least of all for grand narratives of progress. The city's twentieth-century history frequently brings to mind Max Weber's observation that "since Nietzsche we realize that something can be beautiful, not only in spite of the aspect in which it is not good, but rather in that very aspect. You will find this expressed earlier in [Baudelaire's] *Fleurs du mal.*"[32] This is not "modern society" as generations of western social theorists have habituated us to think of it,[33] but a Kafkan world in which the exhibition may turn into a show trial, the interior mutate into a prison cell, the arcade become a shooting gallery, and the idling *flâneur* reveal himself to be a secret policeman at the drop of a

hat. Prague furnishes a very different vantage point on the experience of the modern than London, Paris, Los Angeles, or New York; a perspective that—as with Braque or Picasso's cubism or the Dadaists' photomontages—challenges our familiar fields of vision. It is the contention of this book that this surreal world, as it appears to *us*, is every bit as deserving of the title "modernity" as any of the more familiar spectacles we might encounter on Fifth Avenue, Rodeo Drive, or the Champs-Élysées. It is time we recognized that the gas chamber is as authentic an expression of *l'esprit moderne* as abstract art,[34] and acknowledged that Václav Havel's ethnography of the rituals of knowing complicity that upheld communism is as insightful an analysis of modern power as anything in Foucault.[35]

We shall see plenty of evidence in the pages that follow that Prague's location at "the crossroads of Europe" (I quote the Czech writer Karel Čapek, introducing the PEN-Club Congress in June 1938) provided its artists and intellectuals with abundant fuel for modernist dreaming.[36] The situation of Central Europe during the earlier part of the twentieth century put modernization high on national economic and political agendas, in ways that often proved unusually propitious for the arts. Kenneth Frampton's observation on the extraordinary vitality of Czechoslovakia's architecture between the wars holds more generally; this was "a modernity worthy of the name"[37] whether in film, theater, literature, music, or the visual arts. Until recently this "other modernity"—to paraphrase Milan Kundera[38]—has been in large part forgotten because of the way Cold War geographies have shaped the writing of histories on both sides of the erstwhile Iron Curtain. Contributing to retelling that story would be sufficient justification for writing this book, whether or not readers are persuaded by its wider arguments. But what, to my mind, makes Prague a fitting *capital* for the twentieth century is that this is a place in which modernist dreams have time and again unraveled; a location in which the masks have sooner or later always come off to reveal the grand narratives of progress for the childish fairy tales they are.

It is no coincidence that twentieth-century Prague has given world literature the grim comedies that are Franz Kafka's *The Trial* and *The Castle*, Jaroslav Hašek's *The Good Soldier Švejk*, Bohumil Hrabal's *Too Loud a Solitude*, Václav Havel's *The Memorandum*, or Milan Kundera's *Laughable Loves*—or that the Czech capital should have become the world's second center of surrealism after Paris, though it should be said at the outset that Prague's surrealism has generally been both less mystical and less romantic than its French counterpart. The city's modern history is an object lesson in *humour noir*. Where better to acquire an appreciation of irony and absurdity, an enduring

suspicion of sense-making grand theories and totalizing ideologies, and a Ra-
belaisian relish for the capacity of the erotic to rudely puncture all social and
intellectual pretensions toward rationality? This is quintessentially the terri-
tory explored in this book, and it is not always pretty. The Prague on display
here is a town for grown-ups who (in André Breton's words) would rather
walk in darkness than pretend they are walking in daylight.[39] To look out on
the twentieth century from Charles Bridge is rather like looking out on the
nineteenth from Matthew Arnold's Dover Beach—a convulsively beautiful
prospect, to be sure, but one that leaves us in no doubt as to the shakiness of
the ground on which we stand.

 If Walter Benjamin's objective was to uncover the prehistory of moder-
nity, this book might be regarded as a contribution to the prehistory of post-
modernity. In his first (1935) version of "Paris, Capital of the Nineteenth
Century," Benjamin looked forward to an awakening in which "we begin to
recognize the monuments of the bourgeoisie as ruins even before they have
crumbled."[40] My concern is a very different one.[41] It should by now be clear
(except, perhaps, to a few big children in university chairs)[42] that Marx's
commodity was far from the only fetish to bewitch twentieth century imagi-
nations. The monuments that I seek to recognize as ruins are those of *moder-
nity itself*; or at least, to be a little more modest, of what has been construed
as modernity in the grand narratives that have been so central to the self-con-
sciousness of the age. Interestingly, toward the end of his life Benjamin him-
self came close to concluding that far from being the defining feature of the
bourgeois era, modernity was (in Karl Marx's phrase) the illusion of the
epoch. The second (1939) version of "Paris, Capital of the Nineteenth Cen-
tury" replaces the final paragraph about a Hegelian awakening with a brief
meditation on the "vision of hell" presented in Auguste Blanqui's *L'Éternité
par les astres* (Eternity through the Stars)--a work, Benjamin makes a point
of telling us, that Blanqui wrote while imprisoned in the fortress of Taureau
during the Paris Commune of 1871. The Commune, as he was well aware, was
an event hailed by Marx as the first example of the "dictatorship of the prole-
tariat" that was supposed to usher in the brave new world of communism.[43]

 Blanqui's text, claims Benjamin, "presents the idea of eternal return ten
years before *Zarathustra*—in a manner scarcely less moving than that of
Nietzsche, and with an extreme hallucinatory power." "There is no progress,"
writes Blanqui, the permanent revolutionary despairing at the last; "the uni-
verse repeats itself endlessly and paws the ground in place." "Blanqui ...
strives to trace an image of progress that (immemorial antiquity parading as
up-to-date novelty) turns out to be the phantasmagoria of history itself,"

comments Benjamin. He ends: "*The world dominated by its phantasmago-rias—this, to make use of Baudelaire's term, is 'modernity.'*"[44]

It may or may not be coincidence that on 15 March 1939, the same month that Benjamin revised the text of "Paris, Capital of the Nineteenth Century," Adolf Hitler's armies marched into Prague.

1

The Starry Castle Opens

On the side of the abyss, made of philosophers' stone, the starry castle opens.

—ANDRÉ BRETON, *MAD LOVE*[1]

THE SURREALIST SITUATION OF THE OBJECT

"André Breton in Prague!" screamed the Czech surrealists' flyers.[2] Accompanied by his old friend Paul Éluard, his new bride Jacqueline Lamba, and the Czech painter Josef Síma, the surrealist leader arrived in the Bohemian capital on 27 March 1935. According to Brassaï, whose photographic images of *Paris after Dark* had electrified the city of light three years earlier, Éluard was then "a man of about forty, tall and proud in his bearing. . . . His clear, limpid, wide-open, azure blue eyes expressed a slightly feminine tenderness and sweetness, under a high forehead and within the pink carnation of a long, curiously asymmetrical face. Ease, litheness, and an indefinable fragility emanated from his whole being." The poet had a "soft-spoken and slightly husky voice, so direct, so captivating," but "the hand he held out to me was trembling." The tremble, Brassaï later learned, was the legacy of a lifetime of ill health. Breton cut a more intimidating figure:

> With his regular features, straight nose, light-colored eyes, and artist's mane, which fell back off his forehead and onto his neck in curls, he looked like an Oscar Wilde transformed hormonally into someone more energetic, more

male. His presence, the leonine bearing of his head, his impassive, grave, almost severe face, his sober, measured, extremely slow gestures, gave him the authority of a leader of men, born to fascinate and to reign, but also to condemn and to strike.... Éluard suggested Apollo, but Breton looked like Jupiter in person.[3]

The visitors' welcome exceeded their wildest expectations. "We are more famous here," wrote Éluard to his ex-wife Gala, "than in France."[4] More than seven hundred people turned out two nights later to hear Breton lecture on "The Surrealist Situation of the Object" at the Mánes Gallery on Žofín Island. Rich in the poetry of unexpected encounters, the little sliver of land in the River Vltava, opposite the golden-roofed National Theater, was a fitting venue for the topic. Žofín had been patriotically renamed[5] Slavic Island (Slovanský ostrov) in 1925 in memory of the Slavic Congress held there in the revolutionary year of 1848—a somewhat farcical event, as it turned out, in which the delegates of the Habsburg Empire's Slavic minority nations found they could understand one another only when speaking German. Hardly anybody yet called it that, though. The Czechoslovak Republic had declared its independence from Austria-Hungary on 28 October 1918, but the trace of Emperor Franz-Josef's mother, Archduchess Sophia, Žofie in Czech, lingered on—a soft, pretty name, at one with the place. The Mánes Gallery, designed by Otakar Novotný and built in 1930, struck very different chords. It epitomized the modernist aesthetic of what a landmark exhibition at New York's Museum of Modern Art (MoMA) would shortly baptize *The International Style*.[6] Stark, white, and unencumbered by the detritus of the past, the concrete and plate-glass building spoke of and for a brave new state, looking west. The gallery wrapped itself, all the same, around an onion-domed water tower built in 1588–91, the sole survivor of a group of mill buildings dating back to 1419 that the Mánes Artists' Society demolished after it purchased the site in 1926.[7] History is not so easy to escape here.

Breton opened his talk with a backhanded nod of recognition. "I am very happy to be speaking today," he began,

> in a city outside of France which yesterday was still unknown to me, but which of all the cities I had not visited, was by far the least foreign to me. Prague with its legendary charms is, in fact, one of those cities that electively pin down poetic thought, which is always more or less adrift in space. Completely apart from the geographical, historical,

and economic considerations that this city and its inhabit-
ants may lend themselves to, when viewed from a distance,
with her towers that bristle like no others, it seems to me to
be the magic capital of old Europe.

"By the very fact that [Prague] carefully incubates all the delights of the past
for the imagination," he told his audience, "it seems to me that it would be
less difficult for me to make myself understood in this corner of the world
than any other."

"For many long years," he went on, "I have enjoyed perfect intellectual fel-
lowship with men such as Vítězslav Nezval and Karel Teige," his Czech hosts.
"Constantly interpreted by Teige in the most lively way, made to undergo an
all-powerful lyric thrust by Nezval, Surrealism can flatter itself that it has
blossomed in Prague as it has in Paris."[8] Surrealism was indeed flourishing in
Prague, but that "many long years" was not strictly true. Breton had met Nez-
val for the first time when the Czech poet visited Paris two years earlier on 9
May 1933 in the Café de la place Blanche. It was one of the French surrealists'
regular hangouts, like the Café Cyrano on the same seedy square, which Luis
Buñuel later recalled as "an authentic Pigalle café, frequented by the working
class, prostitutes, and pimps."[9] Inevitably perhaps, Nezval compared the
meeting to a scene from *Nadja* (1928), the story of the love affair that fol-
lowed Breton's chance encounter on a Paris street with the ingénue of its
title.[10] This was Breton's first meeting with the critic, theoretician, and
graphic artist Karel Teige, whose standing within the Czech avant-garde be-
tween the World Wars was comparable to his own in France. The Group of
Surrealists in Czechoslovakia (Skupina surrealistů v Československu), to
give the Prague surrealists their official name, came into being only in March
1934. This was a full decade after Breton published his first *Manifesto of Sur-
realism*, though Nezval's review *Zvěrokruh* (Zodiac),[11] which was surrealist
in all but name, had appeared at the end of 1930, and the *Poesie 1932* exhibi-
tion at the Mánes Gallery brought together the painters Jindřich Štyrský
and Toyen (Marie Čermínová), the sculptor Vincenc Makovský, Josef Šíma,
and several other Czech artists alongside Jean Arp, Salvador Dalí, Giorgio
De Chirico, Max Ernst, Paul Klee, Joan Miró, Wolfgang Paalen, and Yves
Tanguy—not to mention a group of anonymous "Negro sculptures"—in
what was probably the largest display of surrealist art yet seen anywhere in
the world.[12]

Breton's exaggeration was poetic—the deeper truth of a thought always
more or less adrift in space, which becomes that much more magical when it

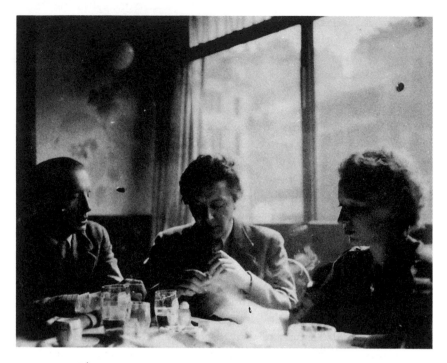

FIGURE 1.1. Paul Éluard, André Breton, and Jacqueline Lamba, Prague, 1935. Unknown photographer. Památník národního písemnictví, Prague.

is unexpectedly pinned down in the fortuitous coincidences of the moment. Such appeared to be the intellectual—and by 1935, the political—consonances between the French and the Czech surrealists that he may well have felt that their meeting was preordained by "objective chance" (*hasard objectif*), just as he did his relationship with Jacqueline. He tells that tale in *L'Amour fou* (*Mad Love*), which was serialized in the surrealist review *Minotaure* from 1934 and published in book form in 1937. Though Lamba was a painter it was in the image of a mermaid, his *ondine*, that Breton chose to fix her, fusing together a fragment of conversation ("Ici, l'on dîne!") overheard in a café, Jacqueline's night job of performing naked in an "underwater ballet" at the Montmartre music hall Le Coliséum, and what he came to see as the premonitions of their first night's walk together through the streets of Paris in "The Sunflower" (*Le tournesol*), an automatic poem he had written eleven years previously in 1923. "The ones like this woman who seem to be swimming / And a touch of their substance enters into love"[13] were the words that had come unbidden to his mind back then, words that at the time he did

not much like and still less understand.[14] But *hasard objectif*, he explained to his listeners at the Mánes Gallery, is "that sort of chance that shows man, in a way that is still very mysterious, a necessity that escapes him, even though he experiences it as a vital necessity."[15]

The French surrealists spent two weeks in the Czech Lands,[16] departing on April 10. Despite plans to return for a longer stay[17] it was to be Breton's only visit, though not Éluard's. Breton lectured on "The Political Position of Today's Art" and Éluard recited surrealist poetry at the City Library on April 1 to the Left Front (*Levá fronta*), an organization of left-wing artists and in-tellectuals founded in 1929 of which Karel Teige had been the first president. Some 350 people showed up, filling the hall to capacity.[18] Like his Mánes talk, Breton's lecture had been specially prepared for Prague. He lectured again on April 3 to 250 students ("when Bergson only had 50" gloated Élu-ard)[19] at the Philosophical Faculty of Charles University, the oldest in Cen-tral Europe, on "What Is Surrealism?" and repeated his lecture on the surre-alist situation of the object in the Moravian capital Brno the next day. Originally delivered as a talk in Brussels the previous year, "What Is Surreal-ism?" appeared in print in Czech in 1937.[20] It has since been widely recog-nized as a key text of the surrealist movement. Breton also gave several press and radio interviews[21] and signed over four hundred copies of his latest book *Les Vases communicants* (*Communicating Vessels*, 1933), which had recently been translated into Czech by Nezval and the theater director Jindřich Honzl. It was his most ambitious attempt to reconcile Marxism and surreal-ism to date. Paul Éluard, too, recited one of his poems, titled "Woman, the Principle of Life, Ideal Conversational Partner," on the radio. Hearing the re-cording, he told Gala, "gave me a strange impression of sincerity."[22]

During their time in Prague the visitors worked with their Czech hosts on the *Bulletin international du surréalisme/Mezinárodní bulletin surrealismu*, a project Nezval says originated over dinner at the Mánes Gallery on April 5 and Éluard reckoned "very important."[23] The *Bulletin* signaled the beginning of the official internationalization of the surrealist movement. The first issue was published in a dual-column French and Czech bilingual edition in Prague on April 20.[24] The second number (in French and Spanish) followed in Tenerife in May; the third, devoted to the Belgian surrealist group, came out from Brussels in August; and the fourth (in French and English) was published in London in May 1936, a month before an International Surreal-ist Exhibition opened at the New Burlington Galleries. Breton hailed the London show as "the highest point in the graph of the *influence* of our move-ment, a graph which has risen with ever increasing rapidity during recent

years."[25] The event achieved more notoriety at the time for such stunts as Salvador Dalí delivering an address from inside a deep-sea diving suit (in which he nearly suffocated) and Sheila Legge wandering Trafalgar Square as the "Phantom of Sex Appeal" in a clingy white dress torn at the hem, her face enmeshed in a cage covered with roses. A souvenir volume called simply *Surrealism*—which its editor, the anarchist critic Herbert Read, regarded as a "manifesto"—came out a few months later. "After a winter long drawn out into bitterness and petulance, a month of torrid heat, of sudden efflorescence, of clarifying storms," Read began his introduction, "the International Surrealist Exhibition broke over London, electrifying the dry intellectual atmosphere, stirring our sluggish minds to wonder, enchantment and derision." He had nothing but scorn for the "armory of mockery, sneers, and insults" with which the spectacle had been greeted in the press. "In the outcome people, and mostly young people, came in their hundreds and their thousands not to sneer, but to learn, to find enlightenment, to live. When the foam and froth of society and the press had subsided, we were left with a serious public of scientists, artists, philosophers and socialists."[26] Štyrský and Toyen were among the exhibitors at the London show, as they were in every major international surrealist exhibition of the time. Somewhat more puzzlingly, *Surrealism* also reproduced what was claimed to be "a drawing by a Czecho-Slovakian peasant in a state of trance."[27]

Despite the visitors' busy schedule in Prague time was found for excursions, including to the spa towns of Karlovy Vary (Karlsbad) and Mariánské Lázně (Marienbad)—surreal locations enough, with their wedding-cake hotels haunted by the shades of Goethe and Marx and mock-classical colonnades thronged with pilgrims sipping the waters from specially shaped cups. The surrealists did a good deal of walking around the magic capital, taking in Úvoz, Hradčany (Prague Castle), Kampa Island, Charles Bridge (Karlův most), and the Old Town Square (Staroměstské náměstí), which Breton much admired. The square still looks like a film set, as it must have done to Breton and Éluard, even if its antiquity was less pristine in the 1930s than it appears to tourists today. Tramlines still cut through the cobblestones then, the authentically gothic House at the Stone Bell had yet to be unpeeled from its baroque façade, and the Old Town Hall boasted a nineteenth-century neo-gothic wing that would be destroyed during the Prague Uprising of 5–8 May 1945—some of the last fighting of World War II on European soil. The visitors were entranced by the city's idiosyncratic house signs, stone or plaster bas-reliefs that identified buildings in the days before 1770 when they were ordered to be numbered—"surrealist objects," Vítězslav Nezval explains,

"with latent sexual significance."[28] Éluard also found hidden meaning in pup-
pets (a centuries-old Czech popular pastime) and painted eggs (Easter was
coming up on April 21). Had he been aware of what he was seeing, he might
have pondered the sexual significance of the gaily beribboned *pomlázky*,
plaited willow wands that would have been for sale on the market stalls in the
weeks leading up to Easter as they still are today. Boys use them to whip girls'
bottoms on Easter Monday in celebration of our Lord's resurrection, and the
girls give them the decorated eggs in return. The word *pomlázka* comes from
the verb *pomladit*, which means to make younger.

Brno was a notable center of architectural modernism between the wars,
but Nezval chose instead to draw the surrealists' attention to "the chance en-
counter of a town hall, a crocodile, and a wheel"—the crocodile being the
Brno dragon (*brněnský drak*), a Turkish gift to the sixteenth-century Bohe-
mian king Matyas Corvinus that the town's inhabitants had mistaken for a
dragon and whose embalmed corpse hangs to this day in the entrance pas-
sage to Brno City Hall.[29] Breton thought the juxtaposition worthy of the
Comte de Lautréamont himself—Isidore Ducasse, the author of *Chants de
Maldoror* (*Songs of Maldoror*), who coined the most famous of all surrealist
images when he likened the beauty of an English boy to "the chance meeting
on a dissecting table of a sewing-machine and an umbrella."[30] Breton went to
some lengths to explain the store the surrealists set by such serendipitous en-
counters in his lecture at the Mánes Gallery, quoting the German painter
Max Ernst, for whom a "fortuitous meeting of two distant realities on an in-
appropriate plane . . . or, to use a shorter phrase, the cultivation of the effects
of a systematic bewildering" was first and foremost among the "means (of be-
witching reason, taste, and conscious will)" available to surrealist artists. "A
complete transmutation followed by a pure act such as love," Ernst main-
tained, "will necessarily be produced every time that the given facts—*the cou-
pling of two realities which apparently cannot be coupled on a plane which ap-
parently is not appropriate to them*—render conditions favorable."[31]

Just such a fortuitous coupling, as it turned out, was close to hand. Breton
was enchanted by the image of Star Castle (Letohrádek Hvězda) at Bílá hora
on the western outskirts of Prague, a renaissance hunting lodge built by the
Italian architects Giovanni Mario Aostalli and Giovanni Lucchese for the
Habsburg royal governor Archduke Ferdinand and his (secret) Jewish wife
Philippine Welser in 1555–57. The building owes its name to the fact that its
walls are built in the shape of a six-pointed star. Star Castle is a *lieu de mé-
moire* if ever there was one, though just what, and how much, it recalled for
Czechs is unlikely to have been apparent to the French surrealists. It was here

on 8 November 1620 that the Battle of the White Mountain (Bílá hora) put an ignominious end to the Rising of the Czech Estates, the event that triggered the Thirty Years' War. Western historians have generally regarded that war as the crucible in which the state system with which Europe entered the modern era was forged. But the battle was remembered as a twofold catastrophe in the Czech Lands. Not only did it seal the victory of the Counter-Reformation over the homegrown Protestantism whose origins lay in the preaching of the fifteenth-century Czech heretic Jan Hus; it also opened the road to the final reduction of the once-proud medieval Kingdom of Bohemia into a mere province of the Austrian Empire. Though many of the architectural glories trumpeted in Prague's guidebooks are legacies of the baroque, the century that followed the defeat at Bílá hora was recalled by nineteenth-century Czech nationalists simply as "The Darkness" (*Temno*): a long night of economic confiscations, religious persecution, political repression, and mass emigration that resulted in a decapitation of Czech culture so wholesale that for a time the very survival of the Czech language itself seemed in jeopardy. This picture, too, is both exaggerated and one-sided, but its historical accuracy is not what matters here. The past incubated in the imagination and was refashioned.

Breton published an essay-cum-travelogue the next year in *Minotaure*, freely associating his love for Jacqueline, the landscapes of the Canary Islands (which he visited for a surrealist exhibition soon after his return from Prague), and musings on *hasard objectif* under the title "Le Château étoilé" (The Starry Castle).[32] Founded by the Swiss publisher Albert Skira in 1933, *Minotaure* was one of the most important, as well as the most beautiful of the surrealist magazines. It aimed to "rediscover, reunite and resume the elements that have constituted the modern movement,"[33] including not only literature and the visual arts, music, architecture, film, and theater but also ethnography, archaeology, the history of religion, mythology, and psychoanalysis. The young Jacques Lacan, whom many now regard as the greatest psychoanalytic theorist of the twentieth century after Freud, contributed an article to the first number; the second was entirely devoted to the recent French ethnographic expedition to Dakar-Djibouti, whose recording secretary was the writer Michel Leiris.[34] The venture also temporarily brought together Breton and "surrealism's old enemy *from within*" (as he described himself)[35] Georges Bataille, whom Breton had virulently attacked in his "Second Manifesto of Surrealism" of 1929.[36] Bataille responded in kind, orchestrating the scurrilous pamphlet *Un cadavre* (A Corpse), which depicted Breton on its front page garlanded with a crown of thorns and mocked the surrealist leader as "a great big

soft strumpet armed with a gift-wrapped library of dreams."[37] Only the surrealists' revolutionary politics were banished from *Minotaure's* glossy pages. "Although they were able to maintain the surrealist spirit in *Minotaure*," explains Brassaï, "they had to give up the combativeness that had once characterized their reviews. And that sumptuous publication . . . inaccessible to proletarian pocketbooks, could be addressed only to the despised bourgeoisie, to a milieu of titled and moneyed arbiters of taste, the first patrons and collectors of surrealist works." "Faced with the eternal alternative of surrealism: 'Go out in the street with a revolver in hand' or 'Go back into art,' " he goes on, "Breton and Éluard chose the second path. With *Minotaure*, there was no longer a 'radical break with the world' but rather the great entrance of surrealist art and poetry into the world and even into the world of high society."[38]

What above all set *Minotaure* apart from its predecessors *La Révolution surréaliste* (The Surrealist Revolution, 1925–29) and *Surréalisme au service de la révolution* (Surrealism in the Service of the Revolution, 1930–33) was the extravagance of its visual presentation. The surrealists were well aware of the irony of such a lavish production appearing in the depths of the Great Depression, but it did not deter them. "Although . . . this luxury itself constitutes a paradox for our epoch," wrote the editors in 1936, "we consider that THE EYE, in its quality as the first auxiliary of THE SPIRIT, demands to be satisfied."[39] Picasso designed the cover for the first issue, a seated Minotaur holding erect a phallic dagger; the authors of later covers, all of which were in full color, included Man Ray, Marcel Duchamp, Joan Miró, Salvador Dalí, Henri Matisse, René Magritte, Max Ernst, and André Masson.[40] *Minotaure* finally expired in the spring of 1939, less because of the darkening political situation in Europe than because Skira could no longer afford to produce it. "If in a few years time somebody wants to take stock of the underbelly [*dessous*] of our times, that is to say the preoccupations, the researches, the curiosities of these semi-secret groups who form the opinion the least exterior to an epoch, those who work in the shadows, who prepare the currents, influence the fashionable trends, confer value on the new men," wrote Edmond Jaloux, "it will be necessary for them to consult *Minotaure*."[41] He was probably right. Whatever misgivings Brassaï may have had about surrealism as a movement—or André Breton as a person—he, too, was in no doubt that *Minotaure* was "the best art review in the world," which contained "in germ, or already in full flower, everything that burst forth in art, poetry or literature twenty or thirty years later."[42]

"The Starry Castle" in due course found its way into *Mad Love*. Illustrating the sentence with which the text published in *Minotaure* ends—"On the

side of the abyss, made of philosophers' stone, the starry castle opens"[43]—was a postcard of Star Castle. Breton provided no clue as to what the photograph depicted or where the card came from; the image is cut loose from historical, geographical, and economic circumstance to drift off in poetic space, where it finds a new home among photographs by Brassaï, Henri Cartier-Bresson, and Man Ray. When Breton's text had originally appeared in *Minotaure* the connections of the starry castle with Bohemia, the disastrous engagement of 1620, and Czech memories were still more obscured. Breton's poetic peregrinations were accompanied by seven white-on-black frottages by Max Ernst. The last of them portrays a castle perilously perched above a void; behind it looms what is likely, from the context, the summit of Mount Teide in Tenerife. To those in the know, the silhouette of the building is unmistakably that of the old hunting lodge at Bílá hora; Ernst must have worked from Breton's postcard. Yet even as the renaissance outline remains its singular self the image steps out of place and time to transmute into something disturbingly other. The castle's planar walls are pierced by regular rows of strip windows in the best International Style.[44] It is a conjunction of antiquities and modernities I find unaccountably menacing—but more of that later.

A Choice of Abdications

Breton's lecture to the Left Front had more obviously contemporary concerns. His topic was "The Political Position of Today's Art." He began with what he described—not without eagerness—as "the hard, occasionally tragic, and at the same time exciting realities of this hour":

> On the one hand the reinforcement of the mechanism of oppression based on the family, religion, and the fatherland, the recognition of the necessity of man to enslave man, the careful underhanded exploitation of the need to transform society for the sole profit of a financial and industrial oligarchy, the need also to silence the great isolated appeals through which the person who up to now has been intellectually privileged manages, sometimes after a long space of time, to rouse his fellowmen from their apathy, the whole mechanism of stagnation, of regression, and of wearing down: this is night. On the other hand the destruction of social barriers, the hatred of all servitude (the defense of liberty is never a servitude), the prospect of man's right truly to dispose of himself—with all profits to the workers,

the assiduous attention to grasping the whole process of dissatisfaction, of moving rapidly forward, of youth, so as to grant it the greatest possible right to grasp the entire range of human demands, from whatever angle it presents itself: this is day.

"In this regard," he told his listeners, "it is impossible to conceive of a clearer situation." But just what this clarity of political alternatives meant for "today's leftist intellectuals, particularly poets and artists" was a good deal murkier. Since Stalin's rise to power in the Soviet Union the official communist movement had become increasingly hostile toward literary and artistic avant-gardes. Suspicious of "the good faith of innovating writers and artists who may be truly attached to the cause of the proletariat," Breton complained, "leftist political circles appreciate in art only time-honored, or even outworn, forms . . . whereas rightist circles are remarkably cordial, peculiarly friendly in this respect." In France, he reported, the communist daily *L'Humanité* "made a specialty out of translating Mayakovsky's poems into doggerel" even as "the royalist journal *L'Action française* is pleased to report that Picasso is the greatest living painter" while "with the patronage of Mussolini primitives, classic painters and surrealists were soon going to occupy the Grand Palais simultaneously in a huge exhibition of Italian art." Such improbable conjunctures—as the father of surrealism plainly regarded them—presented progressive writers and artists with a dilemma he would describe, he said, as "dramatic," were it not for the infinitely greater drama of the contemporary political situation itself:

> Either [artists] must give up interpreting and expressing the world in the ways that each of them finds the secret of within himself and himself alone—it is his very chance of enduring that is at stake—or they must give up collaborating on the practical plan of action for changing this world.[45]

The "choice between these two abdications"[46] was to preoccupy Breton for the rest of the year—if not for the rest of his life.

In an interview published a week later in the Prague communist paper *Haló-noviny* (Hello-News) Breton remained adamant, as he had for a decade, that "the authentic art of today goes hand in hand with revolutionary social activity; like the latter, it leads to the confusion and destruction of capitalist society." That is why, he explained, "Hitler has understood that in order to strangle the thought of the left it is necessary not only to persecute

Marxists but also to prohibit all *avant-garde* art."[47] The Führer did indeed make that link, notwithstanding Stalin's equally vigorous persecution of the Soviet avant-garde on grounds of its "monstrous formalism"—or, come to that, Mussolini's patronage of the Italian futurists, who for their part found no difficulty in reconciling their undeniably avant-garde art with fascism. Since coming to power two years earlier the Nazis had forced the Bauhaus to close, purged the universities, and driven many of the most prominent artists and intellectuals working in Germany into exile. Oskar Kokoschka, Wassily Kandinsky, Paul Klee, Bertolt Brecht, Fritz Lang, Walter Benjamin, Kurt Weill, Walter Gropius, John Heartfield, George Grosz, and Heinrich and Thomas Mann were among those who had fled the Third Reich already. Kurt Schwitters, Marcel Breuer, Lyonel Feininger, Laszlo Moholy-Nagy, and Mies van der Rohe would soon follow them—though not, in Mies's case, before he had exhausted all possibilities of accommodating his architecture to the regime. The last director of the Bauhaus and creator of the legendary Barcelona Pavilion at the World's Fair of 1929—"perhaps the supreme example of architectural design of the decade of the twenties," according to Henry-Russell Hitchcock in *The International Style*[48]—was one of those who signed a declaration of support for the Führer in 1934 following the Night of the Long Knives in which Hitler murdered Brownshirt leader Ernst Röhm and purged his party of its troublesome left wing.

Europe in the 1930s was not a time or a place in which poets and artists could afford to ignore politics, whatever their own political commitments— or, as was perhaps more often the case, their lack of them. Not that André Breton would have wanted to. He had despised "art for art's sake" since his Dadaist youth, when together with Philippe Soupault and Louis Aragon (Paul Éluard would join the team a few months later) he founded the magazine *Littérature* in March 1919.[49] All the same, he went on to tell his audience at Prague City Library, art could never allow itself to become the mere servant of a political cause without betraying its very essence:

> The fact is that art, somewhere during its whole evolution in modern times, is summoned to the realization that its quality resides in imagination alone, independently of the exterior object that brought it to birth. Namely, that *everything depends on the freedom with which this imagination manages to express and assert itself and to portray only itself*.... There are still a great many of us in the world who think that putting poetry and art in the exclusive service of

an idea, however much that idea moves us to enthusiasm by itself, would be to condemn them in a very short time to being immobilized, and amount to sidetracking them.[50]

This insistence on reconciling the apparently contradictory imperatives of political engagement and artistic freedom was (and would remain) the leitmotif of Breton's politics. It also lay at the heart of the "perfect intellectual fellowship" he believed he had discovered in Prague.

Surrealismus v ČSR (Surrealism in the Czechoslovak Republic), the manifesto with which the Czechoslovak Surrealist Group announced its formation on 21 March 1934, opened with the words: "A specter is haunting revolutionary Europe—fascism." The echo of the opening line of Marx and Engels's *Communist Manifesto* would have been lost on few of its readers. The proclamation was written by Vítězslav Nezval and signed (among others) by Jindřich Štyrský, Toyen, Vincenc Makovský, Jindřich Honzl, the poet Konstantín Biebl, the composer Jaroslav Ježek, and the young psychoanalytic theorist Bohuslav Brouk. Karel Teige welcomed the foundation of the group in the magazine *Doba* (Time), which he edited, with the caveat "Although I am not a member of the surrealist group and do not consider myself a surrealist, this is not because I am unsympathetic to surrealism but because I do not identify with its ideology. I consider it my duty to cooperate with the surrealists, as with all the groups of the left intellectual front, in actions relating to social interests and tendencies, especially in questions of dialectical materialist art-sciences [*uměnovědy*]."[51] He failed to mention his longstanding quarrel with Jindřich Štyrský, with whom he had publicly fallen out in 1930.[52] The two men patched up their differences shortly afterward and Teige joined the group for which, along with Nezval, he was soon to become the leading spokesman.

The surrealists' manifesto was prefaced by two letters, which were reproduced verbatim. The first, from Nezval to Breton, had been written from Paris on 10 May 1933, the day after the two men's meeting at the Café de la place Blanche, and published in *Surréalisme au service de la révolution* a few days later. It had precious little to say about art. What had brought the Czechs finally to embrace surrealism, said Nezval, was a shared understanding of "Marx-Leninism and dialectical materialism":

> If the materialist dialectic enables both of us not to see any
> lasting conflict between reality and surreality, content and
> form, conscious and unconscious, activity and dream, if we
> both do not see any absolute contradiction between evolu-

tion and revolution, invention and tradition, adventure and order, necessity and chance, why should we continue without closer cooperation with surrealism, which was the first of the world's avant-gardes to discover, in the most classical fashion, the point at which these contradictions can be dialectically unified—the idea of surreality?[53]

This conception, Nezval continued, set both the French and the Czech surrealist groups apart from "the vulgar Marxist tendency" of "the official communist leadership." It did indeed. Few Marxists and fewer communists of the day would have imagined "the idea of surreality" as the cornerstone of a dialectical materialist worldview (though Walter Benjamin sometimes came close).[54] The second letter, dated 19 March 1934, was nevertheless addressed to the Agitprop section of the Communist Party of Czechoslovakia (Komunistická strana Československa, hereafter KSČ). It announced the Czech surrealists' readiness to put themselves at the service of the proletarian class struggle "in writing, speech, drawing, painting, the plastic arts, theater, and life itself"—a commitment it reckoned to be "the first success of surrealism in Czechoslovakia." Nezval was careful to add that while the group would refrain from "superfluous polemics" against left-wing writers who used "conventional methods" in their work, it would safeguard its "right to the independence of its own experimental methods."[55] It was a strange beginning, and a still stranger "first success" for a group of painters and poets—but no stranger than the times in which they found themselves.

The Czechoslovak Surrealist Group held its first public exhibition at the Mánes Gallery in January 1935, three months before Breton and Éluard's visit to the city. "In front of the doors of the first exhibition of Czechoslovak Surrealists, above the entrance to the exhibition hall in which the paintings, sculptures, photographs and montages of Toyen, Jindřich Štyrský, and Vincenc Makovský are installed," proclaimed Karel Teige's preface to the catalogue, "there should be placed a sign reminding us that":

> SURREALISM IS NOT AN ARTISTIC SCHOOL.
> To surrealists, art, painting, poetry, and theatrical creation and performance are not the aim, but a tool and a means, one of the ways that can lead to the liberation of the human spirit and human life itself, on condition that it identifies itself with the direction of the revolutionary movement of history. . . . The philosophy and worldview of surrealism are dialectical materialism . . . and if surrealists

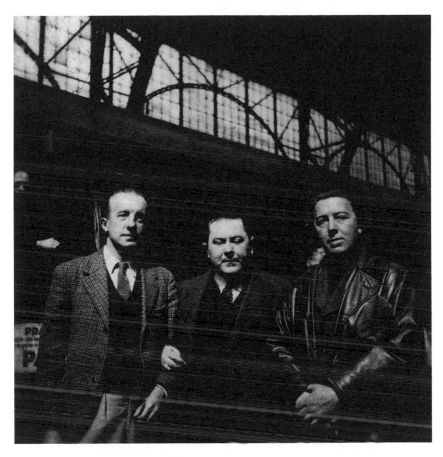

FIGURE 1.2. Paul Éluard, Vítězslav Nezval, and André Breton, Prague, 1935. Unknown photographer. Památník národního písemnictví, Prague.

pronounce the word REVOLUTION, they understand by it exactly the same thing as the followers of that social movement which is founded upon the dialectical materialist worldview.[56]

Such a gloss was perhaps called for, since a Marxist political message was far from immediately apparent from the works on display in the exhibition. Štyrský served up collages from his *Portable Cabinet* (*Stěhovací kabinet*) series in which hams waltz away on stockinged legs and shoes make love over bathtubs, while his photographs documented the assortment of masks, coffins, prostheses, busts, palmists' charts, music boxes, fat ladies, and fallen an-

gels that might be met with on a surrealist *dérive* through any small town in Bohemia on a deserted Sunday afternoon.[57] We are light-years away from the socialist realism favored by the cultural commissars of the communist movement.

Breton would soon irrevocably part company with the French Communist Party (Parti communiste français, hereafter PCF), which he had joined with Éluard, Aragon, Pierre Unik, and Benjamin Péret in January 1927 only to be expelled together with Éluard in 1933. He made his disagreements clear in the pamphlet *The Time When the Surrealists Were Right*, which was published in the fall of 1935, a few months after his return from Prague. His concerns by this time went well beyond the freedom of the artist to paint the products of the imagination. The tract, which was adopted on July 2 at a meeting of the entire Paris surrealist group at the house of Maurice Heine—an expert on the Marquis de Sade—ended with an open condemnation of "the present regime of Soviet Russia and the all-powerful head under whom this regime is turning into the very negation of what it should be and what it has been. We can do no more than formally notify this regime, this chief, of our mistrust."[58] Besides Breton and Éluard the twenty-six signatories to this parting of the ways included Max Ernst, Salvador Dalí, Dora Maar, René Magritte, Benjamin Péret, Meret Oppenheim, Man Ray, and Yves Tanguy. Nezval, who was visiting Paris with Štyrský and Toyen at the time, was present at the July 2 meeting, but after considerable discussion the Czech surrealists declined to endorse the published text of the declaration. The grounds on which they excused themselves would only serve to reinforce Breton's wishful thinking about the magic capital. Although, Nezval wrote, he personally would be prepared to sign "your admirable manifesto" without hesitation, to do so would jeopardize "relations between the group and the Communist Party, which grants the group freedom of opinion."[59] Breton could only envy the Czechs.

The Time When the Surrealists Were Right was reprinted in November 1935 in *The Political Position of Surrealism* together with Breton's *Haló-noviny* interview and both his Prague lectures, which he clearly regarded as important programmatic statements.[60] The Paris surrealists were among the first left-wing intellectuals in Europe to come out openly against Stalin's dictatorship; this was before the infamous Moscow trials, which began the next year (and would also be forthrightly condemned by Breton). In 1938, pursuing his dreams to their rainbow's end, the surrealist leader visited Mexico and coauthored a manifesto titled "For an Independent Revolutionary Art" with the exiled Leon Trotsky—who signed himself, to avoid legal complications,

under the name of Diego Rivera. While the manifesto acknowledged that "for the better development of the forces of material production, the revolution must build a socialist regime with centralized control," the architect of the Red Army and the father of surrealism insisted that "to develop intellectual creation an anarchist regime of individual liberty should from the first be established. No authority, no dictation, not the least trace of orders from above!" "To those who urge us, whether for today or tomorrow, to consent that art should submit to a discipline which we hold to be radically incompatible with its nature," they proclaimed, "we give a flat refusal and we repeat our intention of standing by the formula *complete freedom for art*."[61] Two years later, in what would become one of the defining images of the twentieth century, Trotsky died at the hands of a Stalinist assassin, an icepick buried in his skull.

It was a difficult, perhaps an impossible tightrope Breton was trying to tread—*the coupling of two realities that apparently cannot be coupled on a plane that apparently is not appropriate to them*, we might very well think. But for a brief moment Prague seemed to offer a dissection table upon which these seeming antinomies could make love. The KSČ journalist Záviš Kalandra warmly welcomed Breton and Éluard's addresses to the Left Front in *Haló-noviny*, applauding the surrealists for "not wanting to degrade their poetic activity to . . . agitational doggerel."[62] Kalandra had been equally appreciative of *Communicating Vessels*, whose Czech translation he had reviewed for *Doba* three months earlier. "The Marxist critics who condemn surrealism," he explained, "[would] be right if in his study André Breton had separated the human individual in his 'eternal' subjectivity from the historically and class conditioned individual in his process of ceaseless social change. But Breton never made these mistakes. On the contrary: *Communicating Vessels*—this is the *fundamental thesis* of the book and in this lies its *scientific activity*." The critics failed to comprehend that "in this marvelous *poetic* book of surrealism there is a *scientific* act."[63] Breton and Éluard were astonished to find such understanding among the self-appointed vanguard of the proletariat, and what—they imagined—they saw in Prague gave sustenance to their dreams of reconciling their revolutionary politics with their revolutionary art.

It was this prospect that had drawn Jacqueline Lamba, who had found the leftist meetings she had attended as a rebellious teenager "utterly routine in character, elementary, and gray,"[64] to surrealism—and André Breton—in the first place. Whatever role *hasard objectif* may have played in their meeting, it was Jacqueline herself who had sought André out, "*scandalously* beautiful,"

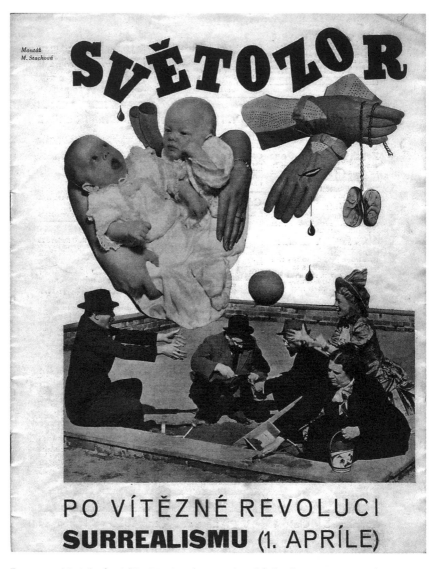

FIGURE 1.3. Marie Stachová, "Po vítězné revoluci surrealismu" (After the Victorious Surrealist Revolution). Photomontage cover for *Světozor*, 1 April 1935. Archive of Jindřich Toman.

he says, as she entered the Café Cyrano where she knew she would find him.[65] Lamba was indeed "the all-powerful commander of the night of the sunflower," as Breton called her in *Mad Love*.[66] The idea and venue had been suggested to her by Dora Maar, a close friend from her student days, who later contrived to meet her own lover Picasso in the same way at Les Deux Magots

on the Boulevard Saint-Germain.[67] This was the same café where Georges Bataille and the poet Robert Desnos had dreamed up "A Corpse."[68] The Cyrano has since been replaced by a burger bar but Les Deux Magots is still there, peddling coffees at inflated prices to literary tourists, though the square on which it stands is now named after two of its later regulars, Jean-Paul Sartre and Simone de Beauvoir.

"This trip is a revelation," wrote Éluard from Prague to Gala, who was by then Señora Salvador Dalí—a circumstance that did not prevent Paul from passionately corresponding and occasionally sleeping with his ex- for (almost) the rest of his days. "Ma belle petite Gala," he began:

> There are several very good people here: first of all Nezval and Teige—two painters: Štyrský and Toyen—a very curious woman—they make magnificent paintings and collages—a sculptor: Makovský. But although there are not many of them, their radiance and influence are so great that they are obliged constantly to restrain them, discourage them. Their situation in the Communist Party is exceptional. Teige edits the only communist periodical in Czechoslovakia. In every issue there are one or more articles about surrealism. They were at the Writers' Congress in Moscow and defended surrealism tooth and nail. They are true poets, full of heart and originality.... Our photos in the magazines, the laudatory articles in the communist newspapers, the interviews, I believe that for us Prague is the gate to Moscow.[69]

Breton and Éluard can be forgiven for believing what they read in the papers. Even the popular illustrated magazine *Světozor* (World Outlook) ran a special spread to coincide with the visitors' presence in the city—though it also coincided with April Fools' Day—illustrated with erotic collages by Marie Stachová titled "The Victory of the Surrealist Revolution."[70] With its unexpected confluence of delights of the past and promises of a future in which Marx's "transformer le monde" and Rimbaud's "changer la vie"[71] seemed capable for once of fusing into a single poetic-revolutionary imperative, the Bohemian capital seemed the city of surrealist dreams.

After the visitors, laden down with parting gifts of canvases from Toyen and Štyrský, had boarded their train for Zurich—where Breton reprised his Mánes lecture, he wrote Nezval, to "apathetic and unapproachable people, who interested me only in their contrast with you"[72]—Nezval went first with Teige, Štyrský, and Toyen to the Café Elektra, and then on to the Metro cof-

fee house. "I'm sad," he confessed. "I write my diary."[73] Éluard, too, found Paris "cold and sad" on his return, notwithstanding the waiting charms of his own bride, Nusch.[74] A month later Jindřich Honzl directed the world premiere of Breton and Aragon's *Le Trésor des Jesuites* (The Jesuits' Treasure, 1928)—a drama for which its authors had not been able to secure a venue in Paris—at the Nové divadlo (New Theater), along with a shorter play of Nezval's in what was billed as a "Surrealist Evening." Jaroslav Ježek provided the music. Dominating Štyrský's set design was an enormous naked female torso—another sign of the times, of a sort. "The whole surrealist atmosphere of the Evening was excellent," Nezval excitedly wrote Éluard. He added: "We were well received in the communist press."[75] Breton penned Nezval what was very much more than a merely formal letter of thanks as soon as he got home. The city on the Vltava had left an indelible impression on him. "My dearest friend," he began, "all the time I was in Prague, I was aware of my happiness." "Often," he recalled,

> in the mornings, before we met up for lunch, I would look out of the window of the room at the rain as beautiful as the sun over Prague and I would enjoy this very rare certainty that I would take away from this city and from you all one of the most beautiful memories of my life.... You know, don't you, that I am completely behind you, that I would do *everything* for you, that you are my best friends. You are men. When I think of intelligence, of beauty, of nobility, of the future, your faces will be the first that appear before me.[76]

These words would in time come back to haunt him, as we shall see. But not for a long while yet.

2

Zone

On the other side of the world is Bohemia
A beautiful and exotic land
Full of deep and mysterious rivers
Which you cross with dry feet in the name of Jesus

KONSTANTÍN BIEBL, *S LODÍ, JEŽ DOVÁŽÍ ČAJ A KÁVU*[1]

LE PASSANT DE PRAGUE

It must have been around this time that Ditie, the diminutive hero of Bohumil Hrabal's novel *Obsluhoval jsem anglického krále* (*I Served the King of England*, 1971), became a waiter at the Hotel Paris (Hotel Paříž) where Breton, Lamba, and Éluard stayed during their time in Prague. Built in the first decade of the twentieth century, the hotel was lovingly restored to its original art nouveau glory after the Velvet Revolution that brought to an end forty-two years of communist rule in Czechoslovakia in November 1989. The building was "so beautiful," the boy relates, "it almost knocked me over. So many mirrors and brass balustrades and brass door handles and brass candelabras, all polished till the place shone like a palace of gold." Ditie learned his trade from the maître d' Mr. Skřivánek, who had once served the King of England. Gradually, he tells us, he "gained the confidence of the young ladies who waited in the café until the exchange closed and then went down to the private chambers, and it didn't matter whether it was eleven in the morning or late afternoon or dusk or late at night, because at the Hotel Paris the lights

were always on, like a chandelier you've forgotten to switch off." In what the girls called the Clinic or the Department of Internal Medicine or Diagnostics 100:

> The older brokers would laugh and make jokes and treat the undressing of a young woman as a collective game of strip poker, removing her clothes little by little, right on the table, while they sipped their drinks from their crystal champagne glasses and savored the bouquet. The girl would then lie back on the table, and the old brokers would gather around her with their glasses and plates of caviar and lettuce and sliced Hungarian salami, and they'd put on their spectacles and study every fold and curve of her beautiful female body, and then, as if they were at a fashion show or a life-study class in some academy of art, they'd ask the girl to sit, or stand up, or kneel, or let her legs dangle from the table and swing back and forth as if she were washing them in a stream ... their animation was like the animation of a painter transferring what excites him in a landscape to his canvas, and so these old men would peer through their glasses at the crook of an elbow, a strand of loose hair, an instep, an ankle, a lap, and one would gently part the two beautiful cheeks of her behind and gaze with childish admiration at what was revealed, and another would shriek in delight and roll his eyes to the ceiling, as if thanking the Lord Himself for the privilege of peering between the open thighs of a young woman and touching whatever pleased him most with his fingers or his lips.[2]

His mind on higher things, Breton seems to have noticed nothing at the Hotel Paris that was out of the ordinary. But then again, perhaps it was not. Paul Éluard did write Gala that Prague was full of "beautiful women, very welcoming." "A very curious city" he added, "that Apollinaire saw well. Mad."[3]

Guillaume Apollinaire, who by coincidence was the first to coin the term *sur-réalisme* in his play *Les Mamelles de Tirésias* (*The Breasts of Tiresias*, 1917),[4] would have been less likely to overlook the *érotique* hiding behind the veils of the hotel's elegant façades. Two decades before Breton and Éluard visited the city Prague found its way into his most famous poem "Zone," the opening work in *Alcools* (*Alcohols*), published in 1913. An unpunctuated composition that dazzles with its constant shifts of rhythm and cascades of

images, "Zone" is a cornerstone of literary modernism—the unmistakably impatient voice of the infant twentieth century making as rude an entrance into the salons and drawing rooms of old Europe as the Fauves spattering their colors at the 1906 Salon d'Automne and the prostitutes Picasso painted the following year in *Les Demoiselles d'Avignon*, modeling their bodies on ancient Iberian statuary and their faces on African masks. Apollinaire's poem begins in a vigorous, bustling Paris where all is movement and modernity:

> The directors the workers and the beautiful secretaries
> Pass from Monday morning to Saturday evening four times daily
> Three times every morning the siren groans
> Around noon a rabid bell barks
> Inscriptions on the walls and the billboards
> The nameplates the posters squawk like parakeets . . . [5]

On what might as well be the other side of the world lies a soft-focus, languorous Prague, an alternating pole for a continent conjured up from the memory of a brief visit Apollinaire made to the city during the first week of March 1902. He was still Wilhelm Kostrowitzki then, the illegitimate son of a Polish mother and an unknown father born in Rome and brought up in Monaco and Nice, a twenty-one-year-old backpacker making his way around Cologne, Berlin ("a horrible as well as a nice town"),[6] Vienna, Munich, and other cities of German *Mitteleuropa*. In all probability he did not get to Brno—or Brünn, as it was better known in those days—as some have mistakenly inferred from his writing, and therefore missed seeing the Brno dragon. "I often asked him about this journey," writes his friend André Billy, "but I was never able to get any details out of him. He traveled mostly on foot, without money, and during his two-day stay in Prague lived on Camembert."[7] It was more likely the local soft cheese Hermelín, but no matter. The poem slows, staccato gives way to legato, and time's very trajectory alters:

> The hands on the clock in the Jewish Quarter run
> backwards
> And you too go backwards in your life slowly
> Climbing Hradčany in the evening listening
> In the pubs the singing of Czech songs . . . [8]

These fleeting images distill the itinerary of a longer story Apollinaire wrote in the year of his visit, retaining only what seems to be its essence, as is the way with memory. It is interesting what gets poeticized away.[9] Published in June 1902 and reprinted in 1910 as the opening piece in *L'Hérésiarque et*

Cie (*The Heresiarch and Co.*), "Le Passant de Prague" ("The Prague Pedestrian," also known in English under the title "The Wandering Jew") is narrated in the first person as if it were a straightforward piece of travel reportage. The story begins matter-of-factly enough in what is recognizably a modern city. Apollinaire arrives by train from Dresden at the Franz-Josef Station—which was later to be renamed the Woodrow Wilson Station, and later still simply Hlavní nádraží, or Main Station—leaves his suitcase at the left luggage and sets off in search of a cheap hotel. Asking passersby for information in German, he is surprised first by their incomprehension and then to get the smiling response, in French: "Speak French, Sir, for we hate the Germans even more than the French do. We detest a race that forces its language on us, profits from our industries and our fertile soil which produces everything: wine, fine jewels, precious metals—everything, except salt. In Prague we speak only Czech. But when you speak French those who know the language will answer you with pleasure."[10] The poet is directed to a hotel on Na poříčí—Vítězslav Nezval was later convinced it was the Hotel Bavaria[11]—whose ground floor is occupied by a *café chantant* where, the old woman who runs the place assures him, he may "easily find a female companion." Going out for a walk he asks another stranger for information and is once again answered in French. The man, who "seemed to be about sixty years old, though still in his prime," with a well-turned muscular calf, turns out to be none other than the Wandering Jew, Ahasuerus himself—though the old man preferred, he said, to be known by the name Isaac Lacquedem. Last year he had passed through Paris, where Apollinaire had seen his name chalked on a wall of the rue de Bretagne from the top of a bus on the way to the Bastille. Ahasuerus offers to show the young man "the beauties and sights of Prague."[12]

Drawing his guest's attention first to the unusual house signs that were to make such an impression on Éluard and Breton—the Virgin, the Eagle, the Knight—the Jew leads him through the Old Town Square, pointing out the twin-towered gothic Týn Cathedral whose "walls still bear the bullet marks of the Seven and the Thirty Years' Wars" and the astronomical clock on the Old Town Hall where "Death, pulling on the rope, rang the bells, nodding his head. Other statues danced, while a cock flapped its wings; and the twelve Apostles passed by an open window, gazing impassively into the street below."[13] The crowing cock was a nineteenth-century addition to the medieval horologe, but Apollinaire was not to know that. They pass on through the Jewish Quarter, where they visit an ancient synagogue forbidden to women (Apollinaire does not name it, but it must have been the Old-New Synagogue, built in the last decade of the thirteenth century), across Charles

Bridge with its melancholy parade of baroque statues, and up the long hill, presumably by way of Neruda Street (Nerudova ulice)—as the winding thoroughfare was renamed in 1895 after the Czech writer Jan Neruda, who lived there from 1845–59 at the House of the Two Suns—to the castle. There Apollinaire has the disturbing experience, which also makes its way into "Zone," of seeing his own face "with its somber jealous eyes" traced in one of the agates that stud the wall of the Saint Wenceslas chapel in Saint Vitus's Cathedral. Saint Wenceslas, or Svatý Václav as he is known in Czech—the same Good King Wenceslas who looked out on the feast of Stephen in the English Christmas carol—is the patron saint of Bohemia. Murdered by his brother (and successor) Boleslav I in 929, or possibly 935, it was Václav who built the earliest church of Saint Vitus on Hradčany.

Towering over the castle and the city, the present cathedral was begun in the time of "Father of the Homeland" (*Otec vlasti*) Charles (Karel) IV, the Holy Roman Emperor who ruled Bohemia from 1346–78. The choir, the bell tower, and the surrounding chapels are the work of the gothic architects Mathias of Arras and Peter Parler, but like much else in Prague the building hides its modernities behind an antique façade. The building was officially "completed" only in 1929, miraculously coinciding with what may or may not have been the thousandth anniversary of Wenceslas's martyrdom but in any event presented a fine opportunity for the state that had been a mere ten years on Europe's map to orchestrate a grand celebration of "our thousand-year culture."[14] The nave, the twin western towers, and many of the stained glass windows are modern. Max Švabinský's monumental "Last Judgment" displays the same reverence for the naked female form, especially when viewed from the rear, as the countless etchings and lithographs of satyrs chasing nymphs, goddesses draped over clouds, and Adam and Eve frolicking in paradise that he produced over a career spanning the 1890s to the 1960s.[15] Shimmering in florescent blues and greens, Alfons Mucha's window (which was sponsored by the Slavia Bank) pays no less pagan homage to Saints Cyril and Methodius, the Byzantine missionaries who brought Christianity to the Czech Lands in the ninth century—this being the same Alfons Mucha who wowed Paris with his posters of Sarah Bernhardt in *Gismonda* on New Year's Day 1895 and whose name, rendered as Alphonse, soon became synonymous with the soft forms and sinuous lines of the artistic style that was variously known across *fin de siècle* Europe as Jugendstil, Secession, or art nouveau.

The one-armed photographer Josef Sudek brought out the incongruities of this twentieth-century gothic beautifully in his book *Svatý Vít* (Saint Vitus's), which was published to great acclaim by Družstevní práce (Coopera-

tive Labor) in 1928.[16] Founded in 1922, Družstevní práce was an artists and designers' cooperative. It boasted 11,000 members by the end of the decade; its first book was the communist novelist Marie Majerová's *Nejkrásnější svět* (The Most Beautiful World). From an avant-garde publishing house the coop expanded into home furnishings, opening a chain of Krásná jizba (The Beautiful Room) stores in Prague, Bratislava, Brno, Pardubice, and other towns. The chain's aspiration, in the words of its artistic director Ladislav Sutnar, was "to sell objects that are well-made, both in terms of artistic value and craftsmanship."[17] The beauty in question was to be thoroughly modern: Krásná jizba products were distinguished by an uncompromising functionalist ethos and an austere modernist aesthetic, which are not always quite the same thing. Highlights of the range included glass and porcelain tableware by both Sutnar himself and Adolf Loos and Antonín Kybal's brightly colored abstract carpets. Sudek did some stunning advertising work for Družstevní práce, using all the tricks of the photographer's trade to transmute Sutnar's tea services into concrete poems that were models of light, air, and clarity. He also exposed the unexpected beauties of gloves, buttons, belts, ashtrays, a jar of Nova Pickles, and the chance encounter of a bowl of soup, a hunk of bread, and a glass of water on a wooden tabletop.[18]

Though *Svatý Vít* is recognizably the work of the same photographer it has a very different feel. The portfolio of fifteen photographs, which was printed in a limited, signed edition of 120 copies, forms "a majestic and grand, spiritual and patriotic album," writes Anna Farová, which "contains the best elements of Sudek's work: monumentality as well as intimacy, luminosity as well as absolute perfection of composition, atmosphere as well as spiritual inspiration, the resplendence of the surroundings as well as the importance of detail and fine tonal harmony." The photographs, she adds, also show "the builders of the cathedral, which in a figurative sense Sudek himself was, the construction workers. Details of the cathedral under construction, formless building materials in an organized space, heterogeneous objects like rope, a wheelbarrow full of sand, a beer-mug beside somebody's packed lunch, tools scattered about, all bring to life the antiquity of the living present."[19] It is a perceptive comment—though we might equally well say that what these images bring to life is the eternally provisional nature of the past. Like all photographs they freeze an instant in time, but it is impossible to pin down precisely what time it is. As for architecture, is that discipline not always figurative, an organization not only of formless building materials but the equally plastic spaces of the mind? What fascinated Sudek in the renovation of the cathedral was the simultaneity of "the prodigious atmosphere of

FIGURE 2.1. Josef Sudek, advertising photograph: Ladislav Sutnar, Glass plates, Goldberg (?), 1930–32. Photo Josef Sudek © Anna Fárová heirs. Photo new print 2003 © Vlado Bohdan, Institute of Art History, Academy of Sciences of the Czech Republic, v.v.i.

things and then their muddle." Like Baudelaire's painter of modern life he glimpsed the imprint of eternity in the fleeting moment.[20] "And suddenly I knew that here is something," he told Jaroslav Anděl in 1976. "You see, it made a greater impression on me as a still life than as architecture. . . . I said to myself: 'Holy, this is something!'"[21]

Sudek left his other arm in Italy, a casualty of Austrian friendly fire during World War I—which did not stop him from perching perilously atop a ladder in Saint Vitus's waiting "with Japanese patience for sunshine and shadows so that he could bestow objects with magic according to his conception of things. He would wait long hours," records his childhood friend and fellow-photographer Jaromír Funke, and "come back again and again—for weeks and months." Funke particularly appreciated Sudek's eye for "uncustomariness seen anew and well turned," which he found much preferable to the fashionable artistic trickery of photomontage.[22] Thirty years later Sudek would lug a nineteenth-century Kodak panoramic plate camera around the industrial wastelands of northern Bohemia so that he could capture the enormity of its ecological devastation without modernist distortion. Turning his back on the strong geometries, sharp focuses, and heightened contrasts with which Funke, Jaroslav Rössler, Eugen Wiškovský, and others among his interwar contemporaries had dramatized the machine age, Sudek shot his 1957–62 series *Smutná krájina* (*Sad Landscape*) entirely in natural light, eschewing all zooming or cropping, and reproduced his images through contact prints that present every detail of the vast polluted landscape in minutely graduated shades of gray.[23] "Here is the silence of an unnatural landscape beneath a sky struck dumb with horror," comments the Czech critic Antonín Dufek; "It is a parable for the dead end that is 'rational' civilization, a metaphor that presents the other side of humanism."[24]

Who knows where Sudek got his reverence for the prodigious atmosphere of things? But World War I may have left its ghostly mark on his technique, as it did in varied ways on the bodies and minds of an entire generation of European artists. "I saw death," he wrote to his friend Petr Helbich following the amputation of his arm in the summer of 1917:

> I got a high fever. It was in the night, I remember. Above me a gas lamp was burning, fizzling very strangely. Suddenly the door opened across from my bed and a headless figure entered, or maybe she had a head all in white bandages, and a body as if in sheets. I knew it was death. I grabbed a glass from the bedside table and hurled it at the

figure. I yelled: I don't want to die! The glass shattered, the
figure disappeared, and the sister came running in to see
what I was playing at. In the morning the fever had gone.[25]

"I had to leave the chapel," Apollinaire continues. "I was pale and distressed
to have seen myself as a madman, I, who am so afraid of becoming one."
Ahasuerus promises him no more monuments. Instead they return to the
Old Town "by way of another, more modern bridge."[26] It was probably the
Bridge of the Legions (Most legií), which was built on the site of an earlier
suspension bridge in 1898–1901. Whatever Apollinaire might have thought,
the bridge's modernity did not spare it from encounters as supernatural as
Sudek's. Leaning over the parapet one night as the clock in Saint Vitus's was
striking twelve, Vítězslav Nezval met a gambler intent on suicide—or so he
claims in "Edison," one of his best known poems, published in 1928. "Hand
in hand in an open-eyed dream," the two men walked silently together
"past the sad kiosks of alcoholics" to Nezval's lodgings in Košíře, a suburb
that begins "where the city ends." "There was something heavy stifling
breath / anxiety and sadness over life and death," runs the poem's nagging
refrain. When Nezval unlocked his door and switched on the light there
was not a shadow of the gambler to be seen, leaving the poet uncertain as to
whether his companion had been a phantom or an illusion.[27] It is not an
uncommon problem in these parts: uncertainty seems built into the very
stones. At the time of Apollinaire's visit the Bridge of the Legions still bore
the name of the Habsburg Emperor Francis I. It metamorphosed into the
Smetana Bridge during the Nazi occupation of 1939–45 and the First of
May Bridge under the communists. Today it once again commemorates the
Czechoslovak Legions formed of exiles, prisoners of war, and deserters who
fought on the Allied side during World War I, even though the state for
whose independence they struggled ceased to exist at midnight on 31 De-
cember 1992. The old-new name of Most legií, which was first given in 1919
in the heady aftermath of Czechoslovak independence, had been restored
just two years earlier.

Our *passants* find a pub and dine on "goulash with paprika, fried potatoes
sprinkled with caraway seeds, [and] bread with poppy seeds," washed down
with "bitter Pilsner beer." One could have the same meal, likely as not in the
same pub, today, though whether it would still be located on the same street
is another matter. The band strikes up the *Marseillaise* in honor of their Gal-
lic visitor. Crossing "the great rectangular square called the Wenzelplatz, the
Vichmarkt, the Rossmarkt or the Václavské náměstí"—or as it is known in

FIGURE 2.2. Josef Sudek, "Svatý Vít" (Saint Vitus's Cathedral), 1926–27. © Anna Fárová heirs.

English, Wenceslas Square—they wind up back in the Jewish Quarter, where Ahasuerus invites his guest to partake of Prague beauties and sights of a different ilk. Apollinaire was no prude—his "paroxysmic and jovial"[28] *Onze mille verges* (*Eleven Thousand Rods*, 1907) is a worthy precursor in the pantheon of twentieth-century surrealist pornography to Georges Bataille's *Histoire de l'oeil* (*Story of the Eye*) and Louis Aragon's *Le Con d'Irène* (*Irene's Cunt*), both of which were published in 1928, the same year as Breton's *Nadja*.[29] Apollinaire's sexual tastes ran in the same direction as those of another French interwar avant-garde writer, Pierre Mac Orlan, who supple-

mented his day-job with nocturnal digressions like *The Countess of the Whip,
Beautiful and Terrible* and *The Beautiful Clients of M. Brozen and the School-
master, with a Selection of Letters Concerning Curious Facts Touching on the
Flagellation of Misses* [English in the original] *and Women*.[30] The poet would
thoroughly have enjoyed Czech Easter Mondays, given his repeated prom-
ises to reduce his lover Louise de Coligny's bottom to "a *mélange* of raspberry
and milk" if she did not stop masturbating in his absence in the army, a pros-
pect that only seems to have made Lou *faire la menotte* all the more.[31] But he
declines his host's "tempting offer" to visit the quarter of the Royal Vineyards
where, Ahasuerus tells him, "one can find young girls of fourteen or fifteen
whom the pedophiles themselves would find to their taste."[32] This upscale
district was one of many Prague suburbs that mushroomed during the later
nineteenth century.[33] It used in those days to be called Královské Vinohrady.
The communists dropped the "Královské" (Royal) in 1948.

The Vinohrady *fillettes* aside—perhaps, although there are plentiful bro-
chures to be found in the lobbies of Prague hotels nowadays advertising the
company of gorgeous young "studentky"[34] by the hour—Apollinaire's whis-
tle-stop tour of the city is pretty much what has since become the standard
tourist trail. But tourists are easily misled; and the more so, perhaps, if they
are of a literary disposition. Like the glitz and glitter of the Hotel Paris the
delights of the past may not always be as straightforward as they seem. The
peculiar clock that made its way into "Zone" adorns the Jewish Town Hall in
what for centuries used to be the walled ghetto. It seems to hold a particular
fascination for poets. Blaise Cendrars was struck by its metaphorical possi-
bilities too, imagining that "the world, like the clock of the Jewish Quarter in
Prague, desperately revolves backwards."[35] So was Philippe Soupault, co-
founder with Breton and Louis Aragon of *Littérature* and coauthor with
Breton of the first "automatic" novel *Les Champs magnétiques* (*The Magnetic
Fields*), published in 1920. Soupault baptized the timepiece "the clock of
memory" in a poem he wrote after his own trip to Prague in 1927. "To Prague"
(*Do Prahy*), as the poem is called, opened the first issue of Karel Teige's jour-
nal *ReD* (1927–30), the most important magazine of the Devětsil group that
dominated the city's avant-garde scene throughout the 1920s.[36] *ReD*'s title is
a contraction of *Revue Devětsilu* (Devětsil Review), but its pun on the Eng-
lish-language color of revolution was no coincidence. The clock's hands in-
deed do revolve counterclockwise, following the Hebrew numbers round the
face. Whether they go backward, on the other hand, depends entirely upon
the vantage point from which they are being viewed.

THIS LITTLE MOTHER HAS CLAWS

The ghetto walls came down early in the nineteenth century, and the Jewish Town (Židovské město), as it had always been known, was legally incorporated into the city at whose geographic center it lies in 1850. It joined the Old Town (Staré město), the New Town (Nové město, founded by Charles IV in 1348), the Little Quarter (Malá Strana), and Hradčany (the castle neighborhood) to become Prague V, the so-called Fifth Quarter. The district was concurrently renamed Josefov in memory of the modernizing Habsburg Emperor Josef II, who brought Prague's four medieval towns under a single municipal authority in 1783. Josef had "emancipated" Bohemia's Jews two years previously, meaning to turn them into good Austrians, though in the event they were not to achieve full civil rights until after the revolution of 1848.[37] For centuries Prague had been home to one of the largest Jewish communities in Europe, but their situation was seldom secure. Josef's mother Empress Maria Theresa had expelled all Jews from the city as late as 1744 for supposed collaboration with an invading Prussian army during the War of the Austrian Succession. She allowed them back four years later, on sufferance, and only in the interests of reviving a seriously depressed economy. In 1837, before the final restrictions on their residence were removed, Jews still made up eighty percent of the ghetto's population. But after 1848 most of them moved out into more salubrious environs of the rapidly expanding city—the upper New Town, Královské Vinohrady, the villa quarter of Bubeneč—leaving behind only the ultra-Orthodox and the very poor. By the end of the nineteenth century only one in four of Josefov's inhabitants was Jewish. The Fifth Quarter became a Prague Bowery, the hangout of rag-and-bone-men, beggars, prostitutes, and crooks, a place where, Ahasuerus tells Apollinaire, "you will see; at night, every house is transformed into a bordello."[38]

In as improbable a beauty as Lautréamont's chance encounter on a dissecting table between the sewing machine and the umbrella, "the din from the *Tantztavernen*, the shouts of the drunks in the streets and the uproarious laughter of the whores [would] mingle with the drone of Sabbath chants issuing from the synagogues."[39] So, at least, imagines Angelo Maria Ripellino. The Italian scholar's *Magic Prague* is one of the most enlightening books ever written on the Bohemian capital—if enlightening is quite the right adjective to use in connection with a *passant* who like André Breton in *Nadja* evidently prefers walking by night to believing he walks by daylight. Academics tend to shy away from Ripellino's work, notwithstanding its prodigious

learning. Perhaps this is because he refuses to admit the distinctions of reality and imagination, present and past, that construct the surfaces and planes of the modern world—the same antinomies that were rejected by Breton and the surrealists. But a city, and especially a city with a history as long and convoluted as Prague's, is never compounded only out of bricks and mortar. It is also a dreamworld of signs and symbols, memories and desires, and it is this ever-shifting infusion of mind and matter that Ripellino grasps better than most, as much because of his poetic imagination as despite it.

Ripellino acknowledges the debt his title owes to Breton, but the magic he conjures up is of a darker hue. Having made Prague his second home for many years until the communists expelled him in 1969, the Italian knew the city far better than either Breton or Apollinaire—intimately, in fact. "Prague is a breeding ground for phantoms, an arena of sorcery," he warns us; "It is a trap which—once it takes hold with its mists, its black arts, its poisoned honey—does not let go, does not forgive."[40] Inevitably he quotes the young Franz Kafka's well-known comment on his hometown, although unlike some others he translates it correctly: "Prague doesn't let go. . . . This little mother has claws."[41] Kafka was born in a house on the edge of the Jewish quarter, just off the Old Town Square, in 1883. The little square on which the house stood is today called náměstí Franze Kafky (Franz Kafka Square). It is a belated act of remembrance; the name was given sometime in the new millennium.[42] *Mutterlein* (little mother), as Kafka calls the city, is a direct equivalent of the Czech *matička*, which is how Czechs sometimes affectionately refer to their capital; to render it as "old crone," as Richard and Clara Winston do in the standard English translation, misses the allusion, the oxymoron, and the point. All the same, Ripellino insists, Prague "is no 'mother' [*matička*]." She has more than a touch of the aging whore about her, "an enticer, an inconstant paramour who makes herself up with an ever-changing eye-shadow of lights and wraps herself in billowing gowns of mists as though they were bizarre brothel *négligés*."[43] Throughout the book Ripellino sexualizes the city (and quotes many a Czech writer who has done the same). *She* is always female, always an object of desire, and never, ever, a mistress to be trusted. Praha—*zlatá Praha, krásná Praha* (golden Prague, beautiful Prague)—is what the city is called in Czech, a feminine noun in a language in which everything and everybody is gendered and it is impossible to speak or be spoken of without being sexed.

> And all the spires like pipes
> of a Gothic organ

play in the evening to the lanterns aglow
a requiem for Europe.
That is Prague, city and lover . . .
Wandering poets
slip onto beautiful girls
stockings woven of apricot blossoms
and fantastic words known only to you.
Only to you.[44]

The verses are by Jaroslav Seifert, who is probably the best-known Czech poet of the twentieth century, at least to Anglophone readers. Seifert began his career in 1920 with a collection of "proletarian verse" dedicated to the older communist poet Stanislav Kostka Neumann called *Město v slzách* (*City in Tears*). The book was prefaced with an uncompromising declaration that ended: "This book is about class and you are its contents. . . . New, new, new is the star of communism. Its communal work is building a new style, and outside it there is no modernity."[45] Sixty-four years later, by which time he and communism had long since gone their separate ways, Seifert would become the first Czech writer to be awarded the Nobel Prize in Literature. "Prague from Petřín Hill," as this poem is called, was published in lieu of any other commentary by way of introduction to Josef Sudek's 1959 album *Praha panoramatická* (*Panoramic Prague*), which portrays the city with the same infinite patience, love, and objectivity as *Sad Landscape*.[46] "The city dies. Its ashes are scattered. But the dream capital . . . raises its unconquerable ramparts under a gelatin sky. The maze of streets pursues its course like a river. And the crossroads serve always for pathetic rendezvous." The words come from Robert Desnos's obituary of Eugène Atget, another photographer incongruously wedded to antiquated technologies, but Desnos might just as well have been writing of Sudek's *Panoramic Prague*.[47]

"To this day, every evening at five, Franz Kafka returns home to Celetná Street (Zeltnergasse) wearing a bowler hat and black suit," *Magic Prague* begins. "To this day, every evening at five, Vítězslav Nezval returns from the oppressive heat of the bars and pubs to his garret in the Troja district, crossing the River Vltava on a raft."[48] In Ripellino's Prague the past is always present. It never went away. The dead will not let the living rest in peace. *Magic Prague* is haunted above all by the specter of Rudolf II, who reigned from 1576 to 1611, the second Holy Roman Emperor to make the city his imperial capital. The first was Father of the Homeland Charles IV, builder among much else of the 520-meter-long bridge whose construction began at thirty-one min-

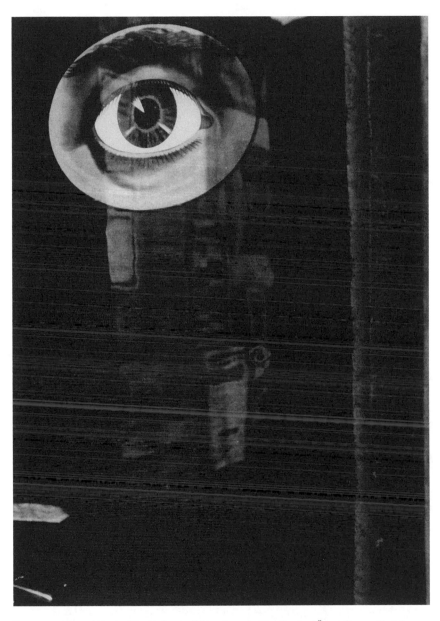

FIGURE 2.3. Jaromír Funke, "Eye Reflection," from the cycle *Time Persists* (*Čas trvá*), 1932. The Museum of Fine Arts, Houston. Gift of Louisa Stude Sarofim in memory of Nina Cullinan.

utes past five in the morning on 9 July 1357 but which has borne his name only since 1870. Legend has it that the bridge derives its strength from eggs that were mixed into the mortar, though that did not stop two of its arches from being washed away in the great flood of 1890. Previously this quintessential symbol of the city, as it has become to present-day eyes—and as it was for André Breton, who remembered it as stretching from here to eternity[49]—was known simply as the Stone Bridge (Kamenný most). It remained the only passage across the river until the Francis I suspension bridge, the precursor of the Bridge of the Legions, was built in 1839–41. There were no statues on the parapet in Rudolf's time. The baroque procession that can so easily—when viewed through the lens of Josef Sudek's camera, for instance[50]—seem to be the very embodiment of Prague's *genius loci* commenced only in 1683 with Jan Brokoff's effigy of Saint John of Nepomuk (Jan Nepomucký). The statue marks the spot from which after being tortured with fire, supposedly by the king in person, and clamped in irons, the unfortunate prelate was thrown into the Vltava three centuries earlier on the orders of Václav IV.

There is confusion as to both the true identity of Nepomucký and the reasons for his martyrdom. Different stories, and quite possibly different people, have incubated in the historical imagination and been conflated. The Vicar-General of Prague whom Václav drowned in 1393 for opposing his proposed takeover of an abbey may or may not have been the same troublesome priest who refused to reveal the secrets of his queen's confession. Whatever the truth of the matter, it was as a "martyr of the secret confession"—as Ahasuerus described the saint to Guillaume Apollinaire[51]—that Innocent XIII canonized Jan in 1729. When his body was exhumed from its grave ten years earlier, so the story goes, "his tongue was found to be uncorrupted though shriveled."[52] A century later Czech nationalist historians were alleging that Nepomucký was merely a Jesuitical fabrication designed to supplant the memory of Jan Hus. If so, it was a gambit that backfired. "The baroque saint" became a focus of popular devotion, bringing rural folk into the capital from up and down Bohemia and Moravia. "In an age of universal Germanization and decline in national awareness, this celebration had enormous importance in that at the time of the Saint Jan pilgrimage even Germanized Prague was Czech," wrote František Ruth in his *Kronika královské Prahy* (Chronicle of Royal Prague), an obsessively detailed street-by-street and building-by-building history of the city published in the same year as Apollinaire's visit; "many Praguers would perhaps have quite forgotten Czech if they had not had to speak it with their country cousins who visited them year after year as May 16 came around."[53] The tradition of the pil-

grimage did not stop monuments to Nepomucký from being vandalized in the aftermath of national independence in 1918 or the Czechoslovak government revoking the status of May 16 as a state holiday in 1925—to the considerable annoyance of the Vatican. It was supplanted by July 6, the date Hus was burnt at the stake in 1415 by the Council of Konstanz, all of which goes to show that Apollinaire was not so very wide of the mark when he wrote in "Zone" that while automobiles have the air of antiques, "religion alone has remained wholly new."[54]

A devotee of what we would nowadays see as the occult—but the distinctions between the natural and the supernatural were less clear cut in those days than they have come to seem since—Rudolf II filled his court with astronomers, alchemists, and artists from all over Europe. Among them were Tycho de Brahe, who "put politeness before his health" at a banquet,[55] died of a burst bladder, and is buried in the Týn Cathedral; Johannes Kepler, who discovered the laws of planetary motion in a house in what is now the tourist-infested alley Charles Street (Karlova ulice); and the Italian mannerist painter Giuseppe Arcimboldo, compositor of grotesque faces collaged out of fruits and vegetables, birds and fishes, library books and platters of roast meats. Tycho, Kepler, and Arcimboldo (who rates an honorable mention in André Breton's *L'Art magique*)[56] have all duly taken their places in the genealogies of the modern. Other luminaries of the Rudolfine court, mere quacks and charlatans to our tastes, have since slipped into oblivion, falling between the cracks of what gets written up as History. Still, according to Ripellino, their spirits prowl Prague's ancient streets: Edward Kelley for one, an itinerant wife-swapping Anglo-Irish alchemist whose ears had been cut off by Lancaster magistrates for forgery. Rudolf knighted him but eventually threw him into prison. Kelley lost a leg in a first botched attempt to escape; after smashing his other leg in a second, he took poison.

Tycho's are not the only famous remains—at least to Czechs—associated with the Týn Cathedral. Interred there "in a secret place" on the afternoon of 30 November 1631, when a Saxon Protestant army that briefly occupied the city took them down from the tower of the Stone Bridge where they had been on educative display for the previous ten years, were the heads of eleven leaders of the Rising of the Czech Estates that met its ignominious end at the White Mountain.[57] The Czech Lords, as they are known—twenty-seven of them in all—were executed on the Old Town Square on 21 June 1621 in a gruesome public spectacle that began with drum-rolls at five o'clock in the morning and lasted a full four hours. One of the victims was Jan Jesenský (or Jessenius), Rector of Prague University, an office Jan Hus had held two cen-

turies before him. In a gesture whose symbolism would resonate as eloquently with nineteenth-century "national awakeners" (*národní buditelé*) lamenting the decline of the Czech language during the centuries after Bílá hora as that of Nepomucký's tongue remaining miraculously intact in his skull, the executioner Jan Mydlář cut out Jesenský's tongue and nailed it to the scaffold before beheading him. Jesenský had originally been invited to stay in Prague by Emperor Rudolf, who was impressed by the doctor's public dissection at the university of a corpse delivered to him fresh from the gallows.[58] Mydlář got through four swords that day. The Czech Lords died "heroically and with dignity," says Ruth's *Chronicle*, "but still more grievous calamities awaited the whole land. Times came, the saddest in the history of Prague and the whole nation, times of terror and then the quiet of the grave."[59] For their part the victors at the White Mountain would have as much pathos to wring from the broken body of twelve-year-old Šimon Abeles, a Jewish boy supposedly tortured to death by his own father for converting to Catholicism, who was ceremonially laid to rest in the Týn Cathedral in 1694. Ripellino relates both stories, as anyone who wants to communicate the complexities of this dreamscape must.[60] Antonín Dvořák knew what he was doing when he collaged together the Catholic Saint Wenceslas chorale and the Hussites' battle-hymn "Ye Who Are the Soldiers of God" in his *Hussite Overture*; Prague is a place over whose fortunes Jan Hus and Jan Nepomucký are equally watchful. Whether Ahasuerus took the time to acquaint Apollinaire with such improbable conjunctions as he led the poet through the Old Town Square "Le Passant de Prague" does not record.

It was more likely tradesmen—among them goldsmiths, which may account for the street's strange name—than Rudolf's alchemists who inhabited the Golden Lane (Zlatá ulička) that hugs the inside of the castle wall in Hradčany. According to the *Guinness Book of World Records* Hradčany is the largest castle in the world. The "Street of the Alchemists" was an obligatory stop on Breton and Éluard's tour, though not a sight Ahasuerus seems to have thought worth showing Apollinaire, who mentions only "the majestic, desolate halls of the Royal Castle of Hradschin."[61] But the gimcrack houses look like they could once have held bubbling alembics tended by wizened old men searching for the elixir of life and the philosopher's stone. At least they would have done in 1935; nowadays it is difficult to imagine anything behind the façades of tourist kitsch. The houses are now gift shops. Franz Kafka briefly lived in number 22, the House of the Golden Pike, which his sister Ottla rented for a few months in 1916–17, adding yet another ingredient to the little street's stew of significations. Having debunked any historical association

of the lane with Rudolf's alchemists Ripellino carries off a no less occult metamorphosis of his own, shape-shifting the Golden Lane into "a Kafkaesque picture of a parasitic world at the perimeter of a mysterious Castle."[62] Prague becomes an incarnation of Kafka's fiction although, as a matter of fact, Kafka's fiction is remarkably parsimonious in its explicit references to Prague. His nightmares could be staged anywhere, in the modern world at least—even if anyone acquainted with the city cannot help wondering, sometimes, precisely *which* grimy nineteenth-century Prague tenement Gregor Samsa, the unfortunate hero of "Metamorphosis," woke up in one morning to find himself changed into a giant bug.[63] Bearing in mind the hermeticism of some of the castle's inmates, from Emperor Rudolf to the communist "President of Forgetting" Gustáv Husák—who presided over the twenty-year "normalization" between the Soviet invasion of 21 August 1968 and the fall of communism in November 1989—it is easy enough to imagine Hradčany as Kafka's *Schloss*, or, at a pinch, to see the Hunger Wall that snakes up Petřín Hill, another of Charles IV's work-for-welfare projects, as the inspiration for his short story "The Great Wall of China."[64] "The Golden Lane acts as the backdrop for the dramatic miracle of transmutation,"[65] explains Ripellino. Paul Éluard, who believed that "everything is transmutable into everything," would doubtless have concurred.[66]

Arcimboldo painted Rudolf as *Vertumnus* in 1591 with pea-pods for eyebrows, a pear for a nose, and a white radish for an Adam's apple. "I am that which without may seem a monster / But within a noble likeness / And Royal image doth conceal," wrote Commanini the year the picture was painted, giving the game away. But by the time Olof Granberg came to catalogue the painting in his 1911 inventory of Arcimboldo's work the gold had transmuted into lead. Incapable any longer of seeing the marvelous in the mundane, Granberg prosaically mistook the Emperor for the gardener.[67] It was after all the modern world now, a daylight of science and reason in which magic has been banished to fairy tales and we expect things to be one thing or the other. But Prague confounds the metaphysics of modernity. On Arcimboldo's canvases things lead double lives, kaleidoscoping into fantastical signifiers even as they remain their quotidian selves. "And on and on," writes Roland Barthes, "the metaphor revolves on itself, but with a centrifugal movement, spattering countless meanings."[68] He is speaking of Arcimboldo's painting *The Cook*, but he might just as well be talking of the city. Nothing here is ever simply itself. Everything gestures back and beyond. Every nook and cranny comes burdened with history, layered with the traces of unquiet pasts.

THE TIME OF ARDENT REASON

The Jewish Town, for Ripellino, is "the focal point of Prague's magic."[69] He offers us Dickensian depictions of the depths the ghetto had sunk to by the 1890s, lovingly detailing the overcrowding, the squalor, the filth, the disease, the absences of light, of air, of sanitation. His descriptions are thick with sexuality, the sexuality of the scene in *The Castle* where K. and Frieda copulate amid the debris and puddles of spilt beer on the barroom floor—which does not make their conjunction any the less magical. "There hours passed, hours of breathing as one, hearts beating as one, hours in which K. constantly had the feeling that he had lost his way or wandered farther into a strange land than anyone before him," writes Kafka.[70] "The rotten cobblestones stank of refuse, stagnant puddles and foul rivulets," writes Ripellino. "Rats were everywhere. In the entrances to the hovels half-naked women relieved themselves in plain view—the quarter had neither latrines nor sewers—and during the sweltering heat they left their suffocating houses to delouse their children." It is an image, he says, that recalls—of all the unlikely times and places to find their way into *fin de siècle* Bohemia—his childhood in Sicily. Inside "these cold, musty hovels, these stinking dens, these fetid holes" were "persons of different age and sex who had met in a tavern or in prison; hardened petty-thieves and bankrupts who had once owned flats lined with plush carpets in other Prague districts packed together indiscriminately." Every room was "a den of rotten straw mattresses and tables used as makeshift beds in which sick old people, passionate couples, prostitutes and children huddled between ghostly chalk lines and women gave birth in the presence of strangers, a Dark Hole in which the crowding increased towards evening as the beggars returned from their rounds."[71] As night fell, "the most dedicated drinkers and whoremongers converged on the ghetto."[72] One of them was Ahasuerus, who chose for himself "a big-breasted, broad-bottomed Hungarian girl." She gave him rare pleasure. "I do not remember another like her," he tells Apollinaire, "except at Forli, in 1267, where I had a virgin." "His circumcised penis," Apollinaire tells us, "reminded me of a knotty tree trunk, or a redskin's totem pole, striped with burnt sienna, scarlet and the dark violet of stormy skies."[73]

Ripellino draws an extended analogy between the contents of Emperor Rudolf's celebrated cabinet of curiosities and the enormous variety of junk that flowed into the Fifth Quarter at the end of the nineteenth century, the one caricaturing the other in a perverted pattern of eternal return. His "unsystematic inventory" of Rudolf's *Kunst und Wunderkammer* begins:

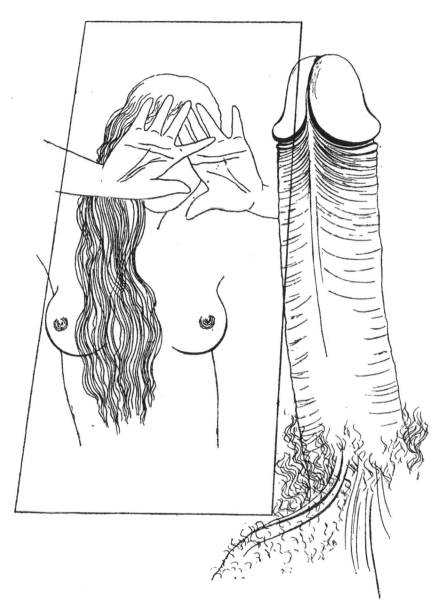

FIGURE 2.4. Toyen, illustration for Marquis de Sade, *Justina* (*Justine*). Prague: Edice 69, 1932. ©
ADAGP, Paris, and DACS, London, 2012.

Plaster casts of lizards and reproductions of other animals in silver, *Meermuscheln*, turtle shells, nacres, coconuts, statuettes of colored wax, figurines of Egyptian clay, elegant mirrors of glass and steel, spectacles, corals, "Indian" boxes filled with gaudy plumes, "Indian" containers of straw and wood, "Indian," that is, Japanese paintings, burnished silver and gilt "Indian" nuts and other objects the great carracks brought from India under full sail, a skin-colored plaster-covered female torso of the kind the Prague Surrealists so loved[74]

—and on, and on, for another three pages. According to Bruce Chatwin, whose novel *Utz* probes the psyche of another maniacal Prague collector only to uncover a buried and convoluted history, and who too believed that "Prague was still the most mysterious of European cities, where the supernatural was always a possibility," Rudolf's treasures also included "his unicorn cup, his gold-mounted coco-de-mer, his homunculus in alcohol, his nails from Noah's Ark and the phial of dust from which God created Adam."[75] Mindful of where he was, the Emperor made sure to leave a place in his cabinet for the peasant cap of Přemysl the Plowman, the legendary founder of the indigenous Přemyslid dynasty that ruled Bohemia for four centuries until the line died out with Václav III in 1306. Přemysl was the husband of the equally mythical Princess Libuše, who one day back in time out of mind gazed across the Vltava from the fortress of Vyšehrad and foretold the rise of "a city whose glory will reach the stars."[76]

The whole world found its way into the castle walls to be reordered according to codes whose keys are long lost. Its logic now escaping us, Rudolf's *Kunst und Wunderkammer* seems as surreal as the classification of animals in a "certain Chinese encyclopedia" with which Michel Foucault, quoting a passage from Borges, begins *The Order of Things*: "Animals are divided into: (a) belonging to the emperor, (b) embalmed, (c) tame, (d) suckling pigs, (e) sirens, (f) fabulous, (g) stray dogs, (h) included in the present classification, (i) frenzied, (j) innumerable, (k) drawn with a very fine camelhair brush, (l) *et cetera*, (m) having just broken the water pitcher, (n) that from a long way off look like flies." Foucault's laughter, he says, "shattered, as I read the passage, all the familiar landmarks of my thought—*our* thought, the thought that bears the stamp of our age and our geography—breaking up all the ordered surfaces and all the planes with which we are accustomed to tame the wild profusion of existing things."[77] Inspired by his friends Picasso and

Braque, Apollinaire aimed at a similar shattering of our habits of mind in his "cubist" poetry, beginning with "Zone" and exploding in the *Calligrammes* of 1914–18, in which the words weave simultaneously in disparate directions all over the page mimicking everything from falling rain to the Eiffel Tower.[78]

Apollinaire's time in the trenches of World War I may have contributed to the typographic mayhem. Cubist reconfigurations of pictorial space had after all by then found a new use in the camouflaging of tanks. Many of the poems in *Calligrammes* exult in and exalt the terrible beauty that was being born:

> August 31, 1914 . . .
> We said farewell to a whole era
> Furious giants were rising over Europe
> Eagles flew from their eyrie to wait for the sun
> Voracious fish ascended from abysses
> Nations hurled together so they might learn to know one another
> The dead trembled fearfully in their dark dwellings[79]

André Masson later recalled how "the odor of the battlefield was intoxicating. 'The air was filled with a terrible alcohol.' Yes, Apollinaire saw all of that. There was only one poet to say it. . . . The shock of the dead in strange positions, like those I saw one day seated on a bank of earth, their heads blown away by an Austrian 85. . . . Others in very beautiful poses, like the one who had the appearance of a wounded lioness,"[80] Small wonder that Masson—who shared with his friend Georges Bataille an obsession with sacrifice—went on to draw picture after picture of body-filled *Massacres*, images that are less protests against the orgy of slaughter than explorations of its poetics. "These acts of murder seem to be dictated by the unconscious," he later commented. "These massacres of women have a ritual, sacrificial appearance. . . . At the time, this wasn't a usual theme: everyone wanted to forget the other massacres, those on the field of battle, which had unfolded for four years."[81]

In his lecture at the Mánes Gallery André Breton compared Apollinaire's poems to the collages of Max Ernst.[82] The poet and the painter indeed had much in common, but also something to set them apart. The two men met just once, at August Macke's house in 1913. Ernst recalled the meeting in "An Informal Life of Max Ernst (as told to a young friend)," a text that dates (in this version) from 1961 and was written in New York, far away from the times and places he was recalling. "Needless to say M. E. was deeply moved. What he had read had dazzled and excited him. 'Zone' had appeared in *Der Sturm*; and the first edition of *Alcools*, published by Mercure de France with a Pi-

casso drawing, had arrived in Cologne. We were speechless, utterly capti-
vated by Apollinaire's winged words which flew from the lightest to the most
serious, from deep emotion to laughter, from paradox to incisively accurate
formulation."[83] When the war to end wars broke out the following summer
Apollinaire joined up with gusto. Ernst, who spent four years at the front as
an artillery engineer for the other side, was a more reluctant soldier. "On the
first of August 1914," he writes, "M. E. died. He was resurrected on the elev-
enth of November 1918 as a young man who aspired to find the myths of his
time."[84] Ernst's first wife, Lou, remembered the painter's second coming
slightly differently. "The four years at the western front had made a man of
[Max]," she relates, "who spoke little, was introverted, and whose beautiful
blue eyes had learned to stare coldly."[85]

Apollinaire was by no means the only avant-garde artist of the early twen-
tieth century to transmute tracer bullets and shell-bursts into objects of Dio-
nysian rapture. "We wish to glorify war—the sole cleanser of the world,"
gloated F. T. Marinetti in his 1909 *Manifesto of Futurism*, a rhapsody of all
things fast and new and modern that also—and by no means coinciden-
tally—advocates "scorn for women."[86] "We scorn woman when conceived as
the only ideal," he clarified the following year, "the divine receptacle of love,
woman as poison, woman as the tragic plaything, fragile woman, haunting
and irresistible, whose voice, weighed down with destiny, and whose dream-
like mane of hair extend into the forest and are continued there in the foliage
bathed in moonlight." This creature looks suspiciously like *la femme surréali-
ste*, at least as conceived by André Breton. Marinetti had more time for the
suffragettes, though he pitied "their childish enthusiasm for the ridiculous,
miserable little right to vote." It is "the tyranny of love," he believed, "horri-
ble, heavy Love," that "impedes the march of men, preventing them from
going beyond their own humanity . . . all that's natural and important in it is
the coitus, whose goal is the futurism of the species."[87] Here is a specimen of
the glorification of "the world's only hygiene" Marinetti had in mind, a pre-
monitory mélange of sex and savagery written in Adrianople in October 1912
in the thick of the Italo-Turkish War:

> Rain (**VIOLET TREMBLING-GREEN**) terri-
> fied bridge streaming teeth chattering aii aii aii flesh carti-
> lage of the wood beams barrels nails weeeary suffering of
> the fibres (**HARD FROZEN TIGHT STUCK GREEN-
> ISH SO SLOW**) underbelly-of-the-sky birth of heavy
> crows crammed with corpses

>Caaw-caaw *tatatatatatatata*
>Get the machines guns ready or else rumbling of carts
>Paris Halles avez-vous une cigarette Serbian officer
>French accent woman's silhouette between his lashes warm
>bustle of Montmartre lacy lights rolled up souls excited
>mirrors sweat bidet castanets breathless display of breasts
>routine legs criiies invasion of bitter noises blonde
>burning of memories-desires . . . [88]

The *explosante-fixe* of futurism was to fire many a European imagination in the succeeding years, not least in Prague where the first exhibition of Italian futurist paintings took place in 1913.[89] Marinetti's *Words in Freedom*, which inspired Apollinaire among many others, was translated into Czech in 1922. It had to wait another seventy years for its first full translation into English.[90] Another futurist show, which was curated by Enrico Prampolini and included twenty-one works by Umberto Boccioni, was staged in the fall of 1921 in the Rudolfinum, an imposing neo-renaissance concert hall and gallery complex opened on the right bank of the Vltava in 1885. Marinetti visited the Bohemian capital in December 1921, directing a production of his *Futurist Syntheses* at the Švanda Theater (Švandovo divadlo). His *Fiery Drum* was presented the following year at the Estates Theater (Stavovské divadlo)—a venue that is better remembered for having staged the world première of Mozart's *Don Giovanni* in 1787. During his visit the futurist leader was considerate enough to give a reading in Karel Teige's apartment for the young tyros of the Devětsil "Union internationale des artistes d'avant-garde révolutionaire" as the group, founded a year earlier in the Café Union on National Avenue (Národní třída), optimistically billed themselves in French, Czech, German, and Russian in the *Revoluční sborník Devětsil* (*Devětsil Revolutionary Miscellany*) that came out the following autumn.[91] Most of them were barely out of their teens. Despite these callow beginnings Devětsil went on to become one of the longest-lived and most vibrant of Europe's interwar avant-gardes, gathering in many of the most talented Czech writers, poets, visual artists, architects, composers, critics, theater designers, and actors of their generation to develop its own trademark "poetist" aesthetic.[92] Later, much later, Karel Teige would dismiss Marinetti as a "second- or third-rate" poet.[93] But that was after Teige had discovered dialectical materialism and the Italian futurist threw in his lot with Mussolini, neither of which prevented Devětsil's Liberated Theater (Osvobozené divadlo) from staging Marinetti's *The Captives* in 1929 with sets designed by Jindřich Štyrský.

Louise de Coligny was the first to read many of Apollinaire's calligrammes, sandwiched in his letters between descriptions of the tedium of military life and ecstatic paeans to her thighs, buttocks, breasts, and the "nine sacred gates" to her body—her "royal vagina," her "pleated anus, yellow as a Chinese, where penetrating I made you cry out in sharp pain"—which, the poet informed her, were his "nine muses,"[94] a poetic thought that drifted in due course to his next love Madeleine Pagès, to whose two last gates he had yet to find a key.[95] On another occasion the poet advised Lou to *métalliser* her *derrière*, which he was intent on chastising until "you won't be able to sit down." The excuse, as usual, was her wandering fingers: "Ton cul payera pour ton petit con, ma chérie" (your ass will pay for your little cunt, my dear).[96] He looks forward to a rendezvous with his "royal slave" in Paris where "we will organize those marvelous *soirées* of which we have spoken . . . I shall whip you with the calm required, with all the comforts so beautiful a captive deserves. At this moment I am thinking of your divinely supple waist, of this waist that has never been shackled, and my thought comes to rest on your posterior . . . puffed up like a tethered balloon which the sun will lash with pitiless rays."[97] Lou seems not to have minded in the least.[98] Could it be that the war was unthinkably *liberating* for them both, exposing the planes and surfaces of civilization for the wafer-thin veneers they are and unleashing the wild profusion of things that exist beneath to wreak what havoc, and give what perverse pleasures, they will?

"Beauty will be CONVULSIVE, or will not be at all," ends Breton's *Nadja*. It is all too easy today to read these famous words as a merely poetic injunction, but surrealism was intended not as a program for literature but for life. Breton's conviction of the *sauvage* that always marches in step with *la pensée*, too, took shape in the "cesspool of blood, mud, and idiocy"[99] of the western front and was given powerful impetus by the ravings of the shell-shocked on whom he waited as a medical orderly at the military hospital at Saint-Dizier in 1917. His youthful sensibility was tutored by Baudelaire's *flâneur* gone off to war, the nihilist dandy Jacques Vaché, as much as by his revelatory reading of Sigmund Freud's *Interpretation of Dreams*. Vaché died of an opium overdose in a hotel room in Nantes in January 1919, nude on a bed with another man, indifferent to the bitter cold.[100] "What I loved most in the world has just disappeared," wrote Breton to Tristan Tzara a few days later.[101] The surrealists began as Dadaists, and Dada was born out of madness—the delirium of the reason that had driven Breton's patients insane as the civilized world tore itself to pieces in the name of the obscenities, as he came to see

FIGURE 2.5. Toyen, illustration for Marquis de Sade, *Justina* (*Justine*). Prague: Edice 69, 1932. ©
ADAGP, Paris, and DACS, London, 2012.

them, of "family, country, religion."[102] "For us," wrote Max Ernst, that reluctant soldier for the other side, "Dada was first and foremost an attitude of mind . . . it resulted from the absurdity, the whole immense stupidity of that imbecilic war. We young people came back from the war in a state of stupefaction, and our rage had to find expression somehow or other. This it did quite naturally through attacks on *the foundations of the civilization* responsible for the war. Attacks on speech, syntax, logic, literature, painting and so on."[103]

"The killing fields are our bordello," taunted Hugo Ball in his 1916 poem "Dance of Death."[104] Ball was the founder of the Cabaret Voltaire in Zurich where Dada was born. "The skull: that is what a girl is called in the Apache language. The outline of her skeleton shines through her worn features. I used once to carry a skull around with me from city to city," he had confided to his diary a few months earlier:

> I had found it in an old chapel. They had been digging up graves and had exposed hundred-year-old skeletons. They wrote the dead person's name and birthplace on the top of the skull. They painted the cheekbones with roses and forget-me-nots. The *caput mortuum* that I carried with me for years was the head of a girl who had died in 1811 at the age of twenty-two. I was really madly in love with the hundred-and-thirty-three-year-old girl and could hardly bear to part from her. But finally, when I went to Switzerland, I left her behind in Berlin. This living head here [that of his lover, Emmy Hennings] reminds me of that dead one. When I look at the girl, I want to take some paint and paint flowers on her hollow cheeks.[105]

Emmy too was half in love with easeful death. "We pull ourselves toward Death with the cord of hope," begins her poem "Prison," which she performed at the Cabaret Voltaire on 14 July 1916:

> Ravens are envious of the prison yards.
> Our never-kissed lips quiver . . .
> We mournfully look out through the iron railing
> And have nothing more to lose
> Than the life God gave us.
> Only Death lies in our hand.

The freedom no one can take from us:
To go into the unknown land.[106]

In that necrophilic moment the familiar landmarks became as unintelligible as the contents of Rudolf's *Wunderkammer*. The thought of the age slipped its moorings, and all of the "old antinomies" in which it had been precariously anchored—"life and death, the real and the imagined, past and future, the communicable and the incommunicable, high and low," as Breton would later summarize them in the *Second Manifesto of Surrealism*[107]—were up for grabs. Surrealists, he mocked, "intend to savor fully the profound grief, so well played, with which the bourgeois public ... greets the steadfast and unyielding need they display to laugh like savages in the presence of the French flag, to vomit their disgust in the face of *every* priest, and to level at the breed of 'basic duties' the long-range weapon of sexual cynicism."[108] It was in this text that Breton notoriously defined the "simplest Surrealist act" as "dashing down into the street, pistol in hand, and firing blindly, as fast as you can pull the trigger, into the crowd. Anyone who, at least once in his life, has not dreamed of thus putting an end to the petty system of debasement and cretinization," he went on, "in effect has a well-defined place in that crowd, with his belly at barrel level."[109]

Wounded in the head in March 1916 and trepanned to relieve pressure on his brain, Apollinaire held up a mirror to the new century. Štyrský and Toyen, who lived in Paris from 1925 to 1929, found time to produce an excellent tourist guide to the French capital between painting their "Artificialist" canvases, as they were then calling them. Their *Průvodce Paříží a okolím* (Guide to Paris and Its Environs), coauthored with the journalist Vincenc Nečas, was published in 1927 by Devětsil's house-publisher Odeon and enthusiastically marketed in *ReD* as providing the keys to the "center of science and art, focus of contemporary culture, cradle of modern architecture."[110] In the section devoted to literary venues the future Czech surrealists imagine Apollinaire sitting in his French officer's uniform with a bandage round his head, sipping a beer in La Rotonde café in Montparnasse, hobnobbing with Leon Trotsky.[111] Jaroslav Seifert, too, saw Apollinaire's head in white bandages before his eyes forever, an image he found funny; or so he said in the opening poem of *Na vlnách TSF* (*On Wireless Waves*) of 1925, a collection whose debt to *Calligrammes* is evident in the playfulness of its typography, which was designed by Karel Teige.[112] Breton first met Apollinaire on 10 May 1916 in his hospital bed the day after the older poet's operation and thereafter saw him

"almost every day until his death."[113] The author of "Zone" died on 9 November 1918, just two days before the signing of the Armistice. Aged only thirty-eight, he was a casualty of the Spanish flu that carried off more victims than did World War I—a statistic that rather like Josef Sudek's *Sad Landscape* puts modernist hubris in its proper place in the great scale of things.

"Here I am before you all a sensible man," begins "La jolie rousse" (The Pretty Redhead), the final poem in *Calligrammes*:

> Knowing life and what a living man can know of death
> Having tested the sorrows and joys of love
> Having sometimes known how to impose my ideas
> Knowing several languages
> Having traveled a fair bit
> Having seen war in the Artillery and the Infantry
> Wounded in the head trepanned under chloroform
> Having lost my best friends in the frightful conflict
> I know as much of the old and the new as one man can know . . .

"Now comes summer the violent season," Apollinaire continues, "And my youth is as dead as the springtime"—

O Sun it is the time of ardent Reason.[114]

The epic slaughter of World War I was not entirely without historical precedent. Emperor Rudolf's collections were scattered to the winds in the turmoils of the seventeenth century, during which, it has been imprecisely estimated, Bohemia may have lost as much as a half of its population through war, pestilence, and emigration. Archduke Maximilian of Bavaria, who led the victorious imperial army at the White Mountain, carted 1,500 wagons of booty back to Munich and the occupying Saxons took another 50 away to Dresden in 1631. Many of Arcimboldo's canvases ended up in the galleries of Queen Christina of Sweden after the siege of the city by the Swedes in 1648, who had taken Hradčany and the Little Quarter but not the Old Town when their pillaging was interrupted by the Peace of Westphalia that ended the Thirty Years' War. Two-and-a-half centuries later, in a carnivalesque reprise of Rudolf's cabinet of incongruities, it was the ghetto itself that "became a kind of *Merzbau*"—Ripellino's allusion here is to another master of collage, the Dadaist Kurt Schwitters, who also twice visited the Bohemian capital during the 1920s—"a babel-like drydock of trifles and tatters scrounged from all over Prague. It was as though all the flotsam and jetsam of creation had

converged there. If silver dominated Rudolf's *Kunstkammer*," Ripellino tells us, "rusty scrap iron dominated the Fifth Quarter":

> Crushed mortars, bent graters, wooden spoons, hammers and chisels, broken tools, unrecognizable machine parts and mousetraps lay piled high in the cavern-like depths of warehouses or spread out on street stands. Unmatched muddy horseshoes, ladles, frying pans and coal rakes, buttless guns, rusty daggers, dress swords with mother-of-pearl handles, timepieces without dials, "Schwarzwald" cuckoo clocks without striking mechanisms, knives without blades, forks without teeth, hiltless swords, bottomless sieves, triggerless muskets and tongueless scales. Plus a *kudlmudl* of dusty tomes it was a joy to rummage in, to say nothing of worn-out shoes, pipe bowls, umbrellas and wrinkled suits reeking of sweat.[115]

Remembering the mysterious iron mask—a grisly relic of World War I, as indecipherable by then as an Egyptian hieroglyph—and the wooden serving spoon with the little boot on which to rest its handle that beckoned to Breton and Giacometti one spring day in 1934 in a Paris flea market, another episode recounted in *Mad Love*, one can imagine with what delight the surrealists would have seized upon this cornucopia of (in Breton's words) "objects that between the lassitude of some and the desire of others, go off to dream at the antique fair . . . nourishing the meditation that this place arouses, like no other, concerning the precarious fate of so many little human constructions."[116] But their visit to the magic capital came too late for that.

The Hangman and the Poet

Ripellino did not simply dream up this "Bohemian kermis worthy of a Bohemian Breughel"[117]— a sight that impressed itself upon Apollinaire, too, as he followed Ahasuerus through "the Jewish quarter, its booths displaying for sale old clothes, old iron, and all kinds of rubbish. Butchers were slaughtering calves. Booted women hurried on their way. Jews in mourning passed by, recognizable by their torn clothes."[118] The major sources for the Italian writer's description are the Czech *fin de siècle* writers Ignát Herrman and Zykmund Winter. Magic Prague is not just a projection of foreigners' desires for the esoteric and exotic, a mysterious East that has the convenience of being located

at the center of Europe, though it is that, too. Gustav Meyrink, Franz Werfel, Jiří Karásek z Lvovic, Jaroslav Vrchlický, and many other Prague authors accreted just as generously in both Czech and German to the ghetto's mystique, which lent itself equally well to the fecundity of the decadent or the expressionist imagination. So, a generation later, did Vítězslav Nezval. But when Ripellino comes to discuss Nezval's invocations of the ghetto his tone unexpectedly changes. He momentarily jolts us out of the dream, disentangling the presents and pasts, realities and surrealities his narrative otherwise treats as one, putting daylight between what once was and how it returns as recollection. He relates how in *Řetěz štěstí* (The Chain of Fortune), published in 1936, "Nezval ... remembers a nocturnal walk with the theater director Jindřich Honzl in the troubled old Josefov district whose—his words—'De Chiricoesque vistas' provided him with the key to a different emotional interpretation of Prague. The dense crush of feverish ratholes," Ripellino dryly comments, "is thus transformed into the nostalgic rarefaction of Metaphysical Painting."[119]

"The troubled old Josefov district" through which Nezval and Honzl were walking was not the Prague ghetto but its mere shadow, a secondhand memory. The ghetto that is described by Ripellino—and whose last vestiges were sampled by Apollinaire—fell victim to the triumphal march of progress before Nezval, who was born in 1900, was out of elementary school. This did not stop the Moravian poet from seeing the town he had made his home through Apollinaire's alcoholic gaze, and reinventing it as a poetic fiction:

> Magic city I have been gazing at you long enough like a
> blind man
> We sought you in the distance today I recognize it
> You are dark as the fire in the deep rocks and like my fantasy
> Your beauty issues from caverns and underground agates
> You are old as the prairie over which a song hovers
> When your horologes strike you are dark as an island night[120]

"I cannot overemphasize the fact," he says in *Pražský chodec* (Prague Pedestrian, 1938), "that it was he [Apollinaire] and he alone, his chimerically veiled eyes, who taught me to look differently at everything that till then had been merely the subject of Old Prague tales";[121] and indeed the very title of Nezval's book gestures to Apollinaire, since *pražský chodec* means a Prague walker or pedestrian, that is to say, a *passant de Prague*.

Nezval was not the only Czech writer intoxicated by Apollinaire's alcohols. "Zone" was first translated into Czech by Karel Čapek, appearing in S.

K. Neumann's journal *Červen* (June) in 1919 and then in Čapek's own anthology *Francouzská poesie nové doby* (Modern French Poetry) the following year. Čapek produced these translations of French poets from Baudelaire to Soupault, he later explained, "under the pressure of the war, as a literary act of solidarity and spiritual alliance with the nation that was then bleeding before Verdun for the cause which was also the cause of our heart and of our faith."[122] It was an act of solidarity that amounted to treason in the circumstances of the time; another Czech poet, Viktor Dyk, was already languishing under sentence of death in a Viennese jail for identifying the Czechs' cause with that of Austria-Hungary's French and British enemies. *Modern French Poetry* had an enormous impact on Czech letters between the wars. Milan Kundera does not exaggerate when he says that Jiří Wolker's "Svatý Kopeček" (The Little Holy Hill, 1921) and Konstantín Biebl's "Nový Ikarus" (The New Icarus, 1929)—landmarks of Czech modernism—as well as Vítězslav Nezval's own "great compositions" like "Edison" and "Podivuhodný kouzelník" (The Wonderful Magician, 1922) would have been "inconceivable" without Čapek's translation of "Zone." Every country, Kundera observes, has its own history of world literature, and improbable as it might seem, Apollinaire stood front and center of global literary history as seen from twentieth-century Prague.[123]

In "The Little Holy Hill" the young Jiří Wolker, who fervently believed "in myself, in steel inventions, and in the good Jesus Christ," takes Apollinaire's lessons in discordant harmonies to heart, blasphemously coupling "Great Russia and the brave Lenin" with the Virgin Mary.[124] The poem takes its title from the village in Moravia where Jiří used to spend his boyhood holidays with his grandmother, a pretty place of hilltop pilgrimage crowned by a glorious baroque church of the Mother of God. The road from Olomouc to Kopeček used then to be lined with chestnut trees planted in the time of Maria Theresa, but most have since perished from the ravages of acid rain. Like Pushkin, Rimbaud, and the great nineteenth-century Czech romantic poet Karel Hynek Mácha, Wolker had the grace to die before he got old, leaving behind him poetry as forever young as the lovers on John Keats's Grecian urn. He was just twenty-three when tuberculosis took him. Indifferent to the sentimental seductions of the premature deathbed, Kundera mercilessly satirizes all such youthful lyricism, including that of Paul Éluard, in *Život je jinde* (*Life Is Elsewhere*), a novel set in the heroic years that followed the KSČ coup d'état of "Victorious February" (*Vítězný únor*), 1948. The central episode of the book is the hero Jaromil's betrayal of his redheaded girlfriend's brother to the secret police out of pure love for the Revolution. Jaromil (the name

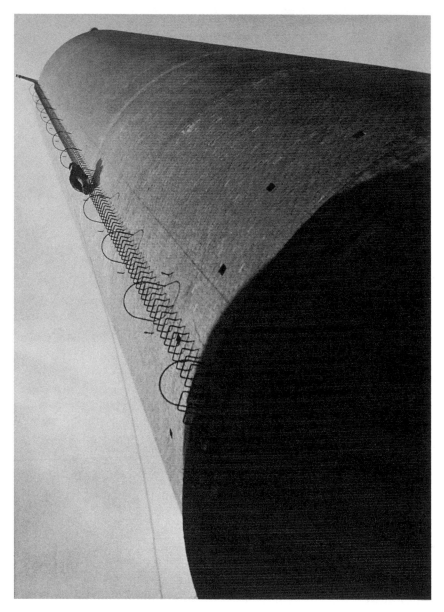

FIGURE 2.6. Eugen Wiškovský, "Chimney (Kolín Power Station)," 1932. The Museum of Decorative Arts in Prague.

means "lover of spring") too is a poet—Kundera is at pains to emphasize, "an authentic poet, an innocent soul."[125] "Today," he insists, "people regard those days as an era of political trials, persecutions, forbidden books, and legalized murder. But we who remember must bear witness: it was not only an epoch of terror, but also an epoch of lyricism, ruled hand in hand by the hangman and the poet."[126]

He should know. Completed in Bohemia in 1969 and published in Paris in 1973, *Life Is Elsewhere* might as well be a self-portrait of the artist as a young man. Before Kundera turned his attention to the unbearable lightness of being, he penned many a verse that fused poetry and politics. Most (in)famous is "Poslední máj" (The Last May, 1955), an ode to the communist journalist Julius Fučík, one time editor of the KSČ daily *Rudé právo* (Red Right) and the party's literary journal *Tvorba* (Creation), who was executed by the Germans in 1943. Fučík's prison diary *Reportáž psaná na oprátce* (Report from the Gallows) was required reading for every schoolchild in communist Czechoslovakia. Kundera's title shamelessly echoes that of Karel Hynek Mácha's "Máj" (May), published in 1836, which is probably the best-loved poem in the Czech language. Every Czech knows the opening lines: "It was late evening—the first of May—evening May—it was the time of love." It has long been a Prague tradition for young lovers to walk hand-in-hand every First of May to lay flowers at the foot of Mácha's statue on Petřín Hill. Coincidentally or not, but probably in this case not, the episode from *Report from the Gallows* around which Kundera's "The Last May" is built also takes place on Petřín Hill, whose steep slopes separate the picturesque Little Quarter from the nineteenth-century tenements of Smíchov. The hill commands a breathtaking view of the city. Fučík was taken there from his cell in Pankrác Prison, wined and dined and shown all the beauties of the world that could be his if only he would talk. But no:

> He heard only the Vltava play on its weir's dulcimer
> And it seems to him, that he is walking in a vast comradely crowd,
> And it seems to him, that they are spreading far across the land,
> Where from the partisans' mountains the rebels are singing![127]

The prosaic truth—that Fučík, like other mortals, cracked under pressure—would emerge only when the full, uncensored version of *Report from the Gallows* finally saw the light of day in 1995.[128]

Reality, though, is not always the same thing as truth, and the reality in which Prague's inhabitants lived in the 1950s was the socialist-realist dreamworld of "The Last May." In his novel *Žert* (*The Joke*, 1967), Kundera recalls

how Max Švabinský's portrait of Fučík, which was commissioned (and drawn from a photograph) in 1950, hung on the wall "as it hung in a thousand other places in our country." Švabinský—the same Max Švabinský who provided Saint Vitus's Cathedral with its sexy "Last Judgment"—portrayed the communist martyr "with infinite grace of line and inimitable taste in such as way as to make him seem almost virginal—fervent, yet pure—and so striking that people who had known him personally preferred Švabinský's noble drawing to their memories of the living face." "Its expression," Kundera says, mixing his genders the better to underscore his point, was "the radiant expression of a young girl in love."[129] There exists no contemporary likeness of Karel Hynek Mácha, who died of pneumonia in the year "May" was published, just shy of his twenty-sixth birthday. But every Czech schoolchild knew exactly what he looked like, too, from another portrait in *Švabinský's Czech Pantheon.*[130] The poet's dark eyes smoldered and he wore a Byronic cloak and broad-brimmed hat, the same cloak and hat that Vilém, the tragic hero of "May," wore to his execution. It was love that brought Vilém to the gallows; he killed his beloved Jarmila's seducer only to discover that the girl's violator was his own father.[131] Švabinský's line is as graceful as ever, though Mácha, who left a juicy diary detailing his sexual encounters with his girlfriend Lori as well as a fatherless child behind him, was no more a virgin than Julius Fučík. What of it? The metaphors endlessly revolve on themselves, coupling Marx and Rimbaud, the Day of Labor and the time of love, as poets slip stockings made of apricot blossoms on beautiful girls every First of May on Petřín Hill.

Nezval's mention of "old Prague tales" also brings to mind a genre of nationalist mythmaking that—on the face of it—conjoins as incongruously with surrealism as Picasso did with *L'Action française,* best exemplified by the historical novelist Alois Jirásek's *Staré pověsti české* (*Old Czech Legends*), which was published in 1894. Born in 1851, the same year the Great Exhibition announced the coming of the modern world to London, the hugely popular Jirásek devoted his life to making the Bohemian past come alive to serve the Czech future. His novels and plays traced the nation's odyssey from its legendary beginnings to the Hussite Wars, through the post-1620 Darkness, to the national revival and the revolution of 1848.[132] The "Czech Walter Scott," as Jirásek was known, gave Old Prague magic a new currency, letting history play on the imagination (and vice versa) as freely as Ripellino—or Breton. Zdeněk Kalista recalls how "We could not pass the Old Town Hall in the dark of night without seeing the horologe scene we knew from 'Le passant de Prague.' Nezval could not walk along the walls of the Old Jewish

Cemetery in the dark without the silence of the place merging with his picture of the Jewish Town at the beginning of the century, a world that no longer existed."[133] It was Old Mr. Jirásek (*starý pan Jirásek*), as Karel Čapek affectionately called him, who had already spellbound these and many other Prague locations with old-new myths, acquainting generations of Czech schoolchildren with the legend of City Council's blinding of Master Hanuš after he made the horologe on the Old Town Hall so that the clockmaker could never repeat his marvelous creation elsewhere, and frightening them with tales of the spirits haunting the Jewish ghetto. The Czech surrealists' path may have meandered past Les Halles and the Tour Saint-Jacques, ending up on the rue Gît-le-Coeur where Breton and Jacqueline finished their nocturnal walk in the magical dawn of the sunflower, but that progress was crossed by well-trodden Czech trails.

Confounding locations and languages, Nezval chose *Ulice Gît-le-Coeur* (Gît-le-Coeur Street, 1935) as the title for the second volume of the trilogy that began with *Neviditelná Moskva* (Invisible Moscow) in 1934 and was completed by *Prague Pedestrian* in 1938, works that were clearly inspired by Breton's *Nadja*. Moscow–Paris–Prague: it is another juxtaposition that is worthy of the Comte de Lautréamont. But it also says much about the coordinates of the dreamworlds that the Czech surrealists inhabited. Latitudes and longitudes kaleidoscoped in a late-night walk Nezval took through the Luxembourg Gardens while visiting *la ville-lumière* in the summer of 1935:

> I see a single city
> Through which flow the Seine the Neva and the Vltava
> Here is also a stream in which countrywomen wash their clothes
> A stream on which I live
> Windows
> Through the first a statue enters the room from the place de
> Panthéon
> The second looks out on Charles Bridge
> Through the third I'm staring down Nevsky Prospect . . . [134]

TONGUES COME TO LIFE

In his collection of poems *Praha s prsty deště* (*Prague with Fingers of Rain*), which also came out in 1936, Nezval rhapsodizes the ancient city that Apollinaire's chimerically veiled eyes have made him see anew. He casts her once again in the role of the lover. "I am only your tongue come to life," he tells her:

> I want to listen to you always and still even in dreams
> So that you reveal yourself to me as I have known you a hundred
> times
> as I never knew you up till now
> So that you reveal yourself to me as I would have wanted to know
> you for the first time . . .
> Remember me
> That I lived and that I walked through Prague
> That I learned to love her in a way that she was never loved before
> That I learned to love her like a girlfriend like a stranger . . . [135]

And Apollinaire's infernal clock in the ghetto returns yet again, a metaphor that comes close to carrying more than it can bear. It transports the poet backward in his life slowly, all the way back this time to the lost eternity of childhood. The contrast in this case, though, is not with faraway Paris as in "Zone," but the nearby thoroughfare of Na příkopě.

Příkopy, as the street is colloquially known, takes its name from what was once the moat between Charles IV's Old and New Towns. Prague's German-speakers called it Am Graben. At the time of Apollinaire's visit it was still the seat of the German Casino, the hub of Prague-German society, and served as the German Corso, where the town's upper echelons promenaded their class. There is little to be seen of this past in the city today, apart from forgotten names on unvisited graves. After World War II Czechoslovakia's three million "Germans" were expelled to create "a united state of Czechs and Slovaks. Let our motto be: to definitively de-Germanize our homeland, culturally, economically, politically," thundered newly restored president Edvard Beneš in a speech in the Old Town Square on 16 May 1945.[136] German names were expunged from Czech maps, the better to reorient Czech memories. One of the twentieth century's more spectacular examples of what we would nowadays call ethnic cleansing, the expulsion—which proceeded with the full blessing of the victorious Allies—was euphemistically known at the time as the *odsun* or "transfer." In a metamorphosis no less improbable than Gregor Samsa's, the Deutsches Kasino turned overnight into Slovanský dům—the Slavic House. But things were once, and not so very long ago, otherwise. Contrary to what Apollinaire's native informant told him, Czech was not the only language spoken in the Bohemian capital in 1902. In Max Brod's oft-quoted (though perhaps not often enough interrogated) description, Prague was then "a city of three nationalities"—Czechs, Germans, and Jews. By the

turn of the twentieth century they increasingly lived in worlds of their own, even if they inhabited the same geographic space.

This ordering of planes and surfaces, too, had something of the old-new about it. Prague had been speaking in several tongues for a millennium and more, but the mutation of linguistic pluralities into national identities was more recent. Jews had been living in the city since (at least) the tenth century,[137] while German-speakers had been a significant minority in Bohemia and Moravia ever since another modernizing monarch, Přemysl Otakar II, invited German merchants and craftsmen into his kingdom in the thirteenth. After 1620 German increasingly became the language of state and culture, while Czech dwindled to little better than a peasants' and servants' vernacular. This "Germanization" likely had more to do with the practical exigencies of Habsburg state-making than any deliberate projects of cultural genocide, but the outcome was that Prague's educated classes entered the modern era transacting their business in what later generations would consider the language of the "foreign" oppressor. According to an imperfect census of 1851 around one-third of the city's population, which then numbered around 150,000 people, were "Germans" (or German-speaking Jews)—though one reason later enumerators thought the census imperfect was that respondents did not always understand the newfangled categories of nationality in terms of which they were required to identify themselves.[138] Many Czech awakeners would have had to be considered Germans if their nationality was judged by the criterion of "language of everyday intercourse" (obcovací řeč/Umgangssprache) by which, from 1880 onward, imperial censuses classified and counted Bohemia's population.

Jindřich Fügner and Miroslav Tyrš, founders in 1862 of the muscularly patriotic (and militantly Slavic) Czech gymnastic movement Sokol, were respectively baptized Heinrich Fügner and Friedrich Emanuel Tirsch. When Fügner, who admitted to speaking no more than "kitchen Czech," was asked by his six-year-old daughter Renata whether he "had been a German" in his youth he replied—truthfully—"No, little one, I was a Praguer, a German-speaking Praguer."[139] The Czech "national composer" Bedřich Smetana kept his diaries in German; Josef Mánes, a painter whom Czech art historians consider "national in his very being," was another who never fully mastered Czech, as his letters sadly testify. The great Czech historian František Palacký famously refused to participate in the Frankfurt Parliament of the German Empire in 1848 on grounds that "I am not a German, at least I don't feel like one. . . . I am a Czech of Slavic stock,"[140] but German was the language he

spoke at home with his wife and children. He wrote the first three volumes (1836–42) of his monumental *Dějiny národu českého v Čechách a v Moravě* (History of the Czech Nation in Bohemia and Moravia) in German; only after the 1848 revolutions failed did subsequent volumes appear in Czech. Palacký's sobriquet "Father of the Nation" (*Otec národa*)—whose distinction from Charles IV's title "Father of the Homeland" (*Otec vlasti*) speaks volumes—is nevertheless well deserved: the *History* arguably did more to imagine its subject into being than any other work, with the possible exception of Josef Jungmann's *Czech-German Dictionary* of 1834–49. It was from Jungmann's dictionary that the journalist and "martyr" of the 1848 revolution Karel Havlíček Borovský acquired fluency in his "native" tongue, copying out lists of words and learning them by heart. Exactly whose language Havlíček was learning is open to question: when Jungmann could not find a contemporary spoken Czech equivalent for a German term he plundered medieval Czech and other Slavic languages like Russian and Polish or simply dreamed one up. In what language Karel Hynek Mácha whispered sweet nothings to his Lori we will never know, but he wrote to her in German.[141]

By the time of Apollinaire's visit to the city such conjunctions of speaking German and feeling Czech would appear as surreal as anything in Lautréamont. During the second half of the nineteenth century the landscape of Bohemian society was systematically reconfigured along linguistic lines. From a marker of social distinction language transmuted into a touchstone of ethnic identity in a world that increasingly demanded one thing or the other. It was a tectonic shift that left little space for pluralities of identity and still less for divided loyalties, as Prague Jews in particular were soon to discover; the sharp decline in the percentage who declared their "language of everyday intercourse" to be German between 1890 (74 percent) and 1900 (45 percent) owes less to demographic changes than political persuasion. The 1892 *Svůj k svému* (Each for His Own) boycott of German and Jewish businesses made it clear that insofar as Jews did not identify themselves as Czechs they would be regarded as Germans; an equivalence hammered home in November 1897 when Czech rioters broke every window not only in the New German Theater—which would duly be renamed the Smetana Theater after World War II—but also in the synagogues of the overwhelmingly Czech-speaking suburbs of Žižkov and Smíchov. It was this shift in the social significance of language as much as migration from Czech-speaking areas of the countryside that finally made Prague a *Czech* capital for the first time since "the Hussite times and the times which immediately followed," to quote the

self-satisfied entry on Prague's changing ethnic demography in *Otto's Encyclopedia* (*Ottův slovník naučný*), gloating over the 1900 census returns.[142] Published in twenty-eight resplendent volumes by the entrepreneur Jan Otto between 1888 and 1909, with contributions from much of the faculty of the newly separated Czech University of Prague, *Otto's Encyclopedia* was in its time the largest encyclopedia in the world after the *Encyclopaedia Britannica*. Like all such compendia of knowledge it did much to narrate into being that which it purported merely to document.

Not that we would glean anything of the mutability of these identities or the modernity of their crystallizations from the rural and historicist imagery that colonized the city's façades during these same years. Josef Mánes added a colorful disk in 1866 to Master Hanuš's astronomical clock depicting the cycle of the agricultural year, whose changing seasons were personified by handsome Czech lads and comely Czech lasses gaily garbed in Czech peasant costumes. Mikoláš Aleš painted *Libuše Prophesying the Glory of Prague* in the vestibule of the Old Town Hall, plastered a youthful Saint Wenceslas on the front of Štorch's bookstore on the other side of the Old Town Square, and decorated the exterior of Rott's hardware store, just around the corner on Malé náměstí (the Small Square), with yet more sentimental frescoes of Czech country life. His no less nationalistic mosaics for the Zemská banka (Land Bank) building, which opened its doors in 1895 on Na příkopě, slipped a knife close to the heart of German Prague; the bank, a symbol of the growing wealth and confidence of the Czech-speaking bourgeoisie, stood next door to what was then still the German Casino. History—real or imagined, in this case it doesn't really matter which—was recycled as myth, "a machine for the suppression of time" as Claude Lévi-Strauss once famously defined it. The effect was to make German-speakers perpetual intruders in a space that was as perpetually Czech as the eternal returns depicted on Josef Mánes's circular calendar.

By 1900, as measured by a census whose implications were by now crystal clear to all, Prague's German-speaking element had fallen to just 6.7 percent of the city's inhabitants, 34,197 people out of a population that had tripled to over half a million. "Germans" nevertheless remained numerically strong in the city center (10.43 percent in the Old Town, 12.51 percent in the New Town) and retained a social visibility out of all proportion to their numbers—to the growing resentment of many Czechs. "Who did not have a title or was not wealthy did not belong to her," recalled "the raging reporter" Egon Erwin Kisch:

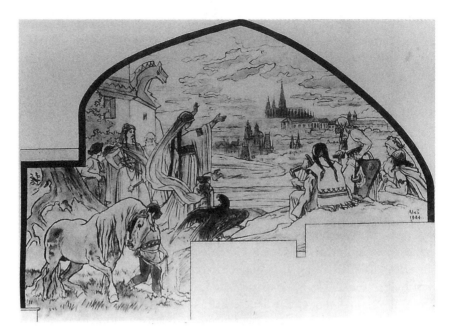

FIGURE 2.7. Mikoláš Aleš, "Libuše Prophesies the Glory of Prague," 1904. Sketch of mural for vestibule of Old Town Hall, Prague.

> German Prague! It consisted almost exclusively of the upper middle class, owners of lignite mines, directors of coal and steel companies and the Škoda munitions works, hop-dealers who commuted between Saatz and North America, sugar, textile, and paper manufacturers, as well as bank directors. Professors and higher-ranking officers and government officials moved in their circle. There was no German proletariat. The twenty-five thousand Germans, who constituted only five per cent of the population of Prague at the time, possessed two magnificent theaters, a huge concert hall, two colleges, five high schools, and four advanced vocational institutes, two newspapers with a morning and evening edition each, large meeting halls, and a lively social life.[143]

Once again this is not an entirely accurate picture. Gary Cohen's analysis of census data for 1910 concludes that around one-third of Prague's German-speakers actually "fell into the laboring or lowest lower-middle-class strata"

and frequently married or otherwise disappeared into the Czech-speaking majority.[144] But once again truth is not always the reality in which human beings live their lives. "All is imaginary," noted Franz Kafka apropos of nothing in particular in his diary for 21 October 1921, "family, office, friends, the street, all imaginary, far away or close at hand, the woman; the truth that lies closest, however, is only this, that you are beating your head against the wall of a windowless and doorless cell."[145]

Prague's Czech burghers took their *fin de siècle* Sunday strolls past the National Theater along Ferdinand Avenue (Ferdinandova třída), which was named after the feeble-minded Emperor Ferdinand V,[146] the last Habsburg ruler to go through the motions of being officially crowned King of Bohemia in Saint Vitus's Cathedral in 1836. Ferdinand the Benign (Ferdinand Dobrotivý), as Czechs remember him, was forced to abdicate in Emperor Franz-Josef's favor in 1848 and lived out the rest of his days as another Hradčany recluse. The Czechs' promenade down Ferdinand Avenue was as laden with significances as the Germans' parade along Na příkopě. The National Theater—the "cathedral of Czech art,"[147] as Alois Jirásek baptized it—was more than just a venue for staging plays and operas. Funded by a campaign for public donations launched in 1845 (and chaired by František Palacký) and richly decorated by Mikoláš Aleš, Václav Brožík, Vojtěch Hynais, Julius Mařák, František Ženíšek, and the rest of the young artists who have been known ever after as the Generation of the National Theater (*generace Národního divadla*), the building was completed in 1881, burned down after only twelve performances, and rose like a phoenix from the ashes in 1883, a metaphor for the fortunes of the nation. "The little golden chapel on the Vltava" (*zlatá kaplička nad Vltavou*), as the monumental building was soon fondly diminutized, ceremonially opened with the first performance of Smetana's *Libuše*, a work composed a decade earlier "not to be included among repertory operas, but kept as a festive work for special commemorative days."[148] The mythical princess was even more clairvoyant than Jirásek makes her in *Old Czech Legends*, foretelling not only the foundation of the city but its golden age under Charles IV and the martyrdom of Jan Hus. Above the proscenium arch is the proud and pointed motto *Národ sobě*—The Nation to Itself.

Occasionally Bohemia's nationalities, as they had now without a shadow of a doubt become, fell to theatrical blows where Ferdinand Avenue and Na příkopě met at the lower end of Wenceslas Square. Milena Jesenská, who is best known to western readers as Franz Kafka's Czech translator and lover, memorably describes one such confrontation that she witnessed as a small child looking out of an upstairs window. Her mother, she recalls, was clutch-

ing her hand "a little too tightly." Her father, Jan Jesenský, a fervent nationalist, was marching in the front rank of the Czechs. The police intervened, shots rang out, a man was left bleeding on the cobblestones. The crowd melted away. "There remained standing before the guns one man—my Dad. I remember clearly, absolutely clearly, how he stood. Calmly, with his hands by his side."[149] A few years later, in a spirit of irreverent youthful rebellion that mocked the nationalist pieties of her parents' generation, Milena would cross that same invisible line in what was less a political than a fashion statement. "On Sunday morning," Josef Kodiček recalled, "Na příkopě was old-Austrian territory":

> The commanding figure of Count Thun, the six-foot, eight-inch governor of Prague towers over the crowd. He's as thin as a stork and the best-dressed man on the continent. He stands serenely, in celestial calm, with one foot tucked into the crook of his other knee, surveying the ebb and flow of the crowd through his black-rimmed monocle. Just then two young girls stroll by, arm in arm. They are both something to look at. The first Prague girls to give themselves a deliberately boyish look. Their style is perfect. Their hairdos are modeled on the English Pre-Raphaelites, they are slender as willow witches, and there is nothing petit-bourgeois about their faces or figures. They are probably the first Czech girls of the pre-war generation to extend their world from the Czech promenade on Ferdinand Avenue to Na příkopě, thus making contact with the younger generation of German literati. They are genuine European women, a sensation! Count Thun swivels on one leg to look at them, and a wave of enthusiasm and curiosity passes through the crowd ... Milena and Miss Staša. Clearly it's Milena who sets the tone.[150]

Ferdinand Avenue would be born again as National Avenue (Národní třída) in February 1919, three months after the declaration of Czechoslovak independence from Austria-Hungary. The Francis I Bridge concurrently morphed into the Bridge of the Legions, the Francis I Embankment into the Masaryk Embankment, Franz-Josef Square into Republic Square (náměstí Republiky), and Elisabeth Avenue (Eliščin třída), which had previously been named after Franz-Josef's wife, into Revolutionary Avenue (Revoluční třída).

The national, the republican, and the revolutionary would endure everything the twentieth century had to throw at the city, with the passing interruption of the German occupation of 1939–45. They are capacious categories, well adapted to survival in a floating world. Other signifiers, more burdened down with traces of the particular and the concrete, proved to be less reconcilable with the swings and roundabouts of outrageous fortune. The Masaryk Embankment, which took its name from Czechoslovakia's "President-Liberator" (*Prezident-osvoboditel*) Tomáš Garrigue Masaryk, underwent a communist metamorphosis to become the Smetana Embankment in 1952, a change of referent that uncomfortably recalls the Nazis' earlier renaming of the Bridge of the Legions after the Czech composer. Smetana is a signifier for all seasons; it is only the signified that changes ever and anon, obligingly deferring to the caprices of the times. "In our country everything is forever being remade," complains a character in Ivan Klíma's novel *Láska a smetí* (*Love and Garbage*, 1988), "beliefs, buildings and street names. Sometimes the progress of time is concealed and at others feigned, so long as nothing remains as real and truthful testimony."[151]

The plasticity of Prague's semiotic landscape has been a recurrent preoccupation of modern Czech writers. It is a comprehensible obsession given the frequently fractured and endlessly rewritten history of the Czech Lands in the twentieth century, which seemingly defies all logic but that of the absurd. But it also speaks to a more general and perhaps a peculiarly modern terror, which is integrally bound up with Baudelaire's identification of modernity with *le transitoire, le fugitif, le contingent*. When the landmarks by which we navigate constantly change their names, how are we to remember where—or who—we are? "The struggle of man against power," insists Mirek at the beginning of Milan Kundera's *Kniha smíchu a zapomnění* (*The Book of Laughter and Forgetting*, 1979), "is the struggle of memory against forgetting."[152] But is it? In *The Art of the Novel* Kundera warns us that Mirek's pronouncement was not intended to be "the book's message," which was a good deal more ironic. "The originality of Mirek's story," he says, "lay somewhere else entirely. This Mirek who is struggling with all his might to make sure he is not forgotten (he and his friends and their political battle) is at the same time doing his utmost to make people forget another person (his ex-mistress, whom he's ashamed of)."[153] Elsewhere Kundera ventures further down what proves to be a very slippery slope, suggesting that we can never simply oppose memory to forgetting because the things we remember are always already transformed into something other in the very act of remembering them.

They are reborn as signifiers whose destiny it is to float on the tide of language, differing from the things they designate and constantly deferring elsewhere—kaleidoscoping like the fruits and vegetables, library books and platters of roast meats in Arcimboldo's paintings.[154] "The present moment," Kundera concludes, "is unlike the memory of it. Remembering is not the negative of forgetting. *Remembering is a form of forgetting.*"[155] The argument opens onto an ontological abyss in which distinctions between the real and the imagined become as tenuous as they were for the surrealists. Metamorphosis is the normal condition of human being; it is the chimera of identity that belongs to the realm of dreams.

Here is Nezval's "The Clock in the Ghetto" (*Hodiny v ghettu*). It loses its charms in translation, but retains its interest as a Czech poet's reworking of a French poet's embroidery on a memory of the impressions Prague had made on him during a passing visit to the city ten years earlier—a case study, we might say, of the imaginative drift of poetic thought:

> While on Příkopy time shifts gear
> like a racing cyclist who thinks
> he is overtaking the vehicle of death
> You seem like the clock in the ghetto
> whose hands go round backwards
> If death takes me by surprise
> I shall die like a six-year-old boy.[156]

3

Metamorphoses

The heretic world
No love / Leni, Kafka's women / swampy soil of experience /
 thighs
The upper ones on the way to the depths / The world of the court /
 Forgetting

—WALTER BENJAMIN, "THE WORLD OF FORMS IN KAFKA"[1]

THE ORIGIN OF ROBOTS

Fifteen years before Nezval published *Prague with Fingers of Rain*, Franz Kafka walked in that same memory, felt the shadow of the old ghetto. But it weighed on him, as a Prague Jew, more heavily than it did on Nezval, a presence that was too palpable, too present, to become an object of poetic nostalgia. It dogged his every footstep, pulling him back to where he never was to begin with—if, that is, we are to believe Gustav Janouch's *Conversations with Kafka*. "Directly after the First World War," Janouch relates, "the most successful German novel was Gustav Meyrink's *The Golem*. Franz Kafka gave me his opinion of the book":

> "The atmosphere of the old Jewish quarter is wonderfully reproduced."
> "Do you still remember the old Jewish quarter?"
> "As a matter of fact, I came when it had already disappeared. But . . ."

Kafka made a gesture with his left hand, as if to say, "What good did it do?" His smile replied, "None."

Then he continued, "In us all it still lives—the dark corners, the secret alleys, shuttered windows, squalid courtyards, rowdy pubs, and sinister inns. We walk through the broad streets of the newly built town. But our steps and our glances are uncertain. Inside we tremble just as before in the ancient streets of our misery. Our heart knows nothing of the slum clearance which has been achieved. The unhealthy old Jewish town within us is far more real than the new hygienic town around us. With our eyes open we walk through a dream: ourselves only a ghost of a vanished age."[2]

This passage, so often quoted, including by Ripellino, is so perfectly Prague, the magic capital of old Europe, that it is almost too good to be true. It may very well not be, even if Max Brod found Janouch's Kafka so vivid he "felt as if my friend had suddenly returned to life and had just entered the room."[3] The vagaries of memory being what they are, Brod's biography of Kafka, which was first published in Prague in 1937, might well have colored both of their recollections by then. When Brod received Janouch's manuscript a decade later, "eight years after I had left my birthplace of Prague for good," he was living in Palestine.[4] He escaped the magic capital in March 1939, catching the last train out before the Wehrmacht rolled in. Milan Kundera savages Brod for castrating Kafka into a mythical "Saint Garta," an enterprise for which the unexpected appearance of Janouch's memoir ("To every church its Apocrypha," sneers Kundera) was undoubtedly fortuitous.[5] One of the "new aspects of Kafka" with which Brod had to come to uncomfortable terms in the second edition of *Franz Kafka: A Biography* was his discovery that Kafka had fathered an illegitimate son.[6] Whether this story is true remains open to doubt,[6] but the famously ascetic Franz was certainly known to frequent whorehouses ("I passed by the brothel as by the house of a beloved" reads one of his diary entries for 1910)[7] and was not above lascivious dreaming of a "very bright, extremely Social Democratic" student girl's "plump little legs."[8] The thoroughly modern Meyrink was also not all he seemed: when not summoning up the ghosts of a vanished age to titillate his readers, he was reputedly the first man to drive an automobile in Prague.[9]

Kafka was not the only writer of the time to confer on Prague's houses of pleasure an aura that comes close to sanctity. In his memoir *Všecky krásy světa*

(All the Beauties of the World, 1981) Jaroslav Seifert recalls a youthful pilgrimage he made from Žižkov to the Little Quarter during the last month of World War I. It was a lengthy walk, and he set off bright and early, "a little out of curiosity, a little for something else as well." Prague was then full of Hungarian soldiers, who frequented "a little lane . . . people called Umrlčí, where there were several bawdy-houses. . . . They said the girls weren't allowed to go out at all and were under close guard." The official name of the street was (and is) Břetislavova, but nobody called it that; it was universally known as Umrlčí ulička, or Corpse Lane, on account of the funeral processions that once upon a time used to pass through it to the cemetery on nearby Jánský vršek. The graveyard was long disused but the name clung on, accumulating new associations with changing times. The poet found the street deserted and the curtains closed. "Obviously the early afternoon was not the moment for love," he sadly reflected. "Maybe the girls were sleeping after lunch." Disappointed, Jaroslav retraced his steps.

> When I got to the last house down, I heard a quiet knocking on the window. I had to look. The curtain parted and in the window stood a girl with a dark braid slung over her shoulder. I stiffened with surprise.
>
> When she noticed how timid I was, she smiled and said something to me. But I couldn't hear her voice from behind the window. The lane was so narrow that in two steps I would have been on the opposite side. It would have been easy to cross. Again, this time more calmly, I looked at the closed window. The girl was good-looking, or at least it seemed so to me. She smiled at me kindly and my fear began to abate a little. Immediately she saw my faint-hearted hesitation she removed her white blouse in a single movement. It seemed to me that I quickly went pale with fright, and then the blood immediately rushed back to my face. I was looking frighteningly through the window at a girl's naked breasts. I stood there confused, as if a bolt of lightning had struck the cobblestones beside me. The girl smiled at me and I staggered back. It all lasted just a couple of seconds. In the meantime the girl slowly fastened her blouse and waved me inside with her hand. Then she closed the curtain again.
>
> I beat a fearful retreat.

Sixty years on the Nobel Prize winner confesses himself still to be a believer in "one of the most beautiful myths in the world . . . the amorous myth of a woman [*milostný mytus ženy*]," even if "these days she's a girl in a million. Women have thrown away an invisible aura and that's why they comb their hair differently. What a pity! There is nothing in the world more beautiful than a naked flower and a naked woman. I know, these beauties are familiar, and yet they are always newly mysterious for us, and we want to discover them again and again."[10]

As an aspiring teenage poet Gustav Janouch knew Kafka, who worked alongside Janouch's father at the Worker's Accident Insurance Institute of the Kingdom of Bohemia on Na poříčí, the street where Apollinaire stayed in 1902. *Conversations with Kafka* was published in Germany in 1951, more than thirty years after the encounters it relates. Janouch had by then fallen foul of the KSČ, who briefly jailed him after World War II. There was nothing heroic about Gustav's incarceration; he did his time for embezzlement. Some have alleged that he was a police informer, too. He would not have been the first to be turned: so, to universal Czech embarrassment, was Karel Sabina, staunch patriot and author of the libretto for Bedřich Smetana's "national opera" *The Bartered Bride* (*Prodaná nevěsta*, 1866). Janouch's other passion, jazz, was also out of political favor after the war as it had been under the Nazis, who thought it degenerate and Negro. He was acutely hard up. "Poor Janouch," writes Josef Škvorecký. "His *magnum opus* is by now very much discredited as an authentic source on Kafka. It seems the old swingman doctored his memories and puffed them up. But do we really have the moral right to condemn him for wanting to make a little money out of his acquaintance with the Master?" Škvorecký fondly recalls a wartime article where we catch a whiff of a more contemporary enchantment. In "The Magic of Jazz" Janouch relates the arrival in 1921 at the Konvikt nightclub on Bartholomew Street (Bartolomějska ulice) of "the first jazz drum to Prague. It was a big, red-painted monster, surrounded by sixteen pipes of the tubaphone, by four strings of bells and jingle bells, by six cowbells, three cymbals, a tom-tom, a gong, and four smaller drums."[11] Janouch's story too is perfectly Prague, a Good Soldier Švejkish rather than a Kafkan Prague perhaps, but one which at least has the merit of not existing in poetic limbo, "apart from the geographical, historical, and economic considerations that this city and its inhabitants may lend themselves to." Prague's location, as close as one can come to the center of Europe, has ensured that its inhabitants have been buffeted by all the crosscurrents of European modernity, including the Nuremberg Laws, communism, and jazz.

Bartholomew Street has been better remembered for other things than the Konvikt nightclub. Introducing an English translation of Jan Neruda's *Povídky malostranské* (Tales from the Little Quarter, better known in English as *Prague Tales*, 1878), Ivan Klíma tells how after returning to Prague from London following the 1968 Soviet invasion

> I was often called in for questioning by the police. The first time I went bearing the opening sentence of Neruda's *Police Tableaux* in mind: "Above the rear of Prague's Bartholomew Street Police Headquarters, a run-down, destitute, gloomy place" A century after Neruda's death, Police Headquarters is still in the same run-down, gloomy street, and that first time—and many times thereafter I found a peculiar sort of comfort in the idea that the premises have retained something of the old Austrian monarchy, that is, of the days of Neruda.[12]

There is something very Kafkan about such masochistic solace, a genre of consolation incomprehensible perhaps to those habituated to more vanilla modernities. The title of an English selection of Ludvík Vaculík's feuilletons from the same period of normalization, *A Cup of Coffee with My Interrogator*, conveys a similar reassurance in the familiarity of the absurd. And possibly something darker, too. As chance would have it, Prague's chief of police at the time of the 1848 revolution was the father of Leopold Sacher-Masoch, the author of *Venus in Furs*, who gave masochism its name. Did the city on the Vltava work its insidious magic on young Leopold? "At a very early age he had found the atmosphere, and even some of the most characteristic elements, of the peculiar types which mark his work as a novelist," thought the sexologist Havelock Ellis.[13]

The clock in the ghetto, which so enthralled passing poets, did not revolve only in poetic space. It was fortunate to survive long enough for Apollinaire to see it. The Jewish Town Hall was one of a handful of buildings in the Fifth Quarter to escape the slum-clearance (*asanace*) launched by Prague City Council in 1894, an urban renewal scheme that echoed Baron Haussmann's ambitions for Paris albeit on a smaller scale—*malé, ale naše*, "little but ours," as Czechs are fond of saying, just like the "Eiffelovka" that still stands on Petřín Hill. The Petřín lookout is a miniature replica of the Eiffel Tower built for the Jubilee Exhibition (*Všeobecná výstava zemská*) of 1891, a spectacle that aimed to show that Bohemia's industrial products and Czech modernities could compete with the best on the world's stage. The slum clearance re-

duced hundreds of other structures, often of no less antiquity but deemed to be of lesser historic significance, to rubble. The Old Jewish Cemetery that so haunted Nezval was also spared—except for that part of it over which the Museum of Decorative Arts (Uměleckoprůmyslové muzeum) was built in 1896—as were six synagogues (out of eighteen): the Old-New, which Apollinaire visited, the Maisl, the High, the Pinkas, the Klaus, and the Spanish. The cemetery dates from the turn of the fifteenth century at the latest, though it may be much older. It had been closed in 1787, also on the orders of the reforming Josef II. Fearing contagion, the Emperor wished to separate the living from the dead. A futile enterprise, one might think, in this neck of the woods, but then Josef was a modern-minded man.

Occupying a plot not much bigger than a football field, nearly twelve thousand gravestones lean drunkenly upon one another's shoulders, in another of Ripellino's images in which life imitates art, "like Brueghel's blind men."[14] Beneath the gravestones, stacked one on top of the other, lie twelve layers of corpses, exquisite fodder for the surrealist imagination. The explanation for the cemetery's picturesque crowdedness is prosaic enough. In death as in life residential options for Prague Jews were severely limited. Before the slum clearance, Ripellino tells us, the Old Jewish Cemetery was surrounded by "bordellos, soaking pits, tanners' booths and huts inhabited by executioners, outcasts and dog catchers"[15]—what else? And where else but living in a flat overlooking the Old Jewish Cemetery would the reader expect to encounter Utz, Bruce Chatwin's obsessive collector of Meissen figurines? But by the time the planners were through the gravestones, the synagogues, and the Jewish Town Hall with its contrary clock were all that remained of what had once been over three hundred buildings lining thirty-one crowded streets. The survivors instantly became proxies for the lost past, promontories on which poetic thought could ever and again alight. There are plenty of photographs to help us recall what the demolished ghetto used to look like, transmuting the passing moment into the eternity of metaphor and inviting the eye, that first auxiliary of the spirit, endlessly to embroider memories of what once was. In the fullness of time they would fill nostalgic publications with titles like *Stará Praha* (Old Prague) and *Zmizelá Praha* (Vanished Prague); reminders, as Roland Barthes once said, of a death to come.[16]

One of the graves in the Old Jewish Cemetery belongs to Rabbi Löwe ben Bezalel, a renowned Talmudic scholar in the time of Rudolf II who was known to his contemporaries as the Maharal—the Hebrew title means "teacher and lord"—but has become more familiar to posterity as the creator

of the legendary Golem of Meyrink's novel. Alois Jirásek told the rabbi's tale before Meyrink in *Old Czech Legends*. A clay man manufactured from secret formulae in the Kaballah, the Golem was animated by a charm placed behind the teeth. One night the Maharal forgot to remove the parchment upon which the *shem* was written and his servant ran amok. "'The same rabbi,'" Prokop tells his friend Zwack in *The Golem*, "'was once summoned to the Imperial Palace by the Emperor, where he conjured up the spirits of the dead and made them visible. . . . The modern theory is that he used a magic lantern.' 'Oh, yes,' said Zwack composedly. 'That explanation is foolish enough to appeal to moderns.'"[17] The Golem is another repeated motif in *Magic Prague*, a recurring nightmare that anchors successive presents in an eternally returning past. Ripellino detects the hand of Rabbi Löwe lurking behind the sci-fi robots manufactured on a Pacific island in the Čapek brothers' 1922 play *R.U.R.*, or Rossum's Universal Robots, an early example of the *Brave New World* genre.[18] Modern nightmares they may be, but the mechanical monsters' real roots, he insists, "are in the humus, the witchcraft of Prague."

The Italian writer sees the shape-shifting heroine of Karel Čapek's *The Makropoulos Case* (*Věc Makropoulos*, 1922), who was doomed to eternal life because she drank an elixir made by her father, Hieronymous Makropoulos, one of Rudolf's alchemists, as a female counterpart of Apollinaire's Wandering Jew[19] Leoš Janáček, who sought to craft opera out of the speech-rhythms of the Czech language and the modalities of Moravian folk songs, would make as improbably modernistic a musical drama out of her many avatars—Elina Makropoulos, Ellian Macgregor, Elsa Müller, Eugenia Montez, Ekaterina Myshkina, Elena Marty—as he did out of Dostoyevsky's *From the House of the Dead*, an opera set in a Siberian gulag in which all the voices are male. Milan Kundera thinks that reduced to "its strange and spare sonority," as it was in Sir Charles Mackerras's 1982 restoration of Janáček's original score, "*From the House of the Dead* emerges alongside Berg's *Wozzeck* as the truest, the greatest opera of our dark [twentieth] century."[20] The critic Michael Kennedy is another who considers Janáček's operas to be among "the principal glories of twentieth-century music," combining "the dramatic impact of Puccini, the reality of Mascagni, the nobility of Verdi, the psychological impact into character of Britten, the ferocity of Shostakovich, all expressed in music that has irresistible vitality, melodic fertility, lyric splendor, savage cruelty, highly original orchestration and, surpassing all else, a profound sense of compassion for human beings and their involvement with their destinies."[21] For Kundera, Janáček's work is "a dizzyingly tight, transi-

tionless juxtaposition of tenderness and brutality, fury and peace," enfolding simultaneities and antinomies in a convulsive beauty that Apollinaire—or Breton, had he had an ear for music—might envy.[22]

Astonishingly, four of Janáček's operas (*Kaťa Kabanová*, *The Cunning Little Vixen*, *The Makropoulos Case*, and *From the House of the Dead*) were written after the composer's sixty-fifth birthday. So was his *Glagolitic Mass* (*Mša glagolskaya*, 1926), a setting of the Old Slavonic liturgy Saints Cyril and Methodius brought to Moravia in the ninth century that is closer in spirit to Stravinsky's *Rite of Spring* than to the plainsong chants of medieval monks. Kundera aptly describes the work as "more an orgy than a mass."[23] When Ludvík Kundera—Milan's father, who was head of the Brno Musical Academy from 1948 to 1961[24]—wrote in a review that "old man Janáček, a strong religious believer, felt with increasing urgency that his creative work would be incomplete without an element expressing his relationship to God," the composer responded with a curt postcard that read "No old man, no believer."[25] But the creative explosion of Janáček's last years was indeed an old man's frenzy, reminiscent of Picasso, who was also not one to go gently into that good night. The author of *Les Demoiselles d'Avignon* (Picasso originally wanted to call his painting *The Brothel of Avignon*) filled the sketchbooks of his dying years with raging carnalities.[26] Janáček's muse at the time he reached pension age was a comely young Jewish woman named Kamila Stösslová. These improbable lovers may no more have consummated their *amour fou* than did Franz Kafka and Milena Jesenská, but the composer was still capable of dreaming. Or did they?

> In the summer of 1928, his beloved and her two children come to see [Janáček] in his little country house. The children wander off into the forest, he goes looking for them, runs every which way, catches cold and develops pneumonia, is taken to the hospital, and, a few days later, dies. She is there with him. From the time I was fourteen, I have heard the gossip that he died making love on his hospital bed. Not very plausible, but, as Hemingway liked to say, truer than the truth. What better coronation was there for the wild euphoria that was his late age?[27]

Presumably Kundera heard the gossip from his dad, who was once a pupil of Janáček's.

Karel Čapek's older brother Josef, a cubist painter whose linocuts illustrated Karel's translation of "Zone" in *Červen*, coined the word "robot." The

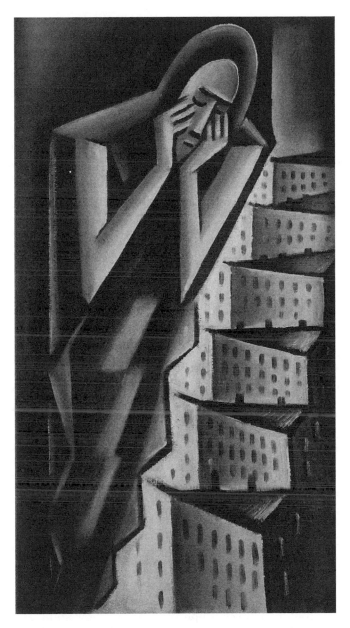

FIGURE 3.1. Josef Čapek, *Žena nad městem* (Woman over the City), 1917–20. Oblastní galerie v Liberci.

brothers had both been members of the Skupina výtvarných umělců (Group of Fine Artists) formed in 1911 in secession from the Mánes Artists' Society. The Group brought together not only painters (Emil Filla, Vincenc Beneš, Antonín Procházka, Václav Špála) and sculptors (Otto Gutfreund) but also architects (Josef Chochol, Josef Gočár, Pavel Janák, Vlastislav Hofman), writers (František Langer), and art critics (Vincenc Kramář, V. V. Štech) inspired by the latest artistic trends in Paris. Kramář, who spent three years in *la ville-lumière* between 1910 and 1913, amassed a fine haul of Picassos and Braques, which in time—and with a little persuasion from the communist authorities—found their way into the Czechoslovak (now Czech) National Gallery and became the jewels of its twentieth-century collection.[28] In April 1918, together with Špála, Hofman, Rudolf Kremlička, and Jan Zrzavý, Josef formed the Tvrdošíjní (Obstinates), who reasserted the claims of prewar modernism in their Prague exhibition *And Yet (A přece)*. The title alluded to the words Galileo supposedly muttered under his breath after being forced to recant his heliocentric views by the Vatican in 1632—*eppur si muove*, and yet it moves—one of the master-images of an emergent modernity turning its back on darkness and superstition and its face toward the scientific light. Arrested by the Nazis (along with Emil Filla and a raft of other anti-Nazi artists and intellectuals) on 1 September 1939, Josef died of typhus during the last days of World War II at Bergen-Belsen. His prewar cartoon cycles *Modern Times*, *Dictators' Boots*, and *In the Shadow of Fascism* related the adventures of a well-polished pair of jackboots trampling across the face of the world.[29]

Karel Čapek was spared the war. He died on Christmas Day 1938, aged just forty-eight. Milena Jesenská believed that the true cause of his demise was a heart broken by the Munich Agreement of three months earlier, at which British Prime Minister Neville Chamberlain and French Premier Edouard Daladier sat down with Hitler and Mussolini and signed away a third of Czechoslovakia's territory and population to the Third Reich in the interests of "peace in our time." The Czechoslovak government was not invited to the *rendezvous des amis*. "How horrible, fantastic, incredible it is," Chamberlain told the British people on BBC Radio on 27 September 1938, "that we should be digging trenches and trying on gas masks here because of a quarrel in a faraway country between people of whom we know nothing!"[30] For the author of *Anglické listy (Letters from England)*, an affectionate memorial of a journey through the British Isles and English eccentricities in 1924, it was England and France's betrayal of "the cause of our heart and of our faith" that beggared belief. The translator of "Zone" had always looked west for civiliza-

tion, and imagined better. Čapek's close friend Ferdinand Peroutka, editor of the reviews *Tribuna* (Tribune, 1919–24) and *Přítomnost* (The Present, 1924–1939) and a frequent contributor to the newspaper *Lidové noviny* (People's News), of which Čapek was the literary editor, recorded that "Karel Čapek sat among us and monotonously repeated: 'How is it possible that treaties are not kept; it is the end of culture.' He had sweat on his forehead. Through his whole adult life he had humbly served democracy and humanism. Now—for some time—arrived the victory of that which in his books he had variously styled the Robots, the Newts, the White Disease"[31] "He just stopped breathing and he just stopped living," wrote Milena. "If you like, you believe that he died of bronchitis and pneumonia."[32]

Vítězslav Nezval was another who saw more than blind coincidence in Karel Čapek's death. For all his surrealism, for all his dialectical materialism, the poet does not hesitate to fall back on tried and tested Czech Catholic imagery:

> The last candle on the Christmas tree
> burns for you today.
> So few of us remain,
> So few of us, in pain,
> To leave the task to
> At such a mournful time,
> In this fateful season
> After disaster—
> Oh, what grief in the house . . .
> You knew it, you know
> That the nation lives, that all it can do is drag its cross
> On its drooping, broken shoulders . . .[33]

Ripellino is possibly claiming too much for the ghosts of Rudolfine Prague when he traces Rossum's Universal Robots back to the Golem, though—if you believe in *hasard objectif*—there may have been a touch of foreshadowing in the Rabbi's tale.[34] The Čapeks were scarcely the first to fantasize the progeny of progress turning vengefully on their makers: Mary Shelley published her classic story of Frankenstein's runaway monster, which she prophetically subtitled "The Modern Prometheus," back in 1818, as England's green and pleasant land was overrun by dark Satanic mills. But unlikely as it may seem—though it is no more improbable than some of the glories of twentieth-century music originating in Leoš Janáček's backwoods Moravian village of Hukvaldy—the word "robot," which has gone on to colonize the

languages and imagination of the world, comes from the Czech *robota*, the name for the labor-services that used to be performed by Bohemian tenants on the estates of their feudal lords. Though the ever-progressive Josef II abolished personal serfdom in 1781 the *robota* endured in the Czech Lands until 1848, where it too incubated in the imagination to metamorphose into a universal archetype of modernity gone mad.

A BEAUTIFUL GARDEN NEXT DOOR TO HISTORY

The Čapek brothers' gravestones can be found side by side in the cemetery of the Church of Saint Peter and Saint Paul at Vyšehrad, the rocky outcrop from which, as Alois Jirásek relates in *Old Czech Legends*, Princess Libuše long ago looked out over the Vltava toward what is now Hradčany and saw a city whose glory would reach the stars. Vyšehrad is in its way as surreal a location as any in Prague. It offers a snapshot of long-gone Bohemian dreams; a yellowed and fading snapshot to be sure, but one that is not without its sepia charms. To take the socialist-era subway across Nusle Viaduct, a spectacular feat of modern engineering that originated in even more spectacular prewar modernist architectural fantasies, and walk down to the cemetery past the Palace of Culture (Palác kultury), a communist showcase completed in 1980 that has since been a venue for trade fairs, art auctions, and occasional erotic entertainments, is to journey back in time—if not quite to the time of Přemysl and Libuše, then at least back to times that were no less constituted by myth. Afterward one can wander down Neklanov Street (Neklanova ulice), pausing to admire Josef Chochol's improbably harmonious cubist apartment block, then stroll along what was upon a time the Friedrich Engels Embankment, past the Palacký and Jirásek Bridges, the Mánes Gallery, and the National Theater, back to the Old Town—a journey of a couple of miles and a million modernities, whose planes and surfaces are as fractured now as Chochol's façades.

The "most sacred place," as Max Švabinský described Vyšehrad in his funeral oration for Alfons Mucha in July 1939, did not always inspire reverence.[35] The ancient fortress ceased to be a royal seat in the twelfth century, and the Hussites had no qualms about sacking it in 1420. The site's latter-day sanctity dates from the second half of the nineteenth century, when it was transmuted into a resting-place for the Czech great and good. Under the auspices of the Svatobor society, founded in 1862 and chaired by the ubiquitous František Palacký, Italianate marble arcades were laid out in the cemetery to the designs of Antonín Barvitius and Antonín Wiehl in 1869. A communal burial vault known as the Slavín (Pantheon), also designed by Wiehl, was added in 1889–93 for "the most illustrious men, those exceling above all oth-

ers in their efforts for the Czech nation, those who by their brilliant writings or artistic endeavors, important inventions or uncommon sacrifices, arduous battles or beneficial successes helped to spread the glory of the Czech nation even beyond the borders of this our motherland."[36] "Though dead they still speak," reads the inscription above the sarcophagus. The Peter and Paul Church was concurrently antiqued in keeping with Vyšehrad's born-again Czechness. Originating as a Romanesque basilica in the eleventh century, the church had been rebuilt in the time of Charles IV and remodeled again, to Giovanni Santini's baroque specifications, in the 1720s. It acquired its present twin-towered gothic silhouette only between 1885 and 1903, when the bell tower dating from 1678 was pulled down. The design was by Josef Mocker, who was also the architect of the neo-gothic "completion" of Saint Vitus's Cathedral discussed earlier.

Father of the Nation František Palacký is not buried at Vyšehrad; nor is Leoš Janáček, or Alois Jirásek, or Tomáš Garrigue Masaryk. All chose more personal, albeit no less Czech resting-places. "Tatíček" (Daddy) Masaryk, as the President-Liberator was fondly known, lies by the side of his American wife, Charlotte, in the presidential country seat of Lány, the site of many of his *Conversations* with Karel Čapek.[37] Czechoslovakia's first president, a professor of sociology at the Czech University of Prague before he turned his hand to politics, was a frequent guest at the Čapek brothers' villa in Královské Vinohrady between the wars. Palacký sleeps in the family grave at Lobkovice; Jirásek in his native Hronov in northeast Bohemia. Janáček is safely tucked away in Hukvaldy. These are not the only illustrious Czechs who haunt this national pantheon by their absence. The homosexual poet Jiří Karásek z Lvovic, author of the confiscated *Sodoma* (Sodom, 1895) and co-founder of the 1890s decadents' magazine *Moderní revue* (Modern Review), finds no room in this stable; nor do F. X. Šalda, F. V. Krejčí, J. S. Machar, and Otakar Březina, whose manifesto *Česká moderna* (Czech Modernism), published in October 1895, could not wait for the dawn of the twentieth century to consign "imitation national songs" and "versified folkloristic baubles" to the dustbin of history.[38] We will also look in vain in the most sacred place for the only Czech yet to have been awarded a Nobel Prize in Literature. Jaroslav Seifert was buried on 21 January 1986 in his mother's hometown of Kralupy nad Vltavou. His funeral, which took place in Prague, was as well attended by the secret police of the day as that of the radical journalist Karel Havlíček Borovský had been a century earlier.[39]

Other absences remind us of the spectral double that shadowed the city for much of the twentieth century—just as it did for most of the seventeenth—which Josef Škvorecký once called the "Bohemia of the soul."[40]

There is a Josef Šíma buried in Vyšehrad, but it is not the painter. Breton and Éluard's 1935 traveling companion died in 1971 in France, where he had made his home since 1921. Toyen sleeps in Batignolles Cemetery in Paris, where she was buried close to André Breton and Jindřich Heisler, the young surrealist poet and graphic artist with whom she abandoned Prague after World War II. She pointedly allowed herself to be described in the list of participants in the surrealists' 1959 *Exposition inteRnatiOnal du Surréalisme*, a spectacle that was entirely devoted to EROS, as "born in 1902 in Prague. Refugee in Paris since 1947."[41] František Kupka, who is probably the best-known Czech painter of the twentieth century—at least to westerners—also lies in French soil. Kupka, who had lived in France since 1895, served as a volunteer in the Czechoslovak Legions during World War I, but neither national independence nor the honorary professorship he was given in 1922 at Prague's Academy of Fine Arts tempted him home. Other illustrious twentieth-century Czechs buried in some corner of a foreign field include the composer Bohuslav Martinů, the designers Ladislav Sutnar and Antonín Heythum, and the architect Jaromír Krejcar. "If you desert me, I shall not perish; if you desert me, you will perish," run the famous lines of Viktor Dyk's poem "The Homeland Speaks" (*Země mluví*),[42] but one sometimes wonders whether Škvorecký is not right in his conviction, nurtured during his own long exile on the shores of Lake Ontario, that the itinerant Bohemia of the soul is more authentic than the real thing.

The "whole company of our great minds," as Max Švabinský went on to call the cemetery's inhabitants, was pretty distinguished nonetheless. "In Vyšehrad, seat of the Princess Libuše," he reassured Mucha, "you will look at Hradčany and Saint Vitus's Cathedral . . . dark autumn clouds will scud above your head and winter will blanket the Slavín with ermine snow, but spring will come again, the meadows and woods will flower in the Czech land." These were not the best of times, and as life in these parts often does they called for metaphor and allusion. It was a bare four months since the German army had occupied the city; the seventy-nine-year-old Mucha had been one of the first arrested for questioning by the Gestapo, though he was soon released. Švabinský's reference to Czech "meadows and woods" (*luhy a háje*) blooming again will have conjured up for every one of his listeners the lyrical strains of the fourth movement of Bedřich Smetana's symphonic poem *Má vlast* (*My Country*, completed 1882), "Z českých luhů a hájů" (From Bohemia's Woods and Fields). The cycle begins in "Vyšehrad" and flows with the "Vltava" (whose main theme is based on the tune of a Czech nursery rhyme) through the green pastures of myth ("Šárka") and the rapids

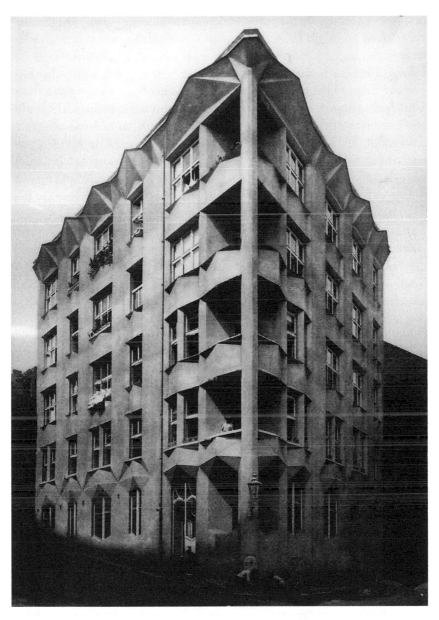

FIGURE 3.2. Josef Chochol, apartment building, Neklanov Street, Prague, 1913. Unknown photographer. Národní technické muzeum, Prague.

of history ("Tábor") to the future indefinite of "Blaník," whose knights—as Alois Jirásek relates in *Old Czech Legends*—will ride to the aid of the land in its hour of direst need with Saint Wenceslas at their head. Šárka was one of Libuše's handmaids and a heroine of the Girls' War (*Dívčí válka*) that supposedly followed the princess's death; she used her beauty to trap the Thane Ctirad, whose body the rebellious women then broke on a wheel. The southern Bohemian town of Tábor—the word means a camp—was a Hussite stronghold. The legend of the knights sleeping beneath Blaník Hill would later inspire wry, if not always—to those accustomed to more vanilla modernities—especially sidesplitting jokes. On the day the first Five Year Plan is announced the knights are encountered cantering toward Prague; they are told to go back to their slumbers and return in five years' time.

But while the winter lasted Vyšehrad would provide Mucha with a consolation not unrelated to that which Ivan Klíma found outside the police headquarters in Bartholomew Street. "You will talk with Bedřich Smetana," Švabinský tells him, "with Antonín Dvořák, with the great Mikoláš Aleš, with Jaroslav Vrchlický, with Josef Myslbek, [and] with the young Jan Štursa." Smetana and Dvořák are familiar enough figures to western concertgoers, these other names perhaps less so. Aleš, whose adornments to Prague buildings we encountered in the previous chapter, was "a draughtsman, illustrator and painter of pictures from patriotic history and Czech folk songs, the founder of the national tradition in painting, our most Czech artist."[43] Vrchlický was a nineteenth-century Parnassian poet who made it his life's work to furnish Czech paradigms of every poetic genre. He was a prime target of *Czech Modernism*. Myslbek and Štursa were sculptors—Štursa an immensely talented one, whose delicate *Puberty* (*Puberta*, 1905) and *Melancholy Girl* (*Melancholické děvče*, 1906) are among the jewels of the Czech Secession. His altogether more monumental groups *Labor* (*Práce*) and *Humanity* (*Humanita*), executed in 1912–13, stand on the pylons of Prague's "cubist" Hlávka Bridge (Hlávkův most), which was designed by Pavel Janák and ornamented with panels by Otto Gutfreund. Is it mere coincidence, a sunflower-night warp in the fabric of time, that the statues have an uncannily anticipatory air of socialist realism about them? These are not the only giants of Czech culture sleeping in Vyšehrad. Mucha could equally well have communed with the shades of the composer Zdeněk Fibich; the poets Julius Zeyer, Adolf Heyduk, and Josef Václav Sládek; the painters Vojtěch Hynais, Antonín Chittussi, Julius Mařák, and Karel Purkyně; the sculptors Stanislav Sucharda and Ladislav Šaloun; the architects Josef Schulz, Josef Mocker, and Antonín Wiehl; and the writers Božena Němcová, Jan Neruda, and Svatop-

luk Čech. Švabinský himself would be laid to rest here in 1962. His art was by then a living anachronism, but so it had been according to modernist calendars for much of the century—which never stopped people liking it.

Ema Destinová might have offered Mucha comfort of another sort. Emmy Destinn, as she is better known to western opera buffs, was one of the leading sopranos of her age. She sang Cio-cio-san in the Covent Garden premiere of *Madame Butterfly* in 1905, partnering Caruso's Pinkerton, and created the title role in Puccini's *La Fanciulla del West*, again singing opposite Caruso, at the Metropolitan Opera House in 1910—the first world premiere to take place at the Met, which was conducted by Toscanini. She also gave New Yorkers their first glimpse of Smetana's *Bartered Bride*, which premiered a year earlier.[44] Destinn's life was as colorful as we expect that of a goddess to be. "I try to translate your perfect breathing control into my own phrasing, and I feel certain that Chopin had exactly that on his mind when he required *rubato* in his works," the young Artur Rubinstein told her at a late-night supper one night in 1907 in Berlin. "All right, all right," Emmy screamed, smashing her champagne glass, "I know I am a good singer, but I am also a woman." Before long the pianist discovered that the diva had a tattoo of a boa constrictor circling her leg from the ankle to the upper thigh. "I am afraid I was not at my best that night," he confessed, "but she seemed not to mind."[45] Having made the dangerous crossing back to Europe from New York in 1916 to join her lover Dinh Gilly—the French baritone had been interned by the Austrian authorities as an enemy alien—Destinn found herself confined to her castle in Southern Bohemia on account of her contacts with the Czech resistance abroad. The medieval castle, which she had bought and refurbished in 1914, provided plentiful diversions: "the colors of the keys on her custom-built piano were reversed and she kept an aquarium with a selection of frogs, each named after a prima donna, whose different pitch of croaking she apparently recognized."[46] The Divine Emmy, as her adoring fans baptized her, would later be commemorated on the Czech Republic's 2,000-crown bill. Her 1910 recording of Isolde's *Liebestod* is arguably a more fitting memorial—even if, like the Met premiere of *The Bartered Bride*, it is sung in German. Powerful, soaring, breasting the waves of the orchestra with an urgency that makes most renditions sound like staid oratorio, she sings as if she really is dying of love.[47]

Alfons Mucha would have been thoroughly at home in this company; as a young student in Munich he had written to Mikoláš Aleš in 1886 assuring him that "We always understood you and shall always understand you, just as everyone certainly will in our Czech nation who is not a reactionary and who

retains an ounce of sense."[48] The older painter's influence on the serpentine lines with which Mucha would captivate Paris a decade later is beyond the horizon of western art historians and as clear as the light of day to anyone familiar with Aleš's work. There is a malicious pleasure to be derived from the thought that Aleš's *Špaliček národních písní a říkadel* (A Chapbook of Folk Songs and Rhymes), the Czech Mother Goose, should be numbered among the influences upon what was once known as the modern style; the same pleasure that comes from the coupling of musical modernism and Janáček's little Moravian village of Hukvaldy. Both bring to mind the laughter with which Foucault read that passage from Borges. But in the unlikely event that the one-time star of Parisian art nouveau posthumously developed an interest in more canonically modernist artistic vocabularies, he could have passed the time of day with the Group of Fine Artists and Obstinates veterans František Langer, Josef Gočár, Vincenc Beneš, and Václav Špála, and even exchanged pleasantries with the interwar Czech avant-garde. They were, after all, his contemporaries, even if in the orderly reconstructions of art-historical retrospect they seem to belong to another age. The architect Jaroslav Fragner, the painter František Muzika, and the theater director Emil František Burian, who were all members of Devětsil, are buried in the most sacred place. So too are Vítězslav Nezval and—rather less expectedly—Karel Teige. Undisturbed, one hopes, by any more utopian dreams, Karel sleeps in the family plot alongside his father Josef, who was once upon a time the Prague city archivist.

At first glance Vyšehrad may bring to mind other *lieux de mémoire* like the Arlington National Cemetery in Washington, DC, but this is not the monument of a place where truths are self-evident and history marches in a straight line from sea to shining sea. There are no military heroes to be found here, and few politicians. Palacký's son-in-law František Ladislav Rieger, the leader of the so-called Old Czech party, is a rare exception; and even he spliced the political with the literary, editing the first Czech encyclopedia *Riegrův slovník naučný* (Rieger's Encyclopedia), a work of ten volumes whose publication commenced in 1860. It is as if Poets' Corner had swallowed up Westminster Abbey. The scale is intimate, the feel homely, like a country churchyard—*malé, ale naše*, we could say. A better comparison might be with Montparnasse Cemetery in Paris, where one can wander among the graves of Charles Baudelaire, Samuel Beckett, Juliet and Man Ray, and Simone de Beauvoir and Jean-Paul Sartre, and smile at the whiskey bottles, metro tickets imprinted with lipstick kisses, and occasional pair of panties that adorn Serge Gainsbourg's tomb. Montparnasse, though, is not a national cemetery—at

least not as we reckon such things—but a private resting place. Vyšehrad is neither quite one thing nor the other. It resists assimilation to the distinctions of *our* thought, the thought that bears the stamp of *our* age and *our* geography. But it might serve to remind us that our thought and our geography have been shadowed by others all along, which inhabit the same time, if not always—by our reckoning—the same age.

Milan Kundera, whose literary insights into the human condition are more bound up with his Bohemian[49] experience than he sometimes cares to admit, endeavors to explain. The context is the essay on Leoš Janáček I quoted earlier, whose title is "The Unloved Child of the Family." Kundera likens Janáček's music to "a beautiful garden laid out just next door to History"— impossible to ignore, but at the same time so utterly alien that "the question of its place in the evolution (better: in the genesis) of modern music doesn't even arise." Janáček's is the music, he says, of "another Europe," "whose evolution runs in counterpoint with that of the large nations":

> Small nations. The concept is not quantitative; it describes a situation; a destiny; small nations haven't the comfortable sense of being there always, past and future; they have all, at some point or another in their history, passed through the antechamber of death; always faced with the arrogance of the large nations, they see their existence perpetually threatened or called into question; for their very existence *is* a question.

This question is not *just* one of marginality, though that is often how it appears when seen from the vantage point of London, Paris, New York, or Berlin—Neville Chamberlain's "faraway country" or Friedrich Engels's "absolutely historically non-existent 'nation,'" as the man who would later lend his name to the embankment beneath Vyšehrad dismissed the Czechs when they failed to measure up to the progressive expectations of the materialist conception of history in 1849.[50] What from the viewpoint of large nations and grand narratives appears as merely peripheral, Kundera argues, is a *different* modernity, and one that is not always as far away as we like to imagine. This "other Europe" has its own "evolutionary rhythm," which syncopates in unexpected ways with what we like to think of as the mainstream of History.

Most of the small European nations, Kundera goes on, achieved independence only during the nineteenth and twentieth centuries. This "historical asynchrony" often proved very fruitful for the arts, allowing for "the curious telescoping of different eras: for instance, Janáček and Bartók were both ar-

dent participants in the national struggle of their peoples; that is their nine-teenth-century side: an extraordinary sense of reality, an attachment to the working classes and to popular arts, a more spontaneous rapport with the au-dience; these qualities, already gone from the arts in the large countries, here merged with the aesthetic of modernism in a surprising, inimitable, felici-tous marriage." I would want to go further than Kundera here. These cou-plings of realities that apparently cannot be coupled on planes that are appar-ently not appropriate to them are sure signs, to my mind, that it is *our* sense of history that is awry. We need instead to rethink the boundaries these mis-cegenations transgress—and the more so when Kundera cites such towering figures in the modernist canon as Ibsen, Strindberg, Seferis, and Joyce as in-stances of the same "asynchrony." I am not sure there is *anything* "nineteenth-century" about Janáček or Bartók's engagement with folk traditions; both found themselves in trouble with the self-appointed guardians of a "national" music. We might likewise want to ponder the paradox that it was not Paris, London, New York, or Berlin but *fin de siècle* Vienna, the Rosenkavalier capi-tal of "the second weakest of the great powers,"[51] that in its twilight years gave the world Klimt, Schiele, and Kokoschka; Mahler and Schoenberg; Witt-genstein and Loos; not to mention the Moravian-born Sigmund Freud. How can we even begin to *think* modernity apart from their legacy?

But this felicitous marriage forged in faraway places also has its downside. Many of the artists Kundera discusses had to spend large parts of their lives abroad before they achieved recognition at home, while Janáček for years suffered a kind of internal exile. It was the German-speaking Jew Max Brod who was largely responsible for bringing Janáček's work to international at-tention—as he also did Franz Kafka's. Janáček's best-known opera *Jenůfa* (*Její pastorkyňa*) premiered in Brno in 1904 but was kept off the stage of the Na-tional Theater in Prague until 1916; "knowing no other musical gods but Smetana, nor other laws than the Smetanesque," Kundera sneers, "the na-tional ideologues were irritated by his otherness." The major obstacle to rec-ognition of the art of small nations, he argues, is not that its creators are "se-cluded behind their inaccessible languages" but "the reverse: what handicaps their art is that everything and everyone (critics, historians, compatriots as well as foreigners) hooks the art onto the great national family portrait photo and will not let it get away." "A small nation resembles a big family and likes to describe itself that way" and "within that warm intimacy, each envies each, everyone watches everyone."[52] Many a Czech will freely admit that envy— *závist*—is one of the less endearing features of the national character. Vyšehrad Cemetery, a portrait of the nation as a family *par excellence*, materi-

alizes that warm, watchful intimacy in both its comforting presences and its spiteful absences. Kundera himself is unlikely to find rest in the Slavín, even if his claims to a Nobel Prize would be considered by many to be at least as good as those of Jaroslav Seifert. He is doubly unpopular, and doubly envied, among his compatriots: having first flourished as the literary golden boy of the 1968 Prague Spring, he went on to mint international celebrity out of the miseries of the land he abandoned when things turned sour. Not that Kundera would relish spending eternity among the whole company of our great minds anyway. He has been writing in French—the ultimate sacrilege in a nation whose language has been justly described as its "cathedral and fortress"[53]—since 1990.

Ferdinand Peroutka found his way back to Vyšehrad from New York, where he had died in 1978, only in 1991. The former editor of *Přítomnost* took the long route home, spending World War II in Dachau and Buchenwald and the last thirty years of his life in the United States, where he found refuge after Victorious February. During his American exile Peroutka provided over 1,500 commentaries for Radio Free Europe. One of them, dating from 1956, drew a connection, unthinkable to many at the time—or since—between the postwar "transfer" of Czechoslovakia's three million "Germans" and other forms of "life without rights or law" in the Czech Lands. "If it is possible to condemn a person for the fact that he belongs to a certain nation," he wrote, "then it is also possible that he will later be condemned for belonging to a certain social class or political party."[54] Likely he had in mind, among many others, the National Socialist parliamentary deputy Milada Horáková, who was hanged in Pankrác Prison after the first great Czechoslovak communist show trial in 1950. Horáková, too, now has a place among the company of our great minds. A metaphorical place, that is: where her body disappeared to remains a mystery. Her gravestone was nevertheless placed in Vyšehrad in 1991 with the inscription "executed, but not buried." Such substitutions of the signifier for the signified were not without historical precedent:[55]

> Here would have been buried Josef Čapek, painter and poet
> Grave far away
> 18 23/3 87 19 -/4 45

Suicide Lane

Like the English words sanitation and sanity and the French *cordon sanitaire*, the roots of the Czech term *asanace*, the neologism coined to describe Prague's turn-of-the-twentieth-century slum clearance, lie in the Latin *sani-*

tas. Poets and artists angrily protested the *Bestia Triumphans* (to quote the title of an 1897 pamphlet by the writer Vilém Mrštík) rampaging through the Jewish Town in the name of hygiene. But they were no match for the modernist imperatives of Josefov's appalling mortality statistics; or, come to that, the lure of the money to be made out of rebuilding on what had suddenly become highly desirable real estate. Between 1890 and 1910 some 1,500 buildings were demolished in the five historic boroughs of the city, amounting to almost half of all residential housing; of these, 620 were casualties of the *asanace*.[56] By the time World War I broke out most of Josefov and parts of the Old Town, including the northern side of the Old Town Square, had fallen to the wrecker's ball. The house in which Franz Kafka was born had vanished, leaving only its portal behind to remember it by. In their place arose an altogether airier quarter of high-priced historicist simulacra, a potpourri of neo-renaissance, neo-gothic, neo-baroque, and art nouveau apartment houses totaling eighty-three buildings on what were now just ten broad streets. It was through these De Chiricoesque vistas that Nezval and Honzl took the nocturnal walk described by Nezval in *The Chain of Fortune.* Nezval's reference to the Italian artist, whose early metaphysical paintings full of empty squares were so beloved of the surrealists, suggests a vaguely disquieting vacancy, the shadow of another absence that will not go away. Like Marinetti, De Chirico would later be seduced by the charms of Mussolini, to the disgust of both Karel Teige[57] and André Breton.

At the heart of the new Fifth Quarter Nicholas Street (Mikulášská ulice) punched its sumptuous way clean through what had been the labyrinth of unhealthy medieval alleys from the Old Town Square to Jan Koula's elegant Svatopluk Čech Bridge (Čechův most) across the Vltava, which was built in the Secession style in 1905–8. In a rhetorical gesture of pan-Slavist solidarity Mikulášská—or as Prague Germans knew it, Niklasstrasse—was named not, as might be thought, after Kilián Ignác Dientzenhofer's Saint Nicholas Church, a showpiece of the Prague baroque that had stood since 1737 on the corner where the street meets the Old Town Square, but in honor of the Russian Tsar Nicholas II whom Lenin's Bolsheviks were to murder along with his wife, his son, and his four daughters in a Siberian basement in 1918. In 1920 Saint Nicholas's became the official seat of the revived Hussite Church encouraged by the new Czechoslovak state. Who knows what inspired Karel Teige, in the dark days of 1941, to choose Dientzenhofer's church as the setting for an untitled collage featuring a naked girl hanging from the dome like an upside-down pastiche of Edgar Degas's *Miss La La at the Cirque Fernando*? The Týn Cathedral across the square, which would have been a more

appropriate headquarters from the point of view of its Hussite history—and its plain and simple gothic architecture—remained in Vatican hands. The Czechoslovak Church, as the new denomination was officially known, managed only half a million converts. Whatever the Hussite past had by then come to mean for their imaginings of the nation, the majority of Czechs continued to worship a Roman Catholic God—when, that is, they bothered to worship at all. The hilariously grotesque field mass celebrated in Jaroslav Hašek's *Osudy dobrého vojáka Švejka za světové války* (*The Good Soldier Švejk*, left unfinished at the author's death in 1923 and continued by Karel Vaněk) might be as accurate a measure of the religiosity of Prague's populace as any of the fictions self-reported in the census.[58] The boulevard's renaming as Paris Street (Pařížská ulice) in 1926 reflected the more westerly diplomatic orientation—not to say cultural longings—of the new Czechoslovak state. Watching the Čech Bridge being constructed with its uncompleted deck perilously jutting out over the river, Franz Kafka, whose up-and-coming parents moved from Celetná Street to Nicholas Street in 1907, sardonically baptized the boulevard "Suicide Lane."[59]

In Jan Koula's original scheme of 1897 Nicholas Street was intended to be the backbone of a renascent *"golden, Slavonic* Prague"—as Mayor Tomáš Černý pointedly described the city in his inaugural speech of 1882, provoking the resignation of the last remaining German members of City Council[60]—furnishing it with a spine that would extend south through the Old Town Square and across Na příkopě to Wenceslas Square and north over the Čech Bridge through a triumphal arch cut into the steep ridge above the riverbank to Letná Plain. Wenceslas Square itself had been semiotically nationalized only in 1848, when at the suggestion of Karel Havlíček Borovský it was rechristened after the Czech patron saint. For the previous five hundred years, since it was first laid out by Charles IV, the square had been known simply as the Horse Market: hence the profusion of names recorded in Apollinaire's "Passant de Prague." Josef Václav Myslbek's equestrian statue of Svatý Václav, around which Czechs have congregated through the crises that punctuated their modernity (1918, 1938, 1945, 1948, 1968, 1989), was installed at the head of the square in front of the National Museum in 1913. The expanse of the Letná plateau, Koula thought, would make an ideal site for the future parliament building of an independent Czech state. Nicholas Street would thus map the progress of the modern Czech nation onto the ancient Bohemian capital, cutting a clarifying swathe through the back alleys of the past.

These dreams came to naught. When independence caught everyone off-guard in 1918 the new Parliament met in the temporary space of the Rudolfi-

num. There were plentiful plans to build a permanent seat under the First Republic, including a luminous design by the Devětsil architect Jaromír Krejcar,[61] but none were ever realized. Was this perhaps another indecipherable premonition of *hasard objectif*? By the time Czechoslovakia acquired a purpose-built Parliament building in 1973 the symbol had lost its point and purpose, since the country was by then to all intents and purposes a one-party state. The brutalist structure, all concrete and glass, stood on what was then Victorious February Street (Ulice Vítězného února) but used once upon a time to be Wilson Street (Wilsonova ulice)—a name bestowed in gratitude for US President Woodrow Wilson's support for the Czechoslovak cause during World War I.[62] Karel Prager's edifice was flanked by the National Museum on one side and what used to be the New German Theater but had now become the Smetana Theater on the other. "What is a Parliament?" ran the inevitable joke: "Something between a theater and a museum" (*něco mezi divadlem a muzeem*). At Václav Havel's suggestion the building became the headquarters of Radio Free Europe after the 1989 Velvet Revolution. Fittingly perhaps, it has now become an annex to the National Museum.

The Old Town Square is still linked to Wenceslas Square by a maze of irrationally narrow streets whose antique charms it is impossible even to contemplate tampering with today, at the beginning of the post-communist—and possibly postmodern—twenty-first century, when the city has hitched its economy and its identity to marketing its magic. Letná was eventually breached farther downriver by an altogether less triumphant tunnel, while above Koula's Svatopluk Čech Bridge rises a flight of grandiose steps that lead only to an empty plinth upon which once stood the largest statue of Joseph Stalin in the world. The author of the monument, Otakar Švec, a pupil of Myslbek's, committed suicide soon before the monstrosity was officially unveiled in 1955. Prague's citizenry Švejkishly dubbed his creation "the lineup for meat" (*fronta na maso*)—an irresistible simile, since Švec's sculpture was made up of four Czechs and four Soviets marching side-by-side behind the Generalissimo into the Promised Land—though the vaults beneath the statue, according to popular belief, were used for warehousing potatoes. Vulgar jokes also made the rounds about one of the figures in the procession, whose eyes are firmly fixed on the horizon of the future but whose hand, from a certain angle, appears to be reaching back into the groin of the proletarian hunk behind her. Until then Švec had been best known for the streamlined *Sunbeam Motorcycle* that stood "as a symbol of the new relation between man and machine" outside the Czechoslovak pavilion at the 1925

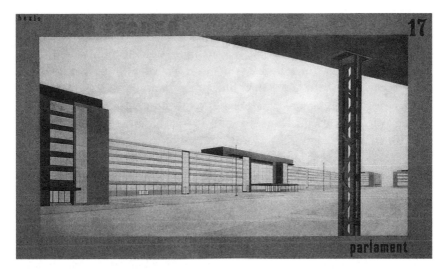

FIGURE 3.3. Jaromír Krejcar, design for Czechoslovak Parliament Building, Prague-Letná, 1928. Národní technické muzeum, Prague.

Exposition internationale des arts décoratifs et industriels modernes in Paris— an event at which Czechoslovakia won more prizes than any nation except France.[63] The steps were designed by the architect Jiří Štursa, Jan Štursa's nephew; the family connections that bind this small nation are not always metaphorical. Today the plinth is occupied by Vratislav Novák's fragile-looking metronome, whose hand goes neither forward nor backward but simply oscillates in time; a sign, perhaps. Štursa's steps have proved a godsend for skateboarders.

The metronome, which was originally erected as a temporary installation in 1991, has sometimes been mistakenly credited to David Černý, the bad boy of contemporary Czech sculpture. Černý first hit the headlines after the Velvet Revolution when he painted pink the tank in Smíchov that commemorated the liberation of the city from the Germans by the Red Army on 9 May 1945. It accrued a different significance when the Russians came back to stay in August 1968, snuffing out Alexander Dubček's short-lived Prague Spring. Soon Czechoslovakia would have the best-educated stokers, garbage collectors, and window-cleaners in the world. Two decades later the sculptor embarrassed his country's government and delighted its citizens when he celebrated the Czech Republic's presidency of the European Union with a gigantic relief map of Europe in which Bulgaria was depicted as a toilet, Germany crisscrossed with autobahns in swastika patterns, and Holland swal-

lowed up by the North Sea leaving only the exposed minarets of mosques to remind us that it ever existed. The British Isles were absent from the map altogether. Černý's other artistic pranks include a pastiche of Myslbek's Saint Wenceslas statue in which he seats the Czech patron proudly astride an upside-down horse.[64] Rudely comic, but at the same time—to anyone who knows their Czech history, and Czechs usually do—profoundly unsettling, the sculpture was originally intended for Prague's Main Post Office, but the director found it "too much." Černý's horse now hangs from the ceiling in the Lucerna passage, a couple of hundred yards down Wenceslas Square from Myslbek's statue. An arcade complex boasting a concert hall, bars, restaurants, and one of Prague's earliest cinemas, the Lucerna Palace was built by Vácslav Havel, grandfather of future president Václav Havel and one of the biggest property developers of his day, between 1907 and 1921. It was the first structure in the city to employ reinforced concrete, that quintessential symbol of building modern, in its construction, and the Lucerna Cinema was the first in the country to show talkies (beginning with *Show Boat* in 1929).

The Havel family was a pillar of interwar Czechoslovakia's flourishing film industry. The Barrandov Studios—at the time among the largest and most technically advanced in Europe—were owned by the future president's Uncle Miloš and built by Václav's father, Václav Maria Havel, in 1931–33. Barrandov was an exclusive suburban villa quarter on the southwest outskirts of the city. "America was my inspiration," Václav M. later reminisced; the "garden city" first took shape in his mind as a twenty-four-year-old student visiting Berkeley after World War I, where he was impressed by the lifestyle of the California rich.[65] The Barrandov Terraces, modeled on a cliff-house in San Francisco,[66] became a popular destination for Prague day-trippers during the 1930s. A free shuttle-bus ran from Wenceslas Square. "Za Prahou a přece v Praze [Outside Prague yet in Prague]. Visit Barrandov. Visitez Barrandov. Besucht Barrandov" read Alexej Hrstka's quadrilingual poster. In the foreground is an elegant young lady sipping a cocktail; behind her terraces lined with sunshades curve away high above the Vltava into endless summer.[67] Lucerna gained an unsavory reputation between the wars as "a haunt for perverted cravings" where "the notorious homosexual [Miloš Havel] gathered around him morally corrupted young men and made them compliant in his acts." I quote from a postwar disciplinary commission of the Union of Czech Film Workers (Svaz českých filmových pracovníků), who were investigating the film mogul's alleged wartime collaboration with the Nazis, a charge of which Miloš was cleared for lack of evidence in December 1947.[68] Eighteen months later he fled to Austria, but he was arrested in the Soviet-occupied zone and sent home to serve two years in prison. He finally made it out to

FIGURE 3.4. Jan Lauschmann, "At Barrandov," 1932. Moravian Gallery, Brno.

Munich on a forged passport in 1952. He successfully sued the German film company Ufa for its wartime use of Barrandov. Some scenes from Veit Harlan's notorious *Jud Süß* were shot there, using Prague Jews (who were otherwise forbidden to work in the film industry) as extras. With the proceeds of his lawsuit Miloš opened a restaurant called Zur Stadt Prag (The City of Prague), a name that conjured up not only his lost homeland but also its vanished bilingual character. Many of his customers would have been Sudeten Germans nostalgic for the tastes of what had once been their *Heimat*, too. The future president's uncle died in February 1968, just in time to miss the Prague Spring.

Lucerna is one of the locations Petr Král, a second-generation Czech surrealist, recalls in his *Prague*, a "poem-guide, reverie-guide, phantom-guide" to the city (as a reviewer in *Le Monde* described it) that came out—in French, not Czech—in 1987. Král, too, was wandering a landscape of memory; he had lived in Paris since 1968. Whether he is conjuring up the metallic screeching of the tramcars or "the young girls exposing their legs to the sun up to mid-thigh" on the square in front of the Rudolfinum, hard by the "wholly modern nudity of the Mánes Bridge," his recall of detail has all the sharpness of Marcel Proust's famous encounter with the *madeleine*.[69] The clean lines of the Mánes Bridge (Mánesův most), built in 1911–14, contrast sharply with the art nouveau fantasia of Jan Koula's neighboring Čech Bridge, though the two structures are almost contemporaneous. The square where Král fondly remembers the *studentky* from the nearby Philosophical Faculty and School of Decorative Arts sunning themselves is named in his book as Red Army Square (náměstí Krasnoarmějců). From 1919 to 1942 and again from 1945 to 1952 it had been Smetana Square (Smetanovo náměstí). What else? In retaliation for the assassination of Reinhard Heydrich, Hitler's Protector of Bohemia and Moravia, by Czech partisans parachuted in from Britain, the square bore no Czech name at all from 1942 to 1945, being known instead in German alone as Mozartplatz. "My Praguers understand me!" the composer is supposed to have gushed after the city gave *The Marriage of Figaro* a far warmer reception than such subversive stuff found in imperial Vienna.[70] After the Velvet Revolution Red Army Square would be rechristened Jan Palach Square (náměstí Jana Palacha) in memory of another Philosophical Faculty student, who set himself on fire beneath Myslbek's Saint Wenceslas statue on 19 January 1969. Buddhist monks were doing the same thing at the time in Vietnam, but Palach was inspired as much by the image of Jan Hus, with whom he was obsessed. He was given a massive public funeral that turned into a silent show of rejection of the country's latest occupiers, just as Alfons Mucha's funeral had thirty years earlier. Palach's grave, too, would prove a movable feast; his body was not allowed to remain long in Olšany Cemetery, where he had first been laid to rest. It drew too many pilgrims.

Tactile as Král's details may be, his vignettes are all at sea. The Czech writer is as alive to the slipperiness of the city as Ripellino. But if Král's book has much in common with *Magic Prague* it also has something to set it apart. Prague, he writes, drifts in a "no-man's land" (the phrase is in English), oscillating between "a here and an elsewhere, a presence and an absence." It is a place where we can turn a corner and stumble across "the Russian steppes between two baroque domes, like an antechamber of the Gulag comfortably

situated in the suburbs of Paris or Munich." The city's temporalities are as fickle as its geographies. Prague inhabits "a time outside time where it seems condemned to slumber," telescoping "the past and the present, the mythical and the quotidian." The Bohemian capital is a city at once "ancient and modern, real and imaginary," compounded of equal parts "nostalgia and promise." But unlike Ripellino—or André Breton—Král locates Prague's surrealities firmly within the geographical, historical, and economic circumstances of the city's modernity. Its nostalgias and promises, most of them broken, are achingly twentieth-century:

> In the summer twilight the nostalgic sigh that rises from the stones and the gardens of the capital is not so much the reminder of a Prague of alchemists or Jesuits, as the tourist guides would like. The spirit, revived by memory, which pulses in the walls and behind the façades is above all that which inhabited the city between the wars. Rather than Rudolf II and his picturesque court it is Nezval or Voskovec and Werich who are remembered one evening in the twenties in a wine cellar that may be historic, but from which you can already hear in the distance the screeching and ringing of the trams. . . . The memory of Mozart's celebrated stay is eclipsed by that of the almost anonymous visit Marcel Duchamp made to Prague for a chess tournament.[71]

On meeting Duchamp in Max Ernst's studio in Paris in 1935 Vítězslav Nezval was dumbstruck to learn that "the legendary precursor of modern painting and surrealism" had wandered Prague's streets "unknown and unrecognized by anybody." The very thought gave yet another layer of meaning to the familiar landscape that Apollinaire's alcohols had already turned upside-down. "That's how poetic beauty works," he marveled. "It transforms for us the cities, the pubs, the whole world."[72]

It is above all in the arcades around Wenceslas Square, Král continues, that "the echoes of the interwar bustle always linger." On a blind façade hidden behind the U Nováků passage on Vodičkova Street "until quite recently" an old poster could be glimpsed advertising "the incomparable 'clowns'"—once again the word is in English—Jiří Voskovec and Jan Werich, whose Liberated Theater, "the most engaging establishment in the world," used once to be located in the arcade.[73] The theater began life in February 1926 under Devětsil's auspices. Its inspiration, says a 1937 *Festschrift* commemorating the compa-

ny's tenth anniversary, lay in "poetism as defined by Teige and Nezval," which "standing on a philosophical foundation of Marxism, extended to the poetry of Apollinaire, the painting of Picasso, and even postwar western Dadaism. On the other side it was close to the new spirit of Russian revolutionary poetry, led by Mayakovsky."[74] The Soviet poet lectured at the Liberated Theater in 1927; so, among others, did Kurt Schwitters, Ilya Ehrenburg, and Le Corbusier.[75] The theater's first productions were staged in rented spaces[76] using amateur actors under the direction of Jindřich Honzl and Jiří Frejka. As well as homegrown avant-garde fare like Vítězslav Nezval's *Depeše na kolečkách* (Dispatch on Wheels, 1926) or Adolf Hoffmeister's *Nevěsta* (The Bride, 1927), the repertoire included an impressive number of foreign plays. Honzl directed Apollinaire's *Breasts of Tiresias* in 1926 in a translation by Jaroslav Seifert with stage sets by Otakar Mrkvička, František Zelenka, and Karel Teige. The *Festschrift* informs us that Apollinaire was "from the beginning the [theater's] lyrical patron."[77] Breton and Soupault's *There You Go*, George Ribemont-Dessaignes' *The Silent Canary* and *The Peruvian Executioner*, Ivan Goll's *Insurance against Suicide* and *Methusalem or the Eternal Bourgeois*, and Marinetti's *Little Theater of Love* and *The Captives* were among the productions that followed. Highlights of the 1928–29 season included Jean Cocteau's *Orpheus* (with stage sets by Jindřich Štyrský)[78] and Alfred Jarry's *Ubu roi* (with Jan Werich playing the title role). By then the company was employing professional actors and regularly performing in larger downtown venues.

The theater's biggest early hit was not an avant-garde drama at all but Jiří Voskovec and Jan Werich's *Vest-Pocket-Revue*, a mélange of jazz and comedy that premiered on 19 April 1927 and was reprised no less than 208 times. The duo's *Smoking Review*—again the title was in English—followed the next year. After Frejka quit to establish the Dada Theater (Divadlo Dada) with E. F. Burian in March 1927 and Honzl left for a new post at the Land Theater (Zemské divadlo) in Brno in May 1929, Voskovec and Werich took over the Liberated Theater and turned it into a hugely successful home for their own inimitable brand of entertainment.[79] The theater moved to its 1,000-seat premises in Vodičkova ulice in 1929, where it soon acquired "a full orchestra and six-member dance troupe known as 'Joe Jenčík's girls.'"[80] Jenčík choreographed most of Voskovec and Werich's subsequent productions, for which the "Czech Gershwin" Jaroslav Ježek, who joined the company in 1929, wrote the music. Beginning with *Caesar* in 1932, Voskovec and Werich turned increasingly toward political satire, lampooning both the Czechoslovak establishment and international fascism. Nationalism of all stripes was their particular bugbear. *Osel a stín* (The Ass and the Shadow, 1933), a production in

which Otakar Švec, the future author of the Stalin memorial on Letná, was credited with "sculptural cooperation,"[81] was inspired by the Reichstag fire. Czech nationalists campaigned to get the theater closed down in 1934, but V + W (as the pair became known) went from strength to strength. The avant-garde Soviet stage director Vsevolod Meyerhold, a close collaborator of Mayakovsky's who would be executed by Stalin's security apparatus in 1940, recalled how "my friend, the dead poet Apollinaire" had taken him in 1913 to a performance at the Cirque Medrano in Montmartre—formerly the Cirque Fernando, where Dégas painted *Miss La La* in 1879. Meyerhold returned to the Medrano several times with the aim of "getting drunk" on the improvised comedy but he was disappointed. "They were no longer the artists Apollinaire had showed me. I looked for them with sadness and longing in my heart, but didn't find them. Until today, 30 October 1936, in the performances of the unforgettable duo V + W, when I again set eyes on 'Zanni' [an archetypal servant character in Italian *commedia del arte*] and I was once again enchanted by the performances rooted in Italian improvised comedy." "Long live *commedia del arte*!" he ends. "Long live Voskovec and Werich!"[82]

The poster in the U Nováků arcade, Král goes on, was "a true mirage, so little visible on the old wall that the eye had each time literally to conjure it up from nothingness." This chimera may have been one of František Zelenka's advertisements for the theater, which have recently been rediscovered and hailed by no less than London's Victoria and Albert Museum as icons of a forgotten modernism; Král doesn't say.[83] An architect as well as a designer, Zelenka provided sets, costumes, and posters for many V + W productions, including *Don Juan & Comp.* (1931), *Golem* (1931), *Balada z hadrů* (A Ballad Made of Rags, 1935), and *Caesar*. To remember the Lucerna Palace as it used to be required a no less Herculean effort of eye and imagination. By the time Král was born in 1941 everything the Liberated Theater stood for had passed away. The arcade he grew up knowing was "a veritable monument to the pleasures of a defunct capitalism," a ruin haunted by memories of bygone dreams and desires. But the past had not altogether disappeared. It never does here. The building looked much as it always had, only shabbier. It still boasted its original paternoster, "an elevator made up of numerous doorless cabins in continual motion." In Král's mind's eye the paternoster seemed "to encapsulate both the spirit of free enterprise with its cult of the circulation of commodities, and capital's ability to make its spaces correspond to its circuits," an eternally revolving reminder of what once was.[84]

Capital would return, eager to reoccupy its restituted spaces and set the *perpetuum mobile* going again, sooner than Král imagined. It had little time

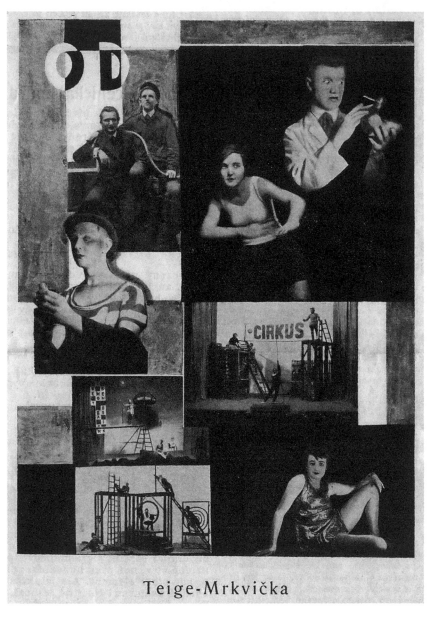

FIGURE 3.5. Karel Teige and Otakar Mrkvička, "OD" (Osvobozené divadlo). Photomontage illustration for *Pásmo*, Vol. 2, No. 8, 1926. Archive of Jindřich Toman. Courtsey of Olga Hilmerová, © Karel Teige - heirs c/o DILIA.

for nostalgia unless, like the recovered memory of Rudolf II and his alche-mists, remembrance of things past could be transmuted into twenty-first-century gold. The émigré surrealist revisited the city soon after the Velvet Revolution. It was a rude awakening, abruptly stopping the drift of poetic thought in its tracks:

> Prague regained reality in my eyes where my memory had
> preserved only the quintessence. It is a true invasion of the
> real, whose theater the city today is after the years of the
> totalitarian sleep. What bustles anew in the streets is first of
> all an avalanche of brute facts in all their pitiless literalness;
> the tiredness of faces and the decrepitude of façades, the
> blackened stone of statues and the massive flesh of but-
> tocks, the ferocity of desires, the murderous stupidity of
> the apparatchiks and the triumphant boorishness of the
> new entrepreneurs, the blindness of frustrated consumers
> squeezed into the same parka, the omnipresent din of rock
> music vainly protesting the irredeemable emptiness of the
> world, everything comes to light again with the insolence
> of a truth long hidden, like at the end of a war. . . . By this
> return to life, of course, Prague also rejoins the banal every-
> day of other modern cities; the daydreaming it until re-
> cently aroused, thanks to its very closure, fades away under
> the horns and beeps of a galloping "back-into-the-world
> ism" [*toutmondisme*].[85]

Easier to live, in some ways, in Josef Škvorecký's Bohemia of the soul. "Prague is made to be inhabited at a distance," sighs Král. "Its spaces are never as vast and as serene as when, in a faraway exile, we transport ourselves there in thought."[86] What occasions this bittersweet reflection is the sudden glimpse of an ozone-soaked Prague dusk at the end of a rainy day—in Rotterdam.

"While standing on the Svatopluk Čech Bridge," suggests Ivan Margolius, "look up at the steep slope leading to the Letná Plain. There"—on the very spot where Jan Koula planned to cut his triumphal arch over the highroad from the National Museum to the National Parliament and Josef Stalin later paternally gazed down Paris Street to the Old Town Square—"Future Sys-tems want to locate a memorial to the victims of Communism—a perma-nent scar carved into the natural setting." We might think there is something distinctly surreal about including an edifice that was never built in a book

that bears the title *Prague: A Guide to Twentieth-Century Architecture*, but in this case the detour into dreamland is thoroughly comprehensible:

> A cut would be made into the hill with a stainless steel lightweight bridge suspended between the sloping side walls, rising in forty-two steps symbolizing the number of years of the Communist regime. The walls would be faced with black glass and inscribed with the names of all the innocent who lost their lives. A fitting and appropriate tribute to those who died on the gallows, in prisons, in police and secret service custody, in labor camps and uranium mines and while illegally crossing the country borders. The project lies particularly close to my heart as my father, Rudolf Margolius, was one of the men unlawfully executed in December 1952 as a result of the infamous Slánský trial.[87]

There has been no shortage of suggestions over the years for this site, which seems to crave the monumental. In 1911 it was proposed to build a memorial here to Sokol's founders Jindřich Fügner and Miroslav Tyrš, which would have been as monstrous as that eventually devoted to Stalin. Queasy parallels might be drawn between Sokol's jamborees of massed gymnasts, which were staged in Prague every few years from 1882 onward, and the healthy-mind-in-a-healthy-body spectacles beloved of both communists and Nazis, but nobody could have foreseen such coincidences back then. A design for the Fügner-Tyrš memorial is reproduced, juxtaposed with a photograph of the Stalin monument being blown up in 1963, in *Surrealistické východisko* (The Surrealist Point of Departure)[88]—a timely compilation by Král, Stanislav Dvorský, and Vratislav Effenberger that crept under the wire before the normalization that followed the 1968 invasion had fully kicked in. The term "normalization" (*normalizace*), by the way, was the KSČ's own. Echoes of Foucault—or, come to that, of John Heartfield's photomontage "Normalisierung," which was published in a German émigré magazine in Prague on 29 July 1936—are entirely coincidental. Heartfield was one of many German refugees from Hitler who had taken up residence in the city by the time of Breton and Éluard's visit. The montage, one of hundreds that the "Monteurdada" (as he once called himself) produced during the five years he spent in exile in the magic capital, showed the "German colony in Austria" sawing the arms off the Austrian cross to transmute it into a swastika.[89] Future Systems, an architectural firm better known for its daring Selfridges store in Birmingham, England, was founded by Jan Kaplický, a Czech

fleeing a different brand of normalization—or maybe it wasn't—in 1973.[90] As Margolius anticipated, their project has joined the long list of unfulfilled Letná dreams.

Looking back in 1930 on the fever of urban development in Prague at the turn of the twentieth century Karel Teige, who was no lover either of historicist sentimentality or the Czech bourgeoisie, found Paris Street "riddled with poor taste," defiled by tacky "apartments decorated in false baroque or false vernacular motifs, with tasteless towers, gables, and other bric-a-brac."[91] He was equally dismissive of the ornate bourgeois apartment houses on the Rieger Embankment opposite Žofín Island and the Mánes Gallery where Breton lectured, which were built around the same time. Unlike Vilém Mrštík, who in his 1893 novel *Santa Lucia* had fantasized the city as a "black temptress . . . hidden in the *négligé* of the white mists of the Vltava"[92]—an image, it goes without saying, that Ripellino relishes—Teige was not pining for magic Prague. Like his one-time hero Le Corbusier, who infamously proposed building over Paris's historic center in his Plan Voisin of 1925, Teige would cheerfully have razed the rest of the old city, wiping clean the historical slate to create a tabula rasa for a better future. Paris Street has finally come into its own since 1989. Today this boulevard of broken dreams provides a suitably opulent backdrop for Dior, Hermés, and Louis Vuitton. Prague's *jeunesse dorée* mingle with foreign tourists and businessmen in high-end restaurants named Pravda and Barock. Baroque and roll is par for the course in a city desperately seeking hipness, but *pravda*—the Czech word for truth—has other echoes in these parts. Centuries before the brave Lenin's Bolsheviks took *Pravda* for the name of their daily paper, "pravda vítězí" (Truth will prevail) was the slogan of the Hussites. Emblazoned on the presidential standard, the words have fluttered above Prague Castle ever since 1918, twisting this way and that in the wind.

The restaurant has funky décor and does a mean *crème brûlée*. Across the river Vratislav Novák's metronome ticks back and forth, marking postmodern time. "The city was changing," begins Jáchym Topol's 1994 short story "A Trip to the Station," a surreal tale of the ruins of Bolshevik dreams being warrened by gangsters and crooks. Doubtless it was. As a character in Stanley Kwan's film *Everlasting Regret* remarks of Shanghai, cities stay young forever; it is only their inhabitants who grow old and cynical and die. Yet still the old tropes return, turning up ever and anew like bad pennies. *What once was* comes back as a recurring dream, ghostly as Král's poster in the U Nováku passage, sharp as his memory of the suntanned legs of the pretty *studentky* in Red Army Square. Postmodern we may—just possibly—be, but we cannot

erase the traces of a past that refuses to lay down and die. The old ghetto metamorphosed into a new cabinet of curiosities:

> The city was changing.... Dusty cellars and dirty beer joints in what used to be the Jewish Quarter were cleverly converted into luxury stores. You could find steamer trunks from the last century, a book dictated by Madonna herself with a piece of her chain included, pineapples and fine tobacco, diaries of dead actresses and trendy wheels from old farmer's wagons, whips and dolls and travel grails with adventurer's blood in them, coins and likenesses of Kafka, shooting galleries with all the proletarian presidents as targets, rags and bones and skins, anything you could think of.[93]

FRANZ KAFKA'S DREAM

All that lay in the eternally surprising future. Directly after World War I had ended, in November 1920 to be exact, seven years after Apollinaire's "Zone" was published in Paris—and whatever he may or may not have said to Gustav Janouch about Meyrink's *Golem*—Franz Kafka was troubled less by the ghosts of the past within him than the specters of that future closing in all around him. The Stars and Stripes flew over the backward-turning clock on the Jewish Town Hall, which had been put under the temporary protection of the US Embassy to safeguard the building from rioting Czechs. They were targeting German and Jewish people and property without discrimination—visible reminders of what were now almost universally seen, in the aftermath of a national independence few but poets and dreamers had ever foreseen, as three hundred years of "foreign" oppression that had begun at the Battle of the White Mountain. Perhaps the most surreal episode of the riots, to latter-day eyes—though it made perfect sense at the time—was the seizure of the Estates Theater, the oldest in Prague, on 17 November 1920. It was three hundred years to the month since the fateful engagement at Bílá hora had ushered in the Darkness. Crying "The Estates to the Nation!" ("Stavovské národu!")—a linguistic *double entendre* that pits plebs against aristocrats as well as Czechs against Germans[94]—the mob threw the German players out of the building on the Fruit Market where Mozart's *Don Giovanni* had its world premiere in 1787. That evening performers from the National Theater mounted Smetana's *Bartered Bride* on the liberated stage. Where the statue of the *commendatore* had first come alive and dragged the hapless Don down

to Hell, the canny peasant-boy Jeník outwitted Kecal the marriage broker and won his pretty Mařenka, proving to all that everything can be transmuted into everything else and dreams are but realities-in-waiting.

Sitting in his parents' apartment in the Oppelt House on the corner of Nicholas Street and the Old Town Square to which the family had shifted in 1913, opposite Dientzenhofer's Saint Nicholas Church, Kafka wrote describing the view from his window to Milena Jesenská, who was living at the time with her first husband, Ernst Pollak, in Vienna. The young couple had moved there partly to escape Milena's virulently nationalist father Jan Jesenský, a professor of orthodontics at the Czech University of Prague. Jesenský claimed descent, quite spuriously, from his namesake whose tongue Jan Mydlář cut out on the Old Town Square in 1621. He had done his utmost to sabotage his daughter's relationship with a Jew, in the end having her committed to a mental hospital for nine months for "moral insanity." That, at least, is Max Brod's version of the story; others, who knew Milena better, concede that her rampant kleptomania likely contributed as much to her confinement as her father's anti-Semitism.[95] A graduate of Minerva, the first girls' grammar school (*Gymnasium*) in the Austro-Hungarian Empire, Milena was a giddy young thing, swimming across the Vltava fully clothed, flirting with the German-Jewish writers and intellectuals who "brodelt und kafkat, werfelt und kischt"[96] at the Café Arco on Hybernská Street, dabbling in drugs filched from her father's surgery—then. "I have been spending every afternoon outside in the streets, bathing in anti-Semitic hate," Franz told her. "I just looked out the window: mounted police, gendarmes with bayonets, a screaming mob dispersing, and up here in the window the unsavory shame of living under constant protection."[97] "Isn't it natural," he asked, "to leave a place where one is so hated?" But unlike Max Brod, who caught the last train out before the Wehrmacht moved in, he never did.

"Surrealism," wrote André Breton in *Communicating Vessels*, "tried nothing better than to cast a *conduction wire* between the far too distant worlds of waking and sleep, exterior and interior reality, reason and madness."[98] Here then, for whatever it is worth, is what Franz Kafka recorded in his diary nine years earlier, on 9 November 1911:

> A dream the day before yesterday: Everything theater, I now up in the balcony, now on the stage. . . . In one act the set was so large that nothing else was to be seen, no stage, no auditorium, no dark, no footlights; instead, great crowds of spectators were on the set which represented the

Altstädter Ring [the Old Town Square], probably seen from the beginning of Niklasstrasse [Nicholas Street]. Although one should really not have been able to see the square in front of the Rathaus clock [the horologe] and the Small Ring [Malé náměstí], short turns and rockings of the stage floor nevertheless made it possible to look down, for example, on the Small Ring from Kinský Palace. This had no purpose except to show the whole set wherever possible, since it was already there in such perfection anyhow, and since it would have been a crying shame to miss seeing any of this set which, as I was well aware, was the most beautiful set in all the world and of all time.... The square was very steep, the pavement almost black, the Tein [Týn] Church was in its place, but in front of it was a small imperial castle in the courtyard of which all the monuments that ordinarily stood in the square were assembled in perfect order: the Pillar of Saint Mary, the old fountain in front of the Rathaus [Old Town Hall] that I myself have never seen, the fountain before the Niklas [Saint Nicholas] Church, and a board fence that has now been put up around the excavation for the Hus memorial.[99]

Kafka had never seen the fountain in front of the Old Town Hall, which dated from Rudolf II's time, because it had been removed from the square after being vandalized in 1863, before he was born. The pillar of the Virgin Mary was erected in 1650 in thanks for the delivery of the city from the plundering Swedes by the Peace of Westphalia two years earlier. It was a replica of a column installed in Munich in 1638 by Maximilian of Bavaria in gratitude for the victory at the White Mountain. The inscription on the Munich pillar read "Rex, regnum, regimen, regio, religio—restaurata sunt sub tuo presidio," alliterating faiths, polities, and subjects into newly disciplined identities. The foundation stone for the monument to Jan Hus was laid on 5 July 1903. The juxtaposition with the Mary Column was an uneasy one: as the historian Josef Pekař pointed out in the speech he delivered on the occasion, Hus's heretical questioning of the papacy from the pulpit of the Bethlehem Chapel was the first step along the road that ended two centuries later in the disaster at Bílá hora.[100] The monument itself, sculpted by Ladislav Šaloun in overblown expressionist vein, was unveiled on 6 July 1915, five hundred years to the day after Hus was burned at the stake. This was in the middle of World

War I: the Austrian authorities heavily censored press coverage of the cere-
mony. Kafka thought Šaloun's edifice "mediocre stuff," preferring František
Bílek's "sketches of incomparable quality," but he had doubts about whether
"this wrong should be rectified by Jewish hands."[101]

The monument nailed memory firmly in its place. Exiles prostrate them-
selves before the Old Town Hall, cowering in the shadow of the executions of
1621. Proud soldiers of God and his law pose before the Týn Cathedral,
which was once, centuries ago, a Hussite stronghold. Between these images,
sheltered behind the towering figure of Hus, the nation is reborn, quietly
nurtured by a nursing mother. It is fitting, but probably coincidental, that
she faces the side of the square recently demolished in the slum clearance.
Hus was positioned to gaze out on the Mary Column as if in perpetual re-
proach. Among the epigraphs inscribed on the monument's pedestal are the
words "I believe that the government of your affairs will return to you, O
people!" They come from a prayer by the last bishop of the Union of Breth-
ren (Jednota bratrska), Jan Amos Komenský, who is better known in the
west as the humanist pedagogue and inventor of children's literature Come-
nius. Having lost his wife, children, and library to the Thirty Years' War the
author of *Orbis Pictus* fled his homeland in 1628 to wander the labyrinth of
the world in search of the paradise of the heart—an early explorer of Josef
Škvorecký's Bohemia of the soul.[102] Alfons Mucha painted Komenský in 1918
in *The Slavic Epic (Slovanská epopej)*, an old man slumped in a chair staring
wistfully out over the cold North Sea during his last days in Naarden.[103]

For a brief moment, as the old Europe whose outlines had been laid down
at the Peace of Westphalia finally expired on the bordello beds of World War
I, Komenský's prayer seemed to have been answered. Czechoslovak indepen-
dence was proclaimed on 28 October 1918 in the Municipal House (Obecní
dům) on what was soon to become Republic Square. Constructed in 1905–
12, the Municipal House was the last grand art nouveau building to go up in
Prague. Janáček and his Kamilka had many a stolen assignation there.[104] It
stands just across the street from the Hotel Paris where Breton, Lamba, and
Éluard stayed in 1935, though it seems to have made no impression on them.
Perhaps the building's surrealities—among them Mikoláš Aleš's country
butchers and goose girls adorning the basement "American Bar"—were too
modern to charm them. Alfons Mucha supplied the decorations for the Lord
Mayor's Chamber; not without a storm of protest from Czech artists' societ-
ies, who objected to so important a commission being given to a celebrity
painter who had spent the previous twenty years living abroad. Beneath a
splendid domed ceiling symbolizing "Slavic Concord" eight spandrel paint-

FIGURE 3.6. Karel Teige, collage, 1941. The building is Saint Nicholas Church on the corner of the Old Town Square in Prague. Památník národního písemnictví, Prague. Courtsey of Olga Hilmerová, © Karel Teige - heirs c/o DILIA.

ings depict heroes of Czech history, each of whom personifies a moral virtue: Hus stands for Justice; Komenský for faithfulness; Eliška Přemyslovna, the Czech mother of Father of the Homeland Charles IV, for maternal wisdom. Three large murals illustrate the texts "Holy mother nation, accept the love and enthusiasm of your son!" "Though humiliated and tortured you will be resurrected, O homeland!" and "With strength for freedom, with love for unity." Two smaller panels show a fetching Czech maiden grieving and dreaming. Saint Vitus's is shown in "Tears over the Ruined Homeland" as it had looked throughout the last three hundred years of suffering, whereas in "The Czech Crown" the cathedral's silhouette is that of Josef Mocker's design for its "completion." The sweet dreamer in bondage, needless to say, is the very image of Smetana's Mařenka, the bartered bride.[105]

On 3 November 1918, a week after independence, revelers returning from a meeting at the White Mountain pulled down and destroyed the Mary Column on the Old Town Square, reclaiming the most beautiful set in all the world and of all time for Jan Hus alone—and whatever, by that date, he had come to signify for Czechs. František Sauer-Kysela, a drinking companion of Jaroslav Hašek, author of *The Good Soldier Švejk*, led the mob.[106] Kafka dreams on:

> They acted—in the audience one forgets that it is only act-
> ing, how much truer is this on the stage and behind the
> scenes—an imperial fête and a revolution. The revolution,
> with huge throngs of people sent back and forth, was prob-
> ably greater than anything that ever took place in Prague;
> they had apparently located it in Prague only because of the
> set, although really it belonged in Paris. Of the fête one saw
> nothing at first, in any event, the court had ridden off to a
> fête, meanwhile the revolution had broken out, the people
> had forced its way into the castle. . . . They walked toward
> Niklasstrasse. From this moment on I saw nothing more.[107]

Kafka's Parisian dream was to be reenacted on the Old Town Square ever and anew as the twentieth century wore on, the eternal return of the never-quite-the-same; most notably when thirty years later KSČ leader Klement Gottwald rallied the masses from the balcony of the Kinský Palace—the balcony, as it happens, of what had once been Franz Kafka's high school class-room, the Royal and Imperial Old Town Gymnasium, above what had once been his father Herman's fancy-goods store—in support of the Victorious February coup of 1948.

This pivotal moment in modern Czech history provided Milan Kundera with the unforgettably surreal opening of *The Book of Laughter and Forgetting*, in which he tells how the only trace left of then deputy foreign minister Vlado Clementis, who stood beside his leader on the balcony that February day but was airbrushed out of photographs following his execution for treason four years later, was the fur hat Clementis had solicitously placed on Gottwald's head as the snowflakes began to fall.[108] Like Ivan Margolius's father Clementis was a victim of the Slánský trial. Jiří Kolář—another Czech artist who would metamorphose into a Parisian after 1968—collaged the original and doctored photos into a bleakly funny composition titled "But Deliver Us," which bears the caption "Malanthios: erasing Aristratos and replacing him with a palm tree, or, three Socialist rules."[109] Three weeks after the KSČ coup Clementis was promoted to foreign minister. His erstwhile boss Jan Masaryk—son of President Tomáš Garrigue Masaryk—had fallen out of a fifth-floor window in the Černín Palace opposite the Loreta Church in Hradčany, one of the loveliest sights in Prague. The jury is still out on whether Jan committed suicide or was pushed. Prague numbers its defenestrations as countries do their monarchs, and this was the third. The first, of councilors from the Town Hall of the New Town on 30 July 1419, launched the Hussite Wars; the second, of imperial officials into the castle moat on 23 May 1618, triggered the Rising of the Czech Estates that met its end at the White Mountain. As for Herman Kafka's fancy-goods shop, the wheel has come full circle; the premises are now occupied by the Franz Kafka Bookstore (Knihkupectví Franze Kafky).

Loreta is another Prague location that makes its way into Petr Král's reminiscences. "Suspended between an immense (but dumb) official palace [the Černín] and a marvelous finely engraved baroque church, with its convent and its dreamy peal of bells," he muses, "the silence of the square floats halfway between town and country." It also "winks from faraway Paris," since it was Loreta Square (Loretánské náměstí) that spontaneously came to Král's mind when he first read the scene set in the place Dauphine in Breton's *Nadja*.[110] According to Breton, the pretty little *place* nestling between the thighs of the Seine at the tip of the Île de la Cité was "one of the most profoundly secluded places I know of, one of the worst wastelands in Paris. Whenever I happen to be there, I feel the desire to go somewhere else gradually ebbing out of me, I have to struggle against myself to get free from a gentle, over-insistent, and, finally, crushing embrace."[111] Only later did he recognize that embrace as eternally feminine. The realization, he says, "nearly dazzled" him:

> I find it unbelievable today that others before me, upon entering the place Dauphine from the Pont-Neuf, were not grabbed by the throat at the sight of its triangular conformation, a slightly curvilinear one at that, and of the slit that bisects it into two wooded areas. Unmistakably, what lies revealed in the shade of these groves is the *sexe* of Paris.[112]

Baron Haussmann probably did not intend to stimulate the surrealist imagination when he laid out his boulevards, but Paris is not conceived on a masculine American grid; *la ville-lumière* abounds with triangular intersections, often tufted with trees. Is Loretánské náměstí, then, the *sexe* of Prague? Maybe not, but Leopold von Sacher-Masoch might have found much to arouse him in the convulsive beauties of the locale. The dreamy bells of Loreta chime next door to Král's Russian gulag in the suburbs in much the same way as Janáček does to modern music. On a narrow street just behind the church is what used to be an infamous StB (Státní bezpečnost, the communist secret police) torture chamber. Today the innocuous-looking building bears a plaque commemorating its communist past. It used to be grimly known, in the affectionate manner of Czech diminutives, as the *domeček* (little house).

Looking down from the Kinský Palace balcony on Kafka's stage set that really belonged in Paris, would the "First Workers' President," as Klement Gottwald liked to describe himself, by chance have recalled a well-known passage from Karl Marx's *Eighteenth Brumaire of Louis Bonaparte*, reflecting upon another *coup d'état* that took place in the city of light a century earlier? It was a pregnant observation, whose implications Marx himself perhaps did not take as seriously as he might:

> The tradition of the dead generations weighs like a nightmare on the minds of the living. And, just when they appear to be engaged in the revolutionary transformation of themselves and their material surroundings, in the creation of something which does not yet exist, precisely in such epochs of revolutionary crisis they timidly conjure up the spirits of the past to help them; they borrow their names, slogans and costumes so as to stage the new world-historical scene in this venerable disguise and borrowed language.[113]

Likely not. Dialectical materialism requires history to go forward, backward not a step—to paraphrase a ubiquitous KSČ slogan of the time (*kupředu,*

zpátky ani krok)—rather than round and round in circles, spattering metaphors without end like one of Arcimboldo's paintings. It is not expected to follow twisted Freudian paths of repetition-compulsion. But Gottwald was not known for his sense of the surreal. The people swept him into the castle all the same, just as they would Václav Havel, who did have a nose for the absurd, four decades later.

In *Testaments Betrayed* Milan Kundera claims Kafka for surrealism *avant le mot*, arguing that "the kind of imagination with which [he] bewitches us" is precisely the "fusion of dream and reality" for which André Breton called in the *Manifesto of Surrealism*, a decade after Kafka began writing his great novels though long before they were published—thanks only to Max Brod, who disobeyed his friend's instructions to burn his manuscripts. "The more alien things are from one another," Kundera contends, "the more magical the light that springs from their contact." He instances K.'s and Frieda's coitus on the barroom floor in *The Castle* as an example of this "density of unexpected encounters."[114] He is speaking of Kafka's art, not his life, and strongly objects to the reduction of the one to the other. This need not stop us from casting a conducting wire between the dream and the events it so uncannily prefigured, as Breton did in *Mad Love* between "Sunflower" and his meeting eleven years later with Jacqueline—if for no other reason than to ponder: what waking transmutes into this sleep, what exterior reality transmutes into this interior reality, and what reason transmutes into this madness? Or vice versa?

Do You Speak German? Are You a Jew?

Kafka died in the summer of 1924, aged forty, from the tuberculosis that had been consuming his body for years.. The question marks finally throttled Shamefaced Lanky.[115] His gravestone can be found in the New Jewish Cemetery, not the Old, at Olšany in the Žižkov district from which the young Jaroslav Seifert began his pilgrimage to the whorehouses of Corpse Lane. Žižkov was a later-nineteenth-century working-class quarter. It took its name from Jan Žižka, who led the Hussite armies "against all" (*proti všem*)—to invoke the title of another of Alois Jirásek's novels[116]—as the papacy mustered the powers of Europe to crush the Bohemian heresy. It was here that the Hussites won the Battle of Vítkov, their first major victory, in 1420. Žižka, too, featured in Mucha's lunettes in the Municipal House, epitomizing Czech fighting spirit (*bojovnost*). Žižkov's street names and murals celebrated the battles and heroes of the Hussite Wars, skewering the fifteenth century deep into the vitals of the modern city. Later the communists would discretely

purge these proletarian streets, replacing what were in hindsight reactionary Utraquists, the Hussite "moderates" who won the fratricidal Battle of Lipany in 1434, with the radical Táborites whom they had defeated.[117] The past was as eternally present for the KSČ as it was for Ripellino—or Breton. In the words of Zdeněk Nejedlý, the septuagenarian Smetana scholar, biographer of Alois Jirásek, and one-time contributor to *Otto's Encyclopedia* who became Gottwald's Minister of Education and National Enlightenment, "To us, history is not the dead past, indeed it is not the past at all, it is an ever-living part of the present too."[118]

Unlike the historic city center Žižkov was overwhelmingly Czech: the new, rather than the old Prague, whose expansion was fueled by migrants from the Bohemian countryside lured less by the city's bristling towers than the promise of employment and the enticements of modern urbanity. In 1900 the census revealed just 824 "Germans" living there, amid a sea of 58,112 Czechs.[119] By 1907 Žižkov was in its own right the third largest city in Bohemia. Like the other Prague inner suburbs of Karlín, Smíchov, and Vinohrady, it was not legally incorporated into the national capital until 1922 even if the combined suburban population had exceeded that of the five historic Prague boroughs by 1890. From a Czech point of view the fiction of separation was one of the façades that sustained the illusion that (as Emperor Franz-Josef appreciatively put it during a rare visit in 1868) "Prague has a thoroughly German appearance."[120] But the fictional division was reality for many Prague Germans—which also at this date meant for many Prague Jews, who had taken Josef II at his word and loyally cleaved to an imagined imperial community. It was an understandable enough locus of belonging for a people who—it was increasingly being made clear—would be accepted neither as German nor as Czech. "He who wants to be a Czech must cease to be a Jew," wrote Karel Havlíček Borovský in 1844; we need "emancipation from the Jews," thundered Jan Neruda in 1869, calling as an unlikely chief witness for the prosecution "the great composer and still greater German and liberal Richard Wagner."[121] Neruda's *Tales from the Little Quarter* may be a gem of Czech literature, but it is replete with Shylock stereotypes. From the perspective of Prague's early-twentieth-century psychological geography Olšany seems an appropriately interstitial resting place for a man who—so to speak—was neither of the village nor the castle. Kafka always entered Žižkov, he recorded in his diary, "with a weak mixed feeling of anxiety, of abandonment, of sympathy, of curiosity, of conceit, of joy of traveling, of fortitude," returning "with pleasure, seriousness, and calm" from a zone that is "partly within our city, partly on the miserable, dark edge of the city," a place "for-

eign to us" yet not entirely so—even though Žižkov is no more than two or three miles, as the tram runs, from the Old Town Square.[122] How many worlds, we might ask, does a city encompass—and whose measures should we use to reckon the distances between them?

"I have never lived among Germans," Franz bluntly told Milena early in their relationship; a love affair, it should perhaps be made clear, that was carried on almost entirely through the mail, and thus left plenty of room for the imagination.[123] "German is my mother-tongue and as such more natural to me, but I consider Czech much more affectionate, which is why your letter removes several uncertainties; I see you more clearly, the movements of your body, your hands, so quick, so resolute, it's almost like a meeting."[124] Franz had asked her to write to him in Czech rather than German "because, after all, you do belong to that language, because only there can Milena be found in her entirety." He reassured her that "of course I understand Czech."[125] His location, linguistic and otherwise, was a good deal more complicated than hers. When he described German as his "mother-tongue" he meant it literally; it was the language his mother spoke to him from his infancy. Not so his father. From the evidence of the few surviving postcards in his hand, Herman Kafka's command of German was poor. The son of a kosher butcher in the entirely Czech-speaking little village of Osek in Southern Bohemia, the ambitious Herman had moved to Prague in 1881, where he set up shop first on Celetná Street and then on the ground floor of the Kinský Palace as "Hermann Kafka, linen, fashionable knitted ware, sunshades and umbrellas, walking sticks and cotton goods, sworn consultant to the Commercial Court."[126] The sign over the door, though, read Herman, not Hermann, Kafka—the Czech, not the German spelling of his name. The shop was spared more than one local *Kristallnacht* as a consequence. Franz's governess, Marie Wernerová, spoke no German. The family knew her as *slečna* (Miss). Kafka was still corresponding with her—presumably in Czech—during the last months of his life.[127]

Franz's mother Julie, *née* Löwy, was socially a cut above her husband. She hailed from a prosperous German-speaking Jewish family in Poděbrady, the birthplace of the "Hussite King" Jiří z Poděbrad, the last Czech to sit on the Bohemian throne back in 1458–71. Her father was a dry-goods merchant and brewery owner; both her grandfather and great-grandfather had been respected Talmudic scholars. These were not poor *Ostjuden* of the sort found in the further-flung imperial outposts of Bukovina and Galicia whose Yiddish theater was later to captivate Franz, but a comfortable upper-middle-

FIGURE 3.7. Miroslav Hák, "Periphery of Prague," 1947. The Museum of Decorative Arts, Prague.

class Bohemian family. Before her marriage Julie lived on the Old Town Square, which she will have called not Staroměstské náměstí but Altstädter Ring. Franz's difficulties with his overpowering father have provided plentiful grist for interpretive mills—not to mention a wonderful caricature by Adolf Hoffmeister, one of the founders of Devětsil, in which the beefy Herman dwarfs the wimpy, cringing Franz.[128] Kafka had a different problem with

his mother. Dissonances of language and identity conferred a surreal quality on the most intimate of relationships. "Yesterday," reads an entry in his diary for October 1911,

> it occurred to me that I did not always love my mother as she deserved and as I could, only because the German language prevented it. The Jewish mother is no "Mutter," to call her "Mutter" makes her a little comic (not to herself, because we are in Germany), we give a Jewish woman the name of a German mother, but forget the contradiction that sinks into the emotions so much the more heavily. "Mutter" is peculiarly German for the Jew, it unconsciously contains, together with the Christian splendor, Christian coldness also, the Jewish woman who is called "Mutter" therefore becomes not only comic but strange.[129]

What Freudian slip of Kafka's pen, we might wonder, put his mother and her Prague "in Germany" at this date—and equally to the point, which "Germany," exactly, were they in? The answer plainly has nothing to do with lines on maps and everything to do with cartographies of the mind. Austria-Hungary still existed after all, even if it had by this time shrunk to Robert Musil's Kakania, a diminutive Imperial-Royal (*kaiserlich-königlich*) Shitland waltzing into the twentieth century on a song and a prayer.[130]

Whatever community of the imagination Julie Kafka may have inhabited, her only son felt anything but at home in that mother tongue of which he is one of the twentieth century's undisputed literary masters. Inbred and infected with both Czech and Yiddish, *Prager Deutsch* was not "good" German. Franz spoke with an accent that immediately identified him as a Praguer[131] and described his feel for the language as being that of a "half-German."[132] He both admired and resented Goethe for the purity of his linguistic usage.[133] He was no more secure about his Czech, which while more than serviceable was less than "classical."[134] He thought highly of Božena Němcová, the author of *Babička* (*Granny*, 1855), the best-loved of all Czech novels[135]— so much so that he was to transmute parts of the setting and plot of her "Pictures from Country Life" (as the work is subtitled) into the surreal world of *The Castle*, which is a bit like staging *The Bartered Bride* in a concentration camp.[136] But he was tongue-tied before the director of the insurance office where he worked, from whom he "first learned to admire the vitality of spoken Czech."[137] He joked with Milena about how "the people who understand

Czech best (apart from Czech Jews of course) are the gentlemen from *Naše řeč* [Our Language], second best are the readers of that journal, third best the subscribers—of which I am one."[138] He joked with his sister Ottla about having "launched into the world the lie about my splendid Czech."[139] The legacy of Josef II's emancipation, which had opened business and commerce to Jews while forbidding the keeping of financial or communal records in Hebrew or Yiddish, ensured that like most Prague Jews of his day Franz spoke neither of the old languages of the ghetto. He began a talk at the Jewish Town Hall on 11 February 1912, beneath the backward-turning clock, with the sarcastic observation "many of you are so frightened of the Yiddish language that one can almost see it in your faces."[140] Kafka belonged in his entirety nowhere, unless it was to the overlaps and interstices of language, the slippages of identity, in this polyglot city that would never let him go. It still has not. Today this "Prague-Jewish author writing in German"—as a communist-period encyclopedia once doubly othered him[141]—is as difficult for any latter-day *passant de Prague* to shake off as the two assistants in *The Castle* who sat on the bar listening all the while K. lay in the puddles of beer with Frieda and wandered further into a strange land than anyone before him. Wearing a bowler hat and a black suit, Franz stares mournfully out at us from postcards, teeshirts, fridge-magnets, and Russian dolls, an unlikely patron saint of tourist kitsch.

Milena published a brief obituary in *Národní listy* (The National Paper). Their affair, such as it was, had abruptly ended at Franz's request in December 1920, leaving Milena distraught and uncomprehending.[142] Kafka, she wrote, was "a man who saw the world so clearly that he couldn't bear it, a man who was bound to die since he refused to make concessions or take refuge, as others do, in various fallacies of reason, or the unconscious"—which would seem to exhaust all the alternatives, at any rate since Nietzsche identified modernity with the death of God. The source of Kafka's sickness, Milena suggests, was not physical but existential. So surreal had his everyday world become, the writer was bewildered by something as mundane as the choices of counters at the post office—though in the case of Prague's Main Post Office, a magnificent Imperial-Royal edifice on Jindřišská Street, one cannot entirely blame him. Milena quotes from one of his letters: "when heart and soul can't bear it any longer, the lung takes on half the burden."[143] "Tuberculosis," Franz had once told Max Brod, "no more has its origins in the lungs than, for example, the World War has its cause in the ultimatum"[144]—this being the ultimatum that Austria-Hungary delivered to Serbia in July 1914 following

Gavrilo Princip's assassination of Archduke Franz Ferdinand in Sarajevo, two pistol shots that started the race to finish off whatever remained of old Europe, very late indeed in the long nineteenth-century day.

Milena came home from the old imperial capital to the new national capital in 1925, the year after Kafka's death, having finally divorced the philandering Pollak. Much as she was irritated by Prague's provincialism, she could not help but be seduced once more by the city's legendary charms. "Nowhere abroad does such a light shine as over Prague," she gushed in the winter of 1926. "I had not seen it for years, and when I saw it again, it seemed to me as if I had found something I had lost. . . . By the National Theater the night fog is like the thick top of milk, and through the creamy crust blue and brilliant lights shine suddenly, and golden lamplight streams clear."[145] Earning a precarious living from journalism she hung out in jazz clubs; partied with Teige, Nezval, and the other young radicals of the Devětsil group; married the architect Jaromír Krejcar; had an affair with the dashing journalist Julius Fučík; gave birth to a daughter, Jana, whom she called by the male diminutive Honza; got hooked on morphine; joined the KSČ and hid its fugitive leader Klement Gottwald for a time in her flat in the Little Quarter. She divorced Krejcar, who had fallen in love with another woman while working with Moshe Ginzburg in the Soviet Union in 1934–35, and left the party again over the Moscow trials—when not for the first time in modern history a declaration of the rights of man metamorphosed into Tricoteuses knitting and purling in the shadow of the guillotine. Krejcar went on to design the functionalist pavilion with which Czechoslovakia was represented at the 1937 *Exposition internationale des arts et techniques dans la vie moderne* in Paris, a structure the architectural historian Kenneth Frampton judges to be "as seminal . . . as the significant pavilions designed for the same occasion by Alvar Aalto, Le Corbusier and Junzo Sakakura."[146] This was the same world exhibition for which Picasso painted *Guernica* and Albert Speer's Nazi pavilion and Boris Iofan's Soviet pavilion stared each other down in monumental pomposity across the mall that led to the Eiffel Tower—a metaphor for the century, should we want one. Disillusioned with communism after his experiences in the Soviet Union and afraid for his Russian wife, Riva Holcova, Krejcar fled Czechoslovakia after Victorious February. He died a year later in London, where he had been given a professorship at the Architects' Association School.

In July 1938, just three years after Breton and Éluard's visit to the magic capital, three months before Chamberlain and Daladier sat down with Hitler and Mussolini to carve the cake in Munich, Milena was approached by

Ahasuerus, the Wandering Jew, in what was then still called Kralovské Vinohrady. A mere shadow of his former self, he was not looking for fourteen- and fifteen-year-old girls:

> On quiet and calm Vinohradská Street, a man stopped me. He was tattered and wretched, but he was not begging. Perhaps a Jew needs courage even to make a request if he has lived through the liberation of Austria. "Do you speak German?" "Yes." "Are you a Jew?" "I'm not." It was certainly that strange form of address that compelled me to turn around and watch his disappointed back because I realized that this man did not care to ask for help from someone who was not Jewish—in the middle of Prague, in the middle of Europe, on a calm, sunny afternoon in 1938. In recent years we have heard many stories like his. He had broken teeth and bloody gums; he had rags instead of clothes; he did not have a single heller and had not eaten for many hours. He did not spend the nights in any one place—for fear that they would send him back. He only walked and walked and walked.[147]

"He walked about all the time! He walked about all the time!" cried the *té tonnière et fessue* Hungarian hooker in Apollinaire's "Passant de Prague" after her fifteen minutes of fun with the Wandering Jew, "tired and roused by love, but also frightened."[148] The section of Milena's article from which I quote, which was published in Ferdinand Peroutka's *Přítomnost*, is called "Ahasuerus on Vinohradská Street."

Vinohradská (Vineyards) Street, says Petr Král, is as characteristic a Prague avenue as any. He warns us not to confuse the city with its spectacles, reminding us that Prague's gothic and baroque glories have ceaselessly had to contend with "grayness, a singular architectural poverty. In reality as in dreams, its soul breathes better in the emptiness of an avenue like Vinohradská, where façades without any particular attraction" line up as far as the eye can see, their only riches "the echoes, innumerable, that they have absorbed down the years."[149] At the time Milena was writing the thoroughfare was officially marked on Prague's maps as Fochova ulice in honor of the French World War I commander Marshal Foch—the Germans were to rename it after the Prussian Marshal Schwerin and the communists after Marshal Stalin, providing Milan Kundera with yet another opportunity for black humor.[150] Milena would not have been ignorant of Apollinaire's tale. Like all of her writing

during this time this article, which is titled "Hundreds of Thousands Looking for No-Man's-Land," shows extraordinary courage. She walks with eyes wide open through a landscape whose surreality, unfortunately, was anything but a dream. The wildest imaginings were becoming ever more real by the day. Arrested by the Gestapo for resistance activities—among them succoring wandering Jews—in November 1939, Milena spent the last four and a half years of her life in Ravensbrück concentration camp. She eventually gave up the ghost on 17 May 1944.

FANTASY LAND. ENTRY 1 CROWN

Ottla Kafka—or Kafková, as the Czechs would call her—probably predeceased her brother's one-time lover. Franz had encouraged his favorite sister's marriage to Josef David, a Czech Catholic, against the opposition of their parents and relatives, and wrote affectionately to his new brother-in-law in Czech. Josef was an official in the patriotic gymnastic association Sokol, which by 1920 had more than half a million members. The wedding took place in October of that year, a month before the riots in which the Estates Theater was stormed and reclaimed for Jeník and Mařenka and good Czech beer. The Davids divorced in 1942. It may not by then have been the happiest of marriages, but the urgency in dissolving the union came from Ottla and Pepa's need to protect their daughters Věra and Helena, who were known to their Uncle Franz—or František—as Věruška and Helenka, Czech being an affectionate language.[151] Under the laws of the Protectorate of Bohemia and Moravia into which the Czech Lands transmuted during the Nazi occupation the girls were not considered Jewish, but in neighboring Slovakia, which became a nominally independent state under German tutelage the day before Böhmen und Mähren were incorporated into the Third Reich, they would have been.[152] This was not a time or place in which things could be counted upon to remain themselves for very long.

Ottla registered with the police as a Jewess and was transported to Terezín—the same camp, as it happens, where Robert Desnos was to perish on 8 June 1945, a month after the war in Europe ended. The surrealist poet arrived the day before Terezín was liberated by the Red Army, half-starved and severely weakened from the twenty-five lashes he had received at his previous camp Flöha, which left him barely able to walk.[153] He was recognized by a couple of Czech students, who gave him a rose. After the war he had planned to publish a cookbook titled *Imprécis de cuisine pour les jours peureux* (Non-Handbook of Cooking for Fearful Days), a compilation of imaginary recipes whose title parodied his *Précis de cuisine pour les jours heureux* (Handbook of

Cooking for Happy Days)—a genre established by Marinetti, whose *Futurist Cookbook* of 1932 offered heroic winter dinners, extremist banquets, and springtime meals for words in freedom.[154] Desnos was not alone among Terezín's inmates in staying alive on a diet of dreams. Women compiled recipe books from receding memories, sometimes forgetting the essential ingredients of a goulash.[155] Children drew pictures in which the food came from fairy tales, served under signs that read: "Fantasy land. Entry 1 crown."[156] The culinary imagination proved no match for the transports—or for the typhus that killed Desnos, as it had Josef Čapek a couple of months earlier in Bergen-Belsen. "I'll see you soon, my darling," wrote the poet's wife, Youki, the former wife of the Japanese Montparnasse painter Foujita, in July 1945, not knowing that by then her Robert was already dead. "I send you a kiss as big as the Eiffel Tower."[157] The Czech students' rose was buried with him. God knows where they found it.

Terezín lies an hour's drive north of Prague in typically sweet, hilly Bohemian countryside, "a lovely countryside without either high mountains or dizzy cliffs, without deep ravines or swift rivers ... only blue hills, green meadows, fruit trees and tall poplars."[158] Not far away is Říp Mountain (Hora Říp)—if it can be called that, for it is decidedly *malá, ale naše* –from which Forefather (*Praotec*) Čech, legendary patriarch of the Czech people, looked out after long wanderings and decided that (as Alois Jirásek relates in *Old Czech Legends*) he had at last found home. Situated on the confluence of the Labe (Elbe) and the Ohře rivers, the town was established by Josef II in 1780 as a bastion against Prussian power. Like the walls of Star Castle at the White Mountain, Terezín's ramparts, designed by Italian military engineers, were built in the shape of a star. Josef's fastness never saw military action, and Theresienstadt, as it was then called, soon lapsed into a slumbering garrison town. Its Small Fortress served for a time as an imperial prison; Gavrilo Princip, its most famous inmate, died there of tuberculosis in 1918. On 19 October 1941, on the orders of Reinhard Heydrich, Protector of Bohemia and Moravia and Heinrich Himmler's deputy at the SS, Josef's starry castle was turned into a "Jewish Resettlement District." Could it be a premonition of this transformation that so disturbs me in Max Ernst's illustration in *Minotaure* for Breton's "Le Château étoilé"—another of those strange instances of *hasard objectif*, showing a necessity to come in a form that is legible only to the unconscious?

Terezín's metamorphosis into a "model ghetto" was a project close to the Protector's heart, though the idea was apparently Himmler's. Heydrich chaired the infamous Wannsee Conference of 20 January 1942, whose brief

was to organize "the final solution of the Jewish question in Europe." Though Terezín was in reality no more than a way station en route to Auschwitz, Sobibor, and Treblinka, Josef's fortress town doubled in surreality as a theater of Holocaust denial. It had a makeover for an International Red Cross inspection in 23 June 1944, and soon afterward provided the set for a propaganda film titled *The Führer's Gift to the Jews*. "It's ridiculous," complained fourteen-year-old Helga Weissová in her diary, "but it seems that Terezín is to be changed into a sort of spa":

> The school building that had served as a hospital up to today was cleared out overnight and the patients put elsewhere while the whole building was repainted, scrubbed up, school benches brought in, and in the morning a sign could be seen afar: "Boys' and Girls' School." It really looks fine, like a real school, only the pupils and teachers are missing. That shortcoming is adjusted by a small note on the door: "Holidays."[159]

"Everything in this small town was false, invented," reflected the writer Jiří Weil after the war was over; "every one of its inhabitants was condemned in advance to die."[160]

In the days before Weil discovered that he was indelibly a Jew—an identity previously foreign to him, since he had thought of his religion as atheist and his nationality as Czechoslovak—he had been among the first to translate avant-garde Soviet poetry into Czech, or indeed any other language. He first visited revolutionary Russia in 1922. Vítězslav Nezval recalls that Weil was "the only one among us who knew Russian and the first to translate for us Mayakovsky's verse. He showed us various Soviet avant-garde reviews, which later, when Teige got hold of them, had a great influence on the typographic layout of our avant-garde magazines."[161] Jiří returned to the Soviet Union in 1933, intending to translate Lenin's collected works into Czech. Instead he found himself inexplicably expelled from the party and exiled to Kazakhstan. He was fortunate to be allowed to return home to Czechoslovakia in 1935. His *Moskva—hranice* (Moscow—The Border), a *roman à clef* that came out in Prague the next year, was the first novel to be set against the background of the Moscow trials. It was not popular with the communist left; Julius Fučík was prominent among those who denounced it. The book's sequel *Dřevěná lžíce* (The Wooden Spoon)—in this case the first novel to be set in the gulag—was completed in 1938, but had to wait until 1992 before it was legally published in Czechoslovakia. Here, too, fact and fiction got hope-

FIGURE 3.8. Karel Teige, "Collage #196," 1941. The diving board is that of the swimming pool at the Barrandov Terraces. Památník národního písemnictví, Prague. Courtsey of Olga Hilmerová, © Karel Teige - heirs c/o DILIA.

lessly mixed up. Ri, the heroine of *Moscow—The Border*, was modeled on Hella Galasová, the daughter of a Prostějov factory owner. Hella was the poet Jiří Wolker's first love, but she wound up marrying a Soviet engineer. After the book was published the couple, who were instantly recognizable from Weil's portrayal, were arrested and executed.

Having contracted the last "mixed marriage" in the Protectorate to his "Aryan" lover Olga—which did not save him from being purely and simply Jewish—Weil evaded his own transport to Terezín by faking suicide from Pavel Janák's Hlávka Bridge. He survived the rest of the war in hiding. In 1946 he published "a collection of stories from the Occupation ... written in pencil on scraps of paper while I hid in hospitals and illegal apartments. Some were lost and rewritten later." They were dedicated to "friends—living and dead," among them Milena Jesenská.[162] The narrative in *Barvy* (*Colors*), the English translator Rachel Harrell remarks, is "non-linear"; "narrative emerges only gradually from the intersections of repeated images and phrases ... until the reader is held fast in a net of interwoven images, unable to look away from the horrors they depict."[163]

> If only your eyes were blind, if only you couldn't see me! I should turn myself into a rat or a hideous beetle, so you would pass me by, utterly indifferent, without so much as a second glance. I should lean against the white railing of the bridge with a harmonica, playing a simple song out of tune, so that you would walk past me and turn away in disgust. I would stand and play: dance, green toads, stomp all over my body, what are your jackboots to me; Jana Marie didn't see me, she walked right by in her limp red scarf and black coat.
>
> The toads are getting impatient; already the trees, the river, and the hillside are growing dark, water soaks into the muddy ground, it smells of rain. I stagger, but dare not fall, for you would look around then, Jana Marie.
>
> "Go on," hiss the toads. "Show your face."[164]

It is impossible not to see Prague in these images. The dark, the rain, the river, the bridge, the trees on the Letná hillside, Josef Čapek's buskers and winos, Gregor Samsa waking up in the shape of a giant bug you just long to squash.

The Bartered Bride had its Terezín premiere on 28 November 1942 to the accompaniment of a battered baby grand without legs that somebody had discovered in a former Sokol gymnasium just outside the town walls and

smuggled into the ghetto. Truda Borger sang Mařenka, Franta Weissenstein sang Jeník, and Bedřich Borges sang the marriage-broker Kecal. The production proved so popular that there were around thirty-five further performances, in the course of which "the magnificent Karel Berman replaced the enthusiastic amateur Borges"[165] as Kecal and Marion Podolier took over the role of Mařenka. "I have heard *The Bartered Bride* three times in Prague," enthused a thirteen-year-old girl in her diary, "but it was never so beautiful as here. It is indeed a miracle that conductor Schächter was able to prepare it like that. When I was walking home and overheard all the small talk about food, black marketing, passes, and work in the fields, I felt like a person having beautiful dreams, who awakens suddenly, and everything is again trite as always."[166] *The Bartered Bride* was not the only opera to be staged in Terezín: so were Mozart's *Marriage of Figaro* and *The Magic Flute*, Bizet's *Carmen*, Verdi's *Rigoletto*, and Puccini's *Tosca*, not to mention Johann Strauss's *Die Fledermaus*, a saccharine piece of Viennese kitsch second only to Franz Lehar in the affections of the Führer. Pictures were drawn, music composed, poems written; the "Jewish Resettlement District" housed what must have been one of the greatest concentrations of artistic talent in Europe.

"By no means did we sit weeping on the banks of the waters of Babylon. Our endeavor with respect to arts was commensurate with our will to live,"[167] wrote Viktor Ullmann, a one-time pupil of Arnold Schönberg's who served as chorus master under Alexander Zemlinsky at Prague's New German Theater through much of the 1920s. Ullmann was a great admirer of Milan Kundera's other nomination for the greatest opera of the dark twentieth century, Berg's *Wozzeck*, whose controversial Prague premiere under the baton of Otakar Ostrčil he witnessed at the National Theater in November 1926.[168] He was transported to Terezín in September 1942. "Here, where artistic substance has to try and endure its daily structure, where every bit of divine inspiration stands counter to its surroundings, it is here that one finds the masterclass,"[169] he concluded. Among the twenty-three works Ullmann composed in Terezín were three piano sonatas, a string quartet, several settings of songs, and *Der Kaiser von Atlantis oder die Tod-Verweigerung* (The Emperor of Atlantis, or The Refusal of Death), a one-act chamber opera that was banned from performance because the camp authorities saw an uncanny resemblance between the Emperor of Atlantis and Hitler. Ullmann's 7th Piano Sonata, dated 22 August 1944, was one of his last works. "Much of the often illegible only sketchily outlined score points to the ... circumstances of its composition," writes Andreas Meyer; "crowded notes, strokes almost too thin to read, passages submitted to several revisions."[170] The last movement

may be titled "Variation and Fugue on a Hebrew Folksong," but it prominently quotes the Hussite hymn "Ye Who Are the Soldiers of God." The stirring melody had been used by Smetana in *My Country* and *Libuše*, Dvořák in his *Hussite Overture*, and Janáček in *The Adventures of Mr. Brouček*, but seldom can it have been as apposite as here.[171] On its first appearance the phrase is hesitant, uncertain—almost like a distant memory. But by the end of the piece it has become an insistent, repeated motif, a stubborn reminder, rumbling away in the depths, of a Bohemia that was nobody's protectorate but the Lord's. Ullmann made a note on the title page reserving the right of performance "for the composer during his lifetime,"[172] but we will never know exactly how he would have liked the sonata to be played. He was deported with his wife, Elisabeth, to Auschwitz on October 16 and they died in the gas chambers two days later.

It was entirely coincidental that Josef II had named Theresienstadt—Theresa's town—after his mother Maria Theresa, who had tried to rid Prague once and for all of its troublesome Jewry back in 1744. The Protector succeeded where the Empress could only dream. Terezín had 7,181 residents in 1930, over half of them soldiers in barracks. After the Czech inhabitants were expelled the same area housed upward of 50,000 Jews—an average *Lebensraum* of 1.6 square meters per person. Over 141,000 people passed through the camp between 1941 and 1945. They came from Bohemia and Moravia, from nominally independent Slovakia—which was paid a bounty by the German state for each Jewish man, woman, and child deported—from Germany, Austria, Hungary, Holland, Denmark, Poland, Luxembourg, and beyond. Of these 33,456 died in the ghetto itself, and a further 88,202 were transported to the death camps in the East.[173] Around 15,000 of Terezín's inmates were children under fifteen. Around 100 of them survived.[174] Numbers numb us:

> The dusk flew in on the wings of evening...
> From whom do you bring me a greeting?
> Will you kiss my lips for him?
> How I long for the place where I was born!
> Perhaps only you, tranquil dusk,
> Know of the tears shed in your lap
> From eyes that long to see
> The shade of palms and olive trees
> In the land of Israel.
> Perhaps only you will understand

> This daughter of Zion,
> Who weeps
> For her small city on the Elbe
> But is afraid ever to return to it.[175]

"So read how we have simply dreamt up our life," begins the commonplace book in which Leoš Janáček wrote down his thoughts for his "little Negress," as he affectionately called Kamila, shuffling the keys of otherness that give color to desire. His youthful muse liked to sunbathe on the banks of the River Opava, toasting herself on the rocks that riddle their correspondence. "I'm by the water the whole time" she teased him, "I'm already so black that I can't even tell you."[176] "If only I could be that rock on which you lie, that water which washes you, that sun which dries you and burns you black,"[177] the old man writes. "I'd like to be that bogeyman who takes you off sunburnt, all warmed up, into his hidey-hole and never lets you go."[178] Janáček's last entry in the book, dated 10 August 1928, two days before his death, ends rhapsodically: "And I kissed you. And you are sitting beside me and I am happy and at peace. In such a way do the days pass for the angels."[179] But had Janáček's *ondine* not died prematurely of cancer in 1935 she might easily have ended taking the trains to Terezín. Though Kamila's husband, David, escaped to Switzerland and her sons Rudolf and Otto survived the Nazi occupation, her father, Adolf, perished in the camps.

THE PRECIOUS LEGACY

In October 1943 Ottla Kafka volunteered to accompany a transport of children to Auschwitz. The children were gassed on arrival. Ottla probably perished with them. Like so many others her exact manner and date of death is unrecorded. After the war her name was inscribed on the walls of Prague's Pinkas Synagogue together with those of her sisters Elli and Valli and the rest of the 77,297 Bohemian and Moravian Jews known to have died at the Germans' hands during the occupation. Some say the monument was the largest grave inscription in the world—though Edwin Lutyens's memorial at Thiepval, which lists the names of over 72,000 officers and men of the British and South African forces *whose bodies were never recovered* from the Battle of the Somme, would run it a close second. Thiepval still stands lonely and commanding on its hillside site, a monument to modern nations learning to know one another as eagles flew from their eyries to await the sun and voracious fish ascended from the abyss. Like Vyšehrad Cemetery it is less visited these days than it used to be: the Great War that let slip the demons of mo-

dernity is on the brink of passing out of memory and into History where it may safely incubate in the imagination, drifting where it will on the wings of poetic thought. The memorial in the Pinkas Synagogue has had a more checkered career. Not for these a quiet forgetting.

Together with the Old Jewish Cemetery and other architectural survivors of the slum clearance the Pinkas Synagogue became part of the newly established State Jewish Museum (Státní židovské muzeum) in 1950. Like most everything else in postwar Czechoslovakia the ruins of the thousand-year history of Bohemia's Jews were being nationalized. Prague's Jewish Museum—another of the sights that had made the city so magical for Breton and Éluard in 1935[180]—had originally been founded by Zionists in 1906 with the aim of preserving artifacts from the synagogues demolished in the *asanace* that opened up Nezval's De Chiricoesque vistas. It was closed to the public following the German invasion of 15 March 1939, only to be reborn in 1942 in the grotesque shape of what was now known as the Central Jewish Museum. To the leaders of the Jewish community who petitioned the occupation authorities when it became clear which way the wind was blowing this metamorphosis was a way of ensuring that Bohemian Jews' place in history would be remembered after they were gone. The Nazis thought the same, only differently. The museum rapidly amassed the largest collection of Jewish religious artifacts in the world. To this day its holdings are unrivaled outside Israel. Even as they waited for their own transports to the camps Jewish intellectuals—Jiří Weil among them—were conscripted to catalogue the flotsam and jetsam of genocide that was converging on what had once been the old Prague ghetto from Jewish communities all over Bohemia and Moravia (and beyond). "I have lain on your cushions, Sofa, and sailed off with you to faraway lands, I have lain and seen the palms of Oceania, roof-gables, wide lanes of passing cars, and colonnades of lights," Weil writes in *Colors*.[181] Is such a delirious transport any more surreal than what actually happened? Over 200,000 separate objects were listed by hand on 101,090 index cards,[182] an inventory more systematic and comprehensive than anything Emperor Rudolf would have dreamed of. There were Torah ornaments—shields, finials, crowns, pointers—candlesticks, plates, beakers, alms-boxes, curtains, canopies, valences, cushions, mantles, shawl bags, kittels, flags and banners, illuminated manuscripts, prayer books, scrolls, wedding contracts, diplomas, ceremonial plaques, portraits, photographs. Among the visual mementos were Zikmund Reach's large-format prints of what the Jewish Town looked like on the eve of its destruction, images of the streets of ancient misery Gus-

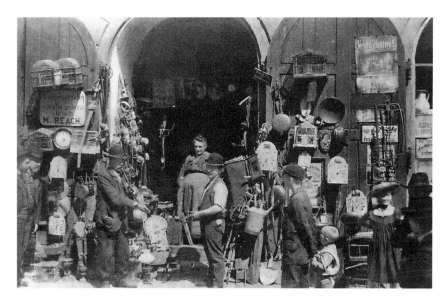

FIGURE 3.9. Zikmund Reach, Moses Reach's secondhand store in the Jewish ghetto, ca. 1908.

tav Janouch tells us were more real to Franz Kafka than the hygienic new town that surrounded him. The old swingman's embroidery of his memories seems to have been another fiction that turned out to be truer than the truth. The whole world once again found its way into the castle walls. Only this time the keys to the *Kunst- und Wunderkammer* had no mystery about them. "First, the objects were given numbers, then the people who had used them," explains Leo Pavlát on the museum's website.[183]

Designed by Václav Boštík and Jiří John, the Pinkas memorial owed its existence largely to the courage and persistence of one woman, the art historian Hana Volavková, who took over the directorship of the Jewish Museum in 1945. One of the few among the museum's wartime staff to survive the Holocaust, Volovková was the author of the volume on the former Jewish Quarter in the *Zmizelá Praha* (Vanished Prague) series.[184] *What once was* had by then taken on a significance that was more than merely nostalgic: in retrospect, the turn-of-the-century slum clearance (and here we might once again ponder the etymology of the Czech word *asanace*) looked very much like another indecipherable premonition of *hasard objectif*. The simplicity of Volovková's concept for the Pinkas monument bears comparison with Maya Lin's Vietnam Veterans Memorial in Washington, DC. The latter was con-

ceived—like Future Systems' proposal for a Memorial to the Victims of Communism, which borrows much from Lin's design—as "a cut into the earth ... an initial violence and pain that time would heal."[185] There was nothing grandiloquent about Volavková's quiet act of remembrance. It did not dwarf those it sought to commemorate, co-opting them for some greater cause. Nor did it smother them anew in the counterfeits of kitsch. Volavková knew the weight of numbers, and was determined to bring things back to a human scale:

> The names, arranged alphabetically and by place, lost the character of a document. Every family steps forward anew here as a whole, every individual remains alone. Those who during the war were degraded into numbers and transports again received a home and a human face. They are freed by the humble script, written with piety, by an anonymous art that is almost medieval.[186]

A fitting antidote to the hubris of modernity, all things considered; plain and simple and hopelessly out of joint with the times, just like the cumbersome panoramic camera with which Josef Sudek photographed the sad landscapes of Northern Bohemia. But the modern world, in which writing, like killing, is seldom done by hand, soon bit back.

The Pinkas Synagogue was once again closed to the public following the Soviet invasion of August 1968, and closed it was to remain throughout the two decades of normalization that followed. The justification was the need for "reconstruction" due to water damage; a plausible enough excuse given the Vltava's propensity to overflow its banks despite all the nineteenth century's heroic attempts to rationalize and regulate its unruly flow. When the building opened its doors again in 1992 a typewritten appeal for donations was tacked on a notice board in the vestibule. It was in English—as clear a sign as any that the planes and surfaces of the world were being rearranged yet again:

> After more than twenty years the State Jewish Museum is opening to the public the Pinkas Synagogue in Prague. In the fifties its walls bore the names of almost 80,000 victims of the Second World War, from Bohemia and Moravia. In the course of the reconstruction, which took place from 1969 to 1989, those names were removed and the

Museum intends to proceed with their renewal immediately, which cannot proceed without the personal assistance of the public.[187]

Still the old tropes return. "Victims of the Second World War, from Bohemia and Moravia," the notice says—*not* Jews, though it was as Jews, and only as Jews, that these families and individuals were classified, counted, transported, and exterminated.

Consciously or not—but probably not—the wording echoes the propaganda of the communist years, during which the museum made a political point of representing "the historical development of the Jewish religious communities . . . as the development of a religious group, forming an integral part of the population of the Czech Lands, and thus not as the historical development of members of the so-called 'world Jewish nation,' which was artificially constructed by the ideologues of Zionism."[188] We have come a long way from Karel Havlíček Borovský, for whom it was self-evident that "we must regard Jews as a separate, Semitic nation which lives only incidentally in our midst and sometimes understands or knows our language . . . and this bond which ties them together is stronger than the bond to the land in which they live."[189] Or have we? Are there not, as Milan Kundera says, as many ways of forgetting people as there are of remembering them? While the Pinkas Synagogue was closed and the names were being scraped off its walls an exhibition of "Judaic treasures from the Czechoslovak state collections"—as the goods and chattels looted by the Nazis had now become—toured the United States under the title *The Precious Legacy*. The catalogue, which was published in conjunction with the Smithsonian Institution in Washington, DC, made a point of stressing that "it is to the credit of the Czechoslovak Socialist Republic that these complex and important dimensions of the human experience are preserved for future generations."[190]

Some may find it tasteless—inconsistent with the comforting daylight we like to put between the tragic and the comic, the murderous and the mundane—to return at this point to Bohumil Hrabal's striptease in the Hotel Paris, where André Breton and Paul Éluard stayed and failed to notice anything surreal in 1935. I do so less to provide Shakespearean light relief than to venture yet further into the darkness.[191] After they had had their fill of looking, the diminutive Ditie relates, "my old men would dress the young woman, like running a movie backward, and dress her just the way they had undressed her, with none of the apathy that comes afterward, none of the indifference,

but with the same courtesy they had shown her from the start." The metamorphoses that followed were as miraculous as any to be found in the magic capital:

> At the end of each session, the young woman they had just examined would hang around the private chamber, breathing heavily, eyeing me greedily as if I was a movie actor, because she was so aroused she couldn't bring herself to leave. So after I finished clearing the table and put away the last piece of cutlery, I'd have to finish what the old men began. The women would throw themselves on me with such passion and eagerness, it was as if they were doing it for the first time, and for those few minutes I felt tall and handsome and curly-haired, and I knew that I was king for those beautiful young women, though it was only because their bodies had been so tickled by eyes, hands, and tongues that they could hardly walk. Not until I felt them climaxing once, twice, would they come to life again, their eyes would return, the glassy absent stare of passion would disappear, and they would see things normally again. Once more I became a tiny waiter, standing in for someone strong and handsome, performing on command every Thursday with increasing appetite and skill.[192]

A couple of years later Ditie would stand in for someone strong and handsome and perform on command once again. Turned down by the Czechoslovak Army because he was too short to be a soldier, he started taking German lessons, going to German movies, reading German newspapers, and dating a German girl, the daughter of the German owner of the City of Amsterdam restaurant in the German-speaking border town of Cheb. "Our naked bodies twined together," he relates, "and everything seemed liquid, as though we were snails, our moist bodies oozing out of their shells and into each other's embrace, and Lise shuddered and trembled violently, and I knew for the first time that I was both in love and loved in return, and it was so different from anything before."[193] And so, the times being what they were,

> I had to stand naked in front of a doctor who lifted my penis with a cane and then made me turn around while he used the cane to look into my anus, and then he hefted my scrotum and dictated in a loud voice. Next he asked me to

masturbate and bring him a little semen so they could examine it scientifically because, as the doctor said in his atrocious Egerlander German—which I couldn't understand, though I got the gist well enough—when some stupid Czech turd wants to marry a German woman his jism better be at least twice as good as the jism of the lowliest stoker in the lowliest hotel in the city of Cheb. . . . And I knew from reading the papers that on the very same day that I was standing here with my penis in my hand to prove myself worthy to marry a German, Germans were executing Czechs, and so I couldn't get an erection.[194]

A German nurse had to jerk him off.

4

Modernism in the Plural

And Teige? And the modernist avant-garde of the 1920s and
1930s? Did they not all walk in the fog? The fog of modernism,
the fog of world revolution, the fog of two world conflagrations,
the fog of fascism and communism, the fog of the illusion of
unstoppable Marxist progress? And, finally, ourselves, who pretend
to see so clearly from the precarious perch of our postmodern
disillusionments, are we really out of the fog? And what about the
past? Should we bury it, or judge it? Or simply tell its tale?

—ERIC DLUHOSCH, FOREWORD TO *KAREL TEIGE 1900–1951*[1]

ALFONS MUCHA, STEEL AND CONCRETE

The photograph disconcerts. The magic capital of old Europe is not where
we would immediately expect to find one of "the four leaders of modern ar-
chitecture," as Le Corbusier was described by Henry-Russell Hitchcock and
Philip Johnson in *The International Style* (the other three being Bauhaus-
founder Walter Gropius, the Dutch De Stijl architect J.J.P. Oud, and Mies
van der Rohe).[2] The author of the Villa Savoye and the Unité d'habitation
stands on the roof of Oldřich Tyl's YWCA hostel on Žitná Street alongside
Karel Teige, Tyl himself, and Jan E. Koula—son of the Jan Koula whose plans
for cutting a clarifying highway from the National Museum to a future Na-
tional Parliament on Letná Plain we encountered in the previous chapter.
But the snapshot, taken in October 1928, is no more an anomaly than is Tyl's
"uncompromising and unique"[3] YWCA hostel, an outstanding exemplar of

interwar Czech functionalist architecture.[4] The photo was a souvenir of Le Corbusier's third visit to the Czech capital in four years. This time he was in town as a delegate to a congress on international intellectual cooperation, but he took the opportunity to lecture at Devětsil's invitation before "a broader forum and a more interested public" at the Liberated Theater on "Technique as the Foundation of Lyricism." "Lyricism, this highest human joy and value, 'the divine spark that lives in humanity,'" he told a packed house, "*can fully and harmoniously flower only on the exact and precise basis of a flawless controlling technique.* From this point of view architecture may be defined as poetry; a poem created by scientific methods with the aid of all technical achievements."[5] It was an age, as Jindřich Toman has remarked, of POETRY in capital letters.[6]

Four years earlier, during the winter of 1924–25, Le Corbusier took part along with Gropius, Oud, Amédée Ozenfant, and Adolf Loos in an ambitious lecture series organized by the Architects' Club (Klub architektů) at the Mozarteum in Prague. Karel Teige lectured on Soviet constructivism at the same event. Though Loos is usually thought of as a Viennese architect he had close ties to the Czech Lands: born in Brno in 1870, he trained in Dresden before moving to Vienna in 1896 and Paris in 1922. A member of the Architects' Club as well as the editorial board of the Brno magazine *Bytová kultura* (Housing Culture), he took Czechoslovak citizenship in 1930.[7] In his 1908 essay "Ornament and Crime," a text widely regarded as a foundational manifesto of modernist aesthetics, Loos measured the march of human progress by the disappearance of decoration on everything from bodies to teacups. "What is natural in the Papuan or the child," he explained, "is a sign of degeneracy in a modern adult." He instanced the fondness for tattoos among the criminal classes. The unfortunate anticipation of Nazi vocabularies was doubtless no more than coincidental. Criticized in *fin de siècle* Vienna for the obscene nudity of his buildings,[8] Loos looked forward to a future in which "the streets of the cities will shine like white walls!" His Müller Villa, built in the Prague suburb of Střešovice in 1930, epitomizes "plain, undecorated simplicity"[9]—at least from the outside. The bald concrete cube conceals an imaginative distribution of split-level public and private (and some have argued, highly gendered)[10] spaces in which volumes are shaped by the purposes they are intended to serve. This did not stop Teige, who was ever one to push critiques to their logical conclusions, from taking Loos to task in his *Moderní architectura v Československu* (*Modern Architecture in Czechoslovakia*, 1930) for succumbing to "obsolete aestheticism" in the villa's lavish employment of expensive hardwoods and marbles in its interior furnishings.[11]

The Architects' Club lectures would not have appeared an improbable *rendezvous des amis* at the time. Czechoslovakia was a hotbed of architectural radicalism between the wars. It says much for the organizers' awareness of international avant-garde trends that *Vers une architecture* (known in English as *Towards a New Architecture*), the collection of essays that popularized Le Corbusier's conception of a house as "a machine for living in," had then been in print for little more than a year. The ideas Le Corbusier first developed as articles in his journal *L'Esprit nouveau* (The New Spirit, 1918–25)[12] were not new to Prague's architectural community. Devĕtsil's anthology *Život II* (Life II), which was edited by Jaromír Krejcar, carried specially commissioned contributions by Le Corbusier and Ozenfant as early as December 1922.[13] In 1926 the "Purist Four" (Puristická čtyřka), as the young architects Jaroslav Fragner, Karel Honzík, Evžen Linhart, and Vít Obrtel then billed themselves, joined Krejcar and Bedřich Feuerstein to found Devĕtsil's architectural wing (ARDEV), one of the most active sections of the group. Czech architects would make their presence felt in CIAM (Congrès internationaux d'architecture moderne), the organization set up by Le Corbusier and Sigfried Giedion less to promote the aesthetics of the international style—though it certainly succeeded in doing that—than to advance the cause of architecture as a tool of social engineering. Loos represented Czechoslovakia at CIAM's founding Congress at La Sarraz in 1928 and Czech contributions on collectivized housing were included in the volume published from the 1930 CIAM Brussels Congress under the title *Die rationalen Bebaungsweisen* (Rational Site Development).[14]

Among his manifold other activities Teige coedited (with Jan E. Koula and Oldřich Starý) the Architects' Club journal *Stavba* (Construction), which Richard Neutra, for one, reckoned to be "the most courageous periodical [that] has been immeasurably effective far beyond the boundaries of your country. I wish," he added, "we could circulate it widely in [the] U.S.A."[15] By 1928 the Devĕtsil leader was lining up with the communist Bauhaus director Hannes Meyer to theorize architecture as a key front in the class struggle and functionalism as its cutting edge. There was nothing new in the Bauhaus connection either. No less than eight Czech architects (Krejcar, Feuerstein, Fragner, Honzík, Koula, Linhart, Obrtel, and Josef Chochol) had participated in the 1923 Bauhaus *International Architecture Exhibition*. Zdenĕk Rossmann, Václav Zralý, and Antonín Urban were all at one time Bauhaus students, and Bauhaus designs, including Marcel Breuer's tubular steel furniture, were manufactured under license in Czechoslovakia and marketed through Družstevní práce's Beautiful Room stores. A book by one "Carel

Teige" titled *Czechoslovak Architecture* was announced in 1927 as forthcoming in the Bauhaus Books series alongside works by Kandinsky, Schwitters, Oud, Marinetti, Mies, Le Corbusier, and other leading lights of the international avant-garde.[16] Hannes Meyer visited Prague in 1928, a month after Le Corbusier, with the intention of deepening his Devětsil contacts. At his invitation Teige offered lecture courses on typography, advertising graphics, and the sociology of architecture at the Bauhaus in 1930—one of the foreign guests, Meyer wrote to the Mayor of Dessau, he had brought in "to counteract the dangers of pseudo-scientific activity" along with Oud among others.[17] That same year *ReD* ran a special issue on the Dessau Bauhaus containing Meyer's essay "The Bauhaus and Society" and Teige published a critical appreciation of "Ten Years of the Bauhaus" in *Stavba*.[18] These collaborations might have gone further had Meyer not been fired in August 1930 and replaced, at Walter Gropius's suggestion, by Mies van der Rohe, who would preside over the remnants of the most influential design school of the twentieth century until the Nazis forced its closure in 1933.[19]

During his 1928 visit Le Corbusier toured a number of recently completed Prague buildings. One of them was Jaromír Krejcar's Olympic Department Store on Spálená Street (1925–26), a glass-fronted showpiece whose upper floors recall the decks of an ocean liner, a common motif in Devětsil art at the time. Krejcar's design sparkled with signifiers of the modern—the signs on the ground floor read *Radio*, *Café Espresso* (*sic*), and *Karpata Dancing*, while the words *Světelná* (neon lighting), *Reklama* (advertisement), and *TSF* (wireless) ascend the building's side.[20] The edifice that made the greatest impression on Le Corbusier was Josef Fuchs and Oldřich Tyl's Trade Fair Palace (Veletržní palác), which was built in 1926–28 in the Holešovice district. The palace was intended to be the first of several buildings in a new complex for the company Prague Trade Fairs (Pražské vzorkové veletrhy, hereafter PVV), though in the event it was the only one to be realized. In its day it was one of the largest functionalist structures in Europe. Occupying an entire city block, it contained a large exhibition hall, a soaring eight-story atrium, an underground cinema, a restaurant and café opening onto the terrace of the flat roof, and an abundance of office space. The concrete curtain walls were interlaced with continuous horizontal strip windows, with the lower and upper floors breaking the monotony by being asymmetrically set back, all features Hitchcock and Johnson would shortly identify as hallmarks of the International Style. A singularly beautiful feature of the building—almost Miesian, one might say—was the illumination of the atrium and Great Hall through glass-paneled roofs, flooding the vast interior spaces with natural light.

Le Corbusier could not conceal his admiration, or indeed his envy, for the magnitude of Fuchs and Tyl's achievement. "The visit," he told Teige in an interview for *Rozpravy Aventina* (Aventinum Debates), "was a genuine experience for me. The first impression of the huge palace is impressive. . . . It was claimed that my proposal for a palace for the League of Nations in Geneva was unrealizable.—The Prague Trade Fair Palace is a practical refutation of such objections. . . . For me it is very instructive to see architecture of this scale in reality." Le Corbusier would not be Le Corbusier, of course, if he did not have his plentiful criticisms. He objected to both the ground plan of the building and its "deficiencies of architectonic form":

> There are three or four buildings here of varied character, which unhappily permeate one another. The desirable refined simplicities are not to be found here. There is no harmony of proportions. The square windows of the northern face are irregular. There should be ramps instead of stairs. I consider the communications within the building to be insufficient. . . . The exterior formation is heterogeneous and shows a mixture of influences: Fiat factories, here Behrens, there modern Russians.

"It is an extraordinarily significant building," he concluded, "but it is not yet architecture." He was nevertheless happy to "congratulate Prague and its architecture on being able to realize so grandiose a building project. When I saw the Trade Fair Palace, I realize how I have to create great buildings, I, who have up till now built only a few pretty small houses on modest budgets."[21] Teige was less stinting in his praises. "The designs of Oldřich Tyl," he wrote in *Modern Architecture in Czechoslovakia*, "are among the most consistent works of rationalist architecture. Tyl's realistic, truly engineering mentality and his mastery of the scientific and technological basis of architecture allowed him to create such complex works. . . . [The Trade Fair Palace] is a remarkable work of modern architecture, a skeletal building that organically integrates light, functional spaces, and great halls; its form is derived from the essence of its purpose, not from artistic speculation."[22] Where Le Corbusier's objections were mostly aesthetic, Teige wished to banish aesthetics from architecture altogether. The tensions between the two men spilled into the open the following year. Teige published a lengthy article in *Stavba* savaging Le Corbusier's design for Paul Otlet's Mundaneum, a proposed museum of world culture to be built on the shores of Lake Geneva. He pitted an archi-

FIGURE 4.1. Josef Fuchs and Oldřich Tyl, Veletržní palác, Prague, 1928. Unknown photographer. Photograph © National Gallery in Prague, 2011.

tecture that "is not born out of abstract speculations, but from actual, living needs, under the dictate of life and in no way under the patronage of any kind of academy or officialdom," against "the error . . . of monumentalism . . . the error, of a palace." "*The Mundaneum*," screamed his italics, "*is a composition*."[23] Le Corbusier's riposte, written while traveling on an express train to Moscow,[24] was the first time that he had ever publicly replied to critics (though, he pointed out, he was used to being their target day in, day out). Published in the Czech journal *Musaion*, it was titled "In Defense of Architecture."[25]

Before long Teige extended his criticisms to Le Corbusier's villas, which he derided in *Nejmenší byt* (*The Minimum Dwelling*, 1932) as "the favorite model of today's luxury architecture. . . . Flat roofs, terraces, horizontal windows, concrete furniture, chrome chairs, plate glass and so on have become a modernistic fetish and have gained the status of an obligatory stylistic formula. And, of course, fashion and style have always been the exclusive domain of the rich." "Le Corbusier's concept of the modern dwelling . . . may be an architectural revolution," he goes on, "but it leaves the essence of the social character of dwelling untouched. His revolution takes place within the con-

fines of a strictly bourgeois definition of dwelling."[26] He was no less caustic about Mies van der Rohe's Tugendhat Villa in Brno, built in 1929–30, which Hitchcock and Johnson considered "one of the two finest houses in the new style" (the other being Le Corbusier's Villa Savoye).[27] The Tugendhat house, Teige mocked, was "not even a genuine villa but a more or less irrational adaptation of [Mies's] German Barcelona Pavilion. . . . All he did in this adaptation of his pavilion (which is nothing but a somewhat Wrightian architectural and sculptural flight of fancy) is to add a toilet and a bathroom. . . . This is theater and sculpture, not architecture—snobbish ostentation, but not a dwelling."[28] Jaromír Krejcar was equally contemptuous of Le Corbusier's "expensive little *objets d'art*" (and described Mies's Tugendhat Villa as being "of even less significance than a parish council meeting in some provincial backwater to decide on the introduction of a village sewer").[29] Evidently much more was at stake in these debates than just questions of style. Or was it?

Holešovice, where the Trade Fair Palace is situated, is a later-nineteenth-century inner suburb made up mostly of factories and tenement housing, which lies downriver from the city center on the left bank of the Vltava. It was formally incorporated into the capital in 1884. The district is typical of Prague—that is to say, it is typical of the grimy industrial town whose spectacular growth after 1850 transformed Prague into a modern *Czech* capital. By 1890 the borough had 15,352 inhabitants, every single one of whom claimed their language of everyday intercourse to be Czech.[30] As we have seen in earlier chapters the incomers did much to make over the city in their own image, overlaying the ancient Bohemian palimpsest with visible signs of its born-again Czechness. Opposite the main entrance to the Trade Fair Palace is one small example, which certainly would not make it into anybody's textbooks. On an unremarkable tenement block are three frescoes depicting Vlasta, the leader of the unruly Amazons who challenged the authority of Přemysl the Plowman during the mythical Girls' War, the less mythical but no less mythologized "Hussite King" Jiří z Poděbrad, and the local hero Heřman z Bubny. This historicist iconography seems a million miles away from the spanking new modernism on display across the street, yet the links are closer than we might care to imagine.

By the 1920s Holešovice had long been familiar to Czech visitors from Prague and beyond. The main attraction of the area was Stromovka Park, which lies to the north and west of the Trade Fair Palace and houses the Výstaviště exhibition grounds. Then as now it was a pleasant place to take a Sunday afternoon stroll. After World War II Výstaviště would mutate into the Cultural Park of Julius Fučík, but that is another story. S. K. Neumann's

"futurist" manifesto "Otevřená okna" (Open Windows), published in 1913, lists "the military concert in Stromovka Park" (as well as the Central Slaughterhouse in Holešovice) among the modernities of which the poet approves, alongside World Exhibitions, railroad stations, artistic advertisements, and steel and concrete. He prescribes "Death to ... folklore, Moravian-Slovak embroidery, Alfons Mucha, [and] old-Prague sentimentality."[31] But the old and the new were not so easily disentangled—not least because the historicizing of the city in accord with its new demographics was itself a quintessentially modern phenomenon. Nowhere was this clearer than in what was on display at the three major exhibitions staged at Výstaviště in the 1890s. The Jubilee Exhibition of 1891 attracted 2,432,356 visitors. The largest of its constructions still stands: Bedřich Münzberger's Industrial Palace, a cast-iron and glass descendant of the Crystal Palace at the Great Exhibition of 1851 and the Hall of Machines at the 1889 Paris World's Fair. The building next door later became the Lapidarium of the National Museum but began life as the pavilion of the City of Prague at the Chambers of Commerce Exhibition of 1908.[32] The catalogue for the latter opens with a short history of the development of the city over the previous half-century, replete with statistics that tell a triumphant tale of the transformation of a Prague that "gave the impression in the 1850s of a German town, of course not purely German, but it seemed that only the common people were of Czech nationality" into a modern *Czech* capital.[33] Its author was Karel Teige's father, Josef, the city archivist. The Lapidarium went on to become a repository for deposed statues, one of them being the Mary Column that once stood in the Old Town Square.

Teige the younger claims, probably rightly, that the Jubilee Exhibition— which also gave Prague its miniature Eiffel Tower on Petřín Hill—had the same effect on the new Czech architecture as the 1889 World Exhibition had on architecture in France. "It prefigured the modern architecture of *glass and iron*," he writes. "Naturally, this caused a negative reaction among the aesthetes of Prague, much as the Eiffel Tower outraged the aesthetes of Paris. Münzenberger's industrial palace ... was in itself a remarkable and important building."[34] But while the exhibition certainly showcased the latest in Czech manufactures from machine tools to glass to clothing to beer, it was as much—and perhaps more consequentially—a celebration of recently recovered Czech memories. In front of the Industrial Palace stood Bohuslav Schnirch's huge bronze equestrian statue of Jiří z Poděbrad, the "Hussite King" who graces the tenement opposite the Trade Fair Palace. Alongside products of modern industry the exhibition displayed plentiful samples of new-Prague sentimentality. One of the most popular exhibits was the "Czech

cottage" (*česká chalupa*) designed by Antonín Wiehl, who was advised by
Alois Jirásek and Jan Koula among others. The cottage was a Disneyland fan-
tasia embroidered out of the vernacular styles of several different regions, but
that in no way diminished its charms. Renata Tyršová, the daughter of Sokol
founder Jindřich Fügner and wife of his comrade-in-arms Miroslav Tyrš, fur-
nished the interior. Renata was a noted folklorist in her own right, and her
Czech, unlike her father's, was fluent. These nationalist overtones led most
German-owned firms in Bohemia to boycott the show.

Encouraged by the runaway success of the "Czech cottage," Výstaviště
hosted a so-called Czechoslavic (*sic*: not Czechoslovak) Ethnographic Exhi-
bition (*Národopisná výstava českoslovanská*) in 1895 that also attracted over
two million visitors. The attractions in this case included a loving reconstruc-
tion of a "Czech village square," rooms dedicated to Jungmann, Havlíček,
Palacký, and other leading lights of the national revival, collections of Hus-
site weaponry, waxwork displays and costumed reenactments of "traditional"
peasant rituals and popular festivals, and a vast assortment of villagers' color-
ful Sunday best, which by this date had been reconfigured as "national cos-
tumes" (*národní kroje*).[35] Paul Éluard might have been intrigued by the sexual
undertones of the Jízda králů (Ride of the Kings), a Moravian Whitsuntide
parade led by a young boy on horseback dressed in woman's clothes, carrying
a rose between his rouged lips. The six-hundred-page catalogue of the exhibi-
tion, another sumptuous Jan Otto publication, went out of its way to stress
that "for the first time at a large event . . . our usual [Czech-German] bilin-
gualism was dispensed with."[36] Similar notes were struck at the third large
Výstaviště spectacle of the decade, the Exhibition of Architecture and Engi-
neering of 1898, whose title might have led us to expect something rather dif-
ferent. A major attraction of the show was Luděk Marold's diorama of the
Battle of Lipany, the culminating engagement of the Hussite Wars. Housed
in a circular pavilion thirty meters across and executed with the help of an
army of assistants, the painting measured an immense ninety-five meters by
eleven.[37]

Whatever we might be tempted to assume from looking at the architec-
ture of the Trade Fair Palace and inserting it into Karel Teige's (or Hitchcock
and Johnson's) progressive narratives of the modern, Fuchs and Tyl's building
no more represented a rupture with this historicist heritage than did Mün-
zenberger's palace of glass and iron. Václav Boháč, the president of PVV, had
long articulated a vision of modernity that saw no contradiction whatever
between steel and concrete and Alfons Mucha. A leader of the business wing
of the National Socialist party, Boháč had first tried to establish a Czech

Trade Fairs' association as far back as 1908. In November 1912 he published an article titled "A Slav Exhibition in Prague" in the newspaper *Národní obec* (The National Community), of which he was the editor, arguing that Prague "is yet only a future Slav Mecca, and only through the astuteness of its representatives will it be made into the richest Slav city." His pan-Slavism had a practical cast—the mark of a truly engineering mentality, we could say. He had little time for empty cultural gestures of the sort epitomized by the Czechoslavic Ethnographic Exhibition. "Let us say immediately in advance, that the program of ethnographic and cultural exhibitions without industry and without business is in our view sheer nonsense, backward Czech impracticality,"[38] he warned. Not altogether surprisingly, the imperial government in Vienna turned down his proposal.

After independence conditions for the venture were more propitious, not least because of Boháč's contacts in the now governing National Socialist party. The Czechoslovak government approved the foundation of PVV in 1920 as a limited company with substantial shareholding by the City of Prague. The association took over Výstaviště and held its first trade fair there in September of that year. Neither the space nor communications to the city center proved adequate to Boháč's ambitions. In 1924 he devoted his entire savings to buying up the Holešovice site, which was then occupied by two old factories. A competition was immediately launched for designs for a new "trade fair city" (originally four buildings were envisaged, including a hotel) in which Tyl's design came first and Fuchs's third. In the second round of the competition the two architects pooled their talents and their joint proposal was accepted by PVV, beating out a more aesthetically traditional but less practical entry by Alois Dryák. Billed as "a gift to the Czechoslovak Republic on the tenth anniversary of its independence," the Trade Fair Palace was ceremonially opened on 28 September 1928.[39] There was a good deal of hyperbole in the Czech press in which the word *palác* took on exactly the monumental, historicist associations Teige would find so offensive in Le Corbusier's design for the Mundaneum. "The building itself does not ingratiate with flourishes on the façade, it tries to convince with its impressive quiet, the quiet of a cathedral, in which seethes, in ten thousand eruptions, unrestrained work, work, and work. . . . I am a castle, in which the modern conquerors of the world long to triumph," ran one such panegyric.[40] "Work, work, and work" (*práce, práce, a práce*) was the slogan of Tomáš Garrigue Masaryk, who thoroughly concurred with Václav Boháč on the need for the nation to get practical. Though he was always careful to give Palacký and the other nineteenth-century awakeners their due, the President-Liberator had

been arguing that Czechs were more obsessed with the past than was good for them since the 1890s.[41]

The cathedral metaphor was used again in *Nová Praha* (New Prague) in anticipation of the first art exhibition to be held in the Great Hall. "The monumental hall of the Trade Fair Palace will be transformed into a splendid cathedral of the Slav spirit, love, and ardor, in which the individual pictures will be like symbolic stations in the historical pilgrimage of Slavdom toward the final victory of the Slavic race,"[42] gushed the newspaper. Whatever S. K. Neumann or Karel Teige believed belonged together with what, Fuchs and Tyl's palace of steel and concrete, the pride and joy of Czech functionalism, was ceremonially inaugurated with the first public showing of Alfons Mucha's *Slavic Epic*, the magnum opus upon which the darling of Paris art nouveau had been working ever since he returned to Bohemia in 1910 to fill his life, in his own words, "exclusively with work for the nation."[43] That work included the Czechoslovak Republic's first postage stamps and banknotes, numerous posters for patriotic causes, and the designs for a spectacular waterborne pageant on the Vltava at the 1926 Sokol Jamboree, all of which played on stock nineteenth-century nationalist imagery.[44] The *Epic* comprises twenty gargantuan canvases whose overall subject may be best summed up by the title of the last picture in the series, *The Apotheosis of the History of the Slavs*. We encountered one of the paintings earlier, depicting Jan Amos Komenský in his dying days in Naarden. The cycle was widely dismissed by modernist Czech critics at the time as an anachronistic throwback to the previous century in both its style and its content, but the carping of progressive intellectuals fell on deaf ears.[45] The next art exhibition to take place in the Great Hall also brings to mind conjunctions of sewing machines and umbrellas, though there was nothing fortuitous about this encounter either: a mammoth posthumous retrospective of the sculptor Josef Václav Myslbek, author of the Saint Wenceslas memorial on Wenceslas Square.[46]

Could we ask for a more flagrant—indeed, for modernist aesthetes, obscene—coupling of two realities that apparently cannot be coupled on a plane that apparently is not appropriate to them than this bizarre marriage of Alfons Mucha and steel and concrete? It seems as improper a union as that of Picasso and *L'Action française*. What makes the conjunction appear surreal, of course, is only our habit of seeing modernity through modernist eyes—or to put it another way, expecting history to behave in accord with the dictates of modernist aesthetics. But the course of modern history, at least in this neck of the woods, does not resemble Alfred Barr's famous flowchart on the cover of his catalogue for the 1936 MoMA exhibition *Cubism and Abstract Art*, in

which Near Eastern art, Japanese prints, Negro sculpture, neo-impression-ism, and Cézanne lead felicitously on through cubism and the machine aesthetic to modern architecture and abstract art.[47] Nor is it even akin to a "flowing stream, at first slow-moving, broad and free, and varied by many eddies and side currents . . . but then confined . . . to a narrower channel, so that for a while it rushed forward, on the principle of the venturi, at almost revolutionary speed"—to quote Henry-Russell Hitchcock's equally celebrated description of the development of modern architecture in his foreword to MoMA's 1965 reissue of *The International Style*.[48] Modernity is and always has been more twisted than that—a chiaroscuro etched in infinite shades of gray, shot through with bolts of darkness as well as light. Just how dark and twisted the further adventures of the Trade Fair Palace will reveal, but not for some time yet.

In the meantime, some vignettes from the life and times of Mies van der Rohe's Tugendhat Villa may deter us from confusing modernity with its architectural spectacles. At the same time as he was working on his Barcelona pavilion Mies was planning the house in Brno, which shares many of the same radical design elements (the onyx partition wall, the cruciform columns, the vistas of plate glass). The architect surveyed the site, which commands a fine view of the old city, in September 1928. Work proceeded rapidly and the newlyweds Grete and Fritz Tugendhat, who both came from wealthy local textile-manufacturing families, were able to move into their new home in December 1930. Their honeymoon did not last long. Jews caught out in the wrong place at the wrong time, the couple fled with their two young daughters in 1938 to Switzerland and moved on three years later to Caracas, Venezuela. The villa was confiscated by the Gestapo after the invasion of March 1939 and occupied by various German tenants, among them the Messerschmidt aircraft company. Near the end of the war the building was shelled and the interior devastated by Soviet soldiers, who used it to stable their horses. After the combat ended the repaired house was turned into a ballet school. Victorious February put an end to the family's attempts to regain ownership, and in 1950 the villa was confiscated by the State Institute of Rehabilitation. It then became a part of the Brno Children's Hospital.

The villa was listed as a "site of special cultural interest" late in 1963, when the first tentative signs of a new Prague Spring were in the air. An exhibition of Mies's work in 1968 at the Brno House of Art, followed by a conference on possible reconstruction in January 1969, gave hope of restoring the building to its original state. By that time the structure had been modified by its successive occupants, and most of Mies's original furnishings and fittings—in-

cluding his trademark Barcelona chairs—had disappeared. Ownership of the
villa was formally transferred to the City of Brno a month later. These efforts
at preservation in turn foundered on the politics of normalization. Recon-
struction stalled until 1982, and the house served in the meantime as a depos-
itory for the archives of the Institute of Marxism-Leninism. After the restora-
tion was completed in 1985 Brno city administration used the villa as an
accommodation and meeting center. It was here that the Czech and Slovak
victors in the 1992 elections, Václav Klaus and Vladimír Mečiar, sat down
around Mies's magnificent circular ebony dining table in the summer of 1992
to negotiate the "Velvet Divorce" that divided Czechoslovakia into two in-
dependent states.

The villa was finally handed over to Brno City Museum and opened to the
public in 1994. Mies's masterpiece was officially granted National Cultural
Monument status a year later—as a monument to architectural modernism,
rather than to the modern history of the nation that now no longer existed in
which it had played so surreal a part. UNESCO, which listed the Tugendhat
Villa as a World Heritage Site in 2001, was no more interested in the absurdi-
ties of the history hidden behind the building's modernist façades. Hailing
the house as "an outstanding example of the international style in the mod-
ern movement in architecture as it developed in Europe in the 1920s," the ci-
tation went on to explain that its "particular value lies in the application of
innovative spatial and aesthetic concepts that aim to satisfy new lifestyle
needs by taking advantage of the opportunities afforded by modern indus-
trial production."[49] That the checkered fortunes of the house might have any
other messages for historians of the modern appears not to have crossed the
minds of those who determine what is, and is not, *our* heritage. Lawsuits
meantime continued to rumble on with Fritz and Grete's daughters, who had
still not given up hope of recovering a family home that had a very different
meaning for them. The youngest daughter, Daniela, was by then an old lady
living with her husband in Vienna. "Perhaps there is still a solution which
will be good for the house and the city," she told a reporter for the London
Observer in 2007. "I don't know. It does not look good."[50]

THE GHOSTS OF FUTURES PAST

"I don't have to talk about old Prague," Le Corbusier assured Karel Teige.
"Believe me, I very genuinely like it. No way Saint Vitus's, but the beauti-
fully proportioned old houses, the ordinary buildings, they may be modest
but they have distinction and nobility: this is the architecture of a southern
spirit. New Prague, behind Wilson Station and here and there all over, is of

course a tasteless German town." He was glad to see that contemporary Czech architects had not been infected by the virus of *die neue Sachlichkeit* (New Objectivity). Germany, he sniffed, was "a neurasthenic and romantic land, which I can't abide. It is not true, as some people say, that it is the cradle of modern architecture." The origins of the latter, he added, lay not in Jugendstil (or "German expressionist hysteria") but the Pont des Arts, the Hall of Machines, and the Bibliothèque nationale. Some of the more nationalist Czech newspapers made hay with Le Corbusier's remarks, prompting Teige to defend him in *Stavba*, not altogether convincingly, against charges of chauvinism.[51]

What Hitchcock and Johnson would have made of this distinctly Parisian perspective on the history of modern architecture I do not know, but it certainly disrupts the smooth cadences of *The International Style*, suggesting once again that we might be better off understanding modernism, as Vítězslav Nezval does Woman (*Žena*), in the plural (*v možném čísle*)—to invoke the title of one of Nezval's best-known collections of poetry, which was published in 1936 and dedicated to Paul Éluard.[52] Those brought up on MoMA's singular abstraction of "the modern movement" might be equally taken aback by Le Corbusier's enthusiasm for the complexities and contradictions of the Prague vernacular. The Swiss-French architect knew he was in the heart of modern Europe, but it was not quite the modern Europe he thought he knew. "Wenceslas Square is splendid," he went on, "its life, its tempo, its stores, its *passants*: well-heeled bourgeois as well as Average Joe types, and I don't know why, I feel in this a little of Asia. It is quite other than in Paris. I believe in a great future: here there is health, strength, enthusiasm, willingness, a little brutalism, some want of classical culture, but no neurasthenia."[53] "Is not Main Street almost right?" he could almost have concluded, looking at "the messy vitality" that was (and is) Wenceslas Square.[54] The only thing that bothered him was that Prague was "too worldly." "In this respect," he confessed, "I prefer typically petit-bourgeois Paris. Your luxurious cafés, full of mirrors, give me the horrors. I prefer a simpler style of life."[55]

Le Corbusier's impression of a vibrant, commercial, future-oriented (not to mention "Asian") Prague was not necessarily any closer to its truth—if such a singular entity ever existed—than the magic capital of old Europe discovered by André Breton, but it was certainly more in tune with the spirit, or at any rate the dreams, of the age. By the time Nezval wrote *Prague with Fingers of Rain* National Avenue, Na příkopě, and Wenceslas Square had come to form the arms of the Golden Cross (Zlatý kříž), as it became known, a neon-lit downtown outfitted in a cacophony of modern architectural styles.

Jaromír John would sourly recall the dislocation of landscapes and land-marks that characterized the early years of Czechoslovak independence in his novel *Moudrý Engelbert* (Wise Engelbert). Country folk up in town for the Jan Nepomucký pilgrimage, he complained, would have had trouble locating their urban kith and kin, let alone keeping them on the national straight and narrow:

> Wenceslas Square became a heaving lake of human bodies, an explosion of motorized vehicles.... Příkopy and Na-tional Avenue changed into great rivers of crowds.... Overnight the old houses disappeared and the palaces of banks, insurance companies, and department stores with arcades, diners, cinemas and bars mushroomed in their place.... The countryman who for decades used to go to a long-established wine-bar or pub would not find it there any longer; if he had his Saint Jan Day list of Prague rela-tives with him, he wouldn't find them living at the same address.... Never in our history were there so many wor-thy men to name streets after. Nor so many geographic names, nor so many numbers.[56]

Wise Engelbert was written in 1940, when Bohemia's old-new occupiers were back and Prague's mad rush into modernity seemed to have come to a shud-dering halt. John was not the only writer of the day to seize hold of a memory flashing up in a moment of danger. Vladislav Vančura, the first president of Devětsil, turned his talents from writing avant-garde fiction to painting *Pic-tures from the History of the Czech Nation* (*Obrazy z dějin národa českého*, 1939–40), while František Halas and Jaroslav Seifert both published collec-tions of poems whose titles invoked the memory of Božena Němcová, the au-thor of the sentimental, rural, and everlastingly Czech nineteenth-century classic *Granny*. As if to confirm the ephemerality of Prague's modernist dreams, Vančura would lose his life at the firing range in the suburb of Kob-ylisy on 1 June 1942, one of 1,381 men and women executed in reprisal for the assassination of Protector Reinhard Heydrich.[57] Nostalgia for threatened pasts was not much in evidence, though, while the twenties roared. Karel Teige and Jaromír Krejcar gleefully established a Club for New Prague (Klub za novou Prahu) in 1924, whose name pointedly parodied that of the conser-vationist Club for Old Prague (Klub za starou Prahu) founded in 1900 to combat the vandalism of the slum clearance.

FIGURE 4.2. Zdeněk Pešánek, light sculptures for Edison transformer station, Prague, 1929–30 (later reconstruction). Photograph © National Gallery in Prague, 2011.

Unlike in Baron Haussmann's Paris, it was not necessary to bulldoze centuries-old rabbit warrens of human habitation to fashion an elegant modern boulevard out of Wenceslas Square. The spacious proportions of Charles IV's medieval Horse Market did very well. The same goes for Na příkopě, a wide and generous street. The makeover was convulsive nonetheless. Only one of the sixty or so buildings lining the square at the time Le Corbusier saw it predated the nineteenth century,[58] and most had gone up during the previous fifty years. The few survivors of Old Prague detectable in photographs taken in 1870, when the upper end of the square was still closed by the Horse Gate, and 1876, when it had been newly planted with rows of trees, did not last long: the renaissance house U Císařských, dating from the second half of the sixteenth century, was demolished in 1895, the gothic house U Lhotků (with its tower added in 1600) disappeared in 1913, and the late-renaissance Aehrentálský Palace was torn down in 1918. The baroque House of the Golden Ram (U zlatého beranka) made way for a department store in 1911, which was soon converted to the Ambassador Hotel. Gas lamps had illuminated the square from 1847 and electricity began to make its storefronts sparkle and seduce from 1882. By the turn of the twentieth century the onetime Horse Market was as bustling with buses and trams—and, no doubt, beautiful secretaries scurrying to and fro—as Apollinaire's Paris.

The Bať́a shoe store, which is situated at the lower end of Wenceslas Square, was one of only four buildings in Czechoslovakia (another was Mies's Tugendhat Villa) to make it into *The International Style*. As far as this part of Europe went, Hitchcock and Johnson's inclusions seem to have been the somewhat serendipitous outcome of a whistle-stop tour.[59] The Bať́a store is not a surprising entry into the MoMA hall of fame: built in 1928–29, the nine-story building, which offered while-you-wait shoe repair in the basement and a buffet and pedicures on the top floor, is a textbook example of what has since become a familiar and instantly recognizable modernism. "The ribbon windows in the façade overlooking Jungmann Square," enthuses Rostislav Švácha, "almost swallow their ledges, so that all that remains are the shiny white strips between them. The façade, boldly suspended on a skeleton of reinforced concrete, is made completely of glass. The aggressive functionalist space surges out through all obstacles, admitting only the existence of the construction."[60] Between the wars the building's purism was somewhat compromised by the blazoning across the frontage of advertisements for the latest in affordable ladies' and gentlemen's footwear and the slogan "Our customer—Our master!" (*Náš zákazník—náš pán*). Those teeming crowds demanded to be served.

The store was the brainchild of a team of designers based in the Baťa company town of Zlín in Moravia, assisted by Ludvík Kysela, the architect of the equally striking (and equally functionalist) Lindt department store next door.[61] Established in 1894, Baťa was one of the world's first true multinationals. Tomáš Baťa, the company's founder and the son of a cobbler, got his big break from supplying boots for Austria-Hungary's armies during World War I. By 1917 his Zlín factory employed 5,000 workers and was turning out 10,000 pairs daily. A visit to Henry Ford's plants two years later—Tomáš's third trip to the United States—enamored him of the latest American production methods. Though Baťa was fortunate to weather the economic storms that followed independence it grabbed the imagination of the Czech public and a huge slice of the domestic market by slashing prices by a full fifty percent in 1922. By 1928 Czechoslovakia had become the world's leading footwear exporter and Baťa production topped 100,000 pairs a day, an output that would more than double by the end of the next decade. Under the leadership of Jan Antonín Baťa, who succeeded his half-brother when Tomáš was killed in a plane crash in 1932, the firm met the challenges of the Great Depression by diversifying into tires, rubber goods, toys, bicycles, airplanes, and artificial textiles. On the eve of World War II Baťa employed 67,000 people in thirty-three countries spread across Europe, Asia, and North America.

Ever a progressive employer, Baťa instigated a profit-sharing scheme for its workers in 1924 and was the first large company in Czechoslovakia to introduce a five-day, forty-hour week in 1930. The Baťa philosophy of cooperation (*spolupráce*), elaborated in a multitude of speeches, articles, and books by both Tomáš and Jan, anticipated the rhetoric of Starbucks and Wal-Mart by several decades in conceiving of its employees as coworkers (*spoluprácovníci*) rather than mere hired hands. "Work as a collective, live as an individual!" was the company slogan. Workers were provided with schools, hospitals, sports and leisure facilities, and low-cost, high-quality housing, the distinctive flat-roofed "shoe-boxes," each with its own little garden, which were pioneered in Zlín and eventually reproduced in Batavilles, Batatubas, and Batanagars across the world. "It was a wonderful place to live," recalls Joan James, whose father moved from the East End of London to the English Baťa development at East Tilbury in Essex in 1940. "At the time, it was very modern. Having a bathroom inside the house was a novelty, and the houses down in the village weren't on electricity yet. But if you lost your job," she warns, "you lost your house. And you had to maintain standards. There would be a gardening competition every summer, for example, so the estate was beautifully

maintained. But if you weren't up to scratch, you got a letter telling you to get your garden sorted out. You were watched over, but it didn't feel oppressive. It was a very safe environment."[62] A gated community, we might nowadays call it, only the gates were those of the Baťa factory and the security was tied to the job.

Zlín itself, whose population mushroomed from 3,000 at the turn of the century to over 21,000 by 1930, was a model—in all senses—of a planned and panoptical modernity. Tomáš Baťa was elected mayor in 1923, the same year in which "Baťovci" candidates took seventeen out of thirty seats on the town council, a figure that would rise to twenty-five in 1927. The company had pretty much a free hand in transforming the little town into an industrial garden city of the kind envisaged by Ebenezer Howard. Le Corbusier was approached to oversee the realization of this vision in 1925, but his plans proved too expensive; in the end the job was entrusted to the local architects František Lydie Gahura and Vladimír Karfík. Karfík had previously worked in both Le Corbusier's studio in Paris (1925–26) and Frank Lloyd Wright's practice (1929–30) in the United States. "Zlín had an admirable destiny—a homogeneous building style," he later wrote. "The simplicity of the construction components and the vigorous honesty of this young town's architecture are what first touch the foreigner who sees Zlín's factories surrounded by greenery, the hostels and Labor Square."[63]

One such admiring foreigner was Le Corbusier himself. František Gahura wrote him an apologetic letter on 19 January 1935:

> A year has gone by since I was your guest in Paris. During this time, I permitted myself to invite you to Zlín and I promised to write you a letter of invitation.
>
> Forgive me that I have not done this until only today. When I returned from my travels, I found my two children, a girl of 14 and a boy of 4½, sick. Four months later the children died. This is why I have neglected my social responsibilities as well as those I had toward you.
>
> Today, having regained my tranquility, I permit myself to invite you to Zlín on behalf of Baťa. . . .
>
> I permit myself to assure you that we will be very happy to receive you here because we think very highly of your attempts to discover a modern form of architecture, which in our view is the only one that conforms to the spirit of our times.[64]

Le Corbusier visited for six weeks in the spring of 1935—the same time, by coincidence, that André Breton and Paul Éluard were electively pinning down the drift of a different strand of poetic thought amid the bristling towers of old Prague. At first sight Zlín struck him as "an American ant-hill; at least, according to appearance. If we arrive there directly from the place de la Concorde it seems to be too rash a transition." But soon he "felt as a man fallen into a world standing apart from all rules, into a new world where happiness seems to exist in such abundance that life there is always interesting. This fact stands out amidst a wonderful organization of work; but . . . under this rational mechanism I perceived a much more valued and effective factor—the human heart." Zlín, he congratulated "Mr. Jan Baťa and his coworkers," "is one of the hot places of the new world: there is life in it! In Paris I have not met anything like Zlín; things in Paris are such that we are asking ourselves whether we have not lulled ourselves to sleep."[65] He excitedly sketched master plans for the further architectural embodiment of the Baťa vision both in Zlín and in Hellocourt in France, though once again nothing was to come of them.[66] Le Corbusier had to wait until 1950, when Jawaharlal Nehru commissioned him to design Chandigarh in the Punjab, before he got the opportunity to translate his dream of *The Radiant City* (*La Ville radieuse*, 1933) into reality.

All Zlín's public buildings exhibited the stylistic uniformity prized by Karfík: the basic unit of construction was a 20 × 20 ft module of the sort advocated in Le Corbusier's Dom-ino system. "From the beginning we have endeavored to have the town grow stylistically in an organic way out of industrial architecture," explained Gahura; "Zlín's appearance is influenced by the industrial object, that is to say the factory building. It is the main motif of Zlín's architecture."[67] The town was built on an American-style grid plan with a brand new center separating the industrial zone from the residential areas. At the core of the downtown was the pointedly named Labor Square (náměstí Práce), flanked by a nine-story department store (Obchodní dům) where the coworkers could spend their hard-earned wages, the eleven-story Social House Hotel (Hotel Společenský dům), and a 2,000-seat cinema—the largest in Europe at the time. The hotel went way over budget, but Tomáš Baťa believed the company's guests deserved the very best: not only could they enjoy restaurants, meeting rooms, and a rooftop terrace with a café and dancing, but this was the first European hotel to provide baths in every room. This novelty was inspired by Karfík's time in the United States. "All the rooms in American hotels where I worked had their own bathroom," he ex-

plained. "That was different from the situation here—even in Prague there was no hotel with its own [en suite] bathroom."[68]

Positioned at the intersection of the factory sector and the downtown, the seventeen-story Baťa administrative building—the company's HQ, which was known simply as Building 21 from its location on the grid—could see and be seen by all. Built in 1936–39 to Karfík's design, it was not only the tallest building in Czechoslovakia but one of the highest anywhere on the European continent. Set against the backdrop of Moravian hills, the rooftop garden cannot but bring to mind Le Corbusier's Unité d'Habitation in Marseille, which Building 21 anticipated by more than a decade. Well over half the skyscraper's skin was made of glass. Most floors were modeled on undivided factory production halls, allowing for open-plan offices that could be sectioned off with movable glass partitions as needed—another American innovation. The exception to this transparency was the eighth floor, which housed the wood-paneled, individually furnished directors' offices. The forward-looking Jan Baťa, however, had his own 6 × 6 meter office installed in an elevator equipped with hot and cold running water, air-conditioning, wireless, telephone, and electrically controlled window-screens, which could "move into any of the administrative departments upon the push of a button, becoming thus the central nerve of the organization and the operations."[69] This portable cabinet might have brought yet more Borgesian laughter bubbling up in Michel Foucault, had it occurred to him to trace the genealogy of the docile and disciplined modern body into the backwoods of Leoš Janáček's rural Moravia.

Speaking on 1 May 1934 in celebration of the fortieth anniversary of the founding of the company, Jan reminded his "Fellow-workers, young men and women!" of how four decades earlier an eighteen-year-old Zlín youth—his brother Tomáš—had stood on the same spot. "He stood on ground that then belonged to foreign aristocrats, who did not grasp the needs of the town and people and barely even understood its language. He stared out on Zlín, a paltry settlement of a handful of cottages, which was the home of poverty, and sometimes of hunger too.... And longing gripped his soul. A longing to help. A longing to improve the hard life of his people. Before his eyes arose the paragons of our history," first and foremost that other great builder and planner "Charles IV, Father of the Homeland, who ... raised his people to the forefront of the civilization of the day by the strength of his labor and his courage." History is never too far away from Czech minds, even when—and perhaps especially when—they turn to the imagining of new worlds. Today, Jan continued, "Zlín has the most marriages of any city in the Republic. In

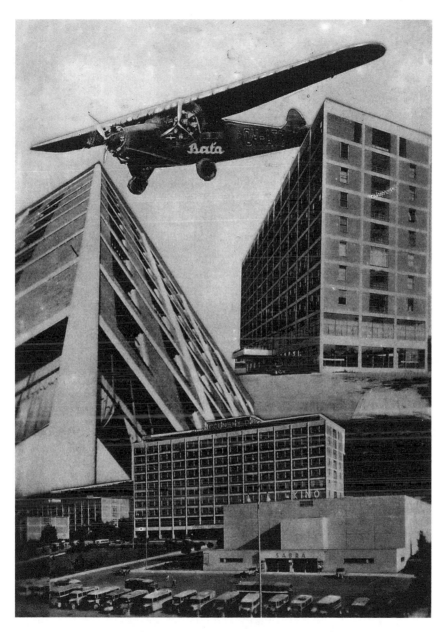

FIGURE 4.3. Hotel Baťa, Zlín (photomontage), 1930s. Anonymous artist. Archive of Jindřich Toman.

Zlín the most children are born and the fewest die. Our town has the most automobiles and the highest annual growth in independent businesses. These are all the results of our labor."[70] František Gahura might by then have had cause to question the limits of what *práce, práce a práce* can secure in the way of human happiness, but to every rule there is an unfortunate exception. Baťa seemingly had every reason to be optimistic for the future.[71]

But history seldom marches to the drum of reason. By the time the finishing touches were put to Building 21 Zlín was part of the Protectorate of Bohemia and Moravia and Jan had fled to Brazil. The Baťa factories continued producing during the German Occupation; the US Air Force bombed them in November 1944. Controversy still rages over whether their self-exiled boss was a Nazi collaborator, as the KSČ (who tried him in absentia after the war) believed, or a hero who protected his coworkers from forced labor in Germany by keeping his factories open and saved his Jewish employees from the Holocaust by transferring them abroad after the Austrian *Anschluss*. One of those who undoubtedly owed Jan his life was eighteen-month-old Tomáš Sträussler, whose father, Eugen, a Baťa company doctor, was hastily posted from Zlín to Singapore in 1938. In due course the young Tomik made his way to England, where in the fullness of time he metamorphosed into the famous British playwright Tom Stoppard. In keeping with the venerable Bohemian tradition of overwriting unwanted complexities in history with white spaces—*bílá místa*, so-called after the blank areas with which the censors spattered the pages of newspapers during the Habsburg era—a recent Radio Prague piece on Baťa and Zlín ducks the issue of Jan's complicity or otherwise in the Nazi takeover by failing to mention his name altogether, handing the firm straight from Tomáš Baťa to his son of the same name, who was affectionately known by the diminutive Tomášek.[72] "A truth," remarks a character in Tom Stoppard's *Lord Malquist and Mr. Moon*, "must be the compound of two opposite half-truths. And you never reach it because there is always something more to say."[73] Whatever the truth in this case—if, once again, there can ever be a singular truth in such cases—the Baťa company was nationalized by presidential decree in 1945 along with the rest of Czechoslovakia's banks, mines, utilities, insurance companies, and large enterprises. Zlín was before long renamed Gottwaldov, Baťa dissolved into Svít (Light), and the Social House Hotel reborn as the Hotel Moskva (Moscow Hotel).

Over the next forty years Bata—as Baťa became after 1945, dropping its diacritic along with its Czechness—reconstituted itself from Ottawa, Canada, under the baton of Tomášek, *aka* Thomas Bata Jr., while Gottwaldov fell on drab times. The town's old name was restored after the Velvet Revolution.

Zlín is still stalked by the ghosts of futures past, even if it is not always entirely clear which pasts, and which futures, are casting their shadow over the present. "In the Hotel Moskva," wrote a bemused *New York Times* correspondent in 2007, "I dine at the Hacienda Mexicana, where beyond the hokey plastic roof timbers are the building's original reinforced concrete beams, the bare bones of Bata's Modernist vision."[74] Le Corbusier may have hailed urban planning in *The Radiant City* as a "rational and poetic monument set up in the midst of contingencies"[75] but in this instance the contingencies swamped all rationality and the only poetry left was of a distinctly elegiac character—though Shelley's "Ozymandias" also comes to mind. Zlín may now be far off the beaten track of History and sadly lacking in the usual tourist attractions, but for aficionados of the surreal it is well worth the detour. Some travelers in this antique land might think that the renaming of the Baťa dreamscape after the First Workers' President was not without its black humor. Those bare bones wrapped up in postmodern schlock could easily be mistaken for relics of socialist construction—and not only in their architectural foreshadowing of the ubiquitous *paneláky*, apartment blocks that get their name from the prefabricated concrete panels out of which they are constructed, that would come to ring Prague and other Czechoslovak cities after World War II.[76]

The Baťa store is not the only modernist showcase to be found on Wenceslas Square. But what to my mind makes this boulevard so quintessentially *modern* is less the conformity of any of its individual buildings to the aesthetic strictures of the International Style than the hubbub of different architectural vocabularies, which succeeded one another with bewildering rapidity. Three doors up from the Baťa store stands Jan Kotěra's Peterka House (Peterkův dům), built in 1898–99, an early (and uncharacteristically restrained) example of Prague art nouveau. A pupil of the Viennese architect Otto Wagner, Kotěra is widely seen as the father of modern Czech architecture; the Mozarteum on Žitná Street, where the Architects' Club lectures were held in 1924–25, is another of his creations. The full flowering of art nouveau, which left as emphatic a mark on the city as it did on Glasgow, Brussels, or Vienna before it disappeared as rapidly as it came, can be sampled a couple hundred meters farther up the square in the curvy exuberance of the Grand Hotel Europa (formerly the Grand Hotel Šroubek, before that the Archduke Štěpán Hotel) and its smaller neighbor the Hotel Meran (originally the Hotel Luna), both of which were built in 1904–6. Across the street stands the neo-renaissance Wiehl House (Wiehlův dům), which was completed only a decade earlier to the design of Antonín Wiehl, the architect of the Slavín in Vyšehrad, yet could have come from a different age. Like the

Land Bank on Na příkopě the Wiehl House sports frescoes that mingle folk motifs, Czech proverbs, and historical scenes by Mikoláš Aleš (and in this case Josef Fanta). The socialist realism of the Hotel Jalta, built in 1954–58, does not seem out of place in this medley: surviving into a time when the communist certainties it once stood for seem as outmoded as crinolines or cassette tapes, it is a poignant reminder that every modernity—to come back to Baudelaire—is always already on its inexorable way to becoming passé.

Riddling this architectural bedlam was a labyrinth of arcades purveying all the beauties of the world. Prague's passages deserve to be better known; they are as eloquent repositories of *temps perdu* as their more famous Parisian counterparts, which set Walter Benjamin off on his interminable quest to find the redemptive truths of history in the ruins it has left behind it.[77] Like much else in the Bohemian capital the passages disorder our sense of time: unlike the Paris arcades Prague's are the leavings not of the nineteenth but the twentieth century. Some forty or so *pasáže* were built on Wenceslas Square, Na příkopě, and National Avenue between 1907 and 1940. They, too, come in a goulash of architectural styles. Threading its way through the Havels' palace of sin and cinema from Wenceslas Square to Vodičková Street, the Lucerna Passage wraps its *passants* in a warm brown cocoon of art nouveau. Antonín Černý and Bohumír Kozák's Broadway Passage on Na příkopě, which once housed the Sevastopol Cinema, is all chrome, glass, and sleek simple lines. Luxuriating in pink and gray marble bathed with light from fittings that simulate gold, the Adria Passage on the corner of Jungmann Square (Jungmannovo náměstí) and National Avenue anticipates the style that would soon sweep the world off its feet at the *Exposition internationale des arts décoratifs et industriels modernes*, the 1925 Paris spectacular from which art deco gets its name. Post-communist renovations are doing what they can to strip this twentieth-century netherworld of its Benjaminian aura, but occasionally one still stumbles across genuine relics of a bygone modernity like Rudolf Kremlička's mosaic on the façade of the Blaník Cinema in the Fénix Passage on Wenceslas Square, which brims over with lush female bodies painted in his inimitable Czech cubist curves.

Pavel Janák's Adria Palace (palác Adria), in which the Adria Passage is situated, was built in the so-called rondocubist "national style" (*národní sloh*) in 1922–25 for the insurance company Riunione Adriatica. It is one of the most unusual—some would say, the most preposterous—structures in Prague. Le Corbusier tactfully described it as "a massive building of an Assyrian character."[78] Karel Teige was less charitable, denouncing Janák's fantasia as "a despicable and monstrous Miramare furnished with bizarre battle-

FIGURE 4.4. Pavel Janák, Palác Adria, Prague, 1922–24. Unknown photographer. Národní technické muzeum, Prague.

ments, giving from afar the impression of a *bonbonnière*. . . . If a mere façade costs enough to build four decent apartment houses," he fumed, "it is a sin against economy and society" equivalent to dumping eggs in Lake Michigan.[79] This being Prague, among the *bonbons* spangling that façade is a procession of nude female figures with pert breasts and perky behinds sculpted by Jan Štursa, an altogether more frivolous contribution to the city's streetscape than his heroic group sculptures of Work and Humanity on the Hlávka Bridge. Neither Teige nor Le Corbusier could have imagined that decades later Janák's improbable confection would host an even more improbable revolution, but it did. Civic Forum (Občanské forum), the motley coali-

tion of dissidents that seized the moment to orchestrate the downfall of communism in November 1989, had its headquarters in the Magic Lantern (Laterna Magika) Theater in the Adria Palace basement. It was a thoroughly fitting stage set for a revolution-cum-fête that in this case unmistakably did belong in Prague rather than Paris. Where else would ten days of demonstrations (and not a single broken window) culminate in the catapulting of an absurdist playwright into the castle? Mere coincidence, no doubt: but it is a coincidence that should alert us, once again, to the dangers of assuming too logical a fit between function and form.

It seems only appropriate that presiding over the Golden Cross is the vast neo-renaissance bulk of the National Museum, fronted by Josef Václav Myslbek's statue of Saint Wenceslas, a suitably out-of-time conductor for this symphony of modern dissonances. Josef Schulz's design for the museum was chosen over its competitors largely because of its domed Pantheon, which contains statues and busts of the Czech great and good. Some of the Pantheon's inmates, like Tomáš Masaryk, have moved in and out with every turn in the political weather, while others like Bedřich Smetana and Božena Němcová have proved infinitely adaptable to changing times. More, however, have simply been forgotten.[80] Wenceslas Square was not Vítězslav Nezval's favorite part of the city, but he was not wholly immune to its charms. Nezval's muse was more perplexing than Le Corbusier's; no bright young thing from the golden twenties she. "Whenever I catch sight of a few illuminated windows in the *Museum* on *Wenceslas Square* at night," he writes in *Prague Pedestrian*, "I would like to go inside, under the illusion that I will meet a sleepwalking woman with a lamp in her hand that wanders through the centuries. It wouldn't bother me at all if she turned out to be some famous actress from the middle of the last century. Black silk stockings and moral dubiousness make love very sexy. I am partial to immorality in these matters." By then the everyday immoralities of the locale appealed to him less. The square, he lamented, had been contaminated by "a hackneyed sort of prostitution," unless perchance it was a Saturday, when "apprentice milliners and hairdressers, who still have a sense of romanticism" might be found on the second floor of the Pasáž Café. "Otherwise," he concluded, "the whole of Wenceslas Square with its lights and its sweet moldy scents can go to the devil. Happiness doesn't flower here for me. Mark my words!"[81]

FROM THE WINDOW OF THE GRAND CAFÉ ORIENT

Just behind the Baťa store, off Jungmann Square, stands Emíl Králíček's "cubist" lamppost, which for some reason always reminds me of the lonely lamp-

post that marked the frontier of the magical land of Narnia in C. S. Lewis's children's fable *The Lion, the Witch and the Wardrobe*. Narnia was reached through the back of a wardrobe in an English country house; at the beginning of the book it had lain for a century under the spell of a beautiful witch-queen who makes sure it is always winter but never Christmas and turns her opponents into stone statues.[82] Králíček's solitary streetlamp, which has a premonitory touch of Brancusi's *Endless Column* about it, opens a door on an equally topsy-turvy wonderland, at least as seen through the eyes of more westerly artistic canons. Czech cubism, as it has nowadays uncertainly come to be called, has left Prague with some of its most distinctive modern buildings. We might go so far as to say that these are among the most distinctive modern buildings to be found anywhere in the world, because this application of Apollinaire's fractured aesthetics to architecture, not to mention wardrobes, armchairs, ashtrays, light-fittings, book covers, stage sets, and much else, has no counterpart elsewhere—if, that is, this was what Josef Chochol, Pavel Janák, Vlastislav Hofman, and Josef Gočár *were* doing. Whatever else Czech cubism might have been it was by no means pure, and its impurity is arguably the most interesting thing about it. It is a sure sign that something is amiss with our categorizations when art historians repeatedly have recourse to uneasy hyphens ("cubo-expressionism") and awkward hybridities ("rondocubism") and the same works turn up in exhibitions devoted to *Czech Cubism* and *Expressionism and Czech Art* without seeming out of place in either.[83]

Karel Teige was predictably disturbed by such deviations from the straight lines of the modern. Looking back in 1930, by which time constructivism and functionalism ruled the architectural roost, he dismissed Czech cubist architecture as "a cul-de-sac dominated by the priests of the romantic imagination" and argued that the rondocubism that succeeded it—a short-lived movement that aimed to infuse the pre-1914 cubist legacy with Slavic elements to create a "national style" appropriate to the country's regained statehood—"cast architectural progress back more than half a century." Behind the angular façades of Chochol, Janák, and Gočár's buildings he detected not only the taint of German expressionist hysteria but the long arm of the baroque. The "indebtedness to the baroque ... [of] those who consider themselves to be modern architects," he smirked, "constitutes a peculiar irony of fate." Teige conceded that the cubists' "abstractly spiritual, dramatically dynamic forms" had given Prague some striking edifices, among them Janák's Hlávka Bridge and Gočár's "remarkably courageous, expressive and historically significant" House of the Black Madonna (Dům u Černé Matky Boží),

but he considered such structures irrelevant to "the modern individual who wears his relatively uniform clothes [and] will also seek modern, that is, adequate lodging and furnishings, in which every object is unambiguously defined by its value, function, and purpose." Those less wedded to teleologies of progress—or the erotics of uniformity—might be retrospectively grateful for the cubists' sensitivity to the city's *genius loci*. They saw no contradiction between standing, in Teige's own words, "in the vanguard of European [architectural] development in the last years before the World War [I]"[84] and being active members of the Club for Old Prague, as many of them were.[85] Seen in hindsight both the playfulness of their buildings and their willingness to riff on the past—a very different thing from the imitative historicism of the nineteenth century—seem almost, dare I say it, postmodern.

The House of the Black Madonna, which sits at the intersection of Celetná Street and the Fruit Market (Ovocný trh), went up in 1911–12, just a couple years after the Municipal House was finished a hundred meters or so down the street. Though the two buildings are almost contemporaneous the contrasts between them could hardly be more extreme. Gočár's six-story department store (as it then was; today it is the Museum of Czech Cubism) strikes no overtly patriotic notes, even if in retrospect its architecture has turned out to be as singularly Czech as Easter fun and games with painted eggs and *pomlázky*. The sole added decoration is a small golden statue of the Madonna housed in a grille at one corner, a twentieth-century nod to the ancient tradition of Prague house signs that so fascinated the surrealists. The figure used to adorn the baroque house that formerly occupied the site. The exterior of the building is regular and geometric, with the two upmost floors symmetrically receding. Much of the frontage on the lower four stories is made of plate glass. What distinguishes the architecture as "cubist" is Gočár's employment of diagonally slanted planes to break up the surface, relieving what could otherwise be an impression of overwhelming heaviness; the front façade is slightly angled at the center, and the fracturing is accentuated by the recessing of the bay windows on the second and third floors. This faceting is taken still further in Josef Chochol's Hodek apartment-block on Neklanov Street, in which scarcely a detail of the exterior, some windows apart, is aligned in a vertical plane. It is not Braque and Picasso, though, that immediately strike the viewer as Chochol's source of artistic inspiration. "The slender column of the corner balcony," observes Rostislav Švácha, "looks as if it had been transferred from some late Gothic church, complete with the appropriate fragment of a diamond vault."[86]

FIGURE 4.5. Josef Gočár, House of the Black Madonna, Prague, 1911–12. Unknown photographer.
Národní technické muzeum, Prague.

Not that Prague lacked exposure to contemporary French influences, in-
cluding Picasso and Braque's experiments with multiple angles of vision, in
the years before World War I. The distance between the French and the
Czech capitals was then a good deal shorter than it became in the second half
of the century; shorter, quite possibly, than the tram-ride taken by Franz
Kafka from the Old Town to Žižkov. Alfons Mucha was not the only Czech
painter to seek fame and fortune on the banks of the Seine; the nineteenth-
century artists Václav Brožík, Jaroslav Čermák, Antonín Chittussi, Luděk
Marold, Karel Vítězslav Mašek, Viktor Oliva, and Vojtěch Hynais (who cre-
ated the curtain for the National Theater) had all spent long periods breath-
ing Parisian air.[87] We have already met the critic and collector Vincenc
Kramář, whose astute purchases from Daniel-Henry Kahnweiler and other
Paris art dealers inspired his colleagues in the Group of Fine Artists to ex-
plore the new cubist visual vocabularies. Gočár, Chochol, Janák, and Hof-
man were all members of the Group; so were the painters Otakar Kubín,
Emil Filla, and Josef Čapek, all of whom made lengthy visits to Paris between
1910 and 1914.[88] Otto Gutfreund, whose works of 1911–13 may fairly be
counted among the earliest cubist sculptures in the world, studied for a year
in the French capital with E. A. Bourdelle in 1909–10. He returned to Paris
in the spring of 1914, where he got to know Picasso, Apollinaire, and Juan
Gris. On the outbreak of war he enlisted in the French Foreign Legion and
fought in Alsace, the Somme, and Champagne, only to find himself impris-
oned from May 1916 until the end of the war for participating in a protest

against conditions in the Legion.[89] Bohumil Kubišta, who declined to join the Group of Fine Artists but remains one of the most original and inventive of the Czech cubist painters, also spent eight months in Paris during his two visits of 1909–10.[90] Confusingly for those who like their art-historical genealogies unmuddled, Kubišta went on to join the Dresden expressionist group Die Brücke in 1911, the same year the Group of Fine Artists was formed.

Equally difficult to pigeonhole is that idiosyncratic Bohemian whom Alfred Barr was later to credit with painting "the first pure abstraction in Western Europe,"[91] František Kupka, who lived in Paris from 1895. With his fiancée, Eugénie Staub, Kupka moved into a small apartment house in the suburb of Puteaux in 1906. His neighbors were Marcel Duchamp's brothers Jacques Villon and Raymond Duchamp-Villon. (Duchamp's sister Suzanne was also an accomplished painter, but that is more often forgotten.)[92] On "Puteaux Sundays" the three men got together with the Section d'Or cubists Jean Metzinger, Albert Gleizes, Fernand Léger, and Sonia and Robert Delaunay; the critics André Salmon and Alexandre Mercereau; and others to digress on "Leonardo da Vinci, cubism, futurism, the golden number, non-Euclidean geometry, Marey's chrono-photography, and the fourth dimension. Guillaume Apollinaire was a frequent visitor."[93] Kupka exhibited two of his (or anybody's) earliest abstract paintings, *Amorpha: Fugue in Two Colors* and *Amorpha: Warm Chromatic*, with the Section d'Or at the Salon d'Automne in 1912. Critical reaction was predictably dismissive, but it was Kupka's canvases that inspired Apollinaire to coin the term *Orphism*. The following year the *New York Times* ran a long article on "Orphism: Latest of Painting Cults" subtitled "Paris school, led by Kupka, holds that color affects senses like music," which was exactly the Czech painter's aspiration.[94] "All in all," Kupka wrote his friend Arthur Roessler early in 1913, "what I am seeking now are symphonies.... You can't imagine the derision I have to put up with." Repeatedly asked by viewers "What does it represent?" and "What is it supposed to be?" he responded with the question that puts the modernity in modern art: "Must then a work of art *represent* something?"[95]

After World War I ended the city of light once again became a magnet for Czech artists, who like many an adventurous American—Man Ray, Gertrude Stein, F. Scott Fitzgerald, Henry Miller, Ernest Hemingway, Berenice Abbott, Alexander Calder, and Lee Miller, to name but a few—went in search of modernity at its mythical source. Josef Šíma settled in France in 1921, married a French girl, and became a French citizen in 1926. It was Šíma who was responsible for the extensive Parisian representation in Mánes's

Poesie 1932 exhibition. The show did not have André Breton's imprimatur, which might go some way toward explaining why despite its size it has received so little attention in most histories of the surrealist movement—though Prague's miraculous translation into "Eastern Europe" after World War II no doubt also helped facilitate such forgetting. Šíma happily straddled cities, languages, and cultures, even-handedly exhibiting his paintings in Paris and in Prague.[96] Together with the young French writers Roger Gilbert-Lecomte, Roger Vailland, and René Daumal he became a founder member of Le Grand Jeu, a dissident surrealist coterie that would prove to be a major thorn in the flesh for André Breton. The Czech writer Richard Weiner, who doubled as the Paris correspondent of *Lidové noviny*, was involved with the same outfit. Vailland visited Prague with Weiner in the summer of 1927. He mistook Karel Teige for "the head of the Czech surrealists," a premonitory slip of *hasard objectif* if ever there was one since Teige had little truck with surrealism at the time.[97] Šíma translated Vítězslav Nezval's "Acrobat" for Le Grand Jeu's eponymously titled magazine in 1929, for which he also designed the cover.[98] The same issue gave plenty of space to André Masson and the erstwhile Dadaist (and frequent contributor to *Littérature*) Georges Ribemont-Dessaignes, neither of whom were then in Breton's good books. *ReD* repaid the favor the following year by devoting a special issue to Le Grand Jeu.[99]

The section on "Czechs in Paris" in Štyrský and Toyen's *Guide to Paris and Its Environs* estimated the "Czech colony" in France at 80,000 souls. The expatriates were served by Czech schools, sports clubs, gardening societies, veterans' associations, flying clubs, banks, newspapers (among them *Parisian Czechoslovak* [*Pařížský Čechoslovák*] and *Paris–Prague*), nine Czech restaurants, and two Czech bars—which did not prevent sojourning Bohemian artists from frequenting Les Deux Magots, the Dôme, La Rotonde, and other Parisian literary and artistic avant-garde watering-holes.[100] Many of them succeeded in showing their work in both solo and group exhibitions. Kupka was honored with a large retrospective at the Jeu de Paume in 1936, the same year as Alfred Barr included four of his canvases in MoMA's *Cubism and Abstract Art*. He shared the premises with Alfons Mucha, an improbable conjunction in art-historical retrospect but one that evidently did not jar at the time. The Czech cubist painter František Foltýn, who lived in Paris from 1923–34, exhibited at the Galerie au Sacré du Printemps in 1927, had two more Paris shows in 1930, and participated in the groups Cercle et Carré and Abstraction-Création (of which Kupka was also a founder-member). Jan

Zrzavý, a member of the Obstinates, made his base in Paris (and Brittany) from 1923 to 1938, though like Šíma he continued to maintain close contacts with his homeland. Other Czechs who spent significant periods in the French capital between the wars included the painters Zdeněk Rykr, Alén Diviš, Jiří Jelínek, and František Muzika; the sculptors Vincenc Makovský and Hana Wichterlová; the avant-garde photographer Jaroslav Rössler; the composers Jaroslav Ježek, Bohuslav Martinů, and Vítězslava Kaprálová; and the actor Jiří Voskovec.[101] Kupka took many of the Czech expats under his wing, allowing them to take the courses he started offering in 1922 whether or not they could afford the fees.[102]

Šíma and Foltýn both showed their work in December 1925 at the exhibition *L'Art aujourd'hui*. So did Štyrský and Toyen, who had just arrived for what would turn out to be their four-year stay in the city. The pair displayed their Artificialist paintings in their Montrouge studio in October 1926, which led to an exhibition at the trendy Galerie d'art contemporain the following month. The next year they had a show at the Galerie Vavin for which Philippe Soupault, who had also by then fallen out with Breton, supplied a glowing preface.[103] Adolf Hoffmeister reported on their success in *Rozpravy Aventina*:

> And finally this heavy fog of peripheral inhabitants, who live in a mad tempo of self-sufficiency on the rollercoaster of success and fiasco. Elegant Manka [a diminutive of Marie], or Toyen, who buys herself clothes fashionable and ultrafashionable and dines on smoked mackerel at "Au rendezvous des chauffeurs" with Jindřich Štyrský, a painter quiet and artificial. Artificialism invites you to an exhibition. We celebrate it with heavy boozing. Nečas's fists will protect us. We won't go home until six in the morning.[104]

Chaperoned by his mother, Hoffmeister first set eyes on *la ville-lumière* in 1922 when he met Man Ray, Osip Zadkine, and Ivan Goll, a disciple of Apollinaire who eventually lost out to André Breton in the battle over the meaning and ownership of the term surrealism.[105] The twenty-year-old liked the city so much that he returned once or twice every year up to the outbreak of World War II. In April 1939 Louis Aragon helped secure a special visa that allowed Hoffmeister to escape the Protectorate, though before long he would find himself imprisoned by the French authorities, along with several other Czech refugees, as a suspected Soviet spy. Exonerated by a military tribunal in the spring of 1940, Devětsil's caricaturist escaped to Casablanca on the day

France fell and made his way via Tangier, Lisbon, and Havana to New York, arriving in the Big Apple in April 1941.[106]

This avant-garde traffic was not just one-way. A stream of exhibitions meantime brought Montmartre and Montparnasse to Prague. The two large retrospectives of modern French art staged in a space of less than four months in 1931 would have graced any capital city. They were organized by Mánes and Umělecká beseda (The Artistic Society) respectively, two of the oldest established Czech artists' associations, whose roots lay in the patriotic fervor of the later nineteenth century.[107] The Umělecká beseda exhibition, which was held in the Municipal House and curated by Josef Čapek, displayed no less than 525 works by Arp, Bonnard, Brancusi, Braque, De Chirico, Derain, Dufy, Ernst, Léger, Maillol, Masson, Matisse, Miró, Picabia, Picasso, Tanguy, Van Dongen, Valadon, Vuillard, Zadkine, and others.[108] Kupka and Šíma were proudly situated within *L'École de Paris*, as the show was called, rather than narrowly claimed for the Czech nation. André Salmon, who had shared the Bateau-Lavoir studios in Montmartre in which Picasso painted *Les Demoiselles d'Avignon*, supplied the introductory essay for the catalogue.[109] Mánes's *Art of Contemporary France* was smaller but still very substantial. There were 220 exhibits, which included fifteen Braques, thirteen Derains, sixteen Picassos, forty-five Matisses, nine Modiglianis, and fourteen Massons. Antonín Matějček's introduction to the catalogue stressed the indissolubility of the bonds between the national and the international, pronouncing two "articles of faith," which, he said, "had become to Mánesites almost a dogma: faith in the strength and creative capacity of the nation and in the future of its art; and faith that the living light of today's art comes from the west and that the representatives of the creative ideas and leaders of the art of our times are the French."[110]

Matějček went on to remind visitors of the old society's long and proud record in bringing Parisian modernities to the Bohemian capital, beginning with its exhibitions of Rodin in 1902, the impressionists (a category that was interpreted loosely to include Van Gogh, Gauguin, and Cézanne) in 1902 and 1907, and *Les Indépendants* in 1910.[111] Mánes's exhibitions, Karel Teige wrote later, were "a practical seminar for Czech artists."[112] With 157 items on display, the Rodin exhibition was the second largest show of the sculptor's work held anywhere in the world during his lifetime.[113] It had a huge impact on Prague's artistic community. The master visited Bohemia for the event, squired by Alfons Mucha, who took him on to visit Moravian Slovakia, an area much beloved of nineteenth-century Czech nationalists (and much derided in "Open Windows" by S. K. Neumann) for its surviving folkways. *Les*

FIGURE 4.6. Dust jacket for Styrský, Toyen, and Nečas, *Průvodce Paříží a okolím* (*Guide to Paris and Environs*). Anonymous artist. Prague: Odeon, 1927. Archive of Jindřich Toman.

Indépendents was a (mostly) Fauvist blast—Bonnard, Braque, Camoin, Derain, Van Dongen, Maillol, Manguin, Marquet, Matisse, Vlaminck—which much inspired the young artists who were shortly to secede from Mánes to form the Group of Fine Artists. Derain's *Bathers* now belongs to the National Gallery of the Czech Republic. "I had the idea," Emil Filla later related, "that Derain's picture—it cost 800 crowns—should be kept for Prague. So we went around the cafés with a subscription form . . . until we had gotten together the 800 crowns."[114] The penultimate exhibition staged by Mánes in Prague before World War I closed the city's gates to east and west alike, *Modern Art: A Collection Assembled by Alexander Mercereau in Paris*, aspired to be the largest cubist exhibition in the world. It introduced Praguers to (among others) Archipenko, Brancusi, Robert Delaunay, Albert Gleizes, and Jean Metzinger.[115]

The sun may have risen on the Seine for Matějček and many others, but fresh winds were also blowing from the north. Mánes's *Edvard Munch* exhibition of 1905, with 121 exhibits, caused no less of a stir than had the Rodin spectacular of three years earlier. Like Rodin, Munch visited the city for his show, meeting Bohumil Kubišta among others. "At the beginning of our journey stood Munch," wrote Emil Filla thirty years later. Karel Teige once cruelly but accurately skewered Filla as "an exceptional example of an artistic satellite, of a moon, which shines with the reflected light of the sun"[116]—over the years the evolution of Filla's work faithfully followed Picasso's every twist and turn—but the "prisoner of cubism," as the Czech painter became known, went on to compare Munch's impact on Prague with Donatello's on Padua, Rembrandt's on Amsterdam, Michelangelo's on Florence, and Caravaggio's on Rome. In a climate dominated by virtuoso academicism on the one hand and the remnants of the Secession on the other, he explained, the Norwegian master held out "the possibility of again expressing the neglected inner state of the individual, of making the individual soul the agency of every emotion and action, especially in artistic creation."[117] Václav Špála was another who had no hesitation in ranking Munch (alongside Van Gogh) as "the greatest stimulus and pointer" for his generation. The Mánes exhibition, he says, "burst like an explosion into our young dreams and longings."[118]

Munch's influence on both the subject matter and the style of the Osma (The Eight), whose first exhibition opened in a disused store behind the Powder Gate (Prašná brána) in April 1907, is palpable. The Eight were Emil Filla, Otakar Kubín, Bohumil Kubišta, Emil Pitterman, Antonín Procházka, and the Bohemian-German artists Friedrich Feigl, Max Horb, and Willi Nowak. Horb died that December and Vincenc Beneš and Linka Scheithau-

rová, the future wife of Procházka, joined the group the following year. The catalogue of exhibits, a single sheet of paper, was headed "Výstava 8 Kunstausstellung."[119] It was a disturbingly discordant piece of bilingualism for the time; along with most everything else in Prague by the beginning of the twentieth century the Modern Gallery of the Kingdom of Bohemia, established in 1902, was divided into separate Czech and German sections.[120] Czech critics generally panned the show, though F. X. Šalda, the principal author of *Czech Modernism*, apparently gave it his "moral support."[121] The only positive review, titled "Springtime in Prague," came from the German-Jewish pen of Max Brod, who always had an unerring nose for the new and interesting and was none too fussed about its national provenance. "I spent several pleasant hours looking at their paintings in a little atelier near the Belvedere [Letná]," he told the readers of *Die Gegenwart* (The Present), "and now they can be seen at a small exhibition":

> A lot of new life, a lot of excitement, a lot of youthful spring on a few walls. I want first to say something about who these new people and artists are, and then something about their pictures. . . . They are artists, but they don't have long hair, broad-brimmed hats, or any such imitations. They dress in a regular way, they have got over Bohemianism. Firing up the bourgeoisie is not their aim; inwardly they feel so distant from the crowd that they have nothing external to prove. So for them contact with ordinary people will once again be possible and welcome. . . . That their pictorial language refuses all literary devices and is only a painting demonstrates the modern view of all eight. . . . It would be very gratifying if some Berlin Gallery, for example Cassirer, were to open its space to this rich new art. [122]

Filla's *Reader of Dostoyevsky* (1907) seems to be collapsing under the weight of the novelist's words, while Kubišta's self-portraits, which serially depict the artist in chromatic gradations of yellows and greens (*Self-Portrait with Cigarette*, 1908), reds and browns (*Self-Portrait with Inverness Cloak*, 1908), and shades of moody blue (*Blue Self-Portrait*, 1909) are depictions of states of mind. This is an expressionist art *avant le mot*, even if it lacks the incandescent palette of Die Brücke and Der Blaue Reiter.

As chance would have it, Antonín Matějček may well have been the first to introduce the word *expressionist* into international art-historical discourse in his preface to *Les Indépendants* (which was dated "Paris, 1910"). Only he

used the term to refer not to the German and Austrian artists with whom it has since become associated but to characterize the work of Cézanne, Matisse, and "the most primitive of the primitives" Braque (who, he warned, is "very young" and whose "art is clearly far from its definitive expression"). Developing "out of the new moral atmosphere, the psyche of the modern individual," he argues, this new art aims "toward the most concentrated and richest artistic expressions, toward symbols that more accurately and profoundly transcribe the emotional content of the time. . . . Impressionism . . . was transformed into EXPRESSIONISM, [which] demanded synthesis in place of analysis, a subjective transcription in place of an objective description [*subjektivní přepis místo objektivního opisu*]." "The expressionist wants above all to express himself," he goes on: "sensations and perceptions are filtered through his soul, freed from all superficial taints, emanating their pure essence."[123] Whether this analysis grasps what was most revolutionary about Cézanne, Matisse, or Braque's painting is open to argument; the critical tradition of Alfred Barr and Clement Greenberg that dominated postwar Anglo-American art history would lay more stress on their formal innovations than their existential stance toward the world. What matters here, though, is what it says about *Czech* understanding of what was modern about modern art on the eve of World War I.

From this vantage point Prague's so-called cubist architecture might no less (but also no more) accurately be described as expressionist. In his influential 1911 article "The Prism and the Pyramid" (*Hranol a pyramida*), Pavel Janák insists that architecture must not only meet practical needs but also aspire to be "a sculptural expression." He does acknowledge a French inspiration for his work, but it is not the cubism of Braque and Picasso. What excited him was "French Gothic around 1300." The article begins by distinguishing "two large European architectural families: the architecture of Southern Antiquity and the architecture of Northern Christianity," which have vied with one another through a thousand years of Bohemia's history. Southern architecture "represents architectural naturalism . . . the only aesthetic intervention consists in placing beautifully hewn and proportionally positioned heavy stones and slabs, quietly and calmly on top of each other in accordance with the simplest natural law of gravity." "Contemporary, so-called 'modern,' architecture," Janák argues, "shares this materialistic view." Le Corbusier would have found little to quarrel with in this characterization: he after all celebrated the Parthenon in *Vers une architecture* alongside grain elevators and ocean liners.[124] But while Janák acknowledges that modernism has been "healthy and effective in curbing the wildest excesses of pseudohis-

torical architecture," he criticizes its "fundamental distaste for any immaterial spiritual form." "Contemporary architecture," he laments, is "materially pedestrian and lacking in real poetry."

The "Northern" tradition, by contrast, "aims to rise above the quotidian of everyday building and reach supernatural beauty.... The aim is to create a building as if made of single matter, with all its parts alive and active, as if in tension." Gothic architecture (and to an extent baroque architecture, which Janák regards as an eruption of a Northern, "abstract" sensibility into a Southern, "materialist" framework) attempted to transcend the limitations of gravity, infusing matter with spirit. Janák draws an analogy with the forms produced in nature by crystallization, in which a "third force" disrupts the vertical and horizontal planes that result from the actions of gravity alone. The outcome is disruption of building based on ninety-degree angles by "a triplane, diagonal, or curved system," which he exemplifies by Gothic cathedrals, Egyptian pyramids, Indian temples, Siamese pagodas, and Chinese roofs.[125] He might have added, though he does not, that modern building materials opened up untold constructive possibilities for realizing such sculptural ideals. In retrospect—a retrospect in which the International Style can be seen as no less dated a memorial to its time and place than any other architectural fad or fashion—it could be argued that modernism universalized the norms of Janák's "Southern architecture" at the very moment when the technological advancements of modernity made it possible to go beyond them. Notwithstanding Karel Teige's dismissal of cubist architecture as irredeemably passé, is not Frank Gehry's Guggenheim Museum in Bilbao, a latter-day Gothic cathedral if ever there was one, evidence that Janák's heretical musings were far ahead of the game? The proverbial owl of Minerva may fly by night, but she doesn't always fly in straight lines.

The Grand Café Orient, which is situated on the second floor of the House of the Black Madonna, is as fine a place as any in Prague to while away a postmodern hour or two, drifting on the wings of poetic thought to the strains of Bach's "Jesu, Joy of Man's Desiring," Abba's "The Winner Takes It All," and Andrew Lloyd Webber's "Memory," all tastefully arranged for baby grand. The café, which opened in 1912, nowadays seems as timeless a part of the fabric of the city as Hradčany or Charles Bridge—except that the original Grand Café Orient closed down after a mere ten years "principally for reasons of the un-modernity of the cubist style."[126] It has now been restored down to the last detail of its "cubist" light-fittings, "cubist" coat-hooks, and "cubist" bar, all of which were personally designed by Gočár—a place out of its time, resurrected to partake in the eternal life of the signifier. The Orient

is one of a number of famous Prague coffee houses of varying dates that have reopened in recent years. Grander still is the Café Imperial in the hotel of the same name on Na poříčí, which was built in 1913–14. It is not difficult to understand why such places gave Le Corbusier the horrors: the mosaic-tiled ceiling is a good thirty feet high, the pale beige walls are entirely lined with white and pastel ceramics, the capitals of the Egyptian pillars dazzle with splashes of deep turquoise blue. The Imperial, the menu tells us, was a popular haunt of German soldiers during the occupation. The communists turned the hotel over to the trade unions, and it embarked on a slow and shabby decline before being beautifully restored in 2005–7.[127] The Café Arco on nearby Hybernská Street, where Franz Kafka, Max Brod, Franz Werfel, and Egon Erwin Kisch used to hang out and the young Milena Jesenská tested the limits of her father's patience, has fared less well: renovated in the 1990s, it has once again closed its doors to the public. Kafka's aura is evidently no longer sufficient to pull in the customers. Perhaps his bowler hat and mournful eyes have by now become so ubiquitous a presence in the city that they have ceased to signify anything at all. Or maybe it is just that the décor, which is as stripped-down as its most famous habitué's prose, is too severe for postmodern tastes.

GRANNY'S VALLEY

Introducing the first Obstinates' exhibition *And Yet!* in April 1918, S. K. Neumann complained that "at a time when art develops fast . . . there are still so few people with an interest in art who, in an era of such critical turns, do not give in to lethargy or are not swayed by the general antipathy toward the new harbored by the masses." He deplores the fact that "a young artist coming up with a new creative sensibility . . . is challenged by the loud, threatening demands of the day. If I were to be direct, I would say that he is the perpetrator of some imaginary or real -ism and -isms have been banned as 'un-national' art." "A good painting," he goes on, "is not an editorial, nor a march blasted out of a military trumpet."[128] These are familiar enough avant-garde defenses of the freedom of the imagination, which would be repeated by successive generations throughout the century. Neumann's own avant-garde pedigree was impeccable; emerging as a decadent (and sometime anarchist and Satanist) in the 1890s, he was involved with two important Czech modernist manifestos, the 1896 *Almanac of the Secession* and the *Almanac for the Year 1914*,[129] as well as writing "Open Windows," the futurist tract whose anathemas on old-Prague sentimentality, Moravian-Slovak embroidery, and Alfons Mucha we read earlier. It was Neumann's magazine *Červen* (June, 1918–21)

that first published Karel Čapek's translation of Apollinaire's "Zone," along with his brother Josef's illustrations. Josef's preferred subjects at the time included beggars, paupers, drunkards, and prostitutes. His *Radicals Read Červen* (*Radikálové čtěte Červen*) and *Woman over the City* (*Žena nad městem*) convey an eminently modern alienation, employing the angular forms developed by Czech cubism to frame human figures amid a solid sea of concrete tower blocks.[130] According to the masthead of *Červen's* first number, the magazine was devoted to "New Art—Nature—The Technical Age—Socialism—Freedom," an agenda Neumann would before long sharpen into "Proletkult—Communism—Literature—New Art."[131] He joined the KSČ on its foundation in 1921. It was a commitment that would in time present him with some awkward choices, but at the dawn of the 1920s it seemed a natural enough home for a poet of all things progressive.

This is the last quarter, we might think, from which we would expect to hear patriotic noises, and still less to find any engagement with the rural imaginaries through which Czech identity had been articulated during the previous century. But as is so often the case in these parts our expectations would be wrong. Neumann goes on to defend the work of the Obstinates as a specifically *Czech* art fostered by the isolation of the country during World War I:

> The present exhibition shows the work of our contemporary obstinate artists. Mostly, the work falls within the wider scope of the new post-impressionist art, for which the way was opened by Cézanne's creative discoveries and which was approached in the most abstract manner by Picasso. Yet, many paintings exhibited here mean much more. These works have matured in a silence undisturbed by foreign slogans that banished a violent era outside its locked doors. This art gained a final liberation from this situation and everything truly beautiful and mature you find in it speaks to you in its own local language. Here, an assertive strong Czech branch of contemporary modern European art deservedly works its way to the light of day. They have tried to drive it away, deprive it of light and air. And yet it thrusts its way forward, stubbornly, in its own direction.[132]

Not everyone appreciated such bold syntheses of the new and the national. "You have raped our most beautiful literary work and should be

banned from publishing books!" exploded one apoplectic bookseller to Otakar Štorch-Marien, the owner of the Aventinum publishing house, in 1923. The object of his ire was Aventinum's paperback edition of Božena Němcová's *Granny*, which was illustrated by Václav Špála. Of 664 copies of the book sent out to bookstores 440 were returned within two weeks.[133] Whether Špála's black-and-white linocuts can be considered "cubist" is moot. Certainly their visual vocabulary is gestural; mere scribbles and daubs, to eyes unused to looking at modern art. The illustrations have all the simplicity of children's drawings, which was evidently part of the problem. But while Špála's pictorial language may be modernist he speaks it with a thick Czech accent, country style. We are unmistakably *u nás,* as the Czechs would say, surrounded by Czech hills and fields, Czech cottages, Czech churches, Czech farmyards, Czech Christmas trees, Czech wooden toys, loaves of good Czech bread, and pretty Czech maidens in national costume. *U nás* is another (very) Czech phrase that is difficult to render into English: it can mean "our place," as in the French *chez nous,* but it also embraces our village, region, country, our way of seeing and doing things, sinewing together (as Karel Čapek once wrote of Mikoláš Aleš) "the greatest things and the smallest things in one single reality which is presented to be seen and loved."[134] A few brushstrokes are all Špála requires to bring to life Němcová's crazy Viktorka, the beautiful farmer's daughter jilted by the "black Hussar" who bewitched her with his smoldering eyes. Viktorka lives unkempt and alone in the forest, never speaking to anyone, returning every evening to sing a lullaby at the spot where, it is rumored, she threw her newborn baby into the river. The Čapek brothers' grandfather (says Karel) knew her.[135] Leoš Janáček used a similar story as the basis for his opera *Jenůfa,* though the infanticide was perpetrated in this instance by Jenůfa's stepmother, the village sexton, rather than the poor girl herself. Such tales show the darker side of the Smetanesque world where brides are bartered, cutting the sentimentality with which *Granny* drips in much the same way as the sauerkraut cuts the richness of the pork in *vepřo-knedlo-zelí,* the traditional Czech Sunday roast.

Špála was not the only modern artist to trample on the sacred turf of Granny's Valley (Babiččino údolí), as the place where Božena Němcová spent her childhood and set her novel has been known ever after. The valley, which lies in Ratibořice near Česká skalice in northeastern Bohemia, is—of course—as lovely a slice of countryside as one can find anywhere in the Czech Lands. Since 1922 it has been adorned (or as many saw it at the time, profaned) by Otto Gutfreund's memorial to Němcová, which portrays the old Granny, her grandchildren, and their dogs. By the time Gutfreund re-

FIGURE 4.7. Václav Špála, illustration for Božena Němcová, *Babička* (*Granny*). The drawing depicts Viktorka. Prague: Aventinum, 1923.

turned to Bohemia from Paris in 1920 he had turned his back on the fractured planes and surfaces of cubism in favor of a "civic realist" style intended to be more comprehensible to ordinary folk. Gutfreund's best-known works from the 1920s are brightly colored plaster or clay sculptures of scenes depicting the bustle of modern life. In *Business* (*Obchod*, 1923) a secretary reads a letter to her bowler-hatted boss, who is urgently speaking on the telephone, while two workers at a lathe personify *Industry* (*Průmysl*, 1923). As in Špála's illustrations for *Granny* it is quite clear what is meant to be what. But realism is a misnomer: the style of these works is deliberately naïve, a three-dimensional equivalent of the paintings of Le Douanier Rousseau. For the poet Otakar Březina, who had once been a pillar of *Moderní revue* and was a signatory of *Czech Modernism*, the conjunction of such primitivism with the national Holy of Holies was a modernity too far. "Gutfreund's Granny in this valley in Česká skalice is something so vulgar, ugly, foreign, un-Czech, un-

Slav," he spluttered, "and you see, the times are such that this sculptor is accepted among us!"[136]

Was there a whiff of anti-Semitism here—Otto Gutfreund being Jewish? Possibly not, but the poet's repudiation of his compatriot's art strikes a familiar chord. The Wandering Jew was once upon a time—any time, in fact, before World War II—as eternal a fixture of Czech rural life as little roadside shrines to the Holy Virgin, the Christmas Eve carp, and the celebration of Easter Monday with *pomlázky* ("a bad day for the female sex," complained Božena Němcová in *Granny*).[137] It is not only Havlíček's "separate, Semitic nation which lives only incidentally in our midst, and sometimes understands or knows our language" that is echoed in Březina's choice of words, but the sweet, innocent othering of Mikoláš Aleš's much-loved *Chapbook of Folk Songs and Rhymes*. The Jews were always there and always apart, a perpetual reminder of the beleaguered boundaries of Czechness:

> Our Jew Liebermann
> Wandered seven years
> Arrived in Krakow
> Bought potatoes

runs one of Aleš's nursery rhymes, which he illustrated with as hunchbacked and hook-nosed a caricature as one could ask for.[138] There was probably no conscious anti-Semitism here either. Those boundaries came with the mother's milk.

Březina was no knee-jerk reactionary; as we shall see later, his views on homosexuality, which were more than broad-minded for his day, put André Breton and Paul Éluard's pretentions to sexual freethinking to shame. But he responded to Gutfreund's *Babička* memorial, as Štorch-Marien's bookseller did to Špála's illustrations, as an act of violation. Rape is a violent metaphor. It is also, in this context, a revealing one. We should not let the fact that Božena Němcová is one of just two women (the other being the nineteenth-century writer and patriot Eliška Krásnohorská) to grace the Pantheon of the National Museum mislead us as to the place of the feminine in the Czech imaginary. To be sure, it was a very old-fashioned notion of the feminine—at least to postmodern eyes—but that did not make it any the less resonant. The way Czechs symbolized their nation was bound up with how they understood their history: which is to say as a history (to recall Milan Kundera) of "a nation whose existence has perpetually been threatened or called into question—a nation whose very existence *is* a question." This is not the land of the majestic Britannia seated on her throne magnanimously receiving the

homage of the four corners of the earth, or even of the delightful Marianne, the fetching incarnation of *la belle France* whom Delacroix painted bare-breasted, a Phrygian cap on her head, leading the people to the barricades. It is a little land located at the cockpit of Europe, precariously inhabited by the *malý český človek* (little Czech guy) who is at home in a language fond of diminutives; a land where the best that can often be said is that it is *malé, ale naše.* A land railroaded by history and bypassed by historians, where small is a situation and a destiny, the warp and woof of national being.

There was a fertile vein of mythical Czech prophetesses and buxom Czech Amazons for nineteenth-century artists, poets, and composers to mine in search of feminine incarnations of the national revival, and they did so with enthusiasm. Mikoláš Aleš delighted in drawing scenes from the legendary Girls' War that allowed him to bring together two of his best-loved subjects, cute chicks and snorting stallions. Leoš Janáček devoted his first opera to the fatally seductive *Šárka* (1887–88, first performed only in 1925), as did Zdeněk Fibich a decade later (1896–97). Karel Vítězslav Mašek concentrated all the mysticism of the Secession into his haunting *Libuše* (1893), who now adorns the Musée d'Orsay in Paris, "a hieratic, spectral moonlit figure, dominating a nocturnal landscape where a river winds across the plain."[139] Such images may say something about Czech male fantasies of the time. But the anonymous nursing mother Ladislav Šaloun chose to represent the national rebirth in his Jan Hus memorial on the Old Town Square probably says more. She speaks more softly than the proud Soldiers of God on the other side of the monument, the Hussite warriors whose against-all version of Czechness was ignominiously defeated two centuries later at the White Mountain leaving Šaloun's abject exiles to shiver in the shadow of the scaffold of 1621. And Božena Němcová's kindly grandmother speaks softest and longest of all. It is anything but coincidence that when Sixty-Eight Publishers, the Toronto-based émigré publishing house run by Josef Škvorecký and his wife Zdena Salivárová during the years of normalization, published its hundredth book, it was not a smuggled *samizdat* manuscript by Ludvík Vaculík, Ivan Klíma, or Václav Havel, but a celebratory reprint of *Granny.*[140] The old lady is a perpetual comfort in times of trouble. It is her fragile indomitability, shining through the Darkness, that truly embodies the spirit of the nation because had it not been for countless women like her a *Czech* nation might never have made it into the modern world at all. Or so it is believed.

It is fitting, then, that the first great work of modern Czech fiction should have been written by a woman, has an ordinary woman for its heroine, and is

neither a grand epic nor a great romance but a set of unpretentious "pictures from country life." Were we to stretch Štorch-Marien's bookseller's sexual analogies further we might say that in the two centuries after the disaster at the White Mountain the Czech nation was emasculated. Some unexpected parallels might be drawn with the psychological terrain of colonial castration explored in Franz Fanon's *Black Skin, White Masks*, even if the Czechs' story was a drama played out within what is too often conceived as a monolithic imperial Europe where both the skins and the masks were white as the driven snow.[141] Before the 1860s there were few walks of life in Bohemia in which a man could aspire to wealth, power, or privilege *as a Czech*. Linguistically and otherwise Czechness had been drained away from the spheres in which male ambition makes its mark—governance, the military, industry and commerce, the upper reaches of the Church, universities, science, literature, and the arts—retreating to the humble realm of the everyday: the realm where women rule. What pulled the nation through its "three centuries of suffering" was not masculine heroism but feminine fortitude:

> For all their great achievements of energy and intellect, men always remain children, seeking in their wives a mother, a friend, someone to bear up all the scaffolding of life. Weak people usually have the tremendous strength of endurance. If woman is weaker than man, then her ability to endure—certainly overdeveloped by the fact of nine-month-long pregnancy and painful labor—is something that far exceeds the strength of man. The heroism and bravery of weakness, the courage and perseverance of natural passivity—a passivity again dictated by a woman's physical and sexual structure—isn't that a mast that can withstand all, a strength that never disappoints, a proffered hand that always rescues?[142]

I quote Milena Jesenská's "A Few Old-Fashioned Comments about Women's Emancipation," an only partly jocular feuilleton published in *Národní listy* (The National Paper) in February 1923. Milena was not, as it happens, talking about her nation, but she might just as well have been. Milan Kundera taps into an old trope when he has Tereza, the heroine of *Nesnesitelná lehkost bytí* (*The Unbearable Lightness of Being*, 1984), return to Prague from Zurich with her dog, Karenin, a few months after fleeing the 1968 Soviet invasion because she knows in her heart that she belongs in "the land of the weak." "The very weakness that at the time had seemed unbearable and re-

pulsive"—the weakness embodied in the long pauses in Alexander Dubček's quavering voice on Czechoslovak Radio announcing the end of the Prague Spring—"suddenly attracted her." Tereza's serially unfaithful partner Tomáš, who cannot get enough of women, abjectly follows her home five days later—not out of love but powerlessness.[143] Both bring to mind Ivan Klíma's masochistically mixed feelings as he set out for his interrogation on Bartholomew Street following his own post-invasion return to Prague, irrationally comforted by a memory of the opening line of Jan Neruda's *Police Tableaux*.

Granny ends with the phrase "Šťastná to žena!" which translates as "A happy (or fortunate) woman!" Along with the opening couplet of Karel Hynek Mácha's "May," these are among the best-known words in all Czech literature. They could hardly be applied to Božena Němcová herself, whose life (illegitimate birth, marriage at seventeen to an older man, a string of unhappy love affairs) scarcely exemplified the homely virtues of her novel, though it might explain her evident sympathy for the unfortunate Viktorka. Nor could we describe Milena Jesenská as conspicuously *šťastná* in either sense of the word. A very Czech connection is nonetheless there in both cases, because we are in a realm of Czech desires and Czech dreams. By the lights of her time Jesenská was a remarkably independent woman—as was Němcová. But according to her fellow concentration-camp inmate Margarete Buber-Neumann, Milena complained bitterly to her friend Fredy Meyer one night in a Prague wine-bar of the men she had known, Ernst Pollak, Franz Kafka, Jaromír Krejcar, intellectuals and artists all. "They talked too much, they were too neurotic, they were too impractical," she snorted. "So many were afraid of life, and it was up to me to bolster them up. It should have been the other way around. I often dreamed of having a lot of children, of milking cows and minding geese, and having a husband who'd thrash me now and then. I'm really a Czech peasant woman at heart."[144] Buber-Neumann, who spoke no Czech and never visited Prague, is not the most reliable of sources, but in this case the sentiment rings true. Such longings for a real man may not be what we want to hear from the mouth of a modern, educated, urban woman, but it is not *our* expectations that are at issue. This is a twentieth-century Czech woman, who sometimes gets weary of mothering her boys.

In time-honored female fashion Milena picks herself up, dusts herself off, and readies herself for the tasks of the day. As we saw earlier, she had little time for the strident nationalism of her father—nor of her Aunt Růžena, a prominent patriotic writer—and moved in determinedly internationalist artistic and political circles throughout the interwar period. She refused to let

the events of 1938–39 compromise her principles: in her article "Am I First and Foremost a Czech?" published in the summer of 1939 in *Přítomnost* she responded to a compliment on her patriotism with the tart comment "I am *self-evidently* a Czech, but I try *first and foremost* to be a decent human being." By then, following Ferdinand Peroutka's arrest that March, she had become the effective editor of the paper. But as Milena saw it hostility to nationalist bigotry did not exclude a right to national self-defense. In "The Czech Mommy" (*Česká maminka*), published a few weeks before her own arrest by the Gestapo, she again entrusts the nation to the feminine hands that had nurtured it through the ages. "Trifles," she writes, "become big symbols. And since it is woman who wields in her hand the trifles she reigns also over the big symbols. Czech song and the Czech book. Czech hospitality. The Czech language and old Czech customs. Czech Easter eggs, little Czech gardens and clumps of Czech roses." Not exactly such stuff as the dreams of great nations are made on; this is the small stuff, the girly stuff, the stuff that is taken for granted until it is taken away. Milena introduces her readers to her grandmother, who (she says) "looked like Božena Němcová's Granny, just as did all your grandmothers." This *babička* obstinately refused to adjust her clocks to imperial summer time, "an Austrian invention," throughout World War I—a small, private, domestic act of keeping faith that would barely register on any historian's scale as resistance, yet mattered enormously all the same.[145] The problem was that Němcová's Granny as portrayed by Špála or Gutfreund did not look like their grandmothers as people wanted to remember them—and perhaps needed to remember them if they were to have a chance of remaining their imagined selves.

Špála's line, like Aleš's and Mucha's before him, has a way with the female form—his favorite subject, along with landscapes and flowers—even if the bodies of his bathers and peasant girls frequently reduce to inviting intersections of triangles and arcs. Is it just coincidence that his preferred palette, and not just in *Country Woman in a Flag Dress* (*Venkovanka s vlajícími šaty*, 1919), is one of national reds, whites, and blues?[146] Jaroslav Seifert, who thought the two most beautiful things in the world were a naked flower and a naked woman, found great comfort in Špála's work in his old age. As a young man the future Nobel Prize winner used to watch the Čapek brothers take their constitutional along the Masaryk Embankment (as it then was), come rain, shine, or snow, from the window of the Café Slavia on the corner opposite the National Theater. "They sported the same hard hats, the same gaudy colored scarves around their necks, golden gloves and a bamboo cane," he relates. "It was showy, but that was exactly what they wanted." Sometimes Špála

would be with them, "a smaller, nimble man with wire-framed glasses and animated gestures." Karel Teige, who was already writing reviews for *Čas* (Time) and *Tribuna* (Tribune) and attending gallery openings, was the only member of Devětsil personally acquainted with the Obstinates; "the rest of us," says Seifert, "were too young and still little known." Later on they all became friends, "even if from the start we noisily enough asserted our right to the critical posture of the new, rising generation toward the older generation. Political events and the danger of fascism brought us all closer and in the years before the Second World War we all gladly put our names to joint proclamations and appeals."

The poet does not remember exactly why it was that the young guns of Devětsil "every so often abandoned the welcoming and hospitable National Café" for "the smoke and odor of the old actors' Slavia.... We used to sit there by the window facing the embankment and drink absinthe. It was a little flirtation with Paris. Nothing more." The Slavia is another legendary Prague café that has lately been restored—largely, one suspects, to serve a clientele of literary tourists and Czechs nostalgic for pasts they never knew. The view across the river to the Little Quarter and Hradčany is as poetic as ever. Viktor Oliva's *The Absinthe Drinker* (*Piják absintu*) hangs on the wall, a souvenir of its author's own sojourn in *la ville-lumière* between 1888 and 1897. He returned home to become artistic editor of the popular and highly patriotic illustrated magazine *Zlatá Praha* (Golden Prague), another Jan Otto publication.[147] A worried-looking middle-aged man sits in a coffee-house, his eyes drawn from his unopened newspaper to the naked young woman who has perched herself on his table; a waiter hovers in the background, discreetly observing the density of this unexpected encounter. Oliva's is a sexier—and, surrealists might argue, a far more realistic—treatment of the seductions of the demon drink than Manet's better-known renditions of the same theme, even if (or should we say especially if?) the shapely temptress comes in a necrophilic shade of translucent green. Manet paints his addicts staring vacantly into space as an outside observer might view them, whereas Oliva looks out from the dreamworlds they inhabit. Le Corbusier would likely not have found the expansive Slavia, with its huge picture windows displaying its customers to the gaze of the street, any more to his tastes than the overblown Café Imperial. In later years the old coffee house became a hangout of Václav Havel and his dissident friends. It was always a theatrical sort of place. What was the point of trying to hide in this town where each envies each and everyone watches everyone? The police headquarters on Bartholomew Street is a cozy five minutes' walk away.[148]

"Evil times arrived," Seifert goes on. The Obstinates went the way of all flesh. The "elegant and tall" Rudolf Kremlička died young in 1932. Kremlička was another aficionado of the female form: like Degas and Bonnard he painted countless women at their toilette. He had a particular affection for the flowing movements of washerwomen. Having "perhaps given up the struggle for life" Karel Čapek, too, slipped away "shortly before the Occupation." Seifert agrees with those contemporaries who thought the author of *R.U.R.* would have done far more for the Czechoslovak cause if he had gone into an English exile after Munich, but the well-traveled and eminently cosmopolitan Karel would have none of it. "Then the Gestapo took away his brother [Josef]. A year after the liberation, in the month of May, among the flowers he so loved to paint, Václav Špála departed." After the war was over Seifert bumped into Jan Zrzavý, one of the group's two remaining survivors, at Špála's posthumous exhibition:

> We went from picture to picture, and Zrzavý didn't attempt to hide his excitement.
> "You know, pal," he suddenly turned to me, "Špála is really the best of us all. And so Czech!"
> I am already an old man and I don't like winter. I don't like snow any more either. When there's a snowstorm, when outside the window it darkens with that familiar white darkness, in this snow I like to visualize the clear colors of Špála's flowers. That's beauty! And I feel better immediately. And I look forward to spring.[149]

That familiar white darkness (*ta známá bílá tma*): it is an image as convulsively beautiful as anything to be found in Lautréamont. Or Breton.

It would seem, then, that there are as many ways of being Czech as there are of being modern. Or was it simply that with the passage of time the shock of the new wore off, making it easier to discern the commonalities of style as well as of subject matter that link the Obstinates back to Alfons Mucha, Mikoláš Aleš, and Josef Mánes and foreshadow such "national artists" (as they would be fêted during the communist era) as Josef Lada, illustrator of *The Good Soldier Švejk*, and Karel Svolinský?[150] In the end Otto Gutfreund's sculpture, too, blended seamlessly enough into the green pastures of Granny's Valley. Once the furor died down the monument became an object of popular affection. In all likelihood it was its very primitivism that allowed it to take its place among all that is *malé, ale naše*, for it catches the homely resonances of *Granny* in a way that a more artistically refined sculpture could

never have done. This was not Gutfreund's only essay in patriotic memorialization. He provided the "Return of the Legions" frieze on the façade of Josef Gočár's Bank of the Legions (1921) on Na poříčí, perhaps the most successful building in the national style, and collaborated with Pavel Janák and František Kysela in 1926 on the winning design for a Smetana monument on the Masaryk Embankment. He died the following year and the monument was never built. It had been intended to replace a wedding-cake memorial to Emperor Francis I, after whom the embankment had originally been named. Francis's equestrian statue was removed in 1918, but the remainder of the sculptural group was left intact, leaving the departed Habsburg's once-upon-a-time subjects to pay eternal homage to a De Chiricoesque vacancy on an empty plinth. Francis quietly made his way back from the Lapidarium of the National Museum to his place on the Smetana Embankment, as it is presently named, in 2003.

Were it not for the baggage with which the communists burdened the term, I would be tempted to suggest that the enduring Czechness (*českost*) of all these artists lies in the *lidovost* of their line, a word that Czech-English dictionaries usually render as "folk" or "popular," though there is no exact English equivalent because words take their meanings from the worlds in which they are embedded and this is not *our* world. A *lidový člověk* is a regular guy. Identification of the national (*národní*) with the popular (*lidový*) long predated the foundation of the KSČ. Tomáš Masaryk was certainly no Marxist,[151] but he too praised the *lidovost* of Božena Němcová and Jan Neruda in *Česká otázka* (The Czech Question, 1894), commending "younger writers and poets . . . [who] are seeking a more concrete Czech human being, and they are naturally discovering him in the Czech countryside and in those classes of the people who were least touched by cultural development . . . In the popular [*lidovost*], Czechness [*českost*] and Slavness [*slovanskost*] are definite, concrete, living."[152] Popular culture was the only possible foundation for the reborn national culture of the nineteenth-century because high culture came in German; hence the importance for the revival of lexicographers, ethnographers, and folklorists. And this popular culture was necessarily in large part a rural culture because Czech speakers were then mostly country folk. In the early twentieth-century a majority of the Czech-speaking inhabitants of Prague, Brno, Plzeň, or Ostrava were still first- or second-generation incomers. To this day the Czechs are a nation of gardeners; allowing families to build cottages in the country where they could cultivate and can their own fruits and vegetables was an important KSČ safety valve in the normaliza-

FIGURE 4.8. Josef Čapek, *Žena s brambory* (Woman Peeling Potatoes), 1931. Severočeská galerie výtvarného umění v Litoměřicích. Photograph © North Bohemian Gallery of Fine Art, Litoměřice, Jan Brodský.

tion period, creating a space in which people knew they would be left alone so long as they kept their noses clean. Some of them may have found Karel Čapek's *Zahradníkův rok* (*The Gardener's Year*, 1929) a trusty companion. We may picture Čapek as Hugo Boettinger once caricatured him, hair brilliantined back, cigarette holder between his lips, every inch the urbane intellectual, but Karel liked to get some dirt under those elegantly manicured nails. "Yes, improve the soil," he urges. "A cartload of manure is most beautiful when it is brought on a frosty day, so that it steams like a sacrificial altar. When its fragrance reaches heaven, He who understands all things sniffs and says: 'Um, that's some good shit.'"[153]

By the end of the 1920s the older Čapek's predominantly urban repertoire was making way for increasingly rural subjects like *The Village* (*Vesnice*, 1929), *A Country Chapel* (*Kaplička v krajině*, 1930), and *Woman Peeling Potatoes* (*Žena s brambory*, 1931). Josef's formal vocabulary if anything becomes even simpler, but it is the geometry of fields and houses, the curves of peasant women's skirts and headscarves, which now form the architectural elements of his canvases. Could this return of traditional motifs, which were never entirely absent from Čapek's work, have been a response—conscious or otherwise—to the old-new German threat to Czechoslovakia's integrity? Josef was an active antifascist in the 1930s. His two great cycles *Oheň* (Fire) and *Touha* (Longing), painted in the aftermath of Munich, are among the glories of Czech modern art. In *Fire* "a threatening, bellicose woman" towers over a landscape of fleeing people and burning buildings, while *Longing* depicts "a woman who, he [Josef] said, is looking with longing on the severed countryside of the borderlands."[154] In some of the *Longing* paintings the woman's body language uncannily—for those used to living with eternal returns—recalls Alfons Mucha's grieving Mařenka (as I have gotten into the habit of thinking of her) in the Mayoral Chamber in the Municipal House. Václav Špála, too, went on to paint many a Czech landscape, as well as designing gaily painted wooden cockerels, hens, owls, and devils in the best folk tradition for Artěl, a precursor of The Beautiful Room, with which Pavel Janák, Vlastislav Hofman, and Ladislav Sutnar were all involved.[155] Jan Zrzavý made visual poetry out of Ostrava's slagheaps.[156] Neumann was right. This is an art that is indisputably modern, a bona fide branch of contemporary European art, but for all that it remains indelibly Czech. We should not be too surprised. Could Cézanne, Van Gogh, or Matisse have revolutionized twentieth-century painting without the local color, the elemental forms, the blinding light, of Provence?

THE ELECTRIC CENTURY

During his 1910–11 sojourn in Paris, where he intended to learn more about avant-garde (at that time, primarily Fauvist) painting, Josef Čapek found himself unexpectedly diverted by the collections of the Musée d'Ethnographie in the Trocadéro. By 1914 he had largely completed *Umění přírodních národů* (The Art of Primitive Peoples), one of the earliest attempts in any language to come to grips with the African, Native American, and Oceanic artifacts that so inspired modern European artists from Gauguin to Picasso. Regrettably the book did not appear in print until 1938.[157] There is much in common between this study of "savage" art and Čapek's small but influential book *Nejskromnější umění* (The Humblest Art), published by Aventinum in 1920. The images and artifacts Josef examines here were no less "primitive" (*přírodní* in Czech, whose primary meaning is "natural") than those that had grabbed his imagination in the Trocadéro, but they were closer to home. He stakes out his terrain carefully: he is not concerned, he says, with "folk art [*lidové umění*], as it is ordinarily understood: national [*národní*], rustic [*selské*] art," but with "contemporary popular art [*umění lidové soudobé*], the work of artisans and amateurs from the people; an art that is urban, or better—suburban [*předměstské*]."[158] He instances the "Sunday painting" found on shop signboards. "This Sunday," he explains, "isn't a genre, but the real world of ordinary people [*malých lidí*], like Henri Rousseau the customs-officer painted in his naïve, hugely lovable pictures."[159] The book goes on to discuss the "pictures of blood, ecstasy and death" that enliven popular adventure stories, portrait-studio "photographs of our fathers," documentary photos in magazines, Hollywood movies, wooden toys, artisans' posters, displays in shop windows, and much else.

What Josef most admires in such art is its simplicity and honesty, its lack of pretention, cultivation, and refinement. Sunday painting, he explains, cannot aspire to be "realistic" because considerable technical skill is required to produce optically convincing copies of nature. These artifacts come from a world of "It is what it is" (*Jest, co jest*, one of the chapter titles), where humans are immersed in the materiality of objects rather than the trickery of simulacra. Josef's concern is with "the grace of things and of people's relation to them."[160] For him there is no hard and fast boundary beyond which "art" begins: "it certainly finishes in truth and beauty, but it begins in truth and beauty too; better, then, to stay rooted in the timeless realm of the everyday than to be carried away by an adulterated art. The most primitive earthen-

ware dishes are far closer to the most beautiful antique vase than are the ceremonial vases that stand on the dresser of an owner of four apartment blocks."[161] These sentiments bring to mind Jean-Jacques as well as Henri Rousseau. They also echo both Vladimír Karfík's enthusiasm for the "youthful honesty" of Zlín's architecture and Josef Sudek's reverence for "the prodigious atmosphere of things." Notwithstanding its mundane and sometimes downright kitsch subject matter, *The Humblest Art* is at bottom a treatise on modernist aesthetics.

Not that Josef was blind to the darker side of the everyday. Some of the homely objects upon which he lights turn out to be as *unheimlich* as the mysterious iron mask Breton and Giacometti chanced upon in the flea market in *Mad Love*. "I think I am getting to the weirdest chapter of this book," he warns us. "Its subject will maybe scare the reader a little and perhaps prey on his mind. I'm disturbed, too."

> I have a thing, which I am going to speak about here, which is in front of my eyes daily, yet which I can never look upon without feeling uneasy; it is too eerie and I would almost say hideous, and this is by no means only because the person it portrays is no longer living. A lot of people have already been frightened by this cold, cadaverous face staring out at them, horribly devoid of vision. It is too palpable and truthful to seem merely an oppressive specter; so truthful, that people take it for a photograph, a much retouched photograph.
>
> It is not a photograph, but a real picture: a chalk drawing on tinted paper. Its origin is very prosaic: the picture depicts my grandmother in her coffin and it was drawn in the year 1877 by a country house painter who for many years lived in our house. She died, and they summoned him to draw her as a memento; otherwise he didn't go in for such work; he painted rooms. His name was Rafael Jörka.[162]

This country Rafael's likeness of Čapek's Granny is indeed haunting, but it is hard to pinpoint exactly why. It is clearly not a photograph, nor is it well drawn. Yet there is something compelling about the closed eyes. The picture doesn't look like anybody's grandmother as they would like to remember her, but it sure makes you feel the presence of the dead.

This is a terrain the surrealists would later make inimitably their own. But in Prague at the beginning of the Roaring Twenties the everyday became the

object of a gaze very different from either Josef Čapek's or André Breton's. "The age has divided in two," trumpeted Devětsil's public announcement of the group's formation, which appeared in *Pražské pondělí* (Prague Monday) on 6 December 1920. "Behind us remains the old time, which is condemned to molder in libraries, and in front of us sparkles a new day."[163] The quotidian was the playpen in which "the youngest generation" (*nejmladší generace*, as the Devětsil artists liked to describe themselves) romped. They found poetry in "film, in the circus, sport, tourism and in life itself . . . the poetry of Sunday afternoons, outings, glittering cafes, intoxicating alcohols, bustling boulevards, and spa promenades," to quote Karel Teige's 1924 manifesto "Poetismus" (Poetism), which proclaimed the birth of a new Czech -ism to end all -isms.[164] Teige had applauded Čapek's *The Humblest Art* three years earlier for drawing attention to a "neglected" art "as crude as the vulgar ditties and anecdotes people relate to one another on the street," something he found much preferable to "our excellent national costumes, which, we tell ourselves, the whole world should envy" and the rest of "that rustic art" [*to ono selské umění*].[165] But the Devětsil artists soon distanced themselves from their elders. Far from regarding the everyday as a sanctum of timeless aesthetic verities they turned the artless quotidian—and above all, the *modern, urban* quotidian—into a base from which to launch an all-out assault on art, period. Or at least that was the rhetoric, for none of them ceased to be artists any more than did the Berlin and Paris Dadaists or the Russian constructivists who were making similar revolutionary noises around the same time.

"THE NEW ART WILL NO LONGER BE ART!!!" thundered Teige in "Umění dnes a zítra" (Art Today and Tomorrow), which was published together with his "Nové umění proletářské" (The New Proletarian Art) in the *Revoluční sborník Devětsil* (Devětsil Revolutionary Miscellany) in the fall of 1922. While art (including "impressionism, fauvism, expressionism, cubism, futurism, and the fashionable neo-classicism") "took up residence in its reservations, the libraries, the galleries, the posh theaters," he sneers, and "in the petit-bourgeois or country dwelling you find tacky color prints or commonplace kitsch, repugnant and sentimental, Alois Jirásek, K. V. Rais, Svatopluk Čech, RUR," workers and students decorate their rooms with "reproductions from the magazines, photographs from the cinema or sporting events tucked behind the mirror, [and] magical even if sometimes 'tasteless' postcards from all over the world." Art is but one of "the faces of modern beauty, this many-headed hydra of modernity and revolution," and "beauty also exists outside of art." He hails the "NEW BEAUTY" of detective novels and adventure stories (Sherlock Holmes, Jack London, Jules Verne), American

engineering ("airplanes, automobiles, modern factories, telephones, locomotives are beautiful plastic facts"), cinema ("a poem in the midst of the world," "the only popular art of today"), popular music ("The jazz band! The accordion! The barbaric barrel organ! The Salvation Army chapel, where the drum that accompanies the singing betrays healthy exotic influences!"), dance halls ("South American dance, Negro cakewalks"), billboards ("visible from everywhere, challenging, sharp, and provocative, unadulterated big-city"), and documentary photography. "We don't need an art from life or for life," he proclaims, "but an art that is a part of life."[166]

This article must be one of the earliest examples of that recurrent twentieth-century fantasy "Students and Workers Unite and Fight!" which found its disillusioning apotheosis in *les evénements* in Paris in May 1968, when for a brief moment it seemed possible to leap the chasm that separates dreaming from waking and sunbathe on the *plage* beneath the *pavé*.[167] I say disillusioning, because as so often the workers declined to play the part assigned to them in the students' dreams. Events in Prague that same year would drive another nail in the coffin of "socialism with a human face." But the future looked more assured to the young radicals of Devětsil at the bright new dawn of the 1920s. For Teige "the healthy heart of the population and the social class to which tomorrow's world belongs" was "*the proletariat* and the progressive intelligentsia."[168] This identification of head and hand by wishful thinking marked a decided shift from Tomáš Masaryk's position in *The Czech Question*, where it was country folk who were the salt of the earth, but the underlying conflation of the progressive with the popular remained the same. Salvation still lay in "those classes of the people who were least touched by cultural development"; it was merely that the intellectuals' chosen vessels of progress had changed. "Today," Devětsil's *Pražské pondělí* statement went on, "young artists and writers, painters, architects and actors, have come together like a family to step up in the front line with those who wear blue coveralls and are going to fight for a new life, because the bourgeoisie will not … These [artists] are young, they are revolutionary, and that is why they cannot do otherwise than go with those who are also revolutionary—which is to say, the working class."[169]

The *Devětsil Revolutionary Miscellany* provided a résumé in Russian—not then a language much spoken in Bohemia except by exiles fleeing the Bolsheviks—that spelled out this political commitment. It is no doubt coincidental that the text anticipated the nomenclature of *The International Style* by a decade, albeit with a political twist Hitchcock and Johnson were careful to ex-

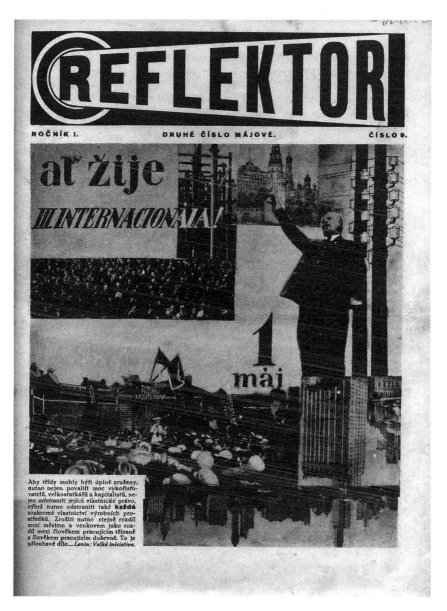

FIGURE 4.9. Karel Teige, photomontage cover with May Day motifs for *Reflektor*, Vol. 1, No. 9, 1925. Archive of Jindřich Toman. Courtesy of Olga Hilmerová, © Karel Teige - heirs c/o DILIA.

cise from their own survey of European architectural modernities.[170] This is another of those coincidences that should alert us to what gets effaced by *our* ordering of the planes and surfaces of the modern world, much as Antonín Matějček's disconcerting use of the term *expressionist* in relation to Cézanne, Matisse, and Braque did earlier. Devětsil had a spatiotemporal cartography, a map of modernity, of its own:

> The great French Revolution announced the dawning of the epoch, at whose grave we stand today. The World War [I] was a cruel, depressing agony of this epoch. On the threshold of this new epoch is the Russian Revolution, which out of the great Eastern empire created the homeland of the proletariat and the cradle of the new world. . . . The Russian Revolution and today's revolutionary ferment in all parts of the world announce the beginning of the great and glorious future. They open the way to a clear goal: for a socialist society, and when this goal is attained there will arise *a new style, a style of all liberated humanity, an international style*, which will liquidate provincial national culture and art.[171]

This is a map with whose contours and landmarks we would do well to make ourselves familiar, for it was with *this* chart that "the youngest generation," who were raised in the shadow of that World War and enthused by the promise of that Revolution, navigated their troubled times. They did not locate themselves in terms of Alfred Barr's flowchart on the cover of *Cubism and Abstract Art*, and still less Sara Fanelli's *Artist Timeline* that currently wends its educative way around levels 3 and 5 of London's Tate Modern, providing the museum's visitors, we are told, with "a useful road map to the major movements and important artists of the last 100 years."[172] The Devětsil artists did not see themselves as *making art*, as we have nowadays gotten used to describing what artists do, at all. They saw themselves as making a new world. Vladislav Vančura, Vítězslav Nezval, and Jaroslav Seifert joined the KSČ long before any such thought had crossed André Breton or Paul Éluard's mind—though Karel Teige, interestingly, did not.

What this political commitment entailed for artistic practice proved to be just as contentious an issue within Devětsil as it would later become for the French surrealists. Adolf Hoffmeister, František Muzika, Alois Wachsmann, and several other participants in Devětsil's First Spring Exhibition, held in May 1922 at the Rudolfinum, left that same fall, and the poet Jiří Wolker quit

the group the following January.[173] Their unhappiness was provoked by what they saw as a move away from Devětsil's initial proletkult program. The group's early orientation is well exemplified in Seifert's first book of verse *City in Tears*, which was published by Rudolf Rejman's Communist Bookstore and Publishing House in December 1921. I quoted the famous concluding lines of the Foreword, which was signed in the name of Devětsil as a whole but actually written by Vladislav Vančura, earlier: "New, new, new is the star of communism. Its communal work is building a new style, and outside it there is no modernity!" Vančura invokes the specter of "New York, bellowing with its greatness, the business enterprise before you . . . monstrous and hostile," with the recommendation "Well then, let it not be!"[174] Karel Teige's cover, a suffocating black-and-white linocut in Josef Čapek's urban jungle mold, sends out the same message. He lightened up considerably in the second (1923) and third (1929) editions of the book, first of all softening the city in a pastel composition of red on pink, then finally abandoning figurative references altogether in a spacious abstract design in black, white, and yellow.[175]

In these early poems Seifert presents the metropolis as an "angular image of suffering," "where neither the nightingale sings nor the fir woods smell/ where not only man is enslaved/but the flower, the bird, the horse, and the humble dog as well."[176] As mawkish as anything in Němcová's *Granny*, "A Sidewalk Prayer" dramatizes the modern conflict of man and machine in the image of a little dog with a pink ribbon being cut in three by a rampaging Prague tram, spoiling the poet's sunny Sunday:

> Distracted
> I found myself at the corner of the Fruit Market and Celetná Street
> and kneeling on the sidewalk,
> I lifted my eyes toward the black Madonna,
> who stands here
> holding her hand over my head,
> and I prayed:
> Virgin Mary,
> when the time comes for me to die too,
> don't let me die like that dog,
> let me die one beautiful day on the barricade of the revolution
> a rifle in my hand.[177]

Upstairs the Grand Café Orient will still have been serving Turkish coffees,[178] though it would not be doing so for much longer.

Had Teige and Seifert not spent the summer of 1922 sampling the delights of Paris, where they made the acquaintance of Le Corbusier, Ozenfant, Fernand Léger, and Man Ray among others, Devětsil might have remained no more than a footnote in the annals of international proletkult. Vítězslav Nezval joined the group the same year, and it was through his auspices that Štyrský and Toyen, who met each other while on holiday in Yugoslavia that summer, joined the following spring. A new direction was apparent in the two Devětsil anthologies that came out within three months of each other at the end of 1922, the *Revolutionary Miscellany* and *Life* (*Život II*). Edited by Teige and Seifert, the *Miscellany* contained poetry by Nezval,[179] Seifert, Wolker, A. M. Píša, Jindřich Hořejší, Artuš Černík, and Karel Schulz; fiction by Schulz ("Hughes's Institute for Suicide") and Vladislav Vančura; and essays by Jaroslav Čecháček on intellectuals and war, Jindřich Honzl on proletarian theater, Jaroslav Svrček on "Tendentious Graphic Artists," Jaroslav Jíra on "Young Art in France," and Vladimír Štulc on "Exoticism." Jíra confidently tells us that in Paris "cubism and orphism . . . are today . . . far outside the efforts and interest of the young,"[180] while Štulc ends on the observation that with Picasso "the culmination and completion of French classicism leaves Europe face to face with the savage and barbarian."[181] Artuš Černík contributed two articles to the collection, a survey of contemporary Russian art and a paean to "The Joys of the Electric Century." Among the latter were cinema, circus, variety-theater, cabaret, bars, modern dance, travel, fairs, carousels, excursions, football, rowing, and messing about in dirigibles.[182] The *Miscellany* also carried translations of poems by Jean Cocteau and Ivan Goll as well as an extract from Ilya Ehrenburg's *And Yet It Moves*. Teige's "The New Proletarian Art" and "Art Today and Tomorrow" bookended the volume.

While the *Miscellany* is less richly illustrated than *Life*, its visual content is not without interest—beginning with the solid black circle in the center of the front cover, a motif that would be repeated in the magazine *Disk* (1923–25) and other Devětsil publications.[183] A Slovak country *vanitas*, children's drawings, and a reproduction of a "flower of popularized impressionism"[184] by the Montmartre Sunday painter Emile Boyer jostle for attention with Fernand Léger's caricatures from Ivan Goll's *Chapliniade* and stills from films by Charlie Chaplin and Douglas Fairbanks. Jíra and Černík illustrate their surveys of French and Russian art with appropriate reproductions, while Černík ends his rhapsody to the electric century with a circus scene by Seurat. Seifert's poem "Paris" is framed by photographs of La Grande Roue, the 100-meter-high Ferris wheel built for the World Exhibition of 1900, as well as (of course) the Eiffel Tower. But it is the illustrations for Teige's "Art Today and

Tomorrow" that truly catapult us into a new world. A photograph of the superstructure of a New York steamship is captioned: "Beautiful, like a modern picture. Bare construction, cleanness of forms, harmonic composition, supreme discipline and precise mathematical order, fit for purpose, in short, all the virtues of a work of art. It is as harmonious as the most beautiful painting; measured against the utilities of life, it is more important than the most beautiful painting." "Elemental architectonic beauty," proclaims the legend beneath a photo of an American railroad snowplow: "Bald geometric form, unadorned monumentality, practicality and elegance. Something that responds to the spirit of our century and its needs infinitely better than the products of the so-called artistic industry that applies the cluelessness of 'art' to the necessities of life. It is here that plastic soundness is to be found, and no way in the toyshops of ornament and decorativism."[185] We might be forgiven for thinking that what Teige most appreciated about the new century was its conformity to purist aesthetics, rather than the other way around.

Life, which appeared in December 1922 under the somewhat unlikely umbrella of Umělecká beseda, was something else. Though it was advertised as "a counterpart and artistic complement" to the *Miscellany*,[186] few could have anticipated just how emphatically this "ANTHOLOGY OF NEW BEAUTY" (as the volume was subtitled) would break with Devětsil's earlier manifestations. The aim was to present "a collection of new art in a way that was uncompromisingly and truly modern."[187] The title page comes in both Czech and French, and the group's internationalist aspirations are further underlined by a listing of collaborators that includes Archipenko, Foujita, Kisling, Lipschitz, Man Ray, Modigliani, Prampolini, Zadkine, Auguste Perret, and Frank Lloyd Wright—not to mention Charlie Chaplin, Douglas Fairbanks, and the Hollywood sirens Mary Pickford and Pearl White.[188] While Peter Behrens, Le Corbusier and Ozenfant, Ilya Ehrenburg, Elie Fauré, and the French film critics Louis Delluc and Jean Epstein all contributed texts to the volume (Le Corbusier and Ozenfant's "Architecture and Purism," the magazine boasted, "was written especially for *La Vie*"),[189] the involvement of the others appears to have amounted to no more than giving their permission for reproductions. *Life* was the first publication in Europe to carry Man Ray's photograms. Karel Teige—remarkably, considering the date—observed: "photography can never, even here, quit reality, but it can become *surrealist*."[190] Together with more shots of La Grande Roue and the Eiffel Tower, stills from Chaplin's "The Kid," and publicity photos of American movie actresses and French music-hall divas, Man Ray's images illustrated Teige's "FOTO KINO FILM"—one of the earliest attempts to theo-

rize the new media.[191] Teige also provided a lengthy article surveying trends in painting since cubism.[192] Štulc wrote on modern sculpture in France, Jíra on contemporary French art, Honzl on theater, and Černík on "The Two Sides of Futurism," while the poems and prose of Seifert, Nezval, Schulz, and Jiří Voskovec added literary luster to the enterprise. The cast of Nezval's "Depeše na kolečkách" (Dispatch on Wheels) was suitably jazz-age: they include a radio-telegrapher, a salesgirl, a clown, a Negro, a sailor, "exotics," a loud-hailer, and two phonographs. The poet pointedly subtitled his script, which would be performed at the Liberated Theater in 1926, "A Vaudeville Dedicated to Karel Teige, Prague II, Černá 12a, Europe"—not Prague II, Czechoslovakia.[193]

Where *Life* was most evidently and self-consciously modern was in its visual impact. Its layout and typography make it a classic of avant-garde page design.[194] The tone was set by the cover, a montage by Jaromír Krejcar, Bedřich Feuerstein, Josef Šíma, and Karel Teige that superimposes the modern beauty of a Praga automobile wheel on the ancient beauty of a Doric column against a backdrop of the open sea.[195] Several contributions are photo-essays akin in form, if not in content, to the popular illustrated magazines of the day. Behrens's piece is built around photographs of his celebrated AEG factory in Berlin, interiors of AEG-manufactured trains, and the clean lines of his fans and lamps,[196] while Ehrenburg's message that "THE NEW ART WILL CEASE TO BE ART" is carried as much on the wings of the aircraft that fly through his text as by the words themselves.[197] Juxtaposition and sequencing of images are used to striking effect. We might not be overly startled today to discover affinities between a Laurens sculpture and an "Indian totem,"[198] but the eerie echoes of a pre-Columbian Peruvian cemetery in a state-of-the-art Düsseldorf operating theater still give pause for thought: "two architectonic facts of varied date and geographic location," comments the caption, "and yet the beauty and grandeur of such unvarnished constructive and purposeful architecture is always of the same family and the same type."[199] We might be similarly provoked into rethinking the spatiotemporalities of the modern by the photographs of Tibetan architecture ("quite distinct from all the rest of Asian art and very close in its character to the modern constructive tendency") that immediately follow a spread on "The Architecture of Ocean Liners."[200]

Josef Šíma's eulogy of advertisements exemplifies its own argument by making S. K. Neumann's slogan "AŤ ŽIJE ŽIVOT!" (Long live life!) dance subliminally down the page.[201] The anthology is spangled with quotations

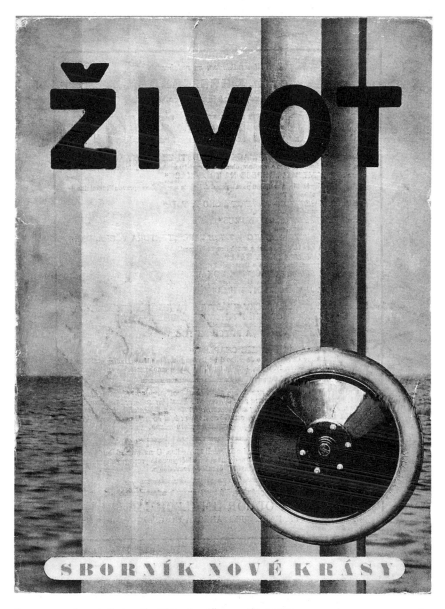

FIGURE 4.10. Jaromír Krejcar, Karel Teige, Josef Šíma, and Bedrich Feuerstein, photomontage cover for *Život* (Life), Vol. II, 1922. The Museum of Decorative Arts, Prague. Courtsey of Olga Hilmerová, © Karel Teige - heirs c/o DILIA.

from Marx,[202] Apollinaire, Flaubert, Whitman, Chaplin, F. X. Šalda, Frank Lloyd Wright and others in a variety of typefaces and font sizes, offsetting the main text. One-liners, marching in bold type across the top or bottom of the page, become banners: "Everything in nature is modeled on the cube, the sphere, the cone and the cylinder" (Cézanne); "Stupidity is National. Intelligence is international" (Vlaminck).[203] The influence of the Russian constructivists' handling of space is apparent, though not everything the Soviet avant-garde did met with Devětsil's approval. The Eiffel Tower is displayed side-by-side with Tatlin's monument to the Third International with the tart observation:

> The Eiffel Tower, an excellent constructive work, was built for the World Exhibition; it is conceived as a lookout-tower and amusement enterprise of its own type, and certainly it faithfully answers to its task. As a whole it is beautiful, if we overlook the bad taste of the time in some of its details. But why does Tatlin construct a memorial to the Third International with the most varied official halls in the form of a tower? It is a blind imitation and craze for "the machine age," which thoughtlessly transplants certain accomplishments into a setting in which they have neither place nor purpose.[204]

In this instance purist aesthetics trumped proletarian politics.

Jaromír Krejcar's article "MADE IN AMERICA," whose exhilarating cocktail of words and images, politics and aesthetics in many ways encapsulates all that made *Life* new and different, attempted a reconciliation of the two. The architect was the editor of the volume, though he profusely thanked Seifert, Honzl, Schulz, Černík, Štulc, Nezval, "and especially K. Teige" for their cooperation.[205] The title of his essay is in international English and all the illustrations hail from the New World. Vladislav Vančura may have wanted to see the "monstrous and hostile" Behemoth of New York disappear from the face of the earth just twelve months previously, but Krejcar celebrates the Big Apple's bellowing greatness as the very pinnacle of the new beauty. He ravishes the eye with photographs of crowded Manhattan streets, the Flatiron Building, the Cortland Building, the Metropolitan Life Insurance Company Building, and the Brooklyn Bridge. The steamship and snow-plow Teige used to illustrate "Art Today and Tomorrow" return alongside an Oliver typewriter and Frank Lloyd Wright buildings in Chicago and Buffalo. There is nary a flower to be seen, though there are still one or two horse-

drawn vehicles picking their way between the trams and the automobiles. "Maybe today American capital can be compared to an Egyptian tyrant," Krejcar ends, "for thousands of modern slaves labor on the building of new pyramids." But today is not forever. A new synthesis is on the horizon:

> America and Russia. Both are working on the social future of humanity. It is pertinent to cite the end of the foreword to Claire Goll's anthology of modern American lyricism:
> **"AMERICA IS THE LAND OF ONE FUTURE, BUT THE LAND OF THE FUTURE IS RUSSIA."**
> Russia needs American civilization so that from a state governed by the proletariat it becomes a state that is really proletarian, whose production is able to supply the entire population abundantly.[206]

It was not an un-Marxist argument. Did not the brave Lenin, after all, define socialism as Soviets plus electrification?

Devětsil's exuberance did not go unnoticed elsewhere in Europe. "That for which it is necessary to struggle in many larger centers, and which still hardly exists, is found in Prague: a creatively active atmosphere," Hans Richter informed the readers of *G: Material zur elementaren Gestaltung* (*G: Journal for Elemental Form-Creation*), a Berlin-based avant-garde architecture, design, and film magazine in which Raoul Hausmann, El Lissitzky, Theo van Doesburg, and Mies van der Rohe were all involved. "Modern convictions can grow in this atmosphere," he went on, "a spirit of collective work, and the kind of activity that arises from a 'faith in life.' The vivacity of a number of young artists is manifested in several journals—most vividly in the anthology *Život* (Life). I know of no illustrated book that is more ahead of its time." Richter describes Karel Teige as "Americo-romance in orientation, sharp, and sensitive," which captures the Devětsil leader exactly—Teige's Marxism notwithstanding. But he ends on a more fanciful note, which (as so often) manages to exoticize and orientalize the city whose extraordinary receptiveness to the modern he has only just acknowledged:

> He [Teige] and his comrades, journals, groups, and energies are ruled absolutely by the beautiful Toyen, a native of Prague who has mastered the Czechoslovak language fluently and who got along entirely using that language, even in Paris. A painter by profession. We have chosen from among all her paintings, which are inferior to those of her

male colleagues neither in power nor delicacy, this per-
sonal work—equally immaculate in content and form—
which she kindly made available to our journal.[207]

Imprinted on a blank sheet of letterhead for LE DISQUE—REVUE IN-
TERNATIONALE (i.e., *Disk*), bearing the legend "Un baiser par T.S.F," the
elegant Manka had sent *G*'s readers a wireless kiss. Needless to say, her lip-
stick was flaming red.

ALL THE BEAUTIES OF THE WORLD

As befitted the spirit of the age *Life* opened with a poem—Jaroslav Seifert's
"Všecky krásy světa" (All the Beauties of the World). It can have left readers
in little doubt as to the group's new direction. "Today's most beautiful pic-
tures," the bard of Žižkov exults, "were painted by nobody / The street is a
flute and it plays its song from morning to night":

> For our poetry we found completely new beauties,
> Moon, island of vain dreams that you extinguish, go out.
> Be silent violins and let the automobile horns carry,
> Let the guy in the intersection suddenly daydream;
> Sing, airplanes, a nightingale's evening song,
> Dance, pink ballerinas, between the letters on the billboards,
> Let the sun go out—the shining floodlights on the towers
> Will beam into the streets a flaming new day . . .
> Well then so long, let us abandon fabricated beauties
> The frigate is heading out to the vast open seas,
> Let your long hair down in sorrow, you Muses,
> Art is dead, the world will get along without it.[208]

"All the beauties of the world" was a favorite Devětsil slogan in the early
1920s. Teige used it to close "Art Today and Tomorrow," centering the words
in bold capitals and framing them in advertising handbill fashion with fin-
gers pointing from either side.[209] By the time Seifert employed the same title
for his memoirs over half a century later it had a bittersweet taste: the poet
was in the surreal but not, in these parts, unusual position of being simulta-
neously a national literary icon and persona non grata. The KSČ Central
Committee put a stop to Odeon's plans to publish the book after Seifert
added his signature to the dissident manifesto Charter 77 (1977), which
called upon the Czechoslovak government to honor its obligations under
the Helsinki Accords on human rights. Parts of the memoir meantime circu-

lated in *samizdat*, while an evening of readings from the manuscript in celebration of the poet's seventy-fifth birthday launched Vlasta Chramostová's Apartment Theater (Bytové divadlo). Twenty-two such clandestine readings followed in flats and basements in Prague, Brno, and Olomouc. In the end Seifert's reminiscences were published by Sixty-Eight Publishers in Toronto in October 1981, over a year before they were finally allowed to see the light of day in a heavily censored edition published by Československý spisovatel (The Czech Writer), an imprint of the Writers' Union of whose presidency Seifert had been stripped in 1969.[210] Whether in the 1920s or the 1980s, the words *všecky krásy světa* would have been as familiar to Czechs as the opening couplet of Mácha's "May" or closing sentence of Němcová's *Granny*. They come from a comic aria sung by the marriage-broker Kecal in *The Bartered Bride*. The Devětsil youngsters were only poking a bit of irreverent fun at the sacred cows of the national culture, but as I have said before, the past is not easy to escape here—even when, and perhaps especially when, you are making new worlds.

Where, then, was the good ship Devětsil headed? The open sea is a recurring motif in the avant-garde art of this landlocked country in the 1920s. It flows through the poetry of Seifert and Nezval; not content with mere transports of the imagination, Konstantín Biebl sailed away to Algeria and Tunisia, Java, Sumatra, and Ceylon, where he found plentiful inspiration for his collection *S lodí, jež dováží čaj a kávu* (With the Ships that Import Tea and Coffee, 1927).[211] It furnishes the terraces of Krejcar's Olympic department store with its receding decks and railings, a motif the architect also used for Vladislav Vančura's villa in Zbraslav. It haunts the "pictorial poems" produced by many members of the group, perhaps Devětsil's most distinctive contribution to modern art. Karel Teige's "Pozdrav z cesty" (Greetings from a Journey, 1924) splices together a ship's flag, a Mediterranean town, a map, a pair of binoculars, and an envelope addressed to "Monsieur J. Seifert, Prague—Žižkov." His "Odjezd ze Kytheru" (Departure from Cythera, 1923–24), which he described as "a moment in a lyric film," montages an ocean liner, a yacht, a crane, the American Line logo, and the words *Au revoir!* and *Bon vent* in constructivist space. Jindřich Štyrský's "Souvenir" (1924), a picture poem that is shaped just like a picture postcard, superimposes palm trees, a moonfish, a sea anemone, sailing ships, and a quintet of bathing beauties on a map of the Gulf of Genoa. A pretty girl poses in a swimsuit, too, in the forefront of Antonín Heythum's "Underground," which collages Edward Johnston's distinctive London **UndergrounD** typography—an icon of modernist graphics—with a street map of the City of London, a medley of Eng-

lish, French, and Dutch train tickets, and a penny stamp commemorating the British Empire Exhibition of 1924.[212] *Life's* six-page photo-spread on the Holland-America liner SS *Volendam*, which immediately followed Karel Schulz's poem "Jazz nad mořem" (Jazz over the Sea), was intended to demonstrate the beauty of form following function, but one cannot help but wonder whether the nautical images do not equally testify to the longings of a little land locked away in the heart of Europe whose only coastlines were those of the mind.[213]

"All the Beauties of the World" was reprinted as the final poem in Seifert's second collection *Samá láska* (*Love Itself*), published in April 1923. *Samá láska* is a clever title, which plays on the range of meanings in the Czech word *sám*; it could equally be translated as *Love Alone*, *Nothing but Love*, or (as Dana Loewy renders it) *Sheer Love*.[214] No less committed to the proletarian cause than *City in Tears*, these "worldly and Soviet verses" (*verše světské a sovětské*), as they were advertised,[215] opened up new imaginative vistas. Otakar Mrkvička's cover alerts us to what is to come: an ocean liner and an airplane traverse the sky over the National Museum on Wenceslas Square, which has been freshly furnished with American skyscrapers, the tallest of them topped by a communist red star. To twenty-first-century eyes this is a cacophony of wildly discordant modernities, which is precisely why it should claim our attention. Decades of Cold War and its lingering aftermath of mutual suspicion have gotten us unused to seeing communist Russia and the United States on the same page, joyfully embracing in an indiscriminate hymn to the electric century. Mrkvička's other illustrations for the book—a cocky sailor, a pair of lovers, a potpourri of Parisian pleasures—speak more of the *světské* than the *sovětské*. So do many of the poems, though Seifert still manages to slip a paean to a First of May demonstration in Wenceslas Square and a set of "Verses in Memory of the Revolution" into his cornucopia of worldly delights.[216] The frontispiece centers a dreaming girl in Jičín, a picturesque town in the Český ráj (Czech Paradise) region of Bohemia that Seifert says he loves "like no other on the world,"[217] but Mrkvička wrenches this Eden out of its customary latitudes, surrounding his modern Mařenka with trains and boats and planes, the Eiffel Tower, and the skyscrapers of New York.[218] In the space of little over a year the angular images of suffering that cast their shadow over *City in Tears* have transmuted into potent metaphors of desire.

In his unsigned afterword to the volume, which was once again credited to Devětsil as a collective, Karel Teige endeavored to square the circle; a dia-

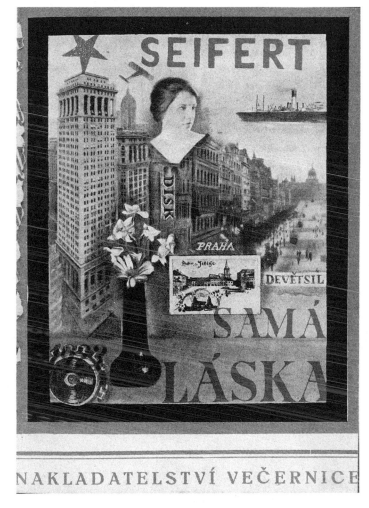

FIGURE 4.11. Otakar Mrkvička, photomontage cover for Jaroslav Seifert, *Samá láska* (Love Itself). Prague: Večernice, 1923. The Museum of Decorative Arts, Prague.

lectical operation at which he was to become adept over the following two decades as he contrived to juggle the antinomies of purism and poetism, constructivism and (eventually) surrealism, miraculously keeping all the balls in the air at the same time. Addressing himself "to all who liked *City in Tears*," he seeks to persuade his readers that "*Love Itself* is so to speak cyclically linked with Seifert's debut, forming its other hemisphere—and technically on the

one hand its development and on the other its opposing pole." He insists that the book's "fabric is woven exclusively in the proletarian world," of whose "new creative spirit and new audacity . . . it sings." Rejecting "made-up illusions about the worker," it "rips away the pitiful, pathetic nimbus of martyrdom which the bourgeoisie and false socialist poets have ascribed to him," showing him in his true light. I wonder:

> It extols the most primitive of his physical dreams, which are: sacred ambrosia and sacred nectar in all their worldly forms. It extols his spiritual joys, which are: devoted love for the lover and the child, enthusiasm toward the collectivity, respect for the revolution, resolution for self-sacrifice. It extols his social pleasures, which are: song, dance, play-acting, the faraway European and exotic homeland, all the beauties of the earth, new beauty. It honors the products of his labor from the hammer to the airplane. It extols his class hatred.

Seifert's work, Teige continues, "has nothing in common with the usual philistine, allegorical social 'tendentious' poetry that is mass-produced today with the petty-bourgeois aims of education, morality, and instruction." So much for proletkult. "His fundamental tendency is dreaminess. . . . Fleeing neither from reality nor into utopia, nor anywhere else, he has the romanticism of this great century in his poetry. In his poems lives Kladno, lives New York—lives Paris, lives Jičín, Prague, the whole world."[219]

So how were this great century, that *whole world*, envisioned? Romanticized? To what lands of nonutopian dreams did Devětsil's frigate set its course? Part of the answer is to be found in a poem in *Love Itself* that is baldly titled "The Negro" (*Černoch*). Romanticism is certainly the right word—though orientalism might do just as well:

> On the shores of the ocean a fresh wind blows
> between empty seashells and shards of coral flotsam
> on their bellies Negro women lie content
> as the waves of the tide slowly rise;
> I think it is sad to be only a European,
> I cannot reconcile myself to this fate,
> Lord, to be able to sit in the shade of palms,
> or like those Negro women lie on the shore.[220]

Toyen's *Ráj černochů* (*Paradise of the Negroes*) puts obscene flesh on Seif-ert's poetic longings. Executed in 1925 the painting, which is as pornographic as anything by Félicien Rops or Jeff Koons, might easily have become as infa-mous as Courbet's *L'Origine du monde* or Manet's *Olympia* were its author better known to Anglo-American art historians. This is not the Czech Para-dise—or maybe, on second thoughts, it is. All the protagonists in the elegant Manka's tableau are naked barring the occasional grass skirt (through which jaunty penises rise), and they are merrily engaged in all manners of sexual pleasuring. At the center of the picture a gentleman wearing nothing but ear-rings, a necklace, and a top hat sits contentedly under a parasol held by a mas-turbating attendant, while being fellated by a kneeling man (who is in turn being sodomized by another) as a reclining nude idly plays with herself at his feet. Josef Čapek's *Černošský král* (*The Negro King*, 1920), which may or may not have been in Toyen's mind when she dreamed up *Paradise of the Negroes*, mobilizes the same incongruities of "primitive" nudity and "civilized" at-tire—in this case a sash, a medal, and another top hat—to hilarious effect.[221] The difficulty today is that it is almost impossible to look at these works and see anything beyond the most offensive of racial slurs. *Paradise of the Negroes*, in particular, draws upon well-worn stereotypes of black sexuality, and its naïve style (this was one of a handful of canvases Toyen painted in 1924–25 in this vein) only serves to reinforce the apparent infantilization of the na-tive. But judging the past by the standards of today is always a dubious exer-cise. What was being mocked in the Czech 1920s was less the "primitive" than the vanities of *western* civilization, of which Čapek's ludicrous top hat is as good a symbol as any.

Had the subjects of Toyen's party under the palm trees been white, we would doubtless nowadays be appreciating the wit and subversion involved in depicting the down and dirty in the simple, childlike manner of Le Doua-nier Rousseau. As it happens, *Paradise of the Negroes* was prefigured in Toy-en's earlier painting *Polštář* (*The Pillow*, 1922), a group-sex brothel scene whose equally enthusiastic participants are all unmistakably Caucasian. In this case cunnilingus prominently features in the smorgasbord of carnal de-lights. Writing in 2001 Annie Le Brun, an intimate of Toyen's during her postwar Parisian exile, doubts "if today one can measure the incredible au-dacity that it took for a young woman twenty years of age to realize this pic-ture . . . in the visual domain, I know no other woman who has made anything approaching this canvas."[222] The half-naked hooker dallying with a customer on the page of Toyen's 1925 sketchbook that bears the legend "Poulet" (chicken,

which is French slang for prostitute) is also black, but the five topless (and in one case bottomless) girls parading their charms at the center of the scene are lily-white. The sketch, which dates from the trip the artist made to Paris in the early months of 1925 prior to her longer move there with Štyrský that December, was likely the product of observation; Toyen certainly frequented *variétés* (the same sketchbook contains scenes of "La Légende du Nil" at the Folies Bergère and "Les Gertrude Hoffmann Girls" at the Moulin Rouge),[223] and she may, like Brassaï, have sought inspiration in the city's brothels. The African-American dancer Josephine Baker was more than happy to wear the skimpy skirts of *Paradise of the Negroes*—when she wore anything at all, that is—parlaying stereotypes of black sexuality into one of the most successful entertainment careers in interwar Europe. On the opening night of the Prague leg of her 1928 world tour the orchestra played too fast and Josephine could not keep up with the rhythm. "I was burning like a torch," she later recalled. "The spectators applauded and wanted to call me back on stage. They didn't raise the curtain. . . . I had fainted. I was bleeding gently onto the carpet, my arms crossed."[224] Štyrský and Toyen probably saw La Baker perform with La Revue Nègre in Paris in 1925. Karla Huebner has suggested that *Paradise of the Negroes* is "perhaps . . . in part a tribute to Baker's unquestionably erotic persona," and reads the painting as a pastiche on Golden Age tableaux of the Renaissance. Certainly Huebner captures the spirit of the work when she observes that "in Toyen's Africa, evidently, we have the real Golden Age, where no-one hesitated to perform any erotic act."[225]

The young (and more than likely, if *All the Beauties of the World* is anything to go by, the old) Jaroslav Seifert was caught up in the same wet dream. "And this black guy is leaving us today," continues "The Negro":

> forgive me, master John, I have to envy you
> in twelve days you will be playing with the Negro women on the
> shore,
> the train is already leaving
> the ship is sailing
> and the airplane is flying over the sea
> and sitting in the station restaurant is me,
> crying quietly over the beauty of civilization,
> what are airplanes, those metal birds, worth to me
> if I can't fly in them,
> and they are lost in the distance above me in the clouds.
> Oh, master John,

we must explode Europe under the clouds,
for until then are locked in three fortresses
all those enchantments and miracles . . .

The words *master John* are in English in the original.[226]

"Why, why did fate condemn us to live / in the streets of this town on the fiftieth parallel?" asks Seifert in "Paříž" (Paris), a poem that had earlier appeared in the *Revolutionary Miscellany* and is dedicated to Ivan Goll. In this case Mrkvička's accompanying illustration features a naked dancer in the place of the Mařenka of the frontispiece, pirouetting in a landscape of cinemas and cafés—La Rotonde is identified—beneath the Eiffel Tower.[227] It is not in Prague that magic is to be found. The city on the Vltava, Seifert complains, is pedestrian, mundane, a place where "life never goes off the rails," where "all feeling must fade before it even flares up." Still, he consoles himself, "There in the west on the River Seine is Paris."[228] If he cannot have the Ivory Coast—or like his hero in "Námořník" (The Sailor), possess five lovers on five continents and taste their tears dropping onto "breasts that are white, red, black, yellow, brown"[229]—why then "Paris is at least a step closer to heaven."

> In the evening, when the sky there ignites with silver stars,
> crowds stroll among the automobiles thronging the boulevards,
> there are cafés, movie-houses, restaurants and modern bars,
> life is merry there, it bubbles, whirls and snatches you away,
> there are famous painters, poets, murderers and thugs,
> things happen there that are unfamiliar and new,
> there are famous detectives and beautiful actresses,
> naked dancers twirl in a suburban revue,
> and the scent of their lace leads your reason astray
> with love, for Paris is too seductive to resist.[230]

Not every Czech brain was overcome by such amorous perfumes. Defending "proletarian art," Josef Kopta brusquely dismissed poetism as "a signpost to a journey that leads from nowhere to nowhere."[231] In a series of "Notes: In No Way a Methodological Study" published in 1924 in *Avantgarda*, the Prague-German communist writer F. C. Weiskopf offered some stinging observations on Devětsil's "Africa in Žizkov." "Jaroslav Seifert," he begins, "came from the periphery: he liked the cinema, the carousel, pickled herrings, he liked his polished Sunday shoes and Celetná Street. . . . The Prague suburbs were small and Seifert took himself off into the wide world. . . . That is to say:

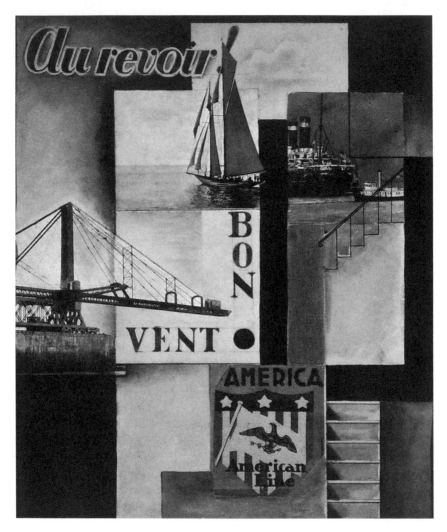

FIGURE 4.12. Karel Teige, "Departure from Cythera," collage, 1923. Galerie hlavního města Prahy. Courtsey of Olga Hilmerová, © Karel Teige - heirs c/o DILIA.

he didn't actually go anywhere, but stayed here and gave Žižkov a new coat of orientalist paint. And behold, Celetná Street was now the rue de la Paix, the Fruit Market the Eiffel Tower, the herrings turned into frozen pineapples, lovers didn't stroll any longer in a spring park but rode in *wagons-lits* and *wagons-restaurants*." "I understand the metamorphosis of Seifert's geography," he concedes; who would pour cold water on a young man's longings?

"What I don't understand is the theorist [Karel Teige] who brands Seifert's new poetry as poetism. The truth is that the whole world was not in *City in Tears*, but Seifert's new book does not contain the whole world either; for a café terrace, even if it be in Paris, is not the whole world and life does not consist just of sunbeams and flowers; beside Miss Gada-Nigi[232] still lives the armless invalid and the worker from the Českomoravská plant [in Prague-Libeň]." Weiskopf summarizes his argument in a typographic semaphore whose style is representative of the avant-garde magazines of the day:

We do not want only	But also:
Paris and Africa	The rest of Europe, all the continents, the coalfields, seas, and factories
The jazzband	The din of machines and the explosion of struggles and signals
Wagon-lits	The panzers of revolution
Sundays and holidays	All the weeks and months
Negroes and Spaniards	All races and classes

We want wine, not a spritzer
and therefore:

No 10% substitute! *Give us the full 100%!*
at least in theory[233]

He had an undoubted point, though which of the two visions, Weiskopf's or Seifert's, was in the end the more far-fetched is a matter for debate. At least Seifert knew he was dreaming.

Devětsil's art was indeed the art of an imagined elsewhere: an imagined Africa, an imagined Paris, an imagined Moscow, an imagined New York—an imagined anywhere but the gray stone town on the fiftieth parallel where life never goes off the rails. Even when the voyage was literal the ship's passengers generally found what they had expected to see, just as tourists usually do. Seifert came back delirious from his 1925 trip with Karel Teige (as part of a Czechoslovak-Soviet friendship delegation) to the Soviet Union. The workers' paradise was everything he imagined. "When I was in Moscow, on the day of the anniversary of the revolution," he wrote the next year, "I found myself caught up in the current of the enthusiastic crowd, which was rolling toward Red Square. In that moment I was dying with longing to become the

poet of this people."[234] One suspects that the much-visited Paris was also ex-
perienced by many a Czech artist as part of a recurring Bohemian dream
haunted by Viktor Oliva's naked green goddess in the Slavia and adolescent
readings of Apollinaire. Vítězslav Nezval's *Gît-le-Coeur Street*, in which ev-
erything Parisian is every bit as marvelous as he had always known it would
be, provides abundant evidence of such transference; but Nezval does after
all begin the book with a confession that he doesn't like traveling and would
much prefer to be able to "transmit himself from place to place by thought
alone." He is "a bad observer," he cheerfully warns us, who sees only "things
from my desire, as happens in dreams."[235] But so what? Who by the 1920s any
longer expected art to confine itself to representing reality? On the contrary:
it was the transformative power of the *imagination* that made Devětsil's art
what it was. Had Prague's young writers and artists not been marooned in the
landlocked center of Europe, far from seas and skyscrapers alike, their work
might well have been a good deal less adventurous than it was. The city was
located at a crossroads of imagined futures that seemed boundless and imag-
ined pasts that eternally threatened to return. The kids in the intersection
were ideally situated for dreaming.

5

Body Politic

Place an unframed mirror perpendicular to a photo of a naked body and slowly turn it or move it forward while retaining a 90° angle, in such a way that the symmetrical halves of the entire visible area gradually shrink or expand in an even fashion. The image, ceaselessly created in bubbles of elasticized skin, emerges by swelling from the somewhat theoretical fissure of the axis of symmetry. Or, if you perform the movement in the opposite direction, the image diminishes to oblivion, the two halves flowing into each other like warm glue sucked into an irresistible void—like a candle placed on top of a hot stove that shrinks because it silently liquefies at its base, which is also the base of its double reflected in the melted wax. Before this abominably natural event that commands one's total attention, the question of the reality and virtuality of the two halves weakens till fading into nothingness at the limits of consciousness.

—HANS BELLMER, *LITTLE ANATOMY OF THE PHYSICAL UNCONSCIOUS*[1]

THE SILENT WOMAN

Three years before Apollinaire's visit to Prague, Gustav Klimt outraged the Viennese art establishment by painting truth in the guise of "a candidly naked woman with long, wavy hair standing unabashed before us, frontally

posed, and holding a mirror up to us"—and by painting that woman, Tobias G. Natter (whose description I quote) might have added, with a flaming bush of auburn pubic hair occupying the exact geometric center of the frame, inexorably drawing the eye to what Gustave Courbet felicitously called *l'origine du monde*.[2] It was not the lady's nudity that was scandalous. In the imperial capital as in provincial Prague unclothed lovelies adorned many a *fin de siècle* façade, prettily impersonating everything from the muses of antiquity to the modern virtues of science and industry. Nor was the problem simply the artist's uncovering of the *mons Veneris*. Vienna was a knowing city and "gallant" erotica a well-established gentlemanly genre. What caused such offense was Klimt's transgression of the boundaries that give the human body, and above all the female body, different meanings within different social settings and for differently situated *voyeurs*. *Nuda Veritas* (The Naked Truth, 1899), as Klimt pointedly called his picture, was neither allegory nor pornography but a troublesome amalgam of the two. In the place of a naked woman representing truth he paints the truth of a naked woman, and he takes that truth out of the accepted underworld of bibliophiles' editions and erotic postcards into the art gallery, rudely thrusting private parts into the public domain. Like Manet's *Olympia*, whose exhibition at the Salon de Paris had caused similar outrage three decades earlier, Klimt's nude gazes directly at the viewer, challenging him—or her—to deny the physical testimony that meets the eye. But despite the frankness of Klimt's portrayal the lady has by no means left the forest of symbols that turn her body into an *objet d'art*. A serpent coils around her feet, suggesting an eternal Eve. This is as explosive a union of opposites as Manet's intrusion of a contemporary prostitute into the place and posture of a Titian nude, and Klimt knew it. Above his portrait he emblazoned a defiant quotation from Schiller: "If you cannot please everyone through your deeds and your work of art, then please the few. It is not good to please the masses."[3]

At least Klimt painted the truth as beautiful, gilding the lily he had so indecently stripped. His young protégés Egon Schiele and Oskar Kokoschka went much further in challenging the visual taboos of the day, painting nakedness in all its ugliness as well as its beauty. Often Schiele takes his own body for his subject, and he treats it unsparingly. He draws men and women copulating, females masturbating, "girlfriends" embracing, pregnant women (he gained access to his friend Erwin von Graff's gynecological clinic in 1910), and prepubescent girls. Once again the scandal does not lie simply in *what* is portrayed but *how*. "Klimt / and Schiele penciled pussies blackly on / their nudes and even limned the labia / that frame the blameless hole men seek and dread," observes John Updike in a poem unapologetically titled

"Klimt and Schiele Confront the Cunt."[4] The great American novelist knows what he is doing when it comes to choosing his words. Schiele's works are not naturalistic depictions of the human body, but they are not Sunday paintings either. He is a brilliant draftsman. The pictures derive their power from the economical and pointed use of space, line, and color to draw the viewer's eye to the heart of the matter: as often as not, reddened genitalia between wantonly spread legs, the stark nakedness of the lower torso heightened by a red blouse, green headscarf, yellow stockings, or hitched-up black skirt. Bodies are cropped, foreshortened, twisted, exaggerated—in a word, to eyes seeking in art mere imitation of nature, *deformed*.

"For a long time reduced to the status of scribes, painters used to copy apples and become virtuosos," declared Paul Éluard in "Poetic Evidence," a lecture he delivered at the International Surrealist Exhibition in London in July 1936: "their vanity, which is immense, has almost always urged them to settle down in front of a landscape, an object, an image, a text, as in front of a wall, in order to reproduce it." But surrealists, he says, "are aware that the relationships between things fade as soon as they are established, to give place to other relationships just as fugitive. They know that no description is adequate, that nothing can be reproduced literally. They are all animated by the same striving to liberate the vision, to unite imagination and nature.... To see is to understand, to judge, to *deform*." He goes on to compare critics of modern art to "those who tortured Galileo, burned Rousseau's books, defamed William Blake, condemned Baudelaire, Swinburne and Flaubert, declared that Goya or Courbet did not know how to paint, whistled down Wagner and Stravinsky, [and] imprisoned Sade."[5] Schiele was more than happy to assume such a martyr's mantle. His poster for his solo exhibition at the Galerie Arnot in Vienna in 1915 was a *Self-Portrait as Saint Sebastian* pierced by viciously barbed arrows: an image whose masochistic allure has been mined by many a modern artist out of joint with the times, including Bohumil Kubišta and (in a poem not published until after his death) T. S. Eliot.[6] Schiele's arms are outstretched as if crucified, his face the very image of Christ suffering for our sins.

The young artist's first brush with an uncomprehending world came in Prague, as it happens, when the police ordered fourteen of his drawings to be withdrawn from an exhibition of the Vienna Neukunstgruppe in 1910 on account of their "obscene character." The next year Egon was run out of his (Czech) mother's hometown of Český Krumlov in Southern Bohemia when the inhabitants objected to his living in sin with his lover Wally Neuzil and still worse, having local maidens—who no doubt resembled Mařenka in *The Bartered Bride*—pose nude for him in the garden. It is poetic justice, of a

sort, that one of Schiele's female portraits is today a prize exhibit on permanent display in the National Gallery of the Czech Republic. Clad in a green blouse and black stockings, her hair bobbed short, she looks a thoroughly modern girl. Schiele painted some sweet watercolors of Český Krumlov that have the feel of Paul Klee about them. He moved to Neulengbach, a village near Vienna, in 1912 with the intention of concentrating on large-scale paintings. There he found himself in trouble with the law again, accused this time of child abuse when a teenage girl stayed the night at his house. He was acquitted of any sexual molestation, but several of his drawings were confiscated as obscene. They hung on his bedroom wall, which for legal purposes was deemed a place of public display. Schiele made sure to leave some suitably pathetic prison sketches behind him.[7] He died young in 1918, three days after his wife, Edith. Like Apollinaire they were casualties of the Spanish flu.

Oskar Kokoschka lived a much longer life but he, too, saw himself as a martyr to *nuda veritas*. He first hit the headlines with his drama *Mörder, Hoffnung der Frauen* (*Murderer, Hope of Women*), which premiered at the Viennese Internationale Kunstschau of 1908, its "savage mood ... heightened with the music of muffled or jangling drumbeats and shrill pipes, and intensified through the use of changing lighting in garish colors."[8] Kokoschka's text was published in the Berlin magazine *Der Sturm* (The Storm) in 1910 accompanied by the author's own illustrations. The cover portrays "a woman already beaten to the ground by a man who is now attacking her with a knife. The behavior of the dog in the background is intended to draw attention to the bloodlust of the man; specifically, the fact that after stabbing the woman, he did not refrain from licking the blood that seeped from the wounds."[9] Needless to say the woman is bare-breasted. Oskar got the *succès de scandale* he was after; around half of *Der Sturm*'s readers canceled their subscriptions, which did not deter the magazine from carrying more of his work in the coming months. On first encountering Kokoschka's paintings at an exhibition in 1911 Archduke Franz-Ferdinand—whose assassination by Gavrilo Princip in Sarajevo three years later sparked off World War I—took the view that "this man deserves to have his every last bone broken."[10] "As I found myself treated like a criminal," Kokoschka relates, "I had my head shaved so that I would look like a marked man" and took to painting himself in the guise of a convict.[11] A quarter-century on Oskar still regarded himself as "misunderstood, hounded and outcast: such has been the path I have chosen since my eighteenth year. A thorny path, like that of almost all artists."[12]

Just as the French surrealists would later, the Viennese expressionists found greater understanding (and patronage) among "the cream of society" that Kokoschka claimed he had "never been able to stand"[13] than they did

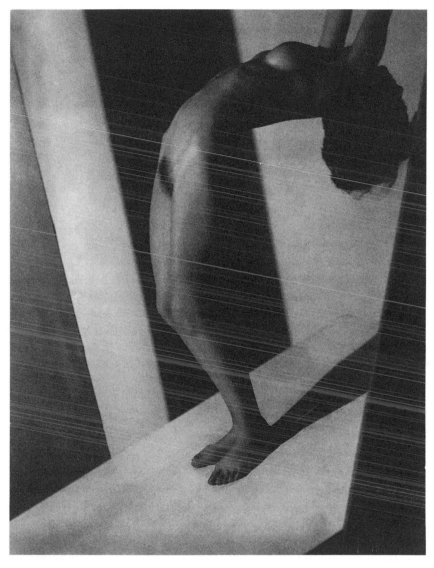

FIGURE 5.1. František Drtikol, untitled photograph, ca. 1929. The Museum of Decorative Arts, Prague.

among the masses. It was in this fashionable milieu that he met Alma Mahler, *née* Schindler, reputedly the most beautiful girl in Vienna and wife, successively, to the composer Gustav Mahler, the architect and future Bauhaus founder Walter Gropius, and the Prague-German writer Franz Werfel. Oskar and Alma began their *amour fou* in 1912, the year after Mahler's death. Ko-

koschka was then twenty-five, Alma thirty-two. He immortalized their pas-
sion in *Bride of the Wind* (*Die Windsbraut*, 1914), "which shows me," he
wrote fifty years later in his autobiography, "with the woman I once loved so
intensely, in a shipwreck in mid-ocean." "My colors had not lied," he goes
on—the picture is composed of chromatic blues and greens, which it is not
too fanciful to suggest conjure up Isolde's *Liebestod*, which Alma sat down at
the piano and sang, she told him, "for him alone" at their first meeting.[14] "My
hand had plucked an embrace out of the stormy shipwreck of my world," he
explains; "The heart needs no more, in order to maintain in days to come an
illusory pledge of survival, a memory as if on ancient tapestry."[15] The ship-
wreck was not long in coming. Soon after *Bride of the Wind* was completed
the relationship hit the rocks. Alma aborted Kokoschka's unborn child after
a quarrel provoked by her insistence on keeping Mahler's death mask in the
house. "So that seems to be over," she recorded in her diary, "something I
thought would last."[16] They staggered on for a few more months until World
War I broke out. Oskar enlisted in the Austrian cavalry in January 1915, rais-
ing the money to buy his horse by selling *Bride of the Wind* to a Hamburg
pharmacist. Adolf Loos secured him his military commission. Seven months
later Alma married Gropius, with whom she had had a fling in the spa town
of Tobelbad back in 1910 while still wedded to Mahler. "Oskar Kokoschka
has become a strange shadow for me," her diary confided; "I have no further
interest in how he lives. And yet I loved him!"[17]

Twice wounded in the war and badly shell-shocked, Kokoschka took lon-
ger to get over Alma. "I went into the slaughterhouse, and got a bullet in my
head and a bayonet through my lungs, only I was rejected by God and sent
back to the life I would have been glad to lose,"[18] he wrote her years later. In
1918, by which time Alma had left Gropius for Franz Werfel, Oskar was con-
valescing in Dresden, where he hoped to secure a professorship at the Acad-
emy of Fine Arts. His landlord Dr. Posse kept a serving-maid, "a pretty young
Saxon girl by the name of Hulda. She had imagination," Kokoschka writes,
"which is why she attracted my attention." Oskar and Reserl, as the artist re-
christened her—the nickname is a local diminutive of Theresa—liked to play
games. "When she served in my rooms she played the part of a lady's maid,
for which I provided her with a cap and a batiste apron, together with black
silk stockings bought from a reserve soldier who had knocked around Paris
for a few years and now kept a black-market store." Reserl did not dress up in
a French maid's costume for the usual clichéd reasons. She was a bit-player in
Kokoschka's fantasies rather than their object. "Above all," he says, "Reserl
helped with the fantasy game I played with my doll"[19]—a doll that was in-

tended to be an exact, life-size replica of Alma Mahler, on whom the servant-girl was destined to wait.

Oskar commissioned the effigy of his lost love in the summer of 1918 from Hermine Moos, a Stuttgart puppetmaker who had once been Alma's dressmaker. His instructions, conveyed in a mass of letters and drawings, were painstakingly detailed:

> Yesterday I sent . . . a life-size drawing of my beloved and I ask you to copy this most carefully and to transform it into reality. . . . Pay special attention to the dimensions of the head and neck, to the ribcage, the rump and the limbs. And take to heart the contours of body, e.g., the line of the neck to the back, the curve of the belly. . . . Please permit my sense of touch to take pleasure in those places where layers of fat or muscle suddenly give way to a sinewy covering of skin. . . . For the first layer (inside) please use fine, curly horsehair; you must buy an old sofa or something similar; have the horsehair disinfected. Then, over that, a layer of pouches stuffed with down, cotton wool for the seat and breasts. . . . The point of all this for me is an experience which I must be able to embrace![20]

"Can the mouth be opened?" he eagerly demanded in December. "Are there teeth and a tongue inside? I hope so."[21]

So fixated was Kokoschka on the impending delivery of "my beloved, for whom I am pining away"[22] that not even the charms of the pretty Reserl, "whom no man had ever seen naked,"[23] could distract him. When Dr. Posse's father died Kokoschka, like Josef Čapek's country Rafael, was asked to draw a likeness from the corpse before the undertaker arrived. It was not a job he relished, and it depressed him. The girl, who had by then fallen hopelessly in love with her "Captain,"[24] sought to give the painter comfort:

> Alone, I worked on my drawing far into the night. Afterwards, wanting a bath, I descended the dark stairs into the cellar, where stood a tall water-butt for use of the whole household. . . . Moonlight shone through the cellar window, and there, to my surprise, like Undine in the story, Reserl emerged from the water. With a provocative casualness she said that she simply wished to take my mind off thoughts of death. . . . I liked the way she blushed so read-

ily; but by now I was preoccupied with anxious thoughts about the arrival of the doll, for which I had bought Parisian clothes and underwear.

"I wanted to have done with the Alma Mahler business once and for all," he explains, "and never again to fall victim to Pandora's fatal box, which had already brought me so much suffering."[25] He only had eyes for Alma's lookalike, to which he now transferred the extreme possessiveness on which his relationship with her original had foundered. "I would die of jealousy," he told Moos in January 1919, "if some man were allowed to touch the artificial woman in her nakedness with his hands or glimpse her with his eyes. . . . When shall I be able to hold all this in my hands?"[26]

The "artificial woman," who arrived in a large packing case full of shavings early that spring, turned out to be a disappointment. "I was honestly shocked by your doll," Kokoschka wrote Moos on April 6, "which, although I was long prepared for a certain distance from reality, contradicts what I demanded of it and hoped of you in too many ways."[27] Nevertheless the games went on. "Reserl and I called her simply the Silent Woman. Reserl was commissioned to spread rumors about the charms and mysterious origins of the Silent Woman: for example, that I had hired a horse and carriage to take her out on sunny days, and rented a box at the Opera in order to show her off."[28] Alma's image spawned yet more images as Kokoschka drew and painted the doll in many poses, usually of sexual availability. In his last such picture, *Self-portrait with Doll*, which he painted from memory in 1920–21, the effigy lolls beside him on a sofa, naked. He is fully clothed. "It is perhaps significant," comments Richard Calvocoressi, "that in this picture he is shown pointing to the doll's sexual parts with a look of resignation or indifference."[29] Maybe. But it is the Proustian alchemy of the image itself that Kokoschka chooses to stress, whatever its infidelities to the absent Alma:

> In a state of feverish anticipation, like Orpheus calling Eurydice back from the Underworld, I freed the effigy of Alma Mahler from its packing. As I lifted it into the light of day, the image of her I had preserved in my memory stirred into life. The light I saw at that moment was without precedent . . . the cloth-and-sawdust effigy, in which I vainly sought to trace the features of Alma Mahler, was transfigured in a sudden flash of inspiration into a painting—*The Woman in Blue*. The larva, after its long winter in the cocoon, had emerged as a butterfly.[30]

Kokoschka does not tell us why a few months later, having expended so much energy and expense on the doll's creation, he decided to dispose of her—if he knew himself. Perhaps the process mattered to him more than the final product. Perhaps the doll had done her job in exorcising Alma's ghost; or maybe Oskar had simply grown tired of the game. In any event, he relates,

> I decided to have a big party, with champagne for all my friends—male and female—and there put an end to my in-animate companion.... I engaged a chamber orchestra from the Opera. The musicians, in formal dress, played in the garden, seated in a Baroque fountain whose waters cooled the warm evening air.... A Venetian courtesan, famed for her beauty and wearing a very low-necked dress, insisted on seeing the Silent Woman face to face, supposing her to be a rival. She must have felt like a cat trying to catch a butterfly through a window-pane; she simply could not understand. Reserl paraded the doll as if at a fashion show; the courtesan asked whether I slept with the doll, and whether it looked like anyone I had been in love with.... In the course of the party the doll lost its head and was doused in red wine.

The next morning the household was rudely awakened by policemen investigating a report of a possible murder. "In our dressing gowns we went down to the garden, where the doll lay, headless and apparently drenched in blood." Matters were explained, Dr. Posse smoothed things over, and the hapless "corpse" was removed. "The dustcart came in the gray light of dawn, and carried away the dream of Eurydice's return," records Kokoschka. "The doll was an image of a spent love that no Pygmalion could bring to life."[31] Some years later he allowed some of his letters to Hermine Moos to be published in an anthology of artists' writings under the apt title "The Fetish."[32]

Despite these indiscretions Kokoschka managed to secure his professorship in the fall of 1919. The following March he acquired yet more notoriety. It was neither the excesses of his art nor the eccentricities of his personal life that occasioned the scandal this time, but his response to the political convulsions that were shaking defeated Germany. A day after troops fired on a workers' demonstration leaving several dead and scores injured, an "Open Letter to the Inhabitants of Dresden" appeared on billboards across the city. It was signed "Oskar Kokoschka, Professor at the Academy of Fine Arts." "I

address this appeal to all those who intend to argue the case for their political theories at gunpoint ... whether of the radical left, the radical right or the radical center," the text began, "not to hold their proposed military exercises outside the Zwinger Art Gallery but in some other place, such as the firing ranges on the heath, where human civilization is not put at risk. On Monday 15 March a masterwork by Rubens was damaged by a bullet. Pictures cannot run away from places where human protection fails them." The work in question was a portrait of Bathsheba bathing on the roof—a stock Biblical pretext, like Susannah and her leering elders, for painting the naked female form. "There can be no doubt," Oskar added, "that in due course the people of Germany will discover more happiness in the contemplation of the pictures, if we save them, than from all the opinions of the politicking Germans of the present day."[33]

The Berlin Dadaists John Heartfield and George Grosz, who had never had much time for expressionism anyway, responded angrily in *Der Gegner* (The Opponent). The magazine was published by Malik-Verlag, the socialist press Heartfield had established in 1917 with his brother Wieland Herzfelde. Born Helmut Herzfeld, Heartfield had anglicized his name in protest against German militarism. The brothers had joined the newly formed German Communist Party on New Year's Eve 1918 together with Grosz (who formerly spelled his name Georg Groß). Kokoschka, sneered Heartfield and Grosz, was "a scab" who "wants his business with the brush honored as if it were a divine mission" when "the cleaning of a gun by a Red soldier is of greater significance than the entire metaphysical edifice of all the painters. The concepts of art and artist are an invention of the bourgeoisie," they thundered, "and their position in the state can only be on the side of those who rule, i.e., the bourgeois caste":

> The title "artist" is an insult.
> The designation "art" is an annulment of human equality.
> The deification of the artist is equivalent to self-deification.
> The artist does not stand above his milieu and the society of those who approve of him. For his little head does not produce the content of his creation, but merely processes (as a sausage-maker does meat) the worldview of his public.

Trading the victorious Allies the entire contents of Germany's art museums in exchange for food supplies, they suggested, "would [do] more for 'the poor people of the future' than leaving them the opportunity of standing, their

legs crippled by rickets, in front of the unblemished masterpieces in the galleries."[34]

Oskar knew a thing or two about the cleaning of guns; a good deal more, in fact, than his critics, who had contrived to avoid military service during the war, in Heartfield's case by feigning insanity. But it is not too difficult to understand why such an ivory-tower perspective should have stuck in the Dadaists' throats. The "politicking" that Kokoschka so scornfully dismisses included the murders of the Spartakist leaders Karl Liebknecht and Rosa Luxemburg, the bloody suppression of the Munich Soviet by the right-wing thugs of the *Freikorps*, and the foundation of Adolf Hitler's Nazi Party. "Kokoschka's statements are a typical expression of the attitude of the bourgeoisie" spat Heartfield and Grosz. "With joy we welcome the news that the bullets are whistling through the galleries and the palaces, into the masterpieces of Rubens, instead of the houses of the poor in the working-class neighborhoods."[35] Neither they nor Kokoschka, of course, could have foreseen that the Zwinger would go up in flames along with the rest of Dresden's historic center and upward of 35,000 of its people on the night of 13 February 1945, casualties of one of the most devastating Allied bombing raids of World War II. The firestorm made no distinction between the palaces and the workers' quarters. In retrospect, Kokoschka's suggestion that "as in classical times, feuds should in future be settled by the leaders of political parties in single combat, perhaps in the circus, and enhanced by the Homeric abuse of their followers" was not so silly after all. It would, as he said, have been "less dangerous and less confused than the methods currently employed."[36]

THE POETRY OF FUTURE MEMORIES

Together with the "Dadasoph" (as he styled himself) Raoul Hausmann, Heartfield and Grosz organized the First International Dada Fair (*Dada-Messe*), which opened in Berlin four months later in July 1920. Hausmann's contributions included *Dada siegt!* (Dada Triumphs), whose centerpiece is a photograph of Prague's Wenceslas Square. The work is subtitled "A Brain of Bourgeois Precision Provokes a World Revolution" (*Ein bürgliches Precisionsgehirn ruft eine Weltbewegung hervor*), a common enough dream among avant-garde artists at the time. The photograph stands on an easel where we would expect a painting to be; in front of it poses Hausmann himself, dandified in overcoat, gloves, and trilby hat, surrounded among other things by a Remington typewriter and several meat grinders. The word *Dada* is etched in red on the cobblestones and one of the buildings on the square is newly numbered *391*—the title of Francis Picabia's itinerant magazine in which

Marcel Duchamp first published his mustachioed Mona Lisa under the punning title *L.H.O.O.Q.* (*Elle a chaud au cul*, which roughly translates as she's got a hot ass). It is possible that *Dada Triumphs!* provided the inspiration for Otakar Mrkvička's cover for Seifert's *Love Itself*, but the echoes may be purely coincidental. Quite why Wenceslas Square found its way into what has since become celebrated as one of the defining exhibitions of twentieth-century art[37] is uncertain, but Hausmann had visited the Bohemian capital a few months earlier with fellow-Dadaists Richard Huelsenbeck and Johannes Baader. Huelsenbeck ends what Robert Motherwell calls his "brilliant history of the Dada movement"[38] with "the great victory won for Dada in Prague on March 1."

Dada being Dada, most everything in Huelsenbeck's account should be taken with a very large pinch of salt; except, perhaps, his appreciation of whom the Dadaists offended and why, which condenses—in the obscure manner of *hasard objectif*—the contrary pressures avant-garde European artists would face over the next two decades. After strutting their stuff "before an audience of fools and curiosity-seekers" in Teplice (or Teplitz-Schönau, as Huelsenbeck calls it), the Dadaists "drank [themselves] into a stupor. 'Überdada' Baader," Huelsenbeck goes on, "who is almost fifty years of age, and, as far as I know, is already a grandfather, then repaired to the Bawdy House of the Bumblebee, where he wallowed in wine, women and roast pork and devised a criminal plan which, he calculated, would cost Hausmann and myself our lives in Prague." Conditions in the city, Huelsenbeck says, were "rather peculiar. We had been threatened with violence from all sides. The Czechs wanted to beat us up because we were unfortunately Germans; the Germans had taken it into their heads that we were Bolsheviks; and the Socialists threatened us with death and annihilation because they regarded us as reactionary voluptuaries ... in the newspaper offices the editors obligingly showed us the revolvers with which, under certain circumstances, they were planning to shoot us down on March 1." The terrified Baader cut and ran, leaving his comrades to face "the fury of the public" alone. "The whole city was in an uproar. . . . Thousands crowded around the entrances of the Product Exchange. By dozens they were sitting on the window-ledges and pianos, raging and roaring. . . . The windowpanes were already beginning to rattle." Happily the Dadaists survived the ordeal to perform two nights later at the Mozarteum "with great success" and went on to repeat the act on March 5 in Karlovy Vary, "where to our great satisfaction we were able to ascertain that Dada is eternal and destined to achieve undying fame."[39]

Great victory or not, the Dadaists' antics seem to have had little impact on the Czech avant-garde despite a return visit to the city by Hausmann, his girl-friend Hannah Höch, and Kurt Schwitters on what they billed as an "anti-Dada tour" the following year.[40] Apart possibly from Adolf Hoffmeister, who may have been present at the Dada evening at the Product Exchange, there is no evidence of any Devětsil artists having attended any of these performances. The lack of interest may have had something to do with the fact that Dada presented itself in the German language to a largely German-speaking audience. When Dada's influence belatedly did begin to percolate into Prague the conduit would not be Berlin but Paris: the mirror captioned "Here is your portrait, viewers!" (*Diváci, zde je vaše podobizna*) that Karel Teige exhibited in Devětsil's *Bazaar of Modern Art* in November 1923 probably originated in a similar play of Philippe Soupault's (titled "Portrait of the Unknown") that had struck Teige when he and Seifert visited the Salon Dada during their 1922 trip to Paris.[41] Both Teige and the poet František Halas would later write appreciatively on Dada, but not until the mid-1920s when the movement's heyday was already past. "Dada = man surprised by modernity," opined Halas.[42] Surrealism, too, found little initial favor in the magic capital, where Ivan Goll's Apollinairean version of *sur-réalité* long counted for more than André Breton's.[43] Notwithstanding Breton's claim in his 1935 Mánes lecture of "many long years" of "perfect intellectual fellowship" there was relatively little contact and still less commonality between Devětsil's artists and the Paris surrealists throughout most of the 1920s. As late as 1928 Teige described Breton's *Surrealism and Painting* as "a significant and instructive study of this episode in modern painting, which was a deviation from the trail blazed by cubism, and which today, as the night of surrealism draws to its end, we can consider closed."[44]

During their four years in Paris Štyrský and Toyen styled themselves "Artificialists" in part to distance themselves from surrealist art, which they dismissed as "formally historicizing painting" without expanding upon exactly what they meant.[45] Reviewing the pair's latest work in 1928, Teige attempted to elucidate the differences. Surrealism, he argued, "is too indebted to Böcklin and expressionism, and, unable to utilize the unlimited possibilities that are the legacy of cubism, [has] degenerated into literary and formal historicism." Štyrský and Toyen adopted the label *Artificialist*, he explains, in order to highlight their "complete independence toward the natural world as well as their complete lack of subordination to the forces of the subconscious." Their pictures "do not have a model and are their own subject."[46] Entirely ab-

stract, these works achieve their lyrical effect through a luminous handling of color and experiments with the texture of the surface, which included mixing sand, sugar cubes, feathers, and other materials into the paint. Like the canvases of Jackson Pollock or Mark Rothko, which in some respects (like Toyen's use of drip-painting) Artificialism strikingly anticipates, these paintings have to be *seen* to be appreciated. Reproductions will not do the job because these are not images of realities outside themselves. Artificialism, in the Czech artists' own words, was a "mirror without image," an art that, "leaving reality alone . . . strives for *maximum imaginativeness*," producing paintings that are "not bound to reality in time, place, and space."[47]

Teige makes a particular point of stressing that Artificialist paintings "are not images of dreams and hallucinations." For Breton, of course, "psychic automatism in its pure state" was *the* defining feature of surrealist activity.[48] Though he later modified his views on the efficacy of automatic writing as a route to the unconscious[49] the Id remained the creative fount he wished to tap, liberating thought from the constraints of reason, aesthetics, and morality. Teige concedes that Štyrský and Toyen's paintings are "perhaps subconsciously inspired"—what, after Freud, was not? Štyrský had in fact been recording his dreams in both words and drawings since 1925; his later conversion to surrealism was not quite as abrupt as it might appear.[50] But what matters most, insists Teige, is that Artificialist paintings are "realized in the full radiance of consciousness":

> the poetry of a new reality, new flowers, new lights, they direct a film of excitement and emotion, they create an *ultraviolet, superconscious world*; they are magical and enchanting works, unforgettable jewels, the colored mist of a new dawn of poetry breaking before us. Toyen and Štyrský's artificialism, deeply linked to Nezval's poetism, lives in the certainty that *the most artificial existence fosters the least illusion and the greatest happiness*. The poetry of colorful games, transfigured, made up, abstract, and of future memories; this is not a passive recording of the subconscious, nor is it astrology or the interpretation of dreams. It is creation, it is invention, it is a poem: a work, a fact, a fruit of poetic superconsciousness.[51]

Could Devětsil's faith in "superconsciousness" (*nadvědomí*) to put the world to rights (and poetry to light it up on Sundays) perhaps have had

something to do with the fact that unlike the French surrealists most members of the group were too young to have fought in World War I? Konstantín Biebl was an exception, but beneath their surface simplicities, his poems have a depth and a hardness that is altogether lacking in Nezval or Seifert's exuberant wordplays. Seifert loved Apollinaire but he was still capable, with all the irreverence and innocence of youth, of finding the bandage round the poet's head merely amusing. Jacques Vaché would likely have found a grim *umour* in the spectacle, too, but that is not quite the same thing. Breton's *Anthologie de l'humour noir* (Anthology of Black Humor), whose proofs—appropriately enough—came off the press just four days before the Germans occupied Paris in 1940, leaving the book to languish unpublished for another five years, abundantly exhibits Vaché's "SENSE . . . of the theatrical (and joyless) pointlessness of everything." The selections, from Jonathan Swift's *A Modest Proposal* to Kafka's *Metamorphosis*, are often bitterly funny but they are singularly lacking in levity. The humor that Breton valued most was deadly serious, "the mortal enemy of sentimentality."[52] "Although he masterfully manipulated irony, sarcasm, acerbic jokes, vengeful weapons directed against others," recalls Brassaï, "I do not think that real humor—sparkling, pleasant, all-encompassing, depriving the world of its gravity and fatality—would be within his reach."[53] Robert Desnos concurred, describing Breton as "that priest who doesn't laugh; who doesn't even know what it means to laugh, no matter how much the desire to do so might consume him."[54] There were obvious artistic affinities between Czech poetism and French surrealism—affinities that perhaps came to look all too obvious, when viewed through the dreams and desires of both parties in the spring of 1935—but they masked a profound difference of sensibility.

Joyless is the last word that comes to mind in connection with Devětsil's art. "Light grief on the face, laughter deep in the heart," reads the epigram to Seifert's *On Wireless Waves*, a playful inversion of another line in Karel Hynek Mácha's "May."[55] Published by Václav Petr in 1925, Seifert's third collection, which is dedicated to Teige, Nezval, and Honzl, continues where *Love Itself* left off. There is not a trace of "Soviet verse." Julius Fučík aptly summarized *On Wireless Waves* as "a denial of ideology, a switch to pure poetry," in which "airplanes are zipping through the skies and transatlantic steamers are sinking under the load of poetry. Ports, ocean, Marseille and Italy, New York and yachts, skyscrapers, pineapples, all the scents of the world, all the beauties of the world, all the nations of the world, Negroes, Chinese, poets, steel construction and exotics. The grandest journey around the world, on wireless

waves." At first, he says, Fučík had trouble with Seifert's apparent "desertion of the proletarian cause," but he quickly changed his mind. "Jaroslav Seifert is not and never was a problem," he repeatedly insists.[56] Laughter bubbles up not just in the poems' ephemeral subject matter ("Lawn-Tennis," "Cigarette Smoke," "Ice-Cream Poetry") but in the book's design. Plundering "almost all the typefaces [the printer] had in his office," Teige orchestrated a "typographic rodeo,"[57] setting Seifert's lines vertically as well as horizontally or cascading them diagonally down the page. The name of a popular brand of condoms (**OLAGUMY**) descends in big bold capitals alongside the lyrical stanzas of "Večerní světla" (Evening Lights). "Objevy" (Discoveries) is superimposed on a map of the Caribbean. (The poem reads, in full: "In the year 1492 the Genoese Christopher Columbus discovered unknown islands / *Thank you Sir! / I smoke cigarettes.*") In "Cirkus" (Circus), the centered black disk that adorned the cover of the *Devětsil Revolutionary Miscellany* returns as a "great balloon" containing the words *TODAY FOR THE LAST TIME (DNES NAPOSLED)*.[58] The most popular poem in the book ("if it can be called a poem," chuckles Seifert half a century later in *All the Beauties of the World*) was an amorous play with antipodean apples[59]:

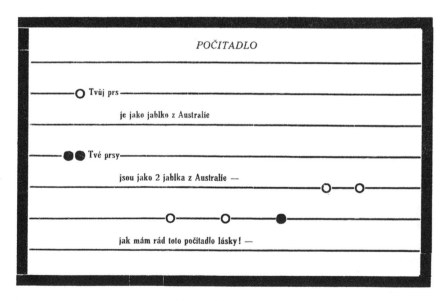

FIGURE 5.2. Jaroslav Seifert, "Počitadlo" (Abacus), from his *Na vlnách TSF* (On Radio Waves). Typography by Karel Teige. Prague: Václav Petr, 1925. Courtsey of Olga Hilmerová, © Karel Teige - heirs c/o DILIA. The poem translates: "Your breast / is like an apple from Australia / Your breasts / are like two apples from Australia / how I like this abacus of love!"

"Back then," the poet explains, "they really did sell Australian apples in the winter in the delicatessens. The taste wasn't anything special because the fruit ripened in transit. But it was very beautiful all the same. Every piece was wrapped in fine tissue paper and Paukert's, the delicatessen on National Avenue, placed them on a platter in the shop window with each one half-unwrapped to reveal a little clearing so that their unusually beautiful coloring could be seen. And they were precious. And expensive."[60] How sexy can you get? We might just as well be back in Corpse Lane gazing into another shop window altogether.

Paukert's still purveys its delicacies on National Avenue, a venerable old Prague institution—or so it would appear. The continuity is as deceptive (or at least, as complicated) as that of Josef Gočár's Grand Café Orient. Founded by Jan and Štěpánka Paukert in 1916, the deli moved to its present premises in 1920. It did a roaring trade between the wars. Jan Paukert claimed to be the inventor of *obložené chlebíčky*, the ubiquitous (and delicious) Czech open-face sandwiches. Voskovec and Werich were regulars, Tomáš Masaryk was known to order take-out, and Emma Destinová used to drop by for a shot of her favorite green liqueur Izarra.[61] The store ceased to be a family business when it was nationalized along with all other retail outlets in 1952. It reopened under its old name forty years later after communism had come and gone. The echo was not just a semiotic lingering of the kind that hovers over Corpse Lane or Žofín Island: it was Jan Paukert Jr., the founder's son, who revived the family business. By then he was in his seventies. The first thing Jan did on regaining the keys to the property was to retrieve a substantial stash of rare cognac he and his father had walled up in the cellar in 1938 to keep the bottles out of the hands of the Nazis. "Not only Mr. Paukert, but also this cognac ... represents, in a certain way, a bridge over the period when Jan Paukert's brand became nationalized," comments Jan's business partner David Železný.[62] There has to be a metaphor in this microcosm of Prague's twentieth-century tragedies and travesties, though for what I am not quite sure. The good soldier Švejk would likely have seen Jan's surviving long enough to lay his hands on his dad's brandy as the only worthwhile moral in the story.

It was the letter *B*, rather than apples cosseted in tissue paper, that formed "a miniature of a lover's breast"[63] in Vítězslav Nezval's *Abeceda* (*Alphabet*), a poetic cycle he wrote late in 1922. The cycle was first published in *Disk* in December 1923 and reprinted in Nezval's debut collection *Pantomima* (Pantomime)[64] the following year. "At a time when factions for or against so-called proletarian poetry were confronting one another," he explained, "I tried to

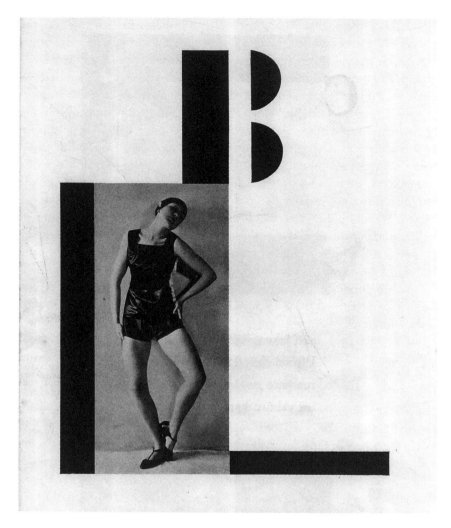

FIGURE 5.3. Letter *B* from Vítězslav Nezval, *Abeceda* (*Alphabet*). Dance composition Milča Mayerová; typographic design Karel Teige. Prague: Otto, 1926. Archive of Jindřich Toman. Courtsey of Olga Hilmerová, © Karel Teige - heirs c/o DILIA.

react against this ideological approach. I jettisoned any kind of theme at all and picked the most subjectless object of poetry as an excuse for gymnastics of the mind—the letter." Working from the associations conjured up by the form, sound, and function of each letter of the alphabet Nezval produced twenty-five quatrains "whose content was autonomous, not complying with the content of any theme, and realistic in the sense that they replaced the pre-

vailing abstract ideology with images rich in material content." He treated the letter not as a subject but "rather a motif, a stone that makes ripples on the surface, a pretext for a poem."[65] Matthew Witkovsky sees an affinity between the poetic practices of *Alphabet* and the linguistic theories of Roman Jakobson, who was both a Devětsil member and a founder with Jan Mukařovský and others of the Prague Linguistic Circle.[66] The poet and the linguist became good friends; a lovely photograph survives of Nezval and Jakobson drinking with Karel Teige in Jiří Kroha's Brno swimming pool.[67] Needless to say the concrete images that flooded Nezval's mind were vintage Devětsil—palm-fringed tropics, cowboys on the pampas and Indians on the prairies, India, Egypt, the Eiffel Tower—but what mattered more, in the context of the polemics of the day, was his defense of the rights of the imagination to portray nothing but itself. André Breton would have approved.

Scintillating as Nezval's gymnastics of the mind may be, it is for other calisthenics that *Alphabet* has been remembered—or more accurately, rediscovered in the last twenty years.[68] If letters can transmute into breasts, then the female body can equally communicate the forms, sounds, and functions of the letter. So, at least, thought Milča Mayerová, who took it into her head to choreograph *Alphabet* with her perky self in the starring role. Milča's performance of the poem, which consisted of one acrobatic pose for each line of each stanza, was the highlight of a "Nezval Evening" at the Liberated Theater in April 1926. Her impersonations of the ABC proved hugely popular and the production was reprised several times that summer and autumn. Who could fail to be seduced by "the elastic body of the dancer"[69]— the first image that came to Nezval's mind when he sat down to contemplate the form, sound, and function of the letter *I*? It was a supremely modernist body: the same healthy, active body Milena Jesenská proselytized in her articles on sport and clothing; the same lithe, toned body of the gymnasts Ladislav Sutnar montaged onto the cover of Družstevní práce's magazine *Žijeme* (We Live, 1931–32); the same disciplined, sculpted body František Drtikol turned into pure poetry in his photographs of athletic nudes posed against geometric backdrops lit to bring out all the beauty of their clean curves.[70] Drtikol was awarded a Grand Prix at the *Exposition des arts décoratifs et industriels modernes* in Paris, but his failure to airbrush pubic hair from his images led to the confiscation by the US Customs of a shipment of his works for the fifth International Photography Exhibition in Seattle in 1929. "Photographs of such sort are illegal to import into this country," the organizers primly informed him. "It is not possible to return them to the sender by international mail, either, as they must be torn up in the name of

the law."[71] Not for the first or the last time the New World proved to be behind the modernist times.

Following her success at the Liberated Theater Mayerová commissioned Karel Paspa, a commercial photographer who did her publicity stills, to capture the eternal in the ephemeral with a view to turning Nezval's poem into an illustrated book. A freestanding edition of *Alphabet* was published "for Christmas 1926." What made the book a modernist icon was not just its combination of gymnastics of the body and the mind, though there can be little doubt that Paspa's images of Milča čavorting in her sporty shorts and top, bathing cap, and Mary Jane pumps added an erotic *frisson* to Nezval's verses. The most remarkable aspect of the project, from a visual point of view, was Karel Teige's page design.[72] Each of Nezval's verses is positioned opposite a full-page "typo-photomontage" in which Mayerová's body is framed by an abstract, geometric representation of the relevant letter of the alphabet. No less remarkably, but rather less expectedly—though we should surely by now be prepared for such unlikely conjunctions—it was not Odeon, Aventinum, or any of the progressive publishing houses who banded together the same year to form the Club of Modern Publishers Kmen[73] that sponsored this modernist masterpiece. *Alphabet* appeared under the venerable imprint of Jan Otto, the publisher of *Otto's Encyclopedia, Golden Prague,* and the "Affordable National Library" (*Laciná knihovna národní*) whose evergreen mainstay was Old Mr Jirásek. By then Otto's list was very staid indeed, but Milča happened to be Jan's granddaughter.

Alphabet may justly be seen as both "a consummate Czech contribution to European modernism" and "a unique distillation of the creative spirit of the 1920s."[74] But as the Roaring Twenties gave way to the Dirty Thirties Devětsil's "easy-going, mischievous, fantastic, playful, non-heroic, and erotic" art—as Karel Teige had described it in his first "Poetist Manifesto" of 1924[75]—was in danger of appearing at best merely childish and at worst willfully frivolous. The "low, dishonest decade"—as W. H. Auden called it when the 1930s came to a premature end on 1 September 1939, bringing "the unmentionable odor of death" into everyone's private lives[76]—was not a time in which reality would leave artists alone, whether they wanted it to or not. The KSČ fired a warning shot across the avant-garde's bow when it expelled the writers Josef Hora, Marie Majerová, Helena Malířová, S. K. Neumann, Ivan Olbracht, Jaroslav Seifert, and Vladislav Vančura from its ranks in 1929 for their "radically petty-bourgeois views." Devětsil did not respond with an outraged defense of the freedom of the imagination; things were already getting too complicated for that. Teige, Nezval, Konstantín Biebl, František Halas, and

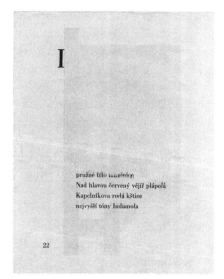

FIGURE 5.4. Poem and typo-photomontage for the letter *I* from Vítězslav Nezval, *Abeceda* (*Alphabet*). Dance composition Milča Mayerová: typographic design Karel Teige. Prague: Otto, 1926. Archive of Jindřich Toman. Courtesy of Olga Hilmerová, © Karel Teige - heirs c/o DILIA.

Jiří Weil were among those who publicly denounced the "grave error" of the Seven, as they became known, "not in order to correct their mistake—but to emphasize that here our ways part."[77] Jindřich Štyrský meantime unleashed an assault on the one-time youngest generation from another quarter. "Our generation has matured: it equates the moon with the electric light bulb, love with sex, and poetry with cash," begins his polemic "A Generation's Corner" (*Koutek generace*), "and now they enjoy their pieces of silver somewhere in a quiet corner . . . [producing] greater quantities of kitsch." "Many are already having their memorials erected by the nation," he goes on, "on which they are portrayed seated, their youth covered in patina."[78] It was this article that led to his break with Karel Teige, whom he accused (among other sins) of being a mere "compiler" rather than a creator.[79]

"Poetism is the crown of life, whose foundation is constructivism," Teige had declared in the "Poetist Manifesto."[80] It was an oxymoronic but extraordinarily productive formulation, as meetings of sewing machines and umbrellas so often are. But in the end Devětsil's improbable balancing act proved too much to sustain. The new decade called for something stronger than a dizzy infatuation with all the beauties of the modern world. As the bright new dawn of poetry receded ever further into the distance, it seemed increas-

ingly urgent to learn to walk by night. Surrealism tore the veils off both the innocent optimism of the poetism and the confident rationalism of the constructivism, offering instead to trawl the depths where the devils lurked and look them in the face without flinching. Imploding under the weight of its own irreconcilabilities, Devětsil disbanded in 1931. Its place in Prague's cultural life had by then largely been taken by the Left Front—a grouping defined less by a common artistic vision than a shared political agenda of "defending modern views and interests against conservatism and reaction."[81] Karel Teige was the Front's first president, though S. K. Neumann, who had by then dutifully returned to the KSČ fold, soon replaced him. Less than a year later *La Révolution surréaliste* gave way to *Le Surréalisme au service de la révolution* in Paris. The journal's change of title (which was accompanied by the adoption of a more sober cover) was meant to signal a similar change of priorities, which Breton announced in the *Second Manifesto of Surrealism* and spelled out in *Communicating Vessels*. The opening editorial in Nezval's *Zodiac*, whose first issue came out in November 1930, denied that it was a surrealist magazine, but its contents strongly suggested otherwise. The second number included the *Second Manifesto*, which Nezval translated in its entirety.[82]

Six months later Karel Teige published his warmest assessment of surrealism yet. What he welcomed above all, he said, was Breton's acceptance of "dialectical materialism as a world view." "*Surréalisme au service de la révolution*," he declared, "isn't only a literary review: it equally sharply condemns literary careerism and prostitution and French colonial politics and all the nightmares of social oppression." "The surrealist movement, and especially the group led by André Breton," he concluded, "is not only the most radical avant-garde in today's confused so-called artistic and cultural world but it is almost the only intellectual current in contemporary French literature which has weight, which has historical significance."[83] The Devětsil leader had come a long way since 1924. "When the city clocks chime the approaching midnight of the old order," he explained later, "poetry cannot be the song of a bird, the intoxication of the summer sun; it is a mouth spewing out blood, a crater overflowing with lava in which the Pompeii of luxury and piracy will perish, a geyser of forces against which the censor of social morality will be powerless."[84]

RENAISSANCE BALLET

It is in some ways ironic that it should have been the overt political commitment of the *Second Manifesto* that opened the door to this *rapprochement* be-

tween Prague and Paris, for among those targeted in Breton's vitriolic text were some of Devětsil's closest Parisian contacts. Breton forced Philippe Soupault out of the Paris surrealist group at the end of 1926 for wasting his talents in journalism, publishing in an Italian fascist journal, and smoking English cigarettes.[85] Soupault met Karel Teige, whom he found "lucid, intelligent, and together,"[86] during his visit to Prague the following April. The two men went on to collaborate on a Czech edition of Lautréamont's *Songs of Maldoror*, which was published by Odeon in 1929 with illustrations by Jindřich Štyrský. The censors promptly seized the book as an offense to public decency. *ReD* immediately launched an international campaign of protest. Among those who publicly denounced the ban were Soupault, Georges Ribemont-Dessaignes, and Josef Šíma's young French colleagues in Le Grand Jeu. Breton remained silent—conspicuously so, in view of his usual reverence for anything to do with Lautréamont. His reticence became clearer when later that year he repudiated these and other former associates of surrealism—most notably Antonín Artaud, Robert Desnos, André Masson, and Georges Bataille—in the *Second Manifesto*. René Daumal angrily responded in *Le Grand Jeu* with an "Open Letter to André Breton,"[87] which was pointedly followed with a reprint of the group's protest in *ReD* against "the Czech Anastasia who excommunicates Maldoror for absence of pants when he has wings." Maintaining that French justice was equally "imbecilic," Daumal went on to "condemn in the name of the Spirit . . . the generals' moustaches, the cult of the Unknown Soldier, and the funeral of Marshal Foch" for "the crime of true obscenity."[88] He had a point.

This was the moment, according to Karel Srp, when the youngest generation finally "grew up," discarding "the veils of poetic metaphor" through which they had seen the world during the previous decade.[89] The most immediate fruit of that newfound maturity was a sustained foray into the erotic. It was an interest that for many on the left seemed an incongruous bedfellow for dialectical materialism. Here as elsewhere the Parisians had pointed the way. George Bataille's *Story of the Eye* and Louis Aragon's *Irene's Cunt* both came out in 1928. When the *Second Manifesto* appeared in *La Révolution surréaliste* in December 1929 the upper part of the page was covered with the bright red imprints of seven of the surrealists' wives' and lovers' lips—Suzanne Muzard, Gala Éluard, Marie-Berthe Ernst, Jeanette Tanguy, Alice Apfel, Yvonne Goemans, and Elsa Triolet—captioned "Why *La Révolution surréaliste* had ceased to appear."[90] The graphic coupling might as well have been an obscene kiss-off to the apostates denounced in the text. That same month saw the publication of *1929*, a slim volume of utterly blasphemous

poems by Benjamin Péret and Louis Aragon that bid *les années folles* adieu
with four photographs of Man Ray's penis being embraced by Kiki de Mont-
parnasse's vagina, Clara Bow lips, and (the position suggests) anus, captioned
"The Four Seasons."[91] Breton—uncharacteristically—coordinated this glee-
fully obscene production to raise money for the Brussels review *Variétés*,
which was unable to pay its printers' bill for the special issue on surrealism it
had published earlier that year.[92] The title was a parody of the fund-raising
annual almanacs put out by the post office and fire brigade. Most copies of
the edition of 215, anonymously printed in Belgium, were impounded by
French Customs at the border.[93] Her Majesty's Customs and Excise in Brit-
ain followed suit, declaring the first English edition of the book porno-
graphic and banning its import—in 1996.[94] Surrealists are not the only ones,
then or now, to find closely observed sexualities subversive.

Štyrský responded to the censors' confiscation of *Songs of Maldoror* by
launching a new journal called *Erotická revue* (*Erotic Review*) whose first
issue came out in October 1930.[95] The venture offered little in the way of the
avant-garde graphics that had enlivened Devětsil's publications during the
1920s. There were no photographs, and all the illustrations were in black and
white.[96] *Erotic Review* was a little magazine published in a limited edition of
150 numbered copies (250 for volume 2, 200 for volume 3) on a shoestring
budget. The colophon made clear that the revue was "intended only for sub-
scribers, not permitted to be publicly sold, nor displayed, nor lent, nor oth-
erwise disseminated nor deposited in public libraries."[97] This baroque word-
ing was necessary to get around the censorship laws of which *Maldoror* had
fallen foul; the Czechoslovak Republic may have been a democracy, but it
was by no means universally liberal. Such unsavory stuff could only be pub-
lished privately. Many of the review's contributors and translators—among
them Vítězslav Nezval, Adolf Hoffmeister, Jaroslav Seifert, František Halas,
and Bohuslav Brouk—were happy to have their work appear under their own
names, but others remained more circumspect. Emil Filla hid behind the ini-
tials *LL*, while Alois Wachsmann disguised himself under the cipher *2x: V*. It
was a comprehensible reticence. Then as now, the body was dangerous terri-
tory. Karel Teige, who had not yet forgiven Štyrský for his insults in "A Gen-
eration's Corner," did not contribute to the venture at all.

Seeking to put *Erotic Review* into historical context, Karel Srp reminds us
that the first nude scene in commercial film was still three years away.[98] As it
happens, the credit for that particular global cinematic breakthrough be-
longs to a Czech movie, Gustav Machatý's *Ecstasy* (*Extase*, 1933), which
starred the then unknown eighteen-year-old Austrian actress Hedwig Kiesler.

Machatý's earlier film *Erotikon* (1929) was based on a story by Vítězslav Nezval. The Devětsil poet also cowrote the screenplay for the same director's *From Saturday to Sunday* (*Ze soboty na neděli*, 1931), whose music was provided by the Liberated Theater's resident composer (and future member of the Czechoslovak Surrealist Group) Jaroslav Ježek. In the most famous scene in the silent *Erotikon* "a girl succumbs to her seducer in heavy rain and . . . we see in detail a drop of water slide slowly down the window."[99] Though *Ecstasy* had sound, its minimalist dialogue was overwhelmed by visual metaphors. "It's one of the most daring and exciting films brought to the screen," enthused Mario Gromo in *La Stampa* when *Ecstasy* showed to a standing ovation at the Venice Film Festival in 1934, "the scent of fields in blossom spread by the wind, the rustling of woods, and all of this changed into musical notes and concrete words which express states of mind. The vision of the beautiful naked body of a naiad which is transformed into that of a wood nymph chased by the sun's rays, all these scenes have the purity of legend."[100] The critics may have adored Machatý's imagination—or maybe it was just Hedy's beautiful naked body—but the authorities were less impressed. *Ecstasy* was banned in Germany and the United States, heavily cut elsewhere in Europe, and denounced by the Vatican—which would find it altogether easier a few years later to turn a blind papal eye to the Holocaust. Hedwig Kiesler meantime metamorphosed into Hedy Lamarr. The Hollywood diva later let slip that the contortions of her face in the throes of orgasmic passion were induced by Machatý's repeatedly jabbing her in the behind with a safety pin.[101]

The first issue of *Erotic Review* opened on a "Dreaming Girl" (*Snící dívka*) lying on a sofa clad in nothing but an unbuttoned blouse. Her eyes are wide open and so are her legs. Penises drift around her in what look like party balloons.[102] The picture, a delicate line drawing, was signed only with the letter *T*, but it was unmistakably the product of Toyen's "serenely daring"[103] pen. According to her own account Marie Čermínová's *nom de plume* Toyen was a contraction of the French revolutionary salutation *citoyen*, though Jaroslav Seifert tells a different story, claiming that he made the name up one day in the National Café. "She was a kind and fine girl," he says. "We all liked her," even if "she spoke only in the masculine gender" which "at the beginning we found a little unaccustomed and grotesque, but in time we got used to it."[104] "Ten—Ta—Toyen," as Adolf Hoffmeister once gently caricatured her,[105] enjoyed screwing with the grammars through which sexual differences are parlayed into gendered identities. *Ten*, *ta*, and *to* are respectively the masculine, feminine, and neuter forms of the demonstrative pronoun in Czech; one says *ten muž* (this man), *ta žena* (that woman) and *to dítě* (this child). Hoffmeis-

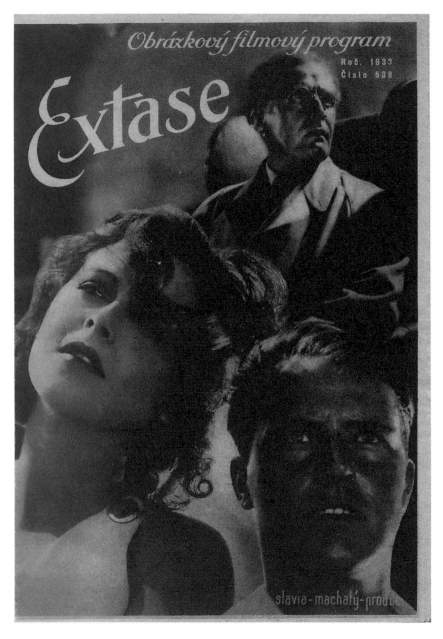

FIGURE 5.5. Illustrated film program for Gustav Machatý, *Ecstasy*, 1933 (*Obrazkový filmový program*, No. 538), cover. Anonymous author. Archive of Jindřich Toman.

ter draws his subject wearing pants and casting a shadow that wears a dress.[106] Toyen adopted masculine attire as well as a male grammatical persona, bending gender further than Marcel Duchamp's occasional feminine *alter ego* Rrose Selavie ever did. Her plentiful contributions to *Erotic Review* ranged from the bawdily Rabelaisian (jugglers with ridiculously Priapic penises, "girlfriends" [*přítelkyně*] tickling one another's pudenda with a feather)[107] to the longingly Orientalist. In "Women of the East" (*Ženy východu*), who are instantly recognizable from the fact that they wear nothing but necklaces, anklets, turbans, and veils, one lovely goes down on another while masturbating a third.[108] Grass-skirted African women straddle a boulder shaped like a giant phallus in "In the Paradise of the Exotics" (*V ráji exotů*).[109] Daydreaming under waving palms, another grass-skirted maiden hugs another giant penis by way of illustration of Bronislaw Malinowsky's *Legends and Tales of Melanesia*.[110] Toyen's girls just want to have fun, it seems—anywhere and everywhere, as long as it is somewhere other than the gray stone town on the fiftieth parallel where life never goes off the rails.

Erotic Review jubilantly trawled the *dessous* of the world, guiding its readers down the highways and byways of the sexual imagination with reproductions of Japanese *shunga*, eighteenth-century English engravings of flagellation scenes, Leonardo da Vinci's *Venus Obversa*, and drawings by Aubrey Beardsley and Félicien Rops. The dangerous diversions lurking in the ordinary were cheekily brought home in an illustration from a school textbook of a *Phallus Impudicus*—the common stinkhorn mushroom. The review's textual contents were equally catholic. There were poems by Byron, Baudelaire, Mallarmé, Rimbaud, and Verlaine; stories by Swinburne, Sade, E.T.A. Hoffman, and Victor Hugo; and an abundance of (what were alleged to be) "popular" rhymes, tales, and songs. Kiki de Montparnasse's account of the troubles she had losing her virginity at the age of fifteen snuggled up to Wanda Sacher-Masoch's memoirs of the troubles she had in satisfying her husband Leopold's insistent desire to be whipped. Selections from Freud's *Psychoanalytic Diary of a Sixteen-Year-Old Girl* bedded down with excerpts from the Kama-Shastra—and Breton and Éluard's poetic experiments with the same genre in *The Immaculate Conception*[111]—not to mention Bohuslav Brouk's essay "Onanism as a World View," passages from Louis Aragon's *Irene's Cunt*, and a directory of Paris brothels. The male visitor to the city of light could now end his tour through the literary cafés and artists' ateliers recommended in Štyrský and Toyen's *Guide to Paris and Its Environs* with a rendezvous at the establishments of Mesdames Nelly, Olga, Daisy, and Jane—or, perhaps,

the Crystal Palace on the rue Colbert.[112] Sadly, no such guidance was provided for the lady traveler.

Though there was much discussion of what a woman wants and by what signs a man might tell whether or not she is getting it, no ladies were present either at the two meetings in which Breton, Aragon, Benjamin Péret, Max Morise, Pierre Naville, Man Ray, Yves Tanguy, and other members of the Paris surrealist group set out to explore the erotic in January 1928. The transcript of their discussions, which was originally published in *La Révolution surréaliste* under the title "Recherches sur la sexualité,"[113] was translated in *Erotic Review* in 1931. Breton cut straight to the chase: "A man and a woman make love. To what extent is the man aware of the woman's orgasm? Tanguy?"[114] Several women, including Jeanette Tanguy and Nusch Éluard, would participate in subsequent surrealist *soirées* on sexuality (of which there were at least twelve between 1928 and 1932), going some way toward redressing what Louis Aragon criticized as "the inevitable preponderance of the male point of view."[115] Other contributors to later sessions included Paul Éluard, Max Ernst, and Antonin Artaud. But although *La Révolution surréaliste* promised the series would be continued the transcripts of the rest of the discussions remained unpublished until 1990. It is a pity, for these are extraordinarily revealing documents—not least, in their unveiling of the mundane fears and phobias haunting many a surrealist imagination.

The "Recherches" were notorious at the time for their frankness. They have become more infamous since for André Breton's far from libertarian stance toward homosexuality, which he regarded as "a moral and mental deficiency"—though he made an exception for "the unparalleled case" of the Marquis de Sade, for whom, he said, "by definition, everything is permitted."[116] "I find the whole thing [homosexuality] utterly repugnant—active or passive, they're all fucked," he exploded. Lesbians, on the other hand, he found "very appealing."[117] The surrealist leader's views on "inverts," which were typical enough of the times, were not shared by all members of the group—Louis Aragon and Raymond Queneau were notable dissenters—but Paul Éluard, who was in general a good deal more relaxed in his attitudes to sexuality than the uptight Breton, equally "abhor[ed] relations between men, because of the mental deformity they produce."[118] Breton was prepared to countenance sexual intimacy between males only as an expression of revolt—as in the case of the Marquis de Sade, "for whom freedom of morals was a matter of life and death."[119] His objection, he made clear, was not to the practice of sodomy, of which he held "the very highest opinion . . . first and fore-

most on moral grounds, principally non-conformism," so long as the orifice being penetrated was female. Gui Rosey was less high-minded: "I double my pleasure by the tightness of the anus and at the same time it enables me to stroke the woman's clitoris."[120]

It was this propensity to parlay the sordid into the sublime that so incensed Georges Bataille. "Too many fucking idealists" was his curt reply to Breton and Aragon's attempt to involve him in exploring "possibilities for joint action" among leftist writers, artists, and intellectuals in March 1929.[121] Bataille was less than impressed by the surrealists' invocation of the Divine Marquis. The prefix *sur-* in *surréalisme,* he sneered in an unpublished article of 1929–30—another outraged response to Breton's *Second Manifesto*—testified to "the predominance of higher ethereal values. . . . The resulting adulterations matter little to the surrealists: that the unconscious is no more than a pitiable treasure-trove; that Sade, emasculated by his cowardly apologists, takes on the form of a moralizing idealist. . . . All claims from below have been surreptitiously disguised as claims from above; and the surrealists, having become the laughing-stock of those who have seen close up a sorry and shabby failure, obstinately hold on to their magnificent Icarian pose."[122] For his part Breton dismissed Bataille as "a staid librarian" who "for hours on end during the day, lets his librarian's fingers wander over old and sometimes charming manuscripts . . . [and] at night wallows in impurities wherewith, in his image, he would like to see them covered."[123] It is an interesting (and no doubt entirely unconscious) reversal of the respective virtues of the diurnal and the nocturnal as presented in *Nadja.*

Otakar Březina, whose reflections on homosexuality were posthumously published in the same volume of *Erotic Review* as the "Recherches sur la sexualité," was less confident about where to draw the line between purity and danger—noticeably less confident than he had been in condemning the obscenity of Otto Gutfreund's memorial to Božena Němcová's *Granny,* where the difference between right and wrong was clear to him as the light of day:

> Human attitudes change. To the Greeks, love for men was something normal. A woman may not let go and want to have all of him; but a sage needs undisturbed peace and freedom for his spiritual endeavors. So he satisfied his longing for the body, which every human being has, through relations with men, and then quietly got on with philosophy. Later times changed, and lo and behold, *the nineteenth*

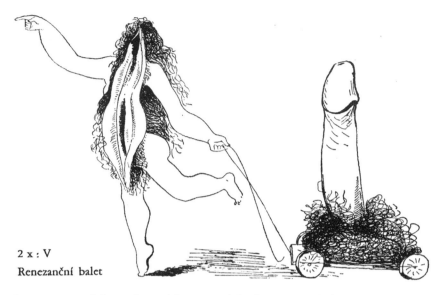

2 x : V
Renezančni balet

FIGURE 5.6. 2x: V (Alois Wachsmann), "Renezančni balet" (Renaissance Ballet). *Erotická revue*, Vol. III, 1933.

century condemned the poet Oscar Wilde to prison for the thing that to the Greeks was moral, while real and dangerous criminals roam the world freely.[124]

The italics, which anticipate René Daumal's question of what is the true obscenity in a world that makes a grisly fetish out of the unidentifiable body of an anonymous soldier, are Březina's own. For the record, the Czech poet was born in 1868—long before the first nude scene in film.

What set *Erotic Review* apart from the literary pornographies of Bataille and Aragon—though not of Apollinaire—was its comic vulgarity, in all senses of that word. One of Alois Wachsmann's pseudonymous drawings is a lavatory-wall variation on the theme of transplanted body parts that René Magritte and other surrealists turned into high art: a girl trips along pulling a hopelessly straining penis on a handcart, her head and torso replaced by an all-devouring vulva. The picture is sardonically titled "A Renaissance Ballet" (*Renesančni balet*).[125] František Bídlo, a close friend of Štyrský's, contributed an equally base series of cartoons to the review under the Balzacian rubric "The Human Comedy" (*Lidská komedie*). Bídlo would go on to become the nominal Czech editor of the German émigré satirical weekly *Simplicus* (later renamed *Der Simpl*), which appeared in simultaneous Czech and German

editions from January 1934 through July 1935. The paper's real editor was Heinz Pol, who had previously worked for the Comintern organizer and publisher Willi Münzenberg in Berlin. Adolf Hoffmeister was closely involved with the same venture.[126] *Simplicus* interleaved its anti-Nazi cartoons with plentiful erotica, a tactic that very effectively deprived Hitler's *neue Ordnung* of its gravity, if not its fatality. The censors added their own less than systematic contribution to the bewildering, leaving readers to puzzle over which particular obscenity, the politically or the sexually graphic, had occasioned this or that white space.

One of Bídlo's drawings for *Erotic Review* portrays Cupid aiming his arrow at a middle-aged man in a suit who is toying with the pudenda of the naked young woman seated on his lap. The caption reads: "It was late evening—the first of May—evening May—it was the time of love," the opening lines of Karel Hynek Mácha's "May," which by that time had taken on a sanctity far removed from the dark and incestuous sexual triangle around which the poem revolves.[127] The magazine's running "Contribution to a Popular Czech Erotic Dictionary" was equally irreverent, itemizing dozens of colloquial Czech terms for penis, vagina, breasts, and the like, and explaining their etymologies and regional variations. It was a wicked parody of the efforts of those generations of earnest awakeners who had so devotedly collected, categorized, and classified "popular" songs, tales, costumes, and customs over the previous century, puncturing the saccharine sentimentality that invariably attends such portraits of "ordinary folk." This is a ribald, music-hall, seaside-postcard humor that harks back to Hašek's *Švejk* and looks forward to the adventures of Hrabal's Ditie—the profane palavering of a body politic that pisses and shits, fucks and farts, and delights in warming up young girls' bottoms on Easter Mondays. We are a million miles away from the deadly family-values kitsch in whose image *das Volk* would shortly be reconstituted in neighboring Nazi Germany;[128] and equally far away from chocolate-box socialist-realist portrayals of "the people" as the hope for all that is good, decent, and moral in a faltering world. This is Prague, the magic capital of old Europe, where Average Joe rubs shoulders with well-heeled bourgeois among the sweet moldy scents of Wenceslas Square.

BEAUTIFUL IDEAS THAT KILL

Seventeen years after the spat between Oskar Kokoschka and the Berlin Dadaists over the relative contributions of painting and politics to human happiness, two blockbuster exhibitions in Munich sought to obliterate any distinction between the two. On 18 July 1937 Adolf Hitler opened *The Great*

German Art Exhibition (Grosse deutsche Kunstausstellung), which inaugurated the city's new House of German Art. Designed by the Führer's favorite architect Paul Ludwig Troost, the gallery was the first public building to be erected by the National Socialist government. Inside Torst's light-filled marble halls was a monster-show of artists whom posterity has largely forgotten and critics mostly dismissed as producers of kitsch. Hitler personally vetted the selection of exhibits, tearing down eighty-nine paintings from the wall in a fit of anger a month before the exhibition opened. The most common subjects on display, in order of frequency, were landscapes, nudes, and farmers, most of them painted in the "realistic" style favored by the Nazi regime. The German leader used the occasion to declare a "cleansing war" (*Säuberungskrieg*) against modern art. The body was much on his mind. "Today," he proclaimed, "the new age is shaping a new human type":

> In countless areas of life huge efforts are being made to exalt the people: to make our men, boys, and youths, our girls and women healthier and thus stronger and more beautiful. . . . Never has mankind been closer to antiquity, in appearance or feeling, than it is today. Steeled by sport, by competition, and by mock combat, millions of young bodies now appear to us in a form and a condition that have not been seen and have scarcely been imagined for perhaps a thousand years. A glorious and beautiful type of human being is emerging. . . . This human type, as we saw him in last year's Olympic Games, stepping out before the world in all the radiant pride of his bodily strength and health—this human type, you gentlemen of the prehistoric, spluttering art brigade, is the type of the new age. And what do you create? Misshapen cripples and cretins, women who can arouse only revulsion, men closer to beasts than to human beings, children who if they lived in such a shape would be taken for the curse of God![129]

The next day, just across the street, a very different exhibition opened. The Nazis did not anticipate that *Degenerate Art (Entartete Kunst)*, as the spectacle was called, would be much better remembered than the *Great German Art Exhibition*. It has become notorious in the annals of art history, though possibly for the wrong reasons; far more was at stake here than a simple confrontation of freedom and censorship, modernism and tradition, or progress and reaction. According to Josef Goebbels the intended destiny of the exhib-

its was for use as "fuel for heating public buildings" once the show was over, though in the event many were sold on the international art market for badly needed foreign currency. Over six hundred fifty "prehistoric splutterings," chosen from more than sixteen thousand works confiscated from public museums and galleries throughout Germany, were put on show in the cramped quarters of the annex to the Municipal Archaeological Institute. The contrast of venues could not have been more striking—or more deliberate. The dark, hastily cleared rooms in which the paintings were cluttered were normally used for storing plaster heads. The artworks on display ranged from the impressionism of Lovis Corinth through the provocations of Dada to the matter-of-fact modernism of New Objectivity, but it was expressionism—perhaps Germany's most distinctive contribution to the artistic vocabulary of the earlier twentieth century—that was most prominently pilloried. In some ways this was surprising, for many at the time believed that expressionism was the art of Nazi dreams.

That modernism need not be incompatible with fascism was proven by the example of Italy, where the futurists, among others, eagerly repaid Mussolini's patronage in kind.[130] Hailing the 1935 Italian invasion of Ethiopia, Marinetti had reminded his readers that:

> For twenty-seven years, we Futurists have rebelled against the idea that war is anti-aesthetic. . . . War is beautiful because—thanks to its gas masks, its terrifying megaphones, its flame-throwers, and light tanks—it establishes man's dominion over the subjugated machine. War is beautiful because it inaugurates the dreamed-of metallization of the human body. War is beautiful because it enriches a flowering meadow with the fiery orchids of machine-guns. War is beautiful because it combines gunfire, barrages, cease-fires, scents, and the fragrance of putrefaction into a symphony. War is beautiful because it creates new architectures, like those of armored tanks, geometric squadrons of aircraft, spirals of smoke from burning villages.[131]

This passage would be quoted by an appalled Walter Benjamin in his celebrated essay on "The Work of Art in the Age of Mechanical Reproduction" in support of his contention that "the logical outcome of fascism is the aestheticization of political life"—a grotesque "consummation of *l'art pour l'art*" in which "humankind . . . can experience its own annihilation as a supreme aesthetic pleasure." To fascism's aestheticization of politics, Benjamin con-

cluded, "communism replies by politicizing art."[132] John Heartfield would have wholeheartedly agreed, but Oskar Kokoschka, who had little time for politics of any stripe, would likely not have grasped the distinction.

Futurists were not the only modernists to benefit from the Italian state's largesse or to idolize Mussolini. Let us leave aside the embarrassing example of Ezra Pound, *il miglior fabbro* (as T. S. Eliot called him),[133] who is (too) readily explained away as a kooky American exception given to poetically confusing ancient and modern Rome. Giuseppe Terragni's Casa del Fascio in Como, built in 1934–36, is a classic of modernist architecture whose visual austerity exemplifies all the aesthetic virtues promulgated in *The International Style*. What the architectural textbooks usually omit to tell us is that Terragni linked "the typically functionalist concept that is uppermost in undertaking the construction of the *casa del fascio*" with "the Fascist faith." His clean, unadorned structure, a pure half-cube free of all obscuring facades and as bare of superfluous ornament as Adolf Loos could have wished, mobilized geometric harmonies to construct a forum for mutual transparency of state and people. "Thousands and thousands of black-shirted citizens," Terragni exulted, could "amass in front of the Casa del Fascio waiting for the voice of the leader to announce the advent of the Empire to Italians and foreigners." "We had to annul every break in continuity between internal and external ... no obstruction, no barrier, no obstacle between political leaders and the people," he explained. He went on to quote Mussolini at his most poetic: "'Fascism is a house of glass,' declares Il Duce, and the metaphoric meaning of the phrase reveals and exemplifies the building's characteristic organic unity, clarity, and honesty." [134] We are a long way from Mies van der Rohe's Farnsworth House, a beautiful goldfish bowl of a dwelling built in Plano, Illinois, in 1951 that has since become a modernist icon—or are we?[135]

Whether expressionism was an authentically "Nordic art" with "Gothic roots" was still being debated in National Socialist circles when Hitler came to power in January 1933. We might uneasily recall Pavel Janák's distinction of Northern and Southern architectures here—and again marvel at the ability of signifiers to recombine, yielding grotesque new syntheses. Josef Goebbels, who requisitioned Emil Nolde's canvases from museums to hang on his office wall at the Ministry of Public Enlightenment and Propaganda, was at loggerheads with Alfred Rosenberg, the President of the Reich Chamber of Culture, over the issue. A founder of the ultra-nationalist Kampfbund für deutsche Kultur (Combat League for German Culture), Rosenberg had rejected expressionism in his 1930 book *Der Mythus des zwanzigsten Jahrhunderts* (*The Myth of the Twentieth Century*) "because it had oriented itself,

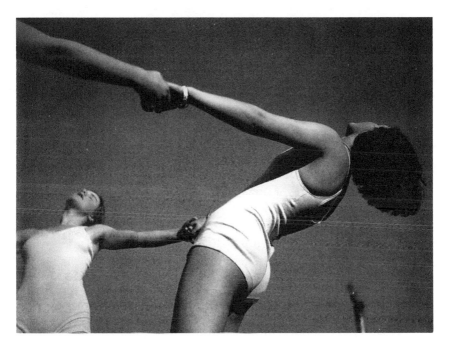

FIGURE 5.7. Václav Jirů, "Exercise on the Roof," 1933. The Museum of Decorative Arts, Prague.

ideologically and artistically, toward a foreign standard and thus was no longer attuned to the demands of life."[136] The poet Gottfried Benn was one of those who saw things differently. His "Confessions of an Expressionist," published in November 1933, is a lucid, passionate, and by no means far-fetched argument for seeing expressionism as a harbinger of fascism; expressionism, here, being understood much as it had been by Antonín Matějček to include *all* the "antinaturalistic expressions" produced in Europe between 1910 and 1925 from Braque and Picasso to Archipenko and Brancusi, which Benn contrasts with the "naïve—i.e., representational—art" that the Nazis were finally to endorse. Marinetti's *Manifesto of Futurism*, he (rightly) points out, anticipated the fascists in extolling "the love of danger," "aggressiveness," "the death leap," and "beautiful ideas that kill"; indeed "Futurism helped create fascism; the black shirt, the battle cry, and the war song, the Giovinezza, all derive from 'Arditismus,' the warlike section of Futurism."[137]

Benn gives an unexpected twist to the familiar avant-garde mantra of the "end of art." Expressionism, he proclaims, was "the last art of Europe," the owl of Minerva taking incandescent flight as the twilight fell on a dying age.

"What is now beginning, what is now making its appearance is no longer art":

> the Ghibelline synthesis of which Evola spoke is approaching politically that moment when Odin's eagles fly to meet the eagles of the Roman legions. This eagle as a coat of arms, the crown as mythos and several great intellects as the world's spiritual inspiration. Mythologically this means: the return home of the Norse gods, white man's earth from Thule to Avalun, imperial symbols there: torches and axes, and the breeding of superior races, solar elites for a world half-Doric, half-magical. Infinite distances being filled with possibilities! Not art. Ritual around torches and fire . . .The architecture of the South, fused with the lyricism of the Northern foglands; the stature of the Atlantids, their symbols will become grand songs, oratorios in Ampitheaters, choirs of fishermen, symphonies of conch shells, in limestone halls blending with the horns of primeval hunters. Infinite distances being filled, a great style approaching.[138]

Karel Teige was not the only one dreaming of a world in which the new art will cease to be art.

As late as March 1934 a large Italian futurist exhibition titled *Aeropittura* opened in Berlin with speeches by Marinetti and Benn. Goebbels was happy to serve on the honorary committee for the show. Hitler finally cut the Gordian knot at the Nuremberg rally that September. Quite why he took the position he did nobody knows. It may have had as much to do with his failed personal artistic ambitions—he was twice refused admission to the Academy of Art in Vienna—as with any more profound relationships between art and politics. It is not self-evidently absurd to entertain the possibility that had Hitler been accepted into art school there might have been no Holocaust; no less absurd, anyway, than our expectation that the course of history will always *make sense*. The Führer dismissed backward-looking *völkisch* fantasies of the kind favored by Rosenberg's Combat League for German Culture; he wanted an art fit for the times. But he also made it clear that Dada, cubism, futurism, and expressionism had no place in the *neue Ordnung*. This is the rally immortalized in Leni Riefenstahl's film *Triumph of the Will*, with its unforgettable opening shots of the Führer's airplane descending on the expectant city whose medieval streets are lined with children, mothers, and grandmothers throwing flowers and waving little swastika flags. Everyone is

scrubbed and smiling. Like the same director's equally powerful *Olympia*, a two-part record of the 1936 Berlin Olympic Games that begins with naked bodies in motion amid the ruins of ancient Greece, *Triumph of the Will* is a cinematic milestone whose technical innovations and inescapably modernist aesthetic resonate uneasily with its Nazi context and content—to us, that is, today. Riefenstahl herself had no difficulties in reconciling the medium and the message. "I was only interested in how I could make a film that was not stupid like a crude propagandist newsreel, but more interesting," she explained to a BBC News interviewer years later. "It reflects the truth as it was then, in 1934."[139]

Goebbels heeded his master's voice and set about ridding the Reich of anti-naturalist expressions with all the zeal of a convert. Despite outraged protests from the German Officers' Association, Franz Marc's Iron Cross and death in the service of the Fatherland at Verdun in 1916 did not save his work from inclusion in *Degenerate Art*. The painter of blue horses was another who had welcomed the Great War as social catharsis. On 14 October 1914 he assured Wassily Kandinsky, with whom he had coedited the *Blaue Reiter Almanac* two years earlier, that "the war will not be regressive for man, instead it will purify Europe, make it 'ready'"[140]—for what exactly, he did not say. Like Marinetti and Apollinaire, Marc discovered in "In War's Purifying Fire," as he titled an article published in July 1915, both beauty and truth:

> We are camped right now with munition wagons at the edge of a forest. It sounds like a storm with the thunder of cannon in the distance and everywhere there are small bursts of shrapnel. Both are part of the landscape, like the echo too, which multiplies every shot and carries it far away into the distance. Suddenly a terrific whirring noise moves over us in a gigantic arc; its sound is uneven, constantly ranging from a shrill whistle all the way to a deep rumble; like the long high screech of a bird of prey; one scream right after the other, like an animal which knows no other call. Then, in the distance, a dull thud. They are enemy heavy artillery shells roaring past us toward some unknown target. One shot follows another. The sky is an autumnal blue, absolutely clear, and yet we sense the channels cut through that sky by every shot.

"An artillery duel, even for the gunners themselves, often has something mystical and mythical about it," he goes on. "We are the children of two different

258 | CHAPTER 5

epochs. We of the twentieth century experience daily that all the sagas, all mysticism and occult wisdom once was truth and someday will again be truth." "Those out here who are living through it ['this dreadful war'] and are beginning to realize what we shall conquer by it," he warns, "realize full well that one cannot put new wine in old bottles. Our *will to a new form* will restructure this new century." Marc was no Nazi—he ends his article with a plea that "we Germans must shun nothing more passionately than narrowness of feeling and national ambition" [141]—but this was a mystic synthesis of antiquity and modernity that uncomfortably augured Benn's half-Doric, half-magical dystopia.

Emil Nolde, a leading light of the expressionist groups Die Brücke (The Bridge) and Der Blaue Reiter (The Blue Rider), did not escape the slur of "degeneracy" either, despite his membership in the Nazi Party since 1920 and disdain for the paintings of "half-breeds, bastards, and mulattoes." [142] In 1936 Nolde was forbidden to engage in "any activity, professional or amateur, in the realm of art" because of his "cultural irresponsibility." [143] Protesting the "defamation raised against my paintings," he assured Goebbels in July 1938 that "I, virtually alone among German artists, fought publicly against the foreign domination of German art. . . . My art is German, strong, austere, and sincere." [144] Seven years later, when Germany lay "prostrate, crushed, and shattered" and "our beautiful home on Bayernallee was destroyed by bombs," he was having second thoughts. "And what if we had won the war?" he bitterly asks. "Germany's spirituality—her most beautiful attribute—would then have been utterly eradicated." [145] During the war Nolde was reduced to painting tiny watercolors on fragments of rice paper, fearing that the smell of oils would give him away. No less than 1,052 of his works were confiscated from German museums in 1937. Twenty-seven of them were exhibited in *Degenerate Art*. The "selection was determined purely according to artistic standards," insisted Adolf Ziegler, the painter who chaired the commission that oversaw the confiscations. "The master of pubic hair," as Ziegler was popularly known—his forte was the female nude, depicted with a realism so meticulous it left nothing for the imagination to work on—had been Hitler's personal artistic advisor since 1929. One of his subjects was the Führer's blonde niece Geli Raubal, reputedly the only woman Hitler ever loved. Ziegler's triptych *The Four Elements: Fire, Water and Earth, Air*, a highlight of the *Great German Art Exhibition*, hung above the fireplace in Hitler's apartment in Munich. [146]

Goebbels's decree empowering the seizures from museums defined degenerate art as works that "insult German feeling, or destroy or confuse natural

form, or simply reveal an absence of adequate manual and artistic skill."[147] This was a dumpster capacious enough to accommodate the divergent talents of Max Beckmann, Heinrich Campendonk, Marc Chagall, Otto Dix, Lyonel Feininger, George Grosz, Raoul Hausmann, Erich Heckel, Alexej von Jawlensky, Wassily Kandinsky, Ernst Ludwig Kirchner, Paul Klee, El Lissitzky, Laszlo Moholy-Nagy, Piet Mondrian, Max Pechstein, Oskar Schlemmer, Karl Schmidt-Rottluff, and Kurt Schwitters—to name but a few of those hung out to dry in *Degenerate Art*'s cabinet of curiosities. Oskar Kokoschka's response to the inclusion of seventeen of his works in the exhibition—one of which was *Bride of the Wind*—was to paint a *Self-Portrait as a Degenerate Artist*.[148] His earlier self-portraits as a shaven-headed convict had proved to be remarkably prescient. So had his intuition that when works of art lose the aura that protects them from the political conflicts of the day it is not just the fate of pictures that is on the line. Many of those named and shamed in *Degenerate Art* were not even Germans, but the fact that only six were Jewish did not stop them all being portrayed as representatives of the "Bolshevik-Jewish onslaught on German art."[149] The offending works were displayed on panels daubed graffiti-style with quotations from Hitler, Goebbels, and Rosenberg, in deliberate parody of the installation techniques pioneered at the 1920 International Dada Fair. On the "Dada Wall," as it was mockingly called, the paintings were originally hung askew, but Hitler put a stop to that.

Degenerate Art showed in Munich from 19 July until 30 November 1937, with twenty thousand visitors a day forming long lines to get in. Over the next four years the spectacle went on to tour eleven more cities throughout Germany and Austria. It was viewed by a total of over three million people—2,009,899 in Munich, 500,000 in Berlin, 147,000 in Vienna—more than five times as many as attended the *Great German Art Exhibition*. It remains the biggest turnout ever seen anywhere then or since for any single exhibition of modern art; a statistic whose surreality should pull us up short, though it probably does not.[150] What the spectators came to see—whether old friends for the last time (as Oskar Kokoschka believed),[151] evidence that Weimar Germany had indeed been going to hell in a hand basket, or merely the titillating delights promised in the exhibition's prurient title—is uncertain. What the Nazis intended them to see was made plain enough. It was not the tale of modernist progress swept ever forward, backward not a step by successive avant-gardes with which we are familiar from the displays at MoMA, the Tate Modern, or the Centre Pompidou.[152] The largest modern art show of all time ordered the planes and surfaces of the world under headings that included "The Cultural Bolsheviks' Order of Battle," "The Jewish

Longing for the Wilderness Reveals Itself—In Germany the Negro Becomes the Ideal of a Degenerate Art," and "Nature as Seen by Sick Minds."[153]

These captions were impromptu: Ziegler had only two weeks in which to prepare the Munich installation. But before the show was over a guide was produced that arranged the works according to "a clear organizational principle" and this served as the "recommended sequence" for the exhibition's later incarnations. It is an idiosyncrasy of English grammar that paintings are hung and men are hanged, but the perspective from which *Degenerate "Art"* (as the guide was titled) was written does away with any such nice distinctions. Art becomes no more than the continuation of politics by other means. The work of art has no meaning, no value, outside of the utilities of its time and place—and certainly no right to exist in the realm of the imagination alone, independently of the exterior object which brought it to birth. The only question to be asked of a painting or sculpture is the question František Kupka refused to entertain: *What does it represent?* The signifier is collapsed into the signified, the object reduced to an image. The formal innovations in the use of space, color, perspective, and materials by which *we* have since come to identify art as "modern" are seen here as no more than symptoms of social (or for the Nazis, racial) degeneration, "the gruesome last chapter of those decades of cultural decadence that preceded the great change."[154]

The first group of paintings in the exhibition, the guide explains, offer "an overall view of the *barbarism of representation* from the point of view of technique," exemplifying "the progressive *collapse of sensitivity to form and color*, the *conscious disregard for the basics of technique* that underlie fine art, the *garish spattering of color*, the *deliberate distortion* of drawing, and the total *stupidity of the choice of subject matter*."[155] The paintings in group 3 illustrate how "the methods of *artistic anarchy* are used to convey *an incitement to political anarchy*. Every single image in this group is an incitement to *class struggle* in the Bolshevik sense."[156] The works in group 6 were particularly odious from the National Socialist point of view, since they supported "that segment of Marxist and Bolshevik ideology whose objective is the *systematic eradication of the last vestige of racial consciousness*," holding up "the *Negro* and the *South Sea Islander* as the evident *racial ideal* of 'modern art.'"[157] The paintings in group 7 showed the "specific *intellectual ideal*" of modern art to be "the *idiot*, the *cretin*, and the *cripple*."[158] In case the latter association was insufficiently clear the guide reproduced drawings by children and psychiatric patients side-by-side with works of modern art. It could equally well have made the point by quoting André Breton, who had told his audience at the Mánes Gallery in Prague two years earlier that the goal of art was "to liberate instinctive

impulses, to break down the barrier that civilized man faces, *a barrier that primitive people and children do not experience.*"[159]

Jarring as it may be to present-day liberal American sensibilities, this equation of the "primitive," the childlike, and the insane—together with, as often as not, "the eternal feminine"—was the common intellectual currency of the day on the political left and right alike. The difference, which seemed more important at the time than it appears to have become for many critics since, was that while the surrealists regarded what was *not* white, adult, sane, and male as sources of liberation from a civilization they despised the Nazis confined women to *Kinder, Küche, und Kirche*, raised their children in the Hitler Youth, and dealt with racial inferiors and mental defectives through the hygiene[160] of the gas chambers. They would have had as little time for Jaroslav Seifert's yearnings for different-colored girls in every port (and still less for the joyful obscenities of Toyen's *Paradise of the Negroes*) as for Devětsil's revolutionary politics. Thirteen of Otto Mueller's canvases were shown in *Degenerate Art*, as much because of his fondness for dark-skinned subjects as his associations with Die Brücke and Der Blaue Reiter. One of them was titled *Gypsy Child with Donkey*. We can imagine her probable fate. Many of Mueller's paintings were female nudes of an angular charm and androgynous delicacy a million miles from Ziegler's Nordic *Frauen*. He took his inspiration from ancient Egyptian frescoes, whose colors and texture he tried to reproduce through lime watercolors. The *mons Veneris* is suggested, but not detailed, in his *Six Nudes in a Landscape*, a heart-shaped blur on a girl like a gazelle.[161]

SEXUAL NOCTURNE

"How ridiculous!" explodes Vítězslav Nezval in *Sexuální nocturno* (*Sexual Nocturne*, 1931). "A writer is expected to make a fool of himself by employing periphrastic expressions while the word 'fuck' [*mrdat*] is nonpareil in conveying sexual intercourse.... I have little tolerance for its disgraceful and comic synonyms. They convey nothing; they are mealy-mouthed puffballs and I practically retch when I have to encounter them."[162] The setting for Nezval's "tale of unmasked illusion" (as the book is subtitled) is certainly a dreamscape, hovering between past and present, reality and imagination, "a mosaic of images where ennui is condensed through the archaism of desolate streetlamps, lunatic nights under a full moon, and floodlit bodies—the archaism of fetishism, garters, divans, make-up, alcohol, and the deep despondency of an insatiable sensibility," to quote the book's promotional flyer.[163] But grasping the surreal, for Nezval, required getting real. The story revolves

around the poet's bumbling, fumbling loss of his virginity to a prostitute in the little Moravian town of Třebíč where his parents sent him away to school at age eleven. As we know from Franz Kafka and Jaroslav Seifert, the brothel was not an uncommon rite of passage for young men in those days. Nice girls didn't, and the red lantern lit the portals of knowledge.

Could Nezval's quotidian tale be *truthfully* told, in all its pathos and hilarity, without the dirty words?

> I said FUCK to myself over and over as I shambled along the footpaths with a constant erection. The whole of my desire fixated on two words: FUCK and BORDELLO. Sensuality led me like a sleepwalker across the town square where two or three factory girls were loitering.
> I walked with my fly open; it was concealed by my cloak.
> I went through the town gate toward the bordello.

A girl came out of the washroom and asked him whether he wanted to go to a room or the bar. He managed to stammer "a room." She took his hand, and singing "an unintelligible operetta" (as Nezval assures us hookers always do) led him upstairs "somewhere beyond that unreal world where fires burn and one is vaccinated for cholera." Taking off her dress, she revealed "a dappled slip" that "roused me. . . . I said to myself BORDELLO. Over and over I said it: BORDELLO, BORDELLO, BORDELLO, BORDELLO. And in coming to my senses there also sounded way back on my tongue the word FUCK." But—of course—the youngster was overcome by embarrassment and signifier and signified parted company. "FUCK suddenly lost its meaning. My prick shriveled pathetically." "You've never fucked before, have you?" the girl asked him. "Play with me, you silly boy." She took off her panties. "This certainly stirred me. Without any segue—and to many it would seem beyond all reason—I thrust my head into her pussy." And soon "I was fucking. I was fucking and I spurted into her cunt, which itself was somehow moving like a slug."

> I shouted out: FUCK, FUCK!
> She said: "Hold on and stay a little longer."[164]

Sexual Nocturne was the first volume in Jindřich Štyrský's Edice 69 (Edition 69), a companion imprint to *Erotic Review* that promised to "bring out works of outstanding literary merit and be an album of graphic art that will have long-lasting artistic value."[165] Like the magazine (and for the same legal reasons) Edice 69 was intended only for "a circle of friends and collectors."

The sexual allusion of the edition's title hardly needs comment. Six books were published in the series between 1931 and 1933, among them the Marquis de Sade's *Justine* and František Halas's *Thyrios*—a collection of erotic poems Halas was subsequently to disown as "juvenilia," even if he had already turned thirty when the book came out. The artwork certainly deserves to be better known. Štyrský's illustrations for *Sexual Nocturne* bring to mind Max Ernst's collage-novels, which were composed from cut-up pictures in dime fiction, Ernst said, "with method and violence."[166] Though "the girl resembled all the women from the xylographic illustrations in pulp novels," insists Nezval, "it was a very real room" and "an absolutely real whore."[167] Toyen illustrated *Justine*. Her frontispiece is a pair of eyes staring out of a vagina, recalling the scene that climaxes Bataille's *Story of the Eye*. Bataille was not the first to employ this conceit: a vaginal eye also surveys all in Hannah Höch's collage "Dada-Ernst" (Serious Dada, 1920–21), whose title puns on the name of the painter to whom, Hannah later said, she always felt closest.[168] Toyen reversed the metaphor in an untitled drawing published in the first volume of *Erotic Review*, portraying a girl's head whose eyes and lips have been replaced by vaginas. Anticipating a recurrent motif of her postwar imagery, a bird pecks away at the mouth.[169]

Apollinaire would have appreciated another of Toyen's illustrations for *Justine*; in the shadow of a female torso tied securely at the waist, buttocks lashed to an angry *mélange* of raspberry and milk, mustachioed lips suck a tumescent cock.[170] "Right now I adore you like a madman," he wrote to Louise de Coligny on 28 January 1914. "I think of your eyes when you are making love to me, of your mouth, a deep wound":

> I remind myself of the adorable position you assumed on Saturday, your upraised buttocks in all their fullness and between them that broad strip of brown and soft flesh where the perpendicular and pouting mouth opens that I adore. It opens every time your bottom moves. It seems on the point of talking, and I, the master armed with the whip of justice, I lash this marvelous map of the world in two hemispheres. You, you suffer it in your pride, you suffer and love changes your suffering into voluptuous pleasure. The harder I whip, the more your bottom moves, it rises higher and higher, unveiling for me your wet and swollen sex. Next time you must spread yourself better so that I can beat your shadowed crack where that yellow lozenge lies with

which you are so stingy. The other day you were bucking
like a carp jumping out of the water.[171]

It is appropriate that Toyen should have provided the frontispiece for the
Czech edition of *Alcohols* that came out in 1932.[172] Karel Srp's assertion that
(with the exception of her illustrations for *Justine*) "during these years Toyen
did not identify eroticism with cruelty, as for instance did Nezval, or with
death, as is typical in Štyrský" is difficult to reconcile with her drawing
Výprask na holou (Bare-bottom Thrashing, 1932), which portrays two well-
whipped posteriors in the same adorable position beside a cane and top
hat.[173] That same year she furnished seventy-two illustrations for the Czech
translation of another classic of feminine bawdy, the sixteenth-century *Hep-
tameron* of Marguerite d'Angoulême, Queen of Navarre. Unlike *Erotic Re-
view* or Edition 69 the *Heptameron* was aimed at a mass market, but that did
not stop Toyen from flirting with the same dangerous liaisons of pain and
pleasure in drawings of girls bound and gagged or lying naked and helpless
on beds while being threatened by drawn swords. Štyrský licked his lips at
the feast of "Female torsos, noble eyes, full of erotic boredom, terrible and
perverted in the moment of orgasm, gently veiled in the moment of death."[174]
Ladislav Sutnar designed the book's sumptuous gold binding, hinting at the
dark delights to be found within.[175]

Edition 69's most significant artistic achievement was probably the last
volume in the series, Štyrský's *Emilie přichází ke mně ve snu* (*Emily Comes to
Me in a Dream*), which appeared in 1933 in a print run of sixty-nine copies.
Like Ernst's *Hundred Headless Woman*, *Emily* was inspired by the death of
the artist's sister at the age of six. Both girls, by further coincidence, were
called Marie. Using materials scissored from English and German porno-
graphic magazines, Štyrský illustrated his text with some astonishing photo-
montages, which have not lost their capacity to shock even today. "An unwit-
ting smile, a sense of the comic, a shudder of horror—these are eroticism's
sisters," he warned his readers. "The sisters of pornography, however, are only
shame and disgust. Some will look at these erotically-charged photomon-
tages with a smile on their lips, others in horror."[176] His distinction would be
lost on the US Customs, who blocked the loan of the original collages for
Emily to the Centre Pompidou for the exhibition *féminimasculin: Le sexe de
l'art*—one of the most challenging explorations of art and sexuality ever
mounted by a major museum—in 1995.[177] In one of Štyrský's tableaux a
woman wearing nothing but lacy knickers, her face covered by a fan, lies be-
side a skeleton whose fleshy penis is enormously erect. It is as ominous an

image as Picasso's *Guernica* or Dalí's *Premonition of Civil War*; an anticipation of obscene couplings to come whose prescience can only be explained, if it can be explained at all, as a manifestation of *hasard objectif*. It was Hugo Ball's bordello, rather than Vítězslav Nezval's homely establishment in Třebíč, that was preparing to open its doors once again to a new generation of fresh-faced boys.

In the final, more joyful image from *Emily* sperm spurts across the Milky Way to link male and female sexual organs like God's finger electrifying Adam on the ceiling in the Sistine Chapel.[178] The visual allusion to Michelangelo's masterpiece is unmistakable—and so is the implied critique of Christianity's displacement of the brute carnalities of creation. Štyrský was tapping into a deep vein of surrealist anti-clericalism here, which extended from the public insults of Antonin Artaud's "Address to the Pope" in *La Révolution surréaliste* ("The world is the soul's abyss, warped Pope, Pope who is external to the soul. Let us swim in our bodies, leave our souls within our souls; we have no need of your knife-blade of enlightenment")[179] to André Breton's private humiliation of René Magritte's young wife Georgette for daring to turn up for dinner wearing a cross—not to mention Man Ray's "Hommage á D. A. F. de Sade," which invitingly positions the crack of a female bottom (which probably belonged to Lee Miller) in the arms of an upside-down crucifix.[180] Inspired, perhaps, by the carnage in Champagne where he was serving in October 1915, Guillaume Apollinaire came up with a still more perverse play on Christian pieties. "My mouth will be crucified," he wrote in his fourth *poème secret* for his fiancée Madeleine Pagès, a teacher at a high school for girls in Oran with whom he started where he left off with Lou:

> And your mouth will be the horizontal bar of the cross
> And which mouth will be the vertical bar of this cross
> O vertical mouth of my love!
> The soldiers of my mouth will assault your womb
> The priests of my mouth will burn incense to your beauty in its
> temple
> Your body will tremble like a region in an earthquake . . . [181]

One of Toyen's drawings for Pietro Aretino's *The Secret Life of Penitents* (*Život kajícnic*), another volume published in Edice 69, portrays a no less sacrilegious combination of cunnilingus and a crucifix. A young nun wearing nothing but a wimple watches the action, a rapt expression on her face.[182]

Max Ernst railed against the Vatican's zoning of the female body in his article "Danger of Pollution," which appeared in *Surréalisme au service de la*

révolution in 1931. The painter is as alive to the erotic productiveness of such carnal cartographies as Michel Foucault,[183] but they disgust him all the same:

> Consummated natural fornication, unconsummated natural fornication, simple fornication, expert fornication, the quick fuck, abduction, prostitution, conjugal duty demanded and given, prevention by impotence, kisses on unusual parts of the body, kisses on moral parts, lovebird kisses, innocent kisses and worldly kisses, ejaculations, simple and expert masturbation, masochistic lusts, chastity, inadvertent or intentional pollution, nocturnal pollution, danger of pollution, sodomy, bestiality, illicit advances, intercourse between spouses, the woman's natural vessel, anterior vessel, posterior vessel, the sacred vessels, plays, dances, interrupted movements, the equestrian way, calculated dripping, the spent sperm, genital spirits, the demon, incontinence, the thorn of the flesh, the procreation of the species, sacred embryology—and all that crap of the doctors of the Church.

And on, and on goes the catalogue of sins venal and mortal, the litany of titillation. "We know the value of words," Ernst sniffs, "and the dangers of pollution have become such a familiar habit that we proudly enjoy them as a sign of urbanity. Thanks to the prescience of the Church doctors the female body is now divided by horribly precise borders into decent and indecent areas. Irresistible passion may sometimes cause these borders to disappear, but they continually return with nauseating sharpness—until the glorious day when a happy massacre will rid the earth of clerical pests forever." "Love has to be made by all and not merely by one," he ends. "Lautréamont said that . . . or almost."[184]

Accompanying *Emily's* text was a more analytic but no less inflammatory afterword by Bohuslav Brouk. Contrasting Štyrský's "pornophilic art" with the "pornographic kitsch" secreted away by "puritans . . . in closed drawers until required for that occasional arousal (which as a rule their shabby wives can no longer produce)," the young psychoanalyst explains that "the artist whose work is not bound to reality sees no need to have naked girls urinate into a chamber pot when he could offer them an Alpine valley instead. An ejaculation need not become a yellow stain on the bedding—it can be transformed into a bolt of lightning and used to cleave a Gothic cathedral."[185] Brouk's essay is as trenchant a statement of the politics of Eros as one can find

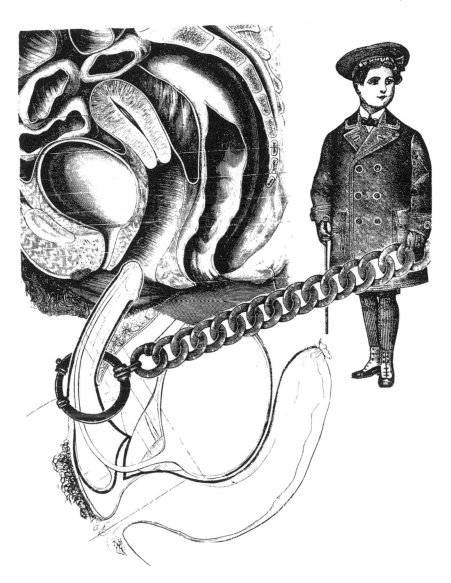

FIGURE 5.8. Jindřich Štyrský, illustration for Vítězslav Nezval, *Sexuální nocturno: Příběh demaskované iluse* (Sexual Nocturne: A Tale of Unmasked Illusion). Prague: Edice 69, 1931.

anywhere in surrealist literature. "Those who conceal their sexuality," he begins, "despise their innate abilities without ever having risen above them":

> Though they reject human mortality, they are incapable of liberating themselves from the lugubrious cycle of life—made possible and guaranteed by the genitals—to achieve the immortality of the mythical gods. And though they have created the illusion of their own immortality, thereby ridding their behavior and even their psyche of any sexual character, they will never eliminate the corporeal proof of their animality. The body will continue to demonstrate mortality as the fate of all humans. It is for this reason that any reference to human animality gravely affects those who dream of its antithesis. They take offence not only at any mention of animality in life, but in science, literature, and the arts as well, as this would disturb their reverie by undermining their rationalist airs and social pretensions. By imposing acts both excremental and sexual on their perception, their superhuman fantasies are destroyed, laying bare the vanity of their efforts to free themselves from the power of nature, which has, in assuming mortality, equipped them with a sex and an irrepressible need to satisfy its hunger.

"The body," Brouk concludes, "is the last argument of those who have been unjustly neglected and ignored; it demonstrates beyond debate the groundlessness of all social distinctions in comparison to the might of nature"[186]—not unlike Josef Sudek's *Sad Landscape*, we might say, or the Spanish flu.

Brouk's emphasis on the animal (and the excremental) positions him closer to Bataille's "base materialism" than to the idealistic Breton, but that difference, too, would be magicked away in the euphoria of the French surrealists' 1935 visit to Prague. What Breton might have made of Nezval's *Sexual Nocturne* is moot, since he would have liked to see all brothels closed down, he said, on the grounds that "they are places where everything has a price, and because they're rather like asylums or prisons."[187] It is perhaps fortunate that the surrealist leader was unable to read Czech; certainly his ignorance helped keep the magic capital firmly located in poetic space. "I detest foreign languages," he had joked during the "Recherches sur la sexualité" in response to his own question of whether it would be pleasant or unpleasant to make love to a woman who did not speak French.[188] The jest was as serious as ever;

Breton notoriously refused to learn English during his wartime exile in the United States. As for the dirty words in whose repetitions Nezval wallowed, this was one area in which the champion of *écriture automatique* was unwilling to let language off the leash. Breton concluded his introduction to the surrealists' 1959 EROS exhibition with the observation that "our deepest concern has been to banish such words—the representations they entail—from this exhibition."[189] "I have the lowest opinion of erotic literature," he pontificated during the "Recherches"—though he once again exempted the Marquis de Sade, whose writings he did not consider erotica.[190] Paul Éluard was less prudish, reminding his fellow-poet "this is an investigation of sexuality, not love."[191]

Knowing Štyrský's interest in Sade, Éluard reciprocated the parting gifts the Czech painter gave him in Prague (two paintings, *Sodom and Gomorra* and *The Man of Ice*, and several collages) by making a present of an original manuscript by the Marquis himself. Štyrský's joy, reported Nezval, was "immense. He is literally *émerveillé*."[192] Štyrský made his own pilgrimage to the ruins of Sade's chateau at La Coste in Provence in the summer of 1932. It was there that he took his first photographs.[193] Sade was an obsession Éluard shared. "Three men have helped my thought liberate itself from itself," he wrote in 1926, "the Marquis de Sade, the Comte de Lautréamont, and André Breton."[194] He elaborated in "Poetic Evidence," the lecture he delivered ten years later at the International Surrealist Exhibition in London, which comes as close to a personal and artistic credo as anything he ever wrote. The "Divine Marquis," he explained, "wished to give back to civilized man the force of his primitive instincts, he wished to liberate the amorous imagination from its fixations. He believed that in this way, and only in this way, would true equality be born."[195] Sade and Lautréamont "both fought fiercely against all artifices, whether vulgar or subtle, against all traps laid for us by that false and importunate reality which degrades man. To the formula: 'You are what you are,' they have added: 'You can be something else.'"

> They demolish, they impose, they outrage, they ravish. The doors of love and hate are open to let in violence. Inhuman, it will arouse man, really arouse him, and will not withhold from him, a mere accident on earth, the possibility of an end. Man will emerge from his hiding-places and, faced with the vain array of charms and disenchantments, he will be drunk with the power of his ecstasy.

He will then no longer be a stranger either to himself or to others. Surrealism, which is an instrument of knowledge, and therefore an instrument of conquest as well as of defense, strives to bring to light man's profound consciousness. Surrealism strives to demonstrate that thought is common to all, it strives to reduce the differences existing between men, and, with this end in view, it refuses to serve an absurd order based upon inequality, deceit and cowardice.[196]

Not everyone present at the New Burlington Galleries was happy to see such doors opened. "Only when Paul Éluard delivered his poetry lecture on 24 June and talked of de Sade, that holy martyr of freedom," relates the English surrealist painter Eileen Agar, "did Augustus John, until then quietly sitting in the audience, get up noisily and exit, dragging his blonde companion with him, slamming the door behind him." John was no innocent in matters of the flesh himself; the old roué had scandalized Edwardian England with his own *ménage à trois* a quarter-century previously, but the Divine Marquis was evidently a transgression too far. "For some," Agar continues, "the liberation was too much."[197] Indeed. As T. S. Eliot once remarked, humankind cannot bear very much reality.[198] The author of *The Waste Land* was another who visited the London surrealist exhibition where, Eileen tells us, he lingered long and lovingly "in front of Meret Oppenheim's teacup and saucer covered in fur, obviously moved by this super-objective correlate of the female sex."[199]

Cut with a Kitchen Knife

In March 1933 the Nazi government seized the Berlin offices of the Malik-Verlag publishing house, froze the company's assets, and confiscated and destroyed around 400,000 of its books. Wieland Herzefelde fled for Prague with just the clothes he was wearing. John Heartfield joined him the following month. "On Good Friday, 1933," the erstwhile Monteurdada relates in his *Curriculum Vitae*, "the SS broke at night into my apartment, where I happened to be packing up works of art. I managed to escape arrest by jumping from the balcony of my apartment, which was located on the ground floor. At the urging of the [Communist] Party, I emigrated by walking across the Sudeten Mountains to Czechoslovakia on Easter."[200] Czech boys would have been doing their best that weekend to emulate Apollinaire's amorous attentions to Louise de Coligny's *mappemonde merveilleuse*, but Heartfield was not the

sort to be diverted by fun and games with *pomlázky*. With the help of Vincenc Nečas, F. C. Weiskopf, and others the brothers swiftly reestablished Malik-Verlag on Czech soil.[201] We encountered Weiskopf earlier as a critic of Jaroslav Seifert's *Love Itself*; he had been working in Berlin since 1928 but returned to Prague following the Nazis' triumph. His *Zukunft im Rohbau* (The Future in the Making, 1932), a panegyric to the Soviet Union, turned out to be Malik's last Berlin publication. Unable as a foreigner legally to incorporate the firm in Czechoslovakia, Wieland arranged for a sign MALIK-VERLAG PUBLISHING COMPANY to be fixed outside the London offices of John Lane's The Bodley Head. All the books Malik published in Prague carried a nominal London imprint, but only one was actually produced there— the sociologist Karl August Wittfogel's fictionalized account of his experiences in *Staatsliches Konzentrationslager VII: Eine "Erziehungsanstalt" im Dritten Reich* (State Concentration Camp VII: An "Educational Institution" in the Third Reich, 1936). Malik brought out a *Neue Deutsche Blätter* (New German Paper) in Prague from September 1933. "He who writes, acts," proclaimed Wieland in the first issue. "We wish to fight fascism with our literary and critical words. In Germany the Nazis are raging, we find ourselves in a state of war. There is no neutrality, not for anyone. Above all, not for writers."[202]

Malik-Verlag published over forty titles during the next five years, including works by Agnes Smedley, Mikhail Sholokhov, Ilya Ehrenburg, and Bertolt Brecht. The passage to print was not always smooth. Weiskopf's tale of the misfortunes of Willi Breder's novel *Begegnung am Embryo* (Encounter in Embryo) would not have been out of place in Breton's *Anthology of Black Humor*. It also brings to mind Lemony Snicket's *Series of Unfortunate Events*, in which the aptly named Baudelaire children suffer one gruesomely improbable disaster after another, but that is of course only children's fiction.

> Shortly after the manuscript was completed, it was lost when the building in which Bredel was living in Barcelona was bombed by Falangist planes. Only by accident was the manuscript recovered from the ruins. The manuscript was then delivered to Prague for publication and had already been set in type when Hitler moved into the Sudetenland, occupying the town outside of Prague where Malik printing was done. The SS broke into the print shop, confiscated the type and melted it down. But the typesetter had already pulled a proof, unbeknownst to Herzfelde, and hidden it. When it was opportune, the typesetter took the proof to

Prague where Herzfelde put it in the hands of an American journalist who took it in a suitcase through Germany to Paris. The book was printed and bound in Paris, with the imprint "Editions du 10 Mai." But war had begun in the meantime, and before the book could be distributed it was confiscated by the French police. The entire edition then came into Nazi possession when they arrived in the summer of 1940. For some reason the Gestapo destroyed only part of the printing and hid the rest. Four years later quantities of copies of the book were found being read by German soldiers in Allied prison camps behind the western front.[203]

As is often the case with paths that pass through the magic capital, this *dérive* through the crumbling planes and surfaces of old Europe suggests ways of mapping modernities that wander far from the beaten tracks to which we are used.

During his years in Prague Heartfield supplied montage after agitational montage for the *Arbeiter-Illustrierte Zeitung* (Workers' Illustrated Weekly, hereafter *AIZ*), a magazine founded in Berlin in 1925 by Willi Münzenberg. *AIZ* shifted its operations to the Czech capital after Hitler came to power,[204] and Weiskopf became editor. In the early 1930s the magazine had a circulation of over half a million. That figure was to fall to a low of 12,000 after the move to Czechoslovakia despite heroic attempts to smuggle small-format copies across the German border camouflaged as brochures for the 1936 Olympics, pudding recipes, and packets of washing powder.[205] By common consent Heartfield's art reached its peak during his years in the magic capital. Many of his best-known montages were produced in Prague—Hermann Goering standing in a bloody butcher's apron before the burning Reichstag; Mussolini's Mount Rushmore–sized bust staring out on a pyramid of Abyssinian skulls; a body broken on a medieval wheel juxtaposed with a body broken on a swastika, captioned "As in the Middle Ages ... So in the Third Reich." In "Blood and Iron," published on 8 March 1934, the Monteurdada reduced the Nazis' crooked cross to its bare essentials—four battleaxes bound together, their blades dripping with blood.[206]

Heartfield's work also appeared in *Svět práce* (The World of Work), *Svět v obrazek* (The World in Pictures), and other Czech magazines, and he designed book covers for Odeon, Družstevní práce, and Synek. Among the latter were a series of covers for Odeon's Writers of the Soviet Union series (*Spi-*

sovatelé Sovětského svazu, 1934–37). His six dust jackets for the tenth edition of *The Good Soldier Švejk*, published by Synek in 1936–37, montage Josef Lada's renditions of Hašek's characters into photographed landscapes.[207] Heartfield was not the first ex-Dadaist to be drawn to Hašek's unedifying portrait of the *malý český člověk* (little Czech guy) gone off to war; a few years earlier George Grosz's stage sets for a 1928 Berlin adaptation of *Švejk* had led to one of the longest-running blasphemy trials in German history. Three drawings reproduced in the portfolio Malik published to accompany this production proved especially incendiary: "You Are Subject to the Authorities," "Distribution of the Holy Spirit," and "Christ with Gasmask." The Holy Spirit being dispensed from the preacher's mouth is a hail of bullets, while a gas-masked Jesus looks down from his cross with the words "Shut Your Mouth and Keep Serving."[208]

Heartfield and "Propagandada Marschall" Grosz had been the organizers, along with Raoul Hausmann, of the International Dada Fair whose installation techniques the Nazis parodied in *Degenerate Art*.[209] The Fair opened in the Otto Burchard Gallery in Berlin on 1 July 1920. "Dada ist politisch!" proclaimed one of the placards with which the walls were festooned. It was a redundant message, since the exhibits pretty much spoke for themselves. Heartfield's own contributions to the spectacle included his and Rudolf Schlichter's *Prussian Archangel*—an effigy of a German officer with a pig's head, suspended from the ceiling—and *The Philistine Heartfield Gone Wild (Electro-Mechanical Tatlin Plastic)*, a stump-legged black mannequin the Monteurdada had confected with Grosz. A far cry from Oskar Kokoschka's Alma-effigy, the doll had a light bulb for a head and a pistol and electric bell for arms, and was adorned with rusty cutlery and an Iron Cross.[210] She also sported a pair of white dentures between her legs, a detail that caught the attention of Kurt Tucholsky, who otherwise thought the installation looked like "a cute junk shop." "It's rather quiet at that small exhibition" he observed in the *Berliner Tageblatt*, "and nobody really gets upset any more. Dada—oh well."[211] The authorities obligingly proved him wrong, prosecuting Grosz, Herzfelde, Schlichter, Johannes Baader, and the gallery owner Otto Burchard for "insulting the German army." In the event the Dadaists got off lightly.

This was the same exhibition at which Raoul Hausmann exhibited *Dada Triumphs!* with its unlikely makeover of Wenceslas Square. Other highlights of the show included Otto Dix's *45% Ablebodied*, also known as *War Cripples*, and Grosz's *Victim of Society*, whose original title was *Remember Uncle August, the Unhappy Inventor*. "Dadamax" Ernst, who was then based in Co-

logne, contributed six works; Francis Picabia and Jean Arp were the main representatives from abroad. Otherwise this was very much a Berlin Club Dada affair, with Grosz, Heartfield, and Hausmann contributing the lion's share of the exhibits. Perhaps the single work that is best remembered today is Hannah Höch's montage "Cut with the Kitchen Knife Dada through the Last Weimar Beer-Belly Cultural Epoch of Germany."[212] "Far from the aggressive militancy of her Berlin Dada friends, closer to the position of Kurt Schwitters," enthuses Sophie Bernhard, "Hannah Höch gives birth to an astonishing work":

> In a dancing, carnivalesque atmosphere innumerable motifs, cut out of the contemporary press, are deployed on lightly-colored Japan paper: wheels with cogs and gears, automobiles and dancers are juxtaposed with the potentates of the Reich, the men of the Empire, and those of the Weimar Republic, as well as eminent personages of the artistic and literary worlds. A pensive Albert Einstein observes the turbulent dynamism of the Berlin metropolis, reduced to a giant weightless mechanism. In counterpoint to the "anti-Dada movement," which is composed of Wilhelm II, identifiable from his martial moustache, and his generals and the Crown Prince, appears *die grosse Welt Dada*, the Club Dada and its precursors.

It is "the emancipated woman, the 'new woman,'" Bernhard goes on, who is "the instigator of the passage from the anti-Dada world to the Dada universe." "The bodies of women and dancers," she contends, "contaminate those of the men. . . . The socialist revolution, materialized in the parades of the unemployed—Karl Liebknecht and Rosa Luxemburg are not represented—is associated with the liberation of woman, and it is the celebrated Berlin dancer Niddy Impekoven who, at the centre of the montage, seems to breath into the composition its dynamism with a single stag leap [*saut de biche*]."[213]

Maybe. But such juxtapositions of dancers and dole queues played less well at the time. Hannah (or Hanna, as she then spelled her name) was lucky to get to exhibit in the International Dada Fair at all. Heartfield and Grosz agreed to her participation only when Hausmann, who was then her boyfriend, threatened to withdraw. They thought her dolls and collages too girly. Uncertainty as to where the feminine belonged in the Dada universe is perhaps evident from the fact that Höch's works were listed under three differ-

ent names in the exhibition catalogue: Hanna Höch, Hanna Höch-Haus-mann, and the diminutive Hannchen Höch.[214] In an unpublished story called "The Painter" the artist offered her own wry perspective on the mascu-line, the feminine, and the modern. "Once upon a time there was a painter," it begins. "He wasn't called Dribble, or anything like that, as he might have been in earlier times":

> It was around 1920—the painter was a modern painter—so his name was Heavenlykingdom. Unlike the real painters of earlier times, he was not asked only to work with brush and palette. This was his wife's fault: she thwarted the boundless flight of his genius. At least four times in four years, he was forced to wash dishes—the kitchen dishes. The first time, actually, there had been a pressing reason. She was giving birth to the baby Heavenlykingdom. The other three times had not seemed necessary to Heavenly-kingdom, Sr. But he wanted to keep the peace—because after all God had created the male to do just that—and so had no choice but to obey her Xanthippian demand. Yet the matter continued to weigh on him. He felt degraded as a man and as a painter under its dark shadow. On the days of crisis he would suffer nightmares. He kept seeing Mi-chelangelo washing up the cups.[215]

"Thirty years ago," Höch later explained, "it was not very easy for a woman to impose herself as a modern artist in Germany…. Most of our male col-leagues continued for a long time to look upon us as charming and gifted am-ateurs, denying us implicitly any real professional status."[216]

Hannah broke up with Hausmann in 1922. She moved to Holland in 1926 with the Dutch author Til Brugman, with whom she lived in a lesbian rela-tionship for the next nine years. They returned to Berlin in 1929. Hannah survived World War II in a small house in the obscure suburb of Heiligensee, happily supplied with a large vegetable garden, "where nobody would know me by sight or be at all aware of my lurid past as a Dadaist or, as we were then called, as a 'Culture Bolshevist.'" Interviewed in 1959, she generously rated Hausmann "the artist who, among the early Berlin Dadaists, was gifted with the greatest fantasy and inventiveness." After they parted, she says, Raoul "found it very difficult to create," though his imagination remained as spar-kling as ever. Grosz was "more of a moralist and a satirist," even if underneath there was "an artist capable of feeling very deeply, but who preferred to con-

ceal his sensitivity beneath the brittle and provocative appearance of a dandy."
Höch is less complimentary about Heartfield, whom she characterizes as "always more doctrinaire in his political intentions." "A Communist," she explains, "always tends to be didactic and orthodox rather than truly free in his fantasies and his humor."[217] Their differences in temperament are reflected in their approaches to their art: whereas Heartfield meticulously rephotographed his assemblages to achieve a surface as smooth as a nineteenth-century academic painting, Höch was happy to let the cuts and joins show.

Art historians have generally attributed more significance to the Dada Fair than Kurt Tucholsky did at the time, though they have had little to say about that *vagina dentata*. Their estimate of the show's importance rests less on the Dadaists' ephemeral politics than their enduring contributions to the formal and technical vocabularies of modern art. Not the least of these was photomontage itself. George Grosz dated the discovery precisely: "John Heartfield and I invented photomontage at five o'clock in the morning one day in May 1916 in my studio in the southernmost part of Berlin."[218] Others gave different accounts. According to his one-time lover Vera Broïdo, Raoul Hausmann "never forgave [Heartfield] for claiming to have invented photomontage. He was quite paranoid about it."[219] The Dadasoph himself claims to have "conceived the idea of photomontage" while on holiday with Höch in the summer of 1918 at the little hamlet of Heidebrink on the isle of Usedom in the Baltic where he was inspired by the locals' custom of a pasting a head cut out of a photograph of a family member upon a colored lithograph of a grenadier. Such surreal mementoes of enlisted sons, brothers, and fathers were then to be found in almost every home. Raoul immediately saw the possibility of making "'paintings' composed entirely of cut-up photographs." "After returning to Berlin in September," he continues, "I began to realize this new vision, using photos from the press and cinema. In my innovator's gusto I also wanted a name for the technique and in agreement with George Grosz, John Heartfield, Johannes Baader, and Hannah Höch, we decided to call these new works 'photomontages.' This term translated our aversion toward playing the artist, and since we called ourselves engineers . . . we pretended to construct, to 'mount our works.'" It was above all Baader and Höch, he adds, who "employed and popularized the new technique; Grosz and Heartfield, too enamored of their caricaturist ideas, remained faithful to collage until 1920."[220]

The Russian constructivists Alexander Rodchenko and Gustav Klutsis might equally well stake a claim to have invented photomontage around the same time. The larger-than-life Lenin striding across Klutsis's 1920 poster *The*

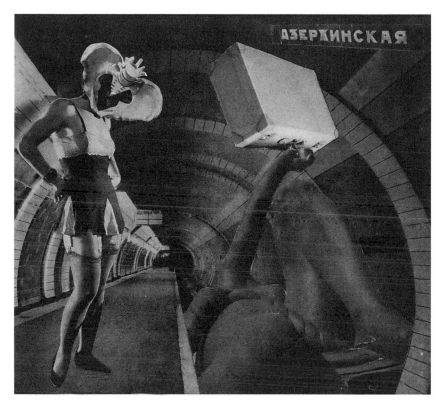

FIGURE 5.9. Karel Teige, "Collage #50," 1938. The setting is the Felix Dzerzhinsky subway station in Moscow. Památník národního písemnictví, Prague. Courtsey of Olga Hilmerová, © Karel Teige - heirs c/o DILIA.

Electrification of the Entire Country with a pylon under his arm is a classic not only of revolutionary propaganda but also of modernist design. Heartfield worked with Rodchenko and Klutsis during the nine-month trip he made to the Soviet Union in 1931–32, where he was the first western artist to be allowed a one-man show.[221] By then he was famous. An entire room measuring 10 × 10 meters and containing 110 wall frames and four large display cases was devoted to his works at the *Film und Foto* exhibition in Stuttgart in 1929, the most extensive international showcase of avant-garde photography of its time.[222] Klutsis was less fortunate. He disappeared into Stalin's gulag in January 1938, shortly after his return from the 1937 *Exposition internationale des arts et techniques dans la vie moderne* in Paris, where he designed the photomontage friezes for Boris Iofan's Soviet Pavilion. Three weeks later he was

summarily executed on an improbable charge of abetting a Lithuanian fascist organization. His wife, Valentina Kulagina, a talented *photomonteuse* in her own right, never found out what had happened to him. "Where is Gustav?" she asked her diary on March 19, 1940. "I miss him so. I dreamed about him again last night—he looked good, clean-shaven, but unhappy about something, looking away. . . . Edik, Edik, your Mama's life is so hard."[223] Edik (Edvard) Kulagin, their son, discovered the truth of his father's fate only in 1989, two years after his mother's death.

Of greater interest than (one would think) the very un-Dadaist question of who had the patent on photomontage is the anonymous undergrowth of modernity upon which all of these artists were drawing. Though the beginnings of collage are conventionally traced back to Picasso and Braque's incorporation of physical objects into the pictorial space of the canvas—"a two-penny song, a real postage-stamp, a piece of newspaper, a piece of oil-cloth imprinted with chair-caning," to quote Apollinaire, writing on Picasso in *Montjoie* in 1913[224]—"supra-real" dreamscapes, as Raoul Hausmann called them, were popping up everywhere by the later nineteenth century, helped along by the fortuitous meeting of commerce and the camera. Incongruously aligned fragments of image and text found their way into children's scrapbooks, fairground amusements, humorous (or pornographic) postcards, and advertisements.[225] Once the camera enabled reality to be replicated as image and the printing press replayed the image back over and over again as reality it was inevitable that hyper-realities, as we nowadays call them, would sooner or later be confected out of permutations of the image alone. What was perhaps not sufficiently realized at the time—though it is a property abundantly displayed in "Cut with the Kitchen Knife"—is that montage has as at least as great a capacity to subvert, pluralize, and explode meaning as to communicate it. "One does not choose what is modern," Apollinaire warns, "one accepts it—the way one accepts the latest fashions, without arguing about them."[226]

There is an undoubted piquancy in the fact that John Heartfield's title "Monteurdada" not only referred to his preferred means of expression but came from the blue boiler suit—known as a *Monteuranzug* in German—that he wore in solidarity with the workers. "He did not want to look like an artist," recalled Wieland Herzfelde, "but he did not want to look like an advertising executive, either."[227] He might just as well have done, since Heartfield's greatest contribution to modern visual culture may turn out to be as a master of slick packaging. During the 1920s he designed scores of covers for Malik books, including Mayakovsky's *150 Million*, Upton Sinclair's *Oil*, John Dos

Passos's *Three Soldiers*, and John Reed's *Ten Days That Shook the World*. Heartfield "turned the book-cover into a political instrument," Walter Benjamin approvingly observed,[228] producing eye-catching dust jackets that (in Wieland's words) were "meant to be attractive at first sight and, at the same time, have an agitational effect" when displayed in booksellers' windows.[229] In this case the medium outlasted the message. Couplings of realities that apparently cannot be coupled on a plane that apparently is not appropriate to them proved at least as well suited to selling the phantasmagoria of the commodity as they were to peddling utopian dreamworlds. "Even today," mused Hannah Höch in her 1959 interview, "I sometimes find myself staring at a poster in a Berlin street and wondering whether the artist who designed it is really aware of being a disciple of Dadasoph Hausmann, of Monteurdada Heartfield, or of Oberdada Baader."[230] Who could have foreseen such frivolous perversions of the dialectic of history, looking out with John Heartfield from a beleaguered Prague in the dark and dirty 'thirties?

Hausmann, too, unexpectedly found himself back in the magic capital, once again on the run from revolvers. By the time Raoul met Vera Broïdo "he had broken completely with those Dadaists who had been Communists—the Herzfelde brothers, Wieland and John (Heartfield)—George Grosz and others. He considered that ideologies of any kind, but particularly political ideologies, were incompatible with Dada. And he had no illusions about Soviet Russia."[231] He made an unlikely appearance in August Sander's *People of the Twentieth Century*, a photographic epic that aspired to provide an encyclopedic documentation of contemporary German society. Bare-chested and monocled, the Dadasoph has one arm around Vera and the other around his wife, Hedwig Mankiewitz. Sander placed this *ménage à trois* (they lived *en famille* from 1928 to 1934) at the end of his portfolio titled "Die Frau und Der Mann," which otherwise consists of happy hetero couples.[232] In the 1920s Hausmann turned increasingly to photography—nudes on Baltic beaches were among his favorite subjects—and the perfection of his "Optophone," a machine for converting colors to sounds and vice versa that he eventually patented in London in 1935. When he left Germany for Ibiza in 1933, it was meant to be for no more than "a longer than usual summer holiday.... He did not like the political situation," says Vera, "but he did not feel personally threatened. After all, he was only one-eighth Jewish and he had long ago ceased to be active in left-wing politics."[233]

Events at home soon persuaded Raoul to stay put, though it would not be for long. He traveled to Paris in 1934, where his nudes were exhibited at the Ouvert la nuit gallery in Pigalle;[234] Man Ray included six of them in his

album *Nus*, which came out the following year. Following General Franco's occupation of Ibiza in September 1936 Hausmann left for Zurich, where the Cabaret Voltaire was by then no more than a distant memory. He wound up in Prague the following February. His experiments with infrared photography, as well as his photographs of Ibiza's indigenous architecture, were exhibited at the Museum of Decorative Arts the same year. According to his own account Raoul was cold-shouldered by the Czech avant-garde, notwithstanding the "great victory for Dada" won in the city seventeen years earlier. "Karel Teige, who knew all about me, not only ignored me, but because (at that time) he was a Surrealist, spoke up against me," he complained to the poet Miloslav Topinka in November 1969.[235] He moved to Paris in May 1938 and survived the war in hiding with Hedwig—who was more than one-eighth Jewish—in the small village of Peyrat-le-Château near Limoges, where he would spend the rest of his days. He died there in 1971.

A WAR ECONOMY, WORDS OF COMMAND, AND GAS

Oskar Kokoschka arrived in Prague by an equally roundabout route, always trying to get somewhere else. The *enfant terrible* of Viennese expressionism abandoned Germany, where he had lived on and off since his Dresden days, in 1931. "Here I am, in exile again, all alone and friendless. It makes my third exile since leaving Austria, and now Germany," he complained to Alice Lahmann, one of his Dresden students who became a lifelong friend; "there is hardly any furniture in this little house I've rented in Paris, where I intend to live for several years."[236] Things did not work out as he had hoped. "I must have 1,000 marks, no matter what it costs, no matter who it comes from, my life is in danger," he wrote in January 1933 to his old friend Albert Ehrenstein, an Austrian-Jewish poet who was by then living in Moscow:

> My lungs are playing up, my temperature keeps soaring, and I must have abscesses in my bronchial tubes or some other damned place, because the fever always stops when I bring up some bloody pus, after which I have a few days remission. I am undernourished and of course I haven't a doctor or any other person to tend me, and have to do everything for myself. Sometimes I'm too weak to crawl, and then I have to go without food for a few days, even if there happened to be any oats or a few potatoes in the kitchen.

And it was snowing, and Kokoschka had been threatened with eviction. "Among my former friends," he continues, "there isn't a shit who will help or

even answer," "they all sit on their fundaments, as they did in the war." He had nothing but contempt for "George Grosz, the well-known International Communist [*Euer George Großkommunist*]," who (he claimed) "has annexed himself to fatherlandish sentiments, and runs a drawing-school for American pork-butchers and the daughters of war profiteers to boot. I was the real revolutionary who got into trouble for it, and now they'll let me snuff it without lifting a finger."[237] Dada's most scurrilous satirist had by then moved to the United States, where he blotted his socialist copybook by trying to live the American dream.

Kokoschka returned to Vienna later that year but neither the political situation nor his financial prospects were conducive to his staying. He arrived in Prague in September 1934 en route for Russia where he planned to "spend a year, perhaps, painting everything important for a big traveling show ... a kind of New World Symphony, like the Czech composer Dvořák's."[238] In the event his debts obliged him to stay put. Although his father, Gustav, hailed from a long line of Czech goldsmiths, Oskar did not find the Bohemian capital the easiest of sanctuaries. "My lung is playing up, and Prague's dust, fog, and pollution are not the best medicine for it,"[239] he complained, fearing that he would have "all my cells destroyed by lack of oxygen."[240] His recurrent respiratory problems were a consequence not of a delicate artistic constitution but that World War I bayonet. Disillusioned with "life in this damned Europe of ours,"[241] disgusted with "our hypocritical, bloodthirsty, murderous white civilization,"[242] Oskar dreamed of journeys to Morocco in the company of "energetic American women" (who, he improbably fantasized, would be "beautiful and not handicapped by the insane condescension most whites have for other peoples"),[243] across Russia where the smiles of "the lovely girls of Tartary and Little Russia and Great Russia ... would have made a few of my gray hairs drop out,"[244] and on to Shanghai "to see thousands of lovely girls on the flower-boats, before Edith Rosenheim and her society industrialize it all. Then there will be nothing but a war economy, and then just words of command, and gas."[245]

In the event Kokoschka was to "squat ... amid the laundry odors of Prague, when he might be in Shanghai with Sung women, or in Hoggar with the Queens of Sheba"[246] for four more years, living off an unhealthy diet of smoked pork, goulash, and dumplings.[247] Despite his grumblings the city and its inhabitants grew on him. He painted several fine landscapes—the window of his studio overlooked the Vltava—as well as a commissioned portrait of Tomáš Garrigue Mararyk, who was by then "eighty-six, rather frail, but very patient. It's a history painting," he explained to Anna Kallin, a lover

from his Dresden years who was by then living in London, "with the Hrad-schin [Hradčany] on the right, Comenius's *Orbis Pictus* on the left, and Hus at the stake in the background, somewhat indistinct." Kokoschka was much attracted to the pedagogic legacy of Comenius, coming to the conclusion that "the Czech mission = the elementary school."[248] Not entirely unreason-ably, given Tomáš Masaryk's own political and intellectual predilections,[249] Oskar tried to enlist the aged Czechoslovak president's support for a "plan to wrest elementary education out of the hands of individual nation-states—that is, the political parties that run them—and put it under scientifically-organized international control." "A person with the wit to make the best use of isolated chances," he wrote to Alma Mahler, "can also realize this miracle, which will set up a self-evidently rational and life-affirming goal, in opposi-tion to the suicidal urge that has gripped mankind ever since the end of the war."

"Go to every Tom, Dick and Harry who has ever been a guest in your house," he begged his former lover, who was then still living in Vienna but would not do so for much longer:

> Seek them out, muster them all, and bellow in their ears
> that on the one hand there is a housepainter from Austria
> who intends to use the power apparatus he has seized from
> the Germans to have his supposed rivals, real painters, cas-
> trated! And then tell them that on the other hand there is a
> painter who wants the world to understand that when you
> are faced with a maniac who is given an official platform to
> make pathological speeches before an elite group of cow-
> ards, the so-called upper ranks of society (which I despised
> as heartily in your time as I do now), the courage must be
> found to put him in the lunatic asylum, along with the
> "upper" ranks who listen to him.

Kokoschka's reference to castration was not metaphorical; it was exactly what Hitler threatened degenerate artists with in his speech opening the *Great German Art Exhibition*. "Help me, Alma, help me at once," Oskar went on, slipping and sliding between the personal and the political as he was wont to do, "and then I may be able to believe that it has all been a bad dream since I knew that you were alone in the nursing home, after they took away your child, my child. I've never wanted a child again, since then, and yet I'm so dreadfully fond of children."[250]

Oskar asked Anna to try to place an article he had written on his elementary education scheme, a bowdlerized version of which had originally been published in the *Prager Tagblatt* (Prague Newspaper) in July 1935, in the *Labour Leader* or the *Manchester Guardian* as "a manifesto and an appeal to the League of Nations." "England ought to have a fellow-feeling for the Czechs," he added, "because there are parallels in the history of the Reformation in both countries, and because the Czechs are the nation most exposed to political dangers here in the east: to the Reichswehr to the north, to the Habsburgers to the south."[251] Like Karel Čapek Kokoschka had an idealized view of the scepter'd isle. "I like the English as much as if they were my own kinfolk," he assured Anna, praising "the official who performs his duties in the consciousness of his own responsibility, no longer serving robber-barons or a priest-king, but the whole of barbarian humanity, which the English took it upon themselves to tend like a *nursery*."[252] We can imagine what John Heartfield would have thought of such rank political naïveté. The author of "The Art Scab" nevertheless joined the Oskar-Kokoschka-Bund (Oskar Kokoschka League), a Prague-based anti-fascist émigré artists' organization to which the older painter lent his name (though not much else). Exile sometimes makes for strange bedfellows. No less improbably, both artists became members of the Mánes Artists' Society and showed their work in its annual exhibitions.

Kokoschka took out Czechoslovak citizenship after Germany annexed Austria in the *Anschluss* of March 1938. It was a precautionary measure; he was already planning to move to England, forced out, he informed Herbert Read, "because your Lords have made the Nazis a present of my homeland."[253] By then he had no illusions left about perfidious Albion. "The Czechs are wonderful, good-nerved and good-humored," he told Augustus John, but they knew that the British government might "not be able or willing . . . to save them from the horrible fate of Austria."[254] He fled to London that September, arriving just in time to hear Neville Chamberlain's speeches lauding the Munich Agreement. He brought with him £5, his Czech lover Olda Palkovská—they would eventually marry in a London air-raid shelter in 1941—a small painting called *Girls Bathing*, and his "painting things," which he pawned for four guineas.[255] "I feel sorry for Olda," he had told Anna Kallin a couple years previously, "because she still regards life as something certain, as insurance against the void. Because she believes me, here, although I see the maggots and worms wriggling on the cadaver of humanity, yet do not trust myself to speak of it, and cannot do anything about it, lack-

ing money, a voice, friends, or a future. For her generation there will be nothing but the lumpy, lime-bespattered straw mattresses used by victims of the plague."[256] Once again his premonitions would prove unerringly accurate.

The Red Egg, which Kokoschka painted in 1940–41, was most definitely a subjective transcription rather than an objective description. It shows a grossly deformed Hitler and Mussolini sitting down with Britain (a supercilious imperial lion) and France (a fat, contented cat) about to plunge their forks into a gigantic egg. Beside them lies the text of the Munich Agreement. A rat scuttles around the table while a plucked chicken flies off into the distance with a knife in its back. In the background is the familiar Prague skyline; a naked woman lies face down in the Vltava, her body splashed with red. Fittingly perhaps, the painting now belongs to the Czech National Gallery.[257] The first canvas Kokoschka painted after his arrival in London, however, was titled *Prague, Nostalgia*. It is now owned by the National Gallery of Scotland, whose website informs us "it features the famous view of Prague with the old Charles Bridge and cathedral in the background. The pair of lovers near the shore is thought to be Kokoschka and his future wife Olda. In a reference to Kokoschka's emigration, the couple are being beckoned into a boat. . . . In this painting the artist is expressing his grief for the loss of his home country."[258] Oskar was doing no such thing—acquiring a Czechoslovak passport had not turned him into a Czech in his own eyes or anybody else's—but the magic capital had clearly gotten under his skin. What the Gallery does not tell us is that the template for *Prague, Nostalgia* is Mikoláš Aleš's mural of *Libuše Prophesying the Glory of Prague* in the Old Town Hall.[259] How could they possibly have known? The view is identical, but where the princess once raised her arms in expectation of glories that will touch the stars Oskar and Olda stand, expecting only a boat out—if, that is, they are indeed the lovers in question. Assigning meanings to paintings is seldom as easy as it is with *The Red Egg*.

After the war was over Kokoschka found himself doubly displaced. "As you know, in Czechoslovakia one must speak correctly the Czech language, or one is bound to end in a Detention-camp," he complained to Augustus John; "Austria is occupied by the four Big Powers, and even Vienna is divided into four zones. . . . So what can I do in this world, born a Viennese and a bearer of a Czech passport?"[260] To his enormous credit Kokoschka passionately opposed the expulsion of Bohemian Germans from liberated Czechoslovakia, not because they spoke his language but "on ethical grounds."[261] "Many letters from the C.S.R.," he informed Herbert Read in September 1945, "often from the inhabitants of the Nazi concentration camps and Jews,

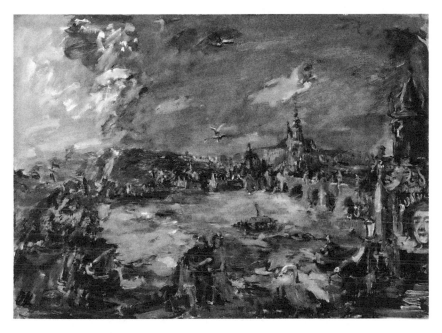

FIGURE 5.10. Oskar Kokoschka, *Prague, Nostalgia*, 1938. Scottish National Gallery of Modern Art. © Fondation Oskar Kokoschka/DACS 2011.

implore us here to arrange for their escape because, as citizens of the German language, they are automatically destined for expulsion. They have to wear the degrading badges of 'Germans' because Dr. Beneš in his official declaration identifies language with race. This is the new version of Fascism that will (possibly) be supported by the Gentlemen of the City with the help of financial loans. It all seems to end with a 'Völkerwanderung' into hell."[262] Again he was right.

John Heartfield soon joined Kokoschka in his English exile, arriving in London on 6 December 1938. Wieland followed his brother, but was refused a residence permit by the British government. He eventually found refuge in New York. Heartfield's exhibition *One Man's War against Hitler*, which showed at the Arcade Gallery in 1939, did not prevent him from being interned the following year as an enemy alien, category C (political refugee). Heartfield was not the only Dadaist to do time in British camps; so did Kurt Schwitters, who died in 1948 in the little Lake District town of Ambleside, where he made his last *Merzbau* in a local barn.[263] The original *Merzbau* was destroyed in an Allied bombing raid on Hanover in 1943. Lord Faringdon

probably did not know what a hornet's nest he was disturbing when during a parliamentary debate on internment on 15 August 1940 he told his noble peers "John Heartfield is the inventor of what is called 'photomontage.'"

> His cartoons have appeared in English papers. I venture to suggest that, as propaganda, there is very little which is more effective than the cartoon. This man is interned, and I suggest that his internment is not only unnecessary but definitely disadvantageous to ourselves. It may be my Scottish blood, but whatever it is there is one thing in the world that I think revolts me almost more than anything else, and that is waste, not merely, as in this case, the waste of public money which is being spent on keeping in concentration camps persons who can support themselves outside, but the waste of the useful work and the invaluable assistance that these proved enemies of Nazism can give to us in this time of trouble.[264]

Released after a few weeks on medical grounds, Heartfield worked in the Free League of German Culture in Great Britain, an émigré organization whose international presidents included Albert Einstein, Thomas Mann— and Oskar Kokoschka, who was saved from internment by his Czechoslovak passport. Heartfield provided most of the artwork for the League's publication *Inside Nazi Germany* and was a major contributor to the exhibition *Allies inside Germany* in 1942. He supported himself by freelance work for *Picture Post*, *Reynolds News*, and *Lilliput* as well as designing books for Lindsay Drummond, Penguin, and other English publishers, which doubtless gratified Lord Faringdon's Presbyterian soul. He rejoined Wieland in what had by then become the German Democratic Republic in 1950 to work at the Berliner Ensemble, the theater created for Bertold Brecht, and remained a devoted communist for the rest of his days.

Alma Mahler also escaped the tightening net, crossing the border from France into Spain with Franz Werfel on 13 September 1940. They, too, traveled on Czechoslovak passports, which Werfel had managed to obtain through the Czech consul in Marseille, "an angel of a man" who by then occupied the Kafkan office of a representative of a state that no longer existed. Alma was "wearing old sandals and lugging a bag that contained the rest of our money, my jewels, and the score of Bruckner's Third. We must have looked pretty decrepit," she relates, "surely less picturesque than the stage smugglers in *Carmen*."[265] Two weeks later Walter Benjamin took the same

difficult and dangerous path from Banyuls-sur-Mer through the Pyrenees to Port Bou, burdened with no less improbable luggage. He carried with him a black leather attaché-case containing "a new manuscript," which he said was "more important than I am." It was not *The Arcades Project*; Walter had left that unfinished treasure-trove behind in Paris with Georges Bataille. It may have been the final text of "On the Concept of History," in which Benjamin casts Paul Klee's *Angelus Novus* as the Angel of History—or so, at least, his admirers would like to believe, casting a redemptive veil of meaning over an event that lacks all sense, even of tragedy, though it might have brought a knowing smile to the lips of Jacques Vaché. This angel is a pretty abject Seraphim. "His face," writes Benjamin, "is turned to the past":

> Where a chain of events appears before *us, he* sees one single catastrophe, which keeps piling wreckage upon wreckage and hurls it at his feet. The angel would like to stay, awaken the dead, and make whole what has been smashed. But a storm is blowing from Paradise and has got caught in his wings; it is so strong that the angel can no longer close them. This storm drives him irresistibly into the future, to which his back is turned, while the pile of debris before him grows toward the sky. What we call progress is *this* storm.[266]

On his arrival at Port Bou Benjamin was informed that the border had been closed to refugees and he would be returned to France the following morning. He checked into the Hotel de Francia and wrote a last letter: "In a situation presenting no way out, I have no other choice but to make an end of it. It is in a small village in the Pyrenees, where no one knows me, that my life will come to its end." Then he took enough morphine to kill a horse.[267]

The next day the Franco-Spanish border reopened.

6

On the Edge of an Abyss

People at Night Guided by the Phosphorescent Tracks of Snails
Rare are those who've felt the need for such help in broad
daylight—this broad daylight in which the common mortal has
the amiable pretension of seeing clearly . . . I deem it that the
others, who flatter themselves on having their eyes wide open,
are unwittingly lost in a wood. On awakening, best to deny to
fallacious clarity the sacrifice of this labadorite glimmer which
all too quickly and too vainly robs us of the premonitions and
solicitations of the night dream when this is all we really possess to
guide us unfalteringly through the maze of the street.

—André Breton, *Constellations*, 1958[1]

The Beautiful Gardener

One of the few surrealist works on display in the *Degenerate Art* exhibition
was Max Ernst's *The Beautiful Gardener* (*La Belle jardinière*), also known as
The Creation of Eve. The painting was a full-size, full-frontal nude, though
not one whose femininity was portrayed as Adolf Ziegler would have liked.
The mother of humanity hung in Room 3 of the original Munich spectacle,
whose wall texts included "An Insult to German Womanhood" and "The
Ideal—Cretin and Whore." Painted in 1923 and acquired by the Düsseldorf
Kunsthalle in 1929, *La Belle jardinière* was one of three works reproduced on
the final page of the exhibition guide under the headline "The ultimate in

stupidity or impudence—or both!"[2] Ernst tells us that the fashion designer Jacques Doucet had wanted to buy the picture when it was first exhibited in Paris in 1924 "but decided not to when his wife disapproved ('No naked women allowed!')."[3] Slender are the threads upon which the fate of paintings sometimes hangs. *The Beautiful Gardener* is now lost, presumed destroyed; it may have been one of 1,004 canvases considered "unsalable" that the Nazis ceremonially burned in the yard of the Berlin Fire Brigade on 20 March 1939.[4] Ernst's son Jimmy lined up several times over to see his father's painting when *Degenerate Art* traveled to Hamburg in November 1938. It was an encounter that finally decided him to leave Germany for good. The young man eventually made his way to the United States, where he worked for MoMA before becoming Peggy Guggenheim's assistant at her Art of This Century gallery, which opened in October 1942. Peggy had married Max, with whom she had fled France in July 1941, the previous December. "I did not like the idea of living in sin with an enemy alien," she later explained, "and I insisted that we legalize our situation."[5]

On the outbreak of war Max had been interned as a "citizen of the German Reich" at the camp of Les Milles outside Aix-en-Provence where, as chance would have it, he shared a room with the German surrealist Hans Bellmer. "The Les Milles camp was a former brick factory. Broken bricks, brick dust, were everywhere, even in the little they gave the internees to eat. This red dust even crept into the pores of one's skin. One had the feeling that one was oneself gradually turning into a crumbling brick. Hans Bellmer and Max drew continually, partly in order to assuage their anger and hunger. Bellmer did a portrait of Max, with a face like a brick wall."[6] I quote Ernst's own *Biographical Notes* here, a constantly reworked collage subtitled *Tissue of Truth, Tissue of Lies* in which the artist always refers to himself in the third person. Max owed his release from Les Milles to Paul Éluard, who interceded with the French authorities on the artist's behalf. "Max Ernst left his country, without any idea of returning, more than nearly twenty years ago," Paul wrote to the French president. "He was the first German painter to exhibit in a French salon. He is fifty years old. He is a simple, proud, loyal man, and my best friend. . . . I will answer for him myself."[7]

The two men's friendship went back a long way. The model for *La belle jardinière* was Éluard's first wife, Gala, and Max was well used to seeing her without her clothes. Eugène Paul Émile Grindel, as Éluard was baptized, first met the Russian-born Elena Dmitrievna Diakonova at the Clavadel Sanatorium near Davos in Switzerland, where he was hospitalized from December 1912 to February 1914. They were both receiving treatment for tuberculosis,

both just seventeen, and they soon fell in love. It was Paul who gave Elena the pet name Gala by which she has been known ever since. They married on 21 February 1917 (Éluard was given three days' leave from the front for the ceremony), and Gala gave birth to Paul's daughter Cécile—his only child—the following year. The Nazis need have looked no further for proof of "the *moral* aspect of degeneracy in art . . . [in which] the entire world is clearly no more or less than a *brothel* and the human race is composed exclusively of *harlots* and *pimps*"—to quote the *Degenerate "Art"* guide once again[8]—than *La Belle jardinière*. The painting was a souvenir of the *ménage à trois* Paul, Gala, and Max shared in Saint-Brice and Eubonne in the Paris suburbs in the early 1920s. Ernst had moved to France illegally on Éluard's passport in 1922, leaving his first wife, Lou Straus-Ernst, and child behind him in Cologne.

Jimmy Ernst's "very first remembered graphic image"—and his earliest memory, according to Lou[9]—was of a *déjeuner sur l'herbe* near Tarrenz in the Austrian Alps earlier that summer in the company of his parents, his nanny Maja Aretz, Paul and Gala, Tristan Tzara, Hans Arp, and assorted other Dadaists. "In the warm afternoon sun everyone went swimming in the nude. My mother was holding me in her arms, letting the mysterious water cover my legs. Suddenly the mirrorlike surface ahead of me was broken. A head and then a torso rose up from beneath. Max was laughing as the water streamed from his face. He raised his arms to me, and Lou was lifting me toward him." Terrified by the "innumerable long-legged, water-skating insects on the glassy surface surrounding Max's body," the boy "began to scream and struggle against being handed over. Max's face went dark and angry, he turned and swam away."[10] It is interesting what sticks in the mind. Lou takes up the story:

> As we walked back through the woods my sad face must have made an impression on [Max] and he tried to console me in a strange way. <It had been a foregone conclusion that he would follow Gala to Paris. "For a while," he had said. For several weeks now he had not only shared the Éluards' rooms across the hall but also Gala with Paul.> "You know," he said, "actually you don't need a man anymore. You are <28> years old, you know love, you have a son. . . . What more do you want? You will be able to live quite happily with the child." I could not know what my future life had in store for me then, but I still found his words very cruel.

"The evening before his departure," she adds, "we went to Jimmy's bedside together. He was innocently sleeping. We both cried."[11] Ernst's account of that

summer in *Tissue of Truth, Tissue of Lies* is more laconic. "Another summer holiday in Tarrenz near Imst, with Éluard, Tzara, [Sophie] Taeuber-Arp. . . . What a madhouse. Friendships and marriages broke up. Max went to Paris."[12] He makes no mention of Gala, who had by then long since moved on to pastures new.

Lou's opinion of "the Russian, this floating, glowing creature with dark curls, crooked sparkling eyes, slim features and limbs that were reminiscent of a panther" would be echoed down the years by many others.[13] Gala has not had a good press. Jimmy would long be estranged from his father—and from anything to do with art and artists, which he detested—until he eventually realized "how much valuable time I was wasting in setting up standards of personal conduct for my father that were quite normal in their breach all around me." In the end Jimmy became a painter, too. "The perpetual battles of that era," he reflects, "including the constant specter of hunger and personal economic disaster, dictated an, at times, total disregard of what complacent minds chose to label 'decency' or 'human values.' I would be hard pressed if I were asked to single out, in retrospect, individuals of that generation who, in one way or another, could not be called 'monsters.'" There were nevertheless "some positive aspects to the terrors and upheavals that caused the quixotic and migratory personal history of my younger years. Had it been more tranquil, I might well have become saddled with the luxury of a 'properly furnished mind.'"[14]

The surrealists had no time for such mental décor. Scorning the bourgeois family and refusing either to deny desire or to treat a lover as a possession, many of them, men and women alike, were scandalously promiscuous by the standards of their day—or ours. Their moral attitudes were uncompromisingly expressed in an article titled "Hands off Love!" published in *La Révolution surréaliste* in October 1927 beneath a reproduction of Ernst's painting *Le Paradis*. The text had first appeared in English a month earlier in *transition*, the first magazine to publish Henry Miller as well as to carry excerpts from James Joyce's *Finnegan's Wake*. This "terrific Document defending Genius against Bourgeois Hypocrisy and American Morality," as the *transition* editors billed the surrealists' declaration, was written by Louis Aragon and translated by his then-lover Nancy Cunard. She thought the poet "beautiful as a young God."[15] Nancy "was slim and undulating and reminded me of my slinky grass snake," remembers Eileen Agar, who was the shipping heiress's fellow-pupil at finishing school. It did not take long for Cunard to gain herself a reputation as "a wild young woman who slept with Negroes and quarreled with her mother—both reprehensible activities."[16] The vivacious Eileen did not see eye to eye with her own mother either. "Although gay and flirta-

tious," she complained, Mummy "was very proper, and when that ugly little word 'sex' reared its beautiful head, she could only condemn. She never knew the intoxicating and creative pleasures of having a lover."[17]

"Hands off Love!" took up the cudgels on behalf of Charlie Chaplin, who was then facing a divorce suit that threatened to end his film career. The grounds for the action were the comedian's alleged "immorality"; his young wife, Lida, claimed that he had seduced her, married her only after she refused to abort his baby, and "did not have *the usual marital relations*" thereafter (the italics were her lawyers'). Among other things, the indictment charged, Chaplin had asked his bride to perform the "abnormal, against nature, perverted, degenerate, and indecent" practice of fellatio. "And during these months while the wickedness of a woman and the danger of public opinion have forced on him an insufferable farce," the surrealists raged, Chaplin "remains nonetheless in his cage, a living man whose heart has not died":

> "Yes, it's true," he said one day, "I am in love with someone and I don't care who knows it; I shall go to see her when I please and whether you like it or no; I don't love you and I live with you only because I was forced to marry you." This is the moral foundation of this man's life, and what he defends is—Love. And in this whole matter it so happens that Charlot is simply and solely the defender of love. . . .
>
> We recall the admirable moment in *The Imposter* when suddenly in the middle of a social ceremony, Charlot sees a very beautiful woman go by; she could not be more alluring, and immediately he abandons his adventure (the role he is playing) to follow her from room to room and out onto the terrace until finally she disappears. At the command of love—he has always been at the command of love, and this is very consistently demonstrated by his life and by all his films. Love sudden and immediate, before all else the great, irresistible summons. At such a time everything else is to be abandoned, as for instance, at the minimum, the home. The world and its legal bondages, the housewife with her brats backed up by the figure of the constable, the savings bank—from these indeed is the rich man of Los Angeles forever running away, as is that other poor devil, the Charlot of miserable suburbs in *The Bank Clerk* and *The Gold Rush*.[18]

Aragon's text bore thirty-two signatures. Among them were those of Breton, Éluard, and Ernst.

"A la lueur de la jeunesse / Des lampes allumées très tard / La première montre ses seins que tuent les insectes rouges," runs the last stanza of Éluard's 1922 poem "Max Ernst." When the lines were later translated into English in Marcel Jean's *Autobiography of Surrealism*, "les insectes rouges" (red insects) had unaccountably transmuted into "incests red"—a Freudian slip if there ever there was one.[19] But the *glissade* is not without warrant in Éluard's original:

> In a corner agile incest
> Circles around the virginity of a little dress
> In a corner the liberated sky
> Leaves white balls to thorns of thunder.
> In a corner for all eyes
> We wait for the fishes of anguish.
> In a corner the verdant car of summer
> Glorious and forever immobile.
> In the glimmer of youth
> Of lamps lit very late
> The first one bares her breasts for red insects to kill.[20]

The poem opens *Répétitions*, in which Éluard's verses "illustrated" Ernst's collages. The book was the first collaboration of many between the poet and the painter. Paul and Max shared a good deal more in these years than a suburban villa—which Ernst decorated with surrealist murals that were not at all to André Breton's taste—a daily commute into town, and a mistress. I use the latter term advisedly, for it seems always to have been Gala who called the shots.

A moral commitment to open marriage (which is what, let us be clear, it was) did not necessarily make it any the easier for Paul to reconcile his love for Gala and his love—as he himself described it[21]—for Max. Whatever resentment he felt toward either of them would have been made all the more miserable by guilt at feeling such bourgeois emotions at all. One night in March 1924 Éluard abruptly rose from his restaurant table and vanished, so far as his friends were concerned, into the blue (though there would be persistent rumors later that he spent that night at Louis Aragon's). Ever on the lookout for signs and portents, the surrealists read much into the dedication to his *Mourir de ne pas mourir* (Dying of Not Dying), which appeared the same month complete with a portrait of the author by Ernst. "To simplify ev-

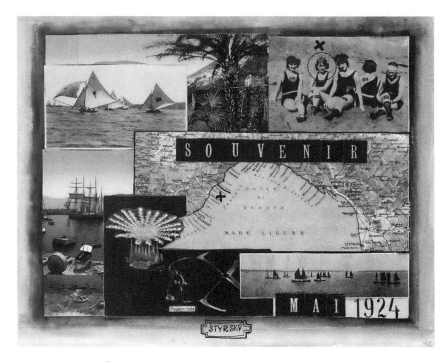

FIGURE 6.1. Jindřich Štyrský, "Souvenir," collage, 1924. Photograph © National Gallery in Prague, 2011.

erything," Éluard wrote, "I dedicate my last book to André Breton."[22] Many feared that the poet had committed suicide; Breton told his wife, Simone Kahn, "we'll never see him again."[23] What actually happened was a good deal more revealing, both of the man and the milieu. "I entered the surreal through a door opened by Éluard's disappearance," wrote Pierre Naville in *Le Temps du surréel*.[24] So, perhaps, might we.

Paul first ransacked the accounts of the business his property-developer father had set up for him, stealing 17,000 francs. "I've had enough," he wrote to Grindel *père* from the Côte d'Azur. "Don't call the cops, state or private. I'll take care of the first one I see. And that won't do anything for your name."[25] He then embarked on a *voyage idiot*, as he would later dismiss it, which lasted six months and took him around the world. From Marseille he crossed the Atlantic to Guadeloupe and Martinique, passed through the Panama Canal and continued across the Pacific to Tahiti where he spent five days in the tracks of Paul Gauguin photographing the local girls and having himself photographed in local costume. He sailed on by way of the Cook Islands,

Wellington, Sydney, Brisbane, and the Melanesian archipelago to the Dutch East Indies, as they then were, calling at Makassar, Surabaya (which would soon be immortalized as Heartbreak Central in Kurt Weill's song "Surabaya-Johnny"), Semarang, Cheribon, Batavia, and Muntok, before finally landing in Singapore. There he met up with Gala and Max, who had secretly left France to join him. Gala raised the money for the trip by selling part of Paul's extensive art collection. "My darling little girl," he had written her from Tahiti, "I hope you'll pass this way before long.... You are the only precious one. I love only you, I have never loved anyone but you. I cannot love anything other."[26]

From Singapore the trio sailed on for Saigon in what was then still French Indochina, arriving on August 11. They stayed at the Hotel Casino, no longer *à trois*. Paul and Gala soon returned to Marseille via Colombo, Djibouti, and the Suez Canal on the Dutch luxury liner SS *Goentoer*, leaving Max to find his own way home later on an old tramp steamer. Éluard arrived back in Paris at the end of September 1924, just in time for the publication of Breton's first *Manifesto of Surrealism* and the opening of the Bureau de recherches surréalistes. His friends were relieved to find him alive and well but understandably angry at having been kept so long in the dark. The mystery, to be fair, had not been entirely of Paul's making. His *pneumatique* from Marseille had requested that his father tell "<u>everyone</u>" the same story: that he had had a hemorrhage in Paris, was taken to hospital, and was now recovering in a sanatorium in Switzerland.[27] For whatever reasons Gala and Max kept what they knew to themselves. During one of his trances Robert Desnos located Éluard in the New Hebrides, which was not too far off the truth, but for six months the surrealists had received no more substantial information as to the poet's whereabouts—or indeed as to whether he was dead or alive. "Would you believe it?" wrote a nonplussed Breton to Marcel Noll:

> Éluard, it's a fact, was happily in Tahiti, in Java, and then in
> Saigon with Gala and Ernst.
>> The latter will be back any day.
>> But as for Paul and Gala, it's as if nothing had happened . . .
>> I know, you think that's fine.
>> Well, he drops me a line yesterday, to let me know he'd be
> expecting me at the Cyrano, no more, no less.
>>> It's him, no doubt about it.
>>> On holiday, that's all.
>>> He asked after you.[28]

"Gala knew where he was three months ago," fumed Simone. "I will never forgive her, not for her lies, but for her lying attitude when he left. I feel unbounded repulsion toward her. I cannot forgive anyone for stealing my emotions. Still less André's. . . . I would like to spit on her." "What is a creature," she sarcastically asks, "compared to a symbol?"[29]

It was some consolation for Max, perhaps, that he got to visit the fabled temples at Angkor Wat, an opportunity Paul, eager to have Gala all to himself again, passed by. Images of abandoned cities overwhelmed by jungle soon found their way into Ernst's painting, culminating in the magnificent *Petrified City* series of 1935–36—more metaphors for the century, whatever the contingencies of their genesis. Ernst seems to have been as keen to draw a veil over the episode as Éluard, covering up the entire tangled triangle in his *Biographical Notes* with the brief (not to say misleading) entry: "Selling his works of the Paris years willingly and cheaply to Mother Ey of Düsseldorf, M. E. boarded ship for Indochina. Rendezvous with Paul and Gala Éluard in Saigon, where he convinced Paul to reconsider his decision to 'disappear and never come back.' Paul and Gala returned to Paris, Max following a few months later."[30]

Éluard returned from his travels haunted less by the ruins of the past than what he had seen firsthand of the contemporary realities of European colonialism. "In Indochina the white man is no more than a corpse, and this corpse throws his shit in the faces of people with yellow skin," he wrote in an article titled "La suppression de l'esclavage" (The Abolition of Slavery) in December 1924—the same month that *La Révolution surréaliste* was launched. This impassioned denunciation of "the imbecilic cruelties of white decadence" was Éluard's first venture into political journalism.[31] Ernst's exhibition of *La Belle jardinière* at the Salon des Indépendants in February 1924, suggests Robert McNab, "may well have been the last straw" that provoked Paul's disappearance.[32] It would be an appropriately surreal point of departure for the poet's lifelong navigation between the crosscurrents of his loves, his poetry, and his politics—and another example of the mysterious ways in which *hasard objectif* can show a man a necessity that escapes him. Should we not by now expect beautiful gardens laid out next door to history to be tended by beautiful gardeners?

Whatever passed between them in Saigon, Max and Paul remained close friends ever after. They anonymously published a joint tribute to the woman they both loved in 1925 titled *Au défaut du silence* (In the Absence of Silence). The book couples twenty pen-and-ink sketches of Gala by Ernst with eighteen poems by Éluard, which Philippe Soupault reckoned to be the most

beautiful lyrics that anyone had written since Baudelaire.[33] The first two poems read, in their entirety, "I shut myself up in my love, I dream" and "Which of us two invented the other?"[34] More scurrilously, Éluard features in Ernst's 1926 painting *The Virgin Mary Disciplining the Infant Jesus before Three Witnesses: André Breton, Paul Éluard, and the Artist*, which must be reckoned one of the most blasphemous images of the century. Jimmy Ernst says the inspiration for the scene was his own childhood chastisements at the hands of the loving Maja, though Marcel Jean claims the idea was André Breton's.[35] The picture appalled the artist's father as much as it did the Archbishop of Cologne, who succeeded in closing down the exhibition in which it was being shown. It is hard to say what is most shocking in this latter-day allegory of God made Man and rudely brought down to earth: the Christchild's bottom reddening under the impact of the Virgin's implacable hand or the surrealists peeking surreptitiously at the undignified spectacle through the window. Mary's halo is intact; our Lord's has slipped to the floor. The painting now hangs in Cologne's Museum Ludwig. Ernst might have been more gratified, though, to see it displayed on *Pandora Blake: Spanked, Not Silenced*, the blog of a self-described "young and opinionated submissive model in the UK spanking scene." "Ernst seems to be trying to bring the image of the Madonna and child more in line with real human experience," Pandora suggests. "I'll leave you with the strange fact that three surrealist painters including the artist—are watching the proceedings. A comment on critical scrutiny, or plain old voyeurism? Who can tell?" By a nice coincidence, she lists her favorite film as Philip Kaufman's adaptation of Milan Kundera's *The Unbearable Lightness of Being*.[36]

Éluard later recalled his first contact with Ernst in "Poetic Evidence," the lecture he delivered at the London Surrealist Exhibition of 1936 whose glorification of the Marquis de Sade so appalled Augustus John. The world had changed mightily in the dozen years that had passed since Paul's *voyage idiot*, even if his listeners at the New Burlington Galleries might have been forgiven for seeing in the changes no more than the eternal return of the eversame—"a period of such upheaval, when Europe—even the world itself—may at any moment become one furnace,"[37] in the prophetic words of André Breton, written for the same occasion. Éluard's recollections particularly moved the English painter Roland Penrose, the "surrealist by friendship" (as Breton once called him) who was the main organizer, along with the communist poet David Gascoyne, of the London exhibition.[38] "There is a word which exalts me, a word I have never heard without a tremor, without feeling a great hope, the greatest of all, that of vanquishing the power of the ruin and

death afflicting men," Paul told his audience. "That word is fraternization." "In February 1917," he went on, "Max Ernst and I were at the front, hardly a mile away from each other" at Verdun. This strange meeting,[39] too, was worthy of Lautréamont:

> The German gunner, Max Ernst, was bombarding the trenches where I, a French infantryman, was on the lookout. Three years later, we were the best of friends, and ever since we have fought fiercely side by side for one and the same cause, that of the total emancipation of man.
>
> In 1925, at the time of the Moroccan war, Max Ernst upheld with me the watchword of fraternization of the French Communist Party. I affirm that he was then attending to a matter which concerned him, just as he had been obliged, in my sector in 1917, to attend to a matter which did not concern him. If only it had been possible for us, during the war, to meet and join hands, violently and spontaneously, against our common enemy: THE INTERNATIONAL OF PROFIT.[40]

Again we are reminded of René Daumal's observations on varieties of obscenity. Max, by the way, did not expose Gala's pubic hair in *La Belle jardinière*. He garlanded her genitals with a dove, a motif he had anticipated in the 1921 collage "Santa Conversazione" on which the painting is modeled. His son tells us that at the Hamburg staging of *Degenerate Art*, which took place in a number of converted moving vans, "*La Belle jardinière* was one of those works that seemed to create periodical jam-ups, as did other paintings of female nudes." "The prominent image of a dove partially shielding the vaginal area of the *Jardinière*," he says, "caused many a spectator to lean over the restricting rope as if in hope of seeing what the bird was hiding."[41] Is there no end to man's search for *l'origine du monde*?

THE BRIDE STRIPPED BARE

As André Breton would have been the first to agree, the mood of the moment colors everything. The surrealists' 1935 visit to Prague came at an auspicious conjuncture in Breton and Éluard's personal lives, with which the reception they found in the city merged to create a single rose-tinted memory. Breton had married his beloved *ondine*, the twenty-five-year-old Jacqueline Lamba, the previous August, with Giacometti and Éluard officiating as witnesses. The marriage followed a painful and expensive divorce from Simone

in 1931—a divorce provoked by Breton's no less agonizing affair with Suzanne Muzard, the anonymous "You" who explodes into the final pages of
Nadja. The bride stripped bare for her guests and Man Ray's camera at the
wedding picnic in a re-creation of Manet's *Déjeuner sur l'herbe*.[42] André and
Jacqueline's daughter Aube may have been conceived in the magic capital, as
Angelo Maria Ripellino romantically asserts.[43] *Mad Love* ends with a tender
letter to the infant Aube, addressed as "Dear Hazel of Squirrelnut," who is
imagined "in the lovely springtime of 1952" when "you will be just sixteen,
and perhaps you will be tempted to open this book, whose title, I like to
think, will be wafted to you euphonically by the wind bending the hawthorns."[44] Breton had by then evidently rethought the opposition to fatherhood he had expressed during the "Recherches sur la sexualité." "I am absolutely opposed to it," he had assured the group. "If it ever happened to me
despite everything, I would make sure I never met the child. Public Welfare
has its uses." He had reserved the right to change his mind, though, in a case
of "passionate love."[45]

Éluard married his own fiancée, Nusch (*née* Maria Benz), a week after
André and Jacqueline's nuptials, with Breton returning the legal favor. Gala
had finally abandoned him for Salvador Dalí in 1929. The loss of his first love
did not prevent Paul from joining Breton in penning an enthusiastic publisher's blurb for Dalí's *La Femme visible*, published in December 1930.[46] The visible woman in question was Gala herself, to whom the book—Dalí's first, in
which he explains his "paranoiac-critical" method[47]—was dedicated. On its
cover was a 1925 work by Max Ernst from which Dalí took his title, a landscape penciled across Gala's face as photographed by Man Ray. Her great
dark eyes look straight back at us from beyond the horizon, unflinching as
those of as Manet's *Olympia* or Klimt's *Nuda Veritas*. Dalí presented Éluard
with a personal copy of the book decorated with erotic drawings in the margins in pink ink.[48] Paul did his best to take it like a surrealist man, but he was
heartbroken at Gala's departure. "I have loved you for seventeen years and I
am still seventeen," he wrote her in April 1930. "The idea of unhappiness was
born today with love for you."

The same letter relates how Éluard wept on reading the note left by Vladimir Mayakovsky, who had killed himself earlier that month "par chagrin
d'amour."[49] The Russian poet gave a reading at the Liberated Theater in
Prague three years before. "Then we photograph him on the roof of Krejcar's
Olympic Department store. God, that Mayakovsky, what a hunk!" remembered Milena Jesenská's friend Jaroslava Vondráčková. "Soon after that came
the news of his suicide. We are horrified, uncomprehending. Why, we asked,

only why? Nobody explained it to us."[50] The Soviet government's refusal to grant the bard of the October Revolution an exit visa to join his lover abroad was probably what pushed Mayakovsky over the edge, but Éluard has nothing to say about that. Nor does Breton in the article he wrote on the poet's suicide for *Surréalisme au service de la révolution*, which takes its title from Mayakovsky's last poem "Love's Boat Has Been Shattered against Everyday Life." Still "the splendid incurable illness" wins hands down. "To love or not to love, that is the question," Breton insists. "There is nothing in this world that cannot be resolved, at least momentarily, in the madness of a kiss, the kiss a man exchanges with the woman he loves and with this woman alone.... Mayakovsky could not help it when he lived; I could not; there are breasts that are too pretty."[51]

Éluard evidently could not help himself either. "My only delight," he had told Gala earlier that month, is "to look ceaselessly at your nude photos, where your breasts are sweet enough to eat, where your belly breathes and I lick and eat it, your sex is completely open over my whole face, then my sex completely penetrates you and I hold your buttocks which move marvelously, like the springtime."[52] "Every night I dream of you, you naked in the mountains with Crevel and me, you in Saint-Brice, etc.... You rarely leave me, but I miss you more and more," Paul confessed to Gala the night before his wedding to Nusch.[53] It was not infidelity—Nusch knew all, and so did Dalí—so much as a refusal, as Václav Havel would say in another time and place, mixing up the personal and the political as hopelessly as Oskar Kokoschka, to live in lies.[54] "I loved you fiercely and I didn't give you a bad life," Paul wrote Gala a few months later. "Our love made us aware of ourselves, master our puerility, our innocence like that of the mad. Now, I love you calmly.... Nusch is delighted by your friendship toward her. She is for me, as Dalí is for you, an entirely loving and devoted being, perfect."[55] Breton took the same moral (not to say, in his case, moralistic) stance. "I pride myself on having lived my life *in broad daylight*," he wrote to Simone in November 1928, shocked at the discovery—or so he said—not of her affair with Max Morise but of the fact that Simone had kept it from him when he had been completely open with her about his liaisons with Nadja and Suzanne. "I've never hidden a thing from you, and I've always infinitely respected what I thought I knew about you (stupidly)."[56]

The solace Éluard found with Nusch was amply spiced with varieties, but there is no reason to think the marriage was any the less happy for that. Paul was "tall and classic-looking, sensitive and romantic in emotion," recalled Eileen Agar, "a fountain of joy and faith in life, a living Eros."[57] She remem-

bered Nusch as "a French peach much painted, loved and admired by Picasso
... sweet, gentle and dark-haired, light in spirit and laughing." Nusch's back-
ground in the circus, Eileen thought, was "to prepare her well for her later life
with Éluard" since "her part of the act was to be chained up by her father, and
by invited members of the public, and then in some mysterious way escape
and perform a little dance in triumph at her freedom.... She was a delightful
being who could never be permanently tamed."[58] Paul and Eileen first met
when the young Englishwoman was studying under the Czech painter
František Foltýn in Paris in the late 1920s. They renewed their acquaintance
at the 1936 London surrealist exhibition. When Éluard paid a return visit to
England the following year Eileen's partner, Joseph Bard, took him for lunch
at the Savage Club. The poet was fascinated by "the early collection of Afri-
can sculpture scattered around the rooms," but even more entranced by the
delights of the dessert. "He became quite excited," Eileen relates, "when pre-
sented at the end of the meal with an orange jelly which shook and trembled
like a breast, most erotically, for he could give a sensuous existence to the cur-
vatures of his pudding by merely touching it with his spoon. He contem-
plated it for some time before deciding to devour this object of his desire."[59]

Paul got to devour Eileen herself later that summer during what she de-
scribes as a "delightful Surrealist house party"[60] hosted by Roland Penrose at
his brother's house at Lambe Creek in Cornwall. It was a "brief but exciting
affair," she confides, of "delicious days and nights together." The obliging Jo-
seph had no objection, "perhaps because he was himself enjoying a liaison
with Nusch."[61] "It's very healthy in this marvelous country," Paul wrote Gala,
"but none too warm." Many of the company, including Nusch (who sent
kisses), added their greetings to Éluard's postcard. Max Ernst—conspicu-
ously, but it may have been no more than coincidence—did not.[62] The other
houseguests were the American photographer Lee Miller, the English painter
Leonora Carrington, Man Ray and his lover Adrienne (Ady) Fidelin, and the
Belgian art dealer and surrealist poet E.L.T. Mesens. Henry Moore and his
wife, Irena, dropped by. Love—or something—was in the air. Lee was enjoy-
ing her first European holiday from her wealthy Egyptian husband, Aziz
Eloui Bey, in three years. She had met the recently divorced Roland, who was
masquerading as a beggar, a few days earlier at a fancy dress ball in Paris. Max
was on the run again, though in this case it was only a playful dress rehearsal
for the flight that would before long take him by way of Les Milles to the
arms of Peggy Guggenheim and New York. Leonora's father, a wealthy Lan-
cashire textile manufacturer who did not at all approve of his twenty-year-
old daughter's liaison with a surrealist painter more than twice her age, had

persuaded the police to issue a warrant for Ernst's arrest on grounds of the pornographic content of his current London exhibition. Needless to say a jolly good time was had by all, "with Roland taking the lead, ready to turn the slightest encounter into an orgy. I remember going off to watch Lee taking a bubble-bath," Eileen relates, "but there was not quite enough room in the tub for all of us."[63]

There is a touching (or maybe it was just a desperate) innocence in this seaside surrealism—to borrow from the title of a charming essay by Paul Nash, on whom the free-spirited Eileen had also bestowed her favors the previous year—as if they really believed they *could* shed Éluard's "false and importunate reality which degrades man" along with their clothes. Nowhere was this prelapsarian longing better caught than in the snapshots they took of one another that summer. Paul, Nusch, and Ady dance hand-in-hand against a background of ancient Cornish hills; Eileen and Paul pose back to back, rigid as medieval statues, on either side of a distinctly phallic obelisk at Old Kea Church; Leonora, Nusch, Ady, and Lee recline in deckchairs, eyes wide shut, surrealist muses for a modern world. In one shot (by Roland) Lee is hanging cheerfully naked out of an upstairs window; in another she caresses the bare breasts of a ship's figurehead triumphantly rescued from a chandler's store in Falmouth, whose pose would later fuse with her own headless torso in Roland's 1938 painting *Good Shooting*. Jimmy Ernst might have found a photograph of his father rising from the waves covered with seaweed a more troubling reminder of where Bohemian house parties can lead.[64] History would repeat itself, as it so often does, in a manner that is wearisomely familiar yet always fresh enough to wound anew. The circumstances were not at all the same, but the old man of the sea left a distraught Leonora Carrington behind him in France when he fled to the United States in 1940, just as he had left Lou Straus-Ernst behind him in Cologne twenty years earlier. Leonora's memoir of her subsequent descent into madness has become a classic of surrealist literature.[65]

Like Raoul Hausmann, Lou and Jimmy were among the subjects August Sander photographed in 1928 for *People of the Twentieth Century*. Sander's aim, he said, was nothing less "than to use absolutely true-to-life photography to provide an image of our times."[66] He classified his monumental opus, which was intended to contain between five and six hundred photographs, into seven groups: "The Farmer," "The Skilled Tradesman," "The Woman," "Classes and Professions," "The Artists," "The City," and "The Last People." The latter comprised "Idiots, the Sick, the Insane, and Matter"—which is to say, faces of the dead. These groups were in turn subdivided into forty-five

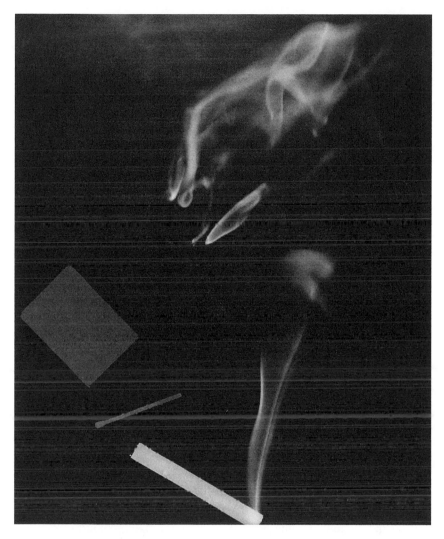

FIGURE 6.2. Jaroslav Rössler, "Smoke," 1929. The Museum of Decorative Arts, Prague.

portfolios that were intended to reflect the social structure of Germany. As the times changed the planes and surfaces began to fray at the edges. Sander found it necessary to add three new portfolios to his "City" group, though the logic of their being placed there is as baffling as that which governed Emperor Rudolf's cabinet of curiosities. "Foreign Workers" were Ukrainian slave laborers forced to work in the Third Reich during the war. "Political

Prisoners" were the inmates of Siegburg Prison, where Sander's own son Erich was serving a ten-year sentence and would eventually die. His death mask would provide the last image of the collection.[67] "The Persecuted," wrote August apropos of his third new portfolio in August 1947, were "people who either emigrated or breathed their last in the gas chambers; all outstanding head portraits of non-political people."[68]

Lou and Jimmy had originally found themselves in this mugs' gallery not as representatives of the persecuted but exemplars of the altogether more innocuous category "Mother and Child."[69] Classifications can be slippery things. In the course of his father's cremation in Père Lachaise Cemetery in 1976, "on the edge of a knife, with fifty-five years littering the cobblestones and beyond in a bewildering lack of sequence," Jimmy was struck by "a sudden thought [that] was almost audible to me. It was of an image I had never seen. More than thirty years ago and many days by cattle car, to the east from here, my mother had also risen in smoke, namelessly joining the vapors of other burned ciphers. I did not even know if the sun had been shining when Lou Straus-Ernst became a statistic of Hitler's 'Final Solution.'"[70] Straus-Ernst fled to Paris in 1933, leaving a successful career as a journalist and art historian behind her. Jimmy was left in Maja's care in Cologne. Lou's transport left on 30 June 1944, the next to last train to leave the city of light for Auschwitz.[71]

GULPING FOR AIR AND VIOLENCE

Paul Nash was intensely jealous of Eileen's dalliance with Éluard, though she never quite understood why. His essay "Swanage, or Seaside Surrealism" had been published in *Architectural Review* the year before. The little Victorian resort, he reflected, had "a strange fascination, like all things which combine beauty, ugliness, and the power to disquiet." Among the town's oddities were lampposts with inscriptions round the base identifying them as intended for squares in London, "a stone column surmounted by a pyramid of cannonballs . . . raised to commemorate King Alfred's victory over the Danes," and "a huge clockless clock tower, a repulsive Victorian-Gothic structure, gray and papery against the solid sea, standing in the remains of a villa garden, jutting out over a lonely beach."[72] Before long Nash would be trading the *malé, ale naše* surrealities of the Dorset Coast for Messerschmidt graveyards. It was not the first time he had served as an official War Artist. If *Totes Meer* (Dead Sea, 1940–41) is one of the eeriest paintings to have come out of World War II, *We Are Making a New World* (1918) leaves us in no doubt as to the impact on the artist's youthful sensibilities of World War I, which led him to a ner-

vous breakdown. *Totes Meer* took its inspiration from a dump for shot-down German aircraft at Cowley in Oxfordshire. It is strikingly reminiscent of Nash's earlier painting *Winter Sea* (1925, reworked 1937), except that in this case the "great inundating wave, a vast tide moving across the fields, the breakers rearing up and crashing on the plains"[73] was made up of the shattered wings and fuselages of aircraft—a solid sea indeed. *We Are Making a New World* is equally devoid of human presence, though it offers plentiful evidence of where human dreams can lead. The canvas portrays a no-man's-land of brackish ponds and bare and broken trees, balefully lit by a sullen sun. "I am no longer an artist interested and curious," Nash wrote from the front to his wife, Margaret—to whom he was still married at the time of his affair with Eileen Agar—in November 1917. "I am a messenger who will bring back word from the men who are fighting to those who want the war to go on forever. Feeble, inarticulate, will be my message, but it will have a bitter truth, and may it burn their lousy souls."[74]

Ady Fidelin, a mulatto dancer from Guadeloupe, was Man Ray's first serious love interest since Lee Miller left him five years before. She appeared in the September 1937 issue of *Harper's Bazaar*, the first black model to break the color bar imposed by its owner William Randolph Hearst (or indeed to grace any leading American fashion magazine). The occasion was a two-page spread by Man Ray titled "The Bushongo of Africa Sends His Hats to Paris," which was inspired by an exhibition of Congolese headdresses at the Galerie Charles Ratton. Paul Éluard supplied appropriately poetic captions.[75] These were not the only studies Man made of "his exotic girlfriend" (as Agar described her).[76] It comes as no surprise to find that Ady was the subject of several nude portraits, but these images are exceptional in Ray's work for their simplicity and spontaneity. There are no solarizations, no double exposures, no artful tricks with light and shade. "Man Ray's nudes of Ady, with their strangely natural expression, contain all the youthful instinctiveness and latent primitivism of the Creole woman," explains Pilar Parcerisas, introducing an exhibition in Valencia in 2007. Present-day Americans might wince at such language, but I suspect that this was exactly what Ray *was* photographing: "the image of the *Venus naturalis*, of flesh and blood, as opposed to the types of *Venus celest* and *Surrealist Venus* inspired by the artificial beauty of the mannequin." Adolf Ziegler would likely not have approved of Man's photographs of Ady either, albeit for different reasons.

Whatever the lures of Adrienne's "simple habits and her *café au lait* skin, her totally harmonious integration with nature,"[77] this surrealist muse, too, would find herself left behind in Paris when Man returned home to New

York in 1940. The separation was Ady's choice rather than his. As a Jew he had little option but to leave. At the last moment (Man had secured exit permits to Spain for himself and his "wife") Fidelin elected to stay in the occupied city to take care of her family. Had the photographer taken his *Venus naturalis* with him to William Randolph Hearst's America, of course, their relationship might have faced many more obstacles than it did in France, where they were (in his words) "in love, and . . . received by the others in the south with open arms."[78] Miscegenation was then still a crime in over half the states of the Union. Man promised to replace Ady's beloved gold-painted bicycle, which disappeared in the chaos following the fall of Paris, with "a bicycle in solid gold, ornamented in mink,"[79] but he never did. Ady survived the German occupation, during which she married a young Frenchman called André and kept safe much of Ray's hastily abandoned work. She exits the art-historical record dancing at a fashionable "Negro" club on the Champs-Élysées.

The surrealist house party resumed a few weeks later at the sun-drenched village of Mougins, whose hotel Le Vaste Horizon—an appropriate name, Roland Penrose thought—provided a pleasant retreat for three lovely summers (1936–38), offering "ideal conditions for rest as well as intense and uninterrupted activity," the "idyllic atmosphere of the Mediterranean coast . . . broken only by the terrible news of Franco's invasion of Spain."[80] Eileen remembered "a hotel of beautiful simplicity overlooking a courtyard and vineyards, while way below could be seen the roofs of Cannes and the dark sea."[81] More moments of verdant summer, forever immobile, were captured by the camera for the museum postcards and fridge magnets of the future: there they are, eternally picnicking at the Île Ste Marguerite, Paul and Nusch, Man and Ady, Lee and Roland, all the women bare-breasted—documents of a world on the edge of the abyss, shining all the more brightly against the darkness that came after.[82] The summer of 1914, by all accounts, was lovely too. Eileen remained sufficiently fond of the image of her youthful self, dancing on a Mougins roof clad only in see-through gauze, to reproduce the photograph in the autobiography she published fifty years later.[83] Like Proust, she said, she had come to believe "that people who have no memories of the past, or do not reflect upon it, are like undeveloped negatives."[84]

Partners were swapped as enthusiastically in the Midi sunshine as they had been in bleak and blustery Cornwall. Picasso, the life and soul of the party, would not want to insult his good friend Paul, he said, by suggesting that Nusch was undesirable.[85] Though the poet and the painter had known each other since 1926 it was the Spanish Civil War, rather than eating the

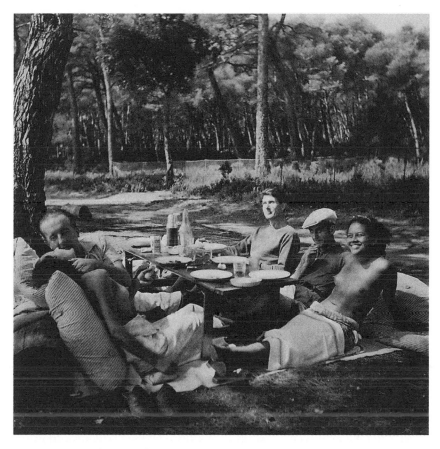

FIGURE 6.3. Lee Miller, "Picnic, Île Ste Marguerite, Cannes, France," 1937. From left to right: Nusch Éluard, Paul Éluard, Roland Penrose, Man Ray, Ady Fidelin. © Lee Miller Archives, England, 2011. All rights reserved. www.leemiller.co.uk.

same French peach, that cemented their relationship—or so, at any rate, thought Brassaï. The two men's "lust for life, their power, their will to transform pain and sorrow into the joy of creation are the common denominators of their friendship," he writes. "For the most realist of painters and the most visual of poets, neither of whom can imagine life without love, art is the art of living and seeing and not of imagining and dreaming; built on the physical, it requires the support of reality and flees everything gratuitous."[86] He was certainly right about the two men's intoxication with the physical, in which they both sharply contrast with the cerebral André Breton. But Brassaï was reminiscing in 1945, after the planes and surfaces of the world had

been torn up and knitted together anew. By then Paul Éluard had become someone else; let us call him, for reasons I shall explain later, Didier Desroches. The poet would certainly not have made any such distinctions between living and seeing and imagining and dreaming *at the time*.

Lee Miller would go on to produce some of the most haunting photographic images of World War II. Her series *Grim Glory: Pictures of Britain under Fire*, taken in London during the Blitz, is another that turns moments into metaphors: a mound of bricks spewing out of the door of a Nonconformist chapel; the shattered roof of University College reflected in a shimmering pool of rainwater; the twisted keys of a "Remington Silent" typewriter. "Revenge on Culture" depicts a nude female statue lying atop a bed of debris left by the Luftwaffe, her throat slashed by a stray cable.[87] This was probably not quite what André Breton had in mind when he commended Max Ernst's *Hundred Headless Woman* for "bridging the distance between a statue set up in its designated place and the same statue lying in a ditch; unnoticed in its proper place, in a ditch it might be utterly fascinating,"[88] though the photograph accomplishes exactly that. Lee followed the Allied armies from the Normandy landings to Berlin and beyond—the only female journalist to do so—in the unlikely guise of a war correspondent for *Vogue*.[89] She documents the ruins of European modernity in all their convulsive beauty: the daughter of the Burgermeister of Leipzig all dressed up for death in her uniform on the sofa (she had "extraordinarily pretty teeth," Lee observed);[90] the soprano Irmgard Seefried singing an aria from *Madame Butterfly* alone and unaccompanied in the bombed-out remains of Vienna cathedral ("perched on a plank across a drop . . . her dress was safety-pinned to fit her hungry thinness");[91] a murdered SS-guard floating in the canal beside Dachau, peaceful as Ophelia, a beautiful boy.[92]

Lee had David Scherman—another of her lovers—photograph her taking a bath in Hitler's private apartment at Printzregentenplatz 16 in Munich, which they were the first Allied correspondents to enter. Her muddy combat boots soil the white bathmat. Many critics have commented on the multiple ironies of this picture, but the plays of resemblance take us beyond good and evil. The bathroom could not but bring to mind the bathhouse Lee had toured at Dachau earlier that day where, in her own words, the "elected victims having shed their clothes walked in innocently. . . . Turning on the taps for the bath, they killed themselves."[93] She left the camp, she wrote *Vogue* editor Audrey Withers, "gulping for air and for violence." Hitler, she went on, had "never really been alive for me until today."[94] It was not the atrocities of Dachau that brought the Nazi leader's monstrosity to life so much as the ba-

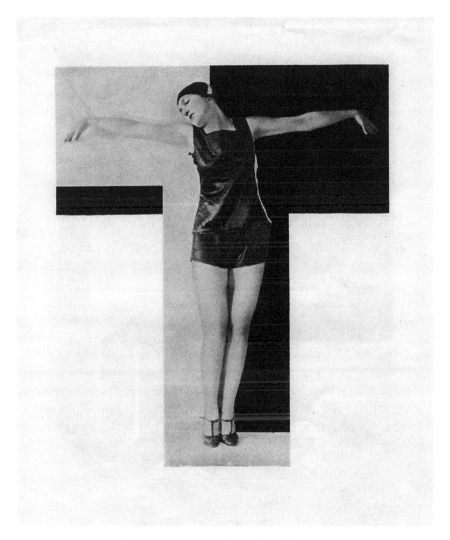

FIGURE 6.4. The letter *T* from Vítězslav Nezval, *Abeceda* (*Alphabet*). Dance composition Milča Mayerová; typographic design Karel Teige. Prague: Otto, 1926. Archive of Jindřich Toman. Courtsey of Olga Hilmerová, © Karel Teige - heirs c/o DILIA.

nalities of his apartment. "It lacked grace and charm, it lacked intimacy, but it was not grand." The everyday objects the Führer had touched made him seem "less fabulous and therefore more terrible," transforming him from "an evil machine-monster" into "an ape who embarrasses and humbles you with his gestures, mirroring yourself in caricature."[95] One such gem of kitsch was a

George VI souvenir beer mug that played the British national anthem when lifted, a present from Neville Chamberlain.[96] But the *punctum* of the photograph is surely the positioning of the *corpus delicti*. Behind the tub is a framed portrait of the Führer. A statuette of a naked woman, of whose classical proportions Adolf Ziegler would surely have approved, stands on the washstand. Between them, soaping herself in a pose that mimics that of the figurine, is the blue-eyed American blonde with the most beautiful breasts in Paris.[97] "There but for the grace of God," Lee dryly told Withers, "walk I."[98]

Needless to say Nusch's nudity, too, was caught by Man Ray's ever-welcoming lens. Her body forms the backdrop to Éluard's love poems in *Facile*, which came out a few months after the surrealists' visit to Prague. Many of the photographs are solarized, giving an unearthly halo to Nusch's boyish curves. René Char congratulated the poet, the photographer, the model, and the printer on achieving "carnal perfection."[99] It is a judgment many have echoed since. "Certainly one of the most beautiful books ever made," writes Shelley Rice, "*Facile* literally intertwines Man Ray's photographs and Éluard's poems, allowing sensuous nudes to enhance the pleasure of amorous words, and the silver tones of prints to embody the lights and shadows of love. Language transmutes into pictures; ideas become flesh."[100] There was a precedent for such miraculous transmutations, of course, in Vítězslav Nezval's *Alphabet*, though whether Éluard saw Karel Teige's typo-photomontage intertwinings of Nezval's poems with Milča Mayerová's elastic body during his visit to Prague I do not know. It is not unlikely. The only illustration in *Facile* that is not of Nusch's naked flesh is a pair of gloves, fingertips just touching. It says something, maybe, about Paul and Nusch's relationship:

> Éluard was living with Nush [*sic*]. He loved her, and I may, perhaps, have a chance to describe how delicately he treated her. He was then suffering from tuberculosis and spent part of the year in sanatoria. And yet, if Nush dropped her glove or a piece of paper, he would rush to pick it up—even though he knew he wasn't supposed to make sudden moves. Still, despite his constant attention to Nush, I always had the feeling that the memory of Gala (and not just her memory, for she was there in person) continued to fascinate him.

Roger Caillois, whose memoir of Éluard I quote here, joined the French surrealist group in 1932, left it two years later, and went on to found the Col-

lège de Sociologie with Michel Leiris and Georges Bataille in 1937. He was a frequent contributor to *Minotaure*. Caillois was then by his own account "a very young man," "naïve, doctrinaire, uncompromising, and rather aggressive," "earnestly cultivating chastity and reserve" in order to imitate his "favorite hero" Saint-Just. The issue over which he left the group betrays something of the same mindset—which is not to say that he did not have a point. When Breton refused to slice open a Mexican jumping bean because (as Caillois later reminded him) "you did not want to find an insect or a worm inside (that would have destroyed the mystery, you said), my mind [was] made up."[101] The young man found Éluard's adoption of a pseudonym "unworthy of a poet (especially a surrealist poet)." "This attitude," he relates, "irritated Éluard, who often reproached me in a friendly way for being more interested in ideas than young women. But he could see that my case was hopeless. Perhaps he could also discern the affectation that entered into this naïve embodiment of the theorist, the 'incorruptible' doctrinairian. When he wrote me postcards, he would often send me scantily clad girls."[102]

The times could certainly have done with lightening up, and with something more cheering than Jacques Vaché's grim *umour*. Paul did his best, publishing a selection from his large and eclectic collection of postcards in *Minotaure*. The images that most appealed to him, as we might expect, were those that occupied the poetic spaces of metaphor and metamorphosis. He had little time for pictorial panoramas, which he said "tend to unify all the memories, to immortalize all the towns, all the villages, to compose one Country [*Patrie*] from all the little localities [*patries*]," and considered Easter cards to be "generally pornographic." He had no illusions about the postcard being "a popular art"; it was but "the small change of art and poetry," harnessed by "the exploiters to distract the exploited." "But this small change," he explains, "sometimes brings gold to mind." The gold, as we should also by now expect of Éluard, often came in feminine form—"*femmes-enfants, femmes-fleurs, femmes-étoiles, femmes-flammes* ... luminous virgins, perfect courtesans, princesses from legend." Among Paul's favorites were "a haughty girl with her hair done as a peacock, a cat with a woman's head, a swarthy beauty at the gate of a cemetery, a naked young girl upside-down on a rocking chair, another at the bottom of the sea, sitting on a table in an indecent pose, smoking a cigarette and pouring herself a glass of wine." "Everything," he explains, "is a pretext for showing us feminine nudity. L'Institut général Psychologique publishes cards in which *Science*, fully dressed, *unveils Nature*, in which *Nature, freed of its veils, stands radiant, a true incarnation of Beauty*. Eve is in the

apple. Innumerable naked women, in unlikely positions, make up faces and animals"[103]—just like the fruits and vegetables, library books and platters of roast meats in Arcimboldo's paintings. Or almost.

Much to Paul's regret the gentle, laughing Nusch (as everyone remembered her) did not accompany her husband to Prague in 1935, even if the editors of Breton's *Oeuvres complètes* say that she did, an error that is repeated in both Gérard Durozoi's magisterial *History of the Surrealist Movement* and the catalogue for the mammoth 1991 Breton retrospective *La Beauté convulsive* at the Centre Pompidou.[104] The mistake originates in photographs showing Nusch and Paul together with the Czech surrealists, which are reproduced in the two latter sources and wrongly identified as having been taken in the Bohemian capital. The truth is that Éluard had decided to come with Breton only at the last moment and was so broke at the time that he needed to borrow from friends to pay for the journey. Had Nusch been with him she would surely have left traces, as she did everywhere else, yet she figures neither in Nezval's diaries nor in Breton's souvenir photographs from the trip.[105] After Paul got home he wrote to Nezval, Štyrský, and Toyen, thanking Toyen again for the "magnificent" watercolors she had given him and telling them that "I speak often of you to my wife who already dreams of meeting you. Still a month."[106] He was anticipating the Czech surrealists' imminent visit to Paris, where the photographs were in fact taken in the summer of 1935—a trip I shall return to later. It was not the first or the last time the Seine and the Vltava had got mixed up in the imagination. Here as elsewhere, Prague can prove elective in the way it pins down poetic thought.

ORDERS OF THINGS

Less than two months after *Degenerate Art* closed in Munich another *Exposition internationale du Surréalisme* opened in Paris. With over three hundred works by sixty artists from fourteen countries on display, it was the largest and greatest of the surrealists' prewar shows—"the climax of Surrealist activity" said Man Ray, who was seldom one to resist a sexual metaphor.[107] It also proved to be the original Paris surrealist group's last hurrah. Although the surrealist movement would survive the coming conflagration—its many obituaries have never ceased to be premature—Éluard, Ernst, Ray, and Dalí would all part company with Breton before the year was out. The *Exposition*, which was held in Georges Wildenstein's Galerie des Beaux-Arts on the upscale rue du Faubourg Saint-Honoré, was scarcely a spectacle designed to please the masses. The invitations required guests to wear evening dress for the opening, which commenced at ten o'clock at night on 17 January 1938

with a speech delivered by Paul Éluard dressed in frock coat and tails. "We had not seen such a jostle of society people since the fire at the Bazar de la Charité," wrote one press reviewer.[108] Needless to say the *vernissage* continued long past the workers' bedtime.

There is something faintly elegiac about the *Dictionnaire abrégé du surréalisme* (Abbreviated Dictionary of Surrealism) that Breton and Éluard produced in lieu of a catalogue—almost as if something told them that this would be their last collaboration.[109] The dictionary provides an excellent guide to the personalities and preoccupations of the prewar surrealist movement, not least because (for once) it does not seek to write the backsliders out of the story. Aragon, Artaud, de Chirico, Desnos, Masson (who was by then reconciled with Breton), and Soupault are all given their due. Georges Bataille is not, but "surrealism's old enemy from within" had never been part of Breton's entourage. Vítězslav Nezval and Karel Teige—who would also soon be going their separate ways, as we shall see—are listed as surrealist writers and "promoters of surrealism in Czechoslovakia." Somewhat curiously, Štyrský and Toyen are not, but the *Abbreviated Dictionary* includes reproductions of several of their works.

The text is interspersed with nearly two hundred illustrations, which are in their way as much miniatures of their age as any of John Heartfield's montages. Marcel Duchamp's bottle-rack *Ready-Made* and *Belle Haleine* perfume, labeled with his own face made up as Rrose Sélavy, are here; so, too, are Hans Bellmer's notorious adolescent doll, René Magritte's *Le Viol* (*The Rape*), and a two-page spread of *femmes surrealists* as photographed by Raoul Ubac and Man Ray, one of whom turns out to be Lee Miller with her head fetchingly meshed in a saber-guard. Magritte's *Rape*, which superimposes a woman's torso on her face in such a way that her breasts substitute for her eyes, her navel for her nose, and her vagina for her mouth, is Exhibit A in the feminist case against surrealist misogyny, but other readings are possible: had its author been female the painting might well now be seen as a searing comment on the male gaze. There are photographs of Breton, Éluard, Dalí (who poses with Harpo Marx), and Ernst, as well as group portraits taken in various times and places, including in Prague in 1935. Ernst's *Au rendez-vous des amis*, which was painted in 1922, the year Max left Lou and Jimmy for Gala and Paris, strikes a poignant note; among the friends gathered on the canvas are the excommunicated Aragon, Desnos, De Chirico, and Soupault. Paul Éluard stands close to the center of the frame, outshone only by a flamboyant Breton. Ernst is seated beside Feodor Dostoyevsky, whose virtual presence in this company may be compared—and perhaps usefully contrasted—with

Charlie Chaplin and Douglas Fairbanks's honorary membership of Devětsil. Gala glances over her shoulder at the viewer from the extreme right of the painting, her back turned on the men.[110]

The only thing the *Abbreviated Dictionary* has in common with a regular dictionary is its alphabetical arrangement. It delights in its own obscurities, multiplying meanings and cascading allusions—as we might expect from a movement that believed, as Paul Éluard once put it, that "no word will ever again be subordinated to matter."[111] Fittingly perhaps, the first entry is for the word *ABSURDE*, which is explicated by way of quotations from Baudelaire ("these vulgar reasoners who cannot raise themselves to the logic of the Absurd") and Éluard ("the derangement of logic to the point of the absurd, the use of the absurd to the point of reason"). But the text does provide some keys to its own untangling. There is a surrealist genealogy, of sorts: *BAUDELAIRE, (Lewis) CARROLL, FREUD, HEGEL, HERACLITUS, JARRY, LAUTRÉAMONT, NERVAL, MARX, NOVALIS, (Ann) RADCLIFFE, SADE, TROTSKY, VACHÉ*, not to mention "the celebrated medium, painter and inventor of languages" *(Hélène) SMITH*. There are the usual surrealist obsessions: *AMOUR, BEAUTÉ, FEMME, HASARD, MERVEILLEUX, OBJET, RÊVE*. Most of the key concepts in the surrealist lexicon are elucidated—if that is the right word, for it would be a mistake to approach so gnostic a work in search of clarity of meaning. We would do better to follow the meanderings of metaphor: *AZUR, BAISER, CERISIER, DENTS, ÉTOILE*. Beside the entry for *CUILLER* is a photograph of the wooden spoon with the curious heel from *Mad Love*, "one of the kitchen utensils," Breton helpfully explains, "that Cinderella had to employ before her metamorphosis."

The *Dictionary* is not devoid of humor, albeit of a kind far removed from the cheery Czech vulgarities of *Erotic Review*. Marinetti might have appreciated *VIOL* (rape) being defined as "love of speed," though a famous photograph of the father of futurism proudly posing with his wife and daughters, every inch the bourgeois paterfamilias, might suggest otherwise.[112] An *AVION* is "a sexual symbol, which serves to get quickly from Berlin to Vienna," a joke attributed to Sigmund Freud. The entry *HYMEN* consists of a single punning word: "humain." *DALÍ* is described as a "Prince of the Catalan intelligentsia, colossally rich," *ÉLUARD* as "the wet nurse of the stars," *ERNST* as "Loplop, supreme among birds," *PICASSO* as "the bird of Benin"—in-jokes all. *BRETON* is "the tea-cup in the storm" (*le verre d'eau dans la tempête*). An acid one-liner from Francis Picabia's *319*, dating from

February 1920, might have served as well: "We await the moment when sufficiently compressed, like dynamite, [Breton] will explode." Marcel Duchamp was described in the same Dada source—which was the first to reproduce his mustachioed Mona Lisa—as "intelligent, a little too occupied with *les femmes*."[113] By the time of the *Exposition internationale du Surréalisme* the urinal Duchamp had been prevented from exhibiting in New York twenty years earlier was well on its absurd way to becoming the most influential work in the history of modern art, displacing even Picasso's *Les Demoiselles d'Avignon*.[114] "Our friend Marcel Duchamp," fawns Breton, "is assuredly the most intelligent and ... brilliant man of the first part of the twentieth century." *GALA* gets shorter shrift in an entry credited to Salvador Dalí: "a violent and sterilized woman." *JACQUELINE*, on the other hand, dissolves into pure poetry. We learn neither Lamba's surname nor her date of birth, and still less the fact that she is a painter. "'When the hand of Jacqueline X opens like a casement-window on a nocturnal garden' (A. B.)," reads the entry—in its entirety. The line is from Breton's 1934 poem "Zinnia-red eyes."[115]

The *Abbreviated Dictionary* owed not a little to an earlier *Critical Dictionary* that had been serialized in Georges Bataille's journal *Documents* in 1929–30.[116] Bataille himself wrote the majority of the entries, which varied in length from brief paragraphs to mini-articles; other contributors to this anarchic lexicon included Robert Desnos and Michel Leiris. Among the motley assortment of subjects were *Aesthete, Camel, Crustaceans, Dust, Eye, Factory Chimney, Hygiene, (Buster) Keaton, Materialism, Metamorphosis, Metaphor, Mouth, Museum, Skyscraper,* and *Slaughterhouse.* The latter entry is illustrated with Elie Lotar's photographs of the abattoir at La Villette, the most memorable of which is probably the row of severed hocks and hooves matter-of-factly lined up against a wall. Some of his other images, which are in fact composed of blood and guts, eerily anticipate the landscapes of abstract expressionism. The slaughterhouse, contends Bataille, is inextricably linked to religion in that "the temples of bygone eras ... served two purposes: they were used both for prayer and for killing," resulting in "a disturbing convergence of the mysteries of myth and the ominous grandeur typical of those places in which blood flows." Today, he laments, "the orgiastic life has survived" but "the sacrificial blood is not part of the cocktail mix." The abattoir has become "cursed and quarantined like a plague-ridden ship," leaving contemporary humanity "to vegetate as far as possible from the slaughterhouse, to exile themselves, out of propriety, to a shabby world in which nothing

fearful remains and in which, subject to the ineradicable obsession of shame, they are reduced to eating cheese."[117] Was the staid librarian a tad nostalgic for Hugo Ball's bordello?

The best-known articles in the *Critical Dictionary*, both of which also flowed from Bataille's merciless pen, are probably those titled "Architecture" and "Formless" (*Informe*). Bataille's definition—if it can be called that—of *informe* reads in full:

> A dictionary would begin as of the moment when it no longer provided the meanings of words than their tasks. In this way *formless* is not only an adjective having such and such a meaning, but a term serving to declassify [*déclasser*], requiring in general that everything should have a form. What it designates does not, in any sense whatever, possess rights, and everywhere gets crushed like a spider or an earthworm. For academics to be satisfied, it would be necessary, in effect, for the universe to take on a form. The whole of philosophy has no other aim; it is a question of fitting what exists into a frock-coat, a mathematical frock-coat. To affirm on the contrary that the universe resembles nothing at all and is only *formless*, amounts to saying that the universe is something akin to a spider or a gob of spittle.[118]

The verb *déclasser* can be rendered in English either as to declassify or to debase; Bataille, who figured out that classifications of discourse *are* orders of things (and vice versa) long before Michel Foucault, was likely playing on both connotations. Yve-Alain Bois and Rosalind Krauss, who want to install *informe* at the heart of contemporary art criticism, translate it as "to bring things down in the world."[119]

Architecture, by contrast, expresses "society's ideal nature," which in Bataille's jaundiced opinion is "that of authoritative command and prohibition. . . . Thus great monuments rise up like dams, opposing a logic of majesty and authority to all unquiet elements; it is in the form of cathedrals and palaces that Church and State speak to and impose silence upon the crowds." He is not just speaking of buildings here. "Whenever we find *architectural construction* elsewhere than in monuments," he warns, "whether it be in physiognomy, dress, music, or painting, we can infer a prevailing taste for human or divine *authority*":

The large-scale compositions of certain painters express the will to constrain the spirit within an official ideal. The disappearance of academic pictorial composition, on the other hand, opens the path to the expression (and thereby the exaltation) of psychological processes distinctly at odds with social stability. This, in large part, explains the strong reaction elicited, for over half a century, by the progressive transformation of painting, hitherto characterized by a sort of architectural skeleton.

In a memorable formulation, Bataille goes on to argue that since "the human and the architectural orders make common cause, the latter being only the development of the former," "man would seem to represent merely an intermediary stage within the morphological development between monkey and building." This impeccable reasoning, which foreshadows the critique of Enlightenment humanism associated with Foucault, Lacan, Barthes, Derrida, and other postwar poststructuralist French thinkers for whom "Man" is less the author of his world than its precipitate, leads to a conclusion that would likely have been as repugnant to André Breton as the sound of a woman farting:[120]

> Therefore an attack on architecture, whose monumental productions now truly dominate the whole earth, grouping the servile multitudes under their shadow, imposing admiration and wonder, order and constraint, is necessarily, as it were, an attack on man. Currently, an entire earthly activity, and undoubtedly the most intellectually outstanding, tends, through the denunciation of human dominance, in this direction. Hence, however strange this may seem when a creature as elegant as the human being is involved, a path—traced by the painters—opens up toward bestial monstrosity, as if there were no other way of escaping the architectural straightjacket.[121]

Perhaps Augustus John had a point after all.

All the masters of surrealism were well represented in the *Exposition internationale*, which had much of the character of a retrospective. Some of the exhibits went back to the movement's beginnings in Dada. The flyer listed Breton and Éluard as "Organisers," Marcel Duchamp (who in his own words

had been "borrowed from the ordinary world by the Surrealists" for the occasion)[122] as "Generator-Arbiter," Dalí and Ernst as "Special Advisors," Man Ray as "Master of Lights," and Wolfgang Paalen as responsible for "Water and Undergrowth."[123] Fifteen of Ernst's paintings were included in the show. Among them was *Elephant Célèbes*, which Paul Éluard had bought from him when the two men met and fell in love in Cologne in 1921, along with several of his collages and original pages from his collage-novel *A Week of Kindness*. Other exhibitors included Arp, Bellmer, de Chirico, Paul Delvaux, Giacometti, Magritte, Masson, Roberto Matta, Miró, and Tanguy. Europeans got to sneak a rare peek into the magical boxes Joseph Cornell made out of bits and bobs and photos of ballerinas and movie stars in the basement of his house on Utopia Parkway in Queens, New York. One of Cornell's obsessions was Hedy Lamarr, whom he once fantasized riding an antique bicycle wearing a double-breasted jacket, starched shirt and bow-tie, "beige bloomers, black stockings and patent leather shoes."[124] Queering the commonplaces of gender as adroitly as Duchamp or Toyen, the homespun American surrealist collaged the "gentle features" of the first woman in the history of the world to bare her all for the silver screen into a reproduction of a Giorgione painting of an adolescent boy.[125]

We are less inclined these days to remember some of the exhibition's other participants, like Picasso,[126] Paul Nash, and Henry Moore as surrealists—when, that is, we remember them at all. Štyrský and Toyen were among the contributors who had dipped beneath the art-historical radar by the time William Rubin put together his blockbuster retrospective *Dada, Surrealism and Their Heritage* at MoMA in 1968.[127] The MoMA exhibition did not include the work of a single Czech artist, and Rubin's accompanying 525-page book *Dada and Surrealist Art* omitted the names of Nezval, Teige, Štyrský, and Toyen altogether from what the publishers claimed to be "this first truly comprehensive history of the two movements." This might not matter were Rubin not the Chief Curator of the Painting and Sculpture Collection at MoMA, which is as authoritative a position from which to define what is or is not part of the modern canon as the world has to offer. Absurdly, but not improbably in a time when few would have challenged New York's claim to have taken over from Paris as the global capital of modern art, the book's chronology begins not in Europe at all but with Francis Picabia's arrival in Manhattan in January 1913 for the Armory Show that jolted America into a belated awareness of what Picasso, Matisse, Duchamp, and company were up to. Rubin's chronology makes no mention of the *Poesie 1932* exhibition at the Mánes Gallery—a show three times the size of *The Newer Super-Realism* ex-

FIGURE 6.5. Illustrated film program for Gustav Machatý, *Ecstasy*, 1933 (*Obrazkový filmový program*, No. 538), inside spread. Anonymous artist. Archive of Jindřich Toman.

hibition the previous November at the Wadsworth Atheneum in Hartford, Connecticut, which was the first surrealist exhibition to take place on American soil.[128] Nor does this listing of key dates, events, and works in the history of the surrealist movement mention Breton and Éluard's 1935 visit to Prague, which gave rise to the *Bulletin international du surréalisme* and several of the texts in *The Political Position of Surrealism*.

The disappearance of the Czechs is not the only lacuna in how the 1938 *Exposition internationale du Surréalisme*, and indeed the entire interwar surrealist movement, came to be remembered. Of the 331 works exhibited in *Dada, Surrealism and Their Heritage*, a grand total of seven were by women. Meret Oppenheim's *Fur Lunch* made the cut, as did her no less evocative *My Nurse* (1936)—a pair of high-heeled shoes neatly tied together with string, soles pointed outward toward the viewer to frame what might just, but of course need not be, another gesture toward *l'origine du monde*. For the artist herself the object recalled "the association of thighs squeezed together in pleasure."[129] Others might see in the composition a bondage metaphor—one can never tell where a signifier on the loose might lead the wandering mind. The other female contributions to the exhibition were Hannah Höch's "Cut with the Kitchen Knife" and "High Finance" (1923), a marionette and a *Dada Head* by Sophie Taeuber-Arp, and a *papier-maché* construction by the young Franco-American artist Niki de Saint Phalle (who would later become famous for her shooting paintings and exuberant Nana-dolls).[130] *Dada and Surrealist Art* similarly neglects to give serious consideration to a single

woman artist.[131] Rubin was quite candid about his intentions, stressing that the aesthetic judgments underlying his selections were "not simply outside of the concerns of the Surrealist poet-critics, they were utterly alien to their beliefs." "Yet," he insists, "despite the Dada posture (accepted by most Surrealists) that rejected the possibilities of inherent aesthetic value, the ultimate survival of the objects in question depends on the fact that they *are* art and not mere cultural artifacts."[132] Art, we might ask, as defined by (and for) whom?

In fact, the *Exposition internationale* was remarkable by the standards of the day for the number of female contributors, who included Eileen Agar, Denise Bellon, Leonora Carrington, Ann Clark, Gala Dalí, Jacqueline Lamba, Rita Kernn-Larsen, Sonia Mossé, Nina Negri, Meret Oppenheim, Sophie Taeuber-Arp, and Toyen. Whatever may since have been written concerning surrealism's supposed "male gaze,"[133] the movement provided more space for female creativity than any earlier avant-garde (with the exception of the Russian)[134] and most since. Eileen Agar went as far as to suggest that surrealism was *intrinsically* feminine, because "the importance of the unconscious in all forms of literature and art establishes the dominance of a feminine type of imagination over the classical and more masculine order."[135] It remains a telling comment, whether or not we accept the essentialism that seems to underlie it. The surrealists' rejection of the sovereignty of reason and deliberately passive stance toward inspiration—as variously exemplified in their fondness for automatic writing, trance, games of chance, or the *objet trouvé*—aligned them with what were, according to the lights of the time, distinctly female qualities. So, it might be argued, did their willingness to plumb the depths of abjection.[136] To the mistresses of surrealism whose works were on display at the Galerie Beaux-Arts we might add the names of Aube and Elisa Breton, Claude Cahun, Ithell Colquhoun, Leonor Fini, Valentine Hugo, Frida Kahlo, Dora Maar, Maria Martins, Emila Medková, Suzanne Muzard, Alice Paalen, Mimi Parent, Kay Sage, Eva Švankmajerová, Dorothea Tanning, Remedios Varo, and Unica Zürn, to name but a few visual artists who at one time or another have considered themselves to be *femmes surrealists*. Were we to include writers and poets like Suzanne Césaire, Nora Mitrani, Gisèle Prassinos, or Joyce Mansour in this list it would be a good deal longer.

So who or what was the surrealist woman? The mostly nude centerfold in the *Abbreviated Dictionary of Surrealism* provides one answer: the muse, the *femme-enfant*, the eternally obscure and obsessively depicted object of desire. Eileen Agar provides another. They are not as mutually exclusive as some

feminist critics would have us believe, though they are by no means free of tensions either:

> The surrealist women, whether painters or not, were equally good-looking [as the men]. They were elegant and dressed with panache, caring about clothes and their surroundings, however strange the interiors. Our concern with appearance was not a result of pandering to masculine demands, but rather a common attitude to life and style. This was in striking contrast to the other professional women painters of the time, those who were not surrealists, who if seen at all, tended to flaunt their art like a badge, appearing in deliberately paint spattered clothing. The juxtaposition by us of a Schiaparelli dress with outrageous behavior or conversation was simply carrying the beliefs of surrealism into public existence.

But Agar is quite clear that "amongst the European surrealists double standards seem to have proliferated, and the women came off worst. Breton's wife, Jacqueline, was expected to behave as the great man's muse, not to have an active creative existence of her own. In fact, she was a painter of considerable ability, but Breton never mentioned her work. The men were expected to be very free sexually, but when a woman like Lee Miller adopted the same attitude while living with Man Ray, the hypocritical upset was tremendous."[137] Eileen was not the only surrealist woman to complain of double standards. Leonor Fini was flattered that the Paris surrealists seemed "impressed by my intelligence, my culture, and my talent," and participated in several of their exhibitions. But she "detested their hatred for homosexuality and their misogyny. . . . The women were expected to keep quiet in the discussions at the café, and me, I thought myself the equal of the men. . . . I appreciated their attentions, but I refused to join the group."[138]

To argue (is it not what immediately comes to mind?) that many of these women found their way into the movement as wives or lovers of surrealist men is spectacularly to miss the point. Would we even *think* of dismissing the work of Max Ernst because he was at one time or another both Leonora Carrington's lover and Dorothea Tanning's husband? (Max married Tanning, in a joint ceremony with Man Ray and Juliet Browner, in Beverly Hills in 1946; the marriage to Peggy Guggenheim lasted no longer than had his previous *amours*.) Would we *dream* of passing over the art of Man Ray or Roland Penrose simply because the undeniably lovely Lee Miller, who started her distin-

guished photographic career at the other end of the camera as a cover girl for *Vogue*,[139] bedded them both? "I was terribly, terribly pretty," Lee later said, "I looked like an angel but I was a fiend inside."[140] Her initial horror at her photograph (by Edward Steichen) being used without her knowledge in 1928 to advertise Kotex sanitary towels under the slogan "It has women's enthusiastic approval!" soon gave way to pride that "she had ruffled so many prudish feathers."[141] She moved to Paris the following year intending to apprentice as a photographer, sought out Man Ray and found him in a café in Montparnasse. "I told him boldly that I was his new student," she relates. "He said he didn't take students, and anyway he was leaving Paris for his holiday. I said, I know, I'm going with you—and I did. We lived together for three years. I was known as Madame Man Ray, because that's how they do things in France."[142] Lee would inspire one of the best remembered exhibits at the *Exposition internationale du Surréalisme*, the eight-foot-long canvas *Observatory Time— The Lovers* (*À l'heure de l'Observatoire—les amoureux*), which a devastated Man painted after she left him to set up her own studio in New York in 1932. The work had already been shown both at the London surrealist exhibition and in MoMA's *Fantastic Art, Dada, Surrealism*, where it had had to be removed from the entrance because it was considered "too provocative."[143] "The red lips," wrote Man later, "floated in a bluish-gray sky over a twilit landscape, with an observatory and its two domes like breasts dimly indicated on the horizon—an impression of my daily walks through the Luxembourg Gardens. The lips, because of their scale, no doubt, suggested two closely joined bodies. Quite Freudian."[144] Roland Penrose's *The Real Woman* (1938), with its "Freudian displacement . . . associating woman with an exotic bird of prey, and her sex with a vibrant sunset,"[145] owed more than a little to Lee's inspiration too.

Lee's lips were not the only part of her body to mutate into metaphors. In 1923 Man had taken a wooden metronome, attached an eye cut out from a photograph to its pendulum, and titled it *Object to Be Destroyed*. When Lee left him he replaced the eye with one of hers and wrote the following instructions on the back: "Cut out the eye from the photograph of one who has been loved but is seen no more. Attach the eye to the pendulum of a metronome and regulate the weight to suit the tempo desired. Keep going to the limit of endurance. With a hammer well aimed, try to destroy the whole with a single blow." He rechristened the assemblage *Object of Destruction*, the title under which it was exhibited at *Fantastic Art, Dada, Surrealism*. But as it turned out it would be the destruction of the image that proved too much for

FIGURE 6.6. Lee Miller, "Revenge on Culture," London, 1940. Originally published in *Grim Glory*. © Lee Miller Archives, England, 2011. All rights reserved. www.leemiller.co.uk.

the jilted artist to bear. When a group of students carried out Man's instructions during a Dada exhibition in Paris in 1957, he responded by making multiple copies of his metonymic metronome (in Roland Penrose's words) "in numbers which allow them to attain the status of household gods."[146] He also changed the work's title for a final time, metamorphosing the *Object of Destruction* into the *Indestructible Object*, under which name Lee's eye now looks out on eager *voyeurs* in umpteen art museums across the world, its gaze as direct and disconcerting as that of Manet's *Olympia* or Klimt's *Nuda Veritas*.[147]

"It is seven o'clock in the morning, before the hunger of the imagination is satisfied," wrote Man in a prose poem published in *Cahiers d'Art* in 1935. "The sun has not yet decided to rise or set—but your mouth comes . . . "

> It becomes two bodies itself, separated by a horizon, slim, undulating. Like the earth and sky, like you and me, and thus like all microscopic objects, invisible to the eye . . . Lips of the sun, you draw me endlessly nearer, and in this instant before awakening, when I cast loose from my body—I am weightless—I meet you in the even light and empty space, and, my only reality, kiss you with all that is left of me: my own lips.[148]

L'ORIGINE DU MONDE

Whatever the mandarins of MoMA might have wished, the surrealists did not envision the *Exposition internationale du Surréalisme* primarily as a contribution to aesthetics. The installation offered a good deal more to the eye—and the mind—than just paintings. There was an abundance of *objets-êtres* (as the flyer called them), spiritual descendants of Marcel Duchamp's ready-mades—though most were "assisted" in the interests of systematic bewildering. Like decalcomania and exquisite corpses, such artifacts allowed writers and other amateurs, men and women alike, to participate in the exhibition on equal terms with professional artists, making it a free-for-all of the imagination. Among the best-known objects on view were Man Ray's *Cadeau* (Gift, 1922)—a domestic iron rendered useless, if not positively menacing, by the line of tacks protruding from the center of its plate—and Salvador Dalí's lobster-shaped *Aphrodisiac Telephone*. Oscar Dominguez's *Jamais* (Never) was as impossible a dream as its title suggests: a pair of shapely legs disappear into the cavernous horn of a phonograph whose turntable-cum-breast is caressed by a hand instead of a needle. Dominguez was not the only one to make visual puns on female anatomy. Kurt Seligmann exhibited a stool supported by four legs clad in pink stockings and pink-and-black shoes titled *Ultra-Furniture* (*Ultra-meuble*). André Breton's own *Object Chest*, an antique gilded chest of drawers surmounted by two hands and a glass dome containing stuffed birds, also stood on two pairs of feminine legs—a life-sized *cadavre esquis*.[149]

Meret Oppenheim's *Déjeuner en fourrure* (*Fur Lunch*), the fur-covered tea-cup, saucer, and spoon that was also previously shown in *Fantastic Art, Dada, Surrealism*, might well be the most famous surrealist object of all. This

"super-objective correlate of the female sex" over which T. S. Eliot lingered so long in the New Burlington Galleries has since become as much of an emblem of the surrealist imagination as Salvador Dalí's soft watches or René Magritte's (*Ceci n'est-pas une*) pipe. André Breton suggested the work's title, which nicely marries Manet's *Déjeuner sur l'herbe* with Sacher-Masoch's *Venus in Furs*. The surrealist leader may have been less comfortable with Oppenheim's role in Man Ray's 1933 series *Veiled Erotic*. In the most famous of these photographs the young Swiss artist poses naked behind the wheel of a printing press whose handle is positioned as if to give her an erect penis. Meret was just nineteen when she disrobed for Man's camera, and was (he said) "one of the most uninhibited women I have ever met."[150] She soon took the photographer to her bed. David Lomas sees the difficulty of reading the image. Something is amiss in what might otherwise be a trite juxtaposition of the softness of the girl and the hardness of the machine: "The handle, in particular, arms the female body with a detachable phallus, a pointer to the ways in which the privileged signifier of sexual difference is 'up for grabs.' Less overtly, the wheel partially covers her breasts, hinting at the erasure of distinctions between the sexes, while the hips angled slightly away from the camera appear rather masculine. Oppenheim also sports a fashionably close-cropped hairstyle,"[151] and thick black printer's ink dirties her pretty little hands. When the photograph was published in *Minotaure* to accompany Breton's reflections on convulsive beauty, only the upper half of Meret's torso was shown. Was this cropping of the phallus, wonders Lomas, "a deliberate act of censorship" intended to keep woman in her place?[152] I know of (and Lomas cites) no evidence that any censorship was intended, but the erasure may well be symptomatic. Certainly there were other occasions of which the surrealist leader was discomfited by irreverent plays with *le sexe de la femme*.

Fur Lunch was not the only allusion to *l'origine du monde* to confront spectators at the *Exposition internationale*. The Beaux-Arts Gallery, which was more accustomed to sober hangings of old masters than the rude intrusions of surrealist mistresses, had a wholesale makeover for the show that involved more than just the removal of its plush red carpets and antique furniture. "The modernist 'white cube' gallery," argues Alyce Mahon, was turned into "a dark, warm, moist space that reeked of feminine abjectivity"—a metamorphosis, she suggests, that exposed "repressed, national desires and fears."[153] The disorientation began at the entrance, where visitors were greeted with a "car bedecked outside with ivy, the headlights full on, glaring with brilliant uselessness into the light of day"—Salvador Dalí's *Taxi pluvieux* (*Rainy Taxi*). A "continuous torrent of water" flowed into the vehicle from

perforated pipes in its roof, "soaking the guests' evening slippers" as it drained into the courtyard. The taxi driver, a male mannequin, wore dark goggles, and a shark's jaws framed his head. "In the back seat," reported the London *Times*, sat "a scantily clad female figure with a few pet snails crawling over her. Beside her [lay] a sewing machine, and on the floor a mass of Pampas grass and other vegetation."[154] Her bodice bore a reproduction of Millet's *Angélus*—an obsession of Dalí's at the time—and her breasts were (almost) bare.[155] The sewing machine obviously gestures to Lautréamont's *Songs of Maldoror*, and the vegetation, which actually consisted mostly of lettuce leaves, provided sustenance for the snails. Their ravages over the weeks turned the mannequin, according to Matta, into "the picture of Dorian Gray."[156] Matta thought she was on her way to the opera but the sign Dalí placed on the taxi reading "Lady Snob" might just as well have been a looking glass held out to the exhibition's well-heeled spectators. As indeed might the entire exhibition—a hall of mirrors that dissolves the *imago* we expect to see into an infinite regression of grotesque carnival masks.

Dolled up to the nines, the visitors entered the gallery through a long corridor, later dubbed the rue Surréaliste, lined with sixteen female figures standing around two meters apart. The lone male, an accessory to Max Ernst's *femme fatale*, lay in prostrate supplication at a woman's feet. Since there was no other way in, face-to-face, eye-to-eye contact with these sirens, positioned like so many streetwalkers parading their wares, could not be avoided—especially on the opening night, when the entire gallery was darkened and viewers had to negotiate their passage through the labyrinth with the help of flashlights handed out by Maître des lumières Man Ray. It was an effective queering of the gaze, turning the tables of spectator and spectacle; a sensation of the sort that may be met with in any Red Light district—or small-town Moravian brothel. On the wall behind each mannequin was a blue metal street-sign situating her in a Parisian landscape that was at once familiar and awry. These were presumably "the most beautiful streets in Paris" promised in the exhibition flyer along with "hysteria," "florescent clips," and "the authentic descendant of Frankenstein, the automat 'Enigmarelle,' constructed in 1900 by the American engineer Ireland,"[157] who was scheduled to appear at half past midnight but in the event failed to show up. The Street of Lips, Cherry Street, and the Street of Panoramas neighbored the rue Vivienne—amid whose glittering twilight shop-windows Lautréamont's Maldoror first glimpsed the English boy Melvyn, "fair as the chance encounter on a dissecting table of a sewing machine and an umbrella"[158]—the rue de la Vieille Lanterne, where Gérard de Nerval committed suicide, and the Porte

de Lilas, the site of one of those flea-markets where objects go off to dream at the antique fair. While some of these names were newly minted and others could be found on any Paris map, it would be a rash observer indeed who would presume to distinguish which were "fictitious"[159] and which real.

Man Ray later related how "nineteen young women were abducted from the display windows of the department stores and handed over to the whims of the Surrealists, who immediately began to ravish them, each in his own and unmistakable way and without in the slightest heeding the feelings of the victims." The description is tongue-in-cheek, but Man evidently relished his Sadean conceit. "The most charming goodwill" with which these "victims" suffered "the offensive displaying of their honor," he continues, "increased the stimulation still further," whereupon "unbuttoning himself" he "fetched his apparatus and recorded the orgy, less out of historic interest than in order to succumb to the burning desire."[160] A sign (which caused disquiet among some of the participants because of its vulgar commercial ring) identified the mannequins as supplied by the leading Paris department store Maison P.L.E.M.[161] Objets trouvés they decidedly were not. An initial group was returned for insufficiently embodying "the Eternal Feminine."[162] These dolls were no mere tailors' dummies on which to display clothes. Indeed, most were strategically unclothed, sporting a galaxy of bodily adornments that served as a foil to their essential nudity.

Though Max Ernst's haughty young Widow is cloaked, hooded, and veiled, she is naked from the waist down—apart, that is, from shoes, stockings, and garters. Ernst had originally placed an electric light bulb where her genitals should be, but Breton insisted on its being removed—as he did the live goldfish swimming in a bowl en guise de sexe with which Léo Malet had intended to adorn his mannequin.[163] The irony in Breton's prudery is that he was censoring what was not there. The mannequins had no sexe for which to substitute anything—an erasure, as Luce Irigaray points out, that has characterized western statuary since the Greeks.[164] As it is Malet's doll cuts a sad figure: she is blindfolded, lacks a right hand, and wears a kerosene stove for a hat. Marcel Duchamp, too, left his mannequin nu dessous—except for a pair of man's shoes, an effect somehow more shocking than Ernst's lascivious stocking-tops. Her outfit is completed by a man's jacket, waistcoat, collar-and-tie, and hat, which suggests there was rather more forethought involved in this gender-bending than Man Ray, who is responsible for the myth that Duchamp simply hung his own jacket and hat on the model and left for London, recollects.[165] Confounding the identity of his mannequin still further, Duchamp ascribed her authorship to Rrose Selavy, whose name is scrawled

across the doll's mound of Venus. Raoul Ubac went down on his knees to shoot her, pointing his camera straight up at her *sexe*-less crotch.[166] Salvador Dalí, who complements his mannequin's belt with elbow-length gloves and a shocking pink facemask and headgear designed by Elsa Schiaparelli, decorates but scarcely conceals her otherwise naked body with forty or so silver coffee-spoons and adorns her navel with an enameled butterfly. Man Ray contented himself with attiring his own minimalist doll with a ribbon round her waist, glass bubble-pipes in her hair, and crystal tears. She is rising from a cylinder like Oskar Kokoschka's Reserl from her bath in the moonlight, another melt-in-the-mouth Jacqueline.

The mannequin André Breton considered to be "the most brilliant" was André Masson's *Le bâillon vert à bouche de pensée* (The Green Gag for a Mouth of Thought), who was loitering on Lautréamont's rue Vivienne.[167] This babe's body, too, is wholly naked, except for a *cache-sexe* and a red ribbon around her waist. She has small stuffed birds under her arms and wears a wicker birdcage over her head through whose opened door she gazes forthrightly at the viewer. Goldfish swim in and out of the bars of the cage. A bowl of chili peppers stands at her feet. Her hand extends forward as if in invitation, but a green velvet band gags her mouth. The Silent Woman, yet again? Not quite. Where her mouth should be is a pansy, which is both a verbal pun on *pensée* and—Masson's sketchbooks leave no room for any doubt[168]—a visual pun on the vulva. Where her vagina should be, had it not been translated to the face and transmuted into thought, is the *cache-sexe* that obscures *l'origine du monde*. Though the costume gestures to the skimpy attire worn by dancing girls in Montmartre's dives, this G-string is no ordinary stripper's cover-up. It is an oval mirror surrounded by tiger-eyes, above which two peacock feathers curl upward like fallopian tubes. Should desire draw the viewer's gaze to that place from which he came into being, he—or she—will see only multiple other eyes gazing back, eyes that frame his own *imago*, reflected in the mirror.

"Wo es war, soll Ich werden" (Where it [the Id] was, there must I [the Ego] come into being) writes Freud—in a passage oft-quoted by Jacques Lacan, whose celebrated paper on "The Mirror-Phase as Formative of the Function of the I" was first delivered two years previously and popularized in *Minotaure*.[169] Like Magritte's *Rape*, and for the same reasons, Masson's mannequin has been the object of much feminist disapproval.[170] But as I have said before, any work of art is an assemblage of signifiers that is open to multiple interpretations. Could we ask for a more suggestive invitation to reconsider the nature of the subject—of language, of history—at least as that

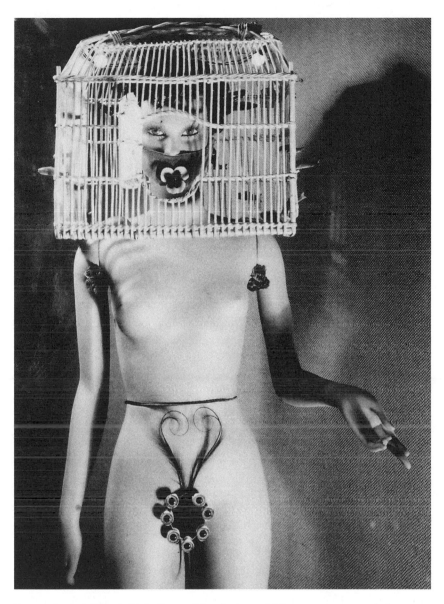

FIGURE 6.7. André Masson, "Le bâillon vert à bouche de pensée." Exposition internationale du surréalisme, Paris, 1938. Unknown photographer. The Getty Research Institute, Los Angeles (92.R.76). © ADAGP, Paris, and DACS, London, 2011.

enigma has been explicated since Freud, than this fetching figurine, who is gagged indeed, yet so very, very eloquent? The difficulty, perhaps, lies in thinking of a *female* figure, and especially a figure as beguiling as this pretty bird in a cage, as signifying a universally *human*, as distinct from a specifically feminine, condition. That Lacan and Masson later became good friends and eventual brothers-in-law (Jacques married Georges Bataille's film star ex-wife, Sylvia, the sister of Masson's wife, Rose) is of course nothing but coincidence. The two men first met a year after the *Exposition internationale du Surréalisme*, when Lacan bought Masson's painting *Ariadne's Thread*.

Having run the gauntlet of the mannequins—a metaphorical vagina, suggests Alyce Mahon—visitors finally penetrated the exhibition's "uterine" central chamber, which was also designed by Marcel Duchamp.[171] Twelve hundred coal sacks hung from the ceiling; in the center of the barely lit room, whose walls were lined with paintings, were a pool and a charcoal brazier surrounded by four large beds with satin sheets. Wolfgang Paalen's brushwood and leaves littered the floor; the air was filled with the sound of hysterical laughter (and by some accounts, German marching music) and the scent of roasting Brazilian coffee. Here, on the opening night, "wearing nothing but a torn white costume" that revealed more than it concealed, "gyrating, wailing and wrestling with a live rooster,"[172] the "surrealist dancer" and "Iris of mists"[173] Hélène Vanel performed an *Unconsummated Act (L'Acte manqué)*, leaping on the beds, splashing in the pool, and muddying the guests' evening finery. She was visibly naked beneath the ripped white dress,[174] and her dance, by all accounts, was a good deal less chaste than Milča Mayerová's performance of Nezval's *Alphabet* in her cute bathing cap and sporty shorts back in the innocent days of Prague poetism—which is not to say that it was any the more erotic. It was merely that the times had changed. By then, as Picasso scribbled one day on the back of a box of matches, it had grown so dark you could see the stars at noon.[175]

We may choose to see in the *Exposition internationale du Surréalisme* no more than another of surrealism's "jokes at the expense of women," a puerile exercise in "the most vacuous variations on the theme of the female body as symbol of desire and dread" (to quote Mignon Nixon, dismissing the rue Surréaliste *en passant* in a recent book on Louise Bourgeois).[176] But *we* are a long, long way from the *Degenerate Art* exhibition that closed a month before the *Exposition internationale* opened and further yet from the measured masculinities of the *Great German Art Exhibition*, where, we should perhaps not forget, there were also female nudes in abundance to entrance the male gaze, neatly hung—or should it be hanged—on gleaming white walls. Only

the Nazis' nudes had nary a pubic hair out of place, and they did not engage in outrageous dances with cocks. There was no room within Torst's light-filled halls for Bohuslav Brouk's lugubrious cycle of life, guaranteed by the sex and impelled by its hungers. The amorous imagination was firmly fixated elsewhere. The gaze was directed up, up and away from *l'origine du monde* toward the manly modern beauties of geometric squadrons of aircraft and spirals of smoke rising from burning villages into azure skies. It was not (as Paul Virilio has argued) the "pitiless art" of Picasso or Kokoschka that opened the road to Auschwitz.[177] Still less was it the surrealist imagination. The images that presided over the coming cataclysm were the perfect Olympians of Leni Riefenstahl.

DREAMS OF VENUS

Looking back on the *Exposition internationale du Surréalisme* ten years later, André Breton endeavored to distinguish "what, in the stir caused by that exhibition, is fairly expressive of the mental climate prevailing in 1938" and at the same time to "put into their true perspective—which, once again, is not an artistic one—those aspects of its structure that, in our minds, were intended to open to everyone that zone of agitation that lies on the borders of the poetic and the real." The surrealists, he insists, had "no other conscious intention in mind" than "creating an atmosphere as remote as possible from that of an 'art' gallery." But in retrospect the critics who deplored "the 'gratuitousness,' superficiality, and bad taste" of the exhibition "went to great lengths mainly to cut their own throat":

> The rooms, lit only by a brazier, squeezed under a ceiling-fitting made with 1,200 coal sacks, or with their four corners weighted down by rumpled brothel beds, one of which waded in a pond edged with rushes, the street signs . . . all that has since then become all too meaningful, has proved to be, alas, only too premonitory, too portentous, has only been too well borne out in terms of gloom, suffocation, and shadiness. To those who, so vehemently at the time, accused us of having wallowed in that atmosphere, it will be all too easy to point out that we had stopped well short of the darkness and of the underhanded cruelty of the coming days. We did not deliberately create that atmosphere: it merely conveyed the acute sense of foreboding with which we anticipated the coming decade. Now, it may be that sur-

realism, by opening certain doors that rationalism boasted
of having boarded up for good, had enabled us here and
there to make an excursion into the future, on condition
that we should not be aware at the time that it was the fu-
ture we were entering; that we should become aware of this
and be able to make it evident only a posteriori.[178]

Hasard objectif seems to have been working its obscure magic yet again. There
was, indeed, very much worse waiting in the wings.

Salvador Dalí reprised *Rainy Taxi* for his Dream of Venus pavilion at the
1939 New York World's Fair. The Fair is better remembered today for its Peri-
sphere and Trylon, symbols of a simpler-minded, cleaner-cut modernity than
anything the surrealists had to offer, but it was a modernity that was already
beginning to look pretty jejune by then. The official slogan for the event was
"Building the World of Tomorrow with the Tools of Today." Though the ex-
hibition grounds offered plentiful orderly *beaux-arts* spaces Dalí preferred to
locate his burning giraffes, soft watches, and "living liquid ladies"—bare-
breasted swimmers, like Jacqueline Lamba at Le Coliséum—in the old weird
America of the Amusement Zone, which among other attractions boasted a
Wall of Death, a Drop of Doom, and a Cuban Village featuring "a completely
nude girl in its voodoo sacrifice routine at the first show of opening day."[179]
Spectators entered Dalí's pavilion through a pair of spread legs surmounted
by a gigantic reproduction of Botticelli's Venus. This time the taxi—which
had in the meantime metamorphosed into a New York cab—was driven by
"yet another sexy lady ... in skintight attire" and the passenger was a her-
maphrodite Christopher Columbus with the body of a woman and the head
of a bearded man. S/he bore the sign "I return."[180]

By the time Dalí translated his rainy taxi to the New World André Breton
had anagrammed the Spaniard's name into Avida Dollars. Gala took much of
the blame for the commercialization of Dalí's art, which seemed to Breton a
betrayal of everything surrealism stood for. But if Dalí's relocation of surreal-
ism's dreams among America's freaks and geeks was inspired by his usual mix
of publicity-seeking, perversity, and love of filthy lucre, it made a good deal
more sense in the circumstances of the time than the facile futurology of the
Perisphere and Trylon. By then it was not only painters who were unleashing
the bestial in man or threatening to reduce old architectures to piles of form-
less rubble. Back in the old Europe from which Columbus had once again set
sail the Nazis were already building tomorrow's world. On 15 March 1939, six
weeks before the festivities were due to open in New York, Prague once again

found itself in Germany. The next day the Führer paid his one and only visit to the magic capital, where he had himself photographed looking out over the pretty roofs of the Little Quarter from a Hradčany window. The image soon made its way onto a postage stamp issued under the authority of the Deutsches Reich. The Fair organizers were left with the embarrassing problem of what to do about a pavilion representing a state that had once again slipped out of History. Their immediate instinct was to collude in the forgetting, but Ladislav Sutnar was having none of that.

The Družstevní práce director, who had previously cooperated with Jaromír Krejcar on the Czechoslovak pavilion at the 1937 *Exposition internationale des arts et techniques dans la vie moderne*, arrived in New York to oversee the installations on 14 April 1939. The pavilion defiantly opened on May 31 in a ceremony attended by representatives of the Czechoslovak diplomatic corps, New York Mayor Fiorello La Guardia, and exiled President Edvard Beneš. The Czechoslovak flag flew at half-staff. In another of those eternal returns in which Czech history abounds, Beneš quoted Jan Amos Komenský's prayer—the same prayer that is inscribed on the Jan Hus Memorial in Prague's Old Town Square—for the return of Czech government to Czech hands. Comenius's words were also emblazoned in English translation across the front of the pavilion itself. A contemporary press photograph of "two Czech folk dancers in traditional dress, with a gas mask" captured the surrealities of the occasion.[181] By then the function of the displays had changed. "The aim of this exhibition," Sutnar wrote, was "to document the fundamental unity of the Czech and Slovak nation with the west and their signal contributions to its civilization. These ideas were mediated by artistic works deliberately selected so that they could be understood in the light of the tensions that led to the 1938 Munich Agreement and subsequent events. Under the circumstances the exhibits thus became symbols, which in the planned context of the whole conception expressed the future hopes of the nation."[182]

Sutnar produced dozens of flyers, posters, and invitations for American Relief for Czechoslovakia and other patriotic organizations during the war, but after the conflict ended he chose to remain in the United States, where he had a huge impact on package, catalogue, and information design. Družstevní práce's aesthetics found their way into the signage for Meadowbrook Hospital and Brooklyn School, logos and advertisements for Sweet's Catalogue Service, Knoll + Drake Furniture and dozens of other firms, a children's book called *The World of Shapes*, and a redesigned US telephone directory. But the great Czech modernist would end his long and distinguished career,

too, *In Pursuit of Venus*, as he titled the series of exuberant pop-art paintings he first publicly exhibited in New York in 1966. He christened the pictures "Joy-Art." "If in our disturbed times, when coldness and estrangement rule in society, these paintings can arouse an emotional response," he explained, "they will fulfill their mission."[183] The ancient goddess came in a multitude of avatars including "Provocative," "Au Go-go," "In a Ten-Gallon Hat," and "All the Way to the USA," but her breasts were almost always big, bouncy, and bare.[184] What inspired this new departure was Sutnar's memory of living on East 52nd Street, "the sexiest place in town" during the war. He remembered the jazz aficionados, the taxi drivers, the soldiers on leave out for a good time. Most of all (as he wrote of his series *The Strip Street*) he remembered

> the shapely disrobing ladies who were so essential a part of the strip street scenery. Their unpredictable, mischievous, and sometimes hilarious exhibitions are presented here, in retrospect, as they were often seen through the doors of the clubs, to dazzle passersby. Each drawing freely interprets the impact of the swift, passing glimpse in the dim, murky, aphrodisiac atmosphere of female bodies in movement, shaking, swinging, quivering, twisting, rolling and jerking. Or maybe just an arm loosening the hair.[185]

Sutnar was not the only Czech artist to find himself marooned on American shores on the eve of World War II. Jiří Voskovec and Jan Werich, the stars of the Liberated Theater, arrived in New York early in 1939. With them came the composer Jaroslav Ježek. Nearly blind since birth, in poor health, unable to speak much English, and prevented from legally working by immigration restrictions, Ježek did not have an easy time of it on Broadway. When his friend Gustav Janouch—the same Janouch we met earlier as the author of the dubious *Conversations with Kafka*—suggested a spell in the home of jazz might be good for his music he angrily responded "Don't give me that nonsense. . . . Pears don't ripen in Kamchatka. My music was planted here, in this land, in this soil. It's something you can't take with you. We can't just pop our homeland in a suitcase. A homeland—that is air, pavement, language, people—that is what you must leave behind. So what's going to be good for me there? Nothing. Nothing at all. Maybe I'm fleeing from one death to another." He turned out to be right. The Czech Gershwin died of kidney failure on 1 January 1942 at the age of thirty-five. His remains were repatriated to Olšany Cemetery in 1947.

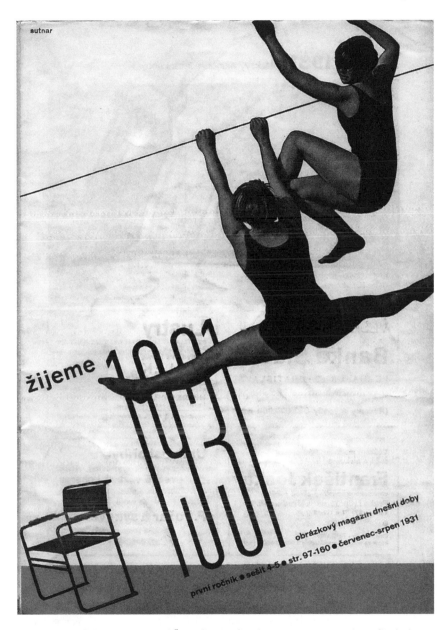

FIGURE 6.8. Ladislav Sutnar, cover of *Žijeme* (We Live), Vol. II, Nos. 4–5, 1931. Archive of Jindřich Toman.

336 | CHAPTER 6

The jazz musician Jiří Stivín later made footage shot at Ježek's funeral into a short film set to his own arrangement of one of the composer's biggest hits, "Dark Blue World" (*Tmavomodrý svět*). The coupling of images and music is heart wrenching. Too heart wrenching, perhaps. As Michael Beckerman remarks, "From this melancholy filmlet we get an inevitable impression that 'Dark Blue World' perfectly sums up Ježek's years of near-blindness, of exile, and finally of death. But this was a song written on a sunny afternoon in 1929 by a couple of young men [the lyricists were Voskovec and Werich]; the composer was only 23, a composer who famously remarked while in the United States: 'I don't like sweet and sentimental music.' Is there perhaps another story somewhere?" He goes on: "Jan Werich also reported that when Ježek first got off the boat in New York broke, ill and with no prospects, his first concern was not where he would find food or a roof over his head, but: 'Where is Benny Goodman playing?'"[186] Whatever the paucity of the dark blue reality the United States was still, among other things, a land of Czech dreams.

Voskovec and Werich fared better in exile, successfully reprising their 1937 review *Heavy Barbara* (*Těžká Barbara*) in 1940 at the Cleveland Playhouse and producing dozens of radio programs for Voice of America. Both returned to Czechoslovakia after the war. Werich eventually found a new comedy partner, Miroslav Horníček, and made a glittering career in Czech movies. He was slated to play the villain Ernst Stavro Blofeld in the James Bond film *You Only Live Twice* (1967) but was eventually replaced by Donald Pleasence because he looked too much like Santa Claus.[187] The following year he signed Ludvík Vaculík's "2000 Words," one of the key manifestos of the Prague Spring, and fled to Vienna after the Soviet invasion. He soon returned, like Milan Kundera's Tereza, to the land of the weak. Under enormous pressure from the authorities, Werich would become one of the saddest signatories of "Anti-Charta," a petition orchestrated by the KSČ repudiating the dissidents' Charter 77. He died in Prague in 1980, a much-loved figure whose Švejkish compromises were well understood by his compatriots. Voskovec found it less easy to don the masks of the national charade. It may or may not be coincidence that his mother was French. He abandoned the homeland again in 1948 and initially settled in Paris. He returned to the United States two years later only to find himself interned for eleven months on Ellis Island for suspected communist sympathies—a somewhat sick joke in the circumstances, but Jiří was certainly, in the McCarthyite jargon of the day, a premature anti-fascist. He was finally granted US citizenship in 1956. George Voskovec, as he then became known, was buried in Pearblossom,

California, a year after Werich; hampered by his thick Czech accent he kept body and soul together by playing character roles in numerous TV shows and movies including *12 Angry Men* (in which he was juror #11) and *The Spy Who Came in from the Cold*. Thus ended the most engaging establishment in the world.

Jarmila Novotná arrived in the Big Apple to perform in an opera season Toscanini was conducting for the World's Fair. As fate would have it her ship docked on March 15, "with the ghastly news greeting me that Czechoslovakia too had fallen prey to the Hitlerian folly. My husband and children were there, so you can imagine my state of mind when I began to rehearse Violetta."[188] The soprano's career moves during the 1920s and 1930s provide as good a barometer of the times as any. A pupil of Ema Destinová's, Jarmila made her radiant debut at the National Theater in June 1925 as an eighteen-year-old *Bartered Bride*. Having put her voice and her beauty on the map as Mařenka, Mimi, Rusalka, and the Queen of the Night, she went on to sing at the Staatsoper in Berlin from 1929–33. But "dark clouds were already on the horizon . . . I was attacked by several newspapers, for having sung Beethoven's Ninth Symphony in Czech in Prague, at a concert honoring President Masaryk's birthday. I was also due to sing Mahler's Fourth Symphony in Berlin with Bruno Walter, who was advised to drop it since the composer had been Jewish"—as was Walter himself, who would soon be removed from his post in Leipzig and forced to emigrate first to Austria, then France, then the United States. Novotná abandoned Berlin for Vienna in 1933, but trouble had a way of dogging her. "I was appearing as Tatiana in *Eugene Onegin* the night of March 12, 1938, at the Vienna Staatsoper when the Germans took over Austria in a matter of a few hours," she explains. "We retired to our castle of Litten in Bohemia, little realizing that this would have to be abandoned soon. Over the years, I had always gone back to Czechoslovakia—I was even given the honor of having my face put on the Czech *kronen*."

Novotná briefly returned to Europe after the World's Fair but soon found herself back on the Hudson. "I was singing *The Marriage of Figaro* in Scheveningen under Bruno Walter's direction the day before the Second World War was declared. The children, thank goodness, were with me in Holland, and our wonderful nurse too; and my husband, who had a sixth sense, managed to get us out in the nick of time. It was a formidable struggle to find passages for the United States, but we arrived there at the end of September, without a cent to our names." She made her debut at the Metropolitan Opera House on 5 January 1940 singing Mimi opposite Jussi Björling's Rudolfo in *La Bohème*, and went on to become the Met's reigning diva, appearing 142

times over seventeen seasons before her retirement in 1956. She, too, eagerly returned to Czechoslovakia in 1945, where she performed in *Eugene Onegin* and *The Bartered Bride* at the National Theater, but Victorious February cut short any dreams of a permanent homecoming. The interview from which I have been quoting was conducted at the soprano's "pretty, sophisticated house with its large garden in the Hietzinger section of Vienna."

Jan Masaryk, after all, had been a close friend. Novotná recorded an album of Czech and Slovak folk songs for RCA Victor in New York in 1942 for which Masaryk, who was by that time Foreign Minister in the Czechoslovak government-in-exile in London, furnished both the piano accompaniment and the liner notes. "Jarmila Novotná used to sing these songs to my father," he explained, "and if I happened to be in Prague, I accompanied her. Today, both Jarmila and I are refugees from Hitler's vulgar terribleness and did these songs for ourselves. Some kind friend suggested that they should be recorded, and with great trepidation I agreed to do my part. Our recording coincided with Heydrich's arrival in Prague, with his thousand-times-deserved death, and with the unbelievable horror of Lidice."[189] Lidice was the site of one of the most infamous Nazi atrocities of World War II. Suspecting that its inhabitants had aided the assassins of the Protector, German troops descended on the little Bohemian village on 10 June 1942, where (in the words of the official communiqué) "the grown men were put to death by shooting, the women were transported into concentration camps, and the children were taken to be appropriately raised. The buildings in the village were razed to the ground and the name of the village was erased."[190] Of Lidice's 96 children 81 perished in the gas chambers at Chelmno; those fortunate enough to be blond and blue-eyed were farmed out to SS families to be Aryanized. "Here a boy tells of his dream," runs Masaryk's synopsis of the song "Zdálo se mi, má panenko" (I dreamed, my darling), "once again he was dancing with his sweetheart in the old village inn, and in the dream the inn was built of golden bricks. He awakens and sadly comments that it was only a dream."[191]

Novotná would get to see Prague again—at the age of eighty-five. The occasion was the first domestic release of *Songs of Lidice* in 1992, exactly fifty years after the album was recorded. Despite the abundant invocations of the memory of the Nazi massacre in postwar KSČ propaganda, issue of the set had twice been prevented, after Victorious February in 1948 and again after the Soviet invasion of 1968.[192] Any reminder that Czechoslovak wartime resistance might have emanated from anywhere but Moscow was unwelcome. *Songs of Lidice* is indeed, in the words of the music critic Alan Blyth, "a re-

markably nostalgic and idiomatic collection."[193] Many of the songs speak of parting, often of soldiers from the girls, pregnant and otherwise, they leave behind them, but this is no ordinary nostalgia. For me at least it is impossible to listen to these songs without hearing echoes of the history with which they are now indissolubly fused: the destruction of the village, whose meticulous documentation by the German authorities Franz Kafka would have grimly appreciated; the matter-of-fact sacrificing of its children to the crazed modern gods of ethnic purity; and most of all Miss Novotná's nervous accompanist tumbling to his death six years later from a fifth-floor window of an enormous dumb palace that looks out on a lovely square that may or may not be the *sexe* of Prague. But I am mixing up my times and totalitarianisms again, tempted down paths of dangerous association by the Proustian ability of the phonograph to cut straight to the heart of what once was.

Sutnar designed the installation for a proposed Lidice Traveling Exhibition in 1942, but money was short and the project was never realized.[194] Bohuslav Martinů's *Památník Lidicím* (Memorial to Lidice), eight minutes of swelling melody assassinated by snatch-squads of baying brass and persistent rumbles of tympani from the depths, proved to be a more lasting memorial to the unthinkable. It was written in Manhattan in 1943. The piece manages to be at once lyrical and menacing, its shifts—or better, simultaneities—of mood conveyed by juxtapositions of orchestral color that are worthy of Lautréamont. Martinů is probably the best-known twentieth-century Czech composer after Janáček. His undeniably modernist voice also hails from Milan Kundera's beautiful garden next door to history; his work is obviously indebted to Stravinsky and Debussy and much influenced by American blues, ragtime, and jazz, but it is also suffused with Czech allusions from Moravian folk songs to the Saint Wenceslas chorale. Martinů had been resident in France since 1923, though he continued to spend his summers in his hometown of Polička in the Czech-Moravian highlands. A chance meeting in a Paris café with Serge Koussewitzky led to his orchestral work *La Bagarre*, which was inspired by the crowds that met Charles Lindbergh's first transatlantic flight, being premiered by the Boston Symphony Orchestra on 18 November 1927. "Seldom has an unfamiliar composition, one by an unknown composer, been so enthusiastically welcomed in Symphony Hall," declared the *Boston Herald*.[195]

Despite his growing international fame Martinů continued to maintain close links with his homeland. Living abroad did not then equate with exile. His operas *Voják a Tanecnice* (The Soldier and the Dancer, 1927), *Hry o Marii*

(Plays about Marie, 1934), *Divadlo za branou* (The Theater in the Suburbs, 1936), and *Julietta aneb snář* (Julietta or the Dream-book, 1937) were all first performed in Prague or Brno. He wrote two operas specifically for Radio Prague, *Hlas lesa* (The Voice of the Woods, 1935) and *Veselohra na mostě* (The Comedy on the Bridge, 1935), the former to a libretto by Vítězslav Nezval. In a time in which many were making desperate preparations to move in the opposite direction Martinů quixotically tried to obtain a position at the Prague Conservatory. "It is certain that the tribulations that lie ahead for us," he wrote the musicologist Otakar Šourek in November 1938, "will be difficult and momentous for our entire nation and painful for every one of us.... I have seen many, many things with which I cannot agree, and even your news concerning the about-face of many people does not surprise me very much." The limbo known to Czech historians as the Second Republic was not the most auspicious moment for contemplating a return to the homeland: in the weeks after the signing of the Munich Agreement President Beneš resigned and fled to England, the KSČ was banned, and the Liberated Theater closed down. "I am convinced, however, that much of [this] is a mannered response to the pain of the first tragic moments," Martinů went on. "I am finally resolved to return to Prague, and there I will be able to serve our new aims even outside of composition."[196] Fortunately for lovers of modern music the Conservatory declined his services.

With the outbreak of war Martinů turned to composing a *Field Mass* (*Polní mše*) for Czech volunteers in the French army. As befits a composition designed for drumhead services it is a sparsely orchestrated work scored only for wind and percussion, piano, and harmonium, which was first performed on instruments borrowed from the Paris police band. Alfons Mucha's son Jiří, who was then living in the city of light, ostensibly as a medical student, wrote the libretto. The young man aspired to be a writer and made his living by penning theatrical reviews for *Lidové noviny*. He had recently returned from his father's funeral at Vyšehrad, where the musical invocations were more Smetanesque—though it is by no means fanciful to hear echoes of *My Country* in Martinů's *Memorial to Lidice*. Jiří talked the Gestapo into allowing him to return to Paris with the promise that he would repatriate some of his father's canvases to the Protectorate, saving them from the French in the event of war. Eager to get to work on the score, Martinů gave him no opportunity to polish the "timid beginnings" of his libretto, which Mucha, aspiring to express "our specific situation and the feelings it aroused in us," had scribbled on the back of an envelope, a page from an exercise book, and a bill while making the rounds of Paris cafés:[197]

O my Lord!
Forgive us our poverty,
Pardon our looks: The mud of trenches on our faces.
And forgive we brought no flowers to your altar.
O my Lord, my Lord, what task hast Thou imposed
Once more upon this people bent under its cross?

Vítězslav Nezval's image of the nation's Calvary returns, but there are other Czech refrains here too. "From foreign shores, O Lord, I call," continues the *Field Mass*, "I pray to Thee from distant lands."[198] One recalls, of course, Jan Amos Komenský, as painted by Jiří's father staring out on the cold North Sea in the much-derided *Slavic Epic*. But also, if one is a lover of Czech music, another Bohuš—as the name Bohuslav diminutizes in Czech—comes to mind: the hero of Antonín Dvořák's *The Jacobin* (*Jakobín*, 1889). "We wandered lost through alien lands," sing Bohuš and Julie in the best-known passage from the opera, "In song alone, in song alone, we found sweet relief."[199] "O my good Lord, keep me alive," Mucha's libretto goes on, "When crushed by battle I shall reel. Just for my life, O Lord, I beg and pray, So that Thy hands may lead me home again."[200] In Martinů's case they never did. The approach of Hitler's armies in 1940 drove the composer and his French wife Charlotte first to the south of France and then via Spain and Portugal to the United States, where Bohuslav taught at the Berkshire Music Center, the Mannes School of Music, and Princeton University. Jan Masaryk's defenestration ended his hopes of resettling in Czechoslovakia, just as they had Jarmila Novotná's. Bohuš became an American citizen in 1952 and spent his final years wandering France, Italy, and Switzerland, where he died—an undoubted exile—in 1959.

Julietta, which is by common consent Martinů's greatest work for the stage, must be one of the strangest operas of the twentieth century—though its subject matter is no more inappropriate to its times than that of Berg's *Wozzeck* or Janáček's *From the House of the Dead*. Certainly this dreambook (as *Julietta* is subtitled) proved as premonitory as anything on the borderline of the poetic and the real exhibited at the *Exposition internationale du Surréalisme*. The premiere took place at the National Theater in Prague on 16 March 1938—exactly a year, by coincidence, before Adolf Hitler's one and only visit to the magic capital. Jindřich Honzl directed the production and František Muzika designed the stage set, Devětsil veterans both. Václav Talich, the leading Czech conductor of the day, wielded the baton. Beside the Martinůs sat Georges Neveux, upon whose 1930 surrealist drama of the same

title *Julietta* is based. The French playwright had originally given Kurt Weill consent to turn his play into a *Singspiel*, but changed his mind on meeting Martinů. "At midnight, descending the staircase, I was profoundly moved," he wrote later. "I had, for the first time in my life, truly entered the world of Julietta. Martinů's liking for the play was obvious, and he enhanced its charm and depth, making of it a masterpiece—I was literally dazzled by it."[201] The composer was overwhelmed by the performance. "It is a true joy to see that one can still find someone who feels what the work requires and who knows how to put himself in its service," he wrote Talich afterward, "as I myself did in trying to express the most secret and most hidden core of art, POETRY, this fragile thing that can bear the touch only of those who seek it, who have a vital need of it and approach it as the most beautiful gift human life can offer, who do not wish to transform it, but accept it as it is."[202] The capitals in this case are mine.

Julietta is set in a small seaside town to which Michel Lepic, a young book-seller from Paris, has returned in search of a beautiful girl he glimpsed singing behind an open window three years before. Michel has long tried to resist falling in love with a chimera, but the girl's voice has haunted his dreams. He arrives by train, though the town's inhabitants assure him that he cannot possibly have done so since there is no railroad station. From this and other absurdities it soon becomes apparent that Michel has stumbled into a land of forgetting. "All of us in this little town have lost our memory," explains the inspector. "Some of us have completely lost it, we don't remember anything at all. Others, like me, have preserved some recollections. From time to time these come to the surface and control their lives. If ever a stranger is discovered here, which seldom happens, the inhabitants obviously lean on him to tell them some stories, which they then regard as their own memories!" The locals frequently accuse one another of dreaming up what they have forgotten; Michel is warned to keep his voice down because "everybody listens behind the windows, to appropriate the memories of others." Letters are delivered three years late because that way "folk who have lost their memory can bring old events to life." Palmists read the past, not the future. Memory-vendors do a roaring trade purveying "old photographs, already faded, locks of hair of all colors, old medallions and a whole bunch more."[203]

"Even though he knows why he has come to the town," explains Martinů, Michel "begins to lose himself in this world which exists only in the present. . . . When, at last, he finds his Julietta, events are transposed into so powerful an illusion of reality that Michel's own 'proven' reality seems empty and pale by comparison."[204] From behind a window the bookseller hears Julietta's

unaccompanied voice: "My love is lost far away over the high seas tonight. Will he return, will my love return, with the return of the star to the sky?" Julietta recognizes Michel as her lost lover but he soon realizes that she is a victim of amnesia too. The girl is entranced by the memory-vendor's postcards of "the main square in Seville . . . and the garden where I waited for you," "the little hotel where we stayed four nights," "the bracelet you bought me for good luck," "the veil . . . you were so fond of." "Look at me now!" she demands of Michel, "Do you recognize me?" "Enough! Enough! All this is just dreamed up!" Michel interrupts, snatching the veil and the postcards from her hands. "I want reality! Our genuine memories! Do you hear? What we really experienced together!" But when he tells Julietta the banal truth—that he heard her singing behind the window three years ago, left town on the next train, and returned to look for her only yesterday—she cannot hide her disappointment. Her fantasy is infinitely more credible than the reality: "Well, this is just a silly tale! You wouldn't know of anything better?" She runs off into the darkness. Michel pulls a pistol from his pocket and fires blindly. A cry is heard behind the stage, then another, followed by silence. Michel sits down, bewildered. "But I didn't shoot, that's not possible."

The final act of the opera finds Michel in the Central Office of Dreams. A clerk is recording entries and exits in a ledger: "In Avignon . . . five dreams . . . Orléans . . . four dreams! Lyon . . . four dreams." "If you stay here," he warns Michel, "you will put yourself in great danger." An unlikely cast of characters drift in and out of the office: an errand-boy who wants to ride with Buffalo Bill in the prairies, a blind beggar who longs for the warmth of the tropics, a convict beginning a life sentence. All of them, it gradually dawns on Michel, are also searching for a woman named Julietta—except, that is, for the engine-driver on the Orient Express, who is looking at a photograph of his dead daughter in an album whose pages turn out to be blank. Figures step out timidly from the darkness. "They are the ones in gray suits," the clerk explains:

> "They arrived here like you . . . and liked it here, and then
> . . . they didn't want to go back! They didn't wake up from
> their dreams and stayed here!"
> "They dream here always? Aren't they insane?"
> "Shh. Shh. Don't say that word here. You're right, in life
> they are confined to cells. But why should that bother
> them, if in reality they are here?"

The clerk warns Michel that if he does not leave by morning he will end up in the same state. Michel promises he will go, but not until the last possible mo-

ment. "I want to remember her here," he explains. "I'm afraid . . . that as soon as I leave, I'll forget everything! And I don't want to forget! This door, it's the end of everything. The end of everything. It's the gray morning! Gray life! And who knows? Who knows if I'll pass through it ever again?"

The lights go out. Michel hears Julietta's voice from behind the door telling him she loves him and pleading with him to stay. He opens the door, flashes his lantern into the darkness, but can see nobody. The voice continues to call him. Ignoring the final warnings of the night watchman Michel chooses to follow love's great, irresistible summons. "Yes! Yes! I heard you! I hear you! You called me Michel! Michel! And I see you, I see! I see you, I see! Ah! How beautiful you are! How beautiful you are, Julietta! Julietta!"[205] The stage slowly revolves to return us to the little town that lost its memory with which the opera began. "Rejecting sanity and reality," explains Martinů, "[Michel] settles for the half-life of dreams. The play could now start again from the beginning. The action is not at an end, it continues—it is but a dream."[206]

A Girl with a Baton

The last time Bohuslav Martinů set foot on Czech soil was in the summer of 1938, when he spent several idyllic weeks with his pupil and lover Vítězslava Kaprálová at her family's summer house in Tři studně in Southern Bohemia. The lovers said their adieus in Martinů's hometown Polička, which a few weeks later would find itself in the Third Reich. Photographs, as ever, survive as mute witnesses to a paradise lost: conventional souvenirs in this case rather than the surreal mementos of Lambe Creek and Mougins, but these holiday snapshots were no less carefree intimations of deaths to come.[207] The camera seldom flattered Vítka but she was by all accounts a mesmerizing presence. "People were seduced by this fragile, petite, almost diaphanous woman," writes her biographer Jiří Macek. She was "full of energy, of a real pleasure in living, of a childlike naivety, wise and capricious by turns. . . . Everyone willingly let themselves be carried away by the seduction of this feminine creature."[208] This is almost too clichéd a portrait of a *femme-enfant* but Kaprálová had all the attributes of a surrealist muse. She was free-spirited, impulsive, and romantic. The combination of physical fragility with imperious musical talent only increased her sexual allure; portraits of a fresh-faced, boyish Vítka dressed in bow-tie and tails to conduct an orchestra, an occupation that was then (as now) an overwhelmingly masculine preserve, produce the same androgynous *frisson* as Meret Oppenheim in *Veiled Erotic* or Milča Mayerová in Nezval's *Alphabet*. Vítka was no more constant in her loves than the *femmes*

surréalistes—or maybe it was her constancy in her loves that made her so fickle a partner. "She managed to be faithful to several people at once," Jiří Mucha observes, "and each time completely sincerely."[209]

Špaliček and Písnička, as Bohuš and Vítka came to call one another in the embarrassing way that lovers do, first met at the Café Metro in Prague in April 1937 when the middle-aged composer urged the talented young student to further her graduate studies in Paris. These pet names speak volumes. Not only do Martinů's works include a *Špaliček*, "a ballet of national games, customs and fairy tales" whose original version (1931–32) closed with the nineteenth-century folklorist Karel Jaromír Erben's ballad "The Specter's Bride." The word *špaliček*, whose literal meaning is a stick, has multiple connotations in Czech, one of them being an old peasant. It also conjures up Mikoláš Aleš's *Chapbook of Folk Songs and Rhymes* (*Špaliček národních písní a říkadel*), an indispensible ingredient of a Czech childhood. Aleš's title recalled the wood-bound chapbooks sold at renaissance country fairs, inside which the lucky buyer might find "a pressed flower, a song, a story, some news, a prayer . . . the very 'collection of unlike things' that always characterized Martinů, and certainly by intent characterized Martinů's works of that period."[210] Vítka kept one of Aleš's drawings of a laborer on her piano. She had composed a work titled *Písnička* in 1936, and once again the diminutive, which means "little song," evoked more than just the composition. "The word *písnička*," says Jiří Mucha, "defined very precisely what Vítka represented in Martinů's loving heart. She was petite, radiant, spirited and changeable, and truly resembled a *chansonnette* flowing with *joie de vivre* or an excess of love. And for his part, Martinů was a kind of *špaliček*, something of a stick, a kindly rustic, a little raw. . . . Martinů-Špaliček, this was a sort of roughhewn piece of wood, composed entirely of music. Vítka loved to invent these nicknames for others as well as for herself. It was the greatest proof of love."[211]

Martinů and Kaprálová renewed their acquaintance at the Dôme café that October, two days after Vítka's arrival in the French capital. Like many another Bohemian and not a few Czechs, Bohuš was in the habit of wiling away his evenings in Montparnasse, lingering for hours over a fifty-centime cup of coffee; except, his wife, Charlotte, fondly recalls, on washdays, when "he would not leave as long as I was not finished, and he would play Beethoven sonatas for me on the piano."[212] Whatever Charlotte forgot to remember or remembered to forget, before long Bohuš and Vítka had fallen deeply in love and were living in a world of their own that had as little connection to their pasts and futures as the little seaside town in *Julietta*. "Martinů could be truly happy," writes Mucha. "Vítka was in Paris, they worked as partners linked by

a reciprocal regard, they had their secret nest *chez* Betz [the family from whom Vítka had rented a room at 1, rue de Médicis, overlooking the Luxembourg Gardens], and they began to compose little love-songs for one another on folk texts.... For the time being, this love that bound them was in full bloom. Martinů dealt with the problem of Charlotte: whether he sent her to the country, to [her family's house at] Vieux Moulin, or simply risked a conjugal storm, he now stayed at the Betzes' not only during the day, but also the night."[213]

Kaprálová, who had graduated top of her class at the Brno and Prague Conservatories, already had some notable compositions to her name, among them four settings of poems from Jaroslav Seifert's collection *Jablko z klína* (An Apple from a Lap, 1933). She arranged Vítězslav Nezval's "Sbohem a šáteček" ("A Goodbye and a Handkerchief") for piano accompaniment two weeks before she left for Paris, dedicating her composition to "the most beautiful city of Prague." "It was exquisite alas everything has its end," run Nezval's lines:

> be silent tolling bell be silent this sadness I know already
> kiss handkerchief siren ship's bell
> three four smiles and then to remain alone[214]

The mood is more pensive here than it used to be in Devětsil's gay poetic voyages of the 1920s, but Nezval's collection of "Poems from a Journey" (as *Sbohem a šáteček* is subtitled) was published in 1934, not 1924. Ludvík Kundera thought Kaprálová's setting of "A Goodbye and a Handkerchief" one of the best Czech art songs of its time, finding "something quite new in this atmosphere and illumination."[215] He accompanied the first performance of Kaprálová's settings of *An Apple from a Lap* in December 1936.

Vítka made a brief trip back to Prague in November 1937 to conduct the all-male Czech Philharmonic—the first woman ever to do so—in the premiere of her *Military Sinfonietta*, which took place in Lucerna Palace before an audience that included President Beneš, as he then still was. "The composer," she explained, "uses the language of music to express her emotional relationship towards the questions of national existence, a subject permeating the consciousness of the nation at the time. The composition does not represent a battle cry but it depicts the psychological need to defend that which is most sacred to the nation."[216] The *Sinfonietta* was chosen to open the sixteenth festival of the International Society for Contemporary Music in London the following June, an event that also featured new compositions by Bartók, Britten, Copland, Hindemith, Messiaen, and

FIGURE 6.9. Otakar Mrkvička, frontispiece for Jaroslav Seifert, *Samá láska* (Love Itself). Prague: Večernice, 1923.

Webern. "[Kaprálová's] performance was awaited with interest as well as curiosity—a girl with a baton is quite an unusual phenomenon," reported a proud Martinů from London in *Lidové noviny*, "and when our 'little girl conductor' (as the English newspapers put it) appeared before the orchestra, she was welcomed by a supportive audience. She stood before the orchestra with great courage and both her work and performance earned her respect and applause from the excellent BBC Orchestra, the audience, and the critics."[217] Havergal Brian hailed the *Sinfonietta* in *Musical Opinion* as "an amazing piece of orchestral writing"[218] and the audience gave Vítka no less than eight encores.[219] Had Kaprálová lived longer she might well have become as celebrated in the annals of twentieth-century music as those famous names with whom she shared the London limelight.

Josef Sudek photographed the Martinůs, who according to Charlotte's memoirs had been blissfully happy together for the past dozen years, during their visit to Prague for the premiere of *Julietta*.[220] Charlotte gazes straight into the camera while Bohuš looks sidelong at his wife, a quizzical expression on his face; or perhaps that is just my imagination, fueled by the knowledge that the composer was hatching plans to begin a new life with his little girl conductor in the United States. Vítka reassured her concerned parents that their age difference had "so far never bothered me. I might complain about it of course from time to time in the future, but by then there would be children which would solve it all." Rather than "a good husband, children, the kitchen"—the prospect offered by her fiancé Rudolf Kopec, whose hands, mouth, and body Vítka longed for even as she found his fascist politics repellent[221]—Martinů held out the promise of "love and profound understanding."[222] But for whatever reason, be it Vítka's inability to choose between Martinů's celestial love and the corporeal charms of her multiple terrestrial suitors, Bohuslav's unwillingness to abandon Charlotte, or the whirlwind of events in which they were all caught up, these plans came to nothing. It was a time in which (as Martinů later wrote of the dilemma confronting Michel in *Julietta*) "normal and logical thought processes clash at every turn with unforeseen and curiously absurd events." Vítka might well have been engaged in "a desperate struggle to find some prop to lean on, something stable and concrete,"[223] but that prop would not be her Špalíček.

"I got stuck in Paris and like it but I do get homesick," she wrote Hanuš Weigl, a fellow-student at the Brno Conservatory who was by then living in Palestine, in December 1939. "Not only do I miss my folks but I am such a 100% Czechoslovak that I cannot imagine a life without Brno or Prague." The letter had a postscript ("Give my regards to the Promised Land and come

back after the storm is over") signed by Jiří Mucha who, Vítka explained, was "Alfons Mucha's son and maybe my future husband."[224] Jiří and Vítka met at the Café Bonaparte on 27 April 1939, a few weeks after the German invasion had cut them both adrift in *la ville-lumière*. "It was a warm spring night.... We ended up back at my place," Jiří relates, "in this little room without a window lit by a simple skylight in the attic ceiling. When the light was turned off you could make out the stars. When it rained, you could hear the murmur of the rain on the glass. Like very quiet music. That night," he confides, "Vítka didn't go home."[225] Like many other Czechs stranded in Paris the young lovers became involved in patriotic activities. Jiří worked on the Paris-based paper *Československý boj* (The Czechoslovak Struggle) and eventually volunteered for the Czech division of the French army, which was then based at Agde on the Languedoc coast.

Writing was no more Vítka's strong suit than modesty or mathematics, but Jiří talked her into contributing some brief articles to *Československý boj*, one of which was on Hussite chorale. "There are some melodies," she begins, "which adapt themselves to the nation, as if it was its own voice.... Czech music lives in the signature, so to speak, of two principal motifs which, and it is not by coincidence, are also an expression of the whole two-sided spiritual life of the nation. On the one side is the Hussite Chorale, on the other Saint Wenceslas.... The Hussite Chorale," she concludes, "is the credo of everything valiant in the Czech nation ... the expression of the Czech soul, just as its words are the call-up papers for Czech arms."[226] Before too long Viktor Ullmann would be quoting the same valiant melody in his last piano sonata, honed to its bare essentials by his master class in Terezín. *Co Čech, to muzikant* (if he's Czech, he's a musician) goes the old Czech saying, though—speaking of the dualities of the Czech character—we might also Švejkishly remind ourselves that the equally popular phrase *Já nic, já muzikant* (roughly, I'm just a song-and-dance man) is a way of shrugging the shoulders and saying it's got nothing to do with me.

Not without some last-minute dramatics—during Jiří's absence in the south Vítka fell momentarily in love with his boyhood friend (and future RAF hero), the dashing Ivan Tondr—Mucha and Kaprálová married on 23 April 1940. Jiří forced Vítka's hand; or maybe it was Vítka who forced his. "With this Ivan, it's a funny story, but finally vain," she wrote Jiří without a trace of apology. "When he showed up, with his 'objective and logical' spirit, so opposed to your complicated and changeable nature, he literally seduced me. His gallantry conquered me.... In company, even when he was talking with someone else, I remained the center of his attention.... He knew how

to listen to me with an admiring air and above all, in spite of his *adventurous* character, I felt in him a security and an unwavering love. . . . Given my nature I could not but respond with a yes."[227] Like Paul Éluard a World War earlier, Jiří was granted a brief furlough for the ceremony. The newlyweds contrived to spend their wedding night together but that was all the happiness they would be granted. Jiří returned to his barracks at Agde, and Vítka was hospitalized shortly afterward. Less than two months later she was dead. It was no malady of modernity that brought the little girl conductor to an early grave. Kaprálová was a victim of tuberculosis—or so, at any rate, says the death certificate. She was just twenty-five. Jiří reached the hospital in Montpellier (to which he had succeeded in evacuating his young bride) by truck, on foot, and by stolen bicycle two days before she died. The personal and the political came cataclysmically together in a shattering coincidence that underlined his abject powerlessness in the face of both: "I looked at her with the pain of impotence. France was collapsing, the whole world was falling into ruins and at the same time I was losing the most precious being I had known."[228]

Jiří's long night at the deathbed gave way to the beautiful indifference of "a new day. . . . After the nocturnal rain the garden was covered with rose petals glittering in the sun's rays. Flowers everywhere. So many flowers. As I passed through the door of the hospital the radio announced that France had capitulated."[229] The date was 16 June 1940. Vítka was hastily buried the next day in the section of the Saint-Lazare Cemetery in Montpellier reserved for paupers and the unknown. Jiří found an abandoned iron cross, planted it at the head of the grave, and strewed the fresh yellow earth with hundreds of wild poppies "until the grave was covered with them as if by drops of blood."[230] "Instead of an organ, the thunder of black clouds. Little Vítka—you would prefer things without pretension," he recorded. [231] Then he got on with the business of living and partly living.[232] He escaped to England, where he flew in the RAF and later became a BBC war correspondent in North Africa, the Middle East, Burma, China, Italy, and northwestern Europe. Unlike Martinů, he returned home after the war. He was arrested and sentenced to six years imprisonment for alleged espionage in 1951—not an uncommon fate among those who had been caught in the western emigration.

Writing "eighteen hundred feet below ground, in total darkness lit only by the flickering light of a miner's lamp"[233] in November 1952, Jiří had a sudden flashback of the Luxembourg Gardens. He had done his utmost to bury the memory of Vítka deep in the vaults of his being. "The dead have enormous strength, enormous power," he explains, "and the taste of death is as sweet as

the perfume of a fading rose. And I had to live, to live at all costs, when all around me there was so much dying."[234] But this was a memory that overwhelmed him:

> Paris was sleeping restlessly, uneasily, and in the sounds of her sleep were the first indications of the tragedy to come. Through the tops of the trees the moonlight filtered down on the gravel path. The seats were empty and the pond, where in daytime the children would sail their little boats, shone like a black metal mirror.
>
> We stopped, leaning against the rail which was cold with the dampness of night. All I could make out in the faint light was her pale childlike face and the graceful line of her lips. Vítka was just like a small girl who had lost her way and found herself in an adult world.
>
> Her heart was beating as fast as that of a little bird held in one's hand. The clock on the Val de Grâce struck the hour. Three notes of a mournful unfinished tune. A bus roared down the Boulevard Saint-Michel, the sound dying away in the distant streets.
>
> We were whispering, as though afraid of being overheard. Vítka, her eyes half-closed, suddenly looked into my face.
>
> "Be careful," she said. "You may just be in love with love."[235]

I quote here from Mucha's diary of his imprisonment, which was later published under the title *Studené slunce* (Cold Sun, translated into English under the title *Living and Partly Living*). Jiří wrote the entries in notebooks smuggled in and out of the camp by a sympathetic miner. The hard labor down the pit came as welcome relief after months of solitary confinement.

Mucha was amnestied after Klement Gottwald's death in 1953. It was he who first spilled the beans on the relationship between Martinů and Kaprálová in his "memoir-novel" *Podivné lásky*—best rendered in English as *Peculiar Loves*, though the adjective *podivný* can also be translated as uncanny—which was published in 1988, half a century after the events it describes. The title of the French translation, *Au seuil de la nuit* (On the Threshold of the Night) does equally well. By then in his seventies, Jiří obsessively scoured his own and Vítka's old diaries, her correspondence with parents and lovers, *in search of the truth* (*d'après la vérité*)[236] of what had slipped his mem-

ory as well as what had obsessively stuck there, refusing to let him be. "Once he embarked on this novel," recalled his second wife, Geraldine—a Scottish girl he met during the war—"it wholly consumed him."[237] As desperate to recapture the reality of what once was as the inhabitants of the little town in *Julietta*, Jiří hounded down every last Proustian scrap that might bring back the past. Among much else that he admits was painful to relive, he reveals that Vítka spent the morning before her wedding with Martinů. Five days later, she sat down to compose what would turn out to be her last song, setting a 1924 text by the Czech poet and children's writer Petr Křička. The song is titled "Dopis" (A Letter). It is scored for a male voice, but who is to say, in this case, who is writing to whom?

> You said "No." Well, so be it . . .
> It was fate that separated us.
> I regret that but I see you're happy—
> So I accept it.
> I don't judge who's the guiltier
> Or whose loss is bigger.
> Yesterday there was just one path
> Today there are two.
> I understand that now, and blame no one.
> Who knows? . . . Perhaps, one day,
> Your heart will recognize me again.
> For God is a great artist,
> And has his mysterious ways . . .[238]

If "A Letter" was meant to achieve closure with Bohuš, it failed. A week before her death, writing in pencil, in a large disjointed script, in a high fever, Vítka complained of vivid, horrible nightmares. She was "haunted," she wrote, by "this megalomaniac, this Martinů, even though I throw away his letters, his irritating words, and don't reply, and him like a demon, like a demon!"[239] But according to Jiří her last words were "To je Julietta"—"It's Julietta." Vítka heard the strains of Martinů's opera in the rain beating on the windowpane of the hospital ward in Montpellier—just as fourteen months earlier she had heard it raining crochets and quavers on the skylight of Jiří's little attic room in the Quartier Latin.[240]

Martinů completed *Julietta* in January 1937, four months before he met Kaprálová, but its music became, so to speak, their song. For Mucha this was a textbook case of "what often happens, namely that the dream, composed as a painful premonition or desire, is realized a year later. . . . For [Martinů] she

was Pisníčka and Julietta at the same time."[241] Erik Entwistle has traced how "the *Julietta* chord" and "the *Julietta* motif" bounced back and forth between the compositions of teacher and pupil, becoming "a musical code for their mutual affection" and shifting their colors, now lyrical, now angry, with the ups and downs of their star-crossed love. The same figures returned again and again in Martinů's works after Kaprálová's death, including in his first American composition, a *Mazurka* "haunted by Czech, not Polish ghosts," in the *Memorial to Lidice*, where "we hear the descending melodic pattern as the work builds to its climax," and in the 1957 *Adagio for Piano* that Martinů wrote at the request of Kaprálová's mother in memory of Vítka, Vítka's father Václav—who was a pupil of Leoš Janáček's and his daughter's first teacher— and that verdant summer, forever immobile, they all spent together at Tři studně in 1938.[242]

How Boluš longed to remain in the eternal present of his dream:

> What a beautiful summer, Václav! Without doubt I never feel as well anywhere as I do in your place at Tři studně.... One day I would like to celebrate these highlands and all these brooks and springs in a little composition full of children's voices that resonate with a laugh like Vítulka's.... She is so frail, lively as a little sparrow, and it feels so good to have her near one. Who has displayed such creative energy? A young girl—but who has not been afraid of the composer of the *Military Sinfonietta*? ... I am lying on the grass near your chalet at Tři studně and I feel good, even if a kind of bad cloud oppresses my soul, as if I will never come back here alive and as if in a few days neither Vítulka, nor you, Václav, will still be alive—you see the stupidities that now come into my mind! ... I can't tell you, Václav, how much I love you both, your daughter Vítulka and you, and how I would wish not to be going anywhere tomorrow ... so that everything stops and doesn't change any more.[243]

Vítka had the same urge to suspend time. "Card to Rudek [Kopec]," she noted in her diary on 21 January 1939, "for him to delay the official engagement. If this will achieve anything. Reception this evening, beautiful enough, but what sadness, what sadness. What is happening with Špalíček? Why can't it be like last year? Ah—the string won't tune at all." The next day: "Difficult awakening. ... I don't know how I'm going to hold on here. My God, I who so rarely call for your help—right now, I would so much desire that time goes

backwards. It's got to the point where like before I don't want to leave my dreams."[244]

Martinů's dream of Venus never left him, even if his Písnička merged in his musical imagination with everything he had ever loved and lost. "Perhaps Kaprálová herself," Entwistle muses, "came to symbolize, as the baritone soloist declares at the conclusion of *The Opening of the Wells*, 'the keys to home.'"[245] It would not be the first or the last time the image of a woman had gotten mixed up in the poetic imagination with a country—or any other ideal, virtue, or desire to which a man longs to give tangible face and form. Is this, then, how the best-known twentieth-century Czech composer after Janáček came to remember the homeland he would never see again? I like to think so:

> They were preparing the opening of the new Čedok [travel] agency, which would be accompanied by a song and dance spectacle in folk costume; Vítka and Martinů adapted old songs and developed a program in which Vítka sang, danced and played the piano. Now Písnička was in folk dress too, the composer's dream had put on fairy-tale clothes: in his letters of autumn 1938 he ceaselessly evokes the memory of this day where he saw the beautiful little Moravian with her short skirt and her embroidered blouse waving him goodbye on the Betzes' balcony.[246]

And what of the hard-bitten son of Alfons Mucha, the sometime fighter pilot, war correspondent, and survivor of Klement Gottwald's gulag? After his death, in a final twist of the knife, it would be alleged that Jiří had been a KSČ spy.[247] Whether or not Mucha was at some point turned, he could well have said of himself, as Apollinaire did in "The Pretty Redhead," that having known several languages, traveled a fair bit, seen war and lost his best friends in the frightful conflict he knew as much of the old and the new as one man can. Though he had tasted the sorrows and joys of love in abundance he had no wish to escape into a land of dreams. Not for him the eternal returns of *Julietta*. "So far I have never lived on my past," he defiantly wrote, by the flickering light of a miner's lamp, eighteen hundred feet beneath the ground. "Only people whose blood is cooling off, who mistrust the future, have that need to warm themselves by the questionable fire of their memories. I am made of the past, which resonates whenever the present touches it in the way the strings of a piano come to life when a clear note rings out nearby. But what draws me into life is the vision of all those tomorrows, infinitely more

beautiful than all memories of past happiness."[248] Maybe dreams of beautiful futures were what he needed, then, to get him through the night.

The trouble was, the little girl conductor never left Jiří's dreams either. He could not forget the day France fell, the blinding light of Provence. In the darkness of the pit Vítka was the brightest thing to be seen, and that brightness was unbearable.

> The whole scene keeps coming back to me again and again. I cannot exorcise the vision of those hot Provençal hills, that strip of sea and the slender shadows of the cypress trees; I can hear the ringing of the cicadas in the lavender and the creaking of the old hearse up the track to the cemetery. It is like a nightmare. The action is played over and over again, with the same cruel beauty that marked it years ago.
>
> The ships sailed away and the ships sailed back. In the cemetery outside Montpellier I found the grave again, overgrown with grass and hundreds of wild poppies. The wind was chasing small white clouds across the sky out to the sea, and the last grapes were ripening in the vineyards. There was a whispering in the moving grass, in the bushes, among the dew-wet leaves. It sounded like a gentle rain falling on a window at daybreak. It was like faint footsteps, like words, like the tinkling of an invisible piano.
>
> No, the dead do not forget.[249]

7

Love's Boat Shattered against Everyday Life

The fourth [prison] was an earthly paradise; a beautiful house, splendid garden, select society and pleasant women when, all of a sudden, the site of executions was moved to right beneath our windows and the cemetery of the victims was placed in the middle of the garden. In thirty-five days, my dear friend, we buried some eighteen hundred people, of which one third came from our wretched house.

—D.A.F. DE SADE, LETTER OF 19 NOVEMBER 1794[1]

A NATIONAL TRAGEDY WITH PRETTY LEGS

When thirty-six of John Heartfield's photomontages were displayed alongside cartoons by George Grosz, Otto Dix, Jean Cocteau, František Kupka, Josef Čapek, Adolf Hoffmeister, and others in the *First International Exhibition of Caricature and Humor* at the Mánes Gallery in April 1934, the German Embassy angrily protested. "Adolf the Superman: Swallows Gold and Spouts Trash" caused the most outrage: it shows the Führer in full rhetorical flight, his chest cut open to reveal a spinal column made up of gold coins and a swastika in place of a heart. The links between fascism and capitalism were one of Heartfield's hobbyhorses—as we would expect of an orthodox communist, convinced that anything and everything could be made sense of in the last instance by the hidden hand of the economic base. His 1933 montage "Instrument in God's Hand? Or Plaything in Thyssen's Hand?" says it all, portraying Hitler as a diminutive puppet whose strings

are being pulled by the steel magnate Fritz Thyssen, whom Heartfield has pointedly supplied with a swastika tie-pin and a big fat cigar.[2] The Czechoslovak government eventually caved in to the Nazis' pressure and ordered several of Heartfield's works to be removed. The furor did no harm to the gallery's attendance figures. The exhibition had over 3,000 visitors on the following Sunday. By the time the show closed on June 3, a month after it was originally scheduled to end, around sixty thousand people had seen it. Heartfield responded to the confiscations with a biting composition in *AIZ* captioned "The More Pictures They Remove, the More Visible Reality Becomes!" It showed a photograph of the display at the Mánes Gallery with several of his works removed. Through the gaps one could discern a looming prison wall.[3] More exhibits were removed in May following protests by the Austrian, Italian, and Polish governments as well as from the Vatican, who found Heartfield's transgressions every bit as obscene as the beautiful naked body of Hedy Lamarr.

In response to these events the Association des Écrivains et Artistes Révolutionaires (Association of Revolutionary Writers and Artists), a front organization for the PCF, invited Heartfield to exhibit one hundred fifty of his montages at the Maison de la Culture in Paris in the spring of 1935. The Monteurdada spent several months in France in connection with the exhibition, which is one reason why he was not among the audience for Breton and Éluard's Prague lectures. He likely would have given them a miss anyway, since he considered surrealism to be "reactionary."[4] So, by then, did Louis Aragon, who opened the proceedings at the Maison de la Culture on May 2—just two weeks after Breton and Éluard had returned from their visit to the magic capital—with a lecture titled "John Heartfield et la beauté révolutionnaire." Aragon began with a résumé of the "crisis" of painting whose culmination came in cubism—not, he insisted, in Dada or surrealism, which he now regarded as merely "violent signs of a reaction against this extreme point of art that cubism had reached." The development of photography, he argued, rendered it "puerile" for painters any longer to struggle to achieve "resemblance" to reality. But in Germany at the end of World War I Heartfield, Grosz, and Ernst had employed "this very photography that threw down the gauntlet to painting for new poetic ends," transforming the photograph from a means of "imitation" into a vehicle for "expression." While the *papiers collés* of Braque and Picasso had blurred the boundaries between the real and its representation, the "force and attraction" of the Berlin Dadaists' collages lay precisely in the "verisimilitude" lent by the "figuration of real objects" out of which they were assembled; "in the face of modern art's decomposition of appearances a new, living taste for reality was thus reborn in the guise of a

simple game." The *photomonteur* "created modern monsters, made them parade at his pleasure in a bedchamber, on the Swiss mountains, at the bottom of the seas . . . the *salon at the bottom of the lake* of [Rimbaud's] *Season in Hell* became the habitual climate of the picture."

Fifteen years later, Aragon complains, Ernst had still not left this "lacustrine décor" where he crafted poetry out of cut-up bits and pieces of the real "with all the imagination one could wish for" and no end other than poetry itself. "We know what became of George Grosz" he sneers, unknowingly echoing Oskar Kokoschka's contempt for *Euer George Großkommunist*. But "today John Heartfield knows how to salute Beauty. While he played with the fire of appearances, reality caught fire around him." Aragon reminded his audience that there were Soviets in Germany in November 1918 and it was the German people, not the French armies, who in a "magnificent, splendid up-ending of reality" put an end to the war in Hamburg, Dresden, Munich, and Berlin. "How feeble a miracle is a salon at the bottom of a lake," he gushes, "when the big blond sailors of the North Sea and the Baltic ride through the streets on armored cars with red flags!" But a dream it was to remain—at least for the time being. "The men in evening dress in Paris and Potsdam came to an agreement, Clemenceau gave the Social Democrat Noske back the machine-guns that would arm the future Hitlerites, Karl [Liebknecht] and Rosa [Luxemburg] fell, the generals re-waxed their moustaches," and "social peace flowered, black, red, and gold, over the gaping charnel-houses of the working class." And suddenly "John Heartfield was not playing any more":

> He took up the fragments of photographs that he had not long ago assembled for the simple delight of amazing and made them *signify*. The *social forbidden* very quickly replaced the *poetic forbidden*, or more precisely, under the pressure of events, in the struggle where the artist now found himself, the two blended together: *there was no longer any poetry except the poetry of the Revolution*. Fiery years, with the Revolution suppressed in one place, triumphant in another, when in the same way, at the extremities of art, Mayakovsky emerged in Russia and Heartfield in Germany. And these two, under the dictatorship of the proletariat, under the dictatorship of capital, coming out of poetry at its most incomprehensible, from the ultimate form of art-for-the-few, achieved the most brilliant contemporary illustration of what art for the masses could be, that magnificent and incomprehensibly decried thing.

Aragon makes no mention of Mayakovsky's suicide; he was writing, after all, about revolutionary beauty now, not love sudden and immediate, the great, irresistible summons. Enough time had evidently elapsed for the creature to be transformed into a symbol. Those who detect "the old shadow of Dada" in Heartfield's montages, he goes on, should pause at "this dove spitted on a bayonet in front of the palace of the League of Nations, this Nazi Christmas tree whose branches are contorted into a swastika." This is the heritage of "all the painting of the ages":

> Here, simply, by means of scissors and a pot of paste, the artist has succeeded in surpassing the best of what modern art attempted, with the cubists, on that lost highway of the mystery of the everyday. Simple objects, like Cézanne's apples and Picasso's guitar were in their time. But here, in addition, there is *meaning*, and meaning has not disfigured beauty.[5]

With "no other guide than the materialist dialectic, than the reality of the historical movement, which he translates into black and white with all the anger of combat," Aragon concludes, Heartfield's art is "the very beauty of our time," its palette "all the aspects of the real world."[6]

Well, not quite all. Simple, direct, and immensely powerful as they undoubtedly are, Heartfield's images can easily come to stand in for an age; too easily, perhaps, as the age itself recedes into history leaving just the images behind to remember it by. Only, Heartfield didn't do nudes. And his sole engagement, artistically speaking, with the vast human comedy laid bare in Štyrský's *Erotic Review* seems to have been that rather puerile *vagina dentata* at the International Dada Fair of 1920. Some will no doubt heave a sigh of relief, preferring to have neither their art nor their politics sullied by reminders of their origin *inter urinam et faeces*. But what troubles me in this "translation" of "the reality of the historical movement" into "black and white" is the nagging suspicion that it is exactly this refusal of the down and dirty of human existence that gives such images—and such politics—their clarity and power in the first place. History never comes in black and white. Hitler was more than just a puppet dancing on the end of Thyssens's string, and Nazism fed off dreams and desires that were both darker and more quotidian than the compulsion to accumulate capital. Goering was not only a butcher but also a connoisseur of fine art, and that density of unexpected encounters is part of what makes him so monstrous. I would suggest, on the contrary, that the "force and attraction" of Heartfield's cut-outs derives less from their roots in the real than the simplicity with which he launders it, using scissors

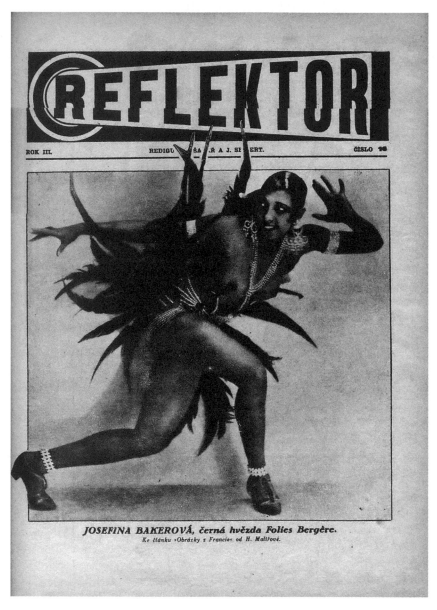

FIGURE 7.1. *Reflektor*, Vol. 3, No.16, 1927, cover picture of Josephine Baker. Anonymous artist. Archive of Jindřich Toman.

and paste to excise anything and everything that might muddy and mess with the clarity of the picture.

Josep Renau must have been devastated when Heartfield, visiting his East Berlin studio in 1958, took the Spanish *fotomontador* to task for his frivolous use of color. Renau had idolized the Monteurdada since he was a young man cutting his artistic and political teeth in Valencia in the early 1930s. He made his first photomontage "The Arctic Man" (*El hombre ártico*) in 1928 and joined the Spanish Communist Party in 1931. His series *The Ten Commandments* (*Los diez mandamientos*, 1934) has echoes of Goya's *Disasters of War*, but many of the trademarks of his later style—color, symbolism, and satirical placement of the female nude—are already evident.[7] With the outbreak of the Spanish Civil War Renau was appointed Director General of Fine Arts in the Ministry of Public Education and Fine Arts, in which capacity he oversaw the evacuation of the national art collections in the Museo del Prado first to Valencia, then to Barcelona, and eventually to Switzerland. One of his first acts was to appoint Pablo Picasso as the Prado's new director. It was Renau who involved Picasso in the Spanish pavilion at the *Exposition internationale des arts et techniques dans la vie modern*; Dora Maar's famous photographs of *Guernica* were first published in his magazine *Nueva Cultura*.[8] The *fotomontador* spent several months in Paris preparing the pavilion, for which he created a series of large-scale photomontage murals.

Renau fled Spain in February 1939, was interned for a while in France, and boarded the New York bound steamer *Vendamm* along with his family and a raft of other Spanish artists and intellectuals on May 6. On arriving in the United States he headed south to Mexico City, which would be his home until 1958 when he moved to the German Democratic Republic. Quite why Renau returned to the Old World and a second exile is debated. He told the writer Juan Antonio Hormigón "They were hard years. The Cold War was at its height. [The Mexican mural painter David] Siqueiros and various other people were in prison. I had several accidents which I suspect were premeditated. So I decided to leave Mexico."[9] Josep had not been inactive either politically or artistically. He worked with Siqueiros in 1939–40 on the mural *Portrait of the Bourgeoisie* (*Retrato de la burguesía*), a commission from the Mexican Electricians' Union that was intended to be "a visually revolutionary space . . . with a range of themes that combined references to the electrical industry and the workers' movement."[10] Siqueiros meantime organized an armed attack by members of the Mexican Communist Party on Leon Trotsky's home at Coyoácan. Renau's covers for the Mexican Workers' University magazine *Futuro* (1940–46) followed the progress of World War II

("1941—A Moscu; 1942—A Berlin")[11] across a technicolor Europe in which the French guillotine and the Brandenburg Gate stand together beneath a sun setting in a blood-red sky. In another gesture to Goya he wishes readers a Happy New Year for 1943 with a tree stump rising from a heap of skulls from whose denuded branches hang nooses ready for Hitler, Franco, Mussolini, and Hirohito. He celebrated peace in 1945 with a hammer surmounted by a dove; in the background stand a group of figures with their right arms raised in a clenched fist salute. Bold and colorful, these designs are far more reminiscent of Soviet constructivism—with a nod to Mexican film posters and pictures of saints—than anything in John Heartfield's somber *oeuvre*.

The summit of Renau's lifework was *The American Way of Life*, which he began in Mexico in 1949 and completed in East Germany in 1966. Around forty (out of more than a hundred) montages from the series were published in Berlin in 1967. *Fata Morgana USA*, as the book was called, juxtaposes the montages with clippings from newspapers and *Life* magazine, anonymous press photographs, Carl Sandburg's poetry, excerpts from the Bible and Lincoln's Gettysburg Address, and quotations from among others Harry S. Truman ("The atomic era will be an American era"), Georges Sadoul ("Charlie Chaplin was ... driven out of America by McCarthy's witch hunt"), and Marilyn Monroe ("That is what annoys me: a sex symbol becomes an object. I hate being an object").[12] Renau's selection and ordering of the sixty-nine montages that form the final, definitive series was exhibited for the first time at the Venice Biennale in 1976. While the political content of *The American Way of Life* may be exactly what we would expect of an orthodox communist, its technique is anything but. Renau has no interest in verisimilitude. Though he uses juxtaposition as effectively as Heartfield (a clean-cut young white couple kissing beneath a black corpse hanging from a tree, a bare-breasted anti-communist Jane Russell straddling the Holy Bible), his is a more complicated semiotic universe. Employing the dizzying discrepancies of scale and perspective pioneered by Klutsis and Rodchenko, the montages spill out of their rectangular frames. They do not employ color naturalistically but as a highlighting device: the luscious female flesh and iconic Americana (Colgate toothpaste, Old Glory, Lucky Strikes, hot dogs, marching bands, Pepsi and Coke) that reiterate themselves in montage after montage are supersaturated, while the hidden realities of poverty, racism, and imperialist war lurk in the background in shades of sepia or gray. Renau was aiming at a higher realism, which enters into the American dreamworld—and is fully aware of its fatal seductions.

"It is noteworthy," he writes in *Fata Morgana USA*, "how much society in the USA is most effectively softened up by the powerful eroding actions of the big monopolies and how it has become sensitive to the striking feedback of the mass media (film, radio, television, newspapers, comics, magazines, etc.). This takes place to such a degree," he believes, "that the formula 'American way of life'—partially and tendentiously abstracted from social reality itself—is taking on the shape of a real 'model'; this concerns a considerable part of the US population which has of necessity formed itself in accordance with the commandments of such an abstraction."[13] A later generation of social theorists would talk in terms of hyper-realities and mediated subjectivities, but the essential message is the same: it is no longer possible to draw hard and fast lines between image and reality, dreaming and waking, because the dreamworld has become the everyday. Under these conditions, Renau thinks, "what *AIZ* achieved is unrepeatable now":

> After traveling through the USA and during the early years of my exile in Mexico I realized that if the "knife" [of photomontage] is daubed with florescent colors and neon lights—as in traffic lights and shop windows—it "pierces every heart" more subtly and profoundly. Because they are things that irritate the optic nerve and soften the critical sense, making the path to the heart speedier and more perilous. . . . In Heartfield's world—in the proletarian districts of Berlin—"color" did not play the poisonous, criminal (in the broadest sense of the word), reactionary part that it plays in the great cities of the modern age, camouflaging the same socio-political categories that he combated so dauntlessly. Perhaps that is why Heartfield was "irritated" when he saw my political photomontages in color. Perhaps it was because his heart was already hardened by all that black and white.[14]

As Apollinaire said, one does not choose what is modern, one accepts it. Certainly these montages *signify*: the question is what. Josep Renau's America looks a lot like Tom Wesselmann's or Andy Warhol's America; a gross, gaudy, bellowing monstrosity, to be sure, but a New World that is mesmerizing in its very monstrosity. Whatever Renau's intention, the lovely legs of the Washington teletypist posing beside the stacks of Pearl Harbor Committee records in "Gone with the Wind"[15] may incline us to think about many

things other than the dead soldiers on the beach behind her. The difficulty is that Josep did do nudes and he did them big time. He larded *The American Way of Life* with strippers and showgirls, calendar pin-ups, and burlesque queens, and Marilyn's lips are everywhere. The ubiquitous flesh lends an undeniable sexiness to evil—even if we *know* it is evil—eroticizing Colgate, Coca-Cola, and the rest of his freewheeling signifiers of the American dream. The message slips out of its Marxist frame, implicating its author and viewers alike in the perverted pleasures of the spectacular parade. Everything, as Paul Éluard said, becomes a pretext for showing us feminine nudity—Wall Street, Main Street, the Ku Klux Klan, Moloch Hollywood, Hiroshima. It is difficult to avoid the suspicion that at the end of the day Renau just *liked* looking at cheesecake. No doubt it was mere coincidence that led him to settle on the number 69 as the final tally of montages to be included in *The American Way of Life*, though Štyrský or Toyen might have taken some persuading. To the artist's chagrin, the communist authorities in the German Democratic Republic only allowed *Fata Morgana USA* to be distributed abroad.

THE POET ASSASSINATED

By the time Louis Aragon hailed John Heartfield's photomontages as the pinnacle of modern art he had come a long, long way from *Irene's Cunt*. Just how far, and by what strange paths, is worth spending a little more time exploring. Breton and Aragon first met during the last year of World War I at Adrienne Monnier's Amis des Livres bookstore on the rue de l'Odéon in the Quartier Latin. Monnier was a leading light of Paris lesbian circles and Les Amis des Livres the first independent bookstore to be run by a woman in France. Adrienne remembered Aragon as "the sweetest, most sensitive boy anyone could imagine, not to say the most intelligent."[16] The two poets were both then working as military orderlies in the nearby Val-de-Grâce hospital and taking courses in wartime medicine, but their hearts lay elsewhere. High on "what we then called 'modern' among ourselves," "new ways of feeling and *saying*, the search for which implied, by definition, a maximum of *adventure*," they threw themselves into "the activity that, starting in March 1919, was to begin its explorations in *Littérature*, soon explode into 'Dada,' and then be forced to revitalize itself from top to bottom as Surrealism."[17] I quote Breton here, interviewed on French radio in 1952. He did not conceal his affection for the friend he fondly remembered from his youth:

> I can still recall the extraordinary walking companion he
> was. The areas of Paris I visited with him, even the most

nondescript, were enhanced several notches by a magic, ro-
mantic fantasizing that was never caught short for long,
and that burst forth at a bend in the street or before a shop
window. Even before *Paris Peasant*, a book such as *Anicet*
already gives an idea of these riches. No one was ever a
more able detector of the unusual in all its forms; no one
was ever more inclined toward such intoxicating reveries
on a kind of hidden life of the city. . . . In this sense, Aragon
was staggering—even for himself. . . . He was extremely
warm and generous in friendship. The only danger he
courted was his excessive desire to please. *Scintillating . . .* [18]

The surrealist leader could almost be describing an old flame who had long
ago captivated him with her dazzling charms. It is a generous tribute, consid-
ering how far apart the two men had by then become.

Aragon joined the PCF in 1927 along with Breton and Éluard, largely at
Breton's urging. Only three years earlier he had loftily dismissed "doddering
Moscow," sniffing that "the problems of human existence have nothing to do
with the miserable little revolutionary activity that has been going on in the
East these past few years."[19] His troubles began—if it is ever possible in such
matters to pin down a singular point of origin—during a trip to the Soviet
Union in November 1930, where much to their surprise he and fellow-surre-
alist Georges Sadoul found themselves accredited as the official French del-
egates to the Congress of Revolutionary Writers taking place in Kharkov. By
this time Breton's relations with the PCF were getting very sour: apart from
the difficulties with the "undesirable characters, policemen and others" and
"puerile accusations" of which he complains in the *Second Manifesto*,[20] the
expulsion of Trotsky from the Soviet Union in 1929 marked a turning-point
in his attitudes toward the workers' state. Aragon and Sadoul believed they
had made significant gains at the congress, including what Breton called the
"undeniable coup"[21] of getting a resolution adopted denouncing Henri Bar-
busse's newspaper *Monde*, with which the surrealists were then at odds. But
just before they left Russia, the pair were persuaded to sign a letter critical of
aspects of surrealism in exchange for a promise of influence within Comin-
tern cultural organs. The text dismissed Freudianism as an "idealist ideology,"
and rejected the *Second Manifesto of Surrealism* "to the extent that it contra-
dicts dialectical materialism." Worse still, as far as Breton was concerned,
Aragon and Sadoul agreed to submit their future literary output to "the dis-
cipline and control of the Communist Party." "This was the first time," he

said later, "that I saw open at my feet the abyss that since then has taken vertiginous proportions, growing as fast as the impudent idea that truth must take a back seat to expediency, or that neither conscience nor individual personality are worthy of consideration, or that the end justifies the means."

On his return to Paris Aragon was hardly welcomed with open arms. But "the sentimental chord," says Breton, "nonetheless managed to provoke a response, especially on my part," and "after agreeing to some minimal public retraction, in the form of a letter 'To Revolutionary Intellectuals'—an extremely ambiguous letter, to tell the truth—[Aragon] again took his place among us, though not without some lingering afterthoughts."[22] Unfortunately sentiment was not enough to overcome the choice of abdications that would not go away. Aragon tried his best to restore his surrealist credentials with an article titled "Le Surréalisme et le Devenir révolutionnaire" (Surrealism and the Revolutionary Future). It chokes with emotion—"more emotion than it pleases me to say"—at the "singular enterprise of those who today would like to separate me from you. . . . Whence this madness? It seems it is because I went on a journey."[23] But even as Louis was doing his best to explain away the Kharkov indiscretion in a manner that would cause least offense on all sides, *mes amis* got him into yet more hot water with the PCF. The problem was that little word *sex* raising its ugly head again.

"Surrealism and the Revolutionary Future" appeared in issue 3 of *Surréalisme au service de la révolution* in December 1931. Issue 4 of the review came out simultaneously. Opening with an unpublished manuscript by the Marquis de Sade, the number did little to bear out Aragon's claims that the journal's new title proved the "anti-individualist and materialist" direction of the surrealists' recent evolution.[24] The issue closed with Salvador Dalí's "Revérie," a graphic and (Dalí insists) "absolutely involuntary" daydream centering on his desire to sodomize an eleven-year-old girl called Dulitha "amidst the shit and rotting straw" of a stable.[25] If these were the "means of expression . . . extremely precious for the life of the group and the extension of its action"[26] Aragon claimed its latest recruits Dalí and Luis Buñuel had brought to surrealism, the communists wanted nothing to do with them. Together with the other surrealists who were then still active party members (Sadoul, Pierre Unik, and Maxime Alexandre), Louis was summoned before an internal PCF disciplinary commission and asked to explain what pornography had to do with the proletarian revolution. According to Alexandre the quartet "tumultuously" refused to renounce surrealism.[27]

Into this tangle of conflicting loyalties and—we might think—absolutely antithetical conceptions of human liberation burst what became known as

l'affair Aragon. While in Moscow Aragon had been moved to write a poem called "Red Front" (*Front rouge*), which was published in *Littérature de la révolution mondiale* (Literature of the World Revolution) and reprinted in his 1931 collection *Persécuté persécuteur* (Persecuted Persecutor). It was not the first time a pilgrimage to the Soviet capital had led an avant-garde poet to ignore the warning of Klimt's *Nuda Veritas*. The young Jaroslav Seifert embarrassed us in Red Square earlier, "dying with longing to become the poet of this people."[28] Longing sometimes has a lot to answer for. "Red Front" is not great writing, even by the dubious standards of *la beauté révolutionnaire*:

> Bring down the cops
> Comrades
> Bring down the cops ...
> Fire on Léon Blum
> Fire on Boncour Frossard Déat
> Fire on the dancing bears of social democracy ... [29]

The times being what they were, the poem was taken more seriously than it deserved to be. In January 1932 Aragon was indicted for "inciting soldiers to disobey orders and incitement to murder," an offense that carried a sentence of five years' imprisonment.

Despite Breton's dismissal of "Red Front" as "a poem of political agitation, full of the verbal violence and excess to which we had seen Aragon resort in other circumstances,"[30] he came to his old friend's defense in two pamphlets. Issued in the name of the entire surrealist group, *L'Affair Aragon* attracted over three hundred signatures, including those of Braque, Picasso, Duchamp, Matisse, Ozenfant, Le Corbusier, Walter Benjamin, Bertolt Brecht, Lászlo Moholy-Nagy, Thomas Mann, and Karel Teige. It straightforwardly protested "all attempts at interpretation of a poetic text for judicial ends."[31] *The Poverty of Poetry* was a more convoluted defense of poetic liberties, which appeared under Breton's name alone. Its unease with Aragon's "poetically regressive ... poem of circumstance"[32] is palpable. The burden of Breton's argument was that "Red Front" was, after all, *merely a poem*. Why should one line ("comrades, bring down the cops") be treated literally, he rhetorically asked, when others ("the stars descend familiarly to earth") were not? Poetry and prose were "sharply distinct spheres of thought" and should not be judged by the same standards. Reprisals against poetry, he went on, were a "more intolerable intrusion than others (it is a matter of judging rationally things that are by definition irrational), [and] an incomparably more arbitrary and profound blow against freedom of thought (in a domain where the manner of

thinking is inseparable from the manner of feeling)."[33] *L'Humanité* gleefully took up Breton's distinction and ran with it, deriding the surrealists for seeking "political liberty for poems and poets alone."[34]

There are different versions of what happened next. Aragon says he agreed to the pamphlet's publication on condition that Breton remove a footnote referring to the PCF commission on Dalí's "Rêverie," which was a confidential party matter that should be kept under wraps. Not wishing to give the communists any excuse to expel him, he claims, Breton deleted the note from the galley proofs in his presence. But when the pamphlet appeared the next day the note had mysteriously reappeared. It was this "incredible deception" that led Aragon to repudiate *The Poverty of Poetry* in *L'Humanité* on March 10 in a statement that was effectively an announcement of his break with the surrealist group.[35] He never talked to Breton again. The surrealist leader tells a different story. He made it clear, he says, that he was not prepared to excise a passage illustrating "just how much bad faith or mental indigence we were up against" despite Aragon's threat to break off relations if the text was published in its original form. Thus "paradoxically, our break became final the moment my pamphlet saw daylight, even though its object had been to defend him."[36] The truth will never be known, but I am more inclined to trust Aragon's incredulous outrage than Breton's self-serving memory. Besides, there is something reassuringly surreal in the possibility that responsibility for this most poignant of surrealist partings should be laid at the door of an inattentive printer.

"Nothing I have ever done in my life cost me so dearly," Aragon wrote later. "To break up like that with the friend of my entire youth was horrible. . . . It was a wound I inflicted on myself, which never healed."[37] Breton, too, admitted that the breach "was painful on both sides—some tender souls are still weeping over it."[38] Paul Éluard was not one of them. He was sufficiently incensed to publish his personal *Certificat* in addition to the group's collective announcement of Aragon's departure. "I have known Louis ARAGON for fourteen years," he began:

> I long had unreserved confidence in him. My admiration and friendship made me shut my eyes to what I took to be defects of character. When he went into the "world" I thought he was lighter, more sociable, than I; when he tried to temporize with our wish to manifest our spleen publicly I attributed this attitude to an excess of critical

spirit; his defects of language rendered him only a little pu-
erile, a little inoffensive, to my eyes; his errors, I always
thought intelligent enough, courageous enough, honest
enough, to be repaired. I loved him, I admired him, I de-
fended him.

Am I alone in detecting a twinge of jealousy for the beautiful boy? It was only
when Aragon threatened to commit suicide if the text of the Kharkov letter
was made public, Éluard goes on, that he "grew dim for me. . . . Troubled, de-
moralized, skeptical to see his bad faith appearing a little more every day
under an increasing sentimental blackmail, I awaited the leap he could not
fail to make into the definitive night." Aragon finally "unmasked himself"
when "he dared to ask us, he, the author of three clandestinely published
books, to excise Salvador Dalí's works from our publications on the pretext
that ill-wishers would represent them as pornography." Paul always did have
a soft spot for Dalí. "Aragon becomes *another*," he thunders, "and his mem-
ory can no longer have any hold on me." The *Certificat* closes with a quota-
tion from Lautréamont, set in bold typeface lest the message be missed: "**All
the water in the sea cannot wash away a stain of intellectual blood.**"[39]

Maybe it was that lingering sentimental chord, or possibly just his appre-
ciation for *humour noir*, that led Breton later to deflect the blame for Ara-
gon's apostasy onto the vagaries of coincidence—and the wiles of a woman.
Had it not been for a unique "combination of circumstances," he insists,
"Aragon, as I knew him then, would never have taken it upon himself to do
anything that would risk his separation from us." The Kharkov trip, he as-
sures us, "was in no way Aragon's idea but that of Elsa Triolet, whom he had
just met and who urged him to join her. . . . In retrospect, and given her sub-
sequent profile, there's every reason to believe that she made known and ob-
tained what she wanted once they got there." Triolet went on to become a
successful popular novelist and a prominent figure in the PCF. Sadoul, says
Breton, followed the lovers to Russia for similarly serendipitous reasons. A
few months previously he had gotten roaring drunk and sent a seditious let-
ter to the first-placed graduate at the elite Saint-Cyr Military Academy, for
which he was prosecuted in absentia and sentenced to three months in
prison. He was "ready if need be to make concessions toward a regime in
which he saw the negation of the one that had just sentenced him. I'm stress-
ing this," Breton explains, "only to show a progression of facts that started
from the most insignificant thing in the world: *a drunken practical joke*."[40] He

was probably right; this was another of those great events that have paltry causes. But neither he nor Éluard were prepared to cut the prodigal poet such surrealist slack at the time and nor, for the most part, has posterity.

Elsa Triolet, the villain of this piece, was the younger sister of Mayakovsky's lover Lily (Lilya) Brik. Aragon took up with her on the rebound from Nancy Cunard, who had left him broken-hearted. Elsa was no slinky grass snake, but she didn't let that get in her way. Despite being "short, plump, and not especially beautiful," Breton's biographer Mark Polizzotti tells us, the cunning little vixen "maneuvered [Aragon] into a darkened back room and seduced him" at a dinner party thrown for the Russian poet in the fall of 1928 at the house in the rue du Château in Montparnasse where Aragon, Jacques Prévert, André Thirion, and other surrealists were then living. "Shortly afterwards she matter-of-factly informed Aragon that she was moving in," "organized his belongings, removed all traces of former mistresses, and set about eliminating Aragon's friends—most notably the Surrealists, whom she considered cumbersome and boring." Elsa went on to become Louis's "lover, promoter, dominatrix and mother all in one." The pair married in 1939 and stayed together till Elsa died in 1970, becoming "the John Lennon and Yoko Ono of surrealism."[41] "After Elsa's death," Polizzotti adds in a bitchy little footnote, "Aragon dropped his role of proletarian troubadour for that of homosexual libertine-about-town; like the *xiphorus helleri*, he seemed to change sex with advancing age."[42] Poor Louis. Reading such descriptions one does not know whether to feel sorry for him, despise him, or cheer for him, driving to gay pride parades in his old age in his pink convertible, free at last of the apron-strings of the dumpy little Elsa.

But some questions ought still to be asked. Aragon was certainly what we would nowadays call bisexual and clearly enjoyed having a mistress take him in hand; many men do. According to his own testimony in the "Recherches sur la sexualité" he had "a horror of virgins," preferring "real women who know what love is and make no bones about it." He got his greatest sexual satisfaction "coming when I am performing cunnilingus."[43] (The ubermasculine Breton, by contrast, was convinced that "it is very rare for women to have orgasms through the use of the lips or tongue on the clitoris."[44]) Much has been made of the effeminacy of Aragon's upbringing. "Born 'of unknown parents' (he was the natural son of a former police prefect and ambassador)," Gérard Durozoi informs us in his *History of the Surrealist Movement*, Louis "was raised among women in an environment that could only contribute to his confusion: his mother, who only revealed his origin to him in 1917, pretended to be his sister, and his grandmother, his mother."[45] Echoing Éluard's

charge of puerility, André Thirion casts his erstwhile roommate as a "little boy" whom the communists sent to "the New Jesuits to learn good manners." "The author of *Irene's Cunt* was suddenly shocked by [Dalí's *Rêverie*]," he acidly adds. "He was thinking compassionately about those unhappy jobless proletarians who may have been also masturbating in front of little girls but [he] didn't have any money to buy them pornographic albums."[46] Maybe, as Polizzotti contends, Aragon indeed did have "a deep-seated need to submit to a higher authority—a role that had so far been filled by Breton."[47] Certainly he would more or less obediently toe the party line for the next three decades (though he refused to support the Soviet invasion of Czechoslovakia in 1968). But so did many others, who did not have wayward mothers or whip-wielding wives to blame for their political incorrectness. It is not usually thought necessary to descend to such below-the-belt analysis when discussing Breton or Éluard's politics. So what *exactly*, we might ask, is the problem here? Breton himself, after all, once remarked that he would like to be able to change his sex as often as he changed his shirt—though the thought, in his case, was likely no more than a passing poetic fancy.[48]

Aragon's "confused" sexuality does not seem to have diminished his contribution to surrealism during the 1920s, when according to this line of reasoning he was Breton's obedient bitch. His *Une Vague de rêves* (*A Wave of Dreams*, 1924) ranks with the *Manifesto of Surrealism* as a foundational text of the surrealist movement, while *Paris Peasant* and *Traité du style* (Treatise on Style, 1928) are classics of surrealist literature. So, in its own way, is *Irene's Cunt*, which Julia Kristeva, for one, considers a masterpiece of the French language.[49] It would not be surprising, from a surrealist viewpoint, if it was precisely Aragon's sexual ambiguity that made his eyes so open to "the unusual in all its forms" in the first place. Robert Benayoun argues exactly such a case in his article "The Assassination of the Equivocal" in the catalogue of the 1959 EROS exhibition, which attacks the aspirations of science to "cure" sexual "deviations," because they threaten "the disappearance of this disquieting penumbra, the sea of unexplored uncertainties, the mother of balances of thought, the glittering kingdom of the imagination."[50] One notable occasion on which Aragon did stand up to Breton was during the "Recherches sur la sexualité":

> ANDRÉ BRETON: Are you a homosexual, Queneau?
> RAYMOND QUENEAU: No. Can we hear Aragon's view of homosexuality?
> LOUIS ARAGON: Homosexuality seems to me to be a sex-

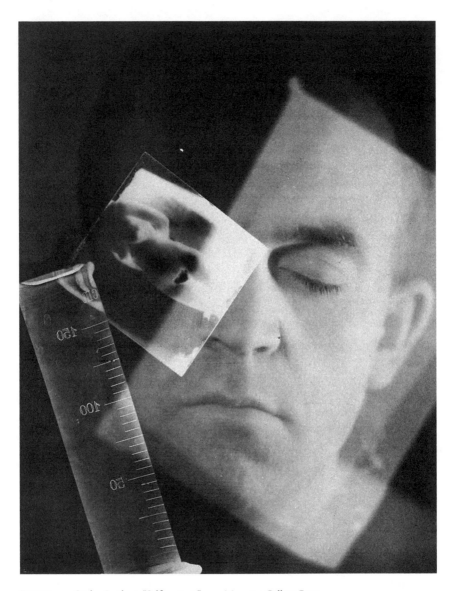

FIGURE 7.2. Otakar Lenhart, "Self-portrait," 1935. Moravian Gallery, Brno.

ual inclination like any other. I don't see it as a matter for
any moral condemnation, and, although I might criti-
cize particular homosexuals for the same reasons I'd crit-
icize "ladies men," I don't think this is the place to do so.

. . .

ANDRÉ BRETON: I am absolutely opposed to continuing
the discussion of this subject. If this promotion of ho-
mosexuality carries on, I will leave this meeting forth-
with.

LOUIS ARAGON: It has never been a question of promot-
ing homosexuality. This discussion is becoming reactive.
My own response, which I would like to elaborate upon,
isn't to homosexuality so much as to the fact that it has
become an issue for us. I want to talk about all sexual
inclinations.

ANDRÉ BRETON: Do people want me to abandon this
discussion? I am quite happy to demonstrate my obscu-
rantism on this subject.[51]

Later on Aragon complains of "the notion which I believe I can detect of the
inequality of the man and the woman" in the majority of the participants'
comments, which he thinks undermine the validity of the "Recherches." "For
myself," he adds, "nothing can be said about physical love if one doesn't start
from the fact that men and women have equal rights in it."[52] To present-day
eyes Aragon's contributions are refreshingly free of the macho posturing that
characterizes much of the discussion. He also evidently had a sense of humor.
When Breton says he feels "diminished" if a woman touches his limp penis,
Louis flippantly responds: "if a woman only touched my sex when it was
erect, it wouldn't get that way very often."[53]

It is curious, to say the least, to find the poet's lack of conventional, domi-
nant, heterosexual masculinity so persistently invoked not only by his surre-
alist peers but also by latter-day commentators by way of explanation of a po-
litical choice they find unpalatable. The slip is very Freudian; an interruption
in the discursive flow that is as impossible to reconcile with the surrealists'
own idealization of the "eternal feminine" (which seems suddenly to have re-
verted here to its traditional Christian status as the root of Man's fall) as it is
with the sanitized, gender-neutered norms that have become obligatory in
much of today's academic writing. I doubt Polizzotti would get away with
such a farrago of sexist, racist,[54] and homophobic innuendo were he dealing

with a more contemporary figure. Could this displacement of Aragon's agency onto the unruly feminine, I wonder, be a symptom of a more fundamental anxiety that was (and maybe still is) easier for self-proclaimed progressive intellectuals to repress than to acknowledge: the dawning realization that the only choice facing avant-garde writers and artists in Europe in the later 1930s *was* the castrating choice of abdications that Breton would outline in his 1935 Prague lecture to the Left Front—a choice that makes a mockery of any rational agency whatsoever, revealing that preening master of selves and circumstances "Man" to be as abject a plaything of his dreams as André Masson's pretty mannequin-in-a-birdcage?

More curious still, in light of all this *érotique voilé*, is the footnote in *The Poverty of Poetry* over whose publication Breton and Aragon in the end fell out. What Louis so desperately wished to keep in the closet, even at the price of the most painful parting of his life, was a communist functionary's outburst in the face of Dalí's "Revérie" that "you [surrealists] only seek to complicate the so simple and so healthy relations between man and woman."[55] Aragon, of all people, knew that there was nothing remotely simple about human sexuality. He also knew that there are more convulsive beauties in the world than the art of a John Heartfield can begin to comprehend; he had spent years enough, after all, exploring them, not least in *Irene's Cunt*. "Collaborating on the practical plan for action for changing the world" required him henceforth to live in lies for the greater good, subordinating art to agitation and sublimating both his critical faculties and his longings for big blond sailor boys in the vanilla pieties of *la beauté révolutionnaire*. In the face of the usual condescending characterizations of the poet as weak, unmanly, a toy boy in the hands of the Wicked Witch of the East, it is tempting to argue that so comprehensive a renunciation, in the circumstances of the time, was nothing short of heroic. Ruth Brandon is probably closer to the mark, though, when she suggests that "all [Aragon] wanted was to be universally loved; all he wanted was to please everyone."[56] At the command of love, as all true lovers know, is not always the most comfortable place to be.

A Wall as Thick as Eternity

Guided through the streets of *la ville-lumière* by *The Songs of Maldoror*, *Nadja*, and *Communicating Vessels*, loading every chance encounter with more significance than it could possibly sustain, Vítězslav Nezval had a fine surrealist time of it during his visit to Paris with Štyrský and Toyen in the summer of 1935. The visitors were enchanted to discover that the accommodations they had casually booked on the place du Panthéon neighbored "a

hotel we knew well from the illustration in *Nadja* ... the Hôtel des Grands Hommes" in which Breton and Soupault wrote *The Magnetic Fields*. "Everything," wrote Nezval in *Gît-le-Coeur Street*, "is like in a dream."[57] The French surrealists amply repaid the hospitality Breton and Éluard had enjoyed three months earlier in Prague, welcoming the poet to their nightly gatherings and bringing to life locations he knew only from books. Breton chose the venue for the get-togethers, which usually took place near his home on the rue Fontaine on the sleazy southern fringes of Montmartre but moved once or twice a week to the Left Bank because Salvador Dalí, Max Ernst, and Man Ray all lived in Montparnasse. Nezval got to meet Benjamin Péret, whom he was lucky enough to observe publicly insulting a priest, Oscar Dominguez, Dora Maar, Breton's "dear friends"[58] Claude Cahun and her stepsister and lover Suzanne Malherbe, Maurice Heine, Joan Miró, Gisèle Prassinos, and Yves Tanguy, who gave him a treasured watercolor. He visited the studios of Man Ray, Salvador Dalí, and Max Ernst, where to his amazement and delight he was introduced to the legendary Marcel Duchamp. Knowing Nezval's love of *Nadja*, Paul Éluard presented him with a luxury copy of the book containing many more photographs than the published version, letters by the heroine, and a handwritten commentary by Breton himself. Breton went one better, taking his guest out to Saint-Denis to meet *Nadja*'s "lady of the glove" Lise Deharme who, Nezval discovered, was not only young and lovely but an avid fan of Karel Čapek's *The Gardener's Year*.[59]

There were Apollinairean beauties and sights to be explored, too. The Czechs arrived in Paris on Friday, 14 June. The next evening they joined the surrealists at the Café de la place Blanche where Nezval had met Breton two years earlier. Everybody ordered green aperitifs except Éluard, who "drank pink lemonade and smoked many cigarettes." Just around the corner from Breton's apartment, the place Blanche is better known as the home of the legendary Moulin Rouge. It was as dubious a neighborhood then as it is now. Afterward Paul took the visitors on to sample one of "the many entertaining establishments" of the area, a cabaret on the rue Fontaine where Nezval was much taken with the "extraordinarily attractive" dancers whose "nipples were painted with hearts, spades, diamonds, and clubs." "They had the charm," he tells us, "of puppets."[60] Two nights later the poet "left the Grand Boulevards behind" him and headed out toward the Porte Saint-Denis in search of "the obscure rue Blondel, No. 32, where there is one of those houses that bears the name Aux belles Poules." He admits that there is little as "grotesque and degrading" as these brothels "where you are greeted by ten or more naked women, who draw your attention to their droopy charms, cack-

FIGURE 7.3. Toyen, illustration for Marguerite d'Angoulême, *Heptameron novel*. Prague: Družstevní práce, 1932. © ADAGP, Paris, and DACS, London, 2012.

ling like a gaggle of geese." Breton, he thinks, could never have crossed the threshold of such dives, "otherwise he could never have maintained the admirable purity that speaks from every one of his gestures." But despite his admiration for the surrealist leader, Nezval confesses that "I do not regret the evenings I have spent with half-naked, burlesque-costumed women in houses of pleasure." "From these times," he says, "there remains in me a certain distrust for innocence."[61] Georges Bataille would have thoroughly approved of this eruption of undisguised claims from below, but he was one Parisian Vítězslav did not get to meet on his excellent adventure. The Czech poet did catch a glimpse of Robert Desnos at the Café de la Coupule. Benjamin Péret assured him that the coinstigator of "Un Cadavre" was "even more repellent than he used to be."[62]

The mood of *Gît-le-Coeur Street* is often reminiscent of the delightful surrealist house parties at Lambe Creek and Mougins. But for all Nezval's deter-

mination to find magic in every mundane corner of Paris, it is also a book overshadowed by death. On the afternoon of the Czechs' arrival Štyrský noticed a shop window full of coffins near their hotel, which led him to joke that their every need would be catered for.[63] The painter suffered a heart attack a few days later. Nezval would return home leaving his friend in hospital, uncertain as to whether he would live or die. Štyrský survived this crisis, but it would be a full year before he was well enough to paint again. As it turned out the episode presaged his premature death in 1942. A chance meeting that same evening had a more immediately fatal outcome. "After dinner," Nezval relates, "we walked down the Boulevard Montparnasse" en route to Man Ray's. "When we got to the Closerie des lilas café Toyen pointed out to me that Ilya Ehrenburg was leaving the café and about to cross the street." The Soviet writer, whom Devětsil had proudly claimed as a collaborator back in 1922, was at the time the Paris correspondent for *Izvestia*. He had publicly accused the surrealists the previous year of "spending their inheritances or their wives' dowries" and being "too busy studying pederasty and dreams" to do an honest day's work.[64]

> "Where is he?" demanded Breton. "I've never seen him."
> "I'm going to settle accounts with you, Sir," he said, stopping Ehrenburg in the middle of the street.
> "Who are you, Sir?" asked Ehrenburg.
> "I am André Breton."
> "Who are you, Sir?"
> André Breton repeated his name several times, each time linking it with one of the insults with which Ehrenburg had dignified him in his lying pamphlet against surrealism. Each of these introductions was followed by slaps. Then Benjamin Péret attended to his own account with the journalist. Ehrenburg didn't defend himself. He stood protecting his face with his hands, and when my friends had finished with him he said: "That wasn't a good thing to do" [*Není dobře, že jste to udělali*].[65]

It probably wasn't. The aim of Nezval's visit to Paris, as he makes clear, was to spend more time with Breton and Éluard and renew "the magic that had never deserted us throughout all the days of their stay in Prague," but the pretext for his presence in the city was an invitation (from André Gide, Romain Rolland, Henri Barbusse, and André Malraux) to serve as the Czech delegate at the First International Congress of Writers for the Defense of Culture—a communist-sponsored event in which, among a galaxy of literary stars, E. M.

Forster, Aldous Huxley, Leon Feuchtwangler, Bertolt Brecht, Robert Musil, Max Brod, and H. G. Wells all participated. It was a gathering Nezval anticipated, he says, "with reluctance"; only the presence of the poet René Crevel in the organizing committee gave him any hope that the surrealist viewpoint would be adequately represented.[66] Though Crevel's relations with Breton were by this time very strained, he had used his position to ensure that the surrealist leader was given an invitation to speak. The committee's other members included Louis Aragon and Tristan Tzara (who had also by then joined the PCF), as well as Ehrenburg himself. The communists had a clear agenda, which was to enforce the socialist-realist doctrine promulgated in the Soviet Union by Andrei Zhdanov the year before. The punch-up on the Boulevard Montparnasse gave them the perfect opportunity to exclude the surrealists from the discussion. Faced with the threat of a Soviet walkout, the committee withdrew Breton's invitation. Crevel made desperate attempts over that weekend to thrash out a compromise, but neither Breton nor Ehrenburg would back down. On the night of Tuesday, June 18, René closed his windows and turned on his gas oven. A note was found on his body the next morning: "Please cremate me. Disgust."[67]

While Crevel may have had other reasons for taking his own life—for one thing, he had just learned that his tuberculosis was beyond cure—there can be little doubt that he was an early casualty of the choice of abdications Breton had spelled out three months earlier in his lecture to the Left Front in Prague. His suicide cast a long shadow over the congress, but Nezval had his own particular cross to bear. During the surrealists' get-together the previous evening—the same evening Vítězslav wound up partying *aux belles poules*—Crevel had repeatedly telephoned Paul Éluard. The two men were close; they had shared much time in the Swiss sanatoria where Paul so fondly remembered Gala "naked in the mountains with Crevel and me." Worried about his friend's state of mind, Paul urged Nezval to call René the next morning. Wary because of Crevel's estrangement from Breton and hesitant to speak on the phone in his bad French to someone he hadn't met, Vítězslav neglected to do so. Better, he thought, to wait for Éluard to introduce them, and for that there would be time enough "tomorrow, the next day, whenever."[68] He was left bitterly regretting what might have been:

> Again I saw Éluard's sad expression, when he emphasized
> his wish that I telephone Crevel on Tuesday morning. . . . I
> saw the perspectives that could have arisen from my meet-
> ing with Crevel, I saw, however absurd it might seem, what

great consolation and support I could have been able to give with a few words to a man who certainly did not suffer only from his wrecked health but also from the misunderstanding that had for some time divided him from his friends.[69]

In the magic capital, Nezval could have told Crevel, relations between surrealists and communists were very much better than they were in Paris—indeed, Crevel's *Les pieds dans le plat* (*Putting My Foot in It*, 1933) was the object of serious debate in the KSČ press.[70]

In deference to Crevel's memory the organizing committee eventually permitted Breton's address to be delivered so long as it was read by somebody else.[71] It was already past midnight when Paul Éluard was given the floor. Almost all the panelists had by then gone home except Tzara and Aragon. During the congress, Nezval tells us, Louis had not been able to keep his eyes from wandering to Breton's face at the back of the hall, "as if he was pulled, as if he was hypnotized." "Sleepwalker," said Breton with a smile.[72] Paul was informed that the room was booked only till 12:30 and the lights might go out anytime. "He lectured to a half-empty hall," relates Nezval. "The speech was interrupted several times by whistling. Some people up in the gallery applauded certain sentences. When the lecture finished Michal Kolcov came up to the podium and said to me: 'Condolences. The surrealists are Trotskyists.'" The Soviet writer later commented that "the Czech poet Nezval, bewitched by the lunacies of the surrealist kindergarten, has joined Breton's band, which flirts with the Trotskyists and other enemies of the Soviet Union."[73] Nezval himself was never called to the microphone, despite his status as the only delegate from Czechoslovakia and repeated assurances that he would be allowed to give the lecture he had prepared for the event (which Benjamin Péret had helped him translate into French). The text is reproduced in full in *Gît-le-Coeur Street*; it is a passionate defense of the compatibility of surrealism and communism. Crevel would certainly have been cheered at its contents, for Nezval quotes the KSČ journalist Záviš Kalandra's review of *Communicating Vessels* in *Doba* at length.[74] At the end of the final session, at Breton's urging, Nezval rushed to the podium to protest "that I, who was invited, wasn't granted a word. . . . I am aware that this occurred only because of the favorable stance I have adopted toward surrealism in my speech. I regard this as cowardice on the part of the congress." "As soon as I had uttered these words," he goes on, "Louis Aragon came up to me and laconically said: 'The congress is finished!'"[75] Reporting these events in *Sur-*

realismus the following February, Nezval tartly observed: "the defense of culture is first and foremost the defense of freedom of speech."[76]

The Time When the Surrealists Were Right, the pamphlet in which, as we saw earlier, the Paris surrealist group finally broke with "the present regime of Soviet Russia and the all-powerful head under whom this regime is turning into the very negation of what it should be,"[77] was a direct response to these events. Nezval was present at the June 2 meeting in Maurice Heine's house at which the text was agreed. If Breton and Éluard had left Prague three months previously believing they had found the gate to Moscow, Nezval—who, we should perhaps remind ourselves at this point, was a longtime KSČ member—left Paris knowing that gate had now been slammed firmly shut. He said his goodbyes to André and Jacqueline, Paul and Nusch (who brought him a parting bouquet of roses), Tanguy, and "dear Benjamin Péret" on the platform at the Gare de l'Est on July 5. His reunion with Breton and Éluard had been as filled with magic as he had hoped, but he went home full of forebodings. "Nothing is sadder than to part with mortals," he reflects, "if a person is himself predestined for death. Some slight thing may result in our never meeting again. Some trifling mistake may put between us, standing here, embraced in friendship, a wall as thick as eternity. Some trifling mistake, some insignificant circumstance, may bring it about that we never again form a magical constellation with our embracing eyes."[78]

Back in Prague Nezval found himself firmly impaled on the horns of Breton's choice of abdications. He was haunted by the memory of another chance Parisian encounter:

> A few weeks later, when we obtained the manuscript of *The Time When the Surrealists Were Right* from Paris, and when I went through days and hours of unutterable uncertainty over what standpoint we should take toward it I kept remembering the pont du Carrousel, where Breton was crossing from the *right* bank to the *left* while my friends and I were going in the opposite direction—and taking this as a symbol in those days of uncertainty I mentally regretted that we did not go along with Breton then onto the *left* bank. After the surrealists' manifesto came out I regretted that the Czech surrealist group had not gone along with it in exactly the same way.[79]

Nezval, Štyrský, Toyen, and Brouk were in favor of signing the French surrealists' declaration, Teige and Biebl against. Several members of the group

were out of town and could not be consulted. At Toyen's suggestion it was finally agreed that the group would neither sign the manifesto collectively nor as individuals, since "the Paris group was particular about obtaining the unanimous agreement of the *whole* Czechoslovak Surrealist Group and in no way the individual signatures of several of its members."[80] Ironically, it would in the end be Nezval who crossed to the Stalinist right bank while Teige accompanied Breton to the Trotskyist left, taking the rest of the group with him. What else should we expect from the mysterious auguries of *hasard objectif*?

In January 1936 an article appeared in the Soviet daily *Pravda* attacking Shostakovich's opera *Lady Macbeth of Mtsensk*. The ensuing campaign against "bourgeois formalism" would eventually engulf Isaak Babel, Sergei Eisenstein, Osip Mandelstam, Vsevolod Meyerhold, and Boris Pasternak among many others. The first Moscow trial concluded that August with the execution of Lenin's old comrades Kamenev and Zinoviev. Teige publicly questioned the verdicts, repeatedly describing them as a "tragedy,"[81] but Nezval remained silent. The following January Teige publicly defended André Gide's recently published *Return from the Soviet Union*, which had consternated the European left with its criticisms of the USSR, at a debate organized by *Přítomnost*. Gide's reportage, he argued, was "a book of *unblinkered* love and *critical* friendship," "inspired by a deep and sincere sympathy for the world's first workers' state and for the struggle and aims of the Soviet and western proletariat." He refused to be cowed by the insinuation that any criticism of the Soviet Union abetted the forces of reaction. The consequences of suppressing "comradely and friendly" criticism, he maintained, were much worse, especially when the methods of suppression were becoming indistinguishable from those of the fascist states themselves. "An atmosphere of free criticism safeguards against bureaucratization, corruption, superficiality, and officialization [*zofíciálnění*]," he warned, "just as silencing of criticism and encouragement for uncritical eulogies leads to passivity and comas ... to claim that criticism and discussion weaken the strength and authority of the [socialist] movement would truly be a repulsively police standpoint."[82]

Such a "police standpoint" was well exemplified by S. K. Neumann's tract *Anti-Gide, nebo optimismus bez pověr a ilusi* (Anti-Gide, or Optimism without Myths or Illusions), published in May 1937. The veteran progressive defends Soviet laws against homosexuality and abortion and portrays the Moscow trials as "the Soviet proletariat ridding itself of saboteurs."[83] Forgetting—or perhaps remembering—his own short-lived expulsion from the KSČ a decade earlier, Neumann reserves his most demagogic insults for

"petty-bourgeois 'intellectuals,'" deriding "bourgeois 'isms,'" "little modernist games," and above all "the noisy Teigeism [*halasná Teigovština—halasná* being a pun on the name of the poet František Halas] that for several years has worked its conjuring tricks among us with Marxist quotations."[84] "The socialist revolution," he sneers, "has nothing in common with today's aesthetic 'revolutions' in the intellectuals' teacup."[85] His championing of "an assertive strong Czech branch of contemporary modern European art" long ago forgotten, he launched an equally low polemic in *Tvorba* titled "Today's Mánes" (*Dnešní Mánes*), in which he ridiculed Emil Filla's "cruel deformation of the human body," Václav Špála's "postimpressionist artistic wandering," and Štyrský and Toyen's use of "sexually pathological literature and erotic photography."[86] Adolf Hoffmeister portrayed him, pipe in mouth, rising triumphant amid the severed heads of his enemies; since Hoffmeister was himself a loyal KSČ member it can only be coincidence that the caricaturist had used the same motif four years earlier in a cartoon of Adolf Hitler titled "Skulls of the Week."[87] Or maybe not. Soviet censors meantime removed Štyrský and Toyen's paintings from an official exhibit of Czechoslovak art in Moscow in October 1937 along with works by Špála, Filla, and other pillars of the Czech modern art establishment. All of Max Švabinský's pictures, which were not by any stretch of the imagination formalist, were excised from the same show on grounds of their "immorality."[88] Švabinský of course did do nudes, in spades.

Introducing the catalogue of another Štyrský and Toyen exhibition at Topič's Salon in January 1938, Teige replied to *Anti-Gide* at length. He makes an eloquent case for "an art that renounces a priori subjects and realistic description of natural models in order to express through colors, forms or words perceptions of the internal world, to come close to the profound and hidden reality of psychic life"—something Neumann would have had little quarrel with as the author of "Open Windows" and editor of *Červen*. But what mattered more, in the circumstances of the time, was Teige's equation of "the wave of terror aimed against those works which are called 'degenerate art' in Germany and 'monstrous formalism' in the Soviet Union." He no longer saw any distinction between "the crusade which was simultaneously proclaimed against independent art and the international avant-garde in Berlin and Moscow, in which the *Degenerate Art* exhibition was staged in Munich with howling rhetorical ballyhoo and a success that flustered the organizers, while left front artists in Russian art were comprehensively purged from the Tretjakov Gallery in Moscow and the most significant forum for scenic poetry, Vsevolod Meyerhold's theater, was sacrificed to the thoughtlessness of

the cultural reaction."[89] Whatever his private doubts about Soviet cultural policy, Nezval found such a public equation of totalitarianisms unthinkable. "If Karel Teige was able . . . to toss Berlin and Moscow into one basket," he explained to an audience of communist students, "this testifies not only to a moral, but also—and above all—to an intellectual mistake."[90]

On 9 March 1938 Nezval telephoned *Haló-Noviny* to report that the Czechoslovak Surrealist Group had been "dissolved." Things had come to a head in the Prague wine bar U locha došlo two days earlier. Nezval had been out of touch with the rest of the group for several months when he showed up at one of their gatherings in a fighting mood. Teige tells the story in *Surrealismus proti proudu* (Surrealism against the Current, 1938):

> In the presence of five members of the group and several close friends Nezval initiated a debate in which he said that it is necessary to endorse even such actions of the Soviet regime as the death sentences in the Moscow trials or the closure of Meyerhold's theater, which, he asserted, is a cover for espionage (!!!). He branded the scientific group in which several of our friends work as suspect, hiding something internationally Jewish [*něco mezinárodně židovského*].—Nezval made chauvinist and anti-Semitic pronouncements without any inhibitions, especially in regard to one of our friends who was not present, who would not pass the test of the Aryan paragraph [in the Nuremberg Laws]. . . . His speech, which it might be possible to consider as delirious were it not for clear signs of conscious intention, closed with abusive attacks on E. F. Burian, Bohuslav Brouk, and Jindřich Štyrský, in words to which Štyrský, owing to the heat of the debate, was unable to give a "merely theoretical" answer.[91]

The absent Jewish friend to whom Teige refers was Roman Jakobson, whom we last encountered cavorting in Jiří Kroha's swimming pool in Brno with Nezval and Teige back in 1931.

Haló-Noviny announced the Czechoslovak Surrealist Group's demise on March 11. The news was welcomed not only in the communist press but also by the fascist *Národní výzva* (National Call), which congratulated Nezval on waking his fellow "erotomaniacs" from "their lethargic, ecstatic, and surrealist dreams" with the words "Be sure, poet of the Night, this will not damage Czechoslovak culture one iota. Accept, Maestro, our most heartfelt thanks!"[92]

Julius Fučík was no less grateful for "Nezval's explosive initiative," albeit for different reasons—or maybe they weren't. "Nezval's action," he wrote in *Tvorba*, "resolutely helps toward the liquidation of a fifth column among the intelligentsia."[93] Denying that the poet had any right to dissolve the group, the remaining members met on March 14 and agreed to carry on their activities without their self-styled founder and leader. The minutes of the meeting list the continuing members as Teige, Štyrský, Toyen, Biebl, Brouk, Honzl, and Ježek and name Jakobson, Jan Mukařovský, Laco Novomeský, Záviš Kalandra, František Halas, Jindřich Hořejší, E. F. Burian, and Vincenc Kramář as collaborators.[94] Jindřich Heisler joined the group sometime that same spring. Nezval found himself in a minority of one. That did not stop him from trying to solicit support from the Paris surrealists, but Breton sided with the majority.[95] Two months later Teige published *Surrealism against the Current*. Subtitled "The Surrealist Group Replies to Vítězslav Nezval, J. Fučík, Kurt Konrad, St. K. Neumann, J. Rybák, L. Štoll and Others"—which is to say, the KSČ literati—it is a Czech counterpart of *The Time When the Surrealists Were Right*. The wheel had come full circle. The meeting on the pont du Carrousel had indeed proved prophetic, though not quite in the way that Nezval would have hoped. But this is Prague, the magic capital of old Europe, where everything is transmutable into everything else.

It is easy, in retrospect, to see Teige as the white knight of this saga and Nezval as its renegade villain, but things were not quite so clear-cut at the time. A good part of Teige's distaste for socialist realism stemmed from the modernist aesthetic snobbery that had led him to dismiss Alois Jirásek, K. V. Rais, Svatopluk Čech, and other popular Czech writers back in 1922 as "commonplace kitsch, repugnant and sentimental." His assertion in *Surrealism against the Current* that there is "an aesthetic affinity across different political flags that mutually links socialist realism, populism, ruralism, and Nazi realism" would have done the young Clement Greenberg proud.[96] This is in no way to downplay his moral repugnance at the Moscow trials. Conversely, many commentators have been content to assert that "by 1938, Nezval . . . had become a voice of Czech nationalism"[97] without attempting to explain how or why. Certainly some of Nezval's work, like the poem on the death of Karel Čapek quoted earlier (or indeed much of *Prague Pedestrian*) had taken a patriotic turn; *Surrealism against the Current* pillories his "three sad sonnets which were printed a few short hours after the death of the President-Liberator, but obviously written while he still lived."[98] But was this turn so strange, or so reprehensible, in the circumstances of the late 1930s? As Milena Jesenská reminded the readers of *Přítomnost*, one does not have to be a na-

tionalist to be concerned for the survival of one's nation. Nezval had done as much as anybody earlier in the decade to defend the independence of the artistic imagination against the self-censoring claims of political engagement. But by 1938, on the eve of Munich, he had come to believe that there were more urgent priorities at stake. Having made his choice of abdications he then loyally followed the party line, keeping whatever misgivings he might have had about the Soviet Union to himself.

When Nezval visited Paris in July 1938, once again as a delegate to a Congress of Writers in Defense of Culture, he did not look up the friends with whom his eyes had locked in a magical constellation at the Gare de l'Est three years earlier. He instead hung out with Tristan Tzara and Louis Aragon—and Paul Éluard, who was also about to jump the surrealist ship.[99] In this case events in the magic capital prefigured developments in *la ville-lumière*. *L'affair Aragon* had a surreal replay, only with the protagonists' roles reversed. Though Éluard and Breton had had their differences in the past (notably over the surrealists' "trial" of Salvador Dalí in 1934 for "counterrevolutionary acts tending to glorify Nazi fascism"),[100] Paul had acted as Breton's loyal lieutenant through the purges of the group in 1929, and we have seen his outraged reaction to Aragon's defection to the PCF. But as the world slipped toward the abyss he found himself increasingly at odds with his old friend. The issue, once again, was that irksome choice of abdications. In February 1937 Paul wrote Gala that Breton was "very involved with the stories of the Moscow Trials. Not me."[101] The following year, while Breton was penning manifestos in Mexico with Leon Trotsky, Éluard published a poem titled "Les Vainquers d'hier périront" (Yesterday's Victors Will Perish) in *Commune*, a PCF magazine edited by Louis Aragon. For Breton this was the last straw. "I have no need to tell you," he wrote Paul on 14 June, "how painful it was for me to discover a poem of yours in . . . the organ of these dogs. Let me add that it seems impossible, even if you are not wholly in political agreement with me, *that you lend your support to as flagrant an enterprise of falsification of the truth*."[102] He might have reminded Éluard, though he did not, that all the water in the sea cannot wash away a stain of intellectual blood.

The two men met on September 1 but were unable to resolve their differences. Over the next few weeks they disentangled the ties that had bound them for two decades. They sorted out the return of the books they had lent one another by letters of October 10 (André to Paul) and 12 (Paul to André). Éluard ends this last letter by asking Breton "to remove my name from the editorial board of *Minotaure*, which would have been the last evidence of our common understanding." He adds: "And to believe, in spite of everything,

that I shall never forget what you have been and what you remain for me."[103]
"At least acknowledge," Breton haughtily replied, "that for months and
months I've done everything in my power to dispel the evil curse threatening
our relations, and to reduce the most profound divergences that were coming
between us." But there were limits to friendship:

> I resigned myself to our separation only when I was certain
> that this current could no longer be overcome and when I
> felt myself faced by this dilemma: either separate myself
> from you, or have to renounce expressing my thoughts on
> that which constitutes, with fascism, the principal disgrace
> of this age. . . . For me it was a question of the very meaning
> of surrealism and of my life.[104]

Then the gloves came off. Demanding that "Éluard . . . officially, publicly be
branded an enemy," Breton urged his fellow surrealists to "commit them-
selves to sabotaging Éluard's poetry by any means at their disposal."[105] Dis-
gusted, Max Ernst and Man Ray followed Paul out of the group.

Seventy years later Milan Kundera penned a brief meditation on the
theme of "Enmity and Friendship." We would not be wrong to detect the lin-
gering influence of his Bohemian upbringing; he begins, after all, with a rem-
iniscence of a quarrel he once had with a Czech friend over Bohumil Hrabal,
whose "profoundly apolitical . . . stance mocked a world where ideologies ran
riot." Kundera recalls three long conversations he had with Aragon in the lat-
ter's apartment in the rue de Varennes in the fall of 1968, during which Louis
spoke repeatedly of his friendship with Breton (who had died two years be-
fore). Seven years later, by which time Kundera was living in exile in *la ville-
lumière* himself, the Czech novelist was introduced to Aimé Césaire in the
atelier of Wilfredo Lam. Kundera had first encountered Césaire's poetry
after the war, back in Prague.

> Aimé Césaire, young, vivacious, charming, barraged me
> with questions: the very first one: "Kundera, did you know
> Nezval?" "Yes, of course. But you—how do you know
> him?" No, he had not known Nezval, but André Breton
> had talked a lot about him. According to my own precon-
> ceived notions, I would have thought that Breton, with his
> reputation as an intransigent man, could only have spoken
> ill of Vítězslav Nezval, who some years earlier had broken
> with the Czech Surrealists, choosing instead like Aragon to

follow the dictates of the Party. And yet Césaire said again that when Breton was in Martinique in 1940, he spoke lovingly of Nezval. And I found that moving. All the more because, I remember well, Nezval too always spoke lovingly of Breton.[106]

It is not entirely irrelevant to record that in the midst of these quarrels between old friends Breton was called up as a medical auxiliary.[107] What got him drafted was the Munich crisis.

DIDIER DESROCHES

The relationship between Breton and Jacqueline began to go downhill after Aube's birth, making the recollection of their brief period of mad love, when the mermaid was attired only in "the water's whole adorable *négligée*,"[108] all the more poignant. Éluard informed Gala in September 1936, just eighteen months after the surrealists' Prague trip (and still six months before *L'amour fou* was published), that "Jacqueline has left Breton, I think for good," although on that occasion the lovers reconciled.[109] It may be that as Mary Ann Caws (who knew Lamba well) says, "This was not, or so it seemed to me, a love that had ever diminished. She had not wanted to be just Madame André Breton."[110] Taking Aube with her Jacqueline finally did leave André in 1942 for the American sculptor David Hare in New York, where the Bretons had fled Vichy France on a ship from Marseille. Their traveling companions included the writer Victor Serge and the anthropologist Claude Lévi-Strauss.[111] Hare was editor of *VVV*, a transatlantic successor to *Minotaure* whose editorial advisors were Breton, Ernst, and Marcel Duchamp, as well as a contributor to the exhibition *First Papers of Surrealism,* whose interior spaces Duchamp wrapped with a mile of string like a gigantic spider's web. As Duchamp saw it this was the moment when the American avant-garde was born: "They admit it. Everyone accepts the fact of Breton's influence."[112] *First Papers* opened a month after Peggy Guggenheim's Art of This Century gallery; both heralded New York's displacement of Paris as the capital of modern art, a move that cleared the ground for history to be rewritten in a manner more attuned to New World dreams.

Accompanied by his Chilean-born soon-to-be third wife, Elisa Claro, "the inconsolable widower," as Breton described himself, retreated to the wilds of the Gaspé Peninsular in Quebec in 1944 to get over his loss.[113] There he wrote *Arcane 17 (Arcanum 17),* which stands beside *Nadja, Communicating Vessels,* and *Mad Love* among his greatest prose works. Ravished by the beauty

of Canadian nature, he had a sudden vision of "the tortured heart of Old Europe feeding the long trails of spilled blood. Somber Europe, just for a moment so far away."[114] "Even while enjoying the present moment as much as possible," he confesses, "I can't overcome the worry penetrating the depths of my soul."

> My privileged position, at this very instant, reinforces in me, by contrast, my awareness of the partiality of the fate which dooms so many over there to terror, to hatred, to slaughter, to famine. This period is so harsh that one can hardly declare these things, ashamed of looking as though one wants to parade one's lovely sentiments. One of the worse effects of the ethics of war erupts when, truly proscribing these sentiments as soft, it succeeds in making them appear suspect, or at least seriously out of place. The state of mind that results from this will become more defensive than ever on the day when it's reported that the Allied armies have reached the gates of Paris.[115]

He was right. In retrospect *Arcane 17* might be seen as the most postmodern of Breton's works, above all in its "perception of the intricate relationships that create the cohesion of the universe . . . and the necessity, in fact, for humankind, deprived of its belief in anthropocentrism, to seek the solidarity of its planet."[116] But the pacific message of the book was hopelessly at odds with the stridency of its times. Along with reflections on love, war, Elisa, *liberté*, the majesty of the Percé Rock, the writing of French history, the myth of Melusina, and the "black god" Osiris, the dense (and often achingly beautiful) prose restates the claims of magical thought as a means of transcending the limitations of scientific rationality—the same science and the same rationality that would soon enough be leaving their signature mushroom cloud over Hiroshima and Nagasaki. Breton is not the only twentieth-century thinker in whom the experience of modern warfare has strengthened skepticism regarding the limits of reason. The sociologist Max Weber was assuredly neither a mystic nor a surrealist, but he bluntly told an audience of students at Munich University in 1918 that "Science is meaningless because it gives no answer to our question, the only question important to us: 'What shall we do and how shall we live?'"[117] Ludwig Wittgenstein, who wrote his *Tractatus Logico-Philosophicus* in his head in a World War I prisoner-of-war camp, was also convinced that "even if *all possible* scientific questions be answered, the problems of life have still not been touched at all."[118]

A less expected feature of *Arcane 17*, at least for those used to equating surrealism with misogyny, is its unqualified feminism—albeit that this is not the kind of feminism to which *we* are accustomed. Breton's postwar vision of redemption is incarnated in the image from which the book takes its title: the seventeenth card in the Major Arcana of the Tarot, which depicts a naked woman pouring water from two urns, one into a pool, the other onto dry land, a star above her head. Variously known as The Star, The Daughter of the Firmament, and The Dweller between the Waters, the card's divinatory meanings for fortune-tellers include hope and renewal, inspiration, and protection.[119] On this occasion I shall let the poet speak in his own words and at length, for this is a remarkable passage both for its author and its time:

> This crisis is so severe that I, myself, see only one solution: the time has come to value the ideas of woman at the expense of those of man, whose bankruptcy is coming to pass fairly tumultuously today. It is artists, in particular, who must take the responsibility, if only to protest against this scandalous state of affairs, to maximize everything that stands out in the feminine world view in contrast to the masculine, to build only on woman's resources, to exalt, or even better to appropriate to the point of jealously making it one's own, all that distinguishes her from man in terms of modes of appreciation and volition. If the truth be told, this direction I'd like art to take is not new; for quite some time art has implicitly complied with it in great measure and the later we move into the modern period, the more we can say that this predilection has become pronounced, that it tends to monopolize. Rémy de Gourmant will be paid back for his insult to Rimbaud: "A girl's temperament," said he. Today, a judgment of this sort shows us the measure of he who made it: it tells us all we need to build a case against the male type of intelligence at the end of the nineteenth century. . . . Let art resolutely yield the passing lane to the supposedly "irrational" feminine, let it fiercely make enemies of all that which, having the effrontery to present itself as sure and solid, bears in reality the mark of that masculine intransigence which, in the field of human relations at the international level, shows well enough today what it

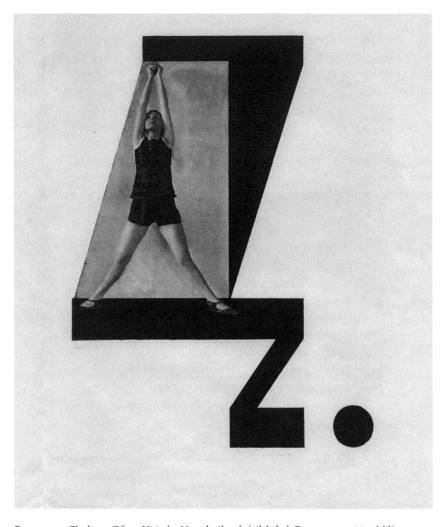

FIGURE 7.4. The letter *Z* from Vítězslav Nezval, *Abeceda* (*Alphabet*). Dance composition Milča Mayerová; typographic design Karel Teige. Mayerová's pose invokes the last line of the poem: "Let's zig-zag up the Eiffel Tower!" Prague: Otto, 1926. Archive of Jindřich Toman. Courtsey of Olga Hilmerová, © Karel Teige - heirs c/o DILIA.

is capable of.... Those of us in the arts must pronounce ourselves unequivocally against man and for woman, bring man down from a position of power which, it has been sufficiently demonstrated, he has misused, restore this power to the hands of woman, dismiss all of man's pleas so long as

woman has not yet succeeded in taking back her fair share
of that power, not only in art but in life.[120]

Maybe Breton was just intoxicated with his latest love, but still. "Who will
give the living scepter back to the child-woman?" he asks. His concept of the
femme-enfant has attracted abundant criticism for its supposed infantiliza-
tion of the female sex, but it is grown-up, civilized, rational "Man" who
comes off much the worse in Breton's comparison:

> Who will discover the method in her reactions, still un-
> known even to her, in her wishes so hastily draped with the
> veil of capriciousness? For a long time he'll have to study
> her as she looks in the mirror and to begin with, he'll have
> to reject all the types of reasoning which men are so shab-
> bily proud of, which they're so miserably duped by, make a
> clean slate of the principles which man's psychology has
> been so egotistically built upon, *which have absolutely no
> validity for woman*, in order to advise woman's psychology
> in its trials with its predecessor, with the ultimate responsi-
> bility of reconciling them. I choose the child-woman not in
> order to oppose her to other women, but because it seems
> to me that in her and her alone exists in a state of absolute
> transparency the *other* prism of vision which they obsti-
> nately refuse to take into account, because it obeys very dif-
> ferent laws whose disclosure male despotism must try to
> prevent at all costs.[121]

Jacqueline might have smiled at the gulf between André's theory and prac-
tice, but that does not entirely dispose of his argument. Besides, I hear a dis-
tant echo of Milena Jesenská, who had plenty of time for women and little
time for "that so-called women's emancipation." Milena's Granny was no
femme-enfant, but she sure "sends fissures through the best organized systems
because nothing has been able to subdue or encompass her."[122]

Paul Éluard had a more manly war. He chose to remain in Europe when
Breton and many others fled, putting his literary talents at the service of the
Resistance. He worked with a clandestine organization for writers in North-
ern France and was a frequent contributor to *Les Lettres françaises*, an under-
ground newspaper whose masthead read "Founder: Jacques Decour, shot by
the Germans." "Liberté," the opening poem in Éluard's illegally published
1942 collection *Poésie et Vérité* (*Poetry and Truth*), was dropped by Royal Air

Force pilots over France in its thousands and read by Allied troops in North Africa as they prepared to invade Italy. That same year Paul and Nusch were forced into hiding. In November 1943 they sought refuge in a psychiatric hospital in Saint-Alban-sur-Limagnole in the Lozère. Jacques Matarasso's photograph of Paul sleeping in the hospital grounds hauntingly prefigures the beautiful boy in Lee Miller's "German Guard, Dachau." The subjects of the two photographs fought on opposite sides, as Éluard and Ernst had during that bombardment at Verdun in February 1917, but the lie of the body, the curve of the arm, the light on the side of the face are exactly the same—only reversed, as in a mirror.[123] It cannot, of course, be any more than coincidence.

E.L.T. Mesens and Roland Penrose published an English translation of *Poetry and Truth* (in a numbered edition of 500 copies) in London in 1944. Mindful, perhaps, of that house party at Lambe Creek when everyone shed their clothes and swapped their spouses to challenge that false and importunate reality that degrades man, the two surrealists were dismayed at the way Paul's poetry was being co-opted for the war effort. Whatever Éluard was fighting for it was not *la Patrie*. Mesens begins his preface with a reminder that "Paul Éluard . . . has been for many years, with André Breton, one of the leaders of the Surrealist movement." "Lately," he goes on, "critics in this country have described Éluard's poetry as 'patriotic'; the poems in this book can hardly be qualified as such. On the other hand, French nationalistic propaganda in allied territories has been using his poems in lectures and on the wireless and often, in one breath, quotes his name in the bewildering company of Claudel, Gide, Pierre Emmanuel, Aragon, etc. I should like to remind these propagandists that Éluard has written the following lines":

CRITIQUE OF POETRY

It is understood that I loathe the reign of the bourgeois
The reign of the cops and the priests
But I loathe still more the man who doesn't
Loathe all these forces
Like me.
I spit in the face of the man smaller than nature
Who doesn't prefer this Critique of Poetry
To all my poems.[124]

When Lee Miller entered Paris with the Allied troops on 25 August 1944 as a war photographer for *Vogue* she immediately searched out old friends.

Picasso remained Picasso, "careless, generous and voluble as always. He offered me his coffee, soap, and cigarettes—what there was of any of them." "Between laughter and tears and having my bottom pinched and my hair mussed" Lee looked at his new pictures "dated on all the Battle of Paris days," which had "stimulated him into an orgy of painting, singing at the top of his lungs during the whole performance."[125] It is an unforgettable image. She found Éluard talking on the telephone in the back room of a bookstore. "He didn't notice who had come into the gloomy little den and waved for silence. Then he noticed my uniform, and froze a little. He hadn't been on sitting terms with a 'soldier' for a very long time." His hands shook—more, according to Brassaï, than they used to.[126] "There was almost nothing to say to each other," Lee continues, "stupid things about how I'd traced him—idiotic remarks on the weather. . . . We went back to the address where the concierge had denied ever having heard of the Éluards—or any other occupants of the flat."

> Nusch was there, a thin, pale, grinning Nusch, with her funny Alsatian accent and her fuzzy hair and her beautiful profile. There wasn't much left of her. She was so thin and delicate that her elbows were larger than her arms, her pelvis bones made sharp twin mountains in her skirt which hung slack and her blouse couldn't disguise the traces of ill-health and privation. There was only her big broad grin, and her big broad teeth.

Nusch sat for Picasso during the war. Brassaï describes the portrait, painted in 1941, which later hung above the mantelpiece in the Éluards' home in La Chapelle, "one of the most desolate neighborhoods in Paris, among goods stations, warehouses, gasometers, pyramids of coal, coke and slag":

> Picasso painted this airy creature with all the gentleness, all the delicacy his brush is capable of, as if he had sought refuge from the terrible in the graceful. Nusch's bust, her frail adolescent's body, her delicate neck, her head with its rebellious hair, her eyes encircled by long lashes, her childlike mouth, the slight smile on her lips, wafted onto the canvas on a beam of light. Emerging from a pale gray background, Éluard's partner looks like a disincarnated, immaterial, being."[127]

He could almost be talking of Hans Bellmer's doll.

"None of us said anything that made any sense," Lee goes on, "partly from emotion and partly because the facts weren't very sensible":

> There they were, in one of the most beautiful flats in Paris, practically starving. The walls were hung with some of the most famous paintings in this city; there were *objets d'art* that were worth a fortune; but no food, no tobacco. They had been camping there after changing domicile eight times in six months. The owner had lent it to them along with his offices in another part of the city, and only this week Paul had lain in the eaves of the adjoining building while it was being searched.

"You can't possibly make sense," she goes on, "out of books of poems published in Monaco under false names; of clandestine reviews and papers which were shipped from occupied areas. What sense can you make out of Paul and Nusch being registered in an official 'loony-bin' as incurably insane, for six months, with the cooperation of a doctor we all know?"[128] Lee always did have a surrealist's eye—and a corresponding suspicion of too much sense-making. On reflection, perhaps *Vogue* was the most appropriate of all venues in which her wartime photographs could have appeared, "the grim skeletal corpses of Buchenwald ... separated by a few thicknesses of paper from delightful recipes to be prepared by beautiful women dressed in sumptuous gowns." "Being a Surrealist artist," continues Antony Penrose—Lee and Roland's son—"must be the only possible training to enable a person to retain their objectivity in the face of the total illogicality of War."[129] But Lee fell apart after the war ended, sinking into uncharted depths of drink and depression on her Sussex farm. One of her solaces as the improbable Lady Penrose—Roland was eventually knighted for his services to art—would be composing surrealist meals whose colorful dissonances rivaled those of Marinetti's *Futurist Cookbook*. Robert Desnos would likely have understood, had he been fortunate enough to survive.

"We were lucky to escape the Gestapo," Paul wrote Gala on 18 March 1945. It was his first letter to his ex-wife in over five years. "I don't know what to tell you about these five years ... as my taste for justice and gentleness hasn't changed, I suffered. The horror was almost always before our eyes.... I no longer know too well how to laugh."[130] Writing from Switzerland, where he was once again convalescing, in November 1946, he repeated: "I really don't know how to laugh as before." It is a striking admission of just what, as well as how much the war had taken out of him. It is difficult to imagine Éluard at this date sending dirty postcards to earnest young men in hopes that they

might keep their eyes on young women and put grand ideas in their proper place in the scale of things. "But I can smile for you," he added, "my little Gala forever, even from far away, even in these mountains that we both know so well." He confided to her the "great task" he had set himself, "to completely begin my poetic life again" under the pseudonym of Didier Desroches, a secret he had hitherto shared only with Nusch. Paul Éluard was a celebrity now, a status with which Eugène Grindel was not altogether at ease. He was tired, he said, of people buying his poems just for the sake of their signature. "I'll soon be sending you what Desroches will have published, his first published poetry, like at Clavadel."[131]

The same letter contained news of Breton, with whom Éluard had now not spoken for eight years. The surrealist leader returned to France on 25 May 1946. He was fifty years old. "From America," writes Jean Schuster, "he returned with splendors: agates from Gaspesia, Elisa, Hopi and Zuni kachinas, the complete works of Charles Fourier, Aube promised to *l'amour fou*, masks from the Pacific Northwest, the friendship of Claude Lévi-Strauss, Robert Lebel, and Georges Duthuit, the magic of his stay in the Antilles and his meetings with Aimé Césaire, Magloire Saint-Aude, Hyppolite."[132] Not just the passage of time but an Atlantic-sized gulf of wartime experiences now separated the two poets. One of the photographs Lee Miller took in Picasso's *atelier* in 1944 captures the changed atmosphere only too well. It is instructive to compare it with earlier anticipations of surrealist deaths to come: the group-shots in the *Abbreviated Dictionary of Surrealism*, for instance, or Ernst's *Rendezvous des amis*. Grouped in the picture are Lee Miller and Roland Penrose, both in uniform, Pablo Picasso, Paul and Nusch Éluard, and Louis Aragon and Elsa Triolet. Paul sits beside Elsa, their hands clasped, presumably in fraternal solidarity, though with Éluard one can never be too sure. Nobody is smiling any more.[133] Paul was by then a good deal less charitable toward the man who, along with Sade and Lautréamont, had once upon a time liberated his thought from itself. "M. Breton," he warned Gala, "has become fixed in a historic attitude, very much the exile—always and everywhere. Take care not to be too indulgent to his memory, for he never misses a chance to slander Dalí. It's not even painful to me any more to see Breton supported by the worst reactionaries. For myself," he added, "I am absolutely at the service of my party, which demands nothing unpleasant from me. On the contrary. I entirely approve of its politics."[134] Paul had rejoined the PCF in February 1942.

Man Ray returned to Paris with his new wife, Juliet Browner, in the fall of 1947. He found it outwardly unchanged "except here and there where the city seemed to be licking its wounds." They visited the Louvre, "grimy Mont-

FIGURE 7.5. Otakar Mrkvička, illustration for Jaroslav Seifert, *Samá láska* (Love Itself). Prague: Večernice, 1923.

martre topped by its phallic, sugar-loaf church, trying to look like a cathedral; and I took Juliet up the Eiffel Tower, which I had never visited during my twenty years in Paris." "A marked change was most evident," he relates, "in the relations of my former friends, both in and out of the Surrealist movement. The bickerings and dissensions of the old days had ended in a complete dissociation of interests." Aragon and Éluard "became engaged, as they say." So, among others, did Picasso, who had joined the PCF at Éluard's urging in 1944, and René Magritte, whose adherence to the Belgian Communist Party was announced in *Le Drapeau rouge* (Red Flag) in September 1945.[135] It was not an engagement of which Man much approved. He goes on:

> Having been most intimate with Éluard whom I found to be the most human and simple of the poets, I contacted him at once. During the Occupation I had received pamphlets in California, published and circulated in the underground resistance movement, containing his soul-stirring poems on liberty and love. The recent death of his wife, Nusch, had transformed him into a moody person, though now and then he put on a gay front, as in the old days. We never discussed politics although he intimated that he would continue to be a mouthpiece—that he was needed, and trying to work for a better world. Poor Paul, I thought, enmeshed in the cog-wheels of ruthless intrigue. Only a simple nature could have been so misled.[136]

Max Ernst waited another two years before venturing back to liberated Europe, also with a new wife in tow. "With Dorothea [Tanning] saw Paris once more—mixed feelings—Paris and its inhabitants slowly, painfully recovering from Nazi occupation, frustration and disorder," he records. He "was glad to greet his old friends," among them Georges Bataille. "Also Paul Éluard, in spite of some difficulties (the poet of freedom caught by a merciless discipline)."[137]

Nusch had died of a cerebral hemorrhage on 28 November 1946, just three days after Paul had written to Gala from Switzerland about his plans to rebuild his poetic life. It was utterly unexpected. "Just this morning she was in very good spirits. We talked a long time on the phone. We were supposed to have lunch together," a distraught Dora Maar told Brassaï later that day. "Éluard is in Switzerland. We sent him a telegram. Nusch was everything to him ... everything. His wife, his friend, his secretary, his guardian angel. A year ago, he told me: 'I can't imagine my life without Nusch. I can't conceive of

the idea of losing her. I could not get along without her.' It's a terrible blow for him."[138] "My pain has perhaps lessened, but the emptiness is now very great, within me and around me," Paul wrote Gala several months later. "Death, the feeling of death, occupies too large a place within me."[139] A year on, he was still asking his ex-wife to "forgive my tone. I received too great a blow. My life is empty."[140] He donated Picasso's portrait of Nusch to the Musée d'art moderne.

Didier Desroches made his debut in 1947 with a volume titled *Le Temps déborde* (*Time Overflows*). The pseudonym scarcely concealed its famous author's identity: the book was illustrated with photographs of Nusch by Dora Maar and Man Ray. Though (to my mind at least) these are some of the most moving love poems ever written, for Paul they marked less the rebuilding of his poetic life than "The Negation of Poetry" (as one of the poems in the cycle is called). Asterisks peremptorily break the flow of the verses:

*

Twenty-eighth of November, nineteen hundred and forty-six
*

We shall not grow old together
This is the day
Too much: time overflows.
*

My love so light takes on the heaviness of a torture. [141]
*

Some of the poems in *Time Overflows* were first published in *La Licorne* (The Unicorn), a magazine with which Roger Caillois was involved. "The journal had already gone to print when Nush [*sic*] died," he recalls. "[Éluard] asked us to cross out his name and replace it with a pseudonym, Didier Desroches. In the issue containing these poems, the name Paul Éluard is illegible. It's covered over by a large stroke of mourning."[142] Paul's last known letter to Gala, written on 21 February 1948, ends with the words "I don't think I can leave my home again, the absence of Nusch. Little Galotchka, how I'd like to see you again."[143]

Éluard was (in his own words) "brought back to life"[144] by the "resurrecting kisses" of Jacqueline Trutat, which he celebrated in *Le Corps mémorable* (*The Memorable Body*, 1948). His new love, as ever, fused the poetic with the carnal. "And the door of time opens between your legs" he writes, "The flower of summer nights at the lips of lightning / At the threshold of the landscape where the flower laughs and cries."[145] The next year he published *Une leçon de*

morale (*A Moral Lesson*), a poetic dialogue between good and evil, though
the two keep bewilderingly transmuting into one another. Near the end of
the collection Paul abandons his formal structuring device of alternations of
"On the side of evil" and "On the side of good" entirely, letting the polarities
mingle and miscegenate as they will. He prefaces the volume with a confes-
sion of uncertainty: "How many times have I changed the order of these
poems, making 'good' what was 'evil' and vice versa? Did day follow night or
night follow day. . . . My virtues, my failings, my optimism and my incompe-
tence become entangled; *I am only human*." "At the crossroads, at the turning
point," he goes on, "I saw a dead body, her corpse, my death. I learned to live
by it, to make it my first principle. No more frivolity. A proverbial voice
henceforth dictates to me: after sorrow, happiness remains a basic premise,
pessimism a vice."[146] Can happiness be made into a moral imperative? Paul
certainly tried. In these years, according to his biographer Raymond Jean, he
"chose to substitute for love of a single being a vaster sum of human frater-
nity, to pass 'from the horizon of one man to the horizon of all.'"[147] "I had
been absolutely happy and, suddenly, I lost *all* hope, except that of dying
quickly," Paul explained to his daughter Cécile in the fall of 1947. "Try then
not to judge me."[148]

Éluard would marry again for the third and last time in June 1951. It was a
"mature" union, Jean suggests, that was born as much out of politics as pas-
sion; Paul and Dominique met at a World Congress for Peace in Mexico.[149]
But try as Paul might it was Nusch's absence that lingered on in his poetry, an
ever-present absence that would not go away—

> Dead visible Nusch invisible and harder
> Than thirst and hunger to my exhausted body
> Mask of snow on the earth and under the earth
> Source of tears in the night, mask of the blind man
> My past dissolves I make way for silence . . . [150]

AM I NOT RIGHT, JAN HUS?

It may be mere coincidence but then again it may not. In December 1938—
three months after Munich and three months before the German invasion of
Czechoslovakia—Bohuslav Brouk asked Toyen to produce a wedding gift
for his brother Jaroslav and future sister-in-law Marie. The result was *Jedna-
dvacet* (Twenty-one), a hand-bound book containing twenty-one pen-and-
ink colored drawings.[151] It is a marital manual, of sorts, for an age that still
preferred to avert its eyes from such immodesties even as it was becoming in-

creasingly at ease with geometric squadrons of aircraft and spirals of smoke rising from burning villages into azure skies. The album opens with the dreaming girl we met in *Erotic Review*. She bows her head before a disembodied penis, a penis as big as she is, in her wedding veil; takes it tenderly into her mouth, still wearing the veil; nestles it between her naked breasts; dances on its head in a ballerina's tutu; tickles its tip with an elegant finger-nail; plays with herself while stroking it; and curls up beside it to sleep, using its head as a pillow. When the penis wilts the girl turns away, her eyes covered. It multiplies into chessmen that she idly manipulates while sprawling naked across the board; pokes its head through the bars of a bird-cage, beside which she is masturbating; provides a swing for her to straddle, dangling from a puppeteer's hand; and comes to rest between her delicately gloved hands, over which it limply dribbles, all passion spent. Lest the bride get bored with the ubiquitous phallus there are Sapphic distractions too. A double-headed dildo lies in wait beside a welcoming vulva; female lips caress a female nipple that has taken the place of the King of Hearts in a deck of cards. Two panels, hanging side-by-side as if in an anatomy lesson, display identical images, save that in the first a penis hovers over a vagina while in the second the vagina hovers over its own mirror-image, beside which is written the magical number "69."[152]

Twenty-one was a rare moment of humanity on the side of an abyss. Its unashamed *joie de vivre* stands in stark counterpoint to the necrophilic obscenities of the time, which came in many shapes and forms from Wandering Jews on Vinohradská Street to Neville Chamberlain's umbrella tidily furled on the dissection table of the Munich Agreement. Toyen's cycles *Střelnice* (The Shooting Range, 1940) and *Schovej se, válko!* (Hide Yourself, War!, 1944) are very different in mood. Not that one could ascribe them a singular *meaning*; this is not the black-and-white world of John Heartfield. As Karel Teige expressed it, "they guard their secrets and leave their magnetic impressiveness untouched." In *The Shooting Range*, he thinks, everything alludes to the devastations of war yet "only one motif—stakes with barbed wire—recalls those years of terror and massacres." The drawings are populated with objects from childhood, depicted with minute realism. This "strange still-life made out of junk and toys," he concludes, is "a *Desastres de la Guerra* of our age":

> Destroyed houses on a lawn built from a children's toy construction set, bombed out ruins of cities and children killed at play; the torn bodies of birds lying on the ground like shot down airplanes; broken dolls; a school girl, departing

somewhere behind the background horizon of the picture; funeral wreaths scattered along the ground around a rickety chair when Paris fell; a puppet theater on which a disembodied finger is suspended limply, plucked poultry set on the stage as at a market stand, slaughtered with their necks dangling down; flyers with sale prices implying that even on the slaughterhouse of history it is possible to do business and make profit; the curtain of a second theater pulled shut, and we don't know what drama will be performed there.... All these things, deteriorating and half-rotten, are pregnant with many and distant meanings. Toys from a children's paradise form scenery for today's historical tragedy and become the object of our alarm; the age of childhood, the lost paradise of humanity ruined in time's wild rage. The playful shooting into a fairground target is being transformed into the blood-ridden horror of world catastrophe.[153]

Toyen's wartime drawings were exhibited for the first time at Topič's Salon in 1945, and *The Shooting Range* was published in Prague the following year. By then the elegant Manka was preparing to turn her back on the magic capital for good. The fact that S. K. Neumann, who was by now in his seventies, was editing *Tvorba* cannot have given her much inducement to stay. Together with Jindřich Heisler, whom she had hidden in her apartment for much of the war—at considerable risk to her own life, since Heisler was Jewish and had gone into hiding when he received orders for his transport—she left for Paris in March 1947. The Czechoslovak Surrealist Group dissolved itself upon their departure.

"Pregnant with many and distant meanings" is a phrase that might equally well be applied to the remarkable series of collages on which Teige had himself been working since 1935. The Devětsil leader had produced pictorial poems during the 1920s and employed photomontage on many of his book covers—not to mention the "typo-photomontage" pages of *Alphabet*—but these late collages represented a new departure. Not only was the collage now an object in itself, freed of any illustrative subordination to the printed word. This was a deeply private project for this most public of intellectuals. Teige never attempted to exhibit or publish these works, showing them (or giving them as gifts) only to his closest friends. It is tempting to conclude that their very existence is testimony to the growing impossibility of reconciling the

personal and the political of which André Breton had so presciently warned in his lecture at Prague City Library. Teige made close to 400 collages between 1935 and his death in 1951,[154] an output that demands comparison with such giants of the genre as Max Ernst, Hannah Höch, or Josep Renau. There is little in these images to recall John Heartfield. Neither didactic nor allegorical, they are unfettered expressions of the pure imagination. But whether the mood is somber, menacing, playful or melancholic, the motif that repeats itself again and again is the naked female body, as often as not dissected and recombined.

Women's bodies (or parts thereof) cavort amid fields, hills, and mountains, frolic on seashores, dance in the Moscow metro, and float in constructivist space. They commandeer the stage of the National Theater, hang upside-down from the dome of Saint Nicholas's Church, and beckon from the diving board at the Barrandov Terraces. Vojtěch Lahoda thinks that "Collage #340" (1948), an amendment to Ladislav Hák's 1947 photograph "Periphery of Prague" in which a fragment of a female leg holds up a sign reading "PRAHA," transforms "entering Prague . . . into the lure of entering an erotic object."[155] Angelo Maria Ripellino might have agreed, but I find the image altogether more desolate. Critics differ over the politics of Teige's "violation, amputation, destruction and reorganization of [female body] parts," which Lahoda thinks gives the collages "a strange, almost masochistic erotic quality."[156] But for me the more interesting question is why the lucid, intelligent, and together Teige should have chosen to take up *this* artistic project, employing *this* visual language, at this stage in his life at all. It sits oddly with the constructivism that had been such a *Leitmotif* in his thinking in the 1920s and goes way beyond the lighthearted poetism that was supposed to balance it. Sometimes his images bring to mind Max Ernst, sometimes Hannah Höch, sometimes Georges Hugnet—or even René Magritte.[157] The strangest connection, though, may be with another lonesome experimenter on the other side of the modern world. The invitation for the first exhibition of the Japanese *photomonteuse* Toshiko Okanoue in Tokyo in 1953 began "Happy New Year! Miss Okanoue is not a painter; she is a young lady. Working by herself, she cuts up illustrated magazines to make collages that depict her very dreams. The resulting album is a contemporary version of Alice in Wonderland. Please come and see for yourself."[158] Okanoue could hardly have known of Teige's collages at that date, but the resemblances are uncanny.

Toyen and Heisler were among the artists exhibited in the first postwar international surrealist exhibition, which opened in Paris at the Galerie

Maeght on 7 July 1947. Organized by André Breton and Marcel Duchamp, *Surréalisme en 1947* (Surrealism in 1947) featured eighty-six artists from twenty-seven countries, "most of which," Breton was at pains to point out, "had yesterday formed coalitions against one another."[159] Some of the participants, like Arcimboldo, Blake, Henri Rousseau, and Hieronymus Bosch, were included on the basis of being "surrealists in spite of themselves," but many prewar surrealists also made their reappearance along with a raft of new recruits to the movement. Among the latter were artists from the United States, Canada, and defeated Japan as well as diverse parts of what would soon be reconfigured as the "Third World"—Argentina, Brazil, Chile, Cuba, Haiti, Mexico, Egypt.[160] Some familiar names from the 1938 *Exposition internationale du Surréalisme* were absent, notably Dalí, Picasso, and the recently excommunicated René Magritte. It was not just Magritte's joining the communist party that angered Breton but his authorship of "Le Surréalisme en plein soleil" (Surrealism in Full Sunlight), a manifesto issued in October 1946 in which the Belgian painter urged surrealists to give a sunnier cast to "our mental universe." "To create charm," he argued, "is a powerful means of opposing this mediocre and dismal *habitus*."[161]

Some have seen Magritte's new rose-tinted palette as reminiscent of Auguste Renoir. But it came perilously close, so far as Breton was concerned, to the kitsch that so disgusted Sabina, the counterpoint to the eternally put-upon Tereza in Milan Kundera's *Unbearable Lightness of Being*. Sabina is another who would rather walk by night than pretend she is walking *en plein soleil*. "Whenever she imagined the world of Soviet kitsch becoming a reality," Kundera explains, "she felt a shiver run down her back. She would unhesitatingly prefer life in a real Communist regime with all its persecution and meat queues. . . . In the world of the Communist ideal made real, in that world of grinning idiots, she would have nothing to say, she would die of horror within a week." She likely wouldn't have had much time for *Forrest Gump* either. Sabina is not a good girl. "In Part Three of this novel," Kundera goes on,

> I told the tale of Sabina standing half-naked with a bowler hat on her head and the fully dressed Tomas at her side. There is something I failed to mention at the time. While she was looking at herself in the mirror, excited by her self-denigration, she had a fantasy of Tomas seating her on the toilet in her bowler hat and watching her void her bowels. Suddenly her heart began to pound and, on the verge of

FIGURE 7.6. Toyen, plate from *Střelnice* (The Shooting Range), 1940. The Museum of Decorative Arts, Prague. © ADAGP, Paris, and DACS, London, 2012.

> fainting, she pulled Tomas down to the rug and immediately let out an orgasmic shout.

Pursuing the train of thought, a few pages later Kundera suggests "we can regard the gulag as a septic tank used by totalitarian kitsch to dispose of its refuse."[162] As ever the sublime and the sordid are inexplicably intertwined.

Vacuous sunshine was the last thing on offer in *Surrealism in 1947*. The installation at the Galerie Meaght was reminiscent of the darkened halls of the 1938 *Exposition internationale du Surréalisme*, albeit with more emphasis this time on the mystical than the erotic. During his wartime exile Breton had come to believe that the world was sorely in need of a new myth. The task of the exhibition, he wrote, was "merely to sketch the outline of what such a myth might be—a sort of mental 'parade' before the real show."[163] Instead of running the gauntlet of the mannequins of the rue Surréaliste the spectators were required to "face a cycle of ordeals."[164] The "successive stages of an INITIATION" began with twenty-one steps painted to look like the spines of books, each of which "corresponded in meaning to the 21 major arcana of the Tarot," and progressed by way of a "superstitions room" to a chamber filled with twelve octagons containing "pagan altars."[165] Heisler designed one of

the altars, Toyen another. Though the exhibition drew some forty thousand visitors—including many young people—and garnered a good deal of media attention, it was not to the intellectual taste of the times. *Lettres françaises*, whose editor was Louis Aragon, dismissed the show as "a rehash of old tricks, worn out from overuse,"[166] while Jean-Paul Sartre, the new toast of the Left Bank, wrote surrealism off as "a phenomenon from after the other war, like the Charleston and the yo-yo."[167] This time Georges Bataille was not among those who joined in the chorus of criticism. "Who today could deny the radiant power of surrealism?" he asked in a review of *Arcane 17* in July 1946.[168] The old enemy from within provided an essay for the *Surrealism in 1947* catalogue titled "The Absence of Myth." "Night is also a sun," he warned, "and the absence of myth is also a myth: the coldest, the purest, the only *true* myth."[169] Hans Bellmer, Benjamin Péret, Jindřich Heisler, and Aimé Césaire were among the other contributors to the volume, but it is better remembered today for Enrico Donati and Marcel Duchamp's cover, a facsimile of a female breast constructed out of latex, velvet, and lipstick labeled "Please Touch" (*prière de toucher*).

It was not only existentialists and surrealists-turned-communists like Aragon and Éluard that regarded Bretonian surrealism as irrelevant to the urgencies of the day. Outside the doors of the Maeght gallery a newly founded Belgian-based group calling themselves Revolutionary Surrealists distributed Christian Dotrement's tract *La Cause est entendue* (The Case Is Understood), which ended with the promise "Surrealism will be what it no longer is."[170] Dotrement and Noël Arnaud went on to produce a "patalogue" of the exhibition's catalogue titled *Surréalisme en 947* whose cover read "Prière de toucher 50 francs."[171] They had a point: only 999 numbered copies of Duchamp's tactile breast were produced (which nowadays sell for upward of $4,000 each); the masses had to be content with a black-and-white photographic reproduction.[172] One of the affiliates of the Revolutionary Surrealists was Skupina Ra (the Ra Group), a Prague- and Brno-based collective of writers (Ludvík Kundera, Zdeněk Lorenc), painters (Josef Istler, Bohdan Lacina, Václav Tikal, Václav Zykmund), and photographers (Miloš Koreček, Vilém Reichmann), which had been clandestinely active during the war. "Our relation to 'orthodox' surrealism (i.e., prewar surrealism)," the Ra manifesto explained, "could not be more critical. This is natural: the terrible years of cultural isolation during the Protectorate and the total break from foreign avant-gardes brought about this state of affairs." "There are three principal remaining members of the dissolved Prague group of Czechoslovak surrealists," they go on: "K. Teige, Toyen, J. Heisler. It goes without saying that we in

no way identify with them."[173] Though Ra were invited to participate in *Surrealism in 1947*, "the old Oedipal barriers" went up and they refused.[174] Lorenc and Istler attended the International Conference of Revolutionary Surrealists in Brussels in October 1948. The conference drew up an "International Declaration" that recognized "on the national plane ... the Communist Party as the only revolutionary force" and went on to "condemn surrealism, as it has been more or less identified with André Breton."[175] Noël Arnaud, who approvingly cited Louis Aragon's "important article ... 'Surrealism and the Revolutionary Future'" in his speech, denounced the "pseudo-surrealism of BRETON" as "magical and mystifying."[176]

Perhaps the most sustained assault came from Roger Vailland in his pamphlet *Le Surréalisme contre la Révolution* (Surrealism against the Revolution). The one-time Grand Jeu writer, who had also by then signed up for his party card, characterized surrealism as "a reaction of the intelligentsia of the petit-bourgeoisie and only them," a section of society "living in the margins of social conflicts." In its "golden age" between 1925 and 1930, he charged, surrealism "manifested itself much less through 'works' than the systematic practice of scandal ... *surrealist activity* essentially consisted in showing *universal derision*.... The surrealists were tempted by the communist battle like children are tempted by the heroic occupations (as they imagine them to be), by the *battles* of the sailor, the pilot, the engine-driver." But "the war and the occupation ... finally put every Frenchman in the *situation* of the worker who becomes a *scab* if he doesn't join the strike.... The margin progressively disappeared." Those surrealists "who had preserved through the derisory years the integrity which had been at the root of their first revolt" joined the Resistance. Breton, by contrast, "passed the most dramatic years of the war in the United States.... A *speaker* [the word is in English] on the radio, thousands of kilometers from occupied France, he was able to continue living in the *margin*," while "Picasso, Tzara, Éluard, Aragon, not to speak of others less renowned, joined the Communist Party." "Hopi dolls and surreal *keys* have no efficacy in a world in which we have conquered the atom," Vailland sneers: "What is derisory today is not only *La Révolution surréaliste* but also *Surréalisme au service de la révolution*; the revolution doesn't need surrealism, it needs coal, steel, no doubt atomic energy, and above all this virile energy which makes the scientists great, the leaders lucid, and the thinkers heroic who rise to the grandeur of their times." We could hardly be further from the feminism of *Arcane 17*. Or, come to that, from the dreamworld of Karel Teige's collages.

Yesterday's "principled" surrealists, Vailland pointedly adds, are now to be found "*elsewhere*: the ambassador of a People's Republic like Rystich, a gen-

eral like another Yugoslav poet, the director of a ministry like Hoffmeister, communist party militants like so many others."[177] He omits to mention that Adolf Hoffmeister, who was then working for (but not heading) Václav Kopecký's Ministry of Information, had also sat out much of the war in the United States. After Victorious February Devětsil's caricaturist became Czechoslovakia's ambassador to Paris. Adolf had loved *la ville-lumière* since he first set eyes on the Seine at eighteen and was not reticent in putting himself forward for the post. "I regard myself as qualified for Paris," he wrote Kopecký and Vladimír Clementis. The latter was at that time still deputy minister of foreign affairs—Jan Masaryk had just over a week to live. "I speak French, I know contemporary French culture, I personally know the leading French politicians; I personally know all the cultural personalities and representatives of the press. I have lived in France, if we total it up, for at least five years."[178] Reading Vailland's diatribe we might wonder to what extent he was trying to atone for his own effeminate youth in Le Grand Jeu.[179] He would not be the only petit-bourgeois intellectual for whom the working class has represented a surrogate masculinity. But it is not difficult to understand why his broadside should have struck a responsive chord, just as John Heartfield and George Grosz's attack on Oskar Kokoschka had in the not dissimilar circumstances of Berlin in 1920. It was one of those dangerous moments in which choices seem all too clear.

A scaled-down version of *Surrealism in 1947* opened in Topič's Salon on National Street in Prague on 4 November 1947, where it showed for a month under the title *Mezinárodní surrealismus* (International Surrealism). The exhibition was a pale echo of the Paris original. There was no cycle of ordeals and only twenty artists—fewer than a quarter of those shown at the Galerie Maeght—were exhibited. Among them were Hans Bellmer, Victor Brauner, Max Ernst, Wilfredo Lam, Joan Miró, Yves Tanguy, and Toyen. The organizers apologized that "for Customs and other unsurmountable reasons" it had proved impossible to include the work of another eighteen "surrealist painters" including Leonora Carrington, Henry Miller, Isamu Noguchi, Roland Penrose, Kay Sage, and Dorothea Tanning. The catalogue, whose editor Jiří Kotalík would many years later become director of the National Gallery, was an equally meager offering by comparison with its Parisian counterpart. There were no latex breasts to caress here, only a flimsy unpaginated octavo brochure containing a list of the 55 exhibits; ten black-and-white reproductions; three poems by Jindřich Heisler, Benjamin Péret, and Hans Arp; and two essays by Karel Teige and André Breton. It is a sign of the times that Toyen is already described as born in Prague but living in Paris.[180] Both the show and the catalogue presaged the world of *samizdat* publications, fly-by-

night exhibitions in abandoned quarries, and itinerant performances in apartment theaters that was waiting in the wings. Victorious February was just three months away.[181]

"Twelve years have gone by since surrealism staged a series of events in Prague," begins Breton's "Second Ark" (*Seconde Arche*), the opening essay in the catalogue, "and half of that period—which may have been harder to endure over there than anywhere else since, when we look back to its beginning, we have to lay a finger on that *unhealed* wound that is called Munich—could not fail to blur, or even tarnish, the memory of it." Refusing to be cowed by the exigencies of *realpolitik*, Breton obstinately holds onto the memory of everything the magic capital had once seemed to promise. "Will surrealism—which, as its name indicated and by explicit definition, aimed at transcending these miserable conditions of thought," he asks, "make a show of repentance, as its turncoats, its renegades, wickedly enjoin it to do?" His answer is a resounding no. "On the contrary, it upholds, in all their integrity, the principles that were formulated during my stay with Éluard in Prague in 1935." "It is *not true*," he insists, "that the problem of free artistic expression should today be restated in other terms":

> I remain as convinced as I was then that "the elucidation of the means of expression that characterize contemporary art worthy of the name can only lead in the end to the unconditional defense of a single cause, that of the *liberation of man*." But more than ever I intend at all costs to keep alive the meaning of that liberation so that it may be continually re-created and perfected, and not to blindly entrust its realization to an apparatus whose devious methods and absolute contempt for the human person fill me with misgivings. That is what prompts me to urge: ART MUST NEVER TAKE ORDERS, WHATEVER HAPPENS!

Reminding his readers that "the offensive against free art, during the years immediately preceding the war, was launched concurrently by regimes claiming to have opposite ideological objectives," Breton calls on artists "to make their calumniators eat such vile expressions as 'degenerate art' and 'bourgeois decadent art,' which are rapidly becoming synonymous." His pen drips with contempt for Stalin's fellow travelers. "Is it at all conceivable," he asks, "that some of them would go along with this game of *self-slaughter* unless they were masochists or shortsighted opportunists? And how can they fail to see that with such a millstone around their necks the more general cause to

which they are fanatically prepared to make this *unnatural* sacrifice is already lost?" Once again more than the fate of pictures was on the line. "It is possible," he concludes, "that Europe (the whole world?), wounded in its vital organs, can no longer fulfill the destiny adumbrated by an irrepressible belief in a progressive 'betterment.'" There was no longer any choice between abdications to be made:

> No politico-military directive can be accepted or promulgated without treason. The sole duty of the poet, of the artist, is to reply with a categorical NO to all disciplinary slogans. The despicable word *engagement,* which has caught on since the war, exudes a servility that is abhorrent to art and poetry. Fortunately, the great testimony of mankind, the one that has managed to endure until now, tramples on these petty prohibitions, on those amends qualified (how ironic!) as "honorable," on those shameful compromises. Am I not right, Jan Hus? Is it so, [Giordano] Bruno? What say you, Jean-Jacques [Rousseau]?[182]

MESSALINA'S SHOULDER IN THE GASLIGHT

Fifteen years after his visit to Prague, on the other side now of a Europe whose planes and surfaces had been torn up and rearranged anew, André Breton found himself involved once again with events in the magic capital. This time it proved more difficult to make himself understood in this corner of the world than he could ever have imagined. His immediate concern—a pressing one—was with the fate of Záviš Kalandra, the communist journalist Vítězslav Nezval had so fulsomely quoted in the speech he was prevented from delivering to the Congress of Writers in Defense of Culture in Paris in 1935. Kalandra joined the Czechoslovak Communist Party in 1923 at the age of twenty-one. Along with Julius Fučík and Václav Kopecký he became one of the militant newspapermen known as the Karlín Boys after the location of the offices of the KSČ daily *Rudé právo.* He ably defended the compatibility of surrealism with dialectical materialism at the Left Front's *Surrealism in Discussion* colloquium held at the City Library in 1934 to debate *Surrealism in the Czechoslovak Republic,* an event that drew over a thousand people and lasted over six hours.[183] Two years later he contributed to the Czechoslovak Surrealist Group's homage to Karel Hynek Mácha *Neither the Swan nor the Moon (Ani labuť ani Lůna),* an anthology intended to expose the hypocrisy of the official commemorations of the centenary of the poet's death.[184] Like

Karel Teige, Kalandra could not stomach the Moscow trials. He was expelled from the KSČ in 1936 and went on to found a left-opposition journal, *The Proletarian* (*Proletář*). Two years later he joined Peroutka's *Přítomnost*. Arrested by the Gestapo in November 1939, he spent the war in Ravensbrück and Sachsenhausen. He survived the camps—for a while. Arrested as a Trotskyist in 1949, he was piggybacked the following year onto the show trial of Milada Horáková, whom he had never previously met.

One of Bohemia's more notable contributions to the theater of the absurd, the Horáková trial became an international *cause célèbre*. Breton was one of those who signed a telegram to the Czechoslovak government pleading for clemency together with Max Ernst, Jean-Paul Sartre, Simone de Beauvoir, Albert Camus, Michel Leiris, and other prominent left-wing French artists and intellectuals. The surrealist leader also published a more personal "Open Letter to Paul Éluard" on 13 June 1950 in *Combat*. Éluard had recently returned from a visit to Czechoslovakia—his second since the war ended—as an official guest of Klement Gottwald's government, following which he had gone on to Moscow, whose gates were now as wide open to him as he could wish. Despite what Paul had told Gala—no doubt sincerely—about his reluctance to leave home ever again, he traveled extensively in the years after Nusch's death, visiting Britain, Poland, Greece, Hungary, Mexico, Czechoslovakia, Bulgaria, Switzerland, and the Soviet Union in search of the perennial beauty queen's dream of world peace. Perhaps it helped fill the void Nusch left behind her.

Breton reminded Éluard of one of the most beautiful memories of his life and the best friends for whom he had promised to do *everything*. "It is fifteen years since we, you and I, went to Prague at the invitation of our surrealist friends," he began, "and certainly you will not have forgotten how we were received in Prague then."

> Recall a man, who hung around, who used to sit down often with us and really try to comprehend us, because this was an *open* man. . . . I think you will remember this man's name: he is—or was—called Záviš Kalandra. . . . According to the newspapers he was sentenced by a Prague court last Thursday to death, self-evidently after prescribed "confessions." You know as well as I do what to think of these confessions. . . . How can you in your soul bear such a degradation of a human being, in the person of he who was your friend?[185]

Éluard's reply, printed in *Action*, was short, sharp, and utterly shattering in its Olympian coldness—at least to a lover of *Facile*, where sensuous nudes enhance the pleasure of amorous words and the silver tones of prints embody the lights and shadows of love—or to a reader of the *Letters to Gala*, where Éluard is still a passionate seventeen at thirty-four, dreaming of a girl's soft buttocks that move beneath him like the springtime—but above all, perhaps, to anyone moved by Didier Desroches's desolation in *Time Overflows*. "I already have too much on my hands with the innocent who proclaim their innocence," the poet pronounced, "to occupy myself with the guilty who proclaim their guilt."[186] *Já nic, já muzikant* ("I'm just a song-and-dance man"), he might just as well have shrugged, and probably would have done if he had been Czech.

Záviš Kalandra was hanged in Prague's Pankrác Prison—the same prison, coincidentally, where the Nazis had executed Julius Fučík seven years earlier—on 27 June 1950. Milan Kundera happened to be in Wenceslas Square the next day, where he was blessed with a truly surrealist vision. "It was God knows what anniversary and the streets of Prague were once again filled with young people dancing in rings," he relates in *The Book of Laughter and Forgetting*. "And that is when I saw him, right in front of me!"

> He had his arms around their shoulders and along with them was singing two or three simple notes and raising his left leg to one side and then his right leg to the other. Yes, it was he, Prague's darling Éluard! And suddenly the people he was dancing with fell silent, continuing to move in absolute silence while he chanted to the stamping of their feet:

> "We shall flee rest, we shall flee sleep,
> We shall outrun dawn and spring
> And we shall shape days and seasons
> To the measure of our dreams."

> ... and a moment later not one of them was touching the ground, they were all taking two steps in place and one step forward without touching the ground, yes, they were soaring over Wenceslas Square, their dancing ring resembling a great wreath flying off, and I ran on the ground below and looked up to see them, as they soared farther and farther away, raising the left leg to one side and then the right to their other, and there below them was Prague with its cafés

full of poets and its prisons full of betrayers of the people, and from the crematorium where they were incinerating a Socialist deputy and a surrealist writer the smoke ascended to the heavens like a good omen, and I heard Éluard's metallic voice:

"Love is at work it is tireless."[187]

The lovely springtime of 1952 came and went. Whether sixteen-year-old Aube Breton read *Mad Love* and if so with what emotions, I do not know. But in the fall of that year the circus came to town again. Of the fourteen KSČ and state functionaries accused in *The Trial of the Leadership of the Anti-State Conspiratorial Center Headed by Rudolf Slánský* (as the show was officially billed) eleven were described in the indictment as being "of Jewish origin." We can imagine the voices of Czech children gaily chanting "Our Jew Liebermann" outside the courtroom window, reminding the judges of what was at stake in this patriotic drama. "Let your judgment fall like an iron fist without the slightest mercy," demanded state prosecutor Josef Urválek. "Let it be a fire, which burns out to the roots this shameful cancer of treachery. Let it be a bell, calling throughout the whole of our beautiful homeland for new victories on the march toward the sun of socialism."[188] He, too, obviously had a taste for *plein soleil*. Eleven of the accused were sentenced to death, three to imprisonment for life. The death sentences were carried out promptly, by hanging. In Slánský's case the verdict might be seen as poetic justice since it was he who had set in motion the infernal machine that had swallowed up Horáková and Kalandra two years earlier. Falling victim to the apparatus he had himself created, the former KSČ general secretary followed the socialist deputy and the surrealist journalist to the gallows on 3 December 1952.

Franz Kafka dreamed this grotesque scenario, too, and not just in *The Trial*, where mere accusation suffices to induce Josef K's penitential guilt, but in his short story "In the Penal Colony," whose commandant dies—of his own free will—on the execution-machine he had himself designed, which kills its victims by writing their crimes on their naked bodies with acid-tipped needles until they *understand and accept* their criminality.[189] The *érotique-voilée* here is worthy of that son of a Prague police chief Leopold Sacher-Masoch, whose wife Wanda's entertaining memoirs were excerpted in *Erotic Review*. But maybe in this case the explanation for the victims' abjection is simpler. Writing eighteen hundred feet below ground, in total darkness lit only by the flickering light of a miner's lamp, Jiří Mucha wondered why "peo-

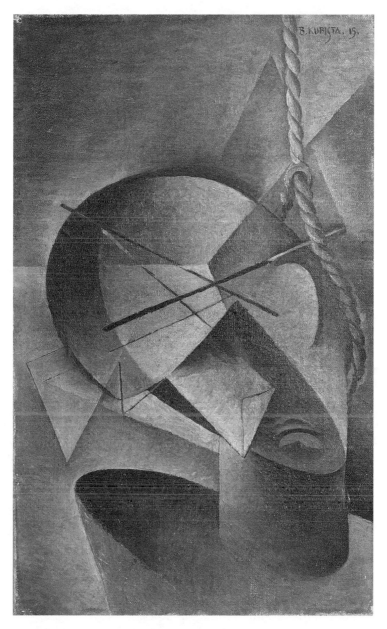

FIGURE 7.7. Bohumil Kubišta, *Obešený* (The Hanged Man), 1915. Moravian Gallery, Brno.

ple say they can never understand these fluent, perfectly crafted confessions. As if those who confess cared!"

> The time of struggle is over. All they are interested in now is not to fluff, not to dry up, not to look silly in front of the microphones. Their fate is sealed anyway. The most they can hope for is that if they now play their part faultlessly they may make things a little easier for themselves. (Some tiny spark of hope inevitably survives.) That is the whole mystery of the show trials. Good food throughout the week before the performance, American cigarettes, carefully pressed clothes and a tie meticulously tied and re-tied. The kind of care lavished on a film star about to go on the set for her key scene. I wish our theaters prepared and rehearsed their productions with the same thoroughness.[190]

This time around Paul Éluard was not in Prague to dance in rings with the cheering masses. Not that he had been there either, except perhaps in spirit, on the day of Kalandra's and Horáková's execution. The poet's ascension over Wenceslas Square was entirely a figment of Milan Kundera's imagination—or maybe it was just a trick of the writer's memory, mixing up times and places in the search to preserve only the quintessence.[191]

Éluard passed away on 18 November 1952 in his home in the Bois de Vincennes. He was buried, like Guillaume Apollinaire and Max Ernst, in Paris's great romantic necropolis Père Lachaise, a location Jindřich Štyrský had spent a lot of time wandering with his camera in the summer of 1935. He lies next to PCF General Secretary Maurice Thorez in a sobering section of the cemetery given over to Holocaust memorials, executed partisans, and communist party luminaries. There is much here to remind us of the atrocities of the twentieth century and little to evoke the love that eternally renews the heart made out of pebbles left by visitors on Apollinaire's tomb. Nothing on Éluard's grave indicates that he was one of France's greatest POETS. But lest we forget, Paul's great call to arms "Liberté" began life as a love poem to Nusch. "To conclude [the poem]," he wrote, "I thought to reveal the name of the woman I loved, to whom the poem was dedicated. But I quickly realized that the only word I had in my mind was *Liberty*. The woman I loved incarnated a desire that was greater than her. I identified her with my most sublime aspiration."[192] Poor Nusch. Some might see this metamorphosis of the woman into the metaphor as a perfect union of the personal and the political. But the question Simone Breton asked of Éluard after his 1924 *voyage*

idiot will not go away: "What is a creature compared to a symbol?" Everything in this world adrift on the wings of poetic thought can be transmuted into everything else. The word becomes flesh, flesh dissolves into words:

> A bright and mutable world, where light is solid and objects transparent, a world *desensitized*, such a country and climate Paul Éluard inhabits with his thought, his desires and his memories. Everything is fugitive and shifting, but of a blinding clarity. Things, beings, images fuse and melt together. All features are blended into one face. . . . Love is clothed in the most beautiful images, unusual, disturbing in their purity, torn trembling and dazzled from the dream which gives them their inevitable, somnambulant air.[193]

I quote Georges Hugnet, appreciating Éluard's poetry in 1936. The emphasis on the word *desensitized* is his. Éluard's rhythms, Vítězslav Nezval once acutely observed, trembled like his hands; "his poetry seems to me like a gentle and dreamlike forgetting of the world, and his appearance resembles it."[194] Do we again hear the shimmering chords of *Julietta*?

Also hanged in Pankrác Prison that December morning were Rudolf Margolius, whose son Ivan wanted Future Systems to sear a permanent scar into the Letná bank from which Joseph Stalin would soon be gazing down Paris Street to the Old Town Square, and Vlado Clementis, who had stood beside Klement Gottwald on the Kinský Palace balcony above what used to be Herman Kafka's fancy-goods shop one snowy afternoon in Victorious February four years earlier, leaving behind only his hat to remember him by. Vlado wrote a last letter to his wife, Lída, on the morning of his execution. "I am smoking a last pipe and listening," he told her. "I hear you clearly singing the songs of Smetana and Dvořák."[195] The letter was published in Clementis's memoir *Nedokončená kronika* (An Unfinished Chronicle) in 1965, by which time all of the defendants in the Slánský Trial had been officially rehabilitated. The one-time foreign minister surfaced again in 1973 on a postage stamp that formed part of a set commemorating "Fighters against Nazism and Fascism during the Occupation," in which guise 11,350,000 exemplars of Vlado's image crisscrossed the land.[196] It was a very Bohemian death and a still more Bohemian resurrection. Was there a whiff of *hasard objectif*, I wonder, in Bohumil Kubišta's *The Hanged Man* (*Obešený*), painted in 1915, one of the most famous images in twentieth-century Czech art? Kubišta was transfixed by the specter of the head geometrically displaced on the neck. Perhaps he was influenced by photographs of the mass executions of Czechoslovak

Legionnaires captured by the Austrians during World War I. Or maybe he was just exploring modernist aesthetics.

Back in Paris, a few months after Éluard's death, André Breton introduced a French monograph on Toyen. The text eventually made its way into his *Surrealism and Painting*. "The lives of our ancestors," he begins, "when we look back at them, appear to have been infinitely less troubled and momentous than our own—it is rather as if Fate had designed us for the *dénouement* of the drama in which we are acting." This was not an honor for which he had asked: "nevertheless . . . we shall have been able, within the brief span of one human life, to witness an astounding quickening of the era foreshadowed in [Olivier Rolin's novel] *Phénomène futur*: 'When the sun, watched in anxious silence by myriad entreating eyes, plunges deep into the water despairing as a cry.'" One of the "world-shaking events which we shall have the doubtful advantage over many generations of our forebears to *witness*, events pushing us a considerable way forward in the night of the Apocalypse," he continues, is "the repression already weighing on Prague, the magic capital of Europe." He goes on to remind his readers of Jindřich Štyrský's death in 1942, of Záviš Kalandra's execution in 1950, of Karel Teige's suicide, as he wrongly believed it to be, on 1 October 1951, and of Jindřich Heisler's recent passing in Paris on 3 January 1953. Had he known of them, he might also have mentioned Jaroslav Ježek's death in 1941 in New York and Konstantín Biebl's suicide in Prague in 1951. Heisler was only thirty-eight. According to Toyen, "The war destroyed his heart."[197] Matthew Witkovsky has remarked on the irony that Heisler died on the same day that Samuel Beckett's absurdist drama *Waiting for Godot* had its premiere at the Théâtre de Babylone. I am sure it was only coincidence.[198]

Breton was probably right to lay the blame for Karel Teige's demise at the doors of the Czech secret police, who had been hounding him for years, but Karel did not take poison to escape arrest. He, too, died of a heart attack, at a tram-stop in Smíchov. He was fifty-one years old—as old as the electric century. But his common-law wife, Jožka Nevařilová, illegitimate daughter of the poet (and signatory of *Czech Modernism*) J. S. Machar, and his lover, Eva Ebertová, did both commit suicide in the two weeks following his death, bringing an appropriately surreal end to another surrealist *ménage à trois*. The StB stripped both Karel's and Eva's apartments of their books and papers. In lieu of an obituary *Tvorba*—the KSČ cultural magazine that Paul Éluard had been so impressed, back in 1935, to discover Teige edited—carried a three-part denunciation titled "*Teigovština*—A Trotskyist Agency in Our Culture."[199] Breton may have continued to remember his "great friend of the

legends"[200] Vítězslav Nezval with affection, but he does not mention him here. The Czech poet was then still alive and well and living in Prague; from 1945 to 1950 he headed the film department at the Ministry of Information. He died in 1958, an honored National Artist. It is a significant omission—when all is said and done, Nezval *was* the heart and soul of the Czechoslovak Surrealist Group—but scarcely a surprising one. Breton had after all sought to obliterate the memory of Éluard's poetry, too. There remains, he says, only "Toyen, whose noble features, reflecting both profound sensibility and adamant resistance to the bitterest attacks, I can never recall without deep feeling; Toyen, with eyes like pools of light."

Castigating "the French attitude to art, the most acutely chauvinistic in the world," the founder of surrealism calls for "a comparative study for every epoch, and for ours more particularly, of the specific (original) features of the art of each country." This would require "making a special category for the extreme forms taken by the art of a new country like Czechoslovakia, which, for all its unprecedented love of freedom, was nonetheless to be swamped by catastrophe—Munich, the German invasion, followed shortly by the Russian occupation." "There could be no nobler, no more punctual reply," he ends, "than the work of Toyen, as radiant as her heart, albeit tinged with dark foreboding." Maybe. But I wonder which Toyen, exactly, he had in mind. Annie Le Brun relates how in her seventies the exiled Czech painter used to "take herself off several times a week to the cinema to see X-rated films. Watching her go silently into the uncertain night, how many times have I not thought of this confession of her friend Štyrský in 1938: 'My eyes need to be thrown constant food. They gulp it down with a brutal avidity. And at night, during sleep, they digest it.'"[201] The elegant Manka always kept her feet firmly in the gutter she had explored in *The Pillow*, *Paradise of the Negroes*, *Erotic Review*, and *Twenty-one*. Though she never spoke to Éluard again after Záviš Kalandra's execution, years later she would tell Jindřich Toman—Heisler's nephew—that Paul was always "one of us."[202] As, of course, he was.

And so the old tropes return, bedeviling any study at all—and least of all of the art of *our epoch*. Much as he mourns Prague's postwar fate the father of surrealism is either unable or unwilling to rethink its situation—the complexities, the ironies, the multiplicities of its modernities—in a story that is as much *his own* as Kalandra's or Éluard's. The unexpected encounter of exquisite love poetry and a surrealist's swinging corpse in the magic capital of old Europe is not one that detains his imagination. Perhaps it was a conjuncture too painful to face. Breton would not, after all, cut open a Mexican jumping bean for fear of discovering a worm or an insect inside it that might

destroy the mystery; any more than he would have followed Vítězslav Nezval into such brutally erotic establishments as *Aux belles poules*. In this instance—just as, perhaps, in his relationships with Jacqueline, who told Mark Polizzotti that Breton "saw in me what he wanted to see, but he didn't really see me"[203]—or with Suzanne, who recalled that "Breton overflattered his loves: he molded the woman he loved so that she should correspond to his own aspirations, and thus become, in his own eyes, an affirmed value"[204]—the poet is not prepared to contemplate the awful possibility that the mystery *is* the worm within: "a form of the Marvelous," as the irritating young Roger Caillois pointed out, "that does not fear knowledge but, on the contrary, thrives on it."[205] He shrinks at the sight of Messalina's shoulder gleaming in the gaslight. His appreciation for *la beauté convulsive* does not extend to "the special beauty of evil, the beautiful amid the horrible." Faced with Baudelaire's "savagery that lurks in the midst of civilization,"[206] Breton elects to remain in the Central Office of Dreams.

An old *amour fou* rises up to consume him anew. Shining through the billowing gowns of mists like brothel *négligés*, the night-fog like the thick top of milk, the old images take on new poignancy as they recede into nostalgia. The metaphors once again revolve on themselves, spattering countless meanings. An unmistakable aura of kitsch settles over the city on the Vltava as the drift of poetic thought transports us way back to an indeterminate when:

> Prague, sung by Apollinaire; Prague, with the magnificent bridge flanked by statues, leading out of yesterday into forever; the signboards, lit up from within—at the Black Sun, at the Golden Tree, and a host of others; the clock whose hands, cast in the metal of desire, turn ever backward; the street of the Alchemists; and above all, the ferment of ideas and hopes, more intense there than anywhere else, the passionate attempt to forge poetry and revolution into one same ideal; Prague, where the gulls used to churn the waters of the Vltava to bring forth stars from its depths. What have we left of all this now?[207]

Michel Foucault once claimed that "the dream for Breton is the unshatterable kernel of night at the heart of the day."[208] Certainly it is the enduring imprint of the night on all the beauties of the modern world that qualifies Prague as a fitting capital for the twentieth century. In 1997, half a century after the events I have recounted here, I stumbled across just such a memento of the night in the shape of *The Sun of Other Worlds*, a canvas that Josef Šíma painted in 1936, the year after he accompanied Breton and Éluard on their

journey to the magic capital. The title is taken from a line in Karel Hynek Mácha's "May." The picture was hanging, in the way that paintings rather than men do, in the Trade Fair Palace, which had by then metamorphosed into Prague's equivalent of the Tate Modern. Šíma was never a card-carrying surrealist, but his paintings depict landscapes of the mind as surely as do Dalí's or Ernst's or Tanguy's. Perhaps his work is more lyrical. His objects—a female torso, a crystal, an egg, a cube—drift in a world of soft colors, often verging on but seldom quite resolving into pure abstraction. *The Sun of Other Worlds* is a typical Šíma dreamscape—though perhaps it is darker in its hues than many. Or maybe that is just my imagination, as susceptible to Prague's necromancy as Apollinaire or Breton's. What made the painting a jarring *objet trouvé*—I certainly was not looking for it—shattering the museum's progressive tale of modernist avant-gardes marching forward, backward not a step, was nothing in the picture itself. What pulled me up short were the words the artist had carved into the wooden frame: "To Vlado Clementis from his Šíma, 1948" (*Vladovi Clementisovi jeho Šíma*, 1948).[209] Walter Benjamin might have called it a dialectical image: one of those sudden eruptions of *what once was* into the "now of recognizability" in which "things put on their true—surrealist—face."[210]

THAT FAMILIAR WHITE DARKNESS

What, then, do have we left of all this now? One might approach Breton's question differently, by way of another *dérive* through modernity's *lieux de mémoire*. Given the comprehensive postwar forgetting of Czech avant-gardes on both sides of the Iron Curtain, the conversion of the Trade Fair Palace in 1995 into a home for the modern collection of the Czech National Gallery— which by a strange accident of *hasard objectif* had never secured a permanent exhibition space since it began life in the shape of the Modern Gallery of the Kingdom of Bohemia in 1902[211]—can only be welcomed. The location seems especially fitting, given the pioneering modernism of the building's architecture. But be warned: what the visitor sees now is not Fuchs and Tyl's original construction, though it might look like it. The palace was burned to a skeleton by a devastating fire in 1974. The gutted shell long stood empty and abandoned, too much of a monument to demolish lightly or easily repair. It was eventually restored to its former glory by the Liberec architectural consortium SIAL. Work began in 1986 and after many delays, like the National Theater a century earlier, the palace rose from the ashes "like a phoenix" (to quote the inevitable title of the exhibition that marked the occasion).[212] The structure looked much as it used to, but one misses the colorful capitalist anarchy of awnings and advertisements that used to soften the severity of the façade.

There were also some modest changes to the interior. Among them was the replacement of staircases by ramps as advocated by Le Corbusier in his 1928 interview with Karel Teige, making the building an even more perfect embodiment of the aesthetics of the International Style than it had been in its original incarnation.

Michelin's *Green Guide* to Prague recommends tourists to make "the short tram ride to the inner-city district of Holešovice" in order to enjoy not only Gauguin, Picasso, Klimt, Schiele, Miró, Kokoschka, and the rest of the "great figures of modern European art" but also "the work of twentieth-century Czech artists, whose contribution to the development of twentieth-century art is no less significant for having remained little known for far too long." It waxes especially lyrical about the Trade Fair Palace itself, explaining that "The Great Hall is only used for occasional exhibitions while other parts of the building are not accessible to the public. The permanent collections and other temporary exhibitions occupy gleaming white galleries running off the Small Exhibition Hall; beneath its glass ceiling, this immaculately restored space can now be appreciated as one of the foremost interiors of the heroic period of modern architecture." "The progressive spirit of interwar Prague," it concludes, "is nowhere expressed more strongly than in this huge palace of glass and concrete."[213] It is difficult not to be swept away by such a perfect union of form and function: both the building and the artworks it contains seem to epitomize Petr Král's "spirit, revived by memory, which pulses in the walls and behind the façades . . . which inhabited the city between the wars." But like the glitz and glitter of the Hotel Paříž the delights of the past may not always be as straightforward as they seem. I would recommend to tourists—and historians of the modern—to take a little time out to explore the neighborhood further, taking a walk in Stromovka Park, perhaps, stopping to admire the Exhibition Grounds at Výstaviště, and then catching the subway back to the city center from Holešovice Station, just ten minutes' walk down the hill. For there are other sights to be seen—other footsteps in which we are treading—that might lead us to question this overeasy equation of modernity with progress.

Modernist architecture is supremely well adapted to forgetting, precisely because of that open-ended functionality and distain for any distinguishing markers of time and place that were so appreciated by Karel Teige. Its ideal is what the Dutch architect Rem Koolhaas calls the Typical Plan, a neutral, minimal, and infinitely adaptable organization of space that can facilitate a multitude of activities while dictating none.[214] The Trade Fair Palace is an extremely flexible container. It could be anything or anywhere in the modern

world: an art museum, a government ministry, the headquarters of an import-export company, a cathedral of the Slav spirit that effortlessly united Alfons Mucha with steel and concrete. The palace has been all of these things in its time. Though the building now provides the ultimate in white cube galleries, it has no *necessary* connection with the avant-garde art that seemingly so appropriately lines its whitewashed walls. Indeed, during World War II the palace's size and location, a short frogmarch down the hill to Holešovice Station and the trains to Terezín, made it the ideal center for warehousing Jews awaiting their transports to the camps:

> Early in the morning of the appointed day we set off while it was still dark with [Agata's] luggage strapped to a toboggan, and without a word we made the long journey through the snow spinning down around us, along the left bank of the Vltava, past the Baumgarten, and further out still to the Trade Fair Palace at Holešovice. The closer we came to it, the more often did small groups of people carrying and dragging their heavy burdens emerge from the darkness, moving laboriously towards the same place through the snow, which was falling more thickly now, so that gradually a caravan strung out over a long distance formed, and it was with this caravan that we reached the Trade Fair entrance, faintly illuminated by a single electric light bulb, towards seven in the morning.

I quote from W. G. Sebald's novel *Austerlitz*.[215] Not that Austerlitz, the oddly named hero of the book, has any memory of Fuchs and Tyl's modernist cathedral in which seethed, in ten thousand eruptions, unrestrained work, work, and work: he grew up far away from the magic capital of old Europe in a small town in Wales not knowing who he was. He learns his true history from Vera, whom he tracks down many years later still living in his parents' apartment in the Little Quarter where he spent his forgotten early childhood. Vera used to be his mother Agata's maid. It turns out that Austerlitz was a Jewish boy who had escaped the occupied city on one of the "children's trains" organized by the English stockbroker Nicholas Winton, which the German authorities allowed to leave for London in the summer of 1939. Winton rescued 669 children on eight trains; among them were Karel Reisz, the future director of the films *Isadora* and *The French Lieutenant's Woman*, the Canadian journalist and CBC news correspondent Joe Schlesinger, and Viktor Ullmann's children Johannes and Felicia.[216] The ninth and largest

Kindertransport was due to leave Prague on 3 September 1939, the day that Great Britain declared war on Germany. "Within hours of the announcement, the train disappeared," Winton related later. "None of the 250 children on board was seen again. We had 250 families waiting at Liverpool Street [Station] that day in vain. If the train had been a day earlier, it would have come through. Not a single one of those children was heard of again, which is an awful feeling."[217]

Winton's unlikely underground railroad began in the art nouveau surrounds of the café on the ground floor of the Grand Hotel Europa, then the Grand Hotel Šroubek, where the young Englishman made the necessary arrangements with distraught Jewish parents amid the sweet moldy scents of Wenceslas Square. The luxurious interior was (and is) just the kind of place that gave Le Corbusier the horrors. Overwhelmed by its gilt and mirrors, tourists in search of souvenirs of Prague's *fin de siècle* might easily miss the little commemorative brass plaque tucked away in the corner under a photograph of Sir Nicholas, as Winton belatedly became in 2002. He had kept the story quiet, even from his family, for over half a century. The plaque is in Czech and English, as befits our postmodern times. But there is nothing new about what is absent from both versions of the text:

> Towards the end of 1938, and at the beginning of 1939, an Englishman Sir Nicholas Winton and his coworkers, organized from this Hotel and often directly from this café, a unique rescue mission of 669 Czech and Slovak children, which has no parallel in modern history.[218]

As I have remarked before, there are as many ways of forgetting people—and histories—as there are of remembering them.

Like all of Sebald's novels—I hesitate to call them fictions—*Austerlitz* meanders through that zone of agitation that lies on the borders of the poetic and the real, circling around chance coincidences and obscure details and following twisted paths of repetition-compulsion until the reader is held fast in a net of interwoven images, unable to look away from the horrors they depict. "We waited there in the crowd of those who had been summoned, a silent assembly stirred only, now and then, by an apprehensive murmur running through it," Vera goes on:

> There were men and there were women, families with young children and solitary figures, there were the elderly and the infirm, ordinary folk and those who had been well-

to-do, all of them, in accordance with the instructions they had received, with their transport numbers round their necks on pieces of string. Agata soon asked me to leave her. When we parted she embraced me and said: Stromovka Park is over there, would you walk there for me sometimes? I have loved that beautiful place so much. If you look into the dark water of the pools, perhaps one of these days you will see my face.

"I tried to think where Agata might be now, whether she was still waiting at the entrance or was already inside the Trade Fair precinct," she tells Austerlitz. "I learned only years later, from one who had survived the ordeal, what it was like there":

> The people being taken away were herded into an unheated exhibition hall, a great barn-like building which was freezing in the middle of winter. It was a bleak place where, under faint, glaucous lamplight, the utmost confusion reigned. Many of those who had just arrived had to have their baggage searched, and were obliged to hand over money, watches, and other valuables to a Hauptscharführer called Fiedler who was feared for his brutality. A great mound of silver cutlery lay on a table, along with fox furs and Persian lamb capes. Personal details were taken down, questionnaires handed out, and identity papers stamped EVACUATED or GHETTOIZED. The German officials and their Czech and Jewish assistants walked busily to and fro, and there was much shouting and cursing, and blows as well. Those who were to leave had to stay in the places allotted to them. Most of them were silent, some wept quietly, but outbursts of despair, loud shouting and fits of frenzied rage were not uncommon. They stayed in this cold Trade Fair building for several days, until finally, early one morning when scarcely anyone was out and about, they were marched under guard to nearby Holešovice railway station, where it took almost another three hours to load them on the trucks.

Sebald may be taking poetic liberties in placing this grisly processing under the glass roof of the Great Hall—though so does the one-time

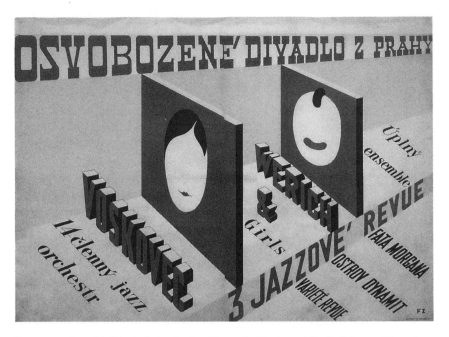

FIGURE 7.8. František Zelenka, "3 Jazz Reviews." Poster for Osvobozené divadlo (Liberated Theater), 1930. The Museum of Decorative Arts, Prague.

Přítomnost editor Ferdinand Peroutka, whose own years in Nazi concentration camps gave him ample opportunity to listen to Prague Jews' stories of their experiences.[219] Such archival evidence as survives in the Prague Jewish Museum suggests that the inmates were housed in huts adjacent to the palace (but still within the Trade Fair complex) while awaiting their transports to the camps; which is doubtless why, today, there is a memorial plaque not on the palace itself but the hotel next door, tidily separating savagery from civilization and the modern from the barbaric. What is certain, though, is that the novelist's imagination captures the quintessence of what the Trade Fair Palace signified *then*. From some points of view—René Daumal's, for instance—the building's metamorphosis into an art museum might be regarded as the ultimate in obscenities, but Jacques Vaché would likely just have laughed his joyless laugh.

Austerlitz has a strange affinity—a sense of *déjà vu*, a memory he cannot place—with the waiting room at London's Liverpool Street Station. František Zelenka took different trains.[220] The first left Holešovice Station for Terezín. Zelenka subsequently caught one of the last transports to Auschwitz, which

left Terezín on 19 October 1944. The exact date of his death is not known. He is one among the sea of Czech names that make reading a book like this so difficult for Anglophone readers, but we have come across him before. Along with Otakar Mrkvička and Karel Teige he designed the sets for the Liberated Theater's 1926 production of Apollinaire's *Breasts of Tiresias*, the drama in which the word *surréalisme* made its debut on the world stage. He may also have been the author of the Proustian poster Petr Král remembered lingering in the U Nováku passage on Vodičkova Street, an image as sharp and enduring as the legs of the pretty student girls sunning themselves in what was then still Red Army Square. His advertisements for V + W captured the dreams of an age, enticing the customers in with images of jazz, *girls*—the word was invariably in English—and all the beauties of the modern world.[221] Needless to say, Zelenka was "of Jewish origin," just like eleven out of the fourteen defendants in the Slánský trial and every single one of those 669 Czech and Slovak children rescued by Nicholas Winton.

František Zelenka is a surrealist point of departure from which we might begin to answer André Breton's question with something more substantial than poetic nostalgia. With his wife and eight-year-old son Martin, the architect and designer passed through one of the foremost interiors of the heroic period of modern architecture—or maybe it was just the miserable huts in back—on or around 13 July 1943 on business that had little to do with modernism and everything to do with modernity. There is no marker in the immaculately restored Trade Fair Palace today to show this past, no equivalents of the Soviet soldiers' obscene graffiti Sir Norman Foster was so careful to conserve when restoring the Berlin Reichstag as a perpetual reminder of the difference between what is remembered and *what once was*.[222] The building's history has been erased by its blinding light, air, and clarity. Yes, I would recommend taking the short tram ride from the city center to Holešovice. The Trade Fair Palace is indeed an extraordinarily significant building. When the majestic glass roof bathes the interior in Miesian light it is easy to believe that all is for the best in the best of all possible worlds. But as often as not it rains in the magic capital, reminding us of ozone-soaked dusks in Rotterdam. If you listen hard enough, you might just hear the strains of Martinů's *Julietta*. Best of all though is to arrive when the snow is falling, and feel that familiar white darkness descending.

8

The Gold of Time

The world dominated by its phantasmagorias—this, to make use of Baudelaire's term, is "modernity."

<div style="text-align: right;">—Walter Benjamin, Paris, Capital of the
Nineteenth Century[1]</div>

The Necromancer's Junk Room

On Wednesday 28 September 1966, just after six o'clock in the morning, André Breton died of heart failure. Elisa and Aube were by his side. The founder of surrealism was laid to rest in Batignolles Cemetery in the northwestern outskirts of Paris, close to Jindřich Heisler and Benjamin Péret. Toyen, who moved into Breton's apartment at Elisa's request after André's death, would join them there in 1980. "I seek the gold of time," reads the inscription on Breton's grave, a line from his *Discourse on the Paucity of Reality*, but it is the ordinariness of the setting that overwhelms. Batignolles has neither the grandeur of Père-Lachaise nor the charm of Montparnasse. The cemetery begins where *la ville-lumière* ends, in the zone that lies partly within the city, partly on the miserable, dark edge of the city, bisected by a flyover of the Boulevard Périphique. Luis Buñuel, Marcel Duchamp, Michel Leiris, Jacques Prévert, Philippe Soupault, and Simone Breton were among the thousand or so mourners who made the long journey to the city limits for the funeral. Picasso, Dalí, and Aragon were not. There were plentiful encomiums. "Breton was a lover of love in a world that believes in prostitution," gushed an unchar-

acteristically lyrical Duchamp; "for me, he incarnated the most beautiful dream of a moment in the world."[2] Michel Foucault wrote that "Breton's death, today, is like the doubling of our own birth. His is an all-powerful death, very close to us, like Agamemnon's death was for the House of Atreus (that is, for every Greek)."[3] But (in the words of Mark Polizzotti, who seems momentarily to have forgotten his own earlier derision at surrealism's proletarian troubadour turned homosexual libertine-about-town) "it was Aragon, Surrealism's much-derided Judas, who provided perhaps the most heartfelt reminiscence of all":

> It will soon be forty-eight years ago, on November 9, 1918, that André Breton sent me one of those collage-letters he was then in the habit of writing. . . . When I received that letter . . . a small square of paper, no doubt added on the morning of the 10th just before mailing it, blinded me to everything else. In the center one could read:
>
> <div style="text-align:center">
>
> But Guillaume
> APOLLINAIRE
> has just
> died.
>
> </div>
>
> Last Wednesday I came across that square of paper among André's letters, which I had sadly begun rereading. And since then, I've been unable to take my mind off it. It is impossible to say here what I would have liked to say about the friend of my youth, about that great poet whom I never stopped loving; impossible to say anything other than one sentence, like an echo . . . a sentence that blinds me to so many things:
>
> <div style="text-align:center">
>
> But André
> BRETON
> has just
> died.[4]
>
> </div>

In his modest apartment at 42 rue Fontaine, just around the corner from the place Blanche, Breton left behind him a cabinet of curiosities to rival, in a twentieth-century manner of speaking, Emperor Rudolf's Hradčany—though some might perhaps see it as more reminiscent of the *Merzbau* of the *fin de siècle* Prague ghetto. His wartime exile apart, Breton had lived at rue

Fontaine since 1922. Paul Éluard had an apartment in the same building until his health forced him to seek more salubrious accommodations elsewhere.[5] "Even on sunny days and in spite of the high windows of the apartment the two rooms, staggered in height by a short staircase, always seemed to me somber," relates the novelist Julien Gracq. "The general tone, dark green and chocolate brown, is that of very old provincial museums. . . . The swelling of works of art clinging everywhere to the walls has gradually shrunk the available space; one can only get around by way of precise pathways, established by use, avoiding the branches, lianas, and thorns of a forest path." "Nothing has changed here since [Breton's] death" he exclaims, "ten years ago already!" Gracq remembers the poet "sitting down, pipe in his mouth, behind the heavy work-table on which a confusion of objects always overflowed . . . retreating every evening among his pictures, his books, and his pipe, after the café, into the necromancer's junk room which was his true raiment, amid the accumulated and immobile sediment of his whole life. Everything in the *interior*—and one visit sufficed to leave to the word all its force—of this fanatic of the new spoke of immobility, of accumulation, of the powerful hold of habit, of the maniacal and immutable ordering a servant would hesitate to disturb." The apartment, he concludes, was "a refuge against all the machinism of the world."[6]

An unsystematic inventory[7] of this latter-day *Kunst- und Wunderkammer* might begin with a *kudlmudl* of dusty tomes it would be a joy to rummage into, many of them signed and dedicated to Breton by some of the most renowned writers of the twentieth century; paintings, drawings, and sculptures whose authors include Arp, Dalí, De Chirico, Duchamp, Gauguin, Lam, Magritte, Masson, Matta, Miró, Oppenheim, Paalen, Picabia, Picasso, Rivera, and Tanguy; photographs by—among many others—Henri Cartier-Bresson, Man Ray, Raoul Ubac, Brassaï, Manuel Alvarez Bravo, Claude Cahun, Pierre Molinier, and Dora Maar. An avid collector of what in his time was still unapologetically known as primitive art, Breton filled the flat to bursting with African, Asian, Oceanic, and Native American artifacts—masks, beads and amulets, necklaces and bracelets, ear ornaments and leg-rattles, dolls and figurines, engraved stones, paintings on bamboo and bark, shields and weapons, paddles, canes, stools, dishes, spoons, pipes, musical instruments, prayer-boards and food hooks and funerary urns. Chocolate-box in style and blasphemous in content, Clovis Trouille's *Italian Nun Smoking a Cigarette*, her skirt lifted to reveal high heels, red stockings, and a suspender belt, provided a little light relief.

The poet's literary remains were the stuff of scholarly wet dreams. No surrealist scrap, however trivial, seems ever to have been thrown away. Aragon, Artaud, Dalí, Desnos, Éluard, Ribemont-Dessaignes, Soupault, Tzara—the excommunicated all left their traces along with the faithful. There was the original manuscript of *Arcane 17* with a photograph of Elisa collaged into a heart-shaped leaf on the skin-bound cover. There were exercise books full of poems, minutes of meetings of the Bureau de recherches surréalistes, accounts of dreams, scorecards for surrealist games, tracts, proclamations, automatic drawings, and beautifully hand-colored astrological charts for Baudelaire, Lautréamont, Rimbaud, Jarry, and Paul and Nusch Éluard. Breton kept the original photographs for *Communicating Vessels* and *Mad Love*—as well as twenty-seven letters to "mon André" from the heroine of *Nadja*, that surrealist *femme-enfant* who ended up in a loony-bin—the manuscript of Hans Bellmer's *Notes on the Subject of the Ball-Joint* accompanied by a letter in which the German artist complains of being taken for "a libertine, an alcoholic, a drug addict, a neurotic, a surrealist, unbalanced, a pederast, a seducer of little girls"[8]—the handwritten records of the "Recherches sur la sexualité," of which only a scandalous fragment was ever published in *La Révolution surréaliste*. Also unpublished, until it surfaced in Prague (of all the unlikely places) in 2004 under the imprint of the Galerie Maldoror, was a spiral notebook containing 33 collaborative collages dating from around 1931 by Breton, Éluard, and Suzanne Muzard.[9]

Then again, we could venture beyond this (relatively) safe territory where we at least still have orderly categories in which to put things, grids with which to make sense according to the lights of our age and our geography, and instead start our inventory with what falls between the cracks, the obscure objects of desire whose presence eats away at the surfaces and planes of what we imagine to be the modern world. There is plenty to choose from in this gallery of the humblest art. We might begin with a crystal ball, perhaps, of the kind used by fairground fortune-tellers; a child's jack-in-the-box, dating from around the year 1900; photographs of copulating elephants and Victorian nudes; seashells and butterflies meticulously mounted in glass cases; a lobster, a crucifixion, a set of dominoes, and a bust of Victor Hugo, all housed in glass bottles; a female hand holding up an oval mirror like the naked girl in Gustav Klimt's *Nuda Veritas*. Should we be surprised, given Breton's lifelong hostility to *family, country, religion*, to discover brightly colored devotional pictures from Latin America, many of them brought back from his visit to Mexico in 1938, or the dozens of vessels for holy water and

cast-iron molds for waffles, wafers, and communion bread that hung on the apartment walls? Probably not, if we have read *Arcane 17* or remember the pagan altars at *Surrealism in 1947*. And on, and on it goes—a collection of antique coins, a bronze cast of a lady's glove, a mummified lizard, a portrait of Saint-Just, a porcelain orchestra, the carapace of a tortoise, a figure of death riding a bicycle—a curiously shaped wooden serving spoon with a little boot on which to rest the handle, picked up in a Paris flea market one fine spring day in 1934.

In search of the down and dirty, the tabloid truths of surrealism, we might linger over the exquisite corpses left behind by Breton's three marriages, assorted *amours*, and a legion of broken friendships; an incomplete set of handmade playing cards for a game invented by artists in exile in Marseille in 1941, in which the suits are Love, Dream, Revolution, and Knowledge, the cards bear portraits of Lautréamont, Novalis, Hegel, Freud, Baudelaire, Pancho Villa, and the Marquis de Sade, and Pére Ubu is the joker; the documentation for the 1934 "trial" of Salvador Dalí, whose paranoiac-critical method had brought him, Breton thought, perilously close to adoration of Hitler. Was there a prefiguring here of the Moscow trials, albeit that in this instance, unlike in Marx's *Eighteenth Brumaire*, the farce came before the tragedy? Dalí's unfettered imagination also led him to paint Lenin with a "naked right buttock … as long and flaccid as a soggy baguette," an image with which Breton was no more comfortable than the Nazis had been with Bolshevik art.[10] What are we to make of the scores kept by Paul Éluard in a surrealist entertainment called "La Femme," in which the participants rated feminine physical attributes and psychological qualities on a scale of plus twenty to minus twenty? Éluard gave the breasts twenty, the *sexe* nineteen, and the buttocks minus twenty—how could he possibly have forgotten Gala's lovely *fesses* moving marvelously beneath him like the springtime—while the ever-romantic Breton reserved maximum points for a woman's hands and eyes. Simone Breton, the only female player in the game, left most of her entries blank. But Simone had long since grown tired of "the procedures employed with certain female members who come to handle certain chores and [are] treated like machines" at the Bureau de recherches surréalistes.[11]

Seeking for souvenirs of Breton's dalliance with the magic capital of old Europe—or should we perhaps say, of her dalliance with him—we would turn up paintings and photographs by Štyrský and Toyen given as gifts in happier days; a photographic self-portrait of Vítězslav Nezval looking fat and jolly with a pipe in his mouth inscribed with the only partly legible legend "Á mon le plus cher ami André Breton tout le génie et le soleil (?) avec (?)

de la (?) de tout mon coeur pour toujours Nezval Vítězslav Prague le 10 IV 1935";[12] a rather more dignified portrait of Toyen looking severe and possibly (though nobody was ever quite sure) lesbian;[13] and a photograph album with eighty-three neatly mounted and labeled snapshots taken in 1935 in Château de Pouy at Jégun, Saint-Jean-aux-Bois, Menfort-en-Chalosse, Karlsbad, Marienbad, Prague, and Tenerife, featuring André and Jacqueline, Paul and Nusch, Nezval and Teige, Štyrský and Toyen, and the young Bohuslav Brouk.[14] We would also uncover a bundle of fraught but now barely comprehensible correspondence dating from 1938 in which Teige, Brouk, Štyrský, Toyen, Honzl, and Konstantín Biebl on the one hand and Vítězslav Nezval on the other solicited Breton's support in the acrimonious disputes that were tearing the Czechoslovak Surrealist Group apart—disputes over what on earth artists devoted to shaping the days and seasons to the measure of their dreams were to do when the choice between abdications Breton had outlined in his 1935 lecture to the Left Front finally came home to roost.[15] *This is the day. Too much: time overflows.* Far away now and long, long ago, the world recalled by these mementoes seems as distant as the Hradčany of Rudolf's astronomers and alchemists—which does not make it any the less haunting. Once upon a time it was the modern world.

Like Emperor Rudolf's cabinet of curiosities and the rag-pickers' stalls in the Prague ghetto this treasure-trove of twentieth-century arcana no longer exists—except, that is, insofar as it is spectrally documented in a sumptuous eight-volume auction catalogue and lives on in the virtual space of the accompanying DVD.[16] Breton's collections, too, went off to dream at the antique fair. After his death Elisa and Aube kept the apartment in 42 rue Fontaine undisturbed as a shrine for visiting scholars and surrealists. Elisa died in 2000. She was buried next to André in Batignolles Cemetery. Aube neared seventy. Despite the family's repeated approaches the French government refused to step in to shoulder the burden of preserving what had now, quite evidently, become part of the national cultural heritage. At Aube's request the entire contents of Breton's flat were eventually sold by the auction-house CalmelsCohen in April 2003. Echoing the Revolutionary Surrealists' protests outside *Surrealism in 1947*, demonstrators distributed fake Euro banknotes bearing Breton's face inscribed with the words "Your money stinks of the corpse of the poet you never dared to become."[17] The wooden spoon from *Mad Love* fetched 18,000 Euros. In all the sale raised 46 million Euros. Not included in the auction was "the cluttered wall behind [Breton's] desk that . . . was given by Mrs. [Aube] Breton Elléouët to the National Museum of Modern Art at the Georges Pompidou Center in lieu of death duties

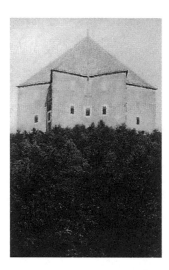

FIGURE 8.1. Period postcard of Letohrádek Hvězda (Star Castle), Prague, date unknown. Reproduced in André Breton, *Mad Love*.

owed to the government by the Breton estate."[18] Meticulously reconstructed and scrupulously annotated, "Breton's Wall" is now one of the Beaubourg's star attractions. In its center, surrounded by the prehistoric stutterings of the world, is a black-and-white photograph of Elisa.

A postcard of Star Castle at Bílá hora, the site of the Battle of the White Mountain, seems of little consequence amid such riches.[19] The guide price for the card, a footnote in most versions of Breton's story though a keynote in ours, was a mere 150/200 Euros. It sold, in the event, for 5,000 Euros. To whom and what it meant to them, I do not know. Inscribed on the back in Breton's own neat hand are the words "À flanc d'abîme, construit en pierre philosophale . . ." (On the side of the abyss, made of philosophers' stone). It is as good an epitaph for this *histoire folle* as any. In a final uncanny coincidence the last *objet trouvé* on which André Breton chanced while vacationing at the pretty little town of Domme in the Dordogne in August 1966 was a discarded piece of rooftop finery carved into multiple triangular facets, in which "above all, [he] recognized . . . the starry castle in Prague."[20] Juxtaposed with the photograph of Star Castle from *Mad Love*, Radovan Ivsic's photograph of the allusive object illustrated the fulsome tributes to the founder of surrealism published in the first issue of the Paris surrealists' new journal *L'Archibras* in April 1967. The ornament now sits on Breton's tombstone in Batignolles Cemetery, which is otherwise as bereft of superfluous

decoration as Adolf Loos would wish. To most visitors to the grave it will be as incomprehensible as any manifestation of *hasard objectif*. It would be nice—poetic, even—to conclude this tale of two cities with such a cryptic reminder of the tangled skeins that forever connect *la ville-lumière* to the magic capital of old Europe. But Prague was not quite through with the French surrealists yet. This little mother has claws.

THE PRAGUE–PARIS TELEPHONE

Less than eighteen months after Breton's death the *annus mirabilis* of 1968 dawned fair over Bohemia. On 5 January Alexander Dubček replaced Antonín Novotný as the KSČ's First Secretary and the road opened to the most beautiful dream of that moment in the world, socialism with a human face. One sign that spring—or something—was in the air was the exhibition *The Pleasure Principle* (*Princip slasti*), which showed in Brno, Prague, and Bratislava to a large and appreciative public. It was the first international surrealist exhibition to be staged in Czechoslovakia since the 1947 show at the Topič Salon for which Breton had written his "Second Ark." Miró, Matta, Lam, and Toyen were the only prewar artists represented. Fresh and young, like the work of the Eight that Max Brod had hailed as "springtime in Prague" sixty years earlier, the exhibition offered "a selection of contemporary works of the surrealist movement" grouped under the headings Violation of the Law, The Law of the Night, Automatic Truth, and The Game. The show was organized by Vincent Bounoure, Claude Cortot, and José Pierre, members of the reborn Paris surrealist group Breton gathered around him in the 1950s and 1960s. Accompanying the catalogue was a leaflet titled *Surréalistický telefon Praha-Paříž* (The Prague–Paris Surrealist Telephone), which consisted of questions by the second-generation Czech surrealists Stanislav Dvorský, Vratislav Effenberger, and Petr Král, and responses by the Paris surrealists. A series of lectures was organized under the rubric "Surrealism and Art" at the Prague City Library, where over a thousand people, including Záviš Kalandra, had gathered to debate *Surrealism in the Czechoslovak Republic* thirty-four years earlier.[21] Following in the footsteps of Éluard, Lamba, and Breton, a new wave of French surrealists hastened to a *rendezvous des amis* in the magic capital.[22]

The visitors and their hosts agreed a statement of principles, the so-called Prague Platform, which they hoped would serve as a basis for a renewal of international surrealist activity. The tract took aim at "the demented imbeciles of progress" on both sides of the Iron Curtain, arguing that surrealism was "especially well placed to verify the fallacious character of the myth of Prog-

ress or historical irreversibility." Linking the new journals "*L'Archibras* in Paris and *Aura*, which is shortly to appear in Prague" as "not only the organs of the surrealist groups in these cities but global expressions of the surrealist movement as it defines itself today," the text concluded with a reminder of Prague's pride of place in the history of surrealism:

> On 9 April 1935 the *Bulletin International du Surréalisme* was published in Prague.
>
> On 9 April 1968 the surrealist exhibition "The Pleasure Principle" will open in Prague.

<div align="center">

THE VASES ALWAYS COMMUNICATE
(André Breton).
Prague–Paris — April 1968[23]

</div>

But while communication on the renewed surrealist telephone was enthusiastic, it was not always easy. Postwar geographies had taken their inevitable toll on the world of dreams.

A singularly poignant example of this disconnection—or an instructively comical one, depending on your point of view—was the French surrealists' pilgrimage in April 1968 to the starry castle at Bílá hora, an item that was high on their agenda. The visitors will have had no more idea of how much, or just what, this *lieu de mémoire* signified to Czechs than did Breton and Éluard thirty-three years earlier. In particular, they knew nothing of what the building had come to signify during the preceding two decades of communist reconstruction of the national imaginary. Petr Král, who was then still living in Prague but would not be doing so for much longer, tells the story:

> The realism of the Czechs, certainly, is not only anti-ideological but also anti-romantic. At the most exalted moment of our history, in 1968, we were not able to share the enthusiasm of our friends from Paris, discovering in their turn, thirty years after Breton, the celebrated "Starry Castle"; metamorphosed in the meantime into the museum of a grotesque local genius, destined for school excursions and guarded by a veritable army of giant slippers (which it was obligatory to wear for the visit), this marvel didn't enchant us any longer other than as a bastion of stupidity. While the two attitudes might not be incompatible, our "cynical" laugh alone rapidly freed our friends from the snare of a beautiful illusion.[24]

There is an undoubted appreciation for the surreal in Král's anecdote, but it is an appreciation less for the marvelous than the absurd.[25] That army of over-sized slippers covered up more than shoes.

In 1951, the year of Karel Teige's death, Klement Gottwald's government had turned Star Castle into a museum to Alois Jirásek in celebration of the hundredth anniversary of the historical novelist's birth. Teige, we might recall, had dismissed the author of *Old Czech Legends* and *Against All* in the *Devětsil Revolutionary Miscellany* as "commonplace kitsch, repugnant and sentimental." The architect of the necessary renovations to the renaissance building was Pavel Janák, the creator of the Hlávka Bridge and the Adria Palace, who had by then long since left his cubist youth behind him. The Jirásek Museum was ceremonially handed over to the custody of Zdeněk Nejedlý's Ministry of Education on March 12. Photographs of the event capture the hunting lodge incongruously poised—to latter-day eyes—between gigantic posters of Klement Gottwald and Joseph Stalin.[26] The visitors would have encountered a marble plaque in the entrance hall whose text was by Gottwald. It sought to explain what might otherwise be regarded as a bizarre coupling, for there was no obvious historical affinity between the old patriotic novelist and the KSČ. Jirásek's name, after all, had stood at the head of the National Democratic Party's list of candidates for the Senate in the first Czechoslovak Parliament—the same National Democrats that were banned in 1945 along with several other prewar right-wing parties deemed to have betrayed the interests of the nation in the years leading up to the Munich Agreement. No matter. "We claim Jirásek," the plaque boasts, "and he is close to us—closer than to the old capitalist society—in that in his work he expressed in masterly fashion what in our traditions leads forward, toward freedom and the blossoming of the nation. His work thus teaches us a correct view of our past, strengthens our national pride, and fills us with historical optimism and faith in the creative powers of the people."[27]

The opening of the museum was the culmination of the "Jirásek Action" (*Jiráskova akce*) launched by the KSČ in November 1948. For the next ten years (in Gottwald's words again) "Jirásek's life and work, as well as the epochs and events that his work records"[28] saturated socialist Czechoslovakia. The novelist was not the only nineteenth-century awakener to be retrospectively enlisted in the service of socialist construction: Božena Němcová, Bedřich Smetana, and other giants of the "national culture" came roaring back in spades. The next year—the year of the Slánský trial—was officially proclaimed the Mikoláš Aleš Year (*Alšův rok*) and celebrated with a six-month-long homage that colonized four separate venues in what was proba-

bly the largest celebration of the work of a single artist ever seen in the city then or since.[29] "Today," wrote František Nečásek in the catalogue of the exhibition in the Riding School at Prague Castle, "[Aleš's] art rings out to us in newer tones than before." The spirits of the past were conjured up once again to stage a new world-historical scene in a venerable disguise and a borrowed language. The old signifiers kaleidoscoped anew:

> Aleš's *Sirotek* [The Orphan] or *Za chlebem* [In Search of Bread], these really are narrations of a past, which will not return; his Cossacks with the Soviet star on their caps really did come to the Old Town Square and have brought us freedom; his Hussites really have come back to life today in our people, in our mighty struggles for peace and the building of socialism; and happily, as never before, the joyful shrieks of Aleš's children and the songs of his skylarks ring out over the freshly green hereditary field of our nation.[30]

It was only fitting that "our most Czech artist" should join his old friend Alois Jirásek in Star Castle, which thereafter became known as the Alois Jirásek and Mikoláš Aleš Museum, in 1964.

The laughter with which Petr Král and his colleagues greeted their guests' reverence for Breton's starry castle is comprehensible. If the experience of communism heightened postwar Czech surrealists' appreciation for the ironic, the erotic, and the absurd, it also led them to a categorical rejection of modernity's more grandiose projects for revolutionizing circumstances and selves. Vratislav Effenberger acknowledged that prewar surrealism "focused on the examination of the everyday miraculous, with its own space of poetry and through unconscious psychic mechanisms, in such a way that it would allow the application of an awareness of the fact that this enormous source of energy is, in connection with the moments of revolt within economic and political laws, able to transform the world and change life." But "subsequent political developments," he bluntly concluded, had shown "that such a revolutionary transformation of history is in its maximalist presuppositions a mere romantic ideal." Breton's dream of reconciling Marx's *transformer le monde* and Rimbaud's *changer la vie* remained just that:

> Concrete irrationality ceases to be understood as a ferment of social revolution; it rather becomes a special kind of ontological deliberation, in which the forces of restlessness are latently present. . . . And if such a restless, magical force

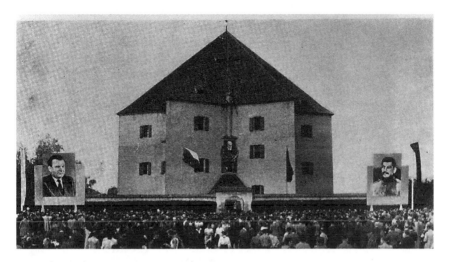

FIGURE 8.2. Ceremonial opening of Alois Jirásek Museum in Star Castle, Prague, 1951. Unknown photographer. Reproduced from Miloslav Novotný, *Roky Aloisa Jiráska*. Prague: Melantrich, 1953.

that is from times immemorial the authentic dynamism of poetry in a poem, image or life, does not overturn history, and more often acts through skepticism rather than enchantment, for it does not declare love, freedom and its poetic urgency, but rather discredits their antitheses, it nevertheless remains the only possibility of human mentality to transgress the limits of its own shadows.[31]

Surrealism retreats to being exactly what Paul Éluard defined it as in "Poetic Evidence"—an instrument of knowledge. Such stoicism would be needed in the years to come.

Four months later the abyss opened again and the reality principle triumphed over the pleasure principle in the shape of Soviet tanks. Needless to say *Aura* never saw the light of day. Effenberger did manage to produce a single issue of a new Czech surrealist journal called *Analogon* in 1969 titled "The Crisis of Consciousness" (*Krise vědomí*), which among other things reproduced Breton and Trotsky's manifesto "For an Independent Revolutionary Art," eight pages of extracts from the writings of Záviš Kalandra, and André Breton's "Open Letter to Paul Éluard." It would be the magazine's last appearance until, on the model of Paukert's delicatessen, it resumed publication under the same name after the Velvet Revolution of 1989.[32] *L'Archibras* published a special, unbound issue *hors série* dated 30 September 1968. It was

headed simply: "Czechoslovakia" (*Tchécoslovaquie*). The word was stamped diagonally across the top of the page inside a rectangle in green ink, as if from a Kafkan bureaucrat's rubber stamp. It was here that the "Prague Platform" first saw the light of day. The text was signed by twenty-eight members of the Paris surrealist group. "In other circumstances," the editors explained, "it would have carried the signatures of twenty-one Czechoslovak surrealists and eleven foreign surrealists resident in Paris."[33]

The issue opened with an editorial titled "Réalité politique et réalité policière," which attempted to cling to the year's fading dreams. The "political reality," it proclaimed, "is one and new, the movement of emancipation of the interior *repressed* which, emancipating individually, invents the collective destiny." Against the "wild forces of the interior world" stand "the ideological uniforms of the cops.... Long live the political reality of S.D.S., of Black Power, of the Vietcong, of the American and African guerillas, of the *enragés* of Nanterre, of the workers of Flins, of the Czechoslovak people!"[34] It is as surreal a montage of long-gone modernities, to twenty-first-century eyes, as Otakar Mrkvička's melding of red stars and skyscrapers on Wenceslas Square. The article that follows is defiantly titled "You Can't Stop the Spring" (*On n'arrête pas le printemps*). It was written, we are told, by "the Czech surrealists who left Prague on the 30th August," who are not named, but one of them was Petr Král.[35] "Despite the tanks with which they have not hesitated to shackle a whole country," the article ends, "the heirs of Stalin have only gained a still greater isolation in their fortified ivory tower ... in the *subterranean* regions where man always recreates himself flamboyant revolts are being born, red as the blood with which the soil is saturated."[36]

But it soon became clear which way the winds were blowing. In its penultimate issue, published in December 1968, *L'Archibras* carried an attempt "to define the interior situation of surrealism in Czechoslovakia" titled "Prague in the Colors of Time" (*Prague aux couleurs du temps*). A prefatory note made clear that "recent events have rendered parts of this text, dated from Prague December 1967–January 1968, purely historical."[37] The moment of the wild forces had passed and the field belonged to History. As it turned out *The Pleasure Principle* would be the last international exhibition mounted by the surrealist movement, at least in so far as that movement was identified with the person of André Breton. To the dismay of many of its affiliates around the world—not least in Prague, where those Czechoslovak surrealists who had not fled abroad were preparing once again to walk by night[38]—the Paris surrealist group formally dissolved itself a few months later on February 8, 1969. The seventh and last issue of *L'Archibras*, dated March 1969, was (in

the words of Gérard Durozoi) "the last collective expression of a surrealist group that had indeed ceased to exist."[39] Its contents included Adrien Dax's "Attempt at Reconstitution of an Associative Visual Trajectory in the Course of a Distracted Observation of the Square Neighboring the Old Prague Horologe on Friday 12 April 1968 at around 3.00 p.m.," which only served to underline how rapidly the city had slipped back into the realm of poetic space.[40]

THE DANCING HOUSE

Were André Breton to join Kafka, Nezval, and the rest of Ripellino's ghostly *passants de Prague*, rising from his grave to wander a landscape that haunts him—and why should he not, since the city furnished him with one of the most beautiful memories of his life—he would find Charles Bridge, the Street of the Alchemists, and the clock in the ghetto still there, still turning backward. Their magic may be a little tarnished now, but seen in the early light of morning, before the souvenir shops are open and the tourists are up and about, Prague still presents a reasonable facsimile of her imagined self. André would surely wish to take the tram to Bílá hora and refresh his memory of the triangular configurations of Star Castle. For the gold of time, though, he might do better to revisit the scene of his lecture on the surrealist situation of the object. People still unaccountably persist in calling it Žofín Island even as—apparently—the city enters the postmodern era, putting the ill-starred twentieth century behind it. The Mánes Gallery is once again owned by a Mánes Artists' Society, even if its connections with its various pasts are as fractured as those of Paukert's delicatessen or the Grand Café Orient. Dissolved in 1949 on grounds that it was "superfluous" and its continued existence "would impede the building of socialism,"[41] the old society was reconstituted by twenty-two surviving members in 1990.[42]

Sipping a beer on a sunny day on the Mánes terrace today, it is difficult not to admire the felicity of the chance encounter of the old onion dome on the water tower around which Otakar Novotný wrapped his up-to-the-minute modernist gallery and the cupola that tops Frank Gehry and Vlado Milunić's postmodern Dancing House on the corner of the Rašín Embankment and Jirásek Square. The cupola is affectionately known to its creators as "Medusa." Built in 1994–96, the Dancing House is the product of another moment when Prague sought to project itself back into Europe (*zpátky do Evropy*), as the slogan ran with which Václav Havel's Civic Forum won the 1990 elections. The playwright-president, whose neighboring apartment Milunić had remodeled a few years earlier, was a keen champion of the riverbank development. Nobody now remembers who nicknamed Gehry's confection

"Fred and Ginger" after the Hollywood stars whose Depression-era movies (*The Gay Divorcee, Top Hat, Shall We Dance?*) seemed to have inspired the amorous twirling of its asymmetric towers, but the sobriquet stuck. An unlikely couple, we might think, to leave so emphatic a mark on the magic capital of old Europe, but we should know by now that the reference is not so out of place as it might seem. Just listen to Jaroslav Ježek's "Dark Blue World."

There are other lingerings here, too. Although the final form of the Dancing House owes more to Gehry than his local Slovenian partner, the celebrity architect was only brought in on the project after the Dutch insurance firm Nationale Nederlanden bought the plot in 1992. Vlado Milunić's initial design, which won the 1990 competition for the site, was inspired by three visions. "The end-result is an extract from these apparent idiocies," he emphasizes, "but nothing will change the fact that this is how the building first arose." Milunić's first inspiration, he says, was "a kind of 'reminiscence of Moscow,' where [the] building is two-thirds constructed in Socialist Realist style with high cornices and Corinthian columns," while "the upper third [is] completed very plainly and economically," "an analogy of a society undergoing its own purification in the form of a striptease." The second was "a building charged with the internal energy of the [1989] revolution, so that it is bursting at the seams like a bean pod, with red-white-and-blue colors"—the colors of the Czech national flag—"pushing themselves out." The third was "a Czech Joan of Arc, straining towards the magical center of the city."[43] This being Prague, where naked females impersonate the Vltava in the courtyard of the National Theater, personify work and humanity on the pylons of the Hlávka Bridge, masquerade as muses on the City Library, and trip prettily across the façade of Pavel Janák's Adria Palace on Jungmann Square, this born-again Maid of Orléans bursts from the building barebreasted, just like her sisters who hold up the windows on the Secession apartment houses on the same embankment—except that Milunić's Dream of Venus is a post-communist porn queen seven stories tall, flashing her pubic hair. "Charged with internal energy," the architect explained in his submission to the jury, "the building is bursting at its seams; the terrace protrudes like the tongue of the Rolling Stones logo stuck out towards Mánes and the Castle."[44]

The Dancing House is the unlikely outcome of a chance encounter between the euphoria of the Velvet Revolution and the new-age building technologies that produced Gehry's titanium-clad Guggenheim Museum in Bilbao, staged in a location left vacant by the combination of a botched World War II Allied bombing raid and four decades of communist neglect. The

American pilots may have mistaken Prague for Dresden—the 150-ton pay-load they dropped from their Flying Fortresses around noon on 14 February 1945 hit neither factories nor military targets—while the site itself, with its downtown location and picture-postcard view across the river to Hradčany, would under any other circumstances have been prime real estate. But these were not other circumstances. Vacant lots lose their value when private property is nationalized, and the communists had no interest in reconstructing the mansions of the rich. The owner of the building destroyed by the B-17s, Jaroslav Nebesář, a prominent left-wing lawyer, was show-tried and sentenced to fifteen years imprisonment for "espionage, sabotage, and treason" in 1954.[45] The Havel family clung onto the remnants of their patrimony next door, where they occupied an apartment in a Secession house built by the president's grandfather in 1904–5.

The Dancing House went on to win *Time* magazine's award for the Best Design of 1996, beating out the new Camel cigarette pack, Calvin Klein's couture, and Rem Koolhaas's *S, M, L, XL*. But the inscription of Jumping Jack Flash—or Ginger Rogers and Fred Astaire, come to that—on the Prague landscape met with less than unanimous approval at home. Gehry and Milunić's creation conspicuously failed to receive even an honorable mention in the 1997 competition for the Grand Prix of the Association of Architects, awarded for the best architectural work in the Czech Republic the previous year. The building's detractors charged that it arrogantly overrode its context—a context that had too great a historical weight to be played with so lightly. "Prague is no longer ours—Czech?" fumed one indignant signatory to the visitors' book; "an architectural monstrosity worthy of Disneyland" spluttered another.[46] Such objections did not come just from architectural conservatives or indeed only from Czechs. Czechoslovakia's long-forgotten "modernity worthy of the name," as Kenneth Frampton has called it, was by then belatedly engaging the imagination of the west.[47] Gehry was widely accused of betraying the heritage of Czech *modernism*, as exemplified by the clean lines of Otakar Novotný's Mánes Gallery across the street. As ever, more than just aesthetics was at stake here. For a world bent on sloughing off the Corinthian façades of socialist realism this memory of what once was, flashing up in *that* moment of danger, had a particular salience.

The moment and the danger passed. The Dancing House has since insinuated itself into its surroundings, joining Hradčany, Charles Bridge, and the rest of the marvels of the magical center of the city as an obligatory stop on the tourist trail. Now that the fuss has died down it has become possible to appreciate the building's echoes of the sinuousness of the Prague Secession,

the daring of Prague cubism, or the exuberance of the Prague baroque, all of which fractured planes and bent surfaces long before Gehry ever set foot in the city. The building seems no more out of place today than the Mánes Gallery, to whose earlier juxtapositions of old and new "Medusa" so eloquently gestures. Josef Pažout has gone so far as to claim that (thanks, he believes, to Vlado Milunić's input into the project) Prague was the first city that compelled the American maestro to bow before its *genius loci* and create "a sort of revelation—the new Baroque of the twentieth century."[48] "My intention," Gehry himself stressed when talking about the Dancing House, "is to be part of each place. My effort is to work contextually, but not to pander to tradition. . . . I think Bilbao relates to there, and Prague to there. I wouldn't have done those buildings in Los Angeles."[49] It came as no surprise when in 2000 the Dancing House was belatedly awarded the Mayor of Prague's prize for "an architectural work of exceptional quality" constructed during the previous decade. The city abounds in such anomalies. Sooner or later they meld into the landscape, their incongruities forgotten as they recede into a past that is as pliable as Salvador Dalí's soft watches.

All too easily overlooked, in the middle of the little square that is framed by Novotný's Mánes Gallery on the one side and Gehry's Dancing House on the other—poised, we might say, between the modern and the postmodern—is a statue of Alois Jirásek. The Czech Walter Scott lived on the square that bears his name from 1903 until his death in 1930—the same year, coincidentally, as the newly erected Mánes Gallery spoiled his view. The monument might come as something of a surprise to Breton, though to a surrealist it really should not; in 1935 Jirásek's brand of backward-looking nationalism was hopelessly passé, at least in the progressive, left-wing circles through which Breton and Éluard made their acquaintance with the city. But as should be abundantly clear by now Prague is not a place in which history always goes forward, backward not a step. The statue was erected in 1960 by grateful communists whose recycling of the dreamworlds of the nineteenth century had given a new meaning to Julius Fučík's unintentionally ironic definition of socialism as "The Land Where Tomorrow Already Means Yesterday."[50] Now that the communists too have gone the way of all flesh the Jirásek monument seems set to become what Zdeněk Hojda and Jiří Pokorný, in their excellent book on Prague's statuary, call a *zapomník*. *Pomník* is the Czech word for a memorial; *zapomník* is Hojda and Pokorný's neologism, which puns on the verb *zapomenout*, to forget. A *zapomník* is a "forgetorial"— a sign that lingers in the landscape only to remind us of the ineluctability of

forgetting, because what it once signified has slipped away into time out of mind.[51]

I would not lay any bets on it, though. Statues have come to life here before, accepting invitations to dinner only to drag their hosts down into the abyss. Old Mr. Jirásek is a forlorn figure now, his head a perch for shitting pigeons. What André Breton might make of him I have no idea. But he irresistibly reminds me, in a diminutive, Czech, *malé, ale naše* kind of way, of Walter Benjamin's abject angel of history.

FIGURE 8.3. André Breton, found object. The object was subsequently placed on Breton's grave. Photograph by Radovan Ivšić, *L'Archibras*, No. 1, April 1967, 21.

Notes

INTRODUCTION

1. "It is necessary to confront vague ideas with clear images." The slogan was emblazoned across the wall of the apartment in which much of the action of Jean-Luc Godard's *La Chinoise* takes place. See the film still reproduced in "La Chinoise," available at http://www.critikat.com/La-Chinoise.html (accessed 1 May 2012).

2. Jean-François Lyotard, *The Postmodern Condition: A Report on Knowledge*, trans. Geoff Bennington and Brian Massumi, Manchester, UK: Manchester University Press, 1984.

3. Walter Benjamin, "One-Way Street," in his *Selected Writings, Volume 1: 1913–1926*, ed. Marcus Bullock and Michael W. Jennings, Cambridge, MA: Belknap Press of Harvard University Press, 1996, 444–88.

4. Walter Benjamin, *The Arcades Project*, ed. Roy Tiedemann, trans. Howard Eiland and Kevin McLaughlin, Cambridge, MA: Harvard University Press, 1999, 458.

5. Charles Baudelaire, *The Painter of Modern Life and Other Essays*, trans. Jonathan Mayne, New York: Phaidon, 2005, 12.

6. Benjamin, *Arcades*, 464.

7. Ibid., 389.

8. Ibid., 389–90.

9. Ibid., 388–89.

10. Ibid., 462. Emphasis added.

11. Ibid., 473. Emphasis added.

12. Marcel Proust, *The Way by Swann's* (Vol. 1 of *In Search of Lost Time*), trans. Lydia Davis, London: Allen Lane, 2002, 50.

13. Benjamin, *Arcades*, 462.

14. Ibid., 391.

15. Ibid., 564.

16. Ibid., 84.

17. Ibid., 458.

18. Ibid., 13.

19. Ibid., 83.

20. Ibid., 461. Emphasis added.

21. Ibid., x.

22. Ludwig Wittgenstein, *Tractatus Logico-Philosophicus*, trans. Brian McGuinness and David Pears, London: Routledge, 2001, 89.

23. Benjamin, *Arcades*, 460. Emphasis added.

24. Ibid., 463.

25. Milan Kundera, *Testaments Betrayed*, trans. Linda Asher, New York: Harper-Collins, 1995, 50.

26. Benjamin, *Arcades*, 13.

27. Eric Hobsbawm, *The Age of Extremes: The Short Twentieth Century 1914–1991*, London: Abacus, 1995.

28. Benjamin, *Arcades*, 456.

29. I allude to Francis Fukuyama, *The End of History and the Last Man*, London: Penguin, 1993—the last gasp, it might be argued, of the twentieth century's dreams. Fukuyama might usefully be read against the background of Timothy Snyder, *Bloodlands: Europe between Hitler and Stalin*, New York: Basic Books, 2010—a chilling study of the fourteen million people murdered by the Nazi and Soviet regimes, *as distinct from casualties of war*, between 1933 and 1945.

30. Though it should be said that neither the Czech ODS nor the Slovak HZDS parties, which negotiated the split, had campaigned in the June 1992 elections on a platform of dividing the country, and a large majority in opinion polls in both the Czech Lands and Slovakia opposed doing so at the time. The immediate cause of the split was a result of the failure of ODS and HZDS to agree a common platform for economic reform.

31. I discuss these events more fully and give plenty of examples of such uses of language in *The Coasts of Bohemia: A Czech History*, Princeton, NJ: Princeton University Press, 1998, 237–48. (Hereafter cited as *Coasts*.)

32. Max Weber, "Science as a Vocation," in *From Max Weber: Essays in Sociology*, ed. H. H. Gerth and C. Wright Mills, London: Routledge, 1974, 148.

33. "Modernity," writes Antony Giddens, is "a shorthand term for modern society, or industrial civilization. Portrayed in more detail, it is associated with (1) a certain set of attitudes towards the world, the idea of the world as open to transformation, by human intervention; (2) a complex of economic institutions, especially industrial production and a market economy; (3) a certain range of political institutions, including the nation-state and mass democracy. Largely as a result of these characteristics, modernity is vastly more dynamic than any previous type of social order. It is a society—more technically, a complex of institutions—which, unlike any preceding culture, lives in the future, rather than the past." *Conversations with Anthony Giddens: Making Sense of Modernity*, Stanford, CA: Stanford University Press, 1998, 94.

34. I am not, of course, the first to advance such arguments. See for instance

Zygmunt Bauman, *Modernity and the Holocaust*, Ithaca, NY: Cornell University Press, 2001.

35. Václav Havel, "The Power of the Powerless," in his *Living in Truth*, London: Faber and Faber, 1987. See my essay "Everyday Forms of State Formation: Some Dissident Remarks on 'Hegemony,'" in *Everyday Forms of State Formation: Revolution and the Negotiation of Rule in Modern Mexico*, ed. Gilbert M. Joseph and Daniel Nugent, Durham, NC: Duke University Press, 1994, 367–78.

36. Karel Čapek, preface to *At the Crossroads of Europe*, Prague: PEN-Club, 1938, reprinted in Eva Wolfová, *Na křížovatce Evropy: Karel Čapek a Penklub*, Prague: Památník Národního písemnictví, 1994, 22–27. Prague was chosen for the congress as a gesture of support in the face of the German pressure that was to lead to Munich.

37. Kenneth Frampton, "A Modernity Worthy of the Name," in *The Art of the Avant-Garde in Czechoslovakia 1918–1938/El Arte de la Vanguardia en Checoslovaquia 1918–1938*, ed. Jaroslav Anděl, Valencia, Spain: IVAM Institut d'Art Modern, 1993, 213–31. See also my essay "Hypermodernism in the Boondocks," *Oxford Art Journal*, Vol. 33, No. 2, 2010, 243–49.

38. See my subsequent discussion, pp. 97–99.

39. André Breton, *Nadja*, trans. Richard Howard, New York: Grove Press, 1960, 60.

40. Benjamin, *Arcades*, 13.

41. See the closing arguments in my book *Capitalism and Modernity: An Excursus on Marx and Weber*, London: Routledge, 1991.

42. I borrow the expression from Max Weber, "Science as a Vocation," in *From Max Weber*, ed. H. Gerth and C. Wright Mills, London: Routledge, 1974, 143.

43. See Karl Marx, *The Civil War in France*, in Karl Marx and Friedrich Engels, *Collected Works*, Vol. 22, New York: International Publishers, 1987.

44. Benjamin, *Arcades*, 25–26. My emphasis.

1. THE STARRY CASTLE OPENS

1. André Breton, *Mad Love*, trans. Mary Ann Caws, Lincoln: University of Nebraska Press, 1987, 97.

2. The flyer is reproduced in *Český surrealismus 1929–1953: Skupina surrealistů v ČSR: události, vztahy, inspirace*, ed. Lenka Bydžovská and Karel Srp, Prague: Galerie hlavního města Prahy/Argo, 1996, 82.

3. Brassaï, *Conversations with Picasso*, trans. Jane-Marie Todd, Chicago: University of Chicago Press, 2002, 11–12.

4. Éluard to Gala, 7–8 April 1935, in Paul Éluard, *Lettres à Gala 1924–1948*, Paris: Gallimard, 1984, 254. The latter is available in English as *Letters to Gala*, trans. Jesse Browner, New York: Paragon House, 1989, though I have used the French edition here.

5. Unless otherwise indicated, all information on the changing names of Prague streets, squares, embankments, and so on in this book is derived from the following sources: *Kronika královské Prahy i obcí sousedních*, 3 vols., ed. František Ruth, Prague: Pavel Körber, 1903; *Původní názvy pražských ulic, nábřeží, nádraží a sadů podle stavu v r. 1938*, Prague: Česká obec turistická, 1945; *Seznam ulic, náměstí atd. hlavního*

města Prahy (stav k 1. květnu 1948), Prague: Dopravní podniky hl. m. Prahy, 1948; *Ulicemi města Prahy od 14. století do dneška*, Prague: Orbis, 1958; and M. Lašťovka, *Pražský uličník: encyklopedie názvů pražských veřejných prostranství*, 2 vols., Prague: Libri, 1998.

6. Henry-Russell Hitchcock and Philip Johnson, *The International Style*, New York: Norton, 1995 (reprint of original 1932 MoMA catalogue, with additional matter).

7. Zdeněk Wirth, V. V. Štech, and V. Vojtíšek, *Zmizelá Praha, 1. Staré a Nové město s Podskalím*, Prague: Václav Poláček, 1945, 63, 66, and plates 34 and 35. There were six volumes of *Zmizelá Praha*; for details, see the bibliography.

8. André Breton, "Surrealist Situation of the Object: Situation of the Surrealist Object," in his *Manifestoes of Surrealism*, trans. Richard Seaver and Helen R. Lane, Ann Arbor: University of Michigan Press, 1972, 255–56.

9. Luis Buñuel, *My Last Breath,* trans. Abigail Israel, London: Fontana, 1985, 106.

10. "In number 42 [rue Fontaine] we discovered that Breton had just left. I'm tired, I'm dejected. I ask Honzl if we can rest awhile at the café on the corner of the square. We go in. We choose the first empty table. Opposite us is sitting André Breton. It's like a scene from Nadja.'" Vítězslav Nezval, *Neviditelná Moskva*, Prague: Borový, 1935, quoted in Bydžovská and Srp, *Český surrealismus*, 21.

11. There were two issues of *Zvěrokruh*, in November and December 1930. Apart from writings by Nezval, Teige, Vančura, Brouk, and other Czechs, they contained translations of prose and poetry by Breton, Éluard, Soupault, Tzara, Cocteau, Mallarmé, and Baudelaire among others. A small extract from *Nadja* was carried in *Zvěrokruh* 1, 4–6, and the *Second Manifesto of Surrealism* was translated in *Zvěrokruh* 2, 60–74. Both issues have been reprinted, together with other key texts of 1930s Czech surrealism, as *Zvěrokruh 1/Zvěrokruh 2/Surrealismus v ČSR/Mezinárodní bulletin surrealismu/Surrealismus*, Prague: Torst, 2004. This collection is hereafter cited as Torst Surrealist Reprints.

12. *Výstava Poesie 1932*, Prague: Mánes, 1932. The other Czech artists represented were the painters František Muzika, Alois Wachsmann, Adolf Hoffmeister, Emil Filla, and František Janoušek, and the sculptors Hana Wichterlová and Bedřich Stefan.

13. André Breton, "Sunflower," in *Earthlight*, trans. Bill Zavatsky and Zack Rogow, Los Angeles: Sun and Moon Press, 1993, 76. Rogi André's photographs of Lamba's naked performances at the Coliséum (one of which was published to accompany Breton's text in *Minotaure* and subsequently reproduced in *Mad Love*) are reproduced in *La Subversion des images: Surréalisme, Photographie, Film*, ed. Marion Diez, Paris: Centre Pompidou, 2009, 368–69.

14. Mark Polizzotti, *Revolution of the Mind: The Life of André Breton*, New York, Da Capo, 1997, 402–4.

15. Breton, "Surrealist Situation of the Object," 268.

16. The term *Czech Lands (České země)*, or *Bohemian Lands*, refers to Bohemia (Čechy), Moravia (Morava), and Czech Silesia (Slezsko). Slovakia (and until 1945, Sub-Carpathian Ruthenia) were joined with the Czech Lands in 1918 to form the state of Czechoslovakia, which was succeeded by the independent Czech and Slovak Republics on 1 January 1993.

17. In his letter to Nezval of 25 August 1936, Breton speaks of his plans to spend "several years in Prague (or Mexico)." Vítězslav Nezval, *Korespondence Vítězslava Nezvala: depeše z konce tisíciletí*, Prague: Československý spisovatel, 1981, 95.

18. See the report in *Rudé Právo*, 3 April 1935, in Torst Surrealist Reprints, 127.

19. Éluard to Gala, 7–8 April 1935, in *Lettres à Gala*, 253.

20. André Breton, *Co je surrealismus?*, Brno: J. Jícha, 1937. This contained "What Is Surrealism?" together with Breton's 1935 Mánes Gallery and Left Front lectures.

21. Breton's talk on Radiojournal Brno, recorded on 5 April 1945, is included in Torst Surrealist Reprints, 203. It is notable among other things for his insistence that "surreality is contained in reality itself."

22. Éluard to Gala, 7–8 April 1935, 253. The poem is reproduced, in Vítězslav Nezval's Czech translation, in Torst Surrealist Reprints, 204.

23. Nezval, diary entry, 5 April 1935, in Bydžovská and Srp, *Český surrealismus*, 83; Éluard to Gala, 7–8 April 1935, 253.

24. The Bulletin was officially dated April 9. *Bulletin international du surréalisme/Mezinárodní bulletin surrealismu*, 9 April 1935, in Torst Surrealist Reprints, 121–132.

25. André Breton, "Limits Not Frontiers of Surrealism," in *Surrealism*, ed. Herbert Read, New York: Harcourt, Brace, n.d. [1937], 95.

26. Read, *Surrealism*, 19.

27. Ibid., plate 96.

28. Nezval, diary entry, 2 April 1935, in Bydžovská and Srp, *Český surrealismus*, 82.

29. Nezval, diary entry, 4 April 1935, in ibid., 83. On Brno's interwar architectural modernism, see Zdeněk Kudělka and Jindřich Chatrný, eds., *For New Brno: The Architecture of Brno 1919–1939*, 2 vols., Brno: Museum of the City of Brno, 2000.

30. Comte de Lautréamont, *Maldoror and the Complete Works of the Comte de Lautréamont*, trans. Alexis Lykiard, Cambridge, MA: Exact Change, 1994.

31. Breton, "Surrealist Situation of the Object," 275.

32. André Breton, "Le Château Étoilé," *Minotaure* (facsimile reprint, 3 vols., Geneva: Skira, 1981), No. 8, 1936, 25–40.

33. *Minotaure*, No. 1 (1933), unpaginated front matter.

34. Dr. [Jacques] Lacan, "Le problème du style et les formes paranoïaques de l'expérience," *Minotaure*, No. 1, 1933, 68–69; *Minotaure*, No. 1 (numéro spéciale), *Mission Dakar-Djibouti*, 1933. Lacan also published an article on the Papin Sisters later that year: "Motifs du Crime Paranoïaque: le crime des soeurs Papin," *Minotaure*, Nos. 3/4, 1933, 25–28.

35. Georges Bataille, "On the Subject of Slumbers," in his *The Absence of Myth: Writings on Surrealism*, ed. and trans. Michael Richardson, London: Verso, 2006, 49.

36. André Breton, "Second Manifesto of Surrealism," in *Manifestoes of Surrealism*, 184–86.

37. Bataille, "The Castrated Lion," in *Absence of Myth*, 28–29.

38. Brassaï, *Conversations with Picasso*, 10–11.

39. *Minotaure*, No. 9, 1936, "A nos lecteurs," unpaginated front matter.

40. *Minotaure*, facsimile reprint, 1981, has all the original artwork, including the covers, in full color. For background, see *Focus on Minotaure: The Animal-Headed*

Review, Geneva: Musée d'Art et d'Histoire, 1987; Dawn Ades, *Dada and Surrealism Reviewed*, London: Arts Council of Great Britain, 1978, 278–329. The latter remains the most comprehensive work yet published on Dada and surrealist periodicals.

41. *Minotaure*, No. 9, 1936, unpaginated front matter.

42. Brassaï, *Conversations with Picasso*, 7, 13.

43. Breton, *Mad Love*, 97–98.

44. Breton, "Le Château Étoilé," 40. The illustration is reproduced (and ascribed jointly to Max Ernst and Man Ray; Ray photographed the frottages for publication but is not credited in *Minotaure*) in Noriko Fuku and John P. Jacob, *Man Ray: Despreocupado pero no indiferente/Unconcerned but Not Indifferent*, Madrid: La Fabrica, 2007, 193.

45. Breton, "The Political Position of Today's Art," in *Manifestoes of Surrealism*, 213–14.

46. Ibid.

47. Breton, "Interview with *Haló-noviny*," in André Breton, *What Is Surrealism? Selected Writings*, ed. Franklin Rosemont, New York: Pathfinder, 1978, Book 2, 142.

48. *The International Style*, Hitchcock's preface to 1962 reissue, 22.

49. The title, which was suggested by Paul Valéry, derived from the last line of Verlaine's poem "Art poétique"—"all the rest is literature." Breton had at first wanted to call the magazine *Le Nouveau Monde* (The New World). Polizzotti, *Revolution of the Mind*, 93–95.

50. Breton, "Political Position of Today's Art," 220–21.

51. Teige in *Doba*, No. 6, 12 April 1934, quoted in Bydžovská and Srp, *Český surrealismus*, 78–79.

52. On Teige's quarrel with Štrysky, see the following, pp. 241–42. Teige gave his own explanation of his delay in joining the group in "Surrealismus proti proudu," in Karel Teige, *Výbor z díla II, Zápasy o smysl moderní tvorby: studie z třicátých let*, Prague: Československý spisovatel, 1969, 523–24. The "old quarrels," he says, "were very smoothly liquidated"; his concern was rather that the group would be based on solid dialectical materialist foundations. The three volumes of these selected works, edited by Jiří Brabec, Vratislav Effenberger, Květoslav Chvatík, and Robert Kalivoda, were published in 1966, 1969 (Prague: Československý spisovatel), and 1994 (Prague: Český spisovatel), respectively, though most copies of Vol. 2 were pulped before reaching the bookstores. Cited hereafter as KTD plus volume number.

53. Nezval to Breton on behalf of Devětsil, *Surrealismus v ČSR*, 21 March 1934, in Torst Surrealist Reprints, 115. The signatories of *Surrealismus v ČSR* were Vítězslav Nezval, Konstantín Biebl, Bohuslav Brouk, Imre Forbath, Jindřich Honzl, Jaroslav Ježek, Katy King, Josef Kunstadt, Vincenc Makovský, Jindřich Štyrský, and Toyen. Forbath, King, and Kunstadt dropped out of the group soon afterward; Makovský was later expelled.

54. See "Surrealism: The Last Snapshot of the European Intelligentsia" (1929), in Walter Benjamin, *Selected Writings, Volume 2 1927–1934*, Cambridge, MA: Belknap Press of Harvard University Press, 1999, 207–21.

55. Letter to Ústřední agitprop KSČ, 19 March 1934, in *Surrealismus v ČSR*, Torst Surrealist Reprints, 115.

56. Karel Teige, "Surrealismus není uměleckou školou," in *První výstava skupiny surrealistů v ČSR: Makovský, Štyrský, Toyen*, Prague: Mánes, 1935, 3–4. Teige's text has recently been translated (by Kathleen Hayes) as "Surrealism Is Not a School of Art," along with Vítězslav Nezval's essay for the same exhibition catalog "Systematic Investigation of Reality through the Reconstruction of the Object, Hallucination, and Illusion," in Karel Srp and Lenka Bydžovská with Alison de Lima Greene and Jan Mergl, *New Formations: Czech Avant-Garde Art and Modern Glass from the Roy and Mary Cullen Collection*, Houston: Museum of Fine Arts/New Haven, CT: Yale University Press, 2011, 180–83 and 183–87, respectively.

57. Collages from *Stěhovací kabinet* are reproduced in Lenka Bydžovská and Karel Srp, *Jindřich Štyrský*, Prague: Argo, 2007, 279–327. Karel Srp, *Jindřich Štyrský*, Torst, 2001 (a bilingual English-Czech edition) provides an excellent selection from Štyrský's three cycles of photographs *Frog Man, Man with Blinkers*, and *Parisian Afternoon*.

58. André Breton (and 21 others), "On the Time When the Surrealists Were Right," in *Manifestoes of Surrealism*, 253.

59. Nezval to Breton, after 7 September 1935, in *Korespondence Vítězslava Nezvala*, 85.

60. André Breton, *Position politique du Surréalisme*, Paris: Éditions du Sagittaire, 1935 ; reprint, Paris: Société Nouvelle des Éditions Pauvert, 1971. This collection also contained Breton's 1935 Speech to the Congress of Writers in Defense of Culture.

61. André Breton and Leon Trotsky, "Manifesto for an Independent Revolutionary Art," in Breton, *What Is Surrealism?*, Book 2, 185.

62. Záviš Kalandra, "A. Breton a P. Éluard v Levé frontě," *Haló-noviny*, 3 April 1935, quoted in *Bulletin international du surréalisme/Mezinárodní bulletin surrealismu*, 1, 1935, 6, in Torst Surrealist Reprints, 126.

63. Záviš Kalandra, *Doba*, 15–16, quoted in *Bulletin international du surréalisme/Mezinárodní bulletin surrealismu*, 1, 1935, 4–5, in Torst Surrealist Reprints, 124–25.

64. Jacqueline Lamba, "A Revolutionary Approach to Life and the World," in *Surrealist Women: An International Anthology*, ed. Penelope Rosemont, Austin: University of Texas Press, 1998, 77.

65. Breton, *Mad Love*, 41.

66. Ibid., 67.

67. For details, see Mary Ann Caws, *Dora Maar with and without Picasso: A Biography*, London, Thames and Hudson, 2000, 60, 81–83.

68. Bataille, "Un cadavre," in *Absence of Myth*, 32.

69. Éluard to Gala, 7–8 April 1935, in *Lettres à Gala*, 252–53. The magazine to which Éluard refers is *Tvorba*.

70. *Světozor*, Vol. 35, No. 13, 28 March 1935. Stachová's cover is discussed in Jindřich Toman, *Foto/montáž tiskem/Photo/Montage in Print*, Prague: Kant, 2009, 69.

71. "Transform the world, said Marx; change life, said Rimbaud: for us, these two watchwords are one (A.B.)." Entry on Karl Marx in André Breton and Paul Éluard, *Dictionnaire abrégé du surréalisme* (1938), facsimile reprint, Paris: José Corti,

2005, 17. Breton is quoting the closing words of his 1935 Speech to the Congress of Writers, which I discuss later, pp. 379–80; *Manifestoes of Surrealism*, 241.

72. Breton to Nezval, 14 April 1935, in *Korespondence Vítězslava Nezvala*, 82.

73. Nezval diary entry, 10 April 1935, in Bydžovská and Srp, *Český surrealismus*, 83. Toyen gave Breton her painting *Promethea* and Éluard *Hlas lesa* (Voice of the Woods), while Štyrský gave Breton his *Kořeny* (*Roots*) and Éluard *Sodom a Gomorha* and *Člověk krmený ledem* (The Man of Ice). Toyen also gave them both watercolors, and Štyrský, collages.

74. Éluard to Nezval, Sunday (April 1935), in *Korespondence Vítězslava Nezvala*, 131.

75. Nezval to Éluard, 19 May 1935, in ibid., 136.

76. Breton to Nezval, 14 April 1935, in *André Breton: La beauté convulsive*, ed. Agnès Angliviel de la Beaumelle, Isabelle Monod-Fontaine, and Claude Schweisguth, Paris: Éditions du Centre Georges Pompidou, 1991, 225. The full text (in Czech translation) can be found in *Korespondence Vítězslava Nezvala*, 81–83.

2. ZONE

1. Konstantín Biebl, *S lodí, jež dováží čaj a kávu* (1927), in his *Cesta na Jávu*, Prague: Labyrint, 2001, 116.

2. Bohumil Hrabal, *I Served the King of England*, trans. Paul Wilson, London: Picador, 1990, 86, 99–100.

3. Éluard to Gala, 7–8 April 1935, in *Lettres à Gala*, 253–54.

4. *Les Mamelles de Tirésias: drame surréaliste en deux actes et un prologue* (1917), in Guillaume Apollinaire, *Oeuvres poétiques*, Paris: Gallimard, 1965, 863–913.

5. Guillaume Apollinaire, "Zone," in *Alcools*, ed. and trans. Donald Revell, Hanover, NH/London: Wesleyan University Press, 1995, 2–3. This is a bilingual French-English edition. I have modified Revell's translation both here and elsewhere.

6. Apollinaire's own words, quoted in Guillaume Apollinaire, *Alkoholy života*, ed. Adolf Kroupa and Milan Kundera, Prague: Československý spisovatel, 1965, 121.

7. André Billy, quoted in Apollinaire, *Alkoholy života*, 121.

8. Apollinaire, "Zone," 8–9.

9. Many of the details that eventually made their way into "Le Passant de Prague" (including the sentence "Bohemia produces everything except salt") were recorded in the notebook Apollinaire kept during his 1902 visit. See *Alkoholy života*, 121–22.

10. Guillaume Apollinaire, *The Wandering Jew and Other Stories*, trans. Rémy Inglis Hall, London: Rupert Hart-Davis, 1967, 3.

11. Vítězslav Nezval, *Pražský chodec*, Prague: Borový, 1938, 172.

12. Apollinaire, "The Wandering Jew," 4.

13. Ibid., 9.

14. Antonín Podlaha and Antonín Šorm, *Průvodce výstavou svatováclavskou*, Prague: Výbor svatováclavský, 1929 (official guide to Saint Václav millennium exhibition in Prague Castle).

15. For an introduction to Švabinský's work, see Jana Orlíková, *Max Švabinský: ráj a mýtus*, Prague: Gallery, 2001. I discuss Švabinský at greater length in *Coasts*.

16. Josef Sudek, *Svatý Vít*, Prague: Družstevní práce, 1928. Torst's excellent

series *Josef Sudek: Works,* of which several volumes have already appeared in simultaneous Czech and English editions (*Portraits,* 2007; *The Window of My Studio,* 2007; *The Advertising Photographs,* 2008; *Still Lifes,* 2008), brought out a volume titled *Svatý Vít/Saint Vitus's* in 2010 that includes not only Sudek's 1924–28 photographs of the cathedral but also his extensive series of 1942–45. Several of the images are reproduced in Anna Farová, *Josef Sudek,* Prague: Torst, 1995—a superbly produced collection of Sudek's work (which includes an English-language abridged translation of Farová's text). A good introduction to Sudek in English is *Josef Sudek: Poet of Prague,* New York; Aperture, 1990, which also contains a biographical profile by Farová.

17. Quoted in Anděl, *Art of the Avant-Garde in Czechoslovakia,* 451. For background on Družstevní práce and Krásná jizba, see Alena Adlerová, "Functionalist Design and the Beautiful Chamber," in ibid., 256–91; Alena Adlerová, *České užité umění,* Prague: Odeon: 1983; and Lucie Vlčková, ed., *Družstevní práce—Sutnar Sudek,* Prague: Uměleckoprůmyslové muzeum, 2006 (bilingual Czech-English edition).

18. See *Josef Sudek: The Commercial Photography for Družstevní práce,* ed. Maija Holma, Jyväskylä, Finland: Alvar Aalto Museum, 2003; Vlčková, *Družstevní práce—Sutnar Sudek;* and Josef Sudek, *The Advertising Photographs.*

19. Anna Farová, *Josef Sudek,* 45–46.

20. I refer again to the passage quoted earlier, p. 3: "By 'modernity,' I mean the ephemeral, the fleeting, the contingent, the half of art whose other half is the eternal and the immutable." Baudelaire, *Painter of Modern Life,* 12.

21. *Josef Sudek o sobě,* ed. Jaroslav Anděl, Prague: Torst, 2001, 92.

22. Jaroslav Funke, "Sudkovy fotografie," *Panorama,* Vol. 6, Nos. 1–2, 1928, pp. 56–59, trans. in Holma, *Josef Sudek: The Commercial Photography,* 11.

23. Josef Sudek, *Smutná krajina/Sad Landscape: Severozápadní Čechy/Northwest Bohemia 1957–62,* 2d ed., Prague: Kant, 2004. For interwar Czech modernist photography more generally, see Vladimír Birgus, ed., *Czech Photographic Avant-Garde 1918–1948,* Cambridge, MA: MIT Press, 2002; Matthew S. Witkovsky, *Foto: Modernity in Central Europe, 1918–1945,* Washington, DC: National Gallery of Art, 2007; Jaroslav Anděl, *The New Vision for the New Architecture: Czechoslovakia 1918–1938,* Bratislava: Slovart, 2005; and Alberto Anaut, ed., *Praha Paris Barcelona: modernidad fotográfica de 1918 a 1948/Photographic Modernity from 1918 to 1948,* Madrid: Museu Nacional d'Art de Catalunya/La Fábrica, 2010.

24. Antonín Dufek, "Memories of Reality," in *Josef Sudek: Dialogue with Silence,* Warsaw: Zachenta Narodowa Galeria Sztuki, 2006, 67.

25. Letter to Petr Helbich, summer of 1917, reproduced in Helbich's unpublished 1987 manuscript "Vzpomínky na Josefa Sudka," in Farová, *Josef Sudek,* 23–24.

26. Apollinaire, "The Wandering Jew," 10–11.

27. Vítězslav Nezval, *Edison,* trans. Eward Osers, Prague: Dvořák, 2003, 12–13. Translation modified.

28. As it is described in the "Lexique succinct de l'érotisme" included in *Exposition inteRnatiOnale du Surréalisme,* Paris: Galerie Daniel Cordier, 1959, 121. This exhibition is discussed later, p. 269. The "Lexique" is reprinted (along with a wealth

of other surrealist erotica) in *Si vous aimez l'amour . . . Anthologie amoureuse du surréalisme*, ed. Vincent Gille and Annie Le Brun, Paris: Éditions Syllepse, 2001, 305–55.

29. Georges Bataille, *The Story of the Eye*, trans. Joachim Neugroschel, San Francisco: City Lights, 1987; Guillaume Apollinaire and Louis Aragon, *Flesh Unlimited: Surrealist Erotica*, trans. Alexis Lykiard, New York: Creation Books, 2000. The latter contains both *Les Onze mille verges* and *Le Con d'Irène*.

30. *L'enfer de la Bibliothèque; Eros au secret*, Paris: Bibliothèque nationale de France, 2007, 253–54.

31. Apollinaire to Louise de Coligny, 8 January 1915, in Apollinaire, *Lettres à Lou*, Paris: Gallimard, 1990, 87.

32. Apollinaire, "The Wandering Jew," 11–12.

33. At the time of Apollinaire's visit, Královské Vinohrady had 47,056 Czech-speaking and 4,769 German-speaking inhabitants (1900 census). In 1851, according to an imperfect census, Prague had around 150,000 inhabitants, some 40 percent of whom claimed their nationality as German; by 1900, the conurbation had over half a million inhabitants, 93 percent of whom identified their "language of daily intercourse" as Czech. The population of the burgeoning suburbs had exceeded that of the five boroughs of historic Prague by 1890. Holešovice-Bubny (population 15,352) was incorporated into the city in 1884, Libeň (population 12,536) in 1901. The contiguous suburbs of Karlín, Smíchov, Žižkov, and Vinohrady, together with thirty-four other communities, were incorporated in 1922 to form Hlavní město Praha (Capital City Prague), at which point the official Prague population count rose from 223,700 (on the 1910 census) to 676,700 (on the 1921 census). As calculated on its 1922 boundaries, Prague had 514,345 inhabitants in 1900. Figures taken from Josef Erben, ed., *Statistika královského hlavního města Prahy*, Vol. 1, Prague: Obecní statistická kommisse královského hlavního města Prahy, 1871; relevant volumes of *Ottův slovník naučný*, Prague: Otto, 28 vols., 1888–1909, and *Ottův slovník naučny nové doby*, Prague: Otto, 12 vols., 1930–43; and Václav Vacek, "Praha—na hlavní evropské křižovatce," *Československo*, Vol. 1, No. 3, 1946.

34. Czech is a heavily gendered language. A *student* is a male student, a *studentka* a female student. Where a man would say "Dělal jsem" (I did), a woman would say "Dělala jsem." The soprano Jarmila Novotná (discussed later, pp. 337–39) titled her autobiography *Byla jsem šťastná* (I was happy) (Prague: Melantrich, 1991); had she been a tenor or a bass, the book would have been called *Byl jsem šťastný*.

35. Quoted in Angelo Maria Ripellino, *Magic Prague*, ed. Michael Henry Heim, trans. David Newton Marinelli, Berkeley: University of California Press, 1994, 109.

36. Philippe Soupault, "Do Prahy," *ReD*, Vol. 1, No. 1, October 1927, 3–4. The poem is in the original French. Soupault also invokes Golden Lane, the agates of Saint Vitus's Cathedral, and the Old Jewish Cemetery—the well-trodden magical trail.

37. I have discussed Josef's reforms and their double-edged impact on the Czech Lands more fully in *Coasts*, 65–69.

38. Apollinaire, "The Wandering Jew," 12.

39. Ripellino, *Magic Prague*, 123.

40. Ibid., 6.

41. Kafka to Oskar Pollak, 20 December 1902, in Franz Kafka, *Letters to Friends, Family and Editors*, trans. Richard and Clara Winston, New York: Schocken, 1977. Translation modified.

42. I have been unable to establish when this name change took place, but náměstí Franze Kafky is not listed in the 1998 *Pražský uličník*.

43. Ripellino, *Magic Prague*, 9.

44. Jaroslav Seifert, "Praha s Petřína," in Farová, *Josef Sudek*, 115. I have used the translation by Derek Paton, which is taken from the English-language abridged summary of Farová's text, p. 16. Seifert's poem was included, at Sudek's wish, in the first (1959) edition of the book. It is absent from the second edition, though the arrangement of photographs is identical.

45. *Dílo Jaroslava Seiferta*, Vol. 1, Prague: Akropolis, 2001, 12 (hereafter cited as DJS plus volume number).

46. Josef Sudek, *Panoramatická Praha*, 2d ed , Prague: Odeon, 1992.

47. Robert Desnos, "Spectacles of the Street—Eugène Atget," 1928, trans. Berenice Abbott, in *Photography in the Modern Era: European Documents and Critical Writings, 1913–1940*, ed. Christopher Phillips, New York: Metropolitan Museum of Art/Aperture, 1989, 17.

48. Ripellino, *Magic Prague*, 3.

49. More precisely, from yesterday toward always: "son magnifique pont aux statues en haie qui conduisait d'hier vers *toujours*." André Breton, "Toyen. Introduction à l'oeuvre de Toyen" (1953), *Le Surréalisme et la peinture*, 3d ed,, in his *Oeuvres complètes*, Vol. 4, *Écrits sur l'art et autres textes*, Paris: Gallimard, 2008, 602. This text is translated in André Breton, *Surrealism and Painting*, trans. Simon Watson Taylor, Boston: Museum of Fine Arts, 2002, 207–14, and in part in *What Is Surrealism?*, 286–90. The four-volume Breton *Oeuvres complètes* (ed. Marguerite Bonnet, Paris: Gallimard, 1988, 1992, 1999, 2008) is cited hereafter as ABOC plus volume number.

50. See, for example, plates 10, 92, and 146 in *Panoramatická Praha*.

51. Apollinaire, "The Wandering Jew," 10.

52. *Catholic Encyclopedia*, "St. John Nepomucene," available at http://www.new advent.org/cathen/08467a.htm (accessed 1 May 2012).

53. František Ruth, *Kronika královské Prahy*, Vol. I, 506.

54. Apollinaire, "Zone," 2.

55. Kepler, quoted in Peter Demetz, *Prague in Black and Gold*, London: Penguin, 1997, 192. I have a good deal of sympathy with Demetz's distaste for the "magic Prague" trope, which he is correct to argue obscures the reality of the city's history. My argument is rather that the reality, when judged by western expectations of what a history should look like, is *itself* surreal. The surrealities that interest me, however, are those of Prague's modernity, not its Rudolfine past. See my essays "André Breton and the Magic Capital," *Bohemia*, Vol. 52, No. 1, 2012, and "Crossed Wires: On the Prague–Paris Telephone," *Common Knowledge*, Vol. 18, No. 2, 2012.

56. André Breton, *L'Art magique*, in ABOC 4, 259.

57. Ruth, *Kronika královské Prahy*, Vol. 3, 1012.

58. Demetz, *Prague in Black and Gold*, 195.

59. Ruth, *Kronika královské Prahy*, Vol. 3, 989.

60. Ripellino, *Magic Prague*, 118–19, 153–55.

61. Apollinaire, "The Wandering Jew," 10.

62. Ripellino, *Magic Prague*, 92.

63. Franz Kafka, "Metamorphosis," in *Franz Kafka: The Complete Stories*, ed. Nahum N. Glatzer, New York: Schocken, 1995.

64. Franz Kafka, "The Great Wall of China," in ibid.

65. Ripellino, *Magic Prague*, 92.

66. Paul Éluard, "Food for Vision," in *Surrealists on Art*, ed. Lucy Lippard, Englewood Cliffs, NJ: Prentice-Hall, 1970, 57.

67. *Arcimboldo*, Milan: Franco Maria Ricci, 1980, 58.

68. Roland Barthes, "Rhetor and Magician," in ibid., 8.

69. Ripellino, *Magic Prague*, 109.

70. Franz Kafka, *The Castle*, trans. J. A. Underwood, London: Penguin, 1997, 38.

71. Ripellino, *Magic Prague*, 120.

72. Ibid., 122.

73. Apollinaire, "The Wandering Jew," 12.

74. Ripellino, *Magic Prague*, 75–76.

75. Bruce Chatwin, *Utz*, London: Picador, 1989, 13.

76. Alois Jirásek, *Legends of Old Bohemia*, trans. Edith Pargeter, London: Hamlyn, 1963, 52.

77. Michel Foucault, *The Order of Things: An Archaeology of the Human Sciences*, New York: Vintage, 1994, xv.

78. Guillaume Apollinaire, *Calligrammes: Poems of Peace and War 1913–1916*, trans. Anne Hyde Geet, Berkeley: University of California Press, 1991. Bilingual French-English edition. I have occasionally modified Geet's translations.

79. Apollinaire, "The Little Car," *Calligrammes*, 105.

80. André Masson, quoted in William S. Rubin, *Dada and Surrealist Art*, New York: Abrams, n.d. [1968], 172.

81. André Masson, quoted in Clarke V. Poling, *Surrealist Vision and Technique: Drawings and Collages from the Pompidou Center and the Picasso Museum, Paris*, Atlanta: Michael C. Carlos Museum at Emory University, 1996, 72. A selection of Masson's *Massacres* was published in *Minotaure*, Vol. 1, 1933, 10–13.

82. Breton, "Surrealist Situation of the Object," 260 ff.

83. Max Ernst, "An Informal Life of M. E. (as told by himself to a young friend)," in *Max Ernst*, London: Arts Council of Great Britain, 1961, 9.

84. Ibid., 10.

85. Lou Straus-Ernst, *The First Wife's Tale*, New York: Midmarch Arts Press, 2004, 43.

86. F. T. Marinetti, "The Foundation and Manifesto of Futurism," 1909, in *F. T. Marinetti: Critical Writings*, ed. Günter Berghaus, trans. Doug Thompson, New York: Farrar, Straus and Giroux, 2006, 14.

87. "Against Sentimentalized Love and Parliamentarianism," 1910, in *Marinetti: Critical Writings*, 55–56. The Futurist Manifesto provoked an interesting response

from Valentine de Saint-Point: *Manifeste de la femme futuriste*, March 1912, reprinted Paris: Mille et une nuits, 2005. "It is absurd," she argues, "to divide humanity into women and men. It is composed only of femininity and masculinity" (8). Castigating contemporary woman's "tears and her sentimentality," Saint-Point concludes by calling for women to "return to your sublime instinct, to violence, to cruelty" (14).

88. "Zong Toomb Toomb," in *F. T. Marinetti: Selected Poems and Related Prose*, selected by Luce Marinetti, trans. Elizabeth R. Napier and Barbara R. Studholme, New Haven, CT: Yale University Press, 2002, 68.

89. The exhibition, which contained works by Umberto Boccioni, Carlo Carrà, Luigi Russolo, and Gino Severini, took place at the Havel Gallery in December 1913. *Czech Modernism 1900–1945*, ed. Jaroslav Anděl, Houston: Museum of Fine Arts/ Bulfinch Press, 1989, 210.

90. *Futurist Words in Freedom*, in *Marinetti: Selected Poems and Related Prose*, 83–123.

91. *Revoluční sborník Devětsil*, ed. Karel Teige and Jaroslav Seifert, Prague: Večernice V. Vortel, 1922.

92. The origin of the group's name is uncertain. A *devětsil* is a flower, the butterbur, but the word also puns on "nine forces" (*devět sil*), which some have interpreted as a reference to the nine muses of antiquity. Jindřich Toman suggests "if we read 'nine' as in 'nine muses' and 'powers' as in 'horsepower'... we gain better insight. In effect, this reading of 'nine powers' proclaims a modern, 'engine-driven' start beyond the traditional pantheon of nine muses" (*Foto/montáž tiskem*, 82). The group eventually crossed the fields of poetry (Jaroslav Seifert, Vítězslav Nezval, František Halas, Konstantin Biebl, and Jiří Wolker), fiction (Vladislav Vančura, Karel Schulz, and Jiří Weil), painting (Jindřich Štyrský, Toyen, Adolf Hoffmeister, František Muzika, Josef Šíma, Jiří Jelínek, Otakar Mrkvička, and Alois Wachsmann), sculpture (Bedřich Stefan and Zdeněk Pešánek), architecture (Jaromír Krejcar, Josef Chochol, Bedřich Feuerstein, Jaroslav Fragner, Karel Honzík, Evžen Linhart, and Vít Obrtel), photography (Jaroslav Rössler), theater (the actors Jiří Voskovec and Jan Werich; the directors Emil František Burian, Jindřich Honzl, and Jiří Frejka; and the dancer Mira Holzbachová), and music (the composers Jaroslav Ježek and Miroslav Ponc). Film critics (Artuš Černík), art historians (Jaroslav Jíra), and journalists (Vincenc Nečas and Egon Erwin Kisch) were also part of the mix, as was the Russian linguist Roman Jakobson, founder of the Prague Linguistic Circle. No western European avant-garde of the time came close to such interdisciplinary breadth. Holding it all together was "the many-headed hydra of modernity and revolution" that was Karel Teige.

93. Karel Teige, "Poezie a revoluce," in KTD 2, 285.

94. Apollinaire to Louise de Coligny, 13 January 1915, in *Lettres à Lou*, 104.

95. See the "poème secret" titled "Les neuf portes de ton corps," included with Apollinaire's letter to Madeleine Pagès of 21 September 1915. He had used the same image in his earlier letter of 10 September 1915. Guillaume Apollinaire, *Lettres à Madeleine: tendre comme le souvenir*, Paris: Gallimard, 2005, pp. 215–22, 177.

96. Apollinaire to Louise de Coligny, 13 January 1915, in *Lettres à Lou*, 103

97. Apollinaire to Louise de Coligny, 27 January 1915, in ibid., 136–37.

98. The graphic description of "the adorable position you adopted on Saturday" in Apollinaire's letter of 28 January 1914 leaves little doubt as to Lou's willing participation in the fun and games. See ibid., 140. The passage is translated on pp. 263–64.

99. André Breton, *Conversations: The Autobiography of Surrealism*, trans. Mark Polizzotti, New York: Marlowe, 1993, 13.

100. The circumstances of Vaché's death (which Breton was convinced was suicide) and the theories surrounding it are discussed at length in Polizzotti, *Revolution of the Mind*, 85–89. Polizzotti attributes Breton's notorious homophobia to the trauma of this incident. See also Breton's article "Jacques Vaché," originally published as the preface to Vaché's *Lettres de guerre*, Paris: Au Sans Pareil, 1919, reprinted in André Breton, *The Lost Steps*, trans. Mark Polizzotti, Lincoln: University of Nebraska Press, 1996, 40–43.

101. Breton to Tristan Tzara, 22 January 1919, in Michel Sanouillet, *Dada in Paris*, trans. Sharmila Ganguly, Cambridge, MA: MIT Press, 2009, 333.

102. Breton, *Second Manifesto of Surrealism*, in *Manifestoes of Surrealism*, 128.

103. Quoted in Rudolf Kuenzli, ed., *Dada*, New York: Phaidon, 2006, 31.

104. Hugo Ball, "Dance of Death," in ibid., 194.

105. Hugo Ball, *Flight Out of Time: A Dada Diary*, ed. John Elderfield, Berkeley: California University Press, 1996, 32.

106. Emmy Hennings, "Prison," in *Dada Performance*, ed. and trans. Mel Gordon, New York: PAJ Publications, 1987, 44.

107. Breton, *Second Manifesto*, 123.

108. Ibid., 128–29.

109. Ibid., 125.

110. Jindřich Štyrský, Toyen, and Vincenc Nečas, *Průvodce Paříží a okolím*, Prague: Odeon, 1927; advertisement in *ReD*, Vol. 2, No. 9, 1929, 292.

111. Štyrský, Toyen, and Nečas, *Průvodce Paříží*, 306.

112. Jaroslav Seifert, "Guillaume Apollinaire," in *Na vlnách TSF* (1925), DJS 2, 7. *The Early Poetry of Jaroslav Seifert*, trans. Dana Loewy, Evanston, IL: Northwestern University Press, 1997, includes Seifert's first four collections, *Město v slzách* (1921), *Samá láska* (1923), *Na vlnách TSF*, and *Slavík zpívá špatně* (1926), though I have used my own translations here.

113. Breton, *Conversations*, 15.

114. Apollinaire, *Calligrammes*, 343–45.

115. Ripellino, *Magic Prague*, 121–22.

116. Breton, *Mad Love*, 28.

117. Ripellino, *Magic Prague*, 122.

118. Apollinaire, "The Wandering Jew," 9.

119. Ripellino, *Magic Prague*, 125–26.

120. Vítězslav Nezval, "Co dělá polední slunce s Prahou," in his *Praha s prsty deště*, Prague: Borový, 1936, 186.

121. Nezval, quoted in Ripellino, *Magic Prague*, 262. The passage comes from *Pražský chodec*, 190; earlier in the book Nezval credits Apollinaire with arousing in him "a new sensibility" (*nový cit*) toward the city (19).

122. Karel Čapek, "Poznámka překladatele," in "Francouzská poezie," *Spisy*, Vol. 24, Prague: Český spisovatel, 1993. Čapek's translation of "Zone" can be found in

the same collection. On *Červen*, see Jaromír Lang, *Neumannův Červen*, Prague: Orbis, 1957.

123. Milan Kundera, introduction to Apollinaire, *Alkoholy života*, 9.

124. Jiří Wolker, *Svatý Kopeček*, Prague: Československý spisovatel, 1960, 7, 10.

125. Milan Kundera, *Testaments Betrayed*, trans. Linda Asher, New York: Harper-Collins, 1995, 233.

126. Milan Kundera, *Life Is Elsewhere*, trans. Peter Kussi, London: Penguin, 1986, 270.

127. Milan Kundera, *Poslední máj*, 2d ed., Prague: Československý spisovatel, 1961, 28–29.

128. Julius Fučík, *Reportáž psaná na oprátce*, Prague: Torst, 1995. This edition indicates previously censored passages.

129. Milan Kundera, *The Joke*, trans. Michael Henry Heim, London: Penguin, 1984, 166.

130. Ludvík Páleníček, *Švabinského český slavín*, Prague: Státní pedagogické nakladatelství, 1985.

131. Karel Hynek Mácha, *May*, bilingual edition, trans. Marcela Sulak, Prague: Twisted Spoon Press, 2005.

132. Alois Jirásek, *Staré pověstí české*, Prague: Papyrus, 1992; trans. as *Legends of Old Bohemia*. Jirásek devoted three large novels, each comprising three books—*Mezi proudy* (Between the Currents, 1891), *Proti všem* (Against All, 1894), and *Bratrstvo* (Brotherhood, 1909)—as well as the plays *Jan Žižka* (1903), *Jan Hus* (1911), and *Jan Roháč* (1913–14) to the Hussite period. His five-volume *F. L. Věk* (1890–1907) and the four-volume *Ú nás* (Here, 1897–1904) are set during the national revival. *Psohlavci* (The Dogheads, 1883–84) portrays a peasant revolt in the border area of Domažlice in 1692–93, while *Filosofská historie* (A Philosophical History, 1878) brings to life the revolution of 1848. I have discussed Jirásek at far greater length in both *Coasts* and "A Quintessential Czechness," *Common Knowledge*, Vol. 7, No. 2, 1998, 136–64.

133. Quoted in Ripellino, *Magic Prague*, 261.

134. Vítězslav Nezval, "Košile" (A Shirt), in his *Ulice Gît-le-Coeur*, Prague: Borový, 1936, 102. There is a full translation of the poem in Vítězslav Nezval, *Antilyrik and Other Poems*, trans. Jerome Rothenberg and Milos Sovak, Copenhagen and Los Angeles: Green Integer, 2001, 24. Nezval was inspired to write the verses by a late-night walk through the Luxembourg Gardens during his visit to Paris in 1935.

135. Nezval, "Praha s prsty deště," in the collection of the same title, 198. This is one of twenty-one poems from *Praha s prsty deště* translated by Ewald Osers in *Three Czech Poets*, London, Penguin, 1971. Osers has since translated the entire collection as Vítězslav Nezval, *Prague with Fingers of Rain*, Tarset, UK: Bloodaxe Books, 2009. The translation here is my own.

136. Edvard Beneš, speech of 16 May 1945, quoted in Tomáš Staněk, *Odsun Němců z Československa 1945–1947*, Prague: Academia/Naše vojsko, 1991, 58. I have discussed the *odsun* more fully in *Coasts*, 237–48.

137. See sources quoted in Ctibor Rybár, *Židovská Praha; glosy k dějinám a kultuře; průvodce památkami*, Prague: TV Spektrum/Akropolis, 1991, 32–33.

138. See Erben, *Statistika královského hlavního města Prahy*, Vol. 1, 122–23. I have discussed the difficulties of trying to read "nationality" from nineteenth-century

census data for Prague in "The Language of Nationality and the Nationality of Language: Prague 1780–1920," *Past and Present*, No. 153, 1996, 164–210.

139. Quoted in Zora Dvořáková, *Miroslav Tyrš: prohry a vítězství*, Prague: Olympia, 1989. Tyrš also struggled with Czech; see Renata Tyršová, *Miroslav Tyrš: jeho osobnost a dílo*, Prague: Český čtenář, 1932–34, 34–35.

140. František Palacký, "Psaní do Frankfurtu," in his *Úvahy a projevy z české literatury, historie a politiky*, Prague: Melantrich, 1977, 158–59.

141. On the figures discussed in this paragraph and the "revival" of Czech in the nineteenth century, see *Coasts*, 107–18.

142. *Ottův slovník naučný*, Vol. 20, 1903, 488.

143. Egon Erwin Kisch, "Germans and Czechs," in *Egon Erwin Kisch, the Raging Reporter: A Bio-anthology*, ed. Harold B. Segel, West Lafayette, IN: Purdue University Press, 1997, 95.

144. Gary B. Cohen, *The Politics of Ethnic Survival: Germans in Prague, 1861–1914*, Princeton, NJ: Princeton University Press, 1981, 122.

145. Kafka, entry for 21 October 1921, *The Diaries of Franz Kafka 1910–1923*, ed. Max Brod, trans. Joseph Kresh (diaries 1910–13) and Martin Greenberg and Hannah Arendt (diaries 1914–23), London: Penguin, 1964, 395.

146. That is, Emperor Ferdinand I of Austria (1793–1875).

147. Alois Jirásek, speech of 16 May 1918 in Pantheon of National Museum. "Řeč Al. Jiráska," in *Za právo a stát: sborník dokladů o československé společné vůli k svobodě 1848–1918*, Prague: Státní nakladatelství, 1928, 298–300.

148. Bedřich Smetana, as quoted in Ladislav Šíp, *Česká opera a její tvůrci*, Prague: Supraphon, 1983, 40.

149. Milena Jesenská, "O umění zůstat stát," *Přítomnost*, Vol. 16, No. 4, 1939, 205–6. This and several other of Jesenská's *Přítomnost* articles are now available in English in *The Journalism of Milena Jesenska: A Critical Voice in Interwar Central Europe*, ed. and trans. Kathleen Hayes, New York: Berghahn Books, 2003.

150. Quoted in Mary Hockaday, *Kafka, Love and Courage: The Life of Milena Jesenská*, Woodstock, NY: Overlook Press, 1997, 20.

151. Ivan Klíma, *Love and Garbage*, trans. Ewald Osers, New York: Vintage, 1993, 45.

152. Milan Kundera, *The Book of Laughter and Forgetting*, trans. Michael Henry Heim, London: Penguin, 1986, 3.

153. Milan Kundera, *The Art of the Novel*, trans. Linda Asher, New York: Grove Press, 1988, 130.

154. I am gesturing here to what Jacques Derrida calls *différance*. For a brief discussion, see his *Positions*, trans. Alan Bass, Chicago: Chicago University Press, 1982, 24–29. I have developed a related argument on memory in my book *Going Down for Air: A Memoir in Search of a Subject*, Boulder, CO: Paradigm, 2004.

155. Kundera, *Testaments Betrayed*, 128–29.

156. Nezval, "Hodiny v ghetu," in *Praha s prsty deště*, 89.

3. Metamorphoses

1. Walter Benjamin, "The World of Forms in Kafka" (1934), in *Walter Benjamin's Archive*, trans. Esther Leslie, London: Verso, 2007, 215.

2. Gustav Janouch, *Conversations with Kafka: Notes and Reminiscences*, London: Derek Verschoyle, 1953, 80.

3. Max Brod, *Franz Kafka: A Biography*, New York: Schocken, 1963, 216.

4. Ibid., 215–16.

5. Kundera, *Testaments Betrayed*, 43.

6. Brod, *Franz Kafka*, 240–42. The basis for the claim, of which there is no independent corroboration, is the letter sent to Brod by the mother, Grete Bloch, a friend and frequent go-between for Kafka's one-time fiancée, Felice Bauer. The child supposedly died at age seven without his existence ever being known to Kafka.

7. Kafka, undated diary entry for 1910, before May 17, in *Diaries*, 12. According to Kundera, Max Brod's edition of the diaries censored out not only this sentence and all other "allusions to whores but anything else touching on sex" (*Testaments Betrayed*, 44–45).

8. Kafka to Max Brod, mid-August 1907, in *Letters to Friends, Family and Editors*, 26.

9. Gustav Mehrink, *The Golem*, ed. E. F. Bleiler, New York: Dover, 1976.

10. Jaroslav Seifert, *Všecky krásy světa*, Prague: Československý spisovatel, 1992, 165–67.

11. Josef Škvorecký, *Talkin' Moscow Blues: Essays about Literature, Politics, Movies, and Jazz*, Toronto: Lester and Orpen Dennys, 1988, 161.

12. Ivan Klíma, introduction to Jan Neruda, *Prague Tales*, Budapest, London, New York: Central European University Press, 2003, vii–viii.

13. Havelock Ellis, *Studies in the Psychology of Sex*, Vol. 3, London: The Echo Library, 2007, 112.

14. Ripellino, *Magic Prague*, 114.

15. Ibid.

16. *Zmizelá Praha*, 6 volumes, various editors, Prague; Václav Poláček, 1945–18; Zdeněk Wirth, *Stará Praha: obraz města a jeho veřejného života v 2. polovici XIX. století*, Prague: Otto, 1942; Roland Barthes, *Camera Lucida*, trans. Richard Howard, New York: Hill and Wang, 2000, 95–96.

17. Meyrink, *Golem*, 26.

18. Karel Čapek, *R.U.R.*, trans. Paul Selver, New York: Washington Square Press, 1973.

19. Ripellino, *Magic Prague*, 108–9.

20. Kundera, *Testaments Betrayed*, 188.

21. Alan Blyth, ed., *Opera on Record*, Vol. 2, London: Hutchinson, 1983, 327.

22. Kundera, *Testaments Betrayed*, 183.

23. Ibid.

24. Ludvík Kundera, 1891–1971, not to be confused with the writer of the same name, Milan Kundera's cousin Ludvík, who was born in Brno in 1920.

25. Quoted in Miloš Štědroň, notes to *Mša glagolskaya*, Supraphon compact disk, 1996, 11.

26. *Picasso: Suite 347*, Valencia: Bancaixa, 2000; see more generally *Picasso érotique*, New York: Prestel, 2001.

27. Kundera, *Testaments Betrayed*, 196–97. For a detailed (and more factual,

which is not necessarily to say more accurate) account of Janáček's last days, see John Tyrrell, *Janáček: Years of a Life*, Vol. 2, *Tsar of the Forests*, London: Faber, 2007.

28. See Vojtěch Lahoda and Olga Uhrová, *Vincenc Kramář od starých mistrů k Picassovi*, Prague: Národní galerie, 2000.

29. These are all reproduced in Josef Čapek, *Dějiny zblízka: soubor satirických kreseb*, Prague: Borový, 1949.

30. Neville Chamberlain, BBC Radio broadcast, 27 September 1938, text published in the London *Times*, 28 September 1938.

31. Ferdinand Peroutka, "Osud Karla Čapka" (1953), in his *Budeme pokračovat*, Toronto: Sixty-Eight Publishers, 1984, 39–40.

32. Milena Jesenská, "Poslední dny Karla Čapka," *Přítomnost*, 11 January 1939, reprinted in Milena Jesenská, *Zvenčí a zevnitř*, Prague: Nakladatelství Franze Kafky, 1996, 28.

33. Quoted in Ivan Klíma, *Karel Čapek: Life and Work*, North Haven, CT: Catbird Press, 2002, 238. Translation modified.

34. See Jindřich Toman, "Renarrating the Rabbi and His Golem," in *Path of Life: Rabbi Judah Loew Ben Bezalel, 1525–1609*, ed. Alexandr Putík, Prague: Academia/The Jewish Museum, 2009, 314–41.

35. Max Švabinský, funeral oration for Alfons Mucha, 19 July 1939, in Ludvík Páleníček, *Max Švabinský: život a dílo na přelomu epoch*, Prague: Melantrich, 1984, 164–66. For more background on Vyšehrad Cemetery and its inhabitants, see Václav Potoček, *Vyšehradský hřbitov—Slavín*, Prague: Svatobor, 2005.

36. Petr Fischer, Mayor of Smíchov (who commissioned the vault), quoted in Ruth, *Kronika královské Prahy*, Vol. 3, 1147.

37. Karel Čapek, *Hovory s T. G. Masarykem*, in *Spisy Karla Čapka*, Vol. 20, Prague: Československý spisovatel, 1990.

38. František Václav Krejčí, František Xaver Šalda, Josef Svatopluk Machar, Antonín Sova, Otakar Březina, Vilém Mrštík, and others, *Česká moderna*, in F. X. Šalda, *Kritické projevy—2, 1894–1895, Soubor díla F. X. Šaldy*, Vol. 11, Prague: Melantrich, 1950, 361–63. For background, see *Moderní revue 1894–1925*, ed. Otto M. Urban a Luboš Merhaut, Prague: Torst, 1995.

39. See Božena Němcová, letter to Dušan Lambl, 2 August 1856, in *Z dopisů Boženy Němcové*, ed. Jana Štefánková, Prague: Státní nakladatelství dětské knihy, 1962, 142–45. I discuss Havlíček's funeral in *Coasts*, 91–92. On Seifert's funeral, see *Zpráva o pohřbu básníka Jaroslava Seiferta*, ed. Jaroslav Krejčí, Prague: Volvox Globator, 1995.

40. Josef Škvorecký, "Bohemia of the Soul," *Daedalus*, Vol. 119, No. 1, 1990.

41. *Exposition inteRnatiOnal du Surréalisme*, 114.

42. Viktor Dyk, "Země mluví," in *Naše umění v odboji*, ed. Miloslav Novotný, Prague: Evropský literární klub, 1938, 105–6.

43. Prokop Toman, *Nový slovník československých výtvarných umělců*, photoreprint of 3d ed. of 1947–49, Ostrava, Czech Republic: Chagall, 1994, Vol. 1, 10.

44. Sung in German. The first American staging of *Prodaná nevěsta* took place in Chicago in 1893, when the opera was sung in Czech. *Kobbé's Complete Opera Book*, ed. Earl of Harewood, London: Putnam, 1976, 963.

45. "Music: Intoxicated with Romance," *Time* magazine archive, 4 June 1973,

available at http://www.time.com/time/magazine/article/0,9171,907361,00
.html (accessed 1 May 2012). Quotes are from Rubinstein, *My Young Life*.

46. Emmy Destinn Foundation, available at http://www.destinn.com (accessed
1 May 2012).

47. Destinová recorded the *Liebestod* twice, in 1910 and 1911. Both recordings
are available on *Ema Destinová, Souborná edice, 3. Richard Wagner*, Supraphon LP
number 1 0120–1 602G, 1989.

48. Quoted in Hana Volavková, *Mikoláš Aleš: ilustrace české poezie a prózy*,
Prague: Státní nakladatelství krásné literatury a umění, 1964, 224.

49. Kundera is Moravian, born and raised in Brno. He uses Bohemia as the
generic location for much of his work—an "existential situation," as he might put it,
as much as a physical place. Czechoslovakia, he writes, is "too young (born in 1918),
with no roots in time, no beauty, and it exposes the very nature of the thing it
names: composite and too young (untested by time)." While "from the standpoint
of political geography" the term Bohemia may well be incorrect, he concedes, "from
the standpoint of poetry, it is the only possible name." *Art of the Novel*, 126–27.

50. Friedrich Engels, "Democratic Pan-Slavism," in K. Marx and F. Engels, *Collected Works*, Vol. 8, New York: International Publishers, 1977, 362–78.

51. The description is the novelist Robert Musil's in *A Man without Qualities*,
New York: Vintage, 1996.

52. All Kundera quotations in the foregoing discussion are from *Testaments
Betrayed*, 192–94.

53. I am alluding here to Pavel Eisner, *Chrám i tvrz: kniha o češtině*, photoreprint
of 1946 edition, Prague: Lidové noviny, 1992.

54. Quoted in Milan Churaň, ed., *Kdo byl kdo v našich dějinách v 20. století*, Vol.
II, Prague: Libri, 1998, 61.

55. Grave inscription, Vyšehrad Cemetery (personal observation). Josef's body
was never found.

56. Kateřiná Bečková, "History of the Society for Old Prague," in *Society for Old
Prague: One Hundred and Two Years*, Prague: Klub za starou Prahu, 2002, 18.

57. Karel Teige, "Poezie a revoluce," in KTD 2, 284–89.

58. Jaroslav Hašek, *The Good Soldier Švejk*, trans. Cecil Parrott, London: Penguin, 1973, 125–33.

59. Kafka to Hedwig W., early 1908, in *Letters to Friends, Family and Editors*, 41.

60. Tomáš Černý, inaugural speech of 8 October 1882, quoted in Jindřich Šolc,
"Tomáš Černý," *Almanach královského hlavního města Prahy*, Vol. 13, 1910, 269,
emphasis in original.

61. Krejcar's design took second place in the 1928 competition for a complex of
parliamentary and ministry buildings on Letná plain. His intention, in his own
words, was to create "an open system allowing in the optimum amount of light and
air." See *Jaromír Krejcar 1895–1949*, ed. Rostislav Švácha, Prague: Galerie Jaroslava
Fragnera, 1995, 91–95.

62. This street was previously named after the last Habsburg Emperor Karl
(Karel) I (1917–19); an industrialist with connections in the Czechoslovak food
industry, and later US President, Herbert Hoover (1923–1940, 1945–47); and the

composer Richard Wagner (1940–45). It bore Woodrow Wilson's name from 1947–52, as it has again since 1990.

63. Yvonne Brunhammer, *1925*, Paris: Les Presses de la Connaissance, 1976, 180–81.

64. For more on David Černý, see his website (English version), available at http://www.davidcerny.cz/startEN.html (accessed 1 May 2012), from which this information is taken.

65. Anna Klementová, "An Entrepreneur with a Sense of Public Duty," *Lidové noviny,* 19 April 2001, translated on the Český dialog website, available at http://www.cesky-dialog.net/clanek/163-vaclav-m-havel (accessed 1 May 2012).

66. Ibid. See also Václav M. Havel, *Mé vzpomínky*, Prague: Lidové noviny, 1993.

67. The poster is reproduced in *Coasts*, 199.

68. Quoted in "Miloš Havel," *Reflex*, No. 9, 3 March 2004. No more details of original source given.

69. Petr Král, *Prague*, Seyssel: Éditions du Champ Vallon, 1987, 19.

70. The commonly attributed quote is apocryphal, but the warmth of Prague's response to Mozart's music was real.

71. Král, *Prague*, 74.

72. Vitězslav Nezval, *Ulice Gît-le-Coeur*, 48.

73. Král, *Prague*, 24.

74. *Deset let Osvobozeného divadla*, ed. Josef Träger, Prague: Borový, 1937, 114. For a recent survey, see Jaromír Farník, ed., *V + W = 100: Vždy s úsměvem. Pocta Jiřímu Voskovcovi a Janu Werichovi*, Prague: Lotos, 2005.

75. Schwitters lectured in May 1926, Ehrenburg in March 1927, Mayakovsky in April 1927, and Le Corbusier in October 1929.

76. Most often in premises provided by the old artists' society Umělecká beseda, discussed more fully on pp. 177 and 477 note 107.

77. *Deset let Osvobozeného divadla*, 115.

78. Other Czech artists and designers who put their talents at the disposal of the Liberated Theater included Vít Obrtel, Antonín Heythum, Josef Šíma, Bedřich Feuerstein, and Alois Wachsmann. See Věra Ptáčková, *Česká scénografie XX. století*, Prague: Odeon, 1982, 58–66.

79. Honzl returned to the Osvobozené divadlo in 1931, where he directed Voskovec and Werich's *Golem* (1931), *Caesar* (1932), *Robin Zbojník* (1932), *Osel a stín* (1933), and other works.

80. Matthew S. Witkovsky, "Avant-Garde and Center: Devětsil in Czech Culture, 1918–1938," PhD dissertation, University of Pennsylvania, 2002, 188. This contains an extensive discussion of the Liberated Theater.

81. *Deset let Osvobozeného divadla*, 148.

82. Meyerhold, "Mejerhold o Voskovcovi a Werichovi," in *Deset let Osvobozeného divadla*, 105.

83. *Modernism 1914–1939: Designing a New World*, ed. Christopher Wilk, London: Victoria and Albert Museum, 2006. This exhibition was remarkable for the range of material shown from interwar Czechoslovakia, including Sutnar's ceramics; Kybal's fabrics; architectural designs by Obrtel and Fuchs; graphic designs by Rössler, Teige (*Abeceda*, which I discuss on pp. 237–40), Kroha (*Sociologický frag-*

ment bydlení, 1930–32), and Sutnar; photographs by Sudek, Jírů, and the Czech Press Agency; and the 1937 Tatra T87 saloon car. The Zelenka poster shown was his 1932 *Aero* (408). For further examples of his work, see *František Zelenka: plakáty, architektura, divadlo*, ed. Josef Kroutvor, Prague: Uměleckoprůmyslové muzeum, 1991.

84. Král, *Prague*, 24–25.

85. Ibid.,114–15. My translation of *toutmondisme* here plays on Civic Forum's 1990 election slogan "Zpátky do Evropy" (Back into Europe).

86. Král, *Prague*, 105.

87. Ivan Margolius, *Prague: A Guide to Twentieth-Century Architecture*, London: Ellipsis 1996, 36.

88. Stanislav Dvorský, Vratislav Effenberger, and Petr Král, eds., *Surrealistické východisko 1938–1968*, Prague: Čskoslovenský spisovatel, 1969, unpaginated plates following p. 232. Though not credited here, the design was probably Pavel Janák's, a 1911 sketch for which can be found in *Czech Cubism*, ed. Alexander von Wegesack, trans Michal Schonberg, Princeton, NJ: Princeton Architectural Press, 1992, 156.

89. Reproduced in *John Heartfield*, ed. Peter Pachnicke and Klauss Honnef, New York: Abrams, 1991, 176.

90. See Jana Tichá, ed., *Future Systems*, Prague: Zlatý řez, 2002. The unbuilt memorial is pictured on pp. 138–39.

91. Karel Teige, *Modern Architecture in Czechoslovakia and Other Writings*, translated by Irena Zantovska Murray and David Britt, Los Angeles: Getty Research Institute, 2000, 80.

92. Quoted in Ripellino, *Magic Prague*, 8.

93. Jáchym Topol, *Výlet k nádražní hale*, Brno: Petrov, 1995, 7–8.

94. The theater was founded in 1783 as the Gräfliches Nationaltheater (Count's National Theater) by Count Franz Anton Nostitz-Rienek, Supreme Burgrave of Bohemia. It was purchased by the Bohemian Estates (Land Diet) and renamed the Estates Theater (Stavovské divadlo) in 1798, but continued to perform in German except for Saturday afternoon matinées in Czech. In either incarnation the theater was an expression of the so-called "land patriotism" of the German-speaking Bohemian aristocracy, which differed sharply from the ethnic Czech nationalism that was to develop over the nineteenth century. I discuss theater as a prime site of nationalist conflicts in detail in *Coasts*, chs. 2 and 3.

95. Brod, *Franz Kafka*, 224; compare Jaroslava Vondráčková, *Kolem Mileny Jesenské*, Prague: Torst, 1991, 23.

96. A play on the names of Max Brod, Franz Kafka, Franz Werfel, and Egon Erwin Kisch, attributed to the Viennese critic Karl Kraus.

97. Kafka to Milena Jesenská, November 1920, in *Letters to Milena*, ed. and trans. Philip Boehm, New York: Schocken, 1990, 212–13.

98. André Breton, *Communicating Vessels*, trans. Mary Ann Caws and Geoffrey T. Harris, Lincoln: University of Nebraska Press, 1997, 86.

99. Kafka, entry for 9 November 1911, *Diaries*, 111–12.

100. Josef Pekař, "In Memoriam," in *Pamětní list . . . k slavnosti položení základního kamene k Husovu pomníku*, Prague: Spolek pro budování "Husova pomníku," 1903, 7.

101. Kafka to Max Brod, end of July 1922, in *Letters to Friends, Family and Editors*, 347.

102. I allude here to Komenský's *The Labyrinth of the World and the Paradise of the Heart* (*Labyrint světa a ráj srdce*), written in Brandýs nad Orlicí in 1623, first published abroad in 1631, and finally published in Bohemia in 1782 (only to be banned again in 1820).

103. "According to legend," writes Karel Srp, "the last bishop of the Unitas Fratrum asked to be carried out on a chair to the edge of the bay. While Mucha portrayed the other representatives of Czech history in dynamic action and at the height of their creative powers, he presented Jan Amos Komenský in abject resignation. Komenský's solitude is emphasized by his being juxtaposed with the water's surface." Karel Srp, *Alfons Mucha: Das slawische Epos*, Krems, Austria: Kunsthalle, 1994, 131; the picture is reproduced on pp. 112–13. I discuss Mucha's *Epic* at greater length in *Coasts*, 151–53.

104. See *Intimate Letters: Leoš Janáček to Kamila Stösslová*, ed. John Tyrell, Princeton, NJ: Princeton University Press, 1994.

105. These are all illustrated in *Obecní dům hlavního města Prahy*, Prague: Obecní dům, 2001.

106. Cynthia Paces discusses the toppling of the column in detail in her *Prague Panoramas: National Memory and Sacred Space in the Twentieth Century*, Pittsburgh: University of Pittsburgh Press, 2009, 87–96.

107. Kafka, entry for 9 November 1911, *Diaries*, 111–12.

108. Milan Kundera, *The Book of Laughter and Forgetting*, 3–4.

109. Jiří Kolář, "Ale zbav nás . . . ," in his *Týdeník 1968*, Prague: Torst, 1993, plate 22. Parts of the latter are also reproduced in David Elliott and Arsén Pohribny, *Jiří Kolář: Diary 1968*, Oxford, UK: Museum of Modern Art, 1984.

110. Král, *Prague*, 42–43.

111. Breton, *Nadja*, 80.

112. André Breton, "Pont-Neuf," in his *Free Rein*, trans. Michel Parmentier and Jacqueline d'Amboise, Lincoln: University of Nebraska Press, 1995, 225.

113. Karl Marx, *The Eighteenth Brumaire of Louis Napoleon*, in his *Surveys from Exile*, London: Penguin, 1993, 146.

114. Kundera, *Testaments Betrayed*, 50.

115. See Franz Kafka to Oskar Pollak, 20 December 1902, in *Letters to Friends, Family and Editors*, 7.

116. See ch. 2, note 132.

117. Or other more acceptable historical figures. For details, see *Coasts*, 289.

118. Zdeněk Nejedlý, untitled preface to *Celostátní výstava archivních dokumentů: od hrdinné minulosti k vítězství socialismu*, Prague: Ministerstvo vnitra, 1958, 7. I discuss Nejedlý, who was a key figure of the period, at some length in *Coasts*, 303–13. His views on the relation of Czech pasts and presents are succinctly set out in "Komunisté, dědici velkých tradic českého národa" (The communists, heirs to the great traditions of the Czech nation), in his *Spisy Zdeňka Nejedlého*, Vol. 16, *O smyslu českých dějin*, Prague: Státní nakladatelství politické literatury, 1953, 217–67.

119. 1900 census figures, taken from *Ottův slovník naučný*.

120. Quoted in A.J.P. Taylor, *The Habsburg Monarchy*, London: Penguin, 1990, 181.

121. Karel Havlíček Borovský, review of Siegfried Kapper's *České listy*, in *Česká včela*, November 1846, quoted in T. G. Masaryk, *Karel Havlíček*, 3d ed., Prague: Jan Laichter, 1920, 446–47; Jan Neruda, "Pro strach židovský," in his *Studie krátké a kratší*, Prague: L. Mazač, 1928, 248. Parts of the latter are translated in *The Jews of Bohemia and Moravia: A Historical Reader*, ed. Wilma Abeles Iggers, Detroit: Wayne State University Press, 1992, 183–90.

122. Kafka, entry for 18 November 1911, *Diaries*, 119.

123. They had two brief trysts, one in Vienna, the other in the border town of Gmünd. Milena's letters have not survived.

124. Kafka to Milena Jesenská, May 1920, in *Letters to Milena*, 14.

125. Kafka to Milena Jesenská, end of April 1920, in ibid., 8.

126. Prague Trade Directory, quoted in Jiří Gruša, *Franz Kafka of Prague*, trans. Eric Mosbacher, New York: Schocken, 1983, 18.

127. See Kafka's letter to his parents of 20 February 1924, in Franz Kafka, *Dopisy rodičům z let 1922–1924*, ed. Josef Čermák and Martin Svatoš, Prague: Odeon, 1990, 93.

128. "Franz Kafka: dopis otci," 1965, reproduced in *Adolf Hoffmeister*, ed. Karel Srp, Prague: Gallery, 2004, 276.

129. Kafka, entry for 24 October 1911, *Diaries*, 88

130. Kakania is Musil's name for Austria-Hungary in *A Man without Qualities*. The word comes from the ubiquitous Habsburg abbreviation "k. und k." (kaiserlich und königlich, or imperial and royal), but also alludes to *kaka*, the German baby-word for shit.

131. See Janouch, *Conversations*, 29; Kafka's letter to Ottla, 6 April 1920, in his *Letters to Ottla and the Family*, ed. N. N. Glazer, trans. Richard and Clara Winston, New York: Schocken, 1982, 43.

132. Kafka to Ottla, 20 February 1919, in *Letters to Ottla*, 36.

133. Kafka, entries of 16 November 1910 and 25 December 1911, in *Diaries*, 28, 152.

134. Kafka to Ottla, third week of January 1921, in *Letters to Ottla*, 58.

135. Kafka to Milena Jesenská, 29 May 1920, in *Letters to Milena*, 17; Kafka to Felix Weltsch, 22 September 1917, in *Letters to Friends, Family and Editors*, 145.

136. See Max Brod, *Franz Kafka*, 221.

137. Kafka to Max Brod, 11 March 1921, in *Letters to Friends, Family and Editors*, 266. Compare his letter to Ottla of January 1921, in *Letters to Ottla*, 57.

138. Kafka to Milena Jesenská, 24 June 1920, in *Letters to Milena*, 58.

139. Kafka to Ottla, first week of January 1924, in *Letters to Ottla*, 89.

140. Franz Kafka, "An Introductory Talk on the Jewish Language," in his *Dearest Father: Stories and Other Writings*, trans. Ernst Kaiser and Eithne Wilkins, New York: Schocken, 1954, 382. This text is based on notes taken by Elsa Brod, who was present.

141. *Malá československá encyklopedie*, Vol. 3, Prague: Academia, 1986, 256.

142. See Milena's letters to Max Brod, in Brod, *Franz Kafka*, 222–39.

143. *Letters to Milena*, 272. Originally published in *Národní listy*, 6 June 1924.

144. Kafka to Max Brod, April 1921, in Franz Kafka, *Letters to Friends, Family and Editors*, 275.

145. Quoted in Alena Wagnerová, *Milena Jesenská*, Prague: Prostor, 1996, 122.

146. Kenneth Frampton, "A Modernity Worthy of the Name: Notes on the Czech Architectural Avant-Garde," in Anděl, *Art of the Avant-Garde in Czechoslovakia*, 217. Krejcar emphasized that the use of glass was not merely functional but designed to demonstrate "the production possibilities of Czechoslovak industry ... doubtless, angular corners would have been just as functional as rounded ones." "Czechoslovak Pavilion at the International Exhibition of Art and Technology in Modern Life, Paris 1937," in Švácha, *Jaromír Krejcar 1895–1949*, 174.

147. Milena Jesenská, "Hundreds of Thousands Looking for No-Man's Land," *Přítomnost*, 27 July 1938, as translated in Hayes, *The Journalism of Milena Jesenska*, 167.

148. Apollinaire, "The Wandering Jew," 12. "Tétonnière et fessue" might be delicately translated as "well endowed and broad in the beam." Guillaume Apollinaire, *Oeuvres en prose complètes*, Vol. 1, Paris: Gallimard, 1977, 91.

149. Král, *Prague*, 80–81.

150. Kundera, *Book of Laughter and Forgetting*, 158.

151. See Kafka's letters of April 1921 (where he signs himself in Czech "František pozdravuje a je zdráv") and 13 October 1923 (where he uses the Czech diminutives for his nieces' names), in *Letters to Ottla*, 68, 81.

152. In the Protectorate, a Jew was defined as any person "who by race is descended from at least three wholly Jewish grandparents"—the latter being defined by membership of a Jewish religious community. "Considered to be a Jew" was any "mixed-blood" (*míšenec*) with two Jewish grandparents, who had belonged to the Jewish religious community in September 1935 or been accepted into it afterward; a "mixed-blood" married to a Jew on or after that date; and a "mixed-blood" born of marriage with a Jew after that date, or out of wedlock after 1 February 1940. In Slovakia, the net was drawn even tighter, but "race" was determined equally capriciously. According to the relevant laws of April 1939, a Jew was anybody who was or had been of the Jewish faith, was or had been of no religion but had at least one parent of the Jewish faith, was descended from a Jew thus defined—unless they had themselves joined a Christian denomination before 30 October 1918—or had married a person of the Jewish faith after the April 1939 law came into effect. In the latter case, a person's Jewishness would expire with the end of their marriage.

153. Katharine Conley, *Robert Desnos, Surrealism, and the Marvelous in Everyday Life*, Lincoln: University of Nebraska Press, 2003, 192–98.

154. F. T. Marinetti, *The Futurist Cookbook*, trans. Susan Brill, San Francisco: Bedford Arts, 1989.

155. Cara De Silva, ed., *In Memory's Kitchen: A Legacy from the Women of Terezín*, Northvale, NJ: Jason Aronson, 1996.

156. Nicholas Stargardt, *Witnesses of War: Children's Lives under the Nazis*, London: Pimlico, 2006, 210–11.

157. Conley, *Robert Desnos*, 201.

158. Jiří Weil, Epilogue, in *I Never Saw Another Butterfly: Children's Poems and Drawings from Terezín*, ed. Hana Volavková, New York: Schocken, 1993, 101.

159. In Volavková, *I Never Saw Another Butterfly*, 62.

160. Weil, Epilogue, in Volavková, *I Never Saw Another Butterfly*, 101.
161. Vítězslav Nezval, *Z mého života*, Prague: Československý spisovatel, 1959, 84.
162. Jiří Weil, *Colors*, trans. Rachel Harrell, Ann Arbor: Michigan Slavic Publications, 2002, 12.
163. Weil, *Colors*, 90.
164. Ibid., 14–15.
165. Joza Karas, *Music in Terezín 1941–1945*, 2d ed., Hillsdale, NY: Pendragon Press, 2008, 24.
166. Ibid., 24–25.
167. Quoted in David Schiff, "A Musical Postcard from the Eye of the Nazi Storm," *New York Times*, 23 March 2003.
168. See Brian S. Locke, "Opera and Ideology in Prague: Polemics and Practice at the National Theater, 1900–1938," *Opera Quarterly*, Vol. 23, No. 1, 2007, 126–130. The Prague premiere, which took place less than a year after *Wozzeck*'s world premiere at the Staatsoper in Berlin (December 1925) and four years before its premiere in Vienna, is not listed in *Kobbé's Complete Opera Book*.
169. Viktor Ullmann, "Goethe and Ghetto" (1944), trans. Michael Haas, on the Viktor Ullmann Foundation website, available at http://www.viktorullmannfoundation.org.uk/index.html (accessed 3 May 2012).
170. Andreas K. W. Meyer, liner notes to *Viktor Ullmann, Piano Sonatas 5–7*, cpo CD no. 999 087-2 (1992), unpaginated.
171. The first modern use of the Hussite hymn "Ktož jsú boží bojovníci," preceding Smetana's, was by Karel Šebor in his 1867 opera *Husitská nevěsta* (The Hussite Bride). More recent uses include Josef Suk's symphonic poem *Praga* (1904) and Karel Husa's *Hudba pro Prahu 1968* (Music for Prague 1968). I owe this information to Michael Beckerman.
172. Meyer, *Viktor Ullmann Piano Sonatas 5–7*, liner notes.
173. Volavková, *I Never Saw Another Butterfly*, xx–xxi.
174. Weil, Epilogue, *I Never Saw Another Butterfly*, 102. Compare Ctibor Rybar's figures in *Židovská Praha*, 158.
175. Unknown author (a child in Terezín), "Dusk," in Volavková, *I Never Saw Another Butterfly*, 58.
176. Kamila Stösslová to Leoš Janáček, 9 July 1924, in *Intimate Letters: Leoš Janáček to Kamila Stösslová*, 50.
177. Janáček to Stösslová, 8–9 May 1927, *Intimate Letters*, 113.
178. Janáček to Stösslová, 30 April 1928, ibid., 262.
179. Janáček's commonplace book, quoted in ibid., 344–45.
180. Éluard to Gala, 7–8 April 1935, in *Lettres à Gala*, 253–54.
181. Weil, *Colors*, 54.
182. Rybár, *Židovská Praha*, 275.
183. The Prague Jewish Museum website, available at www.jewishmuseum.cz/en/amuseum.htm (accessed 3 May 2012).
184. Hana Volavková, ed., *Zmizelá Praha*, Vol. 3, *Židovské město Pražské*, Prague: Poláček, 1947.
185. Maya Lin, *Boundaries*, New York: Simon and Schuster, 2000, 4–10. Lin acknowledges the powerful influence Lutyens's Thiepval Memorial had on her.

186. Rybár, *Židovská Praha*, 276.

187. Personal observation.

188. *Státní židovské muzeum v Praze*, Prague: Státní židovské muzeum, 1979, 7 (official guide).

189. Karel Havlíček Borovský, review of Kapper, *České listy*, quoted in T. G. Masaryk, *Karel Havlíček*, 134–35.

190. *The Precious Legacy: Judaic Treasures from the Czechoslovak State Collections*, ed. David Altshuler, New York: Summit Books, 1983.

191. See Hannah Arendt, *Eichmann in Jerusalem: A Report on the Banality of Evil*, New York: Penguin, 2006; Zygmunt Bauman, *Modernity and the Holocaust*; and David J. Goldhagen, *Hitler's Willing Executioners: Ordinary Germans and the Holocaust*, London: Abacus, 1997.

192. Bohumil Hrabal, *I Served the King of England*, 100–101.

193. Ibid., 128.

194. Ibid., 139–40.

4. MODERNISM IN THE PLURAL

1. Eric Dluhosch and Rostislav Švácha, eds., *Karel Teige 1900–1951: The Enfant Terrible of the Prague Avant-Garde*, Cambridge, MA: MIT Press, 1999, xvi.

2. Hitchcock and Johnson, *International Style*, 44.

3. As it was described in Karel Hannauer, "Architect Jeanneret-Le Corbusier v Praze," *České slovo* X, No. 235, 9 October 1928, 5. Reprinted in Miroslav Masák, Rostislav Švácha, and Jindřich Vybíral, *Veletržní palác v Praze*, Prague: Národní galerie, 1995, 34. The photograph in question is reproduced on p. 38 of the latter.

4. Apart from material on individual architects cited elsewhere in these notes, see Vladimír Šlapeta, *Czech Functionalism 1918–1938*, London: Architects Association, n.d. [1987].

5. Karel Teige, "Rozhled. Polemické výklady. Interview s Le Corbusierem," *Stavba*, Vol. 7, 1928–29, 105.

6. Jindřich Toman, "Poetry, Capitalized Throughout," in Anděl, *Art of the Avant-Garde in Czechoslovakia*, 207–12.

7. Teige claimed Loos's own authority for considering Loos a Czech architect; see his *Modern Architecture in Czechoslovakia*, 301. On Loos's Czech work, see Maria Szadowska, Leslie Van Duzer, and Dagmar Černoušková, *Adolf Loos—dílo v českých zemích/Adolf Loos—Works in the Czech Lands*, Prague: Galerie hlavního města Prahy, 2009.

8. See "Adolf Loos and the Naked Architectural Body," in *The Naked Truth: Klimt, Schiele, Kokoschka and Other Scandals*, ed. Tobias G. Natter and Max Hollein, New York: Prestel, 2005, 138–39.

9. Adolf Loos, *Ornament and Crime: Selected Essays*, Riverside, CA: Ariadne Press, 1998, 167–68. See Jana Horneková, Karel Ksandr, Maria Szadkowska, and Vladimír Šlapeta, *The Müller Villa in Prague*, Prague: City of Prague Museum, 2002.

10. See Beatriz Colomina, *Sexuality and Space*, Princeton, NJ: Princeton University Press, 1996.

11. Teige, *Modern Architecture in Czechoslovakia*, 136.

12. For background, see Carol. S. Eliel, *L'Esprit nouveau: Purism in Paris 1918–1925*, Los Angeles: Los Angeles County Museum of Art; New York: Abrams, 2001.

13. *Život II, Sborník nové krásy*, ed. Jaromír Krejcar, Prague: Umělecká beseda, 1922. I discuss this anthology in detail on pp. 205–10.

14. Teige was part of the Czech delegation, speaking on "The Question of Housing Concerning the Strata of an Existential Minimum." See Klaus Spechtenbach and Daniel Weiss, "Karel Teige and the CIAM: The History of a Troubled Relationship," in Dluhosch and Švácha, *Karel Teige 1900–1951*; Simone Hain, "Karel in Wonderland: The Theoretical Conflicts of the Thirties," in *Karel Teige: architettura, poesie–Praga 1900–1951*, ed. Manuela Castagnara Codeluppi, Milan: Electa, 1996. For background on CIAM, see Eric Mumford, *The CIAM Discourse on Urbanism 1928–1960*, Cambridge, MA: MIT Press, 2002.

15. "R. J. Neutra blahopřeje Stavbě k X. ročníku," *Stavba*, Vol. 10, 1931–32, 94.

16. The advertisement is reproduced in Hans M. Wingler, ed., *The Bauhaus: Weimar Dessau Berlin Chicago*, Cambridge, MA: MIT Press, 1993, 130–31.

17. Hannes Meyer, "My Expulsion from the Bauhaus: An Open Letter to Lord Mayor Hesse of Dessau" (1930), in Wingler, *Bauhaus*, 164. Teige's Bauhaus lectures were published under the title "K sociologii architektury" in *ReD*, Vol. II, Nos. 6–7, 1930, 161–223.

18. *ReD*, Vol. III, No. 5, 1930, 129–59; Karel Teige, "Deset let Bauhausu," *Stavba*, Vol. VIII, No. 10, April 1930, 146–52, reprinted in KTD 1, 477–86. The latter is translated in *Modern Architecture in Czechoslovakia*, 417–30.

19. Teige vigorously protested Meyer's dismissal in the Czech press, and immediately ceased all cooperation with the school. See his "Bauhaus a otravné plyny reakce," *Tvorba*, Vol. 5, Nos. 33–35, August–September 1930; "Hannes Meyer donucen k odchodu z Bauhausu," *Stavba*, Vol. 9, No. 1, September 1930; "Doslov k Bauhausu," *Tvorba*, Vol. 5, No. 38, September 1930.

20. Krejcar's design was published in *ReD*, Vol. I, No. 5, 1928, 180—an issue devoted to "contemporary international architecture." It is reproduced in Anděl, *Art of the Avant-Garde in Czechoslovakia*, 121.

21. Karel Teige, "Le Corbusier v Praze," *Rozpravy Aventina*, Vol. IV, 1928–29, 31–32, reprinted in Masák, *Veletržní palác*, 40.

22. Teige, *Modern Architecture in Czechoslovakia*, 179.

23. Karel Teige, "Mundaneum," *Stavba*, Vol. 7, No. 10, April 1929, 145–55, excerpted in KTD 1, 533.

24. Rumjana Dačeva, "Appendix: Chronological Overview," in Dluhosch and Švácha, *Karel Teige*, 368.

25. Le Corbusier, "Défense de l'architecture," in Le Corbusier and Pierre Jeanneret, *L'Architecture d'aujourd'hui*, No. 10, Paris, 1933, originally published in Czech as "Obrana architektury: odpověď Karlu Teigovi," *Musaion*, Vol. 2, Prague, 1931, 27–52. Le Corbusier's text (together with Teige's response in the same issue of *Musaion*) is available in Czech in Stanislav Kolíbal, ed., *Le Corbusier kdysi a potom*, Prague: Arbor Vitae, 2003. Teige's "Mundaneum" and Le Corbusier's "Defence of Architecture" are both translated into English in *Oppositions*, No. 4, October 1974.

26. Karel Teige, *The Minimum Dwelling*, trans. Eric Dluhosch, Cambridge, MA: MIT Press, 2002, 180–81.

27. Hitchcock and Johnson, *International Style*, 21.

28. Teige, *Minimum Dwelling*, 197.

29. Jaromír Krejcar, "Soudobá architektura a společnost," in *Za socialistickou architekturu*, Prague, 1933, 11–31, and "Hygiena bytu," *Žijeme*, Vol. II, 1932–33, 132–34, both quoted in Rostislav Švácha, "The Life and Work of the Architect Jaromír Krejcar," in Švácha, *Jaromír Krejcar 1895–1949*, 122.

30. 1890 census figures, from *Ottův slovník naučny*.

31. S. K. Neumann, "Otevřená okna," (1913), in *Osma a Skupina výtvarných umělců 1910–1917: teorie, kritika, polemika*, ed. Jiří Padrta, Prague: Odeon, 1992, 138–40.

32. Jan E. Svoboda, Zdeněk Lukeš, and Ester Havlová, *Praha 1891–1918: kapitoly o architektuře velkoměsta*, Prague: Libri, 1997, 13–14. For the Jubilee Exhibition, see *Všeobecná zemská výstava v Praze . . . Hlavní catalog*, ed Josef Fořt, Prague, 1891, and *Sto let práce: zpráva o všeobecné zemské výstavě v Praze 1891*, 3 vols., Vol. 3 in 2 parts, Prague, 1892–95.

33. Josef Teige, "Vývoj kral. hlav. města Prahy od roku 1848–1908," in *Katalog pavillonu kral. hlav. města Prahy a odborních skupin městských*, Prague, 1908, 8.

34. Teige, *Modern Architecture in Czechoslovakia*, 89.

35. I have discussed this exhibition in more detail in *Coasts*, 124–27.

36. *Narodopisná výstava českoslovanská v Praze 1895*, Prague: Otto, 1895, 540–43.

37. See Jana Brabcová, *Luděk Marold*, Prague: Odeon, 1988, 66–74.

38. Quoted in Masák, *Veletržní palác*, 6.

39. Radomíra Sedláková, *Jak fénix: minulost a přítomnost Veletržního paláce v Praze*, Prague: Národní galerie, 1995, 49.

40. Quoted in Masák, *Veletržní palác*, 31.

41. See the texts collected in Tomáš G. Masaryk, *The Meaning of Czech History*, ed. René Wellek, trans. Peter Kussi, Chapel Hill: University of North Carolina Press, 1974.

42. *Nová Praha*, 6 September 1928, quoted in Masák, *Veletržní palác*, 33.

43. See Mucha's undated letter (ca. 1900), quoted in Jiří Mucha, *Alphonse Maria Mucha: His Life and Art*, New York: Rizzoli, 1989, 145.

44. I discuss Mucha's stamps, posters, and banknotes further in *Coasts*, 147–53. On the pageant, see Alfons Mucha, *Slovanstvo bratrské/Fraternal Slavdom*, Prague: Gallery, 2005, where his designs and relevant writings are reproduced.

45. See the excerpts from reviews of the Veletržní palác exhibition of the *Epic* in Jiří Mucha, *Alfons Maria Mucha*, 277, and František Žákavec's review in *Umění*, Vol. 2, 1929–30, 242–44.

46. Myslbek died in 1922. The retrospective was part of the Saint Václav millennium celebrations. See *Umění*, Vol. 3, 1929–30, 62–63.

47. Alfred Barr, *Cubism and Abstract Art*, New York: Museum of Modern Art, 1936, cover.

48. Hitchcock and Johnson, *International Style*, 24.

49. "Tugendhat Villa in Brno," UNESCO website, available at http://whc.unesco.org/en/list/1052 (accessed 3 May 2012). My account of the villa's history also draws on Zdeněk Kudělka and Libor Teplý, *Villa Tugendhat*, Brno: FOTEP/Brno City Museum, 2001.

50. Jim Rendon, "A Mies Home, Deteriorating and Disputed," *Observer* (London), 1 April 2007. The villa has now (2012) been newly restored.

51. Karel Teige, "Rozhled . . . Interview s Le Corbusierem," 105.

52. Vítězslav Nezval, *Žena v možném čísle*, Prague: Borový, 1936. The collection is dedicated to Paul Éluard.

53. Karel Teige, "Le Corbusier v Praze," in Masák, *Veletržní palác*, 40.

54. I allude here to Robert Venturi, *Complexity and Contradiction in Architecture*, 2d ed., New York: Museum of Modern Art, 2002.

55. Teige, "Le Corbusier v Praze," in Masák, *Veletržní palác*, 40.

56. Jaromír John, *Moudrý Engelbert*, 1940, quoted in Michaela Brozová, Anne Hebler, and Chantal Scaler, *Praha: průchody a pasáže*, Prague: Euro Art, 1997, 24. This passage refers to the period 1918–23.

57. The figure is from the published lists of those tried by Prague and Brno courts given in Václav Buben, ed., *Šest let okupace Prahy*, Prague: Orbis, 1946, 173–207. It does not include those killed in the massacres at the villages of Lidice, which I discuss on pp. 338–39, and Ležáky.

58. The House of the Golden Beehive (Dům u Zlatého úlu), at the bottom end of the square, was originally medieval but was rebuilt in renaissance style in 1572. It was further modified, and a further story added, in 1789. It still stands today. My source for information in this paragraph is Yvonne Janková, *Václavské náměstí v Praze: architektonický průvodce/Wenceslas Square in Prague: Architectural Guide*, supplement to *Ad architektura 2*, Prague: J. H. & Archys, 2006.

59. See Philip Johnson's account of the genesis of the book in his "Foreword to the 1995 Edition," *International Style*, 13–14.

60. Rostislav Švácha, *The Architecture of New Prague 1895–1945*, Cambridge, MA: MIT Press, 1995, 270.

61. Kysela was also the co-designer with Jan Jarolím of the functionalist palác Alfa (1927–28), farther up the square on the same side of the street.

62. Steve Rose, "Welcome to Bata-ville," *Guardian* (London), 19 June 2006, available at http://www.guardian.co.uk/artanddesign/2006/jun/19/architecture (accessed 3 May 2012).

63. Vladimír Karfík, quoted in Zdeněk Lukeš, Petr Všetečka, Ivan Němec, and Jan Ludwig, *Vladimír Karfík: Building No. 21 in Zlín: A Monument of Czech Functionalism/Vladimír Karfík: Budova č. 21 ve Zlíně: Památka českého funkcionalismu*, Zlín: cfa nemec Ludwig, 2004, 66. Translation modified.

64. Gahura to Le Corbusier, 19 January 1935, in *Le Corbusier: Le Grand*, (unnamed) Phaidon editors, introductions by Jean-Louis Cohen and Tim Benton, New York: Phaidon, 2008, 290.

65. Le Corbusier to Jan A. Baťa and His Coworkers, 14 May 1935, available at http://web.archive.org/web/20071007225327/http://www.batahistory.com/images/LeCorbusier_letter_to_Jan_Bata_05-14-1935.pdf (accessed 4 May 2012).

66. These plans are reproduced in *Le Corbusier: Le Grand*, 291.

67. František L. Gahura, "Budování Baťova Zlína," *Stavitel*, Vol. 14, 1933–34, in *Baťa: architektura a urbanismus*, ed. Vladimír Šlapeta, Zlín: Státní galerie, 1991, 7.

68. Karfík, quoted in Lukeš, *Vladimír Karfík: Building No. 21*, 28.

69. Alois Kubíček, Maximilián John, and Vladimír Karfík, "Správní budova Baťových závodů ve Zlíně," *Architektura*, Vol. 2, No. 12, 1940, quoted in *Vladimír Karfík: Building No. 21*, 59.

70. Jan A. Baťa, "Ke čtyřicátému výročí podniku," available at http://www.zlin .estranky.cz/clanky/p__234_le-m__234_le_-odkazy/prvni-maje---svatky-prace ---ve-zlinskem-a-batovskem-podani.html (accessed 3 May 2012).

71. The peak of such optimism can be found in Jan Baťa, *Budujme stát pro 40,000,000 lidí* (Let Us Build a State for 40,000,000 People), Zlín: Tisk, 1937.

72. "Zlín," Radio Prague website, available at http://archiv.radio.cz/mapa/ more.phtml?mesto=24 (accessed 4 May 2012).

73. Tom Stoppard, *Lord Malquist and Mr. Moon*, London: Faber, 1986, 53.

74. William Shaw, "Design for Living in Zlín, Czech Republic," *New York Times Travel Magazine*, 25 March 2007, available at http://travel.nytimes.com/2007/ 03/25/travel/tmagazine/03talk.zlin.t.html (accessed 4 May 2012).

75. Le Corbusier, *The Radiant City: Elements of a Doctrine of Urbanism to Be Used as the Basis of Our Machine-Age Civilization*, New York: Orion Press, 1964 reprint, legend on title page.

76. Kimberly Elman Zarecor, *Manufacturing a Socialist Modernity: Housing in Czechoslovakia, 1945–1960*, Pittsburgh: University of Pittsburgh Press, 2011, ably brings out the personal, institutional, and ideological connections between prewar modernist and postwar socialist architecture in Czechoslovakia and fully recognizes the importance of the Zlín experience. See more generally Katrin Klingan and Kirstin Gust, eds., *A Utopia of Modernity: Zlín. Revisiting Bat'a's Functional City*, Berlin: Jovis, 2009.

77. Benjamin, *The Arcades Project*. See the introduction.

78. Quoted in Brozová, *Praha: Průchody a pasáže*, 84.

79. Teige, *Modern Architecture in Czechoslovakia*, 154–55.

80. I discuss comings and goings from the Pantheon in *Coasts*, 99–100, 233, and 269.

81. Vítězslav Nezval, *Pražský chodec*, 182–83.

82. C. S. Lewis, *The Lion, the Witch and the Wardrobe*, New York: HarperCollins, 1994. On Králíček, see Zdeněk Lukeš, Ester Havlová, and Vendula Hnídková, *Emil Králíček: zapomenutý mistr secese a kubismu*, Prague: Galerie Jaroslava Fragnera, 2005.

83. Compare *Český kubismus 1909–1925: malířství, sochářství, umělecké řemeslo, architektura*, ed. Jiří Švestka and Tomáš Vlček, Prague: Národní galerie, 1991, and *Expresionismus a české umění 1905–1927*, ed. Alena Pomajzlová, Dana Mikulejská, and Juliana Boublíková, Prague: Národní galerie, 1994. Other works on Czech cubism include *Le Cubisme à Prague*, ed. Claude Petry, Paris: Jacques London, 1991; *Český kubismus 1910–1925: architektura a design*, ed. Alexander von Vegensack, Weil am Rhein, Germany: Vitra Design Museum, 1991 (available in English as *Czech Cubism: Architecture, Furniture, Decorative Arts*, Princeton, NJ: Princeton Architectural Press, 1992); Michal Bregant, Lenka Bydžovská, Vojtěch Lahoda, Zdeněk Lukeš, Karel Srp, Rostislav Švácha, and Tomáš Vlček, *Kubistická Praha/Cubist Prague*, Prague: Středoevropské nakladatelství, 1995; Vojtěch Lahoda, *Český kubismus*, Prague: Brana, 1996; and Jindřich Toman, *Kniha v českém kubismu/Czech Cub-*

ism and the Book, Prague: Kant, 2004. Substantial discussions can also be found in Anděl, *Czech Modernism 1900–1945*; *Prague 1900–1938: capitale secrète des avant-gardes*, ed. Jacqueline Menanteau, Dijon: Musée des Beaux-Arts, 1997; and *Central European Avant-Gardes: Exchange and Transformation 1910–1930*, ed. Timothy O. Benson, Los Angeles: Los Angeles County Museum of Art; Cambridge, MA: MIT Press, 2002.

84. Teige, *Modern Architecture in Czechoslovakia*, 141–54.

85. For details, see Bečková, "History of the Society for Old Prague."

86. Švácha, *Architecture of New Prague*, 118.

87. Apart from more specific references given in the following, works discussing (or exhibitions devoted to) the artistic links between Prague and Paris include *Paris Prague 1906–1930*, Paris: Musée national d'art moderne, 1966; Pavla Horská, *Prague–Paris*, Prague: Orbis, 1990; Patrizia Runfola, Gérard-Georges Lemaire, and Oliver Poive d'Arvor, *Prague sur Seine*, Paris: Paris Musées, 1992; Marie Mžyková, ed., *Křídla slávy: Vojtěch Hynais, čeští Pařížané a Francie*, 2 vols., Prague: Galerie Rudolfinum, 2000; and Anaut, *Praha Paris Barcelona*.

88. Josef Čapek spent the best part of a year in Paris in 1910–11, and a further three months in 1912; Filla visited in 1910 and 1914; Kubin visited in 1912.

89. For background, see Otto Gutfreund, *Zázemí tvorby*, Prague: Odeon, 1989; and Jan Bauch, Jiří Šetlík, Václav Erben, Petr Wittlich, Karel Srp, and Vojtěch Lahoda, *Otto Gutfreund*, Prague: Národní galerie, 1995.

90. For background, see Mahulena Nešlehová, *Bohumil Kubišta*, Prague: Odeon, 1984.

91. Cited in Meda Mládková and Jan Sekera, *František Kupka ze sbírky Jana a Medy Mládkových/From the Jan and Meda Mládek Collection*, Prague: Museum Kampa, 2007, 385.

92. For more on Suzanne Duchamp, see Ruth Hemus, *Dada's Women*, New Haven, CT: Yale University Press, 2009.

93. *František Kupka: la collection du Centre Georges Pompidou, Musée national d'art moderne*, ed. Brigitte Leal, Paris: Centre Pompidou, 2003, 202.

94. *New York Times*, date not given. On color and sound, see Kupka to Warshawsky, 19 October 1913. Both are quoted in Mládková and Sekera, *František Kupka ze sbírky Jana a Medy Mládkových*, 381.

95. Kupka to Roessler, 2 February 1913, quoted in Mládková and Sekera, *František Kupka ze sbírky Jana a Medy Mládkových*, 375.

96. Šíma had solo exhibitions of his work in Paris in 1927, 1929, and 1930 and in Prague in 1925, 1928, 1929, 1932, and 1936. For background, see *Šíma/Le Grand Jeu*, texts by Antoine Coron, Serge Fauchereau, Jacques Henric, Patrick Javault, and Pierre Restany (Šíma) and Michel Camus, Gérald Gassiot-Talabot, Olivier Poivre d'Arvor, Raphael Sorin, Paule Thévenin, and Marc Thivolet (Le Grand Jeu), Paris: Musée d'art moderne, 1992.

97. Vailland, undated letter to Roger Gilbert-Lecomte, quoted in Karla Tonine Huebner, "Eroticism, Identity, and Cultural Context: Toyen and the Prague Avant-Garde," PhD Thesis, University of Pittsburgh, 2008, 115–16.

98. *Le Grand Jeu, collection complète*, facsimile reprint, Paris: Editions Jean-Marcel Place, 1977, Vol. II, 1929, 33–36. Šíma also translated Seifert's "Le tableau frais" in

Le Grand Jeu, Vol. I, 1928, 30–32. For background, see Coron, *Šíma/Le Grand Jeu*; Nelly Feuerhahn, David Liot, Didier Ottinger, Anna Pravdová, Bertrand Schmitt, Michel Random, Karel Srp, and Alain Virmaux, *Grand Jeu et surréalisme: Reims, Paris, Prague*, Reims: Musée des Beaux-arts, 2004; and *Le rêve d'une ville: Nantes et le surréalisme*, Nantes: Musée des Beaux Arts, 1994. The latter is also a very useful source on Jacques Vaché.

99. *ReD*, Vol. III, No. 8, 1930, 225–26. The issue includes a translation of the French group's manifesto.

100. Štyrský, Toyen, and Nečas, *Průvodce Paříží a okolím*, 774–78.

101. Makovský and Wichterlová lived in Paris from 1926–30, Rössler from 1927–35. Voskovec (whose mother was French) studied in Paris from 1921–24, Ježek from January to June 1928. Martinů and Kaprálová are discussed on pp. 339–55.

102. Among those who attended Kupka's classes were Diviš, Jelínek, Makovský, Muzika, Rykr, Šíma, Wichterlová, Zrzavý, and Martinů. See Luděk Jirásko, "Kupka's Czech Students in Paris, 1923–30," in *Kupka—Waldes: The Artist and His Collector*, ed. Anna Pachovská, Prague: Meissner, 1999, 427–29.

103. Soupault's preface is reproduced in full in *Štyrský, Toyen, Heisler*, ed. Jana Claverie, Paris: Centre Georges Pompidou, 1982, 38–39. It was published in Czech in *ReD*, Vol. I, No. 6, 1928, 217–18. Other literature on Štyrský and Toyen includes Vítězslav Nezval and Karel Teige, *Štyrský a Toyen*, Prague: Borový, 1938; André Breton, Jindřich Heisler, and Benjamin Péret, *Toyen*, Paris: Éditions Sokolová, 1953; *Štyrský a Toyen 1921–1945*, texts by Věra Linhartová and František Šmejkal, Brno: Moravská galerie, 1966; Radovan Ivšić, *Toyen*, Paris: Éditions Filipacchi, 1974; *Štyrský, Toyen, artificielismus 1926–1931*, texts by Lenka Bydžovská and Karel Srp, Prague: Středočeská galerie, 1992; Karel Srp, *Toyen*, Prague: Galerie hlavního města Prahy/Argo, 2000; Karel Srp, *Toyen: une femme surréaliste*, Saint-Étienne Métropole: Musée d'Art Moderne, 2002; Lenka Bydžovská and Karel Srp, *Knihy s Toyen*, Prague: Akropolis, 2003; *Jindřich Štyrský 1899–1942*, Prague: Galerie hlavního města Prahy, 2007 (bilingual Czech-English edition, text by Srp); and Lenka Bydžovská and Karel Srp, *Jindřich Štyrský*, Prague: Argo, 2007. *Surrealism: Two Private Eyes, The Nesuhi Ertegun and Daniel Filipacchi Collections*, New York: Guggenheim Museum, 2 vols., ed. Edward Weisberger, 1999, is unusual among English-language catalogues for the number of works from Štyrský and Toyen that are reproduced, as is Srp, *New Formations*. Some of Štyrský's writings have been republished, including the essays collected in Jindřich Štyrský, *Každý z nás stopuje svoji ropuchu: texty 1923–1940*, Prague: Thyrsus, 1996, and *Texty*, Prague: Argo, 2007, and his annotations and drawings on his dreams (*Sny*, Prague: Odeon, 1970), but very few yet translated into English. Though he wrote some poetry (*Poesie*, Prague: Argo, 2003), Štyrský is mainly remembered for his paintings, collages, and photographs. For the latter, see Karel Srp, *Jindřich Štyrský*, Prague: Torst, 2001 (bilingual Czech-English edition), and Jindřich Heisler and Jindřich Štyrský, *Na jehlách těchto dní*, Prague: Borový, 1941, reprinted in Jindřich Heisler, *Z kasemat spánku*, ed. František Šmejkal, Karel Srp, and Jindřich Toman, Prague: Torst, 1999, 83–144. Stephen Bann could perhaps have been forgiven for taking Štyrský to be a place ("the adjectival form of Štýrsko, a region in North Bohemia under the Austro-Hungarian Empire"—actually, it is in Austria), rather than an artist of whom he had clearly

never heard, when in 1974 he included Štyrský's "Obraz" (Image) in his anthology *The Tradition of Constructivism* (New York: Viking, 1974, 97–102). This text served as the editorial for the first issue of the Devětsil magazine *Disk* (1923); it is translated in Timothy O. Benson and Eva Forgacs, eds., *Between Worlds: A Sourcebook of Central European Avant-Gardes, 1910–1930*, Los Angeles: Los Angeles County Museum of Art/Cambridge, MA: MIT Press, 2002, 364–66. But it is depressing that in 2009, twenty years after the Iron Curtain came down, we can still encounter as inaccurate a characterization in an important exhibition catalogue as this: "in 1922 [Toyen] met the Czech poet Jindřich Štyrský in Yugoslavia. Her artistic career began with her participation in the short-lived, radical Czech avant-garde group Devětsil which brought together constructivists, Dadaists and others" (*Angels of Anarchy: Women Artists and Surrealism*, ed. Patricia Allmer, London: Prestel, 2009, 249). Štyrský was only secondarily a poet, Devětsil was far from short-lived, and the group did not include any Dadaists. Anglophone readers would be better served by tracking down Karla Huebner's superbly researched PhD thesis "Eroticism, Identity, and Cultural Context: Toyen and the Prague Avant-Garde." I hope somebody soon publishes it.

104. Adolf Hoffmeister, "La Rotonde: s kresbami autorovými," *Rozpravy Aventina*, Vol. 2, No. 5, 1926–27, 50, as translated in Huebner, "Eroticism," 100.

105. See Matthew Witkovsky, "Surrealism in the Plural: Guillaume Apollinaire, Ivan Goll and Devětsil in the 1920s," *Papers of Surrealism*, No. 2, summer 2004, available at http://www.surrealismcentre.ac.uk/papersofsurrealism/journal2/index.htm (accessed 4 May 2012). Goll's magazine *Surréalisme*, of which the first and only issue appeared in October 1924 (with contributions by among others René Crevel and Pierre Reverdy), has been reissued in facsimile: Paris: Jean-Michel Place, 2004.

106. Srp, *Adolf Hoffmeister*, 343–44. Jiří Mucha provides a detailed account of the arrests of Hoffmeister and other exiled Czechs in Paris in his autobiographical novel *Podivné lásky/Au seuil de la nuit*, which I discuss on pp. 351–52.

107. Umělecká beseda was founded in 1863 to promote the national cause in literature and music as well as the visual arts; Josef Mánes, Bedřich Smetana, and Jan Neruda were among its luminaries. So was Karel Sabina, the patriot-turned-informer librettist of *The Bartered Bride*. Mánes was set up in 1887 by a younger generation dissatisfied with what they saw as the stagnation of the older organization. Its nucleus was a Czech student society in Munich of which the young Alfons Mucha was a leading light, and its first president was Mikoláš Aleš. See *Coasts*, 103–4, and Jiří Kotalík, *Umělecká beseda: k 125. výročí založení*, Prague: Národní galerie, 1988.

108. *Francouzské moderní umění: l'école de Paris*, Prague: Umělecká beseda, 1931. The exhibition used not only the Municipal House but also the Aleš Hall of Umělecká beseda, where drawings, watercolors, and graphic art were displayed.

109. Ibid., 13–19.

110. Antonín Matějček, Úvod, *Umění současné Francie*, Prague: SVU Mánes, 1931 (unpaginated preface).

111. *Katalog výstavy děl sochaře Augusta Rodina v Praze*, texts by F. X. Šalda and Stanislav Sucharda, Prague: Mánes, 1902; *Francouzští impresionisté: catalogue 23.*

výstavy SVU Mánes v Praze 1907, introduction by F. X. Šalda, Prague: Mánes, 1907; *Les Indépendents: xxxi výstava Sp. výtv. um. "Mánes,"* introduction by Antonín Matějček, Prague: Mánes, 1910.

112. Karel Teige, "Mezinárodní orientace českého umění," KTD 2, 393.

113. See *Pocta Rodinovi 1902–1992*, ed. Marie Halířová, Prague: Národní galerie, 1992; and Cathleen M. Giustino, "Rodin in Prague: Modern Art, Cultural Diplomacy, and National Display," *Slavic Review*, Vol. 69, No. 3, 2010, 591–619.

114. Emil Filla in conversation with V. Závada, *Rozpravy Aventina*, 1932, reproduced in Miroslav Lamač, *Osma a Skupina výtvarných umělců 1907–1917*, Prague: Odeon, 1988, 36.

115. *Moderní umění, soubor sestaven A. Mercereauem v Paříži: 45. výstava SVU Mánes v Praze*, introduction by Alexandre Mercereau, Prague: Mánes, 1914.

116. Karel Teige, "Pražské výstavy podzimní sezony (II)," *Stavba*, Vol. 6, No. 7, 1927–28, in *Zajatec kubismu: dílo Emila Filly v zrcadle výtvarné kritiky 1907–1953*, ed. Tomáš Winter, Prague: Artefactum, 2004, 175–76.

117. Padrta, *Osma a Skupina*, 18–19.

118. Ibid., 21.

119. Reproduced in Lamač, *Osma a Skupina*, 32.

120. See Roman Musil, Martina Nejezchlebová, Alena Pomajzlová, Roman Prahl, Nikolaj Savický, Tomáš Sekyrka, Vít Vlnas, and Jindřich Vybíral, *Moderní galerie tenkrát 1902–1942*, Prague: Národní galerie, 1992.

121. Lamač, *Osma a Skupina*, 31.

122. Max Brod, "Frühling in Prag," *Die Gegenwart XXXVI*, Vol. 71, No. 20, 18 May 1907, 316–17, translated into Czech in Lamač, *Osma a Skupina*, 32.

123. Antonín Matějček, untitled and unpaginated preface to *Les Indépendents*, Prague: Mánes, 1910.

124. Le Corbusier, *Towards a New Architecture*, New York: BN Publishing, 2008.

125. Pavel Janák, "The Prism and the Pyramid," in Benson, *Between Worlds*, 86–91.

126. Grand Café Orient menu, December 2008.

127. Café Imperial menu, December 2008.

128. S. K. Neumann, "And Yet!," introduction to first Tvrdošíjní exhibition catalogue, 1918, in Benson, *Between Worlds*, 196–97.

129. *Almanach secese*, ed. S. K. Neumann, Prague: 1896; contributors included Arnošt Procházka, Karel Hlaváček, Jiří Karásek z Lvovic, Julius Zeyer, and Otakar Březina. *Almanach na rok 1914*, ed. Josef Čapek, Prague: Přehled, 1913; contributors included Josef Čapek, Karel Čapek, Otokar Fischer, Stanislav Hanuš, Vlastislav Hofman, Josef Kodíček, Stanislav K. Neumann, Arne Novák, Václav Špála, Václav Štěpán, Otakar Theer, and Jan z Wojkowicz.

130. See Antonín Slavík, *Josef Čapek*, Prague: Albatros, 1996, 219–88, for these and other examples of Čapek's work in this period.

131. For background, see Jaromír Lang, *Neumannův Červen*.

132. S. K. Neumann, "And Yet!," in Benson, *Between Worlds*, 196–97.

133. Božena Němcová, *Babička*, Prague: Aventinum, 1923; Otakar Štorch-Marien, *Sládko je žít*, Prague: Aventinum, 1992, 187.

134. Karel Čapek, "Starý Mistr," *Lidové noviny*, 22 January 1933, in his *Spisy*, Vol. 19, *O umění a kultuře III*, Prague: Československý spisovatel, 1986, 363–64.

135. Karel Čapek, "Kraj Jiráskův," in his *Spisy*, Vol. 19, 200–201.

136. Quoted in "Babička Vulgaris II," *Nedělní Lidové noviny*, 23 July 1994, 5.

137. Němcová, *Babička*, 118.

138. "Náš Žid Liebermann," in Mikoláš Aleš, *Špalíček národních písní a říkadel*, Prague: Orbis, 1950, 60.

139. Musée d'Orsay website, available at http://www.musee-orsay.fr/en/collec tions/works-in-focus/painting/commentaire_id/the-prophetess-libuse-10610.html ?tx_commentaire_pi1%5BpidLi%5D=509&tx_commentaire_pi1%5Bfrom%5D=8 41&cHash=f8c3602644 (accessed 4 May 2012).

140. *Katalog Sixty-Eight Publishers*, Prague: Společnost Josefa Škvoreckého, 1991, 28.

141. Franz Fanon, *Black Skin, White Masks*, New York: Grove Press, 1994.

142. Milena Jesenská, "A Few Old-fashioned Comments about Women's Eman cipation," *Národní listy*, 17 February 1923, trans. in Hayes, *The Journalism of Milena Jesenská*, 118.

143. Milan Kundera, *The Unbearable Lightness of Being*, trans. Michael Henry Heim, New York: HarperCollins, 199, 29–32, 72–73.

144. Margarete Buber-Neumann, *Mistress to Kafka: The Life and Death of Milena*, London: Secker and Warburg, 1966, 97.

145. Milena Jesenská, "Česká maminka," *Přítomnost*, Vol. 16, No. 16, 1939, 205–6.

146. This painting is reproduced in *Václav Špála: mezi avantgardou a živobytím*, ed. Helena Musilová, Prague: Národní galerie, 2005, plate 151. This catalogue (which has an English resume) provides a good selection of Špála's work.

147. For more on *Zlatá Praha* and Jan Otto's publishing house, see *Coasts*, 93–98.

148. On the history of the Café Slavia, see Karel Holub, *Velká Kavárna Slavia*, Prague: Jan Hovorka, 1998, which reproduces Oliva's *Absinthe Drinker* on its cover.

149. All Seifert quotations in this and the preceding two paragraphs are from his *Všecky krásy světa*, 37–38.

150. For examples of such work, see Pavla Pečinková, *Josef Lada*, Prague: Gallery, 1988; Jan Spurný, *Karel Svolinský*, Prague: Nakladatelství československých výtvarných umělců, 1962; *Karel Svolinský 1896–1986*, ed. Roman Musil and Eduard Bur get, Prague: Národní galerie, 2001.

151. Masaryk's *Otázka sociální* (The Social Question, 1898) is among the classic critiques of Marxism. An abridged edition is available in English under the title *Masaryk on Marx*, Lewisburg, PA: Bucknell University Press, 1972.

152. T. G. Masaryk, *Česká otázka*, Prague: Svoboda, 1990, 112–16.

153. Karel Čapek, *The Gardener's Year*, trans. Geoffrey Newsome, New York: Modern Library, 2002, 102. Translation modified.

154. *Josef Čapek in Memoriam*, Prague: Umělecká beseda, 1945, untitled fore word by Jarmila Čapková (Josef's wife).

155. Examples of all of these can be found in *Václav Špála: mezi avantgardou a živobytím*.

156. For a comprehensive recent monograph on Zrzavý, see Karel Srp and Jana Orlíková, *Jan Zrzavý*, Prague: Academia, 2003.

157. Josef Čapek, *Umění přírodních národů*, Prague: Československý spisovatel, 1949. Jiří Opelík claims that Čapek's then unpublished manuscript was the first sys-

tematic monographic study of "primitive art" in any language, predating Carl Einstein's pioneering *Negerplastik* of 1915. See his *Josef Čapek*, 65–67.

158. Josef Čapek, *Nejskromnější umění*, Prague: Dauphin, 1997, 83.

159. Ibid., 13.

160. Ibid., 11.

161. Ibid., 88.

162. Ibid., 77. For further background, see *Josef Čapek: Nejskromnější umění/The Humblest Art*, ed. Alena Pomajzlová, trans. Branislava Kuburović, Prague: Obecní dům, 2003.

163. "US Devětsil," 6 December 1920, reprinted in *Avantgarda známá a neznámá*, ed. Štěpán Vlašín, Vol. 1, Prague: Svoboda, 1971, 81–83. The three-volume anthology *Avantgarda* is hereafter cited as AZN plus volume number.

164. Teige, "Poetismus," *Host*, Vol. III, 1924, 197–204, reprinted in AZN 1, 561. This text has been translated in Benson, *Between Worlds*, 579–82.

165. Teige, "Nové umění a lidová tvorba," *Červen*, Vol. IV, 1921, 175–77, reprinted in AZN 1, 152. Devětsil was closer at this point to S. K. Neumann and the Obstinates than it became later; Teige and Seifert's July 1924 article "J. Kodíček a jeho generace," in AZN 1, 562–65, summarizes the younger generation's criticisms of the prewar avant-garde.

166. Teige, "Umění dnes a zítra," *Revoluční sborník Devětsil*, 187–202, reprinted in AZN 1, 365–81. This article was written in the fall of 1922, a few months after "The New Proletarian Art," which was written in the spring of that year.

167. There is an old joke in France that André Breton, who died in September 1966, just missed his own revolution. A thoroughly serious (albeit entirely unacademic) attempt to trace the undercurrents of refusal and revolt that run from Dada and early surrealism through the Lettrists, Situationists, and *enragés* of May 1968 to punk, is Greil Marcus, *Lipstick Traces: A Secret History of the Twentieth Century*, Cambridge, MA: Harvard University Press, 1999.

168. Teige, "Umění dnes a zítra," in AZN 1, 367.

169. "US Devětsil," AZN 1, 81–83.

170. Philip Johnson later acknowledged "Marxists and those interested in the social side of architecture objected to the emphasis on design and style." Foreword to the 1995 edition of *International Style*, 14.

171. Reprinted (in Czech translation) in *Poetismus*, ed. Květoslav Chvatík and Zdeněk Pešat, Prague: Odeon, 1967, 63. This was one of three foreign-language résumés; the German and French texts slightly differ, and do not explicitly use the phrase "international style" (стиль интернациональный). See *Revoluční sborník Devětsil*, 205, for the Russian text.

172. Sara Fanelli, *Tate Artist Timeline*, London: Tate, 2006. This is not the only reason there is only one Czech name (František Kupka) in Ms. Fanelli's spreadsheet of several hundred movements and artists—Dada and constructivism, which adopted a similar anti-art stance, make the cut—but it was likely a contributory factor. Devětsil artists (with the important exceptions of Štyrský and Toyen, though they too both did a lot of book design) arguably made their major contributions to twentieth-century visual vocabularies through architecture and the applied arts of design, theater, and photography rather than the classical disciplines of painting and

sculpture, while some of Devětsil's most distinctive products, like the "pictorial poems," Nezval and Teige's *Abeceda* (discussed on pp. 237–41), or Zdeněk Pešánek's kinetic light sculptures, cross genres. This is directly related to both Devětsil's left-wing politics and the "art as part of life" program of poetism, but one might also see it as typically Czech in being *malé, ale naše*.

173. Wolker joined Devětsil early in 1922 despite some disagreements with the group's program. Teige claims that he left because "the method of modern constructivism and poetism collided with the discipline of contemporary neo-classicism and monumental epic poetry, in which Wolker believed." He insists that the divorce was amicable, and they remained personal friends until Wolker's death in January 1924. Contribution to *In Memoriam Jiřího Wolkra* (Prague: 1924), excerpted in KTD I, 514–17. The Devětsil Spring Exhibition took place at the Rudolfinum; its participants included Bedřich Feuerstein, Šíma, and Teige.

174. US Devětsil [Vladislav Vančura], untitled foreword to Jaroslav Seifert, *Město v slzách*, DJS I, 12.

175. The successive covers are reproduced in DJS I, 11 and 18–19.

176. "Angular image of suffering" (*hranatý obraz utrpení*) is the first line of the "Prefatory Poem" that introduces the collection. DJS I, 13.

177. Seifert, "Modlitba na chodníku," DJS I, 23–26.

178. The misnamed "turecká káva" (Turkish coffee), once commonly drunk in Prague but nowadays giving way to the ubiquitous espresso, is made by pouring boiling water on fine-ground coffee and letting the dregs settle.

179. Including the long poem "The Marvelous Magician" (*Podivuhodný kouzelník*), one of Nezval's best-known works.

180. *Revoluční sborník Devětsil*, 158.

181. Ibid., 183.

182. Ibid., 136–42. The article is illustrated by a still from Chaplin's "The Kid" and a circus painting by Seurat.

183. See Karel Srp, in cooperation with Polana Bregantová and Lenka Bydžovská, *Karel Teige a typografie: asymetrická harmonie*, Prague: Arbor/Akropolis, 2009, 29–33, for further discussion.

184. *Revoluční sborník Devětsil*, 176.

185. Ibid., 188, 192. Both photographs are used again in *Život II*, 196, illustrating Krejcar's article "Made in America." So are the Seurat and la Grande Roue de Paris. The pages from *Revoluční sborník Devětsil* with the illustrations for Seifert's "Paris," the steamship, and the snowplow are reproduced in Srp, *New Formations*, 37.

186. *Revoluční sborník Devětsil*, 203.

187. *Život II*, afterword, 208.

188. *Život II*, unpaginated front matter.

189. Ibid., 85. This article was carried in French alone. Le Corbusier and Ozenfant's second contribution, entitled "Le Purisme," was also previously unpublished. The latter was carried both in the original French (8–16) and in Czech translation by Karel Teige (17–27) as the opening article of the volume. Ehrenburg's "Construction" (29–34) was another extract from *And Yet It Moves*, while Behrens wrote on "The Relationship between Artistic and Technical Problems' (54–62). The French film director and critic Delluc wrote on "The Masses in Front of the Cinema Screen"

(148–52), an excerpt from his influential 1920 book *Photogenie*; Fauré wrote on "The Aesthetic of Machines" (94–101); Epstein's essay was entitled "Kino" (Cinema, 143–47).

190. *Život II*, 159–60. Man Ray's album *Les Champs délicieux*, containing twelve rayographs, was published in a limited edition in Paris in December 1921, with a preface by Tristan Tzara. The only reproductions in magazines prior to *Život II* were in the United States, in *The Little Review*, autumn 1922, and *Vanity Fair*, November 1922. See Emmanuelle de l'Écotais, *Man Ray Rayographies*, Paris: Editions Léo Scheer, 2002. Man Ray's work was featured in Devětsil's *Bazaar of Modern Art* (*Bazar moderního umění*) exhibition, which showed in Prague in November and December 1923 and Brno in January and February 1924, as examples of "mechanical and photographic beauty."

191. *Život II*, 153–68.

192. Teige, "Umění přítomnosti," *Život II*, 119–42.

193. *Život II*, 110–18.

194. For a broader context, see Jaroslav Anděl, *Avant-Garde Page Design 1900–1950*, New York: Delano Greenidge, 2002.

195. Neither Feuerstein nor Šíma were listed as Devětsil members in the *Revoluční sborník Devětsil* (207), published three months earlier, though Krejcar was. Devětsil's membership was always somewhat fluid.

196. *Život II*, 54–61.

197. Ibid., 30. Ehrenburg's article is also illustrated by photographs of a lighthouse, a telegraph pole, and (again) the Eiffel Tower and the Manhattan skyline.

198. Ibid., 52–54.

199. Ibid., 46.

200. Ibid., 38–43.

201. Josef Šíma, "Reklama," *Život II*, 102–3. The typographic design is by Teige. The relevant passage from Neumann is reproduced in bold type at the foot of p. 103.

202. The famous passage from the Communist Manifesto beginning "In place of the former local and national self-sufficiency . . . ," *Život II*, 142.

203. Ibid., 21, 62, respectively.

204. Ibid., 45.

205. Ibid., unpaginated front matter.

206. Ibid., 199–200.

207. H. R. [Hans Richter], "Prague," in *G: Journal for Elemental Form-Creation*, No. 3, June 1924, 140, in facsimile (in English translation) in *G: An Avant-Garde Journal of Art, Architecture, Design, and Film, 1923–26*, ed. Detlef Martins and Michael W. Jennings, trans. Steven Lindberg with Margareta Ingrid Christian, Los Angeles: Getty Research Institute and London: Tate, 2010, 140.

208. *Život II*, 5–6. Reprinted in *Samá láska*, DJS 1, 125–26. The poem is translated in full in Loewy, *Early Poetry of Jaroslav Seifert*, 91–92.

209. *Revoluční sborník Devětsil*, 202.

210. For fuller information, see Seifert, *Všecky krásy světa*, "Ediční poznámka," 527–32. The Odeon imprint had nothing in common with Jan Fromek's interwar publishing house except the name; all Czechoslovak publishers were nationalized after 1948.

211. The collection is included in Biebl, *Cesta na Jávu.*

212. Examples of Devětsil's pictorial poems are reproduced in Anděl, *Art of the Avant-Garde in Czechoslovakia*; Anděl, *Czech Modernism*; *Devětsil: česká výtvarná avantgarda dvacátých let*, texts by František Šmejkal, Rostislav Švácha, and Jan Rous, Prague: Galerie hlavního města Prahy, 1986; *Devětsil: Czech Avant-Garde Art, Architecture and Design of the 1920s and 30s*, ed. Rostislav Švácha, Oxford, UK: Museum of Modern Art; London: London Design Museum, 1990; *Karel Teige 1900–1951*, texts by Karel Srp and others, Prague: Galerie hlavního města Prahy, 1994; Codeluppi, *Karel Teige: architettura, poesie–Praga 1900–1951*; and Srp, *New Formations.*

213. *Život II*, 35–42. The article is signed K.

214. See Loewy, *Early Poetry of Jaroslav Seifert.*

215. As it was advertised in the satirical review *Sršatec.* DJS 1, 217.

216. See, for instance, the poems "A Glorious Day" and "Verses in Remembrance of the Revolution."

217. Seifert, "Verše o lásce, vraždě a šibenici," DJS 1, 107.

218. The cover montage also includes an auto wheel, a vase of flowers, a postcard view of Jičín, the words *Praha, Devětsil,* and *Disk,* and the date 1923. The words *Jičín, Paris,* and *New York* are incorporated in the frontispiece. DJS 1, 72–73.

219. Devětsil [Karel Teige], untitled afterword to Jaroslav Seifert, *Samá láska,* in DJS 1, 128–29.

220. Seifert, "Černoch," DJS 1, 121. I have translated *černoch* as "Negro" and *černošky* as "Negro women" rather than, as Dana Loewy does, "black women," on grounds of consistency with the English usage of the 1920s. I think Loewy's rendition of *cerný hoch* as "black boy," on the other hand, somewhat unfortunate given the racist connotations of the term *boy* as applied to black people in US history. There are no such connotations in Czech. *Hoch* can be translated as "boy," "lad," "kid," or alternately "guy," according to context. The adjective *černý* simply means black.

221. "Černošský král" is reproduced in Slavík, *Josef Čapek,* 252.

222. Annie Le Brun, "Toyen ou l'insurrection lyrique," *Nouvelle Revue Française,* No. 559, 2001, 135.

223. These sketches are reproduced together with several others from the same sketchbook in Karel Srp, *Toyen,* 25–28. "In her early French sketchbooks, Toyen experimented with a wide variety of sexual imagery, including lesbian activities, sailors spraying nude women with semen, and even bestiality," writes Karla Huebner ("Eroticism," 101). The dates on many of the sketches show that Toyen was in Paris from at least the middle of January through March 1925.

224. Quoted in Bennetta Jules-Rosette and Njami Simon, eds., *Josephine Baker in Art and Life: The Icon and the Image,* Chicago: University of Illinois Press, 2007, 179. A photograph of La Baker clad (only) in her trademark skirt of bananas was carried in *ReD,* Vol. I, No. 1, October 1927, 25.

225. Huebner, "Eroticism," 106.

226. Seifert, "Černoch," DJS 1, 121.

227. DJS 1, 85. The Café Rotunda is identified by name.

228. Seifert, "Paříž," DJS 1, 82–84. The poem is dedicated to Ivan Goll.
229. Seifert, "Námořník," DJS 1, 119.
230. Seifert, "Paříž," DJS 1, 82–84.
231. Josef Kopta, "Umění proletářské a poetismus," *Přerod*, II, 1924, 157–62, reprinted in AZN 1, 598. See also František Branislav's 1925 satirical verse "Poetis-tická," in AZN 2, 59.
232. A reference to Seifert's poem of that title in *Na vlnách TSF*, in DJS 2, 43.
233. F. C. Weiskopf, "100 Procent," *Avantgarda* Vol. 1, No. 4, April 1925, reprinted in AZN 2, 78–83.
234. Originally published in the "O sobě" column of *Rozpravy Aventina*, quoted in *Reflex*, No. 39, 1992, 68.
235. Vítězslav Nezval, *Ulice Gît-le-Coeur*, 7.

5. Body Politic

1. Hans Bellmer, *Little Anatomy of the Physical Unconscious, or The Anatomy of the Image*, trans. Jon Graham, Waterbury Center, VT: Dominion, 2004, 19–20.
2. Tobias G. Natter, "On the Limits of the Exhibitable: The Naked Body and Public Space in Viennese Art around 1900," in Natter, *Naked Truth*, 20. Courbet's *L'Origine du monde* was painted in 1866 as a private commission for the Ottoman Ambassador to Saint Petersburg. It has spent much of its life under wraps: "He unlocked a painting whose external panel showed a village church in the snow, and whose hidden panel was the picture Courbet painted for Khalil-Bey, a woman's abdomen down to a black and prominent mount of Venus, above the slit of a pink cunt," wrote Éduard de Goncourt in his diary for 29 June 1889 (quoted in Bernard Marcadé, "Le devenir-femme de l'art," in *féminimasculin: Le sexe de l'art*, Paris: Centre Pompidou, 1995, 23). The probable model for the painting was James Abbott McNeill Whistler's mistress Joanna Hiffernan. Courbet thought his work "beauti-ful.... Yes, it is very beautiful, and Titian, Veronese, THEIR Raphael and I MYSELF have never done anything more beautiful" (quoted in Thierry Sabatier, *L'Origine du monde: Histoire d'un tableau de Gustave Courbet*, 2d ed., Paris: Bartil-lat, 2006, 75).
3. Quoted in Max Hollein, Foreword to Natter, *Naked Truth*, 10. The German text reads: "Kannst Du nicht allen gefallen durch Deine That und Dein Kunst-werk—mach es wenigen recht vielen Gefallen ist schlimm."
4. John Updike, "Klimt and Schiele Confront the Cunt," in his *Collected Poems 1953–1993*, New York: Knopf, 1997, 210.
5. Paul Éluard, "Poetic Evidence," in Read, *Surrealism*, 174–76.
6. Schiele, *Self-Portrait as Saint Sebastian*, 1914, reproduced in Natter, *Naked Truth*, 275; Kubišta, *Sv. Šebastián*, 1912, reproduced in Nešlehová, *Bohumil Kubišta*, 125; T. S. Eliot, "The Love Song of St. Sebastian," 1914, in T. S. Eliot, *Inventions of the March Hare: Poems 1909–1917*, ed. Christopher Ricks, New York: Harcourt Brace, 1996, 78–79.
7. Information in this paragraph is taken from Natter, *Naked Truth*, 126–27.
8. Kokoschka, *Mein Leben*, as quoted in Natter, *Naked Truth*, 120. According to *Encyclopaedia Britannica*, Kokoschka explained in 1933 that the play was intended

to contrast "the callousness of our male society with my basic conception of man as mortal and woman as immortal; in the modern world it is only the murderer who wishes to reverse this state of affairs." Regrettably the article does not give the original source for this quotation. "Oskar Kokoschka," available at http://www.britannica.com/EBchecked/topic/321260/Oskar-Kokoschka (accessed 4 May 2012).

9. Natter, *Naked Truth*, 152. The offensive *Der Sturm* cover is reproduced on p. 153.

10. Natter, *Naked Truth*, 476.

11. Kokoschka, *Mein Leben*, quoted in Natter, *Naked Truth*, 121.

12. Open Letter on Behalf of Max Liebermann, May 1933, in *Oskar Kokoschka, Letters 1905–1976*, ed. Olda Kokoschka and Alfred Marnau, London: Thames and Hudson, 1992, 134.

13. Kokoschka to Alma Mahler-Werfel, 16 December 1937, in *Letters*, 150.

14. Oskar Kokoschka, *My Life*, London: Thames and Hudson, 1974, 72–73.

15. Kokoschka, *Life*, 79.

16. Alma Mahler, diary entry, 17 May 1914, quoted in Francoise Giroud, *Alma Mahler: The Art of Being Loved*, Oxford, UK: Oxford University Press, 1991, 109. Mahler gives a slightly different account of the death-mask incident in Alma Mahler Werfel, *And the Bridge Is Love: Memories of a Lifetime*, trans. E. B. Ashton, London: Hutchinson, 1959, 75.

17. Giroud, *Alma Mahler*, 115.

18. Kokoschka to Alma Mahler-Werfel, 30 July 1937, in *Letters*, 146.

19. Kokoschka, *Life*, 116.

20. Kokoschka to Hermine Moos, 20 August 1918, in Frank Whitford, *Oskar Kokoschka: A Life*, London: Weidenfeld and Nicolson, 1986, 119–20.

21. Kokoschka to Hermine Moos, 10 December 1918, quoted in Whitford, *Kokoschka*, 120–21.

22. Kokoschka to Hermine Moos, 15 January 1919, quoted in ibid., 121.

23. Oskar Kokoschka, *A Sea Ringed with Visions*, London: Thames and Hudson, 1962, 7, quoted in Whitford, *Kokoschka*, 123. Here Oskar claims that Reserl later crept into his bed, whispering in his ear "I am at your service body and soul—dispose of me, Sir."

24. See the correspondence reproduced in Whitford, *Kokoschka*, 122–24.

25. Kokoschka, *Life*, 116–17.

26. Kokoschka to Hermine Moos, 15 January 1919, quoted in Whitford, *Kokoschka*, 121.

27. Kokoschka to Hermine Moos, 6 April 1919, quoted in ibid., 121.

28. Kokoschka, *Life*, 118.

29. *Self-portrait with Doll*, 1920–21. Calvocoressi is quoted from *Oskar Kokoschka 1886–1980*, ed. Richard Calvocoressi, London: Tate Gallery, 1986, 309.

30. Kokoschka, *Life*, 117.

31. Ibid., 118.

32. Calvocoressi, *Oskar Kokoschka*, 97.

33. Kokoschka, Open Letter to the Inhabitants of Dresden, March 1920, in *Letters*, 75.

34. John Heartfield and George Grosz, "The Art Scab," originally published as

"Der Kunstlump," *Der Gegner*, Vol. 1, Nos. 10–12, 1920, trans. in Kuenzli, *Dada*, 227–28.

35. Ibid.

36. Kokoschka, Open Letter to the Inhabitants of Dresden.

37. The painting is reproduced in Kuenzli, *Dada*, 94. For background on the Berlin Dada Fair, see Bruce Altshuler, *The Avant-Garde in Exhibition: New Art in the 20th Century*, Berkeley: University of California Press, 1998, 98–105.

38. Robert Motherwell, ed. *The Dada Painters and Poets: An Anthology*, 2d ed., Boston: G. K. Hall, 1981, Introduction, xxiii.

39. Huelsenbeck, "En avant Dada," 1920, in Motherwell, *Dada Painters*, 45–47.

40. The visit took place in September 1921.

41. See Karel Srp, "Poetry in the Midst of the World: The Avant-Garde as Projectile," in Benson, *Central European Avant-Gardes*, 116.

42. František Halas, *Dadaism*, Prague, 1925, excerpt translated in Benson, *Between Worlds*, 372; Karel Teige, "Dada," *Host*, Vol. 6, No. 2, November 1926, reprinted in AZN 2, 285–303, excerpt translated in *Between Worlds*, 376–81. Teige also wrote on Dada in his two-part work *Svět, který se směje* and *Svět, který voní* (The World That Laughs and The World That Smells), Prague: Odeon, 1928 and 1930, respectively, a study of "humor, Dadaists and clowns." Both volumes have been reprinted (Prague: Akropolis, 2004). For further discussion, see Jindřich Toman, "Now You See It, Now You Don't: Dada in Czechoslovakia, with Notes on High and Low," in *The Eastern Dada Orbit: Russia, Georgia, Central Europe and Japan*, ed. Gerald Janeček, New York: G. K. Hall/Prentice International, 1998, 11–40; and Miloslav Topinka, "The Dada Movement in Relation to the Czech Interwar Avant-Garde," *Orientace*, 1970, trans. James Naughton for *Dada East*, 17th Prague Writers Festival, available at http://www.pwf.cz/rubriky/projects/dada-east/miloslav-topinka-the-dada-movement-in-relation-to-the-czech-inter-war-avant-garde_8057 .html (accessed 4 May 2012).

43. See Witkovsky, "Surrealism in the Plural: Apollinaire, Ivan Goll and Devětsil in the 1920s." Lenka Bydžovská and Karel Srp give what is probably the best overview in English of the shifting positions of the 1920s Prague avant-garde toward surrealism in Srp, *New Formations*, chs. 3–5.

44. Karel Teige, "Surréalistické malířství," *ReD*, Vol. 2, No. 1, September 1928, 26–27.

45. Jindřich Štyrský and Toyen, "Artificielismus," *ReD*, Vol. 1, No. 1, October 1927, 28–30, trans. in Benson, *Between Worlds*, 589–90.

46. Karel Teige, "Ultrafialové obrazy, čili artificielismus (poznámka k obrazům Štyrského & Toyen)," *ReD*, Vol. I, No. 9, 1927–28, 315–17. This is translated in Benson, *Between Worlds*, 601–3. The issue of *ReD* in which this article appeared, titled "Manifestoes of Poetism," also contained Nezval's "Kapka inkoustu" and Teige's "Manifest Poetismu."

47. Štyrský and Toyen, "Artificielismus," in Benson, *Between Worlds*, 589.

48. "This word had no currency before we came along. Therefore, I am defining it once and for all: SURREALISM, *n*. psychic automatism in its pure state, by which one proposes to express—verbally, by means of the written word, or in any other manner—the actual functioning of thought. Dictated by thought, in the absence of any control exercised by reason, exempt from any aesthetic or moral

concern." André Breton, *Manifesto of Surrealism*, 1924, in *Manifestoes of Surrealism*, 26.

49. See André Breton, "Le message automatique," *Minotaure*, Vol. 1, Nos. 3–4, 1933, 55–65, trans. in *What Is Surrealism?*, Book 2, 109.

50. See Jindřich Štyrský, *Sny*.

51. Karel Teige, "Ultrafialové obrazy."

52. André Breton, *Anthology of Black Humor*, trans. Mark Polizzotti, San Francisco: City Lights, 1997, vi–vii.

53. Brassaï, *Conversations with Picasso*, 12.

54. Robert Desnos, "Third Manifesto of Surrealism" (1930), in *Essential Poems and Writings of Robert Desnos*, ed. Mary Ann Caws, Boston: Black Widow Press, 2007, 72. This was another bitter response to Breton's *Second Manifesto*.

55. Epigram to Jaroslav Seifert, *Na vlnách TSF*, in DJS 2, 15.

56. Julius Fučík, "Cesta kolem světa," afterword to Seifert, *Slavík zpívá špatně*, in DJS 2, 133–36. This collection was originally published in 1926 by Odeon with illustrations (every one of which involves a naked female body) by Josef Šíma, to whom the book is dedicated. Fučík admits to having at first criticized *Na vlnách TSF* for "desertion of the proletarian cause," on which point, he says, "we were wrong." Reassured by *Slavík zpívá špatně*, he understands *Na vlnách TSF* as part of a poetic "journey around the world" that starts and ends in Moscow.

57. Seifert, *Všecky krásy světa*, 335.

58. Seifert, DJS 2, 22, 51, 34, respectively.

59. Seifert, "Počitadlo," DJS 2, 55.

60. Seifert, *Všecky krásy světa*, 336.

61. Paukert Delicatessen website, available at http://www.mycompanion.cz/en/list/delicatessen-paukert (accessed 4 May 2012).

62. "Again available, the special sandwich from Paukert's," Praha.EU Portal of Prague website, available at http://www.praha.eu/jnp/en/entertainment/leisure_activities/again_available_the_special_sandwich_from_paukerts.html (accessed 4 May 2012).

63. Vítězslav Nezval, *Abeceda*, Prague: Torst, 1993, 8. This is a facsimile reprint of the 1926 Otto edition. Jindřich Toman and Matthew S. Witkovsky have produced a superb English edition of this text, which scrupulously reproduces the typography, photomontages, and layout: *Alphabet*, Ann Arbor: Michigan Slavic Publications, 2001. Subsequent references are to the Otto/Torst Czech edition unless otherwise stated.

64. Vítězslav Nezval, *Pantomima: poesie*, Prague: Ústřední studentské knikupectví a nakladatelství, 1924, reprinted Prague: Akropolis, 2004. "Abeceda" is the first poem in the collection, pp. 7–11.

65. Nezval, *Abeceda*, 3.

66. Witkovsky, "Avant-Garde and Center: Devětsil in Czech Culture, 1918–1938."

67. The photograph is reproduced in Anděl, *Art of the Avant-Garde in Czechoslovakia*, 209, and Srp, *Karel Teige a typografie*, 154. The latter source identifies it as taken at Jiří Kroha's house in Brno in 1933. Kroha is probably best remembered for his 1932–33 "instructional and photomontage cycle" *A Sociological Fragment of Living*, which was exhibited in Brno and Prague (at the Clam-Gallas Palace) in 1934.

The cycle was later issued in book form as Jiří Kroha, *Sociologický fragment bydlení*, Brno: Krajské středisko státní památkové péče a ochrany přírody v Brně, 1973, though this edition does scant justice to the originals. Kroha's montages are better reproduced (and discussed at length by Klaus Spechtenhauser) in *Jiří Kroha (1893–1974): architekt, malíř, designer, teoretik v proměnách umění 20. století*, ed. Marcela Macharáčková, Brno: Muzeum města Brna, 2007, 226–72.

68. *Abeceda* figured prominently in the 2006 Victoria and Albert Museum exhibition *Modernism 1914–1939*, where not only was the book itself on display but also a video re-creation of Milča Mayerová's performance. Teige's design for the letter *G* also forms the cover for Julian Rothenstein and Mel Gooding, eds., *ABZ: More Alphabets and Other Signs*, London: Redstone, 2003.

69. I quote the first line of Nezval's poem on the letter *I*, in *Abeceda*, 22.

70. Some of Jesenská's writings on sport can be found in Hayes, *Journalism of Milena Jesenská*. Sutnar's cover for *Žijeme*, Vol. 1, Nos. 4–5, July–August 1931, is reproduced in Vlčková, *Družstevní práce—Sutnar Sudek,* 96, and Iva Janáková, ed., *Ladislav Sutnar—Praha—New York—Design in Action*, Prague: Uměleckoprůmyslové muzeum/Argo, 2003, 154. For Drtikol, see Anna Fárová, *František Drtikol: Art-Deco Photographer*, Munich and London: Schirmer Art Books, 1993; Vladimír Birgus, *The Photographer František Drtikol*, Prague: Kant, 2000; František Drtikol, *Oči široce otevřené*, Prague: Svět, 2002; and Jan Mlčoch, *František Drtikol: fotografie z let 1918–1935*, Prague: Uměleckoprůmyslové muzeum, 2004 (trilingual Czech-French-English edition).

71. Letter to Drtikol from Dr Koike, April 1929, quoted in Birgus, *The Photographer František Drtikol*, 46.

72. Teige's essay "Modern Typography," which discusses his designs for *Na vlnách TSF*, Nezval's *Pantomima*, and *Abeceda*, is translated (by Alexandra Büchler) in Dluhosch and Švácha, *Karel Teige 1900–1951*, 94–105, and Srp, *New Formations*, 76–84. The original, published as "Moderní typo" in *Typografia*, No. 34, 1927, 189–98, can be found in KTD 1, 220–34. For further discussion, see Polana Bregantová, "Typography," in Dluhosch and Švácha, *Karel Teige*, 72–91. The fullest study to date of Teige's contribution to typography is Srp's *Karel Teige a typografie*, which reprints all of Teige's major writings on the topic.

73. I discuss Kmen in more detail in *Coasts*, 207–8. "We are national, but we want to be cosmopolitan in the best sense of the word. We want to be a bridge between domestic and foreign culture," wrote Otakar Štorch-Marien in the society's founding proclamation (6 April 1926, in *Aventinská mansarda: Otakar Štorch-Marien a výtvarné umění*, ed. Karel Srp, Prague: Galerie hlavního města Prahy, 1990, 7). The annual volumes and spring almanacs of *Almanach Kmene* (1930–38) illustrate how far this ambition was realized. Toyen was the artistic editor for the 1933 spring almanac, devoted to the theme of love, for which she provided many illustrations (*Milostný almanach Kmene pro jaro 1933*, ed. Libuše Vokrová, Prague: Orbis, 1933).

74. Matthew S. Witkovsky, "Creating an Alphabet for the Modern World," in Nezval, *Alphabet* (Michigan edition), 66–69. Chapter 2 of Witkovsky's PhD thesis, "Avant-Garde and Center: Devětsil in Czech Culture, 1918–1938," is a very full study of *Abeceda*.

75. Karel Teige, "Poetismus," originally published in *Host*, Vol. 3, Nos. 9–10, July 1924, 197–204, in KTD 1, 123. This manifesto is translated in Benson, *Between Worlds*, 579–82.

76. W. H. Auden, "September 1, 1939," in Robin Skelton, ed., *Poetry of the Thirties*, London: Penguin, 1964, 280–83.

77. Karel Teige and others, "Zásadní stanovisko k projevu 'Sedmi,'" *Tvorba*, Vol. 4, 1929, reprinted in AZN 3, 54–55.

78. Jindřich Štyrský, "The Generation's Corner," in Benson, *Between Worlds*, 676–77. Originally published as "Koutek generace," *Odeon*, No. 1, 1929, reprinted in Štyrský, *Texty*, 42–43, and AZN 3, 102–3.

79. The relevant texts can be found in AZN 3; see especially Štyrský's criticisms of Teige in "Koutek generace III," AZN 3, 180–82.

80. Teige, "Poetismus," 123.

81. "Levá fronta," in AZN 3, 121; originally published in *ReD*, Vol. III, No. 2, 1929, 48. The text is translated as Left Front, "Founding Manifesto," in Benson, *Between Worlds*, 678–79.

82. There were two issues of *Zvěrokruh*, which came out in November and December 1930. Issue 1 included an extract from Breton's *Nadja* and poetry by Paul Éluard, Louis Aragon, Jean Cocteau, Philippe Soupault, Tristan Tzara, and E.L.T. Mesens; "Surrealist Games," whose participants included Breton, Éluard, Aragon, Robert Desnos, Georges Sadoul, and Benjamin Péret; Karel Teige's "Báseň, svět, člověk"; and writings by Nezval, Brouk, Vančura, and Hoffmeister. Aside from the *Second Manifesto* (60–74), Issue 2 included Breton's and Éluard's "Notes on Poetry" (74–77) and the first Czech translation of Karl Marx's "Theses on Feuerbach." Both issues are reproduced in facsimile in Torst Surrealist Reprints.

83. Karel Teige, "Nová etapa surrealismu," *Rozpravy Aventina*, Vol. 6, Nos. 39–40, June 1931, excerpts in KTD 2, 593–94.

84. Karel Teige, "Od artificielismu do surrealismu," in KTD 2, 465.

85. See Polizzotti, *Revolution of the Mind*, 273–74.

86. Philippe Soupault, quoted in Serge Faucherau, "Quelques semaines au printemps de 1935: L'Internationale Surréaliste," in Spies, *La Révolution surréaliste*, 406.

87. René Daumal, "Lettre ouverte à André Breton," in *Le Grand Jeu*, Vol. III, 1930, 76–83. Ironically, one of Breton's criticisms of Le Grand Jeu was their lack of attention to Lautréamont.

88. *Le Grand Jeu*, Vol. III, 1930, 87.

89. Karel Srp, "Erotická revue a Edice 69," in *Erotická revue*, Vol. 3, 1933, Prague: Torst, 2001 reprint, 136–37.

90. *La Révolution surréaliste*, Vol. 5, No. 12, December 1929, reprinted Paris: Jean-Michel Place, 1975, 1. Georges Sebbag's introduction to the Jean-Michel Place reprint identifies the lips as those of Muzard, Triolet, Éluard, Ernst, Apfel, Goemans, and Tanguy (vi); other accounts slightly differ.

91. Louis Aragon, Benjamin Péret, and Man Ray, *1929*, reprinted Paris: Éditions Allia, 2004. The photographs from *1929* are reproduced in Fuku and Jacob, *Man Ray: Despreocupado pero no indiferente/Unconcerned but not Indifferent*, 173.

92. *Variétés: Le Surréalisme en 1929*, Brussels: June 1929, reprint Brussels: Didier Devillez Editeur, Collection Fac-Similé, 1994.

93. Aragon, Péret, Ray, *1929*, 45.

94. John Baxter, "Man Ray Laid Bare," *Tate Magazine*, Issue 3, January–February 2003, available at http://umintermediai501.blogspot.co.uk/2008/04/man-ray-laid-bare.html (accessed 4 May 2012).

95. *Erotická revue*, 3 vols., Prague, private printing, 1930–33. Reprint, Prague: Torst, 2001. The first volume came out in four issues between October 1930 and May 1931, the second and third both appeared as single annual volumes in May 1932 and April 1933, respectively. For further information, see Srp, "Erotická revue a Edice 69."

96. Except in the small number of luxury copies, where some illustrations—including Toyen's—were hand-colored by the artists.

97. *Erotická revue*, Vol. I, 2001 reprint, inside back cover.

98. Srp, "Erotická revue a Edice 69," 136.

99. Roberto Paolella, quoted on London Czech Centre website, available at http://london.czechcentres.cz/programme/travel-events/erotikon-live-accompani menti/ (accessed 4 May 2012).

100. Mario Gromo, "Sullo schermo, sotto le stelle," *La Stampa*, 8 August 1934, available at http://www.archiviolastampa.it/component/option,com_lastampa/task,search/action,page/id,0028_01_1934_0187_0003_24906700&s=34ad88f1a2 a1d9f3ca0040db352b4b3d (accessed 4 May 2012).

101. Hedy Lamarr, *Ecstasy and Me: My Life as a Woman*, London: W. H. Allen, 1967, 25-26.

102. *Erotická revue*, Vol. I, 1.

103. As it is described in Gérard Durozoi, *History of the Surrealist Movement*, trans. Alison Anderson, Chicago: Chicago University Press, 2002, 700.

104. Seifert, *Všecky krásy světa*, 175.

105. The caricature, dating from 1930, is reproduced in Srp, *Adolf Hoffmeister*, 90.

106. The cartoon strikingly recalls Max Ernst's *Santa Conversazione*, the template for his painting *The Beautiful Gardener* (discussed on pp. 288–89), in both its composition and its use of the dove motif. Hoffmeister may have seen Ernst's original, which belonged to Louis Aragon, on one of his many trips to Paris.

107. *Erotická revue*, Vol. I, 25, 27.

108. Ibid., 40.

109. Ibid., 81.

110. *Erotická revue*, Vol. III, 109.

111. André Breton and Paul Èluard, *L'immaculée conception*, in ABOC 1, 841–86.

112. "Adresář Maison de rendevous v Paříži," *Erotická revue*, Vol. II, 129–30. Sixty-four establishments are listed in all.

113. "Recherches sur la sexualité. Part d'objectivité, déterminations individuelles, degré de conscience." *La Révolution surréaliste*, Vol. 4, No. 11, March 1928, 32–40.

114. *Investigating Sex: Surrealist Discussions 1928–1932*, ed. José Pierre, trans. Malcolm Imrie, New York: Verso, 1992, 3.

115. Ibid., 31.

116. Ibid., 5.

117. Ibid., 132.

118. Ibid., 131.

119. Ibid. 5.

120. Ibid., 151.

121. Quoted in Polizzotti, *Revolution of the Mind*, 316.

122. Georges Bataille, "The 'Old Mole' and the prefix Sur in the Words Surhomme (Superman) and Surrealist," in his *Visions of Excess*, ed. Allan Stoekl, Minneapolis: Minnesota University Press, 2004, 39.

123. André Breton, *Second Manifesto*, in *Manifestoes of Surrealism*, 185.

124. *Erotická revue*, Vol. I, 102.

125. *Erotická revue*, Vol. III, 45.

126. See Karel Srp, "Ti druzí," in Srp, *Adolf Hoffmeister*, 138–67, which reproduces many examples of Hoffmeister's work for *Simplicus*.

127. *Erotická revue*, Vol. I, 128.

128. It is interesting, in this connection, to compare nude photography in Nazi Germany, where there was a widespread cult of healthy open-air nudism. For examples, see Alessandro Bertolotti, *Livres de nus*, Paris: Éditions de la Martinière, 2007, 125–37.

129. Adolf Hitler, Speech at Reich Party Congress 1935, trans. in Stephanie Barron, ed., *"Degenerate Art": The Fate of the Avant-Garde in Nazi Germany*, Los Angeles: Los Angeles County Museum of Art/New York: Abrams, 1991, 384–86.

130. Mussolini would distance himself from the Futurists in the later 1930s. For background, see *Art and Power: Europe under the Dictators 1930–45*, compiled by Dawn Ades, Tim Benton, David Elliott, and Iain Boyd White, London: Hayward Gallery/Thames and Hudson, 1995, esp. 120–85.

131. Quoted in Benjamin, "The Work of Art in the Age of Its Technological Reproducibility: Third Version," in his *Selected Writings Volume 4*, 269. The essay is better (if less accurately) known in English under the title "The Work of Art in the Age of Mechanical Reproduction."

132. Walter Benjamin, "Work of Art," 269–70.

133. Dedication to "The Waste Land," 1922, in T. S. Eliot, *Collected Poems 1909–1962*, London: Faber, 1974, 61.

134. Giuseppe Terragni, "Building the Casa del Fascio in Como," *Quadrante*, 35–36, 1936, translated in Peter Eisenman, *Giuseppe Terragni: Transformations, Deformations, Critiques*, New York: The Monacelli Press, 2003, 262, 266.

135. Rem Koolhaas has provocatively raised the question of the relation between such iconic examples of modernist architecture and "real histories" of modernity in his wholly fictionalized—but surreally accurate—"history" of Mies's Barcelona Pavilion, "Less Is More," in Rem Koolhaas and Bruce Mau, *S, M, L, XL: Small, Medium, Large, Extra-Large*, 2d ed., New York: Monacelli Press, 1998, 46–61. Koolhaas's essay forms the starting-point of my own reflections on the same question in connection with the Tugendhat Villa and Prague's Veletržní palác, in "The Unbearable Lightness of Building—A Cautionary Tale," *Grey Room*, No. 16, summer 2004, 6–35.

136. Alfred Rosenberg, *"Race and Race History" and Other Essays*, New York: Harper and Row, 1970, 154, quoted in Barron, *"Degenerate Art,"* 11.

137. Gottfried Benn, "Confessions of an Expressionist," in *Voices of German Expressionism*, ed. Victor H. Miesel, London: Tate, 2003, 194.

138. Ibid., 202.

139. Leni Riefenstahl, undated BBC interview, quoted in "Film-Maker Leni Riefenstahl Dies," 9 September 2003, available on the BBC website at http://news.bbc.co.uk/1/hi/entertainment/film/3093154.stm (accessed 4 May 2012).

140. Franz Marc to Wassily Kandinsky, October 14, 1914, quoted in Barron, "Degenerate Art," 295.

141. Franz Marc, "In War's Purifying Fire," 1915, in Miesel, Voices of German Expressionism, 160–66.

142. Emil Nolde, Jahre der Kämpfe, 1934, quoted in Barron, "Degenerate Art," 319.

143. Barron, "Degenerate Art," 319.

144. Nolde to Josef Goebbels, July 2, 1938, in Miesel, Voices of German Expressionism, 209.

145. Emil Nolde, "The Second World War," in ibid., 210–11.

146. This is reproduced in Chaos and Classicism: Art in France, Italy, and Germany, 1918–1936, ed. Kenneth E. Silver, New York: Guggenheim Museum, 2010, 134–35. This exhibition was remarkable—especially for New York, which has for so long been the bastion of formalist histories of modern art—in its willingness to tackle the complexities of the relationship between modernism(s) and fascism. It culminated in a room containing (among other works) Ziegler's Four Elements, Georg Kolbe's Young Warrior, Mario Sironi's Soldier, and Giorgio de Chirico's Gladiators Resting—plus a continuous screening of the opening sequence of Leni Riefenstahl's Olympia. Kolbe's Young Warrior also featured in the Great German Art Exhibition. Coincidentally—or not—Kolbe was the author of the female nude sculpture The Dawn standing in the reflecting pool in Mies van der Rohe's Barcelona Pavilion, the sole purely "decorative" element in the building.

147. Josef Goebbels, decree of 30 June 1937 sent to all major German museums, quoted in Barron, "Degenerate Art," 19.

148. For fuller details of works by Kokoschka included in the exhibition, see Barron, "Degenerate Art," 286–89.

149. I quote the official exhibition guide Entartete "Kunst": Ausstellungsführer, as reproduced in facsimile (with English translation) in Barron, "Degenerate Art." The quotation is from p. 362.

150. These figures are taken from Barron, "Degenerate Art," 9–23, and Altshuler, The Avant-Garde in Exhibition, 136–49. Stephanie Barron's re-creation of Entartete Kunst, Los Angeles County Museum of Art, in 1991 was a landmark in addressing the real history of twentieth-century art, and her catalogue is a superbly researched and richly informative document.

151. "The last time, for ten years or more, that my pictures could be shown was at the infamous Exhibition of Degenerate Art in Munich in 1937; this exhibition was visited by two and a half million sad Germans and foreigners who came to say goodbye—as they must have thought then, forever—to my fellows artists and me." Kokoschka to James S. Plaut, 13 May 1948, in Letters, 193. Original in English.

152. When the Tate Modern first opened, it caused some uproar in its decision to group the exhibits from its permanent collections thematically rather than chronologically. While the 2006 rehang keeps to the thematic principle, there is evidence

of a retreat to the standard categories of art history in both the groupings and Sara Fanelli's "map" of the modern-art canon, which lists movements and artists chronologically, in a linear movement from right to left. On the latter, see ch. 4, note 172.

153. *Entartete "Kunst": Ausstellungsführer*, in Barron, *"Degenerate Art."*

154. Ibid., 360.

155. Ibid., 364–66.

156. Ibid., 368.

157. Ibid., 374.

158. Ibid., 376.

159. Breton, "Surrealist Situation of the Object," in *Manifestoes of Surrealism*, 273, emphasis added.

160. Were I writing in Czech, I might be tempted to use the word *asanace* here. See earlier, pp. 99–100.

161. Works by Mueller exhibited in the *Degenerate Art* exhibition are reproduced in Barron, *"Degenerate Art."*

162. Vítězslav Nezval, *Sexual Nocturne*, trans. Jed Slast, in V. Nezval and J. Štyrský, *Edition 69*, Prague: Twisted Spoon Press, 2004, 33. This volume contains translations of Nezval's *Sexual Nocturne*, Štyrský's *Emily Comes to Me in a Dream*, and four of the dream-records later collected in Štyrský's *Sny*.

163. Nezval, *Sexual Nocturne*, 7. The flyer was written by Jindřich Štyrský.

164. Ibid., 37, 49–52.

165. Nezval, Štyrský, *Edition 69*, 128 (from promotional flyer, quoted in translator's note).

166. Vítězslav Nezval, *Sexuální nocturno: příběh demaskované iluse*, Prague: Edice 69, 1931; reprint, Prague: Torst, 2001. Štyrský's illustrations are also included with the translation in *Edition 69*. See Max Ernst, *Hundred Headless Woman (La femme 100 têtes)*, trans. Dorothea Tanning, New York: George Braziller, 1982 (bilingual French-English edition); *A Little Girl Dreams of Taking the Veil (Rêve d'une petite fille qui voulut entrer au Carmel)*, trans. Dorothea Tanning, New York: George Braziller, 1982 (bilingual French-English edition); *Une Semaine de bonté: les collages originaux*, ed. Werner Spies, Paris: Gallimard, 2009. The title *La femme 100 têtes* puns on the homonym *cent/sans*, hence the translation as "headless." "With method and violence": Ernst, "An Informal Life of M. E.," 12.

167. Nezval, *Sexual Nocturne*, 49, 54–57.

168. "Through all phases of development, he [Ernst] has been my closest relative. It began with Dada." Hannah Höch, undated journal entry for December 1951, quoted in Peter Boswell, Maria Makela, Carolyn Lanchner, and Kristin Makholm, *The Photomontages of Hannah Höch*, Minneapolis: Walker Art Center, 1997, 22. "Dada-Ernst" is reproduced on p. 32 of the same volume. For Bataille, see *Story of the Eye*, 84.

169. *Erotická revue*, Vol. I, 1931, 126. Compare Toyen's illustrations for Radovan Ivšić, *Le puits dans la tour*, 1967, and Annie Le Brun, *Sur le champ*, 1967, reproduced in part in Bydžovská and Srp, *Knihy s Toyen*, 78–81.

170. Markýz de Sade, *Justina čili prokletí ctnosti*, reprint of original 1932 edition, Prague: Torst, 2003, 49. Toyen's original colored drawing is reproduced in the unpaginated section at the back of the book.

171. Apollinaire to Louise de Coligny, 28 January 1915, in *Lettres à Lou*, 140.

172. Guillaume Apollinaire, *Alkoholy*, trans Zdeněk Kalista, Prague: Edice Pásmo, 1935. Toyen also provided a frontispiece for Apollinaire, *Básně*, trans. K. Čapek, J. Hořejší, Z. Kalista, and J. Seifert, preface by Karel Teige, Prague: Ústřední dělnické knihupectví a nakladatelství, 1935. Both are reproduced in Bydžovská and Srp, *Knihy s Toyen*, 23, 55.

173. Srp, *Toyen: une femme surréaliste*, 87. "Výprask na holou" is reproduced at the website Divoké víno, available at http://www.divokevino.cz/3107/toyen.php?pos=12#toyen (accessed 4 May 2012).

174. Jindřich Štyrský, "Inspirovaná ilustrátorka," in *Almanach Kmene*, ed. František Halas, 1932–33, 73, quoted in Toman, *Foto/Montáž tiskem*, 189. The full article has recently been translated by Kathleen Hayes as "The Inspired Illustrator," in Srp, *New Formations*, 120–21.

175. Marguerite d'Angoulême, *Heptameron novel*, Prague: Družstevní práce, 1932, 175, 323. Five of these drawings are reproduced in Srp and Bydžovská, *Knihy s Toyen*, 30–31. The relevant chapter of the latter, titled "Pro soukromou potřebu" (For Private Use), discusses Toyen's erotic illustrations from the 1930s in detail. See also the same authors' "Under Covers," in Srp, *New Formations*, 122–27 (and following plates).

176. Nezval, Štyrský, *Edition 69*, 71.

177. Karel Srp, in *Erotická revue*, Vol. III, 135.

178. Jindřich Štyrský, *Emilie přikází k mně ve snu*, Prague: Edice 69, 1933, reprinted Prague: Torst, 2001, 29. This is in color; a black-and-white reproduction is included in Nezval and Štyrský, *Edition 69*, 107. The text of *Emilie* is translated by Iris Irwin in Srp, *New Formations*, 140–43.

179. Antonin Artaud, "Adresse au Pape," *La Révolution surréaliste*, No. 3, April 1925, 16. This issue has the declaration "1925: End of the Christian Era" on the cover.

180. Man Ray, "Hommage à D. A. F. de Sade," 1933. This is reproduced (as "Monument to Sade") in *Dreaming with Open Eyes: The Vera, Silvia, and Arturo Schwarz Collection of Dada and Surrealist Art in the Israel Museum*, ed. Tamar Manor-Friedman, Jerusalem: The Israel Museum, 2000, 94. Scarcely less blasphemous is the same artist's "La prière" (The Prayer), 1930, whose likely model was once again Lee Miller; the latter is reproduced in *Man Ray 1890–1976*, ed. Jan Ceuleers, Antwerp: Ronny Van de Velde/New York: Abrams, 1994, 90.

181. Apollinaire to Madeleine Pagès, 17 October 1915, in *Lettres à Madeleine*, 300.

182. Pietro Aretino, *Život kalícnic*, Prague: Edice 69, 1932. The drawing is reproduced in Bydžovská and Srp, *Knihy s Toyen*, 30.

183. See Michel Foucault, *The History of Sexuality*, Vol. 1, *The Will to Know*, trans. Robert Hurley, London: Penguin, 1998.

184. Max Ernst, "Danger de pollution," *Le Surréalisme au service de la révolution*, No. 3, 1931, 22–25; reprint, New York: Arno Press, n.d. This text is translated in Werner Spies, *Max Ernst: Life and Work: An Autobiographical Collage*, London: Thames and Hudson, 2008, 112–14.

185. Bohuslav Brouk, untitled afterword to Štyrský, *Emilie přichází*, in *Edition 69*, 115.

186. Ibid., 109–10.

187. Pierre, *Investigating Sex*, 13.

188. Ibid., 16. The issue appears to have been linguistic rather than racial—with one exception: Breton was happy to make love "with any non-white woman, so long as it is not a Negress." Asked whether this was a "purely physical repugnance," he replied: "Yes, and also there's the idea of children, which is also possible" (57). How he squared this with his love of African art, I do not know; but perhaps he should be applauded for his honesty.

189. André Breton, "Avis aux exposants/aux visiteurs," in *Exposition inteRnatiOnal du Surréalisme*, 8. This is translated as an appendix to Pierre, *Investigating Sex*, 167–71.

190. Pierre, *Investigating Sex*, 145.

191. Ibid., 111.

192. Vítězslav Nezval to Paul Éluard, 19 April 1935, in *Korespondence Vítězslava Nezvala*, 135–37. See further *Paul Éluard et ses amis peintres*, ed. Annick Lionel Marie, Paris: Centre Pompidou, 1983, 175.

193. Several of these photographs are reproduced in Bydžovská and Srp, *Český surrealismus*, 20, and Bydžovská and Srp, *Jindřich Štyrský*, 206. In the 1930s, Štyrský worked on a book on Sade's life to be called *Obyvatel Bastily* (Incumbent of the Bastille). Jindřich Štyrský, *Život markýze de Sade*, Prague: Kra, 1995.

194. Handwritten dedication to Paul Éluard, *Les Dessous d'une vie ou la pyramide humaine*, 1926, reproduced in Lionel-Marie, *Paul Éluard et ses amis peintres*, 11.

195. Éluard, "Poetic Evidence," 177.

196. Ibid., 179–80.

197. Eileen Agar, *A Look at My Life*, London: Methuen, 1988, 118.

198. T. S. Eliot, "Burnt Norton," in *The Four Quartets*, London: Faber, 1983, 14.

199. Agar, *Look at My Life*, 117.

200. John Heartfield, "Curriculum Vitae," 1951, manuscript in Heartfield-Archiv, Akademie der Künste zu Berlin, quoted in Pachnicke and Honnef, *John Heartfield*, 308.

201. Jindřich Toman, *Foto/montáž tiskem/Photo/Montage in Print*, 248. See also Toman's article "Émigré Traces: John Heartfield in Prague," *History of Photography*, No. 32, 2008, 232–46.

202. Wieland Herzfelde, "Wir wollen deutsch reden," *Neue Deutsche Blätter*, No. 1, September 1933, quoted in Jean-Michel Palmier, *Weimar in Exile: The Antifascist Emigration in Europe and America*, London: Verso, 2006, 138.

203. F. C. Weiskopf, translated in *The Malik-Verlag: 1916–1947*, ed. James Fraser, New York: Goethe House, 1984, 76.

204. The AIZ was retitled the *Volks-Illustrierte* (Peoples' Illustrated) in 1935. Heartfield's montages for the paper are collected in David Evans, *John Heartfield; AIZ/VI*, New York: Kent Fine Arts, 1992.

205. Palmier, *Weimar in Exile*, 757.

206. These are reproduced in Pachnicke and Honnef, *John Heartfield*, 167, 171, 201, and 198, respectively.

207. Jaroslav Hašek, *Osudy dobrého vojáka Švejka*, 6 vols., Prague: Synek, 1936–37. The jackets are all reproduced in Toman, *Foto/montáž tiskem/Photo/Montage in Print*, 249–51.

496 | NOTES TO CHAPTER 5

208. See Ralph Jentsch, *George Grosz: Berlin—New York*, Milan: Skira, 2008, 151–54. The three plates are reproduced on p. 165.

209. Details below taken from *Erste internationale Dada-Messe*, Berlin: Kunsthandlung Dr. Otto Burchard, n.d. [1920].

210. Altshuler, *Avant-Garde in Exhibition*, 103.

211. Kurt Tucholsky, *Berliner Tagblatt*, 20 July 1920, in Pachnicke and Honnef, *John Heartfield*, 85.

212. Hannah Höch, "Schnitt mit dem Küchenmesser Dada durch die letzte weimarer Bierbauchkulturepoche Deutschlands," reproduced in Boswell, *Photomontages of Hannah Höch*, 25.

213. Sophie Bernard, "Hannah Höch: Schnitt mit dem Küchenmesser Dada ...," in *Dada*, ed. Laurent Le Bon, Paris: Centre Pompidou, 2005, 494. In keeping with the anti-art spirit of Dada, this mammoth (1,014-page) catalogue of what is probably the largest Dada retrospective ever mounted looks and is alphabetically organized like a telephone directory. The book is printed on cheap, flimsy paper; the bibliography comes not at the end but between articles on "Berlin Club Dada" and "The Blind Man." When the show moved to the National Gallery of Art, Washington, DC, and MoMA in 2006, a far more conventional glossy catalogue was produced: *Dada*, ed. Leah Dickerman, Washington, DC: National Gallery of Art, 2006.

214. *Erste internationale Dada-Messe* (unpaginated).

215. Hannah Höch, "The Painter," in Kuenzli, *Dada*, 230.

216. Edouard Roditi, "Interview with Hannah Höch," *Arts Magazine*, Vol. 34, No. 3, December 1959, quoted in Boswell, *Photomontages of Hannah Höch*, 8. Excerpts from this interview are reproduced in Kuenzli, *Dada*, 231–33.

217. Höch, interview with Roditi, 1959, in Kuenzli, *Dada*, 232.

218. George Grosz, *Blättern der Piscator-Bühner*, 1928, quoted in *John Heartfield en la colección del IVAM*, Valencia, Spain: Institut Valencia d'Art Modern, 2001 (bilingual catalogue), 167.

219. Interview with Vera Broïdo, *Phases*, No. 2, Paris, 1967, translated in Eva Züchner, Andrei Nakov, Christopher Phillips, Jean-Francois Chevrier, Yves Michaud, and Bartomeu Marí, *Raoul Hausmann*, Valencia, Spain: IVAM Centre Julio Gonzalez, 1994, 314.

220. Raoul Hausmann, "Cinéma synthétique de la peinture," in his *Courrier Dada*, Paris: Éditions Allia, 2004, 42–43.

221. See Hubertus Gassner, "Heartfield's Moscow Apprenticeship 1931–32," in Pachnicke and Honnef, *John Heartfield*, 256–90. During his time in the Soviet Union, Heartfield worked closely with the constructivists of the October group, who had exhibited in 1930 in Berlin. October's members included Klutsis, Rodchenko, Lissitzky, Mayakovsky, the architects Moshe Ginzburg and Alexander Vesnin, the film directors Sergei Eisenstein and Dziga Vertov, and the theater director Vsevolod Meyerhold.

222. Pachnicke and Honnef, *John Heartfield*, 306. For background on the Stuttgart exhibition, see *Film und Foto der zwanziger Jahre: Eine Betrachtung der Internationalen Werkbundasstellung "Film und Foto" 1929*, ed. Ute Eskildsen and Jan-Christopher Horak, Stuttgart: Würtembergischer Kunstverein, 1979.

223. Kulagina, diary, excerpt in Margarita Tupitsyn, *Gustav Klutsis and Valentina Kulagina: Photography and Montage after Constructivism*, New York: International Center of Photography/Steidl, 2004, 235. Information on Klutsis's arrest is taken from the same source.

224. "Pablo Picasso," originally published in *Montjoie*, 14 March 1913, in *Apollinaire on Art: Essays and Reviews 1902–1918*, ed. Leroy C. Breunig, New York: Viking, 1972, 279.

225. For an outstanding collection of examples of nineteenth-century uses of photomontage, see the online exhibition "Photomontage," curated by Alan Griffiths, on the luminous-lint website. This site is a superb digital resource for photographic history. Available at http://www.luminous-lint.com/app/vexhibit/ _THEME_Photomontage_01/6/57/47246195724147283999/ (accessed 4 May 2012).

226. Apollinaire, "Pablo Picasso," in *Apollinaire on Art*, 281.

227. Wieland Herzfelde, "George Grosz, John Heartfield, Erwin Piscator, Dada und die Folgen—oder die Macht der Freundschaft" (1971), in Pachnicke and Honnef, *John Heartfield*, 123.

228. Walter Benjamin, "Neue Sachlichkeit und Photographie" (1934), in Pachnicke and Honnef, *John Heartfield*, 99.

229. Wieland Herzfelde, "John Heartfield" (Dresden 1962), in Pachnicke and Honnef, *John Heartfield*, 96.

230. Hoch, interview with Roditi, 1959, in Kuenzli, *Dada*, 232.

231. Interview with Vera Broïdo, in Züchner, *Raoul Hausmann*, 314.

232. August Sander, *People of the Twentieth Century*, 7 vols., New York: Abrams, 2002, Vol. 3, *The Woman*, photograph III/13/14, p. 49. I discuss Sander further on pp. 302–4.

233. Interview with Vera Broïdo, in Züchner, *Raoul Hausmann*, 315.

234. Hausmann, *Courrier Dada*, 181.

235. Quoted in Miloslav Topinka, "The Dada Movement in Relation to the Czech Interwar Avant-Garde." Topinka also quotes Hausmann's letter of 7 April 1965 to Jindřich Chalupecký: "I have to confirm to you that the Czech painters and sculptors in 1937–38 didn't want to know anything about me, especially Mr Teige. I would like to mention here, that Teige knew somewhat more about my person and my work, for he had collaborated on the revue G, edited by Hans Richter in 1921 to 1924." On *G*, see earlier, pp. 209–10.

236. Kokoschka to Alice Lahmann, 11 June 1931, in *Letters*, 130–31.

237. Kokoschka to Albert Ehrenstein, 18 January 1933, in ibid., 132.

238. Kokoschka to Albert Ehrenstein, 22 September 1934, in ibid., 134.

239. Kokoschka to Albert Ehrenstein, autumn 1934, in ibid., 137.

240. Kokoschka to Helen Briffault, 8 February 1935, in ibid., 139.

241. Ibid.

242. Kokoschka to Alma Mahler-Werfel, summer 1937, in ibid., 145.

243. Kokoschka to Helen Briffault, 8 February 1935, in ibid., 138.

244. Kokoschka to Albert Ehrenstein, autumn 1934, in ibid., 136.

245. Kokoschka to Anna Kallin, 11 July 1935, in ibid., 142.

246. Kokoschka to Helen Briffault, 8 February 1935, in ibid., 140.

247. See Kokoschka's letters to Helen Briffault of 8 February 1935 and Albert Ehrenstein of June or July 1935, respectively, in ibid., 138, 141.

248. Kokoschka to Anna Kallin, 11 July 1935, in ibid., 142.

249. Kokoschka was familiar with Masaryk's writings. See ibid., 140.

250. Kokoschka to Alma Mahler-Werfel, 30 July 1937, in ibid., 146–48.

251. Kokoschka to Anna Kallin, 11 July 1935, in ibid., 141–42.

252. Kokoschka to Anna Kallin, February 1936, in ibid., 143.

253. Kokoschka to Herbert Read, 17 May 1938, in ibid., 153.

254. Kokoschka to Augustus John, 26 May 1938, in ibid., 154 (written in English).

255. Kokoschka to Ruth and Adolf Arndt, 20 October 1938, in ibid., 157.

256. Kokoschka to Anna Kallin, 22 November 1936, in ibid., 145.

257. *The Red Egg* can be viewed at the Artists Rights Society Artchive website, available at http://www.artchive.com/artchive/K/kokoschka/red_egg.jpg.html (accessed 4 May 2012).

258. National Gallery of Scotland website (where the painting is reproduced), available at http://www.nationalgalleries.org/collection/artists-a-z/K/3794/artist Name/Oskar%20Kokoschka/recordId/54063 (accessed 4 May 2012).

259. Mikoláš Aleš, *Libuše Prophesies the Glory of Prague*, mural for vestibule of Prague's Old Town Hall, 1904.

260. Kokoschka to Augustus John, 24 April 1946, in *Letters*, 178.

261. Kokoschka to Jack Carney, 7 September 1946, in ibid., 182 (written in English).

262. Kokoschka to Herbert Read, 6 September 1945, in ibid., 171–72 (written in English).

263. See M. E. Burkett, *Kurt Schwitters: Creator of Merz*, Kendal, UK: Abbot Hall Art Gallery, 1979.

264. House of Lords Debate, 15 August 1940, *Hansard*, Vol. 117, 258, available at http://hansard.millbanksystems.com/lords/1940/aug/15/internment-of-aliens (accessed 4 May 2012).

265. Alma Mahler-Werfel, quoted on website Alma, available at http://www .alma-mahler.com/engl/almas_life/almas_life4.html# (accessed 4 May 2012).

266. Walter Benjamin, "On the Concept of History," in *Walter Benjamin Selected Writings* 4, 392.

267. On Benjamin's death, see *Walter Benjamin: Selected Writings 4*, 444–45; Lisa Fittko, "The Story of Old Benjamin," in Benjamin, *Arcades Project*, 946–54; and Michael Taussig, *Walter Benjamin's Grave*, Chicago: University of Chicago Press, 2006.

6. ON THE EDGE OF AN ABYSS

1. André Breton, "Constellations," in *Constellations of Miró, Breton*, ed. Paul Hammond, San Francisco: City Lights Books, 2000, 201.

2. *Entartete "Kunst": Ausstellungsführer*, in Barron, *"Degenerate Art,"* 390.

3. Max Ernst, *Biographical Notes*, trans. in Spies, *Max Ernst: Life and Work*, 96.

4. Altshuler, *Avant-Garde in Exhibition*, 147.

5. Peggy Guggenheim, *Confessions of an Art Addict*, quoted in Spies, *Max Ernst: Life and Work*, 166.

6. Max Ernst, *Biographical Notes*, 147. For background, see *Des peintres au camp des Milles: septembre 1939—été 1941*, ed. Michel Bepoix, Aix-en-Provence: Actes Sud, 1997.

7. Transcript of the draft of Éluard's letter, in Spies, *Max Ernst: Life and Work*, 157. The French original can be found in Lionel-Marie, *Paul Éluard et ses amis peintres*, 109.

8. *Entartete "Kunst": Ausstellungsführer*, 390.

9. Lou Straus-Ernst, *The First Wife's Tale*, New York: Midmarch Arts Press, 2004, 46.

10. Jimmy Ernst, *A Not-So-Still Life*, New York: St. Martin's/Marek, 1984, 11.

11. Lou Straus-Ernst, *First Wife's Tale*, 46. The sentences in angle brackets are from Jimmy Ernst's rendition of the same passage, taken from the original manuscript in his possession, in *Not-So-Still Life*, 12. The Midmarch edition was reconstructed from an imperfect carbon copy.

12. Max Ernst, *Biographical Notes*, 86.

13. Lou Straus-Ernst, *First Wife's Tale*, 44.

14. Jimmy Ernst, *Not-So-Still Life*, 10–11.

15. Nancy Cunard in conversation with Pierre Daix, 1950, quoted in his *Aragon avant Elsa*, Paris: Éditions Tallandier, 2009, 102.

16. Eileen Agar, *Look at My Life*, 47. "Sleeping with Negroes" refers to Nancy's relationship with the jazz pianist and composer Henry Crowder, whom she described as "a handsome Afro-American of mixed Red Indian and African blood"; Nancy Cunard, *These Were the Hours: Memories of My Hours Press, Réanville and Paris 1928–1931*, Carbondale: Southern Illinois University Press, 1969, 148. "I had absorbed with interest and indignation Henry's accounts of the horrible strife between black and white in the United States," she writes, "but it was not this alone which led me to make my *Negro Anthology*, although Henry's many, ever fairminded narrations were possibly the first cause. Of the accomplishments of the Negro and colored people there was also much to be written" (152). Cunard's *Negro* (as the anthology was called) appeared in 1934, a landmark publication of African-American literature.

17. Agar, *Look at My Life*, 29.

18. "Hands off Love," originally published in *transition*, September 1927, trans. in *The Autobiography of Surrealism*, ed. Marcel Jean, New York: Viking, 1980, 152–54. The text was published in the original French the following month in *La Révolution surréaliste*, Vol. 3, Nos. 9–10, 1–6, with the note: "Contrary to our first intention, we are publishing below the French version of the text 'Hands off Love,' which appeared in English in the review *Transition*, where the conditions of its presentation were not those we had envisaged."

19. Paul Éluard, "Max Ernst," from *Répétitions* (1922), as translated in Jean, *Autobiography of Surrealism*, 78.

20. Éluard, "Max Ernst [1]," in his *Oeuvres complètes*, Vol. 1, Paris: Gallimard, 1968, 103. This edition hereafter cited as PEOC plus volume number.

21. See Jimmy Ernst, *Not-So-Still Life*, 19.

22. Paul Éluard, dedication to *Mourir de ne pas mourir* (1925), in PEOC 1, 136.

23. Robert McNab, *Ghost Ships: A Surrealist Love Triangle*, New Haven, CT: Yale University Press, 2004, 119.

24. Ibid., 116.

25. Éluard to his father, 24 March 1924, in *Éluard: Livre d'identité*, ed. Robert D. Valette, Paris: Tchou, 1967, 49.

26. Éluard to Gala, 12 May 1924, in *Lettres à Gala*, 17.

27. Éluard to his father, 24 March 1924, in Valette, *Éluard: Livre d'identité*, 49.

28. André Breton to Marcel Noll, no date given, quoted in McNab, *Ghost Ships*, 117.

29. Simone Breton to Denise Levy, 3 October 1924, in Simone Breton, *Lettres à Denise Levy 1919–1929*, ed. Georgiana Colville, Paris: Éditions Joëlle Losfeld, 2005, 203.

30. Ernst, *Biographical Notes*, 97.

31. Paul Éluard, "La suppression de l'esclavage," PEOC 2, 797.

32. McNab, *Ghost Ships*, 56.

33. Quoted in PEOC 1, 1369.

34. Paul Éluard, *Au défaut du silence*, in PEOC 1, 165.

35. See Jimmy Ernst, *Not-So-Still Life*, 52; Marcel Jean, *The History of Surrealist Painting*, trans. Simon Watson Taylor, London: Weidenfeld and Nicolson, 1960, 131.

36. "Surrealist Spanking," at website Pandora Blake: Spanked, Not Silenced, available at http://pandorablake.blogspot.com/2008/07/surrealist-spanking.html (accessed 13 May 2012). Paul Éluard included a pencil sketch for Ernst's painting, in which the Virgin is bare-breasted and the witnesses absent, to accompany his three poems dedicated to Ernst in his *Voir: Poèmes Peintures Dessins*, Geneva and Paris: Éditions des Trois Collines, 1948, 49.

37. André Breton, "Limits Not Frontiers of Surrealism," in Read, *Surrealism*, 99.

38. Roland Penrose, "Un œil de liberté," in Lionel-Marie, *Paul Éluard et ses amis peintres*, 15–16.

39. I allude here to Wilfred Owen's poem "Strange Meeting," whose crux is the line "I am the enemy you killed, my friend." *The Collected Poems of Wilfred Owen*, ed. C. Day Lewis, London: Chatto & Windus, 1963, 35.

40. Paul Éluard, "Poetic Evidence," in Read, *Surrealism*, 181. Éluard had used almost the same words during his address to the Left Front in Prague the year before. See Záviš Kalandra, "A. Breton a P. Éluard v Levé frontě," *Haló-noviny*, 3 April 1935, in Torst Surrealist Reprints, 126.

41. Jimmy Ernst, *Not-So-Still Life*, 95.

42. Angliviel de la Beaumelle, *André Breton: La béauté convulsive*, 214.

43. Ripellino, *Magic Prague*, 57.

44. Breton, *Mad Love*, 111–12. The same surprising tenderness—to those who see in Breton only the implacable Pope of Surrealism—suffuses both the texts and drawings and collages in his posthumously published *Lettres à Aube*, ed. Jean-Paul Goutier, Paris: Gallimard, 2009.

45. Pierre, *Investigating Sex*, 61.

46. André Breton and Paul Éluard, "Prière d'insére pour 'La Femme visible' de Salvador Dalí," 1930, in ABOC 1, 1027–28.

47. The method was first explained in Dalí's "L'Ane pourri," *Surréalisme au service de la révolution*, No. 1, July 1930, 9–12, which is the core of *La Femme visible*.

This text is translated as "The Rotting Donkey" in Salvador Dalí, *Oui: The Paranoid-Critical Revolution—Writings 1927–1933*, ed. Robert Descharnes, trans. Yvonne Shafir, Boston: Exact Change, 1998, 115–19.

48. Salvador Dalí, *La Femme visible*, Paris: Éditions surréalistes, 1930. The copy that Dalí gave Éluard is held in the Gabrielle Kieller Collection of the Scottish National Gallery of Modern Art. It is described in Elizabeth Cowling with Richard Calvocoressi, Patrick Elliott, and Ann Simpson, *Surrealism and After: The Gabrielle Kieller Collection*, Edinburgh: Scottish National Gallery of Modern Art, 1997, 157.

49. Éluard to Gala, 27 April 1930, in *Lettres à Gala*, 108–9.

50. Jaroslava Vondráčková, *Kolem Mileny Jesenské*, Prague: Torst, 1991, 100.

51. André Breton, "La barque de l'amour s'est brisée contre la vie courante," *Surréalisme au service de la révolution*, No. 1, July 1930, 16–22.

52. Éluard to Gala, April 1930, in *Lettres à Gala*, 102–3.

53. Éluard to Gala, 20 August 1934, in ibid., 247.

54. See Václav Havel, "The Power of the Powerless," in his *Living in Truth*, London: Faber, 1989.

55. Éluard to Gala, March 1935, in *Lettres à Gala*, 251.

56. André to Simone Breton, 15 November 1928, quoted in Polizzotti, *Revolution of the Mind*, 309.

57. Agar, *Look at My Life*, 120, 132.

58. Ibid., 131, 120, 174. For more on Nusch (including some of her collages), see Chantal Vieuille, *Nusch: Portrait d'une muse du Surréalisme*, Paris: Le Livre à la carte, 2010.

59. Agar, *Look at My Life*, 131.

60. Ibid., 133.

61. Ibid.

62. Éluard to Gala, July 1937, quoted in Antony Penrose, *The Surrealists in Cornwall: "The Boat of Your Body,"* Falmouth, UK: Falmouth Art Gallery, 2004 (unpaginated). Penrose gives a very full account of the "delightful surrealist house party." The text of Éluard's postcard can be found in *Lettres à Gala*, 281–82. For background on the British surrealists, see Michel Remy, *Surrealism in Britain*, Aldershot, UK: Ashgate Publishing, 1999.

63. Agar, *Look at My Life*, 133.

64. All of these photographs are reproduced in Antony Penrose, *Surrealists in Cornwall*, as is *Good Shooting*.

65. Leonora Carrington, "Down Below," *VVV*, No. 4, February 1944. Parts of the text are reprinted in *Surrealist Women: An International Anthology*, ed. Penelope Rosemont, Austin: University of Texas Press, 1998, 150–54, and *Surrealism*, ed. Mary Ann Caws, New York: Phaidon, 2004, 271.

66. August Sander, "An Answer to the Question: What Is Enlightenment," 1927, quoted in August Sander, *People of the Twentieth Century*, Vol. 7, *The Last People*, 53.

67. Erich Sander died shortly before he was due to be released in 1944. Ibid., 51.

68. Sander to Dettmar Heinrich Sarnetzki, 7 January 1947, quoted in Sander, *People of the Twentieth Century*, Vol. 6, 19.

69. Photograph III/14/4, titled "Mutter und Sohn," in Sander, *People of the Twentieth Century*, Vol. 3, *The Woman*, 57.

70. Jimmy Ernst, *Not-So-Still Life*, 3–4.

71. Lou Straus-Ernst, *The First Wife's Tale*, xviii–xxii.

72. Paul Nash, "Swanage, or Seaside Surrealism," *Architectural Review*, April 1936, reprinted in Pennie Denton, *Seaside Surrealism: Paul Nash in Swanage*, Swanage: Peveril Press, 2002, 77–82.

73. Paul Nash to E.M.O. Dickey, 11 March 1941, Imperial War Museum Archives, quoted in *Paul Nash: Modern Artist, Ancient Landscape*, ed. Jemima Montagu, London: Tate, 2003, 46.

74. Paul Nash to Margaret Nash, 16 November 1917, quoted in Leonard Robinson, *Paul Nash: Winter Sea: The Development of an Image*, York. UK: William Sessions/The Ebor Press, 1997, 28.

75. *Vogue*, September 1937. See further Sala Elise Patterson, "Yo, Adrienne," *New York Times*, 25 February 2007. The series is reproduced in *Man Ray Women*, ed. Valerio Dehó, Bologna: Damiani, 2005, 99–115, under the title "Mode au Congo."

76. Agar, *Look at My Life*, 135.

77. Pilar Parcerisas, "Ady Fidelin: the Venus naturalis," in *Man Ray: Luces y sueños*, ed. Pilar Parcerisas, Valencia, Spain: Museu Valencià de la Illustracio i de la Modernitat, 2006, 146–47 (bilingual Spanish-English catalogue). Several of Man Ray's photographs of Ady are reproduced here, others in Dehó, *Man Ray Women*.

78. Man Ray, *Self-Portrait*, New York: Little, Brown, 1998, 237.

79. Ibid., 252.

80. Roland Penrose, "Un œil de liberté," 18.

81. Agar, *Look at My Life*, 135.

82. Both Lee Miller and Roland Penrose took several snapshots at this picnic. One of Penrose's photographs is reproduced in Caws, *Dora Maar*, 134–35; one of Miller's in Richard Calvocoressi, *Lee Miller: Portraits from a Life*, London: Thames and Hudson, 2002, 49.

83. Agar, *Look at My Life*, plate 12a.

84. Ibid., 2.

85. See Caws, *Dora Maar*, 133.

86. Brassaï, *Conversations with Picasso*, 207.

87. Lee Miller, *Grim Glory: Pictures of Britain under Fire*, ed. Ernestine Carter, London: Lund, Humphries, 1941. "Remington Silent," "University College," and "Revenge on Culture" are all reproduced in Mark Haworth-Booth, *The Art of Lee Miller*, London: Victoria and Albert Museum/New Haven, CT: Yale University Press, 2007, 156–57; "Revenge" is also reproduced (as a full-page plate) in Jane Livingston, *Lee Miller: Photographer*, New York: Thames and Hudson/California Art Foundation, 1989, 59, as is "Nonconformist Chapel, Camden Town, London" (61). In a grotesque appropriation of the past to serve the ideological needs of the present, Patricia Allmer reads "Revenge on Culture" as "an ironic commentary on [Miller's] own position as objectified, photographic muse. Here a fallen statue of an angel is represented. Its face bears striking similarities to representations of Miller's statuesque face familiar from Man Ray's photographs and images from Vogue. Miller's

'fallen angel' is discarded. . . . Here the statue, the idealized object of male desire, no longer wakens but is destroyed, as a revenge on the culture which produced it, opening the space for a different kind of representation of femininity and self. Even the title *Revenge on Culture* is two-fold—whilst it refers to the destructive powers of patriarchy in World War II, it also alludes to patriarchy's destruction of women. . . . In *Revenge on Culture*, the common male depiction of Miller as object to be looked at is shattered, is no longer flawless" (*Angels of Anarchy*, 17). Fine, so long as we are happy to ignore the context in which the photograph was shot (the Blitz), the nature of the collection in which it was published (*Grim Glory*), and just about everything that is known about Lee's political convictions. The silly girl thought she was portraying the destruction wrought by fascism, not by "patriarchy." As for the title, I suspect the allusion is more likely to be to Hermann Goering's (apocryphal) statement: "When I hear the word culture, I reach for my Browning."

88. André Breton, "Avis au lecteur pour 'La Femme 100 têtes' de Max Ernst," 1929, in ABOC 2, 305, translated in Dieter Ronte, Irene Kleinschmidt-Altpeter, Lluisa Faxedas, Werner Spies, and Jürgen Pech, *Max Ernst: Invisible a primavera vista: grabados, libros ilustrados, esculturas*, bilingual Spanish-English catalogue, Barcelona: Fundació la Caixa, 2006, 188. Paul Nash also makes reference to Breton's observation when explaining what surrealism is in "Swanage, or Seaside Surrealism."

89. Miller was not the first female photographer to document war. Gerda Taro (who was killed at the Battle of Teruel in 1937) produced more than 800 negatives of the Spanish Civil War. These are available in *The Mexican Suitcase: The Rediscovered Spanish Civil War Negatives of Capa, Chim, and Taro*, ed. Cynthia Young, 2 vols., New York: International Center of Photography/Steidl, 2010.

90. Lee Miller, "Germany: The War That Is Won," first published in *Vogue*, June 1945; reprinted with additions from the original manuscript in *Lee Miller's War: Photographer and Correspondent with the Allies in Europe 1944–45*, ed. Antony Penrose, London: Thames and Hudson, 2005, 176.

91. Lee Miller, quoted in Calvocoressi, *Lee Miller: Portraits from a Life*, 120. The photograph is reproduced on the facing page.

92. Reproduced in ibid., 116, and in Penrose, *Lee Miller's War*, 184.

93. Lee Miller, "Germany: The War That Is Won," 182.

94. Lee Miller, undated service message to Audrey Withers, in Penrose, *Lee Miller's War*, 188–89.

95. Lee Miller, "Hitleriana," first published in *Vogue*, July 1945; reprinted with additions from original manuscript in Penrose, *Lee Miller's War*, 191.

96. Haworth-Booth, *The Art of Lee Miller*, 197.

97. David E. Sherman, "Lee Miller in Hitler's Bath, 1945," reproduced in ibid., 199.

98. Letter to Audrey Withers, undated, in Penrose, *Lee Miller's War*, 188.

99. René Char to Man Ray, undated letter, quoted in Dominique Rabourdin, Postface, in Paul Éluard and Man Ray, *Facile*, Paris: La Bibliothèque des Introuvables, 2004 (unpaginated). This is a facsimile reprint of the original edition of 1935 (Paris: Éditions G.L.M.).

100. Shelley Rice, "When Objects Dream," in Andrew Roth, *The Book of 101 Books: Seminal Photographic Books of the Twentieth Century*, New York: PPP Editions, 2001, 13.

101. Roger Caillois to André Breton, 27 December 1934, in *The Edge of Surrealism: A Roger Caillois Reader*, ed. Claudine Frank, Durham, NC: Duke University Press, 2003, 85.

102. Caillois, "Testimony (Paul Éluard)," in *Edge of Surrealism*, 61–62.

103. Paul Éluard, "Les Plus belles cartes postales," *Minotaure*, Nos. 3–4, 1933, 86–87.

104. Durozoi, *History of the Surrealist Movement*, 294; Angliviel de la Beaumelle, *La béauté convulsive*, 223–24. I repeated the same error in my essay "Surrealities," in Benson, *Central European Avant-Gardes*, 90.

105. For extracts from Nezval's diary, see Bydžovská and Srp, *Český surrealismus*, 80–84; for the photographs, see *André Breton: 42 rue Fontaine*, Paris: CamelsCohen 2003, eight-volume auction catalogue, Vol. 8, *Photographies*, 95, lot 5057. The photographs in the album are reproduced in full on the DVD that accompanied the catalogue.

106. Éluard to Štyrský and Toyen, 19 April 1935, facsimile reproduction in Lionel-Marie, *Paul Éluard et ses amis peintres*, 181.

107. Quoted in Herbert R. Lottman, *Man Ray's Montparnasse*, New York: Abrams, 2001, 219.

108. Quoted in André Breton, "Devant le rideau," in *Le Surréalisme en 1947: Exposition internationale du Surréalisme présentée par André Breton et Marcel Duchamp*, Paris: Édition Pierre a feu, Maeght Éditeur, 1947, 13–19, translated as "Before the Curtain" in Breton, *Free Rein*, 80.

109. Breton and Éluard, *Dictionnaire abrégé du surréalisme*. It would be cumbersome to give page references throughout the following discussion, since the entries in the *Dictionnaire* are arranged in alphabetical order. The gallery also produced its own catalogue: *Exposition internationale du Surréalisme*, Janvier–Février 1938, Paris: Galerie Beaux-Arts. It is clear from other sources that the list of 229 exhibits in the latter was not exhaustive.

110. The original *Rendezvous des Amis* is reproduced in the *Dictionnaire abrégé*. Also included in the picture is the poet René Crevel, whose suicide in 1935 I discuss on pp. 378–379. Ernst published an updated version, under the same title but with different dramatis personae, in *Surréalisme au service de la révolution*, No. 4, December 1931. It is a spiraling photomontage whose legend reads: "From top to bottom, following the serpent of heads: whistling through his fingers, Yves Tanguy—on the hand, in a casket, Aragon—in the fold of the elbow, Giacometti—in front of a portrait of a woman, Max Ernst—below in front of him, Salvador Dalí—to his right, Tzara and Péret—in front of the chained man, with his hands in his pockets, Buñuel—lighting a cigarette, Paul Éluard—above him, Thirion, and to his left, with his hand raised, Char—behind the hand which is closing on Unik, Alexandre—lower down, Man Ray—then, submerged up to his shoulders, Breton. On the wall you can see a portrait of Crevel and at the upper right, turning his back, Georges Sadoul" (36–37). The montage is reproduced in Diez, *La Subversion des images*, 47, without Ernst's explanatory text and under the title "Loplop présente les membres

du groupe surréaliste 1931." This source identifies the photograph of the woman looking over Ernst's shoulder as Pearl White.

111. Quoted in Mary Ann Caws, "Essay on Éluard's Poetry," in Paul Éluard, *Capital of Pain*, trans. Mary Ann Caws, Patricia Terry, and Nancy Kline (bilingual French-English edition), Boston: Black Widow Press, 2006, 244.

112. Taken by Luxardo in 1936, the photograph is reproduced in Marinetti, *Futurist Cookbook*, 15.

113. Francis Picabia, "Carnet du Docteur Serner," in *391*, No. 11, February 1920, 4, facsimile reprint, ed. Michel Sanouillet, Paris: La Terrain Vague, 1960.

114. As it was voted by 500 leading British contemporary artists (including Damien Hirst, Tracey Emin, and David Hockney) and critics in a 2004 poll, beating out *Les Demoiselles d'Avignon*. Nigel Reynolds, "'Shocking' Urinal Better Than Picasso Because They Say So," *Daily Telegraph*, 2 December 2004, available at http://www.telegraph.co.uk/culture/art/3632714/Shocking-urinal-better-than-Picasso-because-they-say-so.html (accessed 13 May 2012).

115. André Breton, "Zinnia-red Eyes," from *L'Air de l'eau*, 1934, in *Poems of André Breton: A Bilingual Anthology*, trans. and ed. Jean-Pierre Cauvin and Mary Ann Caws, Boston: Black Widow Press, 2006, 146–47.

116. *Documents*, 2 vols., 1929–30; reprint, Paris: Jean-Michel Place, 1991. The entries that made up the Critical Dictionary are translated in *Encyclopaedia Acephalica*, ed. Alistair Brotchie, trans. Iain White and others, London: Atlas Press, 1995. For background, see *Undercover Surrealism: Georges Bataille and DOCUMENTS*, ed. Dawn Ades and Simon Baker, London: Hayward Gallery/Cambridge, MA: MIT Press, 2006; Ades, *Dada and Surrealism Reviewed*, 228–49; and Dennis Hollier, ed., *A Documents Dossier*, special issue of *October*, No. 60, 1992.

117. *Encyclopaedia Acephalica*, 72–73. Various of Lotar's photographs of La Villette are reproduced in Alain Sayag, Annick Lionel-Marie, and Alain and Odette Virmaux, *Élie Lotar*, Paris: Musée national d'art moderne/Centre Georges Pompidou, 1993, 79–83; Reinhard Spieler and Barbara Auer, eds., *Gegen jede Vernunft: Surrealismus Paris-Prague*, Ludwigshafen am Rhein, Germany: Wilhelm-Hack-Museum/Belser, 2010, 256; Diez, *La Subversion des images*, 134, 223, and 265–67; and Ades and Baker, *Undercover Surrealism*, 106–11.

118. Georges Bataille, "L'Informe," *Documents*, Vol. 1, No. 1, 1929, trans. in *Encyclopaedia Acephalica*, 51–52.

119. Yve-Alain Bois and Rosalind E. Krauss, *Formless: A User's Guide*, New York: Zone, 1997, 5.

120. Which Breton said he was "appalled by." He found it "very pleasant," on the other hand, to watch a woman he loved urinate. Pierre, *Investigating Sex*, 93.

121. Georges Bataille, "Architecture," *Documents*, Vol. 1, No. 2, 1929, trans. in *Encyclopaedia Acephalica*, 35–36. See also Denis Hollier, *Against Architecture: The Writings of Georges Bataille*, Cambridge, MA: MIT Press, 1992.

122. *Dialogues with Marcel Duchamp*, ed. Pierre Cabanne, London: Thames and Hudson, 1971, 81.

123. The flyer is reproduced in *La Révolution surréaliste*, ed. Werner Spies, Paris: Centre Pompidou, 2002, 85.

124. Joseph Cornell to Parker Tyler, July 2, 1941, quoted in Deborah Solomon, *Utopia Parkway: The Life and Work of Joseph Cornell*, New York: Farrar, Straus, and Giroux, 1997, 125.

125. Joseph Cornell, "'Enchanted Wanderer': Excerpt from a Journey Album for Hedy Lamarr," *View*, Nos. 9–10, December 1941–January 1942, reproduced in facsimile in Solomon, *Utopia Parkway*, 126.

126. See *Picasso surréaliste*, ed. Anne Baldassari, Basel: Fondation Beyeler/Paris: Flammarion, 2005.

127. William S. Rubin, *Dada, Surrealism, and Their Heritage*, New York: Museum of Modern Art, 1968.

128. William S. Rubin, *Dada and Surrealist Art*, New York: Abrams, n.d. [1968]. The Wadsworth Atheneum show was reprised at Julien Levy's gallery in New York on 9–29 January 1932. For background, see Ingrid Schaffner and Julien Lisa Jacobs, *Julien Levy: Portrait of an Art Gallery*, Cambridge, MA: MIT Press, 1998.

129. Meret Oppenheim, quoted in *Surrealism: Desire Unbound*, ed. Jennifer Mundy, London: Tate/Princeton, NJ: Princeton University Press, 2001, 45, where "My Nurse" is reproduced.

130. Rubin, *Dada, Surrealism, and Their Heritage*, list of exhibits, 228–43.

131. To be exact, "Leonora Carrington is represented by one postage-stamp-sized reproduction; Meret Oppenheim is dismissed in one sentence; Frida Kahlo is mentioned once in passing. Marcelle Loubchansky, Maria Martins, Mimi Parent, Judit Reigl, Kay Sage, and Toyen—to cite only women whose work figures in André Breton's *Le Surréalisme et la peinture*—are completely ignored." Penelope Rosemont, *Surrealist Women: An International Anthology*, liv. Rosemont's excellent anthology, which contains texts by ninety-seven women associated with the surrealist movement, should be essential reading for all historians of twentieth-century art—and all feminists convinced of surrealism's misogyny.

132. Rubin, *Dada and Surrealist Art*, 7.

133. Not so very long ago it was "a truth universally acknowledged" (to quote Rosalind Krauss, writing of her own intellectual formation in *Bachelors*, Cambridge, MA: MIT Press, 2000, 1) that "surrealism was deeply misogynist." This stereotype—which was itself, perhaps, conditioned by the overwhelmingly masculine postwar construction of the movement epitomized by Rubin's 1968 MoMA show—continues to haunt much of the Anglo-American literature. The classic arguments for surrealism-as-misogynist can be found in Mary Ann Caws, Rudolf Kuenzli, and Gwen Raaberg, eds., *Surrealism and Women*, Cambridge, MA: MIT Press, 1991. Other recent scholarship, often from feminist perspectives, has led to the extensive "rediscovery" of female surrealist artists, and with it, to varying degrees, a reassessment of the movement's supposed misogyny. See inter alia Roger Borderie, ed., *La Femme surréaliste*, special issue of *Obliques*, Nos. 14–15, Paris, 1977; Whitney Chadwick, *Women Artists and the Surrealist Movement*, London: Thames and Hudson, 1985; Katharine Conley, *Automatic Woman: The Representation of Woman in Surrealism*, Lincoln: University of Nebraska Press, 1996; Whitney Chadwick, ed., *Mirror Images: Women, Surrealism, and Self-Representation*, Cambridge, MA: MIT Press, 1998; Georgiana Colville, *Scandaleusement d'elles: trente-quatre femmes surréalistes*, Paris: Jean-Michel Place, 1999; Alyce Mahon, *Surrealism and the Politics of Eros*

1938–1968, London: Thames and Hudson, 2005; and Mundy, *Surrealism: Desire Unbound.* The resurgence of interest in surrealism over the last two decades in the English-speaking world has been largely led by women curators, critics, and scholars, among them Dawn Ades, Mary Ann Caws, Whitney Chadwick, Katharine Conley, Rosalind Krauss, Jane Livingston, Alyce Mahon, Jennifer Mundy, and Penelope Rosemont. Some of the most sympathetic writing on the much-reviled Hans Bellmer has come from Sue Taylor (*Hans Bellmer: The Anatomy of Anxiety,* Cambridge, MA: MIT Press, 2002), Therese Lichtenstein (*Behind Closed Doors: The Art of Hans Bellmer,* Berkeley: University of California Press, 2001), and Rosalind Krauss. See in particular the latter's "Corpus Delicti," in Rosalind Krauss and Jane Livingston, *L'Amour fou: photography and surrealism,* Washington, DC: Corcoran Gallery/London: Abbeville Press, 1995. Annie Le Brun's *Lâcher tout,* Paris: Sagittaire, 1977, by contrast, is a no-holds-barred polemic against feminism by a *femme surréaliste* who was among other things a very close friend of Toyen's. The introduction is translated in Rosemont, *Surrealist Women,* 306–9. "I object to being enrolled in an army of women engaged in struggle simply because of a biological accident," Le Brun insists.

134. See *Amazons of the Avant-Garde: Alexandra Exter, Natalia Goncharova, Liubov Popova, Olga Rozanova, Varvara Stepanova, and Nadezhda Udaltsova,* ed. John E. Bowlt and Matthew Drutt, New York: Guggenheim Museum, 2000. Paul Wood et al., *The Great Utopia: The Russian and Soviet Avant-Garde 1915–1932,* New York: Guggenheim Museum, 1992, is a remarkably comprehensive and lavishly illustrated treatment of its subject, which covers males and females alike.

135. Legend to Eileen Agar's "Angel of Anarchy," as displayed in Tate Modern, 2006, source not given.

136. See Julia Kristeva, *Powers of Horror: An Essay on Abjection,* New York: Columbia University Press, 1982. Alyce Mahon develops a similar line of argument in *Surrealism and the Politics of Eros.*

137. Agar, *Look at My Life,* 120–21.

138. Leonor Fini, conversation with Peter Webb, 9 February 1994, in Peter Webb, *Leonor Fini: metamorphoses d'un art,* Paris: Éditions Imprimerie Nationale, 2009, 69.

139. Earlier Lee had sat for countless nude studies by her father, a keen amateur photographer. Lee's modeling career was the result of *hasard objectif;* one day she "carelessly stepped into the path of an oncoming car" in New York, "a bystander yanked her back with only inches to spare, and Lee collapsed into his arms." The bystander was Condé Nast, publisher of *Vogue.* Lee's first appearance on the cover was in March 1927. Antony Penrose, *The Lives of Lee Miller,* London: Thames and Hudson, 1988, 16.

140. Quoted in ibid., 16, source not given. Antony Penrose was Lee's son by Roland Penrose.

141. Ibid., 20.

142. Quoted in Penrose, ibid., 22. His source is Brigid Keenan, *The Women We Wanted to Look Like,* London: St. Martin's Press, 1977, 136.

143. Althsuler, *Avant-Garde in Exhibition,* 130.

144. Man Ray, *Self-Portrait*, 207.

145. Mahon, *Surrealism and the Politics of Eros*, 57.

146. Roland Penrose, *Man Ray*, London: Thames and Hudson, 1975, 108–9. The metronome is reproduced as the frontispiece to Diez, *La Subversion des images*.

147. Richard Cork, "Eye of the Beholder," in *Tate Magazine*, Issue 3, January–February 2003. See also Penrose, *Man Ray*, 108–9.

148. Man Ray, "À l'heure de l'observatoire—les amoureux," *Cahiers d'Art*, Vol. 10, Nos. 5–6, 1935, 127, in Phillip Prodger, *Man Ray Lee Miller: Partners in Surrealism*, Salem, MA: Peabody Essex Museum/London: Merrell, 2011, 45.

149. A photograph of Breton's "Object-Chest" is reproduced in Mahon, *Surrealism and the Politics of Eros*, 39. An exquisite corpse, explains the *Dictionnaire abrégé*, refers to a surrealist game in which several players collectively produce a text or picture by writing or drawing on a piece of paper, each folding it and passing it on to the next in such a way that no participant can see what has gone before. "The example, now classic, which has given its name to the game is the first phrase obtained in this manner: *Le cadavre—esquis—boira—le vin—nouveau* (the exquisite corpse will drink the new wine)."

150. Man Ray, *Self-Portrait*, 203.

151. David Lomas, untitled commentary on "Veiled Erotic," in Mundy, *Surrealism: Desire Unbound*, 224. The photograph is reproduced on p. 225. Other photographs from the series are reproduced in Diez, *La Subversion des images*, 103–5, and *Man Ray: Photography and Its Double*, ed. Emanuelle de L'Écotais and Alain Sayag, Corte Madera, CA: Gingko Press, 1998, 168–73.

152. Lomas, in Mundy, *Surrealism: Desire Unbound*, 224. The cropped version of the photograph was published in *Minotaure*, No. 5, 1934, 15, under the title "Érotique-voilée." Indeed!

153. Mahon, *Surrealism and the Politics of Eros*, 19. "The exhibition," she goes on, "created a space which was at once tactile and interactive as well as emphatically feminine . . . the space exposed repressed psychological anxiety and abandoned rationality (a male characteristic according to the western metaphysical tradition), and replaced it with irrationality and its feminine qualities (the insane, the primitive, subjective intuition, emotion and passion according to the same tradition)" (55).

154. "Surrealist Art: Strange Exhibits in Paris," London *Times*, 21 January 1938, 11. Quoted in Lewis Kachur, *Displaying the Marvelous: Marcel Duchamp, Salvador Dalí, and Surrealist Exhibition Installations*, Cambridge, MA: MIT Press, 2001, 31–34.

155. See Raoul Ubac's photograph, in Kachur, *Displaying the Marvelous*, 33. All the mannequins at the *Exposition internationale* were photographed at the time by Denise Bellon, Raoul Ubac, Man Ray, and others, and are illustrated in Kachur's book. Millet's *Angélus* was a widely used motif in Dalí's work at this period.

156. Roberto Matta, "Souvenir d'une cohue, 1938," quoted in Polizzotti, *Revolution of the Mind*, 449.

157. The flyer is reproduced in Durozoi, *History of the Surrealist Movement*, 340.

158. Comte de Lautréamont, *Maldoror*, 193.

159. Hal Foster, Rosalind Krauss, Yve-Alain Bois, and Benjamin H. D. Buchloh,

Art since 1900: Modernism, Antimodernism, Postmodernism, London: Thames and Hudson, 2004, 298.

160. Man Ray, *Les Mannequins—La résurrection des mannequins*, Paris, 1966, quoted in Katherina Sykora, "Merchant Temptress: The Surrealistic Enticements of the Display Window Dummy," in *Shopping; A Century of Art and Consumer Culture*, ed. Christoph Grunenberg and Max Hollein, Frankfurt: Hatje Cantz, 2002, 133.

161. PLEM was also prominently credited on the title page of the Galerie Beaux-Arts catalogue.

162. Georges Hugnet, *Pleins et déliés*, quoted in Polizzotti, *Revolution of the Mind*, 450.

163. See Kachur, *Displaying the Marvelous*, 43, 53.

164. Luce Irrigaray, *This Sex Which Is Not One*, Ithaca, NY: Cornell University Press, 1985, 26. See also, in this connection, Hal Foster's "Violation and Veiling in Surrealist Photography: Woman as Fetish, as Shattered Object, as Phallus," in Mundy, *Surrealism: Desire Unbound*, esp. 218–22.

165. Man Ray, *Self-Portrait*, 191.

166. The photograph is reproduced in Kachur, *Displaying the Marvelous*, 46.

167. André Breton, "Prestige d'André Masson," in *André Masson*, ed. André Dimanche, Paris: André Dimanche, 1993, 113.

168. See Kachur, *Displaying the Marvelous*, 48, as well as Masson's 1938 drawing titled "La pensée," in Dimanche, *André Masson*, 39.

169. Jacques Lacan, "The Mirror-Phase as Formative of the Function of the I," in his *Écrits*, trans. Bruce Fink, New York: Norton, 2007. Lacan first made the acquaintance of the surrealists at Adrienne Monnier's bookstore as early as 1926: see Quentin Bajac, "L'experiénce continue," in Diez, *La Subversion des images*, 253. He also published in *Minotaure*, as noted earlier.

170. Compare Alyce Mahon's subtle discussion in *Surrealism and the Politics of Eros*, which is a no less feminist analysis but stresses the disorienting subversiveness of the figure (47). I have developed the argument of this paragraph further in my essay "Ceci n'est pas un con: Duchamp, Lacan, and *L'Origine du monde*," in *Marcel Duchamp and Eroticism*, ed. Mark Décimo, London: Cambridge Scholars Press, 2007, 160–72.

171. Mahon, *Surrealism and the Politics of Eros*, 50–51.

172. Ibid., 52.

173. *Dictionnaire abrégé du surréalisme*, 76.

174. See the anonymous photographs of Vanel taken at the opening of the *Exposition internationale* on 17 January 1938, in Kachur, *Displaying the Marvelous*, 86, and Karoline Hille, "Ein Traum wird Farbe," in Spieler and Auer, *Gegen jede Vernunft*, 209. Hille's essay also contains two contemporary photographs of the exhibition's central chamber by Denise Bellon, as well as several photographs of the reproduction of the chamber created for this 2010 exhibition.

175. "Il faisait tellement noir à midi qu'on voyait les étoiles." Handwritten by Picasso on the bottom of a box of matches, reproduced in Anne Baldassari, *Picasso: Life with Dora Maar. Love and War 1935–1945*, Paris: Flammarion, 2006, epigram to book and (in facsimile) endpaper.

176. Mignon Nixon, *Fantastic Reality: Louise Bourgeois and a Story of Modern Art*, Cambridge, MA: MIT Press, 2005, 58.

177. Paul Virilio, *Art and Fear*, trans. Julie Rose, New York: Continuum, 2003.

178. André Breton, "Before the Curtain," in *Free Rein*, 80–81.

179. Ingrid Schaffner, *Salvador Dalí's Dream of Venus: The Surrealist Funhouse from the 1939 World's Fair*, New York: Princeton Architectural Press, 2002, 32. I borrow the phrase "old weird America" from Greil Marcus, *The Old, Weird America: The World of Bob Dylan's Basement Tapes*, New York: Picador, 2001.

180. Schaffner, *Dream of Venus*, 26; Kachur, *Displaying the Marvelous*, 150–51.

181. This and other details regarding the pavilion's opening ceremony are taken from the contemporary news reports ("Czech Pavilion, Flags at Half-Staff, Opens," *New York Evening Journal*, 31 May 1939) and photographs (NYPL ID numbers 1669173, 1669197, 1669131, 1669141, and 1669203) reproduced in the "War and the Czech Pavilion" section of the stunning New York Public Library virtual exhibit "The World of Tomorrow: Exploring the 1939–40 World's Fair Collection," available as an iPad app titled "NYPL Biblion." Twenty years earlier Tomáš Masaryk had used Komenský's prayer in his first speech as president of an independent Czechoslovakia. The words would resurface again in 1969 in a song recorded by Marta Kubišová, the lead singer of the group The Golden Kids. "A Prayer for Marta" (*Modlitba pro Martu*) got Kubišová, who later became a signatory of Charter 77, banned from stage, radio and TV, and the recording studio for the next twenty years. The next time she publicly performed the song, she was standing with Václav Havel on the Melantrich Balcony overlooking Wenceslas Square in November 1989 before an audience of half a million demonstrators. Havel would in turn end his first address as President with the words: "People, your government has returned to you!" See *Coasts*, 269–70, for fuller details. I relate this story not as an exercise in happy endings but as an object lesson in the eternal return of the signifier, which lends coherence to history not through any stability of meaning or reference but the comfort of its endless repetition. Ivan Klíma surely felt its reassuring hand on his shoulder in Bartolomějska ulice.

182. Ladislav Sutnar, *Visual Design in Action*, New York: Hastings House, 1961, 14, as quoted in Jindřich Toman, "'Nesmírně zajímavá motanice': Ladislav Sutnar a jeho Amerika," in Janáková, *Ladislav Sutnar—Praha—New York—Design in Action*, 330–31.

183. Unpublished manuscript dating from 1960s, quoted in Janáková, *Ladislav Sutnar—Praha—New York—Design in Action*, 274.

184. See Iva Knobloch, ed., *Ladislav Sutnar: Americké Venuše (U.S. Venus)*, Prague: Arbor Vitae/Uměleckoprůmyslové muzeum, 2011. Many of the Joy-Art paintings are also reproduced in Janáková, *Ladislav Sutnar—Praha—New York—Design in Action*, 273–87. This was an outstanding exhibition, and the catalogue is a comprehensive survey of Sutnar's Czech and American oeuvre.

185. Ladislav Sutnar, introduction to series *The Strip Street: Posters without Words* (limited edition of 25, New York, 1963), quoted in Knobloch, *Ladislav Sutnar: Americké Venuše*, 197–98.

186. Michael Beckerman, "The Dark Blue Exile of Jaroslav Ježek," *Music and Politics*, Vol. II, No. 2, summer 2008, available at http://www.music.ucsb.edu/projects/

musicandpolitics/archive/2008-2/beckerman.html (accessed 13 May 2012). The article contains hyperlinks to Stivin's film as well as several examples of Ježek's compositions in both jazz and "classical" genres. The letter from Ježek to Janouch, dating from January 1939, can be found in František Cinger, *Šťastné blues aneb z deníku Jaroslava Ježka*, Prague: BVD, 2006, 147. The passage quoted here is taken from Beckerman's article, in his translation.

187. David Stewart-Candy, "Pleasence, Bond and Blofeld," Donald Pleasence website, available at http://www.pleasence.com/film/youonly/youonly-1.html (accessed 13 May 2012).

188. This and subsequent quotations from Novotná are taken from her June 1979 interview in Lanfranco Rasponi, *The Last Prima Donnas*, New York: Limelight Editions, 1985, 316–28.

189. Jan Masaryk, liner notes (1942) to Jarmila Novotná, "Songs of Czechoslovakia," RCA Victor LP record number VIC 1383 (1969).

190. Official announcement, June 1942, reproduced in Buben, *Šest let okupace Prahy*, 165–66.

191. Jan Mararyk, liner notes to Novotná, "Songs of Czechoslovakia."

192. Jan Králík, liner notes to Jarmila Novotná, "České písně a arie," Supraphon CD number 11 1491–2201 (1992).

193. Alan Blyth, liner notes to "Jarmila Novotná: The Artist's Own Selection of Her Finest Recordings," Pearl LP record number GEMM 261/2 (1983).

194. Janáková, *Ladislav Sutnar—Praha—New York—Design in Action*, 372.

195. Review quoted in Gregory Terain, "From La Bagarre: A Selective Dip into the Boston Symphony Orchestra Archives," in *Bohuslav Martinu Newsletter*, Vol. 6, No. 2, May–August 2006, 10.

196. Martinů to Otakar Sourek, 8 November 1938, in Alan Houtchens, "Love's Labours Lost: Martinů, Kaprálová and Hitler," *Kapralova Society Journal*, Vol. 3, No. 1, Spring 2006, 2–3. Emil Hácha succeeded Beneš as president of the truncated state on November 30, a position he would retain under the Nazi Protectorate.

197. Jiří Mucha, *Au seuil de la nuit*, trans. Françoise and Karel Tabery, La Tour d'Aigues: Éditions de l'aube, 1991, 273. I have used the French translation here because I was unable to get hold of the Czech original (*Podivné lásky*, Prague: Mladá fronta, 1989) at the time of writing—but it seems somehow appropriate.

198. Jiří Mucha, libretto to Bohuslav Martinů, *Field Mass*, trans. Geraldine Thomsen, with Supraphon CD number SU 3276-2 931 (1997).

199. Marie Červinková-Riegrová, libretto to Antonín Dvořák, *Jakobín* (1889), included with Supraphon record album set number 1112 2481/3 (1980), 35.

200. Jiří Mucha, libretto for Martinů, *Field Mass*.

201. Quoted in Bohuslav Martinů, *Julietta*, Supraphon CD number SU 3626-2 612, 2002 (reissue), commentary by Jaroslav Mihule, 1992, in accompanying booklet, pp. 9–11. Quotations in the following paragraphs are all from the libretto, included with the same set.

202. Martinů to Václav Talich, around 16–17 March 1938, quoted in Jiří Mucha, *Au seuil de la nuit*, 124.

203. All the foregoing quotations are from *Julietta* libretto.

204. Bohuslav Martinů, synopsis of *Julietta*, dated New York, April 1947, in New Opera Company/English National Opera program *Julietta*, 1978, unpaginated.
205. All the foregoing quotations are from *Julietta* libretto.
206. Martinů, 1947 synopsis of *Julietta*.
207. See the photo from July 1938 reproduced in Timothy Cheek, "Navždy (Forever) Kaprálová: Reevaluating Czech Composer Vítězslava Kaprálová through her Thirty Songs," in *Kapralova Society Journal*, Vol. 3, No. 2, Fall 2005, available at http://www.kapralova.org/JOURNAL.htm (accessed 13 May 2012); Jiří Mucha, *Au Seuil de la nuit*, photographs following p. 289; and material on the Kaprálová Society website, available at http://www.kapralova.org/index.htm (accessed 13 May 2012).
208. Quoted in Jiří Mucha, *Au seuil de la nuit*, 67.
209. Jiří Mucha, *Au seuil de la nuit*, 199.
210. Michael Beckerman, private correspondence with the author. I am immensely grateful to Mike for his reading of and suggestions for this and the preceding section of this chapter.
211. Jiří Mucha, *Au seuil de la nuit*, 122.
212. Charlotte Martinů, *My Life with Martinů*, trans. Diderik C. D. De Jong, Prague: Orbis, 1978, 32.
213. Jiří Mucha, *Au seuil de la nuit*, 122–23.
214. Vítězslav Nezval, *Sbohem a šáteček: básně z cesty*, Prague: Československý spisovatel, 1961, 212 (originally Prague: Borový, 1934).
215. Quoted in Cheek, "Navždy (Forever) Kaprálová," 3, 6. My retranslation. Kundera was writing in 1949.
216. Vítězslava Kaprálová, draft analysis of her *Military Sinfonietta*, in Karla Hartl, "Notes to the Catalogue," available at http://www.kapralova.org/OPUS_NOTES.htm#iscm (accessed 13 May 2012).
217. Bohuslav Martinů, in *Lidové noviny*, 28 June 1938, 7, translated in Karla Hartl, "Vítězslava Kaprálová: A Life Chronology" (Part III), in *Kapralova Society Journal*, Vol. 4, No. 1, 2006, 10.
218. Havergal Brian, "The Nature of Modern Music. Contemporary Music Festival," *Musical Opinion*, July 1938, 858.
219. Jiří Mucha, *Au seuil de la nuit*, 140.
220. The photograph is reproduced in *Josef Sudek: Portraits*, Prague: Torst, 2007, 43.
221. "Rudek, I desire you, I am not all water and ice, but blood and fire and I want you, my man, my lover.... Desire torments me and nobody can satisfy it but you, your hands, your mouth, your body." Kaprálová to Rudolf Kopec, 18 April 1938, quoted in Jiří Mucha, *Au seuil de la nuit*, 196.
222. Kaprálová to her parents, 7 June 1939, quoted in Hartl, "Vítězslava Kaprálová: A Life Chronology," Part III, 11.
223. Martinů, preface to 1947 edition of *Julietta* score, quoted in *Julietta*, New Opera Company/English National Opera program, 1978. He is talking of the bookseller Michal.
224. Kaprálová to Hanuš Weigl, December 1939, facsimile in *Kapralova Society Newsletter*, Vol. 2, Issue 1, Spring 2004, 7–8.
225. Jiří Mucha, *Au seuil de la nuit*, 64.

226. Vítězslava Kaprálová, "Hussitský chorale," in *Československý boj*, 9 February 1940, 8, reprint available at http://www.kapralova.org/WRITINGS.htm (accessed 13 May 2012).

227. Kaprálová to Jiří Mucha, 7 April 1940, in *Au seuil de la nuit*, 343.

228. Jiří Mucha, Ibid., 388.

229. Ibid., 392.

230. Jiří Mucha, *Living and Partly Living*, London: The Hogarth Press, 1967, 114.

231. Jiří Mucha, *Au seuil de la nuit*, 393.

232. *Living and Partly Living* is the title of Mucha's book *Studené slunce* in the English translation. The phrase is Mucha's own, but the literal translation of *Studené slunce* would be "Cold Sun."

233. Jiří Mucha, *Living and Partly Living*, 7.

234. Ibid., 113.

235. Ibid., 115.

236. Jiří Mucha, *Au seuil de la nuit*, 7.

237. Interviewed by Lucie Bartošová in November 2009, Geraldine Mucha, then aged 92, said of *Podivné lásky*: "Fifty years later he wrote a book about their relationship. Perhaps he wasn't able to do it earlier. They were together for such a short time, and it was obviously an enormous love. He had to wait, to be sufficiently distant from it. But once he embarked on this novel, it wholly consumed him." I am very grateful to Lucie Bartošová (now Lucie Zídková) for providing me with this transcript.

238. Translated in Karla Hartl, "In Search of a Voice: Story of Vítězslava Kaprálová," *Kapralova Society Newsletter*, Vol. 1, No. 1, Fall 2003, 4. Jiří discovered the manuscript of the previously unknown song while researching *Podivné lásky*.

239. Kaprálová to Jiří Mucha, 9 June 1940, reproduced in Jiří Mucha, *Au seuil de la nuit*, 386.

240. Jiří Mucha, *Au seuil de la nuit*, 391–92.

241. Ibid., 123.

242. Erik Entwistle, "To je Julietta: Martinů, Kaprálová and Musical Symbolism," in *Kapralova Society Newsletter*, Vol. 2, No. 2, Fall 2004, 5.

243. Bohuslav Martinů to Václav Kaprál, undated but presumably (from its content) September 1938, reproduced in Jiří Mucha, *Au seuil de la nuit*, 394.

244. Vítězslava Kaprálová, diary entries for 21 and 22 January 1939, in Mucha, *Au seuil de la nuit*, 182.

245. Entwistle, "To je Julietta," 14.

246. Jiří Mucha, *Au seuil de la nuit*, 123.

247. This is claimed in Charles Laurence, *The Social Agent: A True Intrigue of Sex, Lies, and Heartbreak behind the Iron Curtain*, London: Ivan R. Dee, 2010.

248. Jiří Mucha, *Living and Partly Living*, 117.

249. Jiří Mucha, ibid., 114–15.

7. Love's Boat Shattered against Everyday Life

1. Quoted in Annie Le Brun, *Sade: A Sudden Abyss*, San Francisco: City Lights, 2001, 171.

2. These are reproduced in Pachnicke and Honnef, *John Heartfield*, 194, and *John Heartfield en la colección del IVAM*, 107, respectively.

3. Reproduced in Pachnicke and Honnef, *John Heartfield*, 179.

4. Interview with Francis Klingender, 2 April 1944, quoted in Pachnicke and Honnef, *John Heartfield*, 26.

5. "John Heartfield et la beauté révolutionnaire," in Louis Aragon, *Écrits sur l'art moderne*, Paris: Flammarion, 1981, 46–54. This essay is available in English in Phillips, *Photography in the Modern Era*, 60–67. The montages to which Aragon refers are reproduced in Pachnecke and Honnef, *John Heartfield*: "The Meaning of Geneva," 182, and "O Christmas Tree in Germany, How Crooked Are Your Branches," 295.

6. Aragon, "John Heartfield," 52, 54. Emphasis added.

7. The *Ten Commandments* series is reproduced in full in *Josep Renau fotomontador*, ed. Maria Casanova, Valencia, Spain: IVAM Institut Valencia d'Art Modern, 2006, 96–105; so is "Arctic Man" (95). The fullest published source on Renau's work is *Josep Renau: catálogo razonado a cargo de Albert Forment*, ed. Albert Forment, Valencia, Spain: IVAM Institut Valencia d'Art Modern, 2003, which contains smaller-scale reproductions of both *The Ten Commandments* (59–63) and Renau's 1936 series *Love in History* (64–65) as well as many of his posters and book covers from the period.

8. *Nueva Cultura*, Vol. 3, Nos. 4–5, June–July, Valencia, Spain, 1937. See Carole Naggar, "The Baggage of Exile: Josep Renau and *The American Way of Life*," in Casanova, *Josep Renau Fotomontador*, 261–74. Naggar claims that during this trip Renau met André Breton and the surrealists and saw Heartfield's *150 Collages* exhibition at the Maison de la Culture. The latter seems unlikely; the exhibition took place in 1935, whereas Renau traveled to Paris only in December 1936.

9. Juan Antonio Hormigón, "Un dia con Renau," *Triunfo*, Madrid, 12 June 1976, 36, quoted in Manuel García, "Josep Renau: An Artist's Theory and Practice," in Casanova, *Josep Renau Fotomontador*, 252.

10. José Renau, "Mi experienzia con Siqueiros," *Revista de Bellas Artes*, No. 25, Mexico 1976, quoted in García, "Josep Renau," 251.

11. The legend on the signpost that forms the centerpiece of the June 1942 cover, in Forment, *Josep Renau: catálogo razonado*, 97. Thirty-four of Renau's *Futuro* cover designs, including those discussed here, are reproduced in the same source, pp. 95–103.

12. Josep Renau, *Fata Morgana USA: The American Way of Life*, Valencia, Spain: IVAM Centre Julio Gonzales/Fundació Josep Renau, 1989. This is an enlarged version of the original German publication based on the selection and ordering Renau made for the 1976 Venice Biennale.

13. Renau, *Fata Morgana USA*, 127.

14. Josep Renau, "The Function of Photomontage: Homage to John Heartfield," in Casanova, *Josep Renau Fotomontador*, 275–78, quotations from pp. 278 and 275, respectively. The text was originally published as "Homenaje a John Heartfield" in *Photovision*, No. 1, July–August 1981. The description of Heartfield's work as "a knife that pierces every heart" is taken from Aragon's "John Heartfield et la beauté révolutionnaire."

15. Renau, *Fata Morgana USA*, 69. The full title of the montage is "Gone with the Wind (A national tragedy with pretty legs...)."

16. Adrienne Monnier, *Rue de l'Odéon*, Paris: Albin Michel, 1989, quoted in Ruth Brandon, *Surreal Lives: The Surrealists 1917–1945*, London: Macmillan, 1999, 32.

17. André Breton, *Conversations*, 24–25.

18. Ibid., 27–28.

19. Louis Aragon, quoted in Brandon, *Surreal Lives*, 232. Her source is Pierre Daix, *Aragon, une vie a changer*, Paris: Seuil, 1975, 193.

20. Breton, *Second Manifesto of Surrealism*, in *Manifestoes of Surrealism*, 142–43.

21. Breton, *Conversations*, 129.

22. Ibid., 129–30.

23. Louis Aragon, "Le surréalisme et le devenir révolutionnaire," *Surréalisme au service de la révolution*, No. 3, December 1931, 3.

24. Ibid.

25. Salvador Dalí, "Reverie," *Surréalisme au service de la révolution*, No. 4, December 1931, 31–36, as translated in his *Oui*, 139–52. The quotations are from p. 141.

26. Aragon, "Le surréalisme et le devenir révolutionnaire," 3.

27. See Brandon, *Surreal Lives*, 280. She is quoting Alexandre's *Mémoires d'un surréaliste*, Paris: La Jeune Parque, 1968, 109.

28. See earlier, pp. 219–20.

29. Louis Aragon, "Front rouge," reproduced in André Breton, ABOC 2, 32.

30. Breton, *Conversations*, 131.

31. André Breton, "Misère de la poésie: 'L'Affair Aragon' devant l'opinion publique," in ABOC 2, 5. The signatories are listed. Part of this text is translated in Maurice Nadeau, *The History of Surrealism*, Cambridge, MA: Harvard University Press, 1999, 296–303.

32. Breton, "Misère de la poésie," ABOC 2, 21.

33. Ibid., 14–15.

34. "L'inculpation d'Aragon," *L'Humanité*, 9 February 1932, reproduced in Breton, "Misère de la poésie," ABOC 2, 21–22.

35. See ABOC 2, 1308; Polizzotti, *Revolution of the Mind*, 373–74. The note in question can be found in ABOC 2, 23.

36. Breton, *Conversations*, 131–32.

37. Aragon, quoted in Polizzotti, *Revolution of the Mind*, 374.

38. Breton, *Conversations*, 132.

39. Paul Éluard, "Certificat," in Valette, *Éluard: Livre d'identité*, 110.

40. Breton, *Conversations*, 128.

41. Polizzotti, *Revolution of the Mind*, 307–8.

42. Ibid., 375.

43. Aragon, in Pierre, *Investigating Sex*, 48, 29.

44. Breton, in Pierre, *Investigating Sex*, 105.

45. Durozoi, *History of the Surrealist Movement*, 650.

46. André Thirion, *Revolutionaries without Revolution*, trans. Joachim Neugroschel, New York: Macmillan, 1975, 308.

47. Polizzotti, *Revolution of the Mind*, 308.

48. André Breton, "Convulsionnaires: avant-propos à Man Ray, 'La photographie n'est-pas l'art,'" 1937, in ABOC 2, 1212.

49. Julia Kristeva, *Sens et non-sens de la révolte*, Paris: Fayard, 1966, quoted in Brandon, *Surreal Lives*, 250.

50. Robert Benayoun, "L'asassinat de l'équivoque," in *Exposition inteRnatiOnale du Surréalisme*, 86.

51. Pierre, *Investigating Sex*, 27–28.

52. Ibid., 31.

53. Ibid., 45.

54. Elsa was Russian—like Gala Éluard, for whose "orientalism" see Lou Straus-Ernst's remarks, earlier, p. 291. Polizzotti orientalizes Elsa through the reference to Yoko Ono, who was widely blamed for seducing John Lennon away from the Beatles.

55. Breton, "Misère de la poésie," ABOC 2, 23.

56. Brandon, *Surreal Lives*, 281.

57. Vítězslav Nezval, *Ulice Gît-le-Coeur*, 8–9, 13.

58. Ibid., 95.

59. Ibid., 94–95. Lise was one of Breton's (unrequited) loves.

60. Ibid., 24–26.

61. Ibid., 34.

62. Ibid., 96–97.

63. Štyrský had previously photographed a shop window with coffins for his 1934 cycle *Muž s klapkami na očích* (Man with Blinkers). See Karel Srp, *Jindřich Štyrský*, 26; the photo in question is reproduced as plate 11.

64. Ilya Ehrenburg, *Vus par un écrivain d'U.R.S.S.* (1934), quoted in Polizzotti, *Revolution of the Mind*, 418.

65. Nezval, *Ulice Gît-le-Coeur*, 14.

66. Ibid., 10.

67. René Crevel's suicide note, quoted in Polizzotti, *Revolution of the Mind*, 419.

68. Nezval, *Ulice Gît-le-Coeur*, 36–37.

69. Ibid., 38.

70. See Karel Teige's discussion in "Socialistický realismus a surrealismus," KTD 2, 241–43. He also cited Crevel's book as an exemplary "combination of a novelistic lampoon, social reportage, and political commentary" in his catalogue essay for the first exhibition of the Czechoslovak Surrealist Group (see "Surrealism Is Not a School of Art" in Srp, *New Formations*, 180).

71. André Breton, "Speech to the Congress of Writers (1935)," in *Manifestoes of Surrealism*, 234–41.

72. Nezval, *Ulice Gît-le-Coeur*, 72.

73. Vítězslav Nezval to André Breton, 7 September 1935, in *Korespondence Vítězslava Nezvala*, 85.

74. The speech is reproduced in full in *Ulice Gît-le-Coeur*, 59–67; pp. 61–64 consist largely of quotations from Kalandra's review.

75. Nezval, *Ulice Gît-le-Coeur*, 82–84.

76. Vítězslav Nezval, "Předpoklady Mezinárodního kongresu na obranu kultury," *Surrealismus*, No. 1, February 1936, 25, in Torst Surrealist Reprints, 160.

77. See earlier, pp. 28–29.

78. Nezval, *Ulice Gît-le-Coeur*, 120–21.

79. Ibid., 111–12.

80. Karel Teige, "Surrealismus proti proudu," in KTD 2, 527–29.

81. Karel Teige, "Moskevský proces," *Praha—Moskva*, No. 1, 1936; reprinted in KTD 2, 335–49.

82. Karel Teige, "Projev Karla Teigeho na diskusním večeru Klubu Přítomnost v Praze 13. ledna 1937," partly reproduced (from manuscript in Památník národního písemnictví) in KTD 2, 626–31. Other participants in the debate included Ladislav Štoll, Záviš Kalandra, and Vladimír Clementis.

83. Stanislav Kostka Neumann, *Anti-Gide, nebo optimismus bez pověr a ilusí*, Prague: Svoboda, 1946, 102.

84. Ibid., 117–18.

85. Ibid., 124.

86. Stanislav Kostka Neumann, "Dnešní Mánes," *Tvorba*, Vol. 12, No. 20, quoted in Ivan Pfaff, *Česká levice proti Moskvě 1936–1938*, Prague: Naše vojsko, 1993, 107.

87. "S. K. Neumann" (1938) and "Umrlčí hlavy týdne" (1934), reproduced in Srp, *Adolf Hoffmeister*, 135 and 146, respectively.

88. See Pfaff, *Česká levice proti Moskvě*, 107.

89. Karel Teige, "Doslov k výstavě Štyrského a Toyen," Prague: Topič, January 1938, in KTD 2, 664–65.

90. Vítězslav Nezval, "Řeč ke studentstvu o roztržce se skupinou surrealistů 24.3.1938," *Tvorba*, Vol. 13, 1938, 150, quoted in Pfaff, *Česká levice proti Moskvě*, 130n.

91. Teige, "Surrealismus proti proudu," in KTD 2, 503.

92. *Národní výzva*, 18 March 1938, quoted in Teige, "Surrealismus proti proudu," KTD 2, 505.

93. *Tvorba*, Vol. 13, No. 11, quoted in Teige, "Surrealismus proti proudu," KTD 2, 506. Similar commentaries were carried in *Rudé právo* (16 April 1938) and *Halónoviny* (Kurt Konrad, 19 March 1938), both of which are also quoted by Teige.

94. "Schůzi surrealistické skupiny v Praze 14.III.1938," in KTD 2, 662.

95. André Breton to Vítězslav Nezval, 18 March 1938, in *Korespondence Vítězslava Nezvala*, 96–99. The correspondence between the majority (Teige, Štyrský, Toyen, Biebl, Brouk, and Honzl) and Breton and Péret is reproduced in facsimile on the DVD accompanying *André Breton: 42 rue Fontaine*, Vol. 3, *Manuscrits*, 166, lots 2220 and 2221.

96. Teige, *Surrealismus proti proudu*, 484. Compare "The Avant-Garde and Kitsch" in Clement Greenberg, *The Collected Essays and Criticism, Volume 1: Perceptions and Judgments, 1939–1944*, ed. John O'Brian, Chicago: University of Chicago Press, 1988.

97. Polizzotti, *Revolution of the Mind*, 424.

98. Teige, *Surrealismus proti proudu*, 511–14. Tomáš Garrigue Masaryk died on 14 September 1937. Jaroslav Seifert was among others who published poetic tributes. See his cycle *Eight Days* (*Osm dní*), Prague: Československý spisovatel, 1968.

99. Bydžovská and Srp, *Český surrealismus*, 93.

100. The "trial" is discussed in Polizzotti, *Revolution of the Mind*, 394–97.

101. Éluard to Gala, 14 February 1937, in *Lettres à Gala,* 275.

102. Breton to Éluard, 14 June 1938, ABOC 2, lvi.

103. Éluard to Breton, 12 October 1938, ibid., lvii.

104. Breton to Éluard, 13 October 1938, ibid., lvii.

105. Maurice Nadeau and Jean-Charles Gateau, respectively, quoted in Polizzotti, *Revolution of the Mind,* 468.

106. Milan Kundera, *Encounter,* trans. Linda Asher, London: Faber and Faber, 2010, 110–13.

107. ABOC 2, lviii. Breton was called up from 29 September to 8 October 1938.

108. "The sexual eagle exults," from *L'Eau du temps* (1934), in Breton, *Earthlight,* 144.

109. Éluard to Gala, 15 Sept 1936, in *Lettres à Gala,* 270.

110. Mary Ann Caws, "Remembering Jacqueline Remembering André," in *Surrealist Painters and Poets: An Anthology,* ed. Mary Ann Caws, Cambridge, MA: MIT Press, 2001, 12.

111. Claude Lévi-Strauss, "New York in 1941," in his *The View from Afar,* trans. Joachim Neugroschel, Chicago: University of Chicago Press, 1992, 258–67; André Breton, *Martinique: Snake Charmer,* trans. David W. Seaman, Austin: University of Texas Press, 2008. For background, see Martica Sawin, *Surrealism in Exile and the Beginning of the New York School,* Cambridge, MA: MIT Press, 1997.

112. Cabanne, *Dialogues with Marcel Duchamp,* 84.

113. André Breton, *Arcanum 17,* translated by Zack Rogow, Los Angeles: Sun and Moon Press, 1994, 9.

114. Ibid., 19.

115. Ibid., 33.

116. Anna Balakian, introduction to Breton, *Arcanum 17,* 16.

117. Max Weber, "Science as a Vocation," in *From Max Weber,* ed. H. Gerth and C. Wright Mills, London: Routledge, 1970, 143. Weber is quoting Tolstoy. For a commentary on this essay, see my *Capitalism and Modernity,* London: Routledge, 1991, 148–53.

118. Ludwig Wittgenstein, *Tractatus Logico-Philosophicus,* trans. Brian McGuiness and David Pears, London: Routledge, 2001, 149.

119. "Tarot Cards; The Star," available at http://www.paranormality.com/tarot_star.shtml (accessed 7 May 2012). Breton collaged two examples of the card into his original handwritten manuscript. See André Breton, *Arcane 17: le manuscript original,* ed. Henri Béhar, Paris: Biro, 2008, plate xxxii.

120. Breton, *Arcanum 17,* 61–62.

121. Ibid., 65.

122. Ibid., 64.

123. Photo by Jacques Matarasso, reproduced in Paul André, ed., *Visages d'Éluard: photographies,* Paris: Musée d'art et d'histoire de Saint-Denis/Éditions Parkstone, 1995, 21.

124. E.L.T. Messens, untitled preface to Paul Éluard, *Poesie et Verité 1942/Poetry and Truth 1942,* trans. Roland Penrose and E.L.T. Mesens, London: London Gallery Editions, 1944, 9.

125. Lee Miller, "Paris. Its Joy ... Its Spirit ... Its Privations," first published in *Vogue,* October 1944; reprinted incorporating manuscript of "The Way Things Are

in Paris" (*Vogue*, November 1944) and other additional material, in Penrose, *Lee Miller's War*, 73.

126. Brassaï, *Conversations with Picasso*, 209.

127. Ibid., 210.

128. Lee Miller, "Paris. Its Joy . . . Its Spirit . . . Its Privations," 74–77.

129. Antony Penrose, Afterword to *Lee Miller's War*, 205.

130. Éluard to Gala, 18 March 1945, in *Lettres à Gala*, 305–6.

131. Éluard to Gala, 25 November 1946, in ibid., 261–62.

132. Jean Schuster, "1946–1966, les années maudites," in Angliviel de la Beaumelle, *André Breton: La béauté convulsive*, 398.

133. Reproduced in André, *Visages d'Éluard*, 15.

134. Éluard to Gala, 25 November 1946, in *Lettres à Gala*, 261.

135. *Magritte: catalogue du centenaire*, ed. Gisèle Ollinger-Zinque and Frederik Leen, Brussels: Musées royaux des Beaux-Arts de Belgique/Flammarion, 1998, 332. Magritte left the party two years later.

136. Man Ray, *Self-Portrait*, 289–90.

137. Max Ernst, "An Informal Life of M. E." 16.

138. Brassaï, *Conversations with Picasso*, 283–84.

139. Éluard to Gala, 16 June 1947, in *Lettres à Gala*, 320.

140. Éluard to Gala, 13 October 1947, in ibid., 321.

141. Paul Éluard, *Le Temps déborde*, 1947, in PEOC 2, 108–9.

142. Caillois, "Testimony (Paul Éluard)", in *Edge of Surrealism*, 65.

143. Éluard to Gala, 21 February 1948, in *Lettres à Gala*, 324.

144. Dedication to Paul Éluard, *A Moral Lesson*, trans. Lisa Lubasch, Copenhagen and Los Angeles: Green Integer Books, 2007.

145. *Le Corps mémorable* is reproduced in both the original French text and Marilyn Kallet's English translations in *Last Love Poems of Paul Éluard*, Boston: Black Widow Press, 2006, 98–129. The lines are from "Resurrecting Kisses" (120–21). Kallet's anthology also contains a full translation of *Le Temps déborde*.

146. Éluard, *A Moral Lesson*, 7–8. My emphasis on "I am only human." The evil/good alternation is abandoned beginning with "Bad Night Good Day" (68), a pivotal poem in the collection.

147. Raymond Jean, *Éluard*, Paris: Seuil, 1968, 42.

148. Éluard to his daughter Cécile, August 1947, in Valette, *Éluard: Livre d'identité*, 213.

149. Ibid., 43.

150. Éluard, "Notre vie [1], " in *Le Temps déborde*, PEOC 2, 112.

151. Toyen, *Jednadvacet*, Prague: Torst, 2002. This is the first publication of the work.

152. Toyen provided plenty of depictions of oral sex, but the lesbian 69 she drew for *Josefina Mutzenbacherová neboli Paměti vídeňské holky jak je sama vypravuje*, Prague: Čejka a Hokr, 1930, is particularly sweet. It is reproduced in Bydžovská and Srp, *Knihy s Toyen*, 27.

153. Karel Teige, "Střelnice (The Shooting Range)," trans. William Hollister, "Anthology of Czech and Slovak Surrealism I," in *Analogon*, 37, 2003, xiii–xxi. This text has recently been translated by Kathleen Hayes as "The Shooting Gallery," in Srp, *New Formations*, 235–43. All twelve plates from the series are well reproduced

(in color) in Srp, *Toyen*, 154–61, as are selections from Toyen's series "Schovej se, válko!" (173–77) and "Den a noc" (Day and Night, 1940–41) and some of her illustrations for Heisler's *Z kasemat spánku* (From the Strongholds of Sleep, 1941). *New Formations* has full black-and-white reproductions of both "Střelnice" (198–203) and "Schovej se, válko!" (204–9). Toyen also illustrated Heisler's poem "Přízraky pouště," which was published in a French translation (by Heisler and Benjamin Péret) in Prague in 1939 under the Skira imprint to evade the censor. This was reprinted in French and English in Paris in 1953 (Éditions Arcanes). Stephen Schwartz's English translation was reprinted as Toyen, *Specters of the Desert*, Chicago: Black Swan Press, 1974, and again reprinted in *New Formations*, 224–25, which also contains some of Toyen's illustrations (196–97).

154. Figure given in Toman, *Foto/Montáž tiskem*, 327n.

155. Vojtěch Lahoda, "Karel Teige's Collages, 1935–1951: The Erotic Object, the Social Object, and Surrealist Landscape Art," in Dluhosch and Švácha, *Karel Teige 1900–1951*, 299; Collage 340 is reproduced in Vojtěch Lahoda, Karel Srp, and Rumana Dačeva, *Karel Teige: surrealistické koláže 1935–51*, Prague: Středočeská galerie, 1994, 79. See also the discussions in Toman, *Foto/Montáž tiskem*, Ch. 9, and Codeluppi, *Karel Teige: architettura, poesie—Praga 1900–1951*, which contains many reproductions of Teige's collages.

156. Vojtěch Lahoda, "Teige's Violation: The Collages of Karel Teige, the Visual Concepts of Avant-Garde and René Magritte," in Lahoda et al., *Karel Teige: surrealistické koláže*, 13. Compare Toman, *Foto/Montáž tiskem*, 324.

157. For examples of Hugnet's work, see Timothy Baum, François Buot, and Sam Stourdzé, *Georges Hugnet: Collages*, Paris: Scheer, 2003. On the parallels between Teige and Magritte, see Lahoda, "Teige's Violation."

158. Toshiko Okanoue, *Drop of Dreams*, Tucson: Nazraeli Press, 2002, 9.

159. André Breton, "Surrealist Comet," in *Free Rein*, 96.

160. Like Czechs and women, nonwhite participants in the surrealist movement have been erased in much of the standard postwar historiography of surrealism. See Franklin Rosemont and Robin D. G. Kelley, eds., *Black, Brown, and Beige: Surrealist Writings from Africa and the Diaspora*, Austin: University of Texas Press, 2009, for a sampling of what we have been missing.

161. René Magritte, "Le Surréalisme en plein soleil, dossier," in René Magritte, *Écrits complèts*, Paris: Flammarion, 2001, 196.

162. Milan Kundera, *Unbearable Lightness of Being*, 247–49, 252–53.

163. André Breton, "Before the Curtain" in *Free Rein*, 87. The idea of a new myth is further elaborated in "Surrealist Comet," 88–97.

164. Breton, "Before the Curtain," 85.

165. André Breton, "Projet initiale," in *Le Surréalisme en 1947*, as translated in Polizzotti, *Revolution of the Mind*, 546. The idea for the Hall of Superstitions was Duchamp's; for his role in the exhibition, see *Dialogues with Marcel Duchamp*, 86–87. For fuller discussion of this installation, see Mahon, *Surrealism and the Politics of Eros*.

166. *Lettres françaises*, 18 July 1947, quoted in Polizzotti, *Revolution of the Mind*, 548.

167. Claude Mauriac, "Sartre contre Breton," *Carrefour*, 10 September 1947, 7, quoted in Polizzotti, *Revolution of the Mind*, 538.

168. Georges Bataille, "Surrealism and How It Differs from Existentialism," in his *Absence of Myth*, 57. The review was originally published in *Critique*, No. 2, July 1946.

169. Bataille, "The Absence of Myth," in his *Absence of Myth*, 48.

170. Xavier Cannone, "Le Surréalisme-Révolutionnaire," avant-propos to *Le Surréalisme Révolutionnaire*, Brussels: Didier Devillez, Collection Fac-Similé, 1999, 6. The latter is a reprint of the single issue of the group's journal published in April 1948. For background, see Xavier Canonne, *Surrealism in Belgium: 1924–2000*, Brussels: Mercatorfonds, 2007, 50–56.

171. Canonne, *Surrealism in Belgium*, 52.

172. Four of the 999 copies were listed on the secondhand books network abe books.com on 7 August 2009 at prices ranging from $3,739 to $7,000.

173. Josef Istler, Miloš Korcčck, Ludvík Kundera, Bohdan Lacina, Zdeněk Lorenc, Vilém Reichmann, Václav Tikal, and Václav Zykmund, "Skupina (Ra)," January 1947, in *Skupina Ra*, ed. František Šmejkal, Prague: Galerie hlavního města Prahy, 1988, 126–27. See also Lenka Bydžovská, "Skupina Ra," in Hana Rousová, Lenka Bydžovská, Vojtěch Lahoda, Milan Pech, Anna Pravdová. and Lucie Zadražilová, *Konec avantgardy? Od Mnichovské dohody ke komunistickému převratu*, Prague: Galerie hlavního města Prahy/Arbor Vitae, 2011, 254–26. This exhibition represents an important attempt to come to grips with the specificity of Czech art in the fraught period between the Munich Agreement of 1938 and the KSČ "Victorious February" coup of 1948.

174. Františck Šmejkal, "Le groupe Ra," in Šmejkal, *Skupina Ra*, 149.

175. "Déclaration Internationale," *Bulletin International du Surréalisme Révolutionaire*, Brussels, January 1948, in *Le Surréalisme Révolutionnaire*, 1999 facsimile reprint, 1.

176. Noël Arnaud, "Le surréalisme-révolutionnaire dans la lutte idéologique: vers un surréalisme scientifique," *Bulletin International du Surréalisme Révolution-naire*, 3–4.

177. Roger Vailland, *Le Surréalisme contre la Révolution*, Brussels: Éditions Complexes, 1988. The quotations are from pp. 56, 77, 61, 78, 79–80, 82–83, 85, and 94.

178. Letter of 29 February 1949, quoted in Srp, *Adolf Hoffmeister*, 345.

179. See Olivier Todd, "Préface. Vailland, la littérature et l'engagement," in Vailland, *Le Surréalisme contre la révolution*, 9–27.

180. *Mezinárodní surrealismus, 30. (410.) výstava Topičova salonu od 4. listopadu do 3. prosince 1947*, Prague: Topičův salon, 1947.

181. A number of younger writers and artists—some of them Skupina Ra veterans—including Vratislav Effenberger, Václav Tikal, Karel Hynek, Josef Istler, Mikoláš Medek, Emila Medková, and Libor Fára, regrouped themselves around Karel Teige after 1948. They compiled ten issues of a *samizdat* anthology entitled *Signs of the Zodiac* (*Znamení zvěrokruhu*) in 1951, the year of Teige's death. Surrealism remained a vital though largely clandestine movement in Czechoslovakia throughout the communist period, publicly resurfacing when conditions allowed—notably in the mid-1960s. See here Marie Langerová, Josef Vojvodík, Anja Tippnerová, and Josef Hrdlička, *Symboly obludnosti: mýty, jazyk a tabu české postavantgardy 40.–60. let*, Prague: Malvern 2009; this contains a facsimile of the catalogue of

the important 1966 Prague exhibition *Symboly obludnosti* (Symbols of Monstrosity). Dvorský, Effenberger, and Král, *Surrealistické východisko 1938–1968*, is an invaluable anthology of (mostly) postwar Czech surrealist writings. For background and translation of some key texts, see Král, *Le Surréalisme en Tchécoslovaquie* and the six-part "Anthology of Czech and Slovak Surrealism" in *Analogon*, 37, 38/39, 40, and 41/42, 2003–4, and 43 and 44–45, 2005. Spieler and Auer, *Gegen jede Vernunft*, is unusual among western secondary literature in devoting considerable space to postwar Czech surrealist artists.

182. André Breton, "Second Ark," in *Free Rein*, 99–101, translation slightly modified.

183. Záviš Kalandra, "Nadskutečno v surrealismu," in *Surrealismus v diskusi*, Prague: J. Prokopová, 1934, 84–93.

184. Záviš Kalandra, "Mácha a Palacký," in *Ani labuť ani Lůna: sborník k stému výročí K. H. Máchy*, ed. Vítězslav Nezval, Prague: O. Jirsák, 1936; reprint, Prague: Společnost Karla Teige/Concordia, 1995, 44–62.

185. André Breton, "Lettre ouverte à Paul Éluard," 13 June 1950, in ABOC 3, 896–98. The text is translated in full in *Free Rein*, 229–31.

186. Éluard's reply is given as a footnote to Breton's "Lettre ouverte," in ABOC 3, 898.

187. Milan Kundera, *The Book of Laughter and Forgetting*, 94–95.

188. Quoted in Bedřich Utitz, *Neuzavřená kapitola: politické procesy padesátých let*, Prague: Lidové nakladatelství, 1990, 114. The individual indictments, which repeatedly use the phrase *židovského původu* (of Jewish origin), also give class origin (and thus wherever possible establish a correlation of Jewish and bourgeois). Utitz reproduces them, pp. 16–17. I have translated them more fully in my article "A Quintessential Czechness."

189. "In the Penal Colony," in *Franz Kafka: The Complete Stories*.

190. Jiří Mucha, *Living and Partly Living*, 109.

191. According to the chronology in PEOC, I, lxxv, Éluard was in Prague from 17 April 1950 but went on to Sofia and Moscow, where he celebrated May Day; Kalandra was executed on 27 June.

192. Paul Éluard, "La Poesie de circonstance," *La Nouvelle Critique*, April 1952, in PEOC 2, 941.

193. Georges Hugnet, "1870 to 1936," in Read, *Surrealism*, 220–21.

194. Vítězslav Nezval, *Ulice Gît-le-Coeur*, 25.

195. Vladimír Clementis to Lída Clementisová, 3 December 1952, in his *Nedokončená kronika*, Prague: Československý spisovatel, 1965, 182.

196. Alois Dušek, ed., *Příručka pro sběratele československých známek a celin*, Prague: Svaz československých filatelistů, 1988, 257.

197. Conversation between Toyen and Jindřich Toman, related in Toman, "The Hope of Fire, the Freedom of Dreams: Jindřich Heisler in Prague and Paris, 1938–1953," in Jindřich Toman and Mathew S. Witkovsky, *Jindřich Heisler: Surrealism under Pressure, 1938–1953*, Chicago: The Art Institute of Chicago/New Haven, CT: Yale University Press, 2012, 21.

198. Matthew S. Witkovsky, "Night Rounds: On the Photo-Poem from the Strongholds of Sleep," in ibid., 31.

199. Mojmír Grygar, "Teigovština—trostictická agentura v naší kultuře," *Tvorba*, Vol. 20, Nos. 42–44, October 1951. On Teige's death, see Seifert, *Všecky krásy světa*, 509–11.

200. Breton to Nezval, 25 March 1936, quoted in Angliviel de la Beaumelle, *André Breton: La beauté convulsive*, 226.

201. Annie Le Brun, "A l'instant du silence des lois," in *Štyrský, Toyen, Heisler*, 57. She is quoting from Štyrský's *Emily Comes to Me in a Dream*.

202. Personal conversation with the author.

203. Polizzotti, *Revolution of the Mind*, 404.

204. Suzanne Muzard, untitled 1974 text in Marcel Jean, *Autobiography of Surrealism*, 190, translation revised after Polizzotti, *Revolution of the Mind*, 362.

205. Caillois to André Breton, 27 December 1934, in his *Edge of Surrealism*, 85.

206. Baudelaire, "Painter of Modern Life," 36–38.

207. André Breton, "Introduction to the Work of Toyen," in *What Is Surrealism?*, Book 2, 286–87.

208. Michel Foucault, "André Breton: A Literature of Knowledge," interview with Claude Bonnefoy, *Arts-Loisirs*, 5 October 1966, translated in *Foucault Live: Collected Interviews, 1961–1984*, ed. Sylvère Lotringer, New York: Semiotext(e), 1996, 11.

209. Personal observation. The painting is reproduced in Coron, *Šíma/Le Grand Jeu*, 104.

210. Benjamin, *Arcades Project*, 464.

211. See Musil, *Moderní galerie tenkrát 1902–1942*.

212. Sedláková, *Jak fénix: minulost a přítomnost Veletržního paláce v Praze*.

213. *The Green Guide: Prague*, Watford, UK: Michelin Travel Publications, 2000, 214–15.

214. Rem Koolhaas, "Typical Plan," in *S, M, L, XL*, 243.

215. This and subsequent quotations are taken from W. G. Sebald, *Austerlitz*, New York: Knopf, 2001, 178–80.

216. Gwyneth Bravo, "Viktor Ullmann," Orel Foundation website, available at http://orelfoundation.org/index.php/composers/article/viktor_ullmann/, and Viktor Ullmann Foundation website, available http://www.viktorullmannfounda tion.org.uk/index.html (both accessed 7 May 2012).

217. Quoted at Jewish Virtual Library website, available at http://www.jewish virtuallibrary.org/jsource/biography/Winton.html (accessed 7 May 2012). See also Muriel Emanuel and Vera Gissing, *Nicholas Winton and the Rescued Generation*, London: Vallentine Mitchell, 2001.

218. Personal observation, 2009.

219. Sedláková, *Jak fénix*, contains an extract from Peroutka's *Oblák a valčík*, which describes Jews being brought "na shromadaždiště ve Veletržím paláce" (to the assembly point in Veletržní Palace) and passing the night in the palace under the glass roof before being woken by the gray light of dawn and marched off to Holešovice Station (24).

220. I allude here to the composer Steve Reich's work *Different Trains* (1988).

221. For an introduction to his work, see Kroutvor, *František Zelenka: plakáty, architektura, divadlo*.

222. See Norman Foster, *Rebuilding the Reichstag*, London: Weidenfeld and Nicholson, 2001, Ch. 1.

8. The Gold of Time

1. Walter Benjamin, "Paris, Capital of the Nineteenth Century. Exposé [of 1939]," in *The Arcades Project*, 26.

2. *Arts*, 5 October 1966, 5, 7, quoted in Polizzotti, *Revolution of the Mind*, 622.

3. Michel Foucault, "André Breton: A Literature of Knowledge," interview with Claude Bonnefoy, *Arts-Loisirs*, 5 October 1966, translated in Lotringer, *Foucault Live*, 10.

4. Aragon, "André Breton," *Lettres françaises*, 6 October 1966, 1, quoted in Polizzotti, *Revolution of the Mind*, 622–23.

5. Vítězslav Nezval, *Ulice Gît-le-Coeur*, 17.

6. *42 rue Fontaine: L'atelier d'André Breton*, text by Julien Gracq, photographs by Gilles Ehrmann, Paris: Adam Biro, 2003 (unpaginated). "The private individual, who in the office has to deal with realities, needs the domestic interior to sustain him in his illusions," wrote Walter Benjamin in "Paris, Capital of the Nineteenth Century"; "the interior is the asylum where art takes refuge. . . . The collector delights in evoking a world that is not just distant and long gone but also better—a world in which, to be sure, human beings are no better provided with what they need than in the real world, but in which things are freed from the drudgery of being useful." *Arcades*, 19.

7. The description that follows is based on the auction catalogue *André Breton: 42 rue Fontaine*, 8 vols. plus DVD, Paris: CalmelsCohen, 2003.

8. *André Breton: 42 rue Fontaine*, Vol. 3, *Manuscrits*, 201, lot 2275. The letter is dated 8 March 1947.

9. *33 koláží Breton Éluard Muzard*, Prague: Galerie Maldoror, 2004. This is a trilingual Czech-French-English edition, with a preface by Karel Srp.

10. Polizzotti, *Revolution of the Mind*, 394. Vítězslav Nezval specifically mentions "Salvador Dalí's William Tell" as hanging on the wall of Breton's apartment when he visited in 1935; see *Ulice Gît-le-Coeur*, 18.

11. Quoted in Polizzotti, *Revolution of the Mind*, 229.

12. *André Breton: 42 rue Fontaine*, Vol. 8, *Photographies*, 450, lot 5410.

13. Ibid., 167, lot 5153.

14. Ibid., 95, lot 5057.

15. *André Breton: 42 rue Fontaine*, Vol. 3, *Manuscrits*, 166, lots 2220 and 2221.

16. *André Breton: 42 rue Fontaine*. The DVD, unlike the printed catalogue, contains the full texts of correspondence and complete contents of photograph albums.

17. "Surrealist's treasures for sale," BBC News, 7 April 2003, available at http://news.bbc.co.uk/1/hi/world/europe/2924761.stm (accessed 7 May 2012).

18. "Surrealism for Sale," *New York Times*, Tuesday, 17 December 2001, Section E, 1.

19. *André Breton: 42 rue Fontaine*, Vol. 8, *Photographies*, 348, lot 5405.

20. Caption to Radovan Ivsic's photograph in *L'Archibras*, No. 1, April 1967, 21.

21. The artists shown in *The Pleasure Principle* were E. Baj, J. Benoit, J. Camacho, A. Cárdenes, A. Dax, G. der Kervorkian, F. De Sanctis, H. Ginet, K. Klaphek, R. Legard, Y. Laloy, W. Lam, R. Matta, J. Miró, M. Parent, F. Schröder-Sonnerstern,

J.-C. Silbermann, H. Télémacque, J. Terrossian, and Toyen. See Roman Dergam, "Selected Chronology," in "Anthology of Czech and Slovak Surrealism, III," *Analogon*, No. 40, 2004, xxxii; Dvorský, Effenberger, Král, and Šváb, "Prague aux couleurs du temps," *L'Archibras*, No. 6, December 1968, 9; and Durozoi, *History of the Surrealist Movement*, 640–42 and 763, note 58.

22. Dergam, "Chronology," in "Anthology of Czech and Slovak Surrealism, III," xxxii.

23. "La plateforme de Prague," *L'Archibras*, No. 5, 30 September 1968, 15.

24. Petr Král, *Le surréalisme en Tchécoslovaquie*, Paris: Gallimard, 1983, 28.

25. Král's long opening essay in *Le surréalisme en Tchécoslovaquie* is an extended discussion of the differences in sensibility between French and Czech surrealism, as well as between prewar and postwar Czech surrealism. Among other things he stresses the postwar Czech surrealists' antiromanticism, hostility to ideology, love of the erotic, sense of the absurd, and engagement with the trivia of the everyday. This is a surrealism that owes as much to the spirit of the good soldier Švejk as to anything emanating from Paris.

26. The photograph is reproduced in Miloslav Novotný, *Roky Aloisa Jiráska*, Prague: Melantrich, 1953, 413.

27. Novotný, *Roky Aloisa Jiráska*, 419.

28. Speech of 10 November 1948, in Novotný, *Roky Aloisa Jiráska*, 403. Gottwald is speaking specifically of what will be on display in the Jirásek Museum in Hvězda. The following year Orbis, later renamed SNKLHU (State Publishing House for Literature, Music, and Art), began publication of a 32-volume selected works titled *Jirásek's Legacy to the Nation*, which was billed as presenting "a complete chronological picture of the Czech past from mythological times, from old Czech legends up to the author's own times." Its first volume was *Staré pověstí české*. The standard print-run was 55,000 copies. Between 1953 and 1962, SNKLHU alone published an additional eighteen books by Jirásek outside the Legacy series. Between 1947 and 1953, five of his plays (*M. D. Rettigová, Lucerna, Jan Žižka, Vojnarka*, and *Samota*) were staged—*Lucerna* (The Lantern) in two different productions—at the National Theater, for a total of 632 separate performances. The Hussite trilogy *Jan Hus, Jan Žižka*, and *Jan Roháč* was put on by the Theater of the Czechoslovak Army in 1951–1952, and Karel Kovařovic's operatic setting of Jirásek's novel *The Dogheads* went through no fewer than four new productions at the National Theater between 1945 and 1962. This is the same Kovařovic whose hostility was largely responsible for keeping Leoš Janáček's modernist abominations off the same stage at the beginning of the century. *Jan Roháč* was filmed in 1947, *Temno* in 1950, *Staré pověstí české* in 1953, *Jan Hus* in 1955, *Jan Žižka* in 1956, and *Proti všem* in 1957. Information from Novotný, *Roky Aloisa Jiráska*; Zdenka Broukalová and Saša Mouchová, eds., *Bibliografický soupis knih vydaných SNKLU v letech 1953–1962*, Prague: SNKLU, 1964; and Hana Konečná, ed., *Soupis repertoáru Národního divalda v Praze*, 3 vols., Prague: Národní divadlo, 1983.

29. See *Výstava díla Mikoláše Alše*, ed. František Nečásek, Prague: Orbis, 1952; *Výstava díla Mikoláše Alše: seznam děl vystavených v Jízdárně pražského hradu*, ed. Emanuel Svoboda and František Dvořák, Prague: Orbis, 1952; and *M. Aleš: výstava jeho života a díla pro českou knihu a divadlo*, ed. V. V. Štech and Emanuel Svoboda,

Prague: Národní muzeum, 1952. I have discussed the KSČ's use of Jirásek, Aleš, and other nineteenth-century figures at greater length in *Coasts*, Ch. 7, and "A Quintessential Czechness."

30. František Nečásek, "V Alšově jubilejním roce," in Nečásek, *Výstava díla Mikoláše Alše*, 13–14.

31. Vratislav Effenberger, "Variants, Constants, and Dominants of Surrealism," in "Anthology of Czech and Slovak Surrealism IV," *Analagon*, 41/41, 2004, iii–ix.

32. *Analogon* 1/1, *Krise vědomí*, Prague: Československý spisovatel, June 1969. A "second edition" (reprint) of 100 numbered copies was published in Prague by Surrealistická galerie Gambra sometime in the early 1990s, which is unfortunately undated.

33. "Le plateforme de Prague," *L'Archibras*, No. 5, September 1968, 11–15. Most of the text is translated into English as "The Platform of Prague" in "Anthology of Czech and Slovak Surrealism, III," in *Analagon*, No. 40, 2003, xxiv–xxix. Stanislav Dvorský, Vratislav Effenberger, Roman Erben, Zbyněk Havlíček, Jaroslav Hrstka, Bohuslav Kováč, Petr Král, Ivo Medek, Juraj Mojžiš, Ivana Spanlangová, Martin Stejskal, Ivan Sviták, Karel Sebek, Ludvík Šváb, and Prokop Voskovec are among the Czech signatories listed. So is Toyen.

34. "Réalité politique et réalité policière, *L'Archibras*, No. 5, 1968, 1.

35. Others who fled included Stanislav Dvorský, Ivana Spanlangová, Ludvík Šváb, and Prokop Voskovec, all of whom, unlike Král, returned home to Czechoslovakia within a few months. "Chronologický přehled," *Analogon*, 41/42, 2004, I. Appropriately—if very belatedly—Stanislav Dvorský and Martin Stejskal would get to organize a retrospective of postwar Czech surrealism at (of all places) Hvězda Castle, now under the control of the Museum of National Literature (Památník národního písemnictví), in the summer of 2011. See the exhibition website "Surrealistická východiska 1948–1989," available at http://www.surrealismus.cz/vychod iska/index.html (accessed 14 May 2012).

36. "On n'arrête pas le printemps," *L'Archibras*, No. 5, 1968, 4.

37. Dvorský, Effenberger, Král, and Šváb, "Prague aux couleurs du temps," *L'Archibras*, No. 6, 1968, 6–9.

38. See "The Possible against the Real," in "Anthology of Czech and Slovak Surrealism IV," *Analogon*, 41/42, 2004, x–xii. This text was a response to the quarrels among surrealists in Paris. Jean Schuster's announcement of the dissolution of the surrealist group in *Le Quatrième Chant*, published in *Le Monde* on October 4, 1969, had been challenged by Jean-Louis Bédouin, Vincent Bounoure, Jorge Camacho, and others, who would endeavor to revive an organized surrealist movement around the short-lived periodicals *Bulletin de liaison surréaliste* and *Surréalisme*. For background, see Durozoi, *History of the Surrealist Movement*, 640–44. The Czechs sided with Schuster's critics, arguing that "surrealism, placing the possible in opposition to the real, is an inspiring medium, renewing, in the most concrete way, human consciousness" (xii). "The possible against the real" was dated 22 September 1969 and signed "Stanislav Dvorský, Vratislav Effenberger, Roman Erben, Andy Lass, Albert Marenčin, Juraj Mojžiš, Martin Stejskal, Ludvík Sváb and others." Most of these had been signatories to the Prague Platform.

39. Durozoi, *History of the Surrealist Movement*, 642.

40. Adrien Dax, "Essai de reconstitution d'un trajet visual associative au cours d'une observation distraite de la place avoissinant la vielle horologe de Prague, le vendredi 12 avril 1968 vers 15 heures," *L'Archibras*, No. 7, March 1969, 36–37.

41. Letter of 19 July 1949 dissolving the society, copy in City of Prague archive, reproduced on SVU Mánes website, available at http://www.svumanes.cz/spis.html (accessed 7 May 2012).

42. See SVU Mánes website, available at http://www.svumanes.cz/ospolku .html (accessed 7 May 2012).

43. Vlado Milunić, "View into the Black Kitchen," March 1991, in Frank Gehry and Vlado Milunić, *The Dancing Building*, ed. Irena Fialová, Prague: Zlatý Řez, and Rotterdam: Prototype Editions, 2003, 46.

44. Vlado Milunić, "Technical Report," September 1990, in Gehry and Milunić, *Dancing Building*, 44.

45. On the history of the site, see the introductory essays by Rostislav Švácha and Irena Fialová in Gehry and Milunić, *Dancing Building*. The source given on Nebesář, who was rehabilitated in 1969, is his grandson Ivo Vlček.

46. Quoted in Gehry and Milunić, *Dancing Building*, 156.

47. Kenneth Frampton, "A Modernity Worthy of the Name," in Anděl, *Art of the Avant-Garde in Czechoslovakia*, 213–31.

48. Josef Pažout, *Večerní Praha,* 29 April 1996, quoted in Gehry and Milunić, *Dancing Building*, 152.

49. Frank Gehry, *Gehry Talks: Architecture and Process*, ed. Mildred Friedman, New York, Rizzoli, 1999, 207.

50. Julius Fučík coined the phrase as the title of his book of reportage on the Soviet Union, *V zemi, kde zítra již znamená včera*, published in Prague in 1932.

51. Zdeněk Hojda and Jiří Pokorný, *Pomníky a zapomníky*, Prague: Paseka, 1997.

Bibliography

ABBREVIATIONS

ABOC. Breton, André. *Oeuvres complètes*. 4 volumes. Ed. Marguerite Bonnet. Paris: Gallimard, 1988, 1992, 1999, 2008.

AZN. *Avantgarda známá a neznámá*. 3 volumes. Ed. Štěpán Vlašín. Vol. 1, *Od proletářského umění k poetismu 1920–1924*. Vol. 2, *Vrchol a krise poetismu 1925–1928*. Vol. 3, *Generační diskuse 1929–1931*. Prague: Svoboda, 1969–72.

Coasts. Sayer, Derek. *The Coasts of Bohemia: A Czech History*. Princeton, NJ: Princeton University Press, 1998.

DJS. Seifert, Jaroslav. *Dílo Jaroslava Seiferta*. Vols. 1 and 2. Prague: Akropolis, 2001.

KTD. Teige, Karel. *Výbor z díla*. 3 volumes. Ed. Jiří Brabec, Vratislav Effenberger, Květoslav Chvatík, and Robert Kalivoda. Vol. 1, *Svět stavby a básně: studie z 20. let*. Vol. 2, *Zápasy o smysl moderní tvorby: studie z 30. let*. Vol. 3, *Osvobozování života a poesie: studie z 40. let*. Prague: Československý spisovatel, 1966, 1969, and Aurora/Český spisovatel, 1994, respectively.

PEOC. Éluard, Paul. *Oeuvres complètes*. 2 volumes. Ed. Marcelle Dumas and Lucien Scheler. Paris: Gallimard, 1968, 1996.

Torst Surrealist Reprints. *Zvěrokruh 1/Zvěrokruh 2/Surrealismus v ČSR/Mezinárodní bulletin surrealismu/Surrealismus*. Facsimile reprint in 1 volume. Prague: Torst, 2004.

PERIODICALS, JOURNALS, MAGAZINES, YEARBOOKS

391. Ed. Francis Picabia. Barcelona, New York, Zurich, Paris: 1917–24. 19 numbers. Facsimile reprint. Ed. Michel Sanouillet. Paris: La Terrain Vague, 1960.

Almanach Kmene (Kmen Almanac). Various editors. 12 volumes. Prague: 1930–37.

Almanach královského hlavního města Prahy (Almanac of the Royal Capital City Prague). Annual volumes. Prague, 1898 onward.

Almanach na rok 1914 (Almanac of the Year 1914). Ed. Josef Čapek. Prague: Přehled, 1913.

Almanach secese (Almanac of the Secession). Ed. S. K. Neumann. Prague: 1896.

Analogon. No. 1, ed. Vratislav Effenberger, Prague: 1969. "Second edition" (facsimile reprint), Prague: Surrealistická galerie Gambra, n.d. (early 1990s). The magazine was revived in 1990 and has published several issues a year since.

L'Archibras. Ed. Jean Schuster. 7 issues. Paris: 1967–69.

Avantgarda (Avant-Garde). 2 volumes. Prague: 1925–26.

Bulletin international du surréalisme/Mezinárodní bulletin surrealismu. Issue 1, 1935, in Torst Surrealist Reprints. This was the first of four issues published from Prague, Tenerife, Brussels, and London, respectively, in 1935–36.

Bulletin international du surréalisme révolutionnaire. Brussels: January 1948. With *Le Surréalisme Révolutionnaire*, 1999 reprint.

Červen (June). Ed. Michal Kácha and S. K. Neumann. 4 volumes. Prague: F. Borový, 1918–21.

Československá fotografie (Czechoslovak Photography). Ed. Augustin Škarda et al. 8 volumes. Prague: SČKFA, 1931–38.

Disk. Ed. Artuš Černík. 2 volumes. Prague and Brno: 1923, 1925.

Doba: Časopis pro kulturní, sociální i politický život (Time: A Magazine for Cultural, Social, and Political Life). Ed. Karel Teige. 1 volume. Prague: Lubomír Linhart, 1934–35.

Documents. Ed. Georges Bataille. 2 volumes. Paris: 1929–30. Facsimile reprint, Paris: Jean-Michel Place, 1991.

Erotická revue (Erotic Review). Ed. Jindřich Štyrský. 3 volumes. Prague: Edice 69, 1930–33. Reprint, Prague: Torst, 2001.

G: Material zur elementaren Gestaltung. Ed. Hans Richter. 5 issues. Berlin: 1923–26. Facsimile reprint in English translation by Steven Lindberg with Margareta Ingrid Christian. In *G: An Avant-Garde Journal of Art, Architecture, Design, and Film, 1923–26.* Ed. Detlef Martins and Michael W. Jennings. Los Angeles: Getty Research Institute and London: Tate, 2010.

Le Grand Jeu. Ed. Roger Gilbert-Lecomte, René Daumal, Josef Šíma, and Roger Vailland. 4 volumes. Paris: 1928–32. Facsimile reprint, Paris: Jean-Marcel Place, 1977.

Levá fronta (Left Front). Ed. Ladislav Štoll. 3 volumes. Prague: Levá fronta, 1930–33.

Literární kurýr Odeonu (Odeon Literary Courier). Ed. Jindřich Štyrský. 1 volume. Prague: Jan Fromek, 1929–31.

Magazín Družstevní práce (Družstevní Práce Magazine). Ed. Josef Cerman. 4 volumes. Prague: Družstevní práce, 1933–37.

Milostný almanach Kmene (Kmen Lovers' Almanac). Ed. Libuše Voková, art direction Toyen. Prague: Spring 1933.

Minotaure. Ed. Albert Skira and others. 3 volumes. Paris: Skira, 1933–39. Facsimile reprint, Geneva: Skira, 1981.

Moderní revue (Modern Review). Ed. Arnošt Procházka. 40 volumes. Prague, 1894–1925.

Musaion. Prague: Aventinum, 1920–31. Vols. 1 (1920) and 2 (1921) ed. Karel Čapek; later editions (1923–28) published as monographs dedicated to individual artists; two subsequent volumes (1929–30) reverted to magazine format, ed. František Muzika and Otakar Štorch-Marien.

Obliques. No. 14–15 (special issue) on "La Femme surréaliste." Ed. Roger Borderie. Paris: 1977.

Pásmo (Zone). Ed. Artuš Černík. 2 volumes. Brno: US Devětsil, 1924–26.

Přítomnost (The Present). Ed. Ferdinand Peroutka. 15 volumes. Prague: 1924–38.

Proletcult. Ed. S. K. Neumann. 2 volumes. Prague: 1922–24.

ReD (Revue Devětsilu) (Devětsil Review). Ed. Karel Teige. 3 volumes. Prague: US Devětsil, 1927–31.

Reflektor (Headlight). Ed. S. K. Neumann, Bohumil Šafář, and Jaroslav Seifert. 3 volumes. Prague: Melantrich, 1925–27.

Revoluční sborník Devětsil (*Devětsil Revolutionary Miscellany*). Ed. Karel Teige and Jaroslav Seifert. Prague: Večernice V. Vortel, 1922.

La Révolution surréaliste. Ed. Pierre Naville and Benjamin Péret (1–3), André Breton (4–12). 12 issues. Paris: 1924–29. Facsimile reprint, Paris: Jean-Michel Place, 1975.

Rozpravy Aventina (Aventinum Debates). Ed. Otakar Štorch-Marien. 6 volumes. Prague: Aventinum, 1925–31.

Simplicus (later *Der Simpl*). Prague: January 1934–July 1935.

Stavba (Construction). Ed. J. R. Marek, Karel Teige, Oldřich Starý, Jan E. Koula, et al. 14 volumes. Prague: Klub architektů, 1922–38.

Surréalisme. Ed. Ivan Goll. 1 issue. Paris: 1924. Facsimile reprint, Paris: Jean-Michel Place, 2004.

Le Surréalisme au service de la révolution. Ed. André Breton. 6 issues. Paris, 1930–33. Reprint, New York: Arno Press, n.d.

Le Surréalisme Révolutionaire. Ed. Noel Arnaud. 1 issue. March–April 1948. Reprint, Brussels: Didier Devillez, 1999.

Surrealismus (Surrealism). Ed. Vítězslav Nezval. 1 issue. Prague: 1936. In Torst Surrealist Reprints.

Světozor (World Outlook). Magazines under this title appeared intermittently from 1834 and continuously from 1899–1933 (Prague: Otto, 1899–1933). From 1933–38, the left-wing journalist Pavel Altschul owned the title.

Tvorba (Creation). Various editors including F. X. Šalda, Julius Fučík, and Kurt Konrád. 12 volumes. Prague: 1925–37.

Umělecký měsíčník (Artistic Monthly). Ed. Josef Čapek. 6 issues. Prague: 1911–12.

Variétés. Special issue, "Le Surréalisme en 1929." Ed. P.-G. Van Hecke. Brussels: June 1929. Reprint, Brussels: Didier Devillez Editeur, 1994.

Volné směry (Free Directions). Various editors. Prague: S.V.U. Mánes, 1896–1949.

VVV. Ed. David Hare. 4 issues. New York: 1942–44.

Žijeme (We Live). Ed. Josef Cerman. 2 volumes. Prague: Družstevní práce, 1931–32.

Život II: Sborník nové krásy (Life II: A Collection of New Beauty). Ed. Jaromír Krejcar. Prague: Umělecká beseda, 1922.

Zvěrokruh (Zodiac). Ed. Vítězslav Nezval. 2 issues. Prague: Studentské knikupectví, 1930. In Torst Surrealist Reprints.

Primary Texts: Collections and Anthologies

Ani labuť ani Lůna: sborník k stému výročí K. H. Máchy. Ed. Vítězslav Nezval. Prague: O. Jirsák, 1936. Reprint, Prague: Společnost Karla Teige/Concordia, 1995.

"Anthology of Czech and Slovak Surrealism." Parts 1–6. *Analogon*, Nos. 37–45, 2003–5.

The Autobiography of Surrealism. Ed. Marcel Jean. New York: Viking, 1980.

Avantgarda známá a neznámá. 3 volumes. Ed. Štěpán Vlašín. Vol. 1, *Od proletářského umění k poetismu 1920–1924.* Vol. 2, *Vrchol a krise poetismu 1925–1928.* Vol. 3, *Generační diskuse 1929–1931.* Prague: Svoboda, 1969–72. Abbreviated AZN.

The Bauhaus: Weimar Dessau Berlin Chicago. Ed. Hans M. Wingler. Cambridge, MA: MIT Press, 1993.

Between Worlds: A Sourcebook of Central European Avant-Gardes, 1910–1930. Ed. Timothy O. Benson and Eva Forgacs. Los Angeles: Los Angeles County Museum of Art/Cambridge, MA: MIT Press, 2002.

Black, Brown, and Beige: Surrealist Writings from Africa and the Diaspora. Ed. Franklin Rosemont and Robin D. G. Kelley. Austin: University of Texas Press, 2009.

České umění 1938–1989: programy, kritické texty, dokumenty. Ed. Jiří Ševčík, Pavlína Morganová, and Dagmar Dušková. Prague: Academia, 2001.

Dada. Ed. Rudolf Kuenzli. New York: Phaidon, 2006.

The Dada Painters and Poets: An Anthology. Ed. Robert Motherwell. 2d ed. Boston: G. K. Hall, 1981.

Dada Performance. Ed. and trans. Mel Gordon. New York: PAJ Publications, 1987.

Deset let Osvobozeného divadla. Ed. Josef Träger. Prague: Borový, 1937.

Dobrá zvěst: z cest za poznáním SSSR ve dvacátých a třicátých letech. Ed. Kateřina Blahynková and Martin Blahynka. Prague: Československý spisovatel, 1987.

Encyclopaedia Acephalica. Georges Bataille, Michel Leiris, Marcel Griaule, Carl Einstein, Robert Desnos, and other writers associated with the Acéphale and Surrealist Groups. Ed. Alastair Brotchie, trans. Iain White, Dominic Faccini, Annette Michelson, John Harman, and Alexis Lykiard. London: Atlas Press, 1995.

I Never Saw Another Butterfly: Children's Poems and Drawings from Terezín. Ed. Hana Volavková. New York: Schocken, 1993.

In Memory's Kitchen: A Legacy from the Women of Terezín. Ed. Cara De Silva. Northvale, NJ: Jason Aronson, 1996.

Investigating Sex: Surrealist Discussions 1928–1932. Ed. José Pierre, trans. Malcolm Imrie. New York: Verso, 1992.

The Jews of Bohemia and Moravia: A Historical Reader. Ed. Wilma Abeles Iggers. Detroit, MI: Wayne State University Press, 1992.

Le Corbusier kdysi a potom. Ed. Stanislav Kolíbal. Prague: Arbor Vitae, 2003.

Moderní revue 1894–1925. Ed. Otto M. Urban and Luboš Merhaut. Prague: Torst, 1995.

Naše umění v odboji. Ed. Miloslav Novotný. Prague: Evropský literární Klub, 1938.

Neuzavřená kapitola: politické procesy padesátých let. Ed. Bedřich Utitz. Prague: Lidové nakladatelství, 1990.

Osma a Skupina výtvarných umělců 1910–1917: teorie, kritika, polemika. Ed. Jiří Padrta. Prague: Odeon, 1992.

Pamětní list . . . k slavnosti položení základního kamene k Husovu pomníku. Prague: Spolek pro budování "Husova pomníku," 1903.

Photography in the Modern Era: European Documents and Critical Writings, 1913–1940. Ed. Christopher Phillips. New York: Metropolitan Museum of Art/Aperture, 1989.

Poetismus. Ed. Květoslav Chvatík and Zdeněk Pešat. Prague: Odeon, 1967.

Si vous aimez l'amour . . . Anthologie amoureuse du surréalisme. Ed. Vincent Gille and Annie Le Brun. Paris: Éditions Syllepse, 2001.

Surrealism. Ed. Herbert Read. New York: Harcourt, Brace, n.d. [1937].

Surrealism. Ed. Mary Ann Caws. New York: Phaidon, 2004.

Le Surréalisme en Tchécoslovaquie. Ed. Petr Král. Paris: Gallimard, 1983.

Surrealismus v diskusi. Prague: J. Prokopová, 1934.

Surrealistické východisko 1938–1968. Ed. Stanislav Dvorský, Vratislav Effenberger, and Petr Král. Prague: Československý spisovatel, 1969.

Surrealist Painters and Poets: An Anthology. Ed. Mary Ann Caws. Cambridge, MA: MIT Press, 2001.

Surrealists on Art. Ed. Lucy Lippard. Englewood Cliffs, NJ: Prentice-Hall, 1970.

Surrealist Women: An International Anthology. Ed. Penelope Rosemont. Austin: University of Texas Press, 1998.

Svému osvoboditeli Československý lid. Prague: Orbis, 1955.

The Tradition of Constructivism. Ed. Stephen Bann. New York: Viking, 1974.

Voices of German Expressionism. Ed. Victor H. Miesel. London: Tate, 2003.

Volné směry: časopis secese a moderny. Ed. Roman Prahl and Lenka Bydžovská. Prague: Torst, 1993.

Zajatec kubismu: dílo Emila Filly v zrcadle výtvarné kritiky 1907–1953. Ed. Tomáš Winter. Prague: Artefactum, 2004.

Za právo a stát: sborník dokladů o československé společné vůli k svobodě 1848–1918. Prague: Státní nakladatelství, 1928.

PRIMARY TEXTS: INDIVIDUAL AUTHORS

Apollinaire, Guillaume. *Apollinaire on Art: Essays and Reviews 1902–1918.* Ed. Leroy C. Breunig. New York: Viking, 1972.

Aragon, Louis. *Écrits sur l'art moderne.* Paris: Flammarion, 1981.

Baťa, Jan. *Budujme stát pro 40,000,000 lidí.* Zlín: Tisk, 1937.

Bataille, Georges. *The Absence of Myth: Writings on Surrealism.* Ed. and trans. Michael Richardson. London: Verso, 2006.

———. *Visions of Excess.* Ed. Allan Stoekl. Minneapolis: Minnesota University Press, 2004.

Baudelaire, Charles. *The Painter of Modern Life and Other Essays.* Trans. Jonathan Mayne. New York: Phaidon, 2005.

Bellmer, Hans. *Little Anatomy of the Physical Unconscious, or the Anatomy of the Image.* Trans. Jon Graham. Waterbury Center, VT: Dominion, 2004.

Benjamin, Walter. *The Arcades Project*. Ed. Roy Tiedemann, trans. Howard Eiland and Kevin McLaughlin. Cambridge, MA: Harvard University Press, 1999.

———. *Selected Writings*. 4 volumes. Various editors and translators. Cambridge, MA: Belknap Press of Harvard University Press, 1996–2003.

———. *Walter Benjamin's Archive*. Trans. Esther Leslie. London: Verso, 2007.

Breton, André. *Arcane 17: le manuscript original*. Ed. Henri Béhar. Paris: Biro, 2008.

———. *Arcanum 17*. Trans. Zack Rogow. Los Angeles: Sun and Moon Press, 1994.

———. *L'Art magique*. Paris: Éditions Phebus/Éditions Adam Biro, 1991.

———. *Communicating Vessels*. Trans. Mary Ann Caws and Geoffrey T. Harris. Lincoln: University of Nebraska Press, 1997.

———. *Free Rein*. Trans. Michel Parmentier and Jacqueline d'Amboise. Lincoln: University of Nebraska Press, 1995.

———. *The Lost Steps*. Trans. Mark Polizzotti. Lincoln: University of Nebraska Press, 1996.

———. *Mad Love*. Trans. Mary Ann Caws. Lincoln: University of Nebraska Press, 1987.

———. *Manifestoes of Surrealism*. Trans. Richard Seaver and Helen R. Lane. Ann Arbor: University of Michigan Press, 1972.

———. *Martinique: Snake Charmer*. Trans. David W. Seaman. Austin: University of Texas Press, 2008.

———. *Nadja*. Trans. Richard Howard. New York: Grove Press, 1960.

———. *Oeuvres complètes*. 4 volumes. Ed. Marguerite Bonnetl. Paris: Gallimard, 1988, 1992, 1999, 2008. Abbreviated ABOC.

———. *Position politique du Surréalisme*. Paris: Éditions du Sagittaire, 1935. Reprint, Paris: Société Nouvelle des Éditions Pauvert, 1971.

———. *Surrealism and Painting*. Trans. Simon Watson Taylor. Boston: Museum of Fine Arts, 2002.

———. *What Is Surrealism? Selected Writings*. Ed. Franklin Rosemont. New York: Pathfinder, 1978.

Breton, André, and Paul Éluard. *Dictionnaire abrégé du surréalisme*. Facsimile reprint of 1938 original. Paris: José Corti, 2005.

Caillois, Roger. *The Edge of Surrealism: A Roger Caillois Reader*. Ed. Claudine Frank. Durham, NC: Duke University Press, 2003.

Čapek, Josef. *Nejskromnější umění*. Prague: Dauphin, 1997.

———. *Umění přírodních národů*. Prague: Československý spisovatel, 1949.

Čapek, Karel. *The Gardener's Year*. Trans. Geoffrey Newsome. New York: Modern Library, 2002.

———. *Letters from England*. London: Continuum, 2004.

———. *Spisy*. Vol. 19, *O umění a kultuře* III. Prague: Československý spisovatel, 1986.

Dalí, Salvador. *La Femme visible*. Paris: Éditions surrealists, 1930.

———. *Oui: The Paranoid-Critical Revolution—Writings 1927–1933*. Ed. Robert Descharnes, trans. Yvonne Shafir. Boston: Exact Change, 1998.

Drtikol, František. *Oči široce otevřené*. Prague: Svět, 2002.

Éluard, Paul. *Oeuvres complètes*. 2 volumes. Ed. Marcelle Dumas and Lucien Scheler. Paris: Gallimard, 1968, 1996. Abbreviated PEOC.

Engels, Friedrich. "Democratic Pan-Slavism." In Karl Marx and Friedrich Engels, *Collected Works*, Vol. 8. New York: International Publishers, 1977.

Gutfreund, Otto. *Zázemí tvorby*. Prague: Odeon, 1989.

Hausmann, Raoul. *Courrier Dada*. Paris: Éditions Allia, 2004.

Havel, Václav. *Living in Truth*. London: Faber, 1989.

Jesenská, Milena. *The Journalism of Milena Jesenska: A Critical Voice in Interwar Central Europe*. Ed. and trans. Kathleen Hayes. New York: Berghahn Books, 2003.

———. *Zvenčí a zevnitř*. Prague: Nakladatelství Franze Kafky, 1996.

Kaprálová, Vítězslava. Draft analysis of *Military Sinfonietta*. In Karla Hartl, "Notes to the Catalogue." Available at http://www.kapralova.org/OPUS_NOTES .htm#iscm (accessed 10 May 2012).

Kisch, Egon Erwin. *Egon Erwin Kisch, the Raging Reporter: A Bio-anthology*. Ed. Harold B. Segel. West Lafayette, IN: Purdue University Press, 1997.

Král, Petr. *Prague*. Seyssel: Éditions du Champ Vallon, 1987.

Krejčí, František Václav, František Xaver Šalda, Josef Svatopluk Machar, Antonín Sova, Otakar Březina, Vilém Mrštík, and others. "Česká moderna." In F. X. Šalda, *Kritické projevy 2, 1894–1895, Soubor díla F. X. Šaldy*, Vol. 11. Prague: Melantrich, 1950.

Kundera, Milan. *The Art of the Novel*. Trans. Linda Asher. New York: Grove Press, 1988.

———. *Encounter*. Trans. Linda Asher. London: Faber and Faber, 2010.

———. *Testaments Betrayed*. Trans. Linda Asher. New York: HarperCollins, 1995.

Lacan, Jacques. *Écrits*. Trans. Bruce Fink. New York: Norton, 2007.

Le Corbusier. *Le Corbusier: Le Grand*. Introductions by Jean-Louis Cohen and Tim Benton. New York: Phaidon, 2008.

———. *The Radiant City: Elements of a Doctrine of Urbanism to Be Used as the Basis of Our Machine-Age Civilization*. Reprint, New York: Orion Press, 1964.

———. *Towards a New Architecture*. New York: BN Publishing, 2008.

Loos, Adolf. *Ornament and Crime: Selected Essays*. Riverside, CA: Ariadne Press, 1998.

Magritte, René. *Écrits complèts*. Paris: Flammarion, 2001.

Marinetti, F. T. *F. T. Marinetti: Critical Writings*. Ed. Günter Berghaus, trans. Doug Thompson. New York: Farrar, Straus and Giroux, 2006.

———. *F. T. Marinetti: Selected Poems and Related Prose*. Selected by Luce Marinetti, trans. Elizabeth R. Napier and Barbara R. Studholme. New Haven, CT: Yale University Press, 2002.

———. *The Futurist Cookbook*. Trans. Susan Brill. San Francisco: Bedford Arts, 1989.

Masaryk, Tomáš G. *Česká otázka*. Prague: Svoboda, 1990.

———. *Karel Havlíček*. 3d ed. Prague: Jan Laichter, 1920.

———. *Masaryk on Marx*. Lewisburg, PA: Bucknell University Press, 1972.

———. *The Meaning of Czech History*. Ed. René Wellek, trans. Peter Kussi. Chapel Hill: University of North Carolina Press, 1974.

Miller, Lee. *Lee Miller's War: Photographer and Correspondent with the Allies in Europe 1944–45*. Ed. Antony Penrose. London: Thames and Hudson, 2005.

Mucha, Alfons. *Slovanstvo bratrské/Fraternal Slavdom*. Prague: Gallery, 2005.

Nejedlý, Zdeněk. "Komunisté, dědici velkých tradic českého národa." In *Spisy Zdeňka Nejedlého*, Vol. 16, *O smyslu českých dějin*. Prague: Státní nakladatelství politické literatury, 1953.

Neruda, Jan. "Pro strach židovský." In his *Studie krátké a kratší*. Prague: L. Mazač, 1928.

Neumann, Stanislav Kostka. *Anti-Gide, nebo optimismus bez pověr a ilusí*. Prague: Svoboda, 1946.

Palacký, František. *Úvahy a projevy z české literatury, historie a politiky*. Prague: Melantrich, 1977.

Peroutka, Ferdinand. *Budeme pokračovat*. Toronto: Sixty-Eight Publishers, 1984.

Saint-Point, Valentine de. *Manifeste de la femme futuriste* (March 1912). Reprint, Paris: Mille et une nuits, 2005.

Škvorecký, Josef. "Bohemia of the Soul." *Daedalus*, Vol. 119, No. 1, 1990.

———. *Talkin' Moscow Blues: Essays about Literature, Politics, Movies, and Jazz*. Toronto: Lester and Orpen Dennys, 1988.

Štyrský, Jindřich. *Každý z nás stopuje svoji ropuchu: texty 1923–1940*. Prague: Thyrsus, 1996.

———. *Texty*. Prague: Argo, 2007.

———. *Život markyze de Sade*. Prague: Kra, 1995.

Štyrský, Jindřich, Toyen, and Vincenc Nečas. *Průvodce Paříží a okolím*. Prague: Odeon, 1927.

Sutnar, Ladislav. *Visual Design in Action*. New York: Hastings House, 1961.

Teige, Karel. *The Minimum Dwelling*. Trans. Eric Dluhosch. Cambridge, MA: MIT Press, 2002.

———. *Modern Architecture in Czechoslovakia and Other Writings*. Trans. Irena Zantovska Murray and David Britt. Los Angeles: Getty Research Institute, 2000.

———. *Svět, který se směje*. Prague: Odeon, 1928. Reprint, Prague: Akropolis, 2004.

———. *Svět, který voní*. Prague: Odeon, 1930. Reprint, Prague: Akropolis, 2004.

———. *Výbor z díla*. 3 volumes. Ed. Jiří Brabec, Vratislav Effenberger, Květoslav Chvatík, and Robert Kalivoda. Vol. 1, *Svět stavby a básně: studie z 20. let*. Vol. 2, *Zápasy o smysl moderní tvorby: studie z 30. let*. Vol. 3, *Osvobozování života a poesie: studie z 40. let*. Prague: Československý spisovatel, 1966, 1969, and Aurora/Český spisovatel, 1994, respectively. Abbreviated KTD.

Terragni, Giuseppe. "Building the Casa del Fascio in Como." In Peter Eisenman, *Giuseppe Terragni: Transformations, Deformations, Critiques*. New York: The Monacelli Press, 2003.

Vailland, Roger. *Le Surréalisme contre la Révolution*. Reprint, Brussels: Éditions Complexes, 1988.

Correspondence, Diaries, Memoirs, Interviews

Agar, Eileen. *A Look at My Life*. London: Methuen, 1988.

Apollinaire, Guillaume. *Lettres à Lou*. Paris: Gallimard, 1990.

———. *Lettres à Madeleine: tendre comme le souvenir*. Paris: Gallimard, 2005.

Ball, Hugo. *Flight Out of Time: A Dada Diary*. Ed. John Elderfield. Berkeley: California University Press, 1996.

Brassaï. *Conversations with Picasso*. Trans. Jane-Marie Todd. Chicago: University of Chicago Press, 2002.

Breton, André. *Conversations: The Autobiography of Surrealism*. Trans. Mark Polizzotti. New York: Marlowe, 1993.

———. *Lettres à Aube*. Ed. Jean-Paul Goutier. Paris: Gallimard, 2009.

Breton, Simone. *Lettres à Denise Levy 1919–1929*. Ed. Georgiana Colville. Paris: Éditions Joëlle Losfeld, 2005.

Brod, Max. *Život plný bojů*. Prague: Nakladetelství Franze Kafky, 1994.

Buñuel, Luis. *My Last Breath*. Trans. Abigail Israel. London: Fontana, 1985.

Čapek, Karel. *Hovory s T. G. Masarykem*. Spisy Karla Čapka, Vol. 20. Prague: Československý spisovatel, 1990.

Clementis, Vladimír. *Nedokončená kronika*. Prague: Československý spisovatel, 1965.

Cunard, Nancy. *These Were the Hours: Memories of My Hours Press, Réanville and Paris 1928–1931*. Carbondale: Southern Illinois University Press, 1969.

Duchamp, Marcel. *Dialogues with Marcel Duchamp*. Ed. Pierre Cabanne. London: Thames and Hudson, 1971.

Éluard, Paul. *Lettres à Gala 1924–1948*. Paris: Gallimard, 1984.

———. *Letters to Gala*. Trans. Jesse Browner. New York: Paragon House, 1989.

Ernst, Jimmy. *A Not-So-Still Life*. New York: St. Martin's/Marek, 1984.

Ernst, Max. "Biographical Notes." In *Max Ernst: Life and Work: An Autobiographical Collage*, ed. Werner Spies. London: Thames and Hudson, 2008.

———. "An Informal Life of M. E. (as told by himself to a young friend)." In *Max Ernst*. London: Arts Council of Great Britain, 1961.

Foucault, Michel. *Foucault Live: Collected Interviews, 1961–1984*. Ed. Sylvère Lotringer. New York: Semiotext(e), 1996.

Fučík, Julius. *Reportáž psaná na oprátce*. Prague: Torst, 1995.

Gehry, Frank. *Gehry Talks: Architecture and Process*. Ed. Mildred Friedman. New York: Rizzoli, 1999.

Havel, Václav M. *Mé vzpomínky*. Prague: Lidové noviny, 1993.

Höch, Hannah. Interview with Edouard Roditi. *Arts Magazine*, Vol. 34, No. 3, December 1959.

Janáček, Leoš, and Kamila Stösslová. *Intimate Letters: Leoš Janáček to Kamila Stösslová*. Ed. John Tyrell. Princeton, NJ: Princeton University Press, 1994.

Janouch, Gustav. *Conversations with Kafka: Notes and Reminiscences*. London: Derek Verschoyle, 1953.

Kafka, Franz. *The Diaries of Franz Kafka 1910–1923*. Ed. Max Brod, trans. Joseph Kresh (diaries 1910–13) and Martin Greenberg and Hannah Arendt (diaries 1914–23). London: Penguin, 1964.

———. *Dopisy rodičům z let 1922–1924*. Ed. Josef Čermák and Martin Svatoš. Prague: Odeon, 1990.

———. *Letters to Friends, Family and Editors*. Trans. Richard and Clara Winston. New York: Schocken, 1977.

———. *Letters to Milena*. Ed. and trans. Philip Boehm. New York: Schocken, 1990.

———. *Letters to Ottla and the Family*. Ed. N. N. Glazer, trans. Richard and Clara Winston. New York: Schocken, 1982.

Kaprálová, Vítězslava. Letters 1939–40, various dates. Reproduced in various issues of *Kapralova Society Newsletter* and *Kapralova Society Journal*, as identified in Notes.

Kokoschka, Oskar. *Oskar Kokoschka Letters 1905–1976*. Ed. Olda Kokoschka and Alfred Marnau. London: Thames and Hudson, 1992.

———. *My Life*. London: Thames and Hudson, 1974.

———. *A Sea Ringed with Visions*. London: Thames and Hudson, 1962.

Lamarr, Hedy. *Ecstasy and Me: My Life as a Woman*. London: W. H. Allen, 1967.

Lévi-Strauss, Claude. "New York in 1941." In his *The View from Afar*, trans. Joachim Neugroschel. Chicago: University of Chicago Press, 1992.

Lord, James. *Picasso and Dora: A Personal Memoir*. New York: Fromm International, 1993.

Mahler Werfel, Alma. *And the Bridge Is Love: Memories of a Lifetime*. Trans. E. B. Ashton. London: Hutchinson, 1959.

Martinů, Charlotte. *My Life with Martinů*. Trans. Diderik C. D. De Jong. Prague: Orbis, 1978.

Mucha, Jiří. *Au seuil de la nuit*. Trans. Françoise and Karel Tabery. La Tour d'Aigues: Éditions de l'aube, 1991.

———. *Living and Partly Living*. London: The Hogarth Press, 1967.

———. *Podivné lásky*. Prague: Mladá fronta, 1989.

Muchová (Mucha), Geraldine. Interview with Lucie Bartošová for *Lidové noviny*, November 2009. Transcript kindly supplied by Ms. Bartošová.

Němcová, Božena. *Z dopisů Boženy Němcové*. Ed. Jana Štefánková. Prague: Státní nakladatelství dětské knihy, 1962.

Nezval, Vítězslav. *Korespondence Vítězslava Nezvala: depeše z konce tisíciletí*. Prague: Československý spisovatel, 1981.

———. *Neviditelná Moskva*. Prague: Borový, 1935.

———. *Pražský chodec*. Prague: Borový, 1938.

———. *Ulice Gît-le-Coeur*. Prague: Borový, 1936.

———. *Z mého života*. Prague: Československý spisovatel, 1959.

Novotná, Jarmila. *Byla jsem šťastná*. Prague: Melantrich, 1991.

———. Interview, June 1979. In Lanfranco Rasponi, *The Last Prima Donnas*. New York: Limelight Editions, 1985.

Ray, Man. *Self-Portrait*. New York: Little, Brown, 1998.

Sanouillet, Michel. *Dada in Paris*. Enlarged by Anne Sanouillet, trans. Sharmila Ganguly. Cambridge, MA: MIT Press, 2009. Contains correspondence between Breton, Tzara, and Picabia.

Seifert, Jaroslav. *Všecky krásy světa*. Prague: Československý spisovatel, 1992.

Štorch-Marien, Otakar. *Paměti nakladatele*. 3 volumes. Vol. 1, *Sladko je žít*. Vol. 2, *Ohňostroj*. Vol. 3, *Tma a co bylo potom*. Prague: Aventinum 1992 (2d ed.) and Československý spisovatel, 1969, 1972.

Straus-Ernst, Lou. *The First Wife's Tale*. New York: Midmarch Arts Press, 2004.

Sudek, Josef. *Josef Sudek o sobě*. Ed. Jaroslav Anděl. Prague: Torst, 2001.

Thirion, André. *Revolutionaries without Revolution*. Trans. Joachim Neugroschel. New York: Macmillan, 1975.

Vondráčková, Jaroslava. *Kolem Mileny Jesenské*. Prague: Torst, 1991.

Novels, Poetry, Literary Works

Apollinaire, Guillaume. *Alcools*. Ed. and trans. Donald Revell. Hanover, NH, and London: Wesleyan University Press, 1995.

———. *Alkoholy*. Trans. Zdeněk Kalista. Prague: Edice Pásmo, 1935.

———. *Alkoholy života*. Ed. Adolf Kroupa and Milan Kundera. Prague: Československý spisovatel, 1965.

———. *Básně*. Trans. K. Čapek, J. Hořejší, Z. Kalista, and J. Seifert, preface by Karel Teige. Prague: Ústřední dělnické knihupectví a nakladatelství, 1935.

———. *Calligrammes: Poems of Peace and War 1913–1916*. Trans. Anne Hyde Geet. Berkeley: University of California Press, 1991.

———. *Oeuvres en prose complètes*, Vol. 1. Paris: Gallimard, 1977.

———. *Oeuvres poétiques*. Paris: Gallimard, 1965.

———. *The Wandering Jew and Other Stories*. Trans. Rémy Inglis Hall. London: Rupert Hart-Davis, 1967.

Apollinaire, Guillaume, and Louis Aragon. *Flesh Unlimited: Surrealist Erotica*. Trans. Alexis Lykiard. New York: Creation Books, 2000. Contains Apollinaire's *Les Onze mille verges* and Aragon's *Le Con d'Irène*.

Aragon, Louis, Benjamin Pérct, and Man Ray. *1929*. Reprint, Paris: Éditions Allia, 2004.

Arnold, Matthew. "Dover Beach." Available at http://www.victorianweb.org/authors/arnold/writings/doverbeach.html (accessed 10 May 2012).

Bataille, Georges. *The Story of the Eye*. Trans. Joachim Neugroschel. San Francisco: City Lights, 1987.

Biebl, Konstantín. *S lodí jež dováží čaj a kávu*. In his *Cesta na Jávu*. Prague: Labyrint, 2001.

Breton, André. *Anthology of Black Humor*. Trans. Mark Polizzotti. San Francisco: City Lights, 1997.

———. *Constellations*. Ed. Paul Hammond. San Francisco: City Lights Books, 2000.

———. *Earthlight*. Trans. Bill Zavatsky and Zack Rogow. Los Angeles: Sun & Moon Press, 1993.

———. *Poems of André Breton: A Bilingual Anthology*. Trans. and ed. Jean-Pierre Cauvin and Mary Ann Caws. Boston: Black Widow Press, 2006.

Čapek, Karel. *Francouzská poezie. Spisy*, Vol. 24. Prague: Český spisovatel, 1993.

———. *R.U.R.* Trans. Paul Selver. New York: Washington Square Press, 1973.

Chatwin, Bruce. *Utz*. London: Picador, 1989.

D'Angoulême, Marguerite. *Heptameron novel*. Prague: Družstevní práce, 1932.

Desnos, Robert. *Essential Poems and Writings of Robert Desnos*. Ed. Mary Ann Caws. Boston: Black Widow Press, 2007.

Eliot, T. S. *Collected Poems 1909–1962*. London: Faber, 1974.

———. *The Four Quartets*. London: Faber, 1983.

———. *Inventions of the March Hare: Poems 1909–1917*. Ed. Christopher Ricks. New York: Harcourt Brace, 1996.

Éluard, Paul. *Capital of Pain*. Trans. Mary Ann Caws, Patricia Terry, and Nancy Kline. Boston: Black Widow Press, 2006.

———. *Last Love Poems of Paul Éluard*. Trans. Marilyn Kallet. Boston: Black Widow Press, 2006.

———. *A Moral Lesson*. Trans. Lisa Lubasch. Copenhagen and Los Angeles: Green Integer Books, 2007.

———. *Poesie et Verité 1942/Poetry and Truth 1942*. Trans. Roland Penrose and E.L.T. Mesens. London: London Gallery Editions, 1944.

———. *Voir*: *Poèmes Peintures Dessins*. Geneva and Paris: Éditions des Trois Collines, 1948.

Hašek, Jaroslav. *The Good Soldier Švejk*. Trans. Cecil Parrott. London: Penguin, 1973.

Heisler, Jindřich. *Z kasemat spánku*. Ed. František Šmejkal, Karel Srp, and Jindřich Toman. Prague: Torst, 1999.

Hrabal, Bohumil. *I Served the King of England*. Trans. Paul Wilson. London: Picador, 1990.

———. *Too Loud a Solitude*. Trans. Michael Henry Heim. New York: Harcourt Brace Jovanovich, 1990.

Jirásek, Alois. *Legends of Old Bohemia*. Trans. Edith Pargeter. London: Hamlyn, 1963.

———. *Staré pověstí české*. Prague: Papyrus, 1992.

Kafka, Franz. *The Castle*. Trans. J. A. Underwood. London: Penguin, 1997.

———. *Dearest Father: Stories and Other Writings*. Trans. Ernst Kaiser and Eithne Wilkins. New York: Schocken, 1954.

———. *Franz Kafka: The Complete Stories*. Ed. Nahum N. Glatzer. New York: Schocken, 1995.

———. *The Trial*. Trans. Breon Mitchell. New York: Schocken, 1999.

Klíma, Ivan. *Love and Garbage*. Trans. Ewald Osers. New York: Vintage, 1993.

Kundera, Milan. *The Book of Laughter and Forgetting*. Trans. Michael Henry Heim. London: Penguin, 1986.

———. *The Joke*. Trans. Michael Henry Heim. London: Penguin, 1984.

———. *Life Is Elsewhere*. Trans. Peter Kussi. London: Penguin, 1986.

———. *Poslední máj*. 2d ed. Prague: Československý spisovatel, 1961.

———. *The Unbearable Lightness of Being*. Trans. Michael Henry Heim. New York: HarperCollins, 1991.

Lautréamont, Comte de [Ididore Ducasse]. *Maldoror and the Complete Works of the Comte de Lautréamont*. Trans. Alexis Lykiard. Cambridge, MA: Exact Change, 1994.

Lewis, C. S. *The Lion, the Witch and the Wardrobe*. New York: HarperCollins, 1994.

Mácha, Karel Hynek. *May*. Trans. Marcela Sulak. Prague: Twisted Spoon Press, 2005.

Mehrink, Gustav. *The Golem*. Ed. E. F. Bleiler. New York: Dover, 1976.

Musil, Robert. *A Man without Qualities*. 3 volumes. New York: Vintage, 1996.

Němcová, Božena. *Babička*. Illustrated by Václav Špála. Prague: Aventinum, 1923.

Neruda, Jan. *Prague Tales*. Budapest, London, New York: Central European University Press, 2003.

Nezval, Vítězslav. *Abeceda*. Prague: Otto, 1926. Facsimile reprint, Prague: Torst, 1993.

———. *Alphabet*. Ed. and trans. Jindřich Toman and Matthew S. Witkovsky. Ann Arbor: Michigan Slavic Publications, 2001.

———. *Antilyrik and Other Poems*. Trans. Jerome Rothenberg and Milos Sovak. Copenhagen and Los Angeles: Green Integer, 2001.

———. *Edison*. Trans. Ewald Osers. Prague: Dvořák, 2003.

———. *Pantomima: poesie*. Prague: Ústřední studentské knikupectví a nakladatelství, 1924. Reprint, Prague: Akropolis, 2004.

———. *Prague with Fingers of Rain*. Trans. Ewald Osers. Tarset: Bloodaxe Books, 2009.

———. *Praha s prsty deště*. Prague: Borový, 1936.

———. *Sbohem a šáteček: básně z cesty*. Prague: Borový, 1934. Reprint, Prague: Československý spisovatel, 1961.

———. *Sexuální nocturno: příběh demaskované iluse*. Prague: Edice 69, 1931. Reprint, Prague: Torst, 2001.

———. *Žena v množném čísle*. Prague: Borový, 1936.

Nezval, Vítězslav, and Jindřich Štyrský. *Edition 69*. Trans. Jed Slast. Prague: Twisted Spoon Press, 2004. Contains Nezval's *Sexual Nocturne* and Štyrský's *Emily Comes to Me in a Dream*.

Osers, Ewald, ed. and trans. *Three Czech Poets*. London: Penguin, 1971.

Owen, Wilfred. *The Collected Poems of Wilfred Owen*. Ed. C. Day Lewis. London: Chatto & Windus, 1963.

Proust, Marcel. *The Way by Swann's* (Vol. 1 of *In Search of Lost Time*). Trans. Lydia Davis. London: Allen Lane, 2002.

Sade, Markýz [Marquis] de. *Justina čili prokletí ctnosti*. Reprint of original 1932 edition, illustrated by Toyen. Prague: Torst, 2003.

Sebald, W. G. *Austerlitz*. New York: Knopf, 2001.

Seifert, Jaroslav. *Dílo Jaroslava Seiferta*, Vols. 1 and 2. Prague: Akropolis, 2001. Abbreviated DJS.

———. *The Early Poetry of Jaroslav Seifert*. Trans. Dana Loewy. Evanston, IL: Northwestern University Press, 1997.

———. *Osm dní*. 2d ed. Prague: Československý spisovatel, 1968.

Shelley, Mary. *Frankenstein: Or, the Modern Prometheus*. London: Penguin, 2004.

Skelton, Robin, ed. *Poetry of the Thirties*. London: Penguin, 1964.

Stoppard, Tom. *Lord Malquist and Mr. Moon*. London: Faber, 1986.

Štyrský, Jindřich. *Emilie přikází k mně ve snu*. Prague: Edice 69, 1933. Reprint, Prague: Torst, 2001. Also trans. in Nezval and Štyrský, *Edition 69*.

———. *Poesie*. Prague: Argo, 2003.

———. *Sny*. Prague: Odeon, 1970.

Topol, Jáchym. *Výlet k nádražní hale*. Brno: Petrov, 1995.

Toyen. *Specters of the Desert*. Chicago: Black Swan Press, 1974.

Updike, John. *Collected Poems 1953–1993*. New York: Knopf, 1997.

Vaculík, Ludvík. *A Cup of Coffee with My Interrogator: The Prague Chronicles of Ludvík Vaculík*. Trans. George Theiner. New York: Readers International, 1987.

Weil, Jiří. *Colors*. Trans. Rachel Harrell. Ann Arbor: Michigan Slavic Publications, 2002.

Wolker, Jiří. *Svatý Kopeček*. Prague: Československý spisovatel, 1960.

Exhibition Catalogues

Adolf Hoffmeister. Ed. Karel Srp. Prague: Gallery, 2004.

Adolf Loos—dílo v českých zemích/Adolf Loos—Works in the Czech Lands. Maria Szadowska, Leslie Van Duzer, and Dagmar Černoušková. Prague: Galerie hlavního města Prahy, 2009.

Alfons Mucha: Das slawische Epos. Ed. Karel Srp. Krems: Kunsthalle, 1994.

Amazons of the Avant-Garde: Alexandra Exter, Natalia Goncharova, Liubov Popova, Olga Rozanova, Varvara Stepanova, and Nadezhda Udaltsova. Ed. John E. Bowlt and Matthew Drutt. New York: Guggenheim Museum, 2000.

André Breton: La beauté convulsive. Ed. Agnès Angliviel de la Beaumelle, Isabelle Monod-Fontaine, and Claude Schweisguth. Paris: Éditions du Centre Georges Pompidou, 1991.

André Masson 1896–1987. Ed. Josefina Alix. Madrid: Museo Nacional Centro de Arte Reine Sofía, 2004.

Angels of Anarchy: Women Artists and Surrealism. Ed. Patricia Allmer. London: Prestel, 2009.

Art and Power: Europe under the Dictators 1930–45. Dawn Ades, Tim Benton, David Elliott, and Iain Boyd White. London: Hayward Gallery/Thames and Hudson, 1995.

The Art of Lee Miller. Mark Haworth-Booth. London: Victoria and Albert Museum/New Haven, CT: Yale University Press, 2007.

The Art of the Avant-Garde in Czechoslovakia 1918–1938/El Arte de la Vanguardia en Checoslovaquia 1918–1938. Ed. Jaroslav Anděl. Valencia, Spain: IVAM Institut d'Art Modern, 1993.

Avant-Garde Art in Everyday Life: Early-Twentieth-Century Modernism. Ed. Matthew S. Witkovsky. Chicago: The Art Institute of Chicago/New Haven, CT: Yale University Press, 2011.

Aventinská mansarda: Otakar Štorch-Marien a výtvarné umění. Ed. Karel Srp. Prague: Galerie hlavního města Prahy, 1990.

Baťa: architektura a urbanismus. Ed. Vladimír Šlapeta. Zlín: Státní galerie, 1991.

Celostátní výstava archivních dokumentů: od hrdinné minulosti k vítězství socialismu. Prague: Ministerstvo vnitra, 1958.

Central European Avant-Gardes: Exchange and Transformation 1910–1930. Ed. Timothy O. Benson. Los Angeles: Los Angeles County Museum of Art/Cambridge, MA: MIT Press, 2002.

České imaginativní umění. František Šmejkal. Prague: Galerie Rudolfinum, 1996.

Český kubismus 1909–1925: malířství, sochařství, umělecké řemeslo, architektura. Ed. Jiří Švestka and Tomáš Vlček. Prague: Národní galerie, 1991.

Český kubismus 1910–1925: architektura a design. Ed. Alexander von Vegesack. Weil am Rhein: Vitra Design Museum, 1991. Available in English as *Czech Cubism: Architecture, Furniture, Decorative Arts*. Princeton, NJ: Princeton Architectural Press, 1992.

Český surrealismus 1929–1953: Skupina surrealistů v ČSR: události, vztahy, inspirace. Ed. Lenka Bydžovská and Karel Srp. Prague: Galerie hlavního města Prahy/Argo, 1996.

Chaos and Classicism: Art in France, Italy, and Germany, 1918–1936. Ed. Kenneth E. Silver. New York: Guggenheim Museum, 2010.

Cubism and Abstract Art. Alfred Barr. New York: Museum of Modern Art, 1936.

Cyklus výstav Sbírky moderního malířství, tiskové zpravodajství, 1984–1989. Sixteen exhibitions, curated by Jiří Kotalík at Czechoslovak National Gallery. Cyclostyled press releases in archive of Národní galerie. Prague: Národní galerie, 1984–89.

Czech Functionalism 1918–1938. Vladimír Šlapeta. London: Architects Association, n.d. [1987].

Czech Modern Art 1900–1960. Ed. Lenka Zapletalová. Prague: Národní galerie, 1995. Guide to National Gallery twentieth-century collection in Trade Fair Palace.

Czech Modernism 1900–1945. Ed. Jaroslav Anděl. Houston: Museum of Fine Arts/Bulfinch Press, 1989.

Czech Photography of the Twentieth Century. Vladimír Birgus and Jan Mlčoch. Prague: Kant, 2010. Published to follow 2005 Uměleckoprůmyslové muzeum/Galerie hlavního města Prahy three-part exhibition of same title.

Czech Vision: Avant-Garde Photography in Czechoslovakia. Howard Greenberg and Anette and Rudolf Kicken. Ostfildern, Germany: Hatje Cantz, 2007.

Dada. Ed. Laurent Le Bon. Paris: Centre Pompidou, 2005.

Dada. Ed. Leah Dickerman. Washington, DC: National Gallery of Art, 2006.

Dada and Surrealism Reviewed. Ed. Dawn Ades. London: Arts Council of Great Britain, 1978.

Dada, Surrealism, and Their Heritage. William S. Rubin. New York: Museum of Modern Art, 1968.

"Degenerate Art": The Fate of the Avant-Garde in Nazi Germany. Ed. Stephanie Barron. Los Angeles: Los Angeles County Museum of Art/New York, Abrams, 1991.

Devětsil: česká výtvarná avantgarda dvacátých let. František Šmejkal, Rostislav Švácha, and Jan Rous. Prague: Galerie hlavního města Prahy, 1986.

Devětsil: Czech Avant-Garde Art, Architecture and Design of the 1920s and 30s. Ed. Rostislav Švácha. Oxford, UK: Museum of Modern Art/London: London Design Museum, 1990.

Dreaming with Open Eyes: The Vera, Silvia, and Arturo Schwarz Collection of Dada and Surrealist Art in the Israel Museum. Ed. Tamar Manor-Friedman. Jerusalem: The Israel Museum, 2000.

Družstevní práce—Sutnar Sudek. Ed. Lucie Vlčková. Prague: Uměleckoprůmyslové muzeum, 2006.

Edvard Munch: XX. výstava spolku výtvarných umělců "Mánes" v Praze. Introduction by K. Svoboda. Prague: Mánes, 1905.

Elie Lotar. Alain Sayag, Annick Lionel-Marie, and Alain and Odette Virmaux. Paris: Musée national d'art moderne/Centre Georges Pompidou, 1993.

Emil Králíček: zapomenutý mistr secese a kubismu. Zdeněk Lukeš, Ester Havlová, and Vendula Hnídková. Prague: Galerie Jaroslava Fragnera, 2005.

Entartete "Kunst": Ausstellungsführer. Munich, 1937. Reproduced in facsimile in Stephanie Barron, *"Degenerate Art."*

Erste internationale Dada-Messe. Berlin: Kunsthandlung Dr. Otto Burchard, n.d. [1920].

Exposition inteRnatiOnale du Surréalisme 1959–1960. Ed. André Breton and Marcel Duchamp. Paris: Galerie Daniel Cordier, 1959.

Exposition internationale du Surréalisme, Janvier–Février 1938. André Breton and Paul Éluard. Paris: Galerie Beaux-Arts, 1938.

Expresionismus a české umění 1905–1927. Ed. Alena Pomajzlová, Dana Mikulejská, and Juliana Boublíková. Prague: Národní galerie, 1994.

Fantastic Art, Dada, Surrealism. Alfred Barr. New York: Museum of Modern Art, 1937.

féminimasculin: Le sexe de l'art. Ed. Marie-Laure Bernadac and Bernard Marcadé. Paris: Centre Pompidou, 1995.

Film und Foto der zwanziger Jahre: Eine Betrachtung der Internationalen Werkbundasstellung "Film und Foto" 1929. Ed. Ute Eskildsen and Jan-Christopher Horak. Stuttgart: Würtembergischer Kunstverein, 1979.

Focus on Minotaure: The Animal-Headed Review. Texts by Charles Goerg et al. Geneva: Musée d'Art et d'Histoire, 1987.

Foto: Modernity in Central Europe, 1918–1945. Matthew S. Witkovsky. Washington, DC: National Gallery of Art, 2007.

Francouzské moderní umění: l'école de Paris. Introduction by André Salmon. Prague: Umělecká beseda, 1931.

Francouzští impressionisté: katalog 23. výstavy SVU Mánes v Praze 1907. Introduction by F. X. Šalda. Prague: Mánes, 1907.

František Drtikol: fotografie z let 1918–1935. Jan Mlčoch. Prague: Uměleckoprůmyslové muzeum, 2004.

František Kupka: la collection du Centre Georges Pompidou, Musée national d'art moderne. Ed. Brigitte Leal. Paris: Centre Pompidou, 2003.

František Kupka ze sbírky Jana a Medy Mládkových/From the Jan and Meda Mládek Collection. Meda Mládková and Jan Sekera. Prague: Museum Kampa, 2007.

František Zelenka: plakáty, architektura, divadlo. Ed. Josef Kroutvor. Prague: Uměleckoprůmyslové muzeum, 1991.

Gegen jede Vernunft: Surrealismus Paris-Prague. Ed. Reinhard Spieler and Barbara Auer. Ludwigshafen am Rhein, Germany: Wilhelm-Hack-Museum/Belser, 2010.

Grand Jeu et surréalisme: Reims, Paris, Prague. Nelly Feuerhahn, David Liot, Didier Ottinger, Anna Pravdová, Bertrand Schmitt, Michel Random, Karel Srp, and Alain Virmaux. Reims: Musée des beaux-arts, 2004.

The Great Utopia: The Russian and Soviet Avant-Garde, 1915–1932. Paul Wood et al. New York: Guggenheim Museum/Abrams, 1992.

Gustav Klutsis and Valentina Kulagina: Photography and Montage after Constructivism. Margarita Tupitsyn. New York: International Center of Photography/Steidl, 2004.

The International Style. Henry-Russell Hitchcock and Philip Johnson. Reprint of original 1932 Museum of Modern Art catalogue, with additional matter. New York: Norton, 1995.

Jak fénix: minulost a přítomnost Veletržního paláce v Praze. Radomíra Sedláková. Prague: Národní galerie, 1995.

Jaromír Krejcar 1895–1949. Ed. Rostislav Švácha. Prague: Galerie Jaroslava Fragnera, 1995.

Jindřich Heisler: Surrealism Under Pressure, 1938–1953. Jindřich Toman and Matthew S. Witkovsky. Chicago: The Art Institute of Chicago/New Haven, CT: Yale University Press, 2012.

Jindřich Štyrský 1899–1942. Karel Srp. Prague: Galerie hlavního města Prahy, 2007.

Jiří Kolář: Diary 1968. Ed. David Elliott and Arsén Pohribny. Oxford, UK: Museum of Modern Art, 1984.

Jiří Kroha (1893–1974): architekt, malíř, designer, teoretik v proměnách umění 20. století. Ed. Marcela Macharáčková. Brno: Muzeum města Brna, 2007.

Jiří Kroha: Sociologický fragment bydlení. Photomontage cycle first exhibited in Brno and Prague 1933–34, published in book form Brno: Krajské středisko státní památkové péče a ochrany přírody v Brně, 1973.

John Heartfield. Ed. Peter Pachnicke and Klauss Honnef. New York: Abrams, 1991.

John Heartfield en la colección del IVAM. Valencia, Spain: Institut Valencia d'Art Modern, 2001.

Josef Čapek in Memoriam. Václav Rabas, Emil Filla, and Jarmila Čapková. Prague: Umělecká beseda, 1945.

Josef Čapek: Nejskromnější umění/The Humblest Art. Alena Pomajzlová, trans. Branislava Kuburović. Prague: Obecní dům, 2003.

Josef Sudek: Dialog z cisza/Dialogue with Silence. Photographs from 1940–1970 from the Collection of the Moravian Gallery in Brno. Ed. Jolanta Pieńkos. Warsaw: Zachenta Narodowa Galeria Sztuki, 2006.

Josef Sudek: The Commercial Photography for Družstevní práce. Ed. Maija Holma. Jyväskylä, Finland: Alvar Aalto Museum, 2003.

Josep Renau fotomontador. Ed. Maria Casanova. Valencia, Spain: IVAM Institut Valencia d'Art Modern, 2006.

Karel Svolinský 1896–1986. Ed. Roman Musil and Eduard Burget. Prague: Národní galerie, 2001.

Karel Teige 1900–1951. Ed. Karel Srp. Prague: Galerie hlavního města Prahy, 1994.

Karel Teige: architettura, poesie—Praga 1900–1951. Ed. Manuela Castagnara Codeluppi. Milan: Electa, 1996.

Karel Teige: surrealistické koláže 1935–51. Vojtěch Lahoda, Karel Srp, and Rumana Dačeva. Prague: Středočeská galerie, 1994.

Katalog pavillonu kral. hlav. města Prahy a odborních skupin městských. Prague, 1908.

Katalog výstavy děl sochaře Augusta Rodina v Praze. F. X. Šalda and Stanislav Sucharda. Prague: Mánes, 1902.

Konec avantgardy? Od Mnichovské dohody ke komunistickému převratu. Hana Rousová, Lenka Bydžovská, Vojtěch Lahoda, Milan Pech, Anna Pravdová, and Lucie Zadražilová. Prague: Galerie hlavního města Prahy/Arbor Vitae, 2011.

Křídla slávy: Vojtěch Hynais, čeští Pařížané a Francie. Ed. Marie Mžyková. 2 volumes. Prague: Galerie Rudolfinum, 2000.

Kupka—Waldes: The Artist and His Collector. Ed. Anna Pachovská. Prague: Meissner, 1999.

L'Amour fou: Photography and Surrealism. Rosalind Krauss and Jane Livingston. Washington, DC: Corcoran Gallery/London: Abbeville Press, 1995.

L'enfer de la Bibliothèque: Éros au secret. Ed. Marie-Françoise Quignard and Raymond-Josué Seckel. Paris: Bibliothèque nationale de France, 2007.

L'Esprit nouveau: Purism in Paris 1918–1925. Carol. S. Eliel. Los Angeles: Los Angeles County Museum of Art/New York: Abrams, 2001.

La Révolution surréaliste. Ed. Werner Spies. Paris: Centre Pompidou, 2002.

La Subversion des images: Surréalisme, Photographie, Film. Ed. Marion Diez. Paris: Centre Pompidou, 2009.

Ladislav Sutnar: Americké Venuše [U.S. Venus]. Iva Knobloch. Prague: Arbor Vitae and Uměleckoprůmyslové muzeum, 2011.

Ladislav Sutnar—Praha—New York—Design in Action. Ed. Iva Janáková. Prague: Uměleckoprůmyslové muzeum/Argo, 2003.

Le Cubisme à Prague. Ed. Claude Petry. Paris: Jacques London, 1991.

Le Surréalisme en 1947: Exposition internationale du Surréalisme présentée par André Breton et Marcel Duchamp. Paris: Maeght Éditeur, 1947.

Lee Miller: Photographer. Jane Livingston. Los Angeles: California Art Foundation/New York: Thames and Hudson, 1989.

Les Indépendents: xxxi výstava Sp. výtv. um. "Mánes." Introduction by Antonín Matějček. Prague: Mánes, 1910.

Livres de nus. Alessandro Bertolotti. Paris: Éditions de la Martinière, 2007.

Magritte: catalogue du centenaire. Ed. Gisèle Ollinger-Zinque and Frederik Leen. Brussels: Musées royaux des Beaux-Arts de Belgique/Flammarion, 1998.

M. Aleš: výstava jeho života a díla pro českou knihu a divadlo. Ed. V. V. Štech and Emanuel Svoboda. Prague: Národní muzeum, 1952.

The Malik-Verlag: 1916–1947. Ed. James Fraser. New York: Goethe House, 1984.

Man Ray 1890–1976. Ed. Jan Ceuleers. Antwerp: Ronny Van de Velde/New York: Abrams, 1994.

Man Ray and Lee Miller: Partners in Surrealism. Phillip Prodger. Salem: Peabody Essex Museum/London: Merrell, 2011.

Man Ray: Despreocupado pero no indiferente/Unconcerned but Not Indifferent. Noriko Fuku and John P. Jacob. Madrid: La Fabrica, 2007.

Man Ray: Luces y sueños. Ed. Pilar Parcerisas. Valencia, Spain: Museu Valencià de la Illustracio i de la Modernitat, 2006.

Man Ray: Photography and Its Double. Ed. Emanuelle de L'Ecotais and Alain Sayag. Corte Madera, CA: Gingko Press, 1998.

Man Ray Women. Ed. Valerio Dehó. Bologna: Damiani, 2005.

Max Ernst: Invisible a primavera vista: grabados, libros ilustrados, esculturas. Dieter Ronte, Irene Kleinschmidt-Altpeter, Lluisa Faxedas, Werner Spies, and Jürgen Pech. Barcelona: Fundació la Caixa, 2006.

The Mexican Suitcase: The Rediscovered Spanish Civil War Negatives of Capa, Chim, and Taro. Ed. Cynthia Young. 2 volumes. New York: International Center of Photography/Steidl, 2010.

Mezery v historii 1890–1938: polemický duch Střední Evropy—Němci, Židé, Češi. Ed. Hana Rousová. Prague: Galerie hlavního města Prahy, 1994.

Mezinárodní surrealismus, 30. (410.) výstava Topičova salonu od 4. listopadu do 3. prosince 1947. André Breton and Karel Teige. Prague: Topičův salon, 1947.

Moderní galerie tenkrát 1902–1942. Roman Musil, Martina Nejezchlebová, Alena Pomajzlová, Roman Prahl, Nikolaj Savický, Tomáš Sekyrka, Vít Vlnas, and Jindřich Vybíral. Prague: Národní galerie, 1992.

Modernism 1914–1939: Designing a New World. Ed. Christopher Wilk. London: Victoria and Albert Museum, 2006.

Moderní umění, soubor sestaven A. Mercereauem v Paříži: 45. výstava SVU Mánes v Praze. Introduction by Alexandre Mercereau. Prague: Mánes, 1914.

The Naked Truth: Klimt, Schiele, Kokoschka and Other Scandals. Ed. Tobias G. Natter and Max Hollein. New York: Prestel, 2005.

Na křížovatce Evropy: Karel Teige a Penklub. Eva Wolfová. Prague: Památník Národního písemnictví, 1994.

Narodopisná výstava českoslovanská v Praze 1895. Prague: Otto, 1895.

New Formations: Czech Avant-Garde Art and Modern Glass from the Roy and Mary Cullen Collection. Karel Srp and Lenka Bydžovská with Alison de Lima Greene and Jan Mergl. Houston: Museum of Fine Arts/New Haven, CT: Yale University Press, 2011.

Oskar Kokoschka 1886–1980. Ed. Richard Calvocoressi. London: Tate Gallery, 1986.

Otto Gutfreund. Jan Bauch, Jiří Šetlík, Václav Erben, Petr Wittlich, Karel Srp, and Vojtěch Lahoda. Prague: Národní galerie, 1995.

Paris Prague 1906–1930. Paris: Musée national d'art moderne, 1966.

Paul Éluard et ses amis peintres. Ed. Annick Lionel-Marie. Paris: Centre Pompidou, 1982.

Paul Nash: Modern Artist, Ancient Landscape. Ed. Jemima Montagu. London: Tate, 2003.

The Photomontages of Hannah Höch. Peter Boswell, Maria Makela, Carolyn Lanchner, and Kristin Makholm. Minneapolis: Walker Art Center, 1997.

Picasso érotique. Ed. Jean Clair. Munich/London/New York: Prestel, 2001.

Picasso: Life with Dora Maar. Love and War 1935–1945. Anne Baldassari. Paris: Flammarion, 2006.

Picasso: Suite 347. Ed. Kosme de Baranano. Valencia, Spain: Bancaixa, 2000.

Picasso surréaliste. Ed. Anne Baldassari. Basel: Fondation Beyeler/Paris: Flammarion, 2005.

Pocta Rodinovi 1902–1992. Marie Halířová. Prague: Národní galerie, 1992.

Prague 1900–1938: capitale secrète des avant-gardes. Ed. Jacqueline Menanteau. Dijon: Musée des Beaux-Arts, 1997.

Prague sur Seine. Patrizia Runfola, Gérard-Georges Lemaire, and Oliver Poivre d'Arvor. Paris: Paris Musées, 1992.

Praha Paris Barcelona: modernidad fotográfica de 1918 a 1948/Photographic Modernity from 1918 to 1948. Ed. Alberto Anaut. Barcelona/Madrid: Museu Nacional d'Art de Catalunya/La Fábrica, 2010.

The Precious Legacy: Judaic Treasures from the Czechoslovak State Collections. Ed. David Altshuler. New York: Summit Books, 1983.

Průvodce výstavou svatováclavskou. Antonín Podlaha and Antonín Šorm. Prague: Výbor svatováclavský, 1929.

První výstava skupiny surrealistů v ČSR: Makovský, Štyrský, Toyen. Karel Teige and Vítězslav Nezval. Prague: Mánes, 1935.

Raoul Hausmann. Eva Züchner, Andrei Nakov, Christopher Phillips, Jean-Francois Chevrier, Yves Michaud, and Bartomeu Marí. Valencia, Spain: IVAM Centre Julio Gonzalez, 1994.

Šíma/Le Grand Jeu. Antoine Coron, Serge Fauchereau, Jacques Henric, Patrick Javault, and Pierre Restany (Šíma) and Michel Camus, Gérald Gassiot-Talabot, Olivier Poivre d'Arvor, Raphael Sorin, Paule Thévenin, and Marc Thivolet (Le Grand Jeu). Paris: Musée d'art moderne, 1992.

Skupina Ra. Ed. František Šmejkal. Prague: Galerie hlavního města Prahy, 1988.

Státní židovské muzeum v Praze. Prague: Státní židovské muzeum, 1979.

Sto let práce: zpráva o všeobecné zemské výstavě v Praze 1891. 3 volumes, Vol. 3 in 2 parts. Prague, 1892–95.

Štyrský a Toyen. Vítězslav Nezval and Karel Teige. Prague: Borový, 1938.

Štyrský a Toyen 1921–1945. Věra Linhartová and František Šmejkal. Brno: Moravská galerie, 1966/Prague: Mánes, 1967.

Štyrský, Toyen, artificielismus 1926–1931. Lenka Bydžovská and Karel Srp. Prague: Středočeská galerie, 1992.

Štyrský, Toyen, Heisler. Ed. Jana Claverie. Paris: Centre Georges Pompidou, 1982.

Surrealism and After: The Gabrielle Kieller Collection. Elizabeth Cowling with Richard Calvocoressi, Patrick Elliott, and Ann Simpson. Edinburgh: Scottish National Gallery of Modern Art, 1997.

Surrealism: Desire Unbound. Ed. Jennifer Mundy. London: Tate/Princeton, NJ: Princeton University Press, 2001.

Surrealism: Two Private Eyes, the Nesuhi Ertegun and Daniel Filipacchi Collections. 2 volumes. Ed. Edward Weisberger. New York: Guggenheim Museum, 1999.

Surrealist Vision and Technique: Drawings and Collages from the Pompidou Center and the Picasso Museum, Paris. Clark V. Poling. Atlanta: Michael C. Carlos Museum at Emory University, 1996.

Toyen. André Breton, Jindřich Heisler, and Benjamin Péret. Paris: Éditions Sokolová, 1953.

Toyen. Karel Srp. Prague: Galerie hlavního města Prahy/Argo, 2000.

Toyen: une femme surréaliste. Karel Srp. Saint-Étienne Métropole, France: Musée d'Art Moderne, 2002.

Tschechische Avantgarde 1922–1940: Reflexe europäischer Kunst und Fotografie in der Buchgestaltung. Zdeněk Primus. Münster-schwarzach: Vier-Türme-Verlag, n.d. [1990].

Tvrdošíjní. Karel Srp. Prague: Galerie hlavního města Prahy, 1986.

Tvrdošíjní a hoste. 2. Část, užité umění, malba, kresba. Karel Srp. Prague: Galerie hlavního města Prahy, 1987.

Umělecká beseda: k 125. výročí založení. Jiří Kotalík. Prague: Národní galerie, 1988.

Umění pro všechny smysly: meziváleční avantgarda v Československu. Ed. Jaroslav Anděl. Prague: Národní galerie, 1993.

Umění současné Francie. Introduction by Antonín Matějček. Prague: SVU Mánes, 1931.

Undercover Surrealism: Georges Bataille and DOCUMENTS. Ed. Dawn Ades and Simon Baker. London: Hayward Gallery/Cambridge, MA: MIT Press, 2006.

Václav Špála: mezi avantgardou a živobytím. Ed. Helena Musilová. Prague: Národní galerie, 2005.

Vincenc Kramář od starých mistrů k Picassovi. Vojtěch Lahoda and Olga Uhrová. Prague: Národní galerie, 2000.

Visages d'Éluard: photographies. Ed. Paul André. Paris: Musée d'Art et d'Histoire de Saint-Denis/Éditions Parkstone, 1995.

Všeobecná zemská výstava v Praze . . . Hlavní catalog. Ed. Josef Fořt. Prague, 1891.

Výstava díla Mikoláše Alše. Introduction by František Nečásek. Prague: Orbis, 1952.

Výstava díla Mikoláše Alše: seznam děl vystavených v Jízdárně pražského hradu. Emanuel Svoboda and František Dvořák. Prague: Orbis, 1952.

Výstava Poesie 1932. Introduction by Karel Novotný. Prague: Mánes, 1932.

Zakladatelé moderního českého umění. Miroslav Lamač, Jiří Padrta, and Jan Tomes. Brno: Dům umění, 1957.

GRAPHIC AND PHOTOGRAPHIC ALBUMS

33 koláží Breton Éluard Muzard. Preface by Karel Srp. Prague: Galerie Maldoror, 2004.

Aleš, Mikoláš. *Špalíček národních písní a říkadel.* Prague: Orbis, 1950.

Baum, Timothy, François Buot, and Sam Stourdzé. *Georges Hugnet: Collages.* Paris: Scheer, 2003.

Čapek, Josef. *Dějiny zblízka: soubor satirických kreseb.* Prague: Borový, 1949.

Éluard, Paul, and Man Ray. *Facile.* Paris: Éditions G.L.M., 1935. Facsimile reprint, Paris: La Bibliothèque des Introuvables, 2004.

Ernst, Max. *Hundred Headless Woman (La femme 100 têtes).* Trans. Dorothea Tanning. New York: George Braziller, 1982.

———. *A Little Girl Dreams of Taking the Veil (Rêve d'une petite fille qui voulut entrer au Carmel).* Trans. Dorothea Tanning. New York: George Braziller, 1982.

———. *Une Semaine de bonté: les collages originaux.* Ed. Werner Spies. Paris: Gallimard, 2009.

Gracq, Julien, and Gilles Ehrmann. *42 rue Fontaine: l'atelier d'André Breton.* Paris: Biro, 2003.

Kolář, Jiří. *Týdeník 1968.* Prague: Torst, 1993.

Miller, Lee. *Grim Glory: Pictures of Britain under Fire.* Ed. Ernestine Carter. London: Lund, Humphries, 1941.

Okanoue, Toshiko. *Drop of Dreams.* Ed. Mayako Ishiwata. Tucson: Nazraeli Press, 2002.

Renau, Josep. *Fata Morgana USA: The American Way of Life.* Valencia, Spain: IVAM Centre Julio Gonzales/Fundació Josep Renau, 1989.

Sander, August. *People of the Twentieth Century.* 7 volumes. New York: Abrams, 2002.

Sudek, Josef. *Josef Sudek: Works.* Prague: Torst, ongoing series, simultaneously published in Czech and English. Volumes in print at time of writing include *Portraits* (2007); *The Window of My Studio* (2007); *The Advertising Photographs* (2008); *Still Lifes* (2008); and *Svatý Vít/Saint Vitus's* (2010).

———. *Panoramatická Praha.* 2d ed. Prague: Odeon, 1992.

———. *Smutná krajina/Sad Landscape: Severozápadní Čechy/Northwest Bohemia 1957–62.* 2d ed. Prague: Kant, 2004.

———. *Svatý Vít.* Prague: Družstevní práce, 1928.

Toyen. *Jednadvacet.* Prague: Torst, 2002.

LIBRETTI, RECORD ALBUM LINER NOTES, THEATER PROGRAMS, AUCTION CATALOGUES, EPHEMERA

Agar, Eileen. Legend to "Angel of Anarchy," as displayed in Tate Modern, 2006.

André Breton: 42 rue Fontaine. 8-volume auction catalogue with accompanying DVD. Paris: CalmelsCohen 2003.

Blyth, Alan. Liner notes to *Jarmila Novotná: The Artist's Own Selection of Her Finest Recordings*, Pearl LP no. GEMM 261/2, 1983.

Café Imperial (Prague) menu, December 2008.

Červinková-Riegrová, Marie. Libretto to Antonín Dvořák, *Jakobín* (1889). Included with Supraphon record album set *Jakobín*, no. SU 1112 2481/3, 1980.

Destinová, Ema. *Ema Destinová, Souborná edice, 3. Richard Wagner*. Supraphon LP number 1 0120–1 602G, 1989.

Fanelli, Sara. *Tate Artist Timeline*. Foldout chart. London: Tate, 2006.

Grand Café Orient (Prague) menu, December 2008.

Králík, Jan. Liner notes to Jarmila Novotná, *České písně a arie*, Supraphon CD no. SU 11 1491-2, 1992.

Martinů, Bohuslav. *Julietta* (1938). Libretto by the composer after a play by Georges Neveux. With Supraphon CD set *Julietta*, no. SU 3626-2 612, 2002.

———. *Julietta*. New Opera Company/English National Opera program, 1978. Contains Martinů's 1947 synopsis of the opera.

Masaryk, Jan. Liner notes to Jarmila Novotná, *Songs of Czechoslovakia* (1942). RCA Victor LP record no. VIC 1383, 1969.

Meyer, Andreas K. W. Liner notes to *Viktor Ullmann, Piano Sonatas 5–7*, cpo CD no. SU 999 087-2, 1992.

Mihule, Jaroslav. Liner notes to Bohuslav Martinů, *Julietta*, Supraphon CD no. SU 3626-2 612, 2002.

Mucha, Jiří. Libretto to Bohuslav Martinů, *Field Mass* (1939). Trans. Geraldine Thomsen. With Supraphon CD SU 3276-2 931, 1997.

Stedron, Miloš. Liner notes to Leoš Janáček, *Mša glagolskaya*, Supraphon CD no. SU 3045-2 211, 1996.

ENCYCLOPEDIAS, GUIDEBOOKS, WORKS OF REFERENCE

Bibliografický soupis knih výdaných SNKLU v letech 1953–1962. Ed. Zdenka Broukalová and Saša Mouchová. Prague: SNKLU, 1964.

Dictionnaire générale du Surréalisme et de ses environs. Adam Biro and René Passeron. Paris: Presses universitaires dc France, 1982.

The Green Guide: Prague. Watford, UK: Michelin Travel Publications, 2000.

Katalog Sixty-Eight Publishers. Prague: Společnost Josefa Škvoreckého, 1991.

Kdo byl kdo v našich dějinách v 20. století. 2 volumes. Ed. Milan Churaň. Prague: Libri, 1998.

Kobbé's Complete Opera Book. Ed. The Earl of Harewood. London: Putnam, 1976.

Kronika královské Prahy i obcí sousedních. 3 volumes. Ed. František Ruth. Prague: Pavel Körber, 1903.

Kubistická Praha/Cubist Prague. Michal Bregant, Lenka Bydžovská, Vojtěch Lahoda, Zdeněk Lukeš, Karel Srp, Rostislav Švácha, and Tomáš Vlček. Prague: Středoevropské nakladatelství, 1995.

Malá československá encyclopedie. 3 volumes. Prague: Academia, 1986.
Nový slovník československých výtvarných umělců. Prokop Toman. Photoreprint of 3d ed. of 1947–49. Ostrava, Czech Republic: Chagall, 1994.
Opera on Record, Vol. 2. Ed. Alan Blyth. London: Hutchinson, 1983.
Ottův slovník naučny. 28 volumes. Prague: Otto, 1888–1909.
Ottův slovník naučny nové doby. 12 volumes. Prague: Otto, 1930–43.
Prague: A Guide to Twentieth-Century Architecture. Ivan Margolius. London: Ellipsis 1996.
Prague in Picture Postcards of the Period 1886–1930. Ed. Edmund Orián. Prague: Belle Epoch, 1998.
Pražský uličník: encyklopedie názvů pražských veřejných prostranství. 2 volumes. Ed. M. Lašťovka. Prague: Libri, 1998.
Příručka pro sběratele československých známek a celin. Ed. Alois Dušek. Prague: Svaz československých filatelistů, 1988.
Původní názvy pražských ulic, nábřeží, nádraží a sadů podle stavu v r. 1938. Prague: Česká obec turistická, 1945.
[Ricgrův] *Slovník naučný.* 11 volumes. Ed. F. L. Rieger. Prague: Kober, 1860–74.
Seznam ulic, náměstí atd. hlavního města Prahy (stav k 1. květnu 1948). Prague: Dopravní podniky hl. m. Prahy, 1948.
Soupis repertoáru Národního divalda v Praze. 3 volumes. Ed. Hana Konečná. Prague: Národní divadlo, 1983.
Stará Praha: obraz města a jeho veřejného života v 2. polovici XIX. století. Zdeněk Wirth. Prague: Otto, 1942.
Statistika královského hlavního města Prahy. Vol. 1. Ed. Josef Erben. Prague: Obecní statistická kommisse královského hlavního města Prahy, 1871.
Ulicemi města Prahy od 14. století do dneška. Prague: Orbis, 1958.
Václavské náměstí v Praze: architecktonický průvodce/Wenceslas Square in Prague: Architectural Guide. Supplement to *Ad architektura* 2. Yvonne Janková. Prague: J. H. & Archys, 2006.
Židovská Praha; glosy k dějinám a kultuře; průvodce památkami. Ctíbor Rybár. Prague: TV Spektrum/Akropolis, 1991.
Zmizelá Praha. 6 volumes. Vol. 1, V. V. Štech, Zdeněk Wirth, and Václav Vojtíšek, *Staré a Nové město s Podskalím.* Vol. 2, Cyril Merhout and Zdeněk Wirth, *Malá Strana a Hradčany.* Vol. 3, Hana Volavková, *Židovské město pražské.* Vol. 4, Emanuel Poche and Zdeněk Wirth, *Vyšehrad a zevní okresy Prahy.* Vol. 5, Zdeněk Wirth, *Opevnění, Vltava a ztráty na památkách 1945.* Vol. 6, Antonín Novotný, *Grafické pohledy 1493–1850.* Prague: Václav Poláček, 1945–48.

Monographs, Theses, Articles

Adlerová, Anna. *České užité umění.* Prague: Odeon, 1983.
Altshuler, Bruce. *The Avant-Garde in Exhibition: New Art in the 20th Century.* Berkeley: University of California Press, 1998.
Anděl, Jaroslav. *Avant-Garde Page Design 1900–1950.* New York: Delano Greenidge, 2002.
Anděl, Jaroslav. *The New Vision for the New Architecture: Czechoslovakia 1918–1938.* Bratislava: Slovart, 2005.

Arendt, Hannah. *Eichmann in Jerusalem: A Report on the Banality of Evil.* New York: Penguin, 2006.

Barthes, Roland. *Camera Lucida.* Trans. Richard Howard. New York: Hill and Wang, 2000.

———. "Rhetor and Magician." Introductory essay in *Arcimboldo.* Milan: Franco Maria Ricci, 1980.

Bauman, Zygmunt. *Modernity and the Holocaust.* Ithaca, NY: Cornell University Press, 2001.

Beckerman, Michael. "The Dark Blue Exile of Jaroslav Ježek." *Music and Politics*, Vol. II, No. 2, 2008.

Bečková, Kateřiná. *Society for Old Prague: One Hundred and Two Years.* Prague: Klub za starou Prahu, 2002.

Bepoix, Michel, ed. *Des peintres au camp des Milles: septembre 1939—été 1941.* Aix-en-Provence: Actes Sud, 1997.

Birgus, Vladimír. *Akt v české fotografii/The Nude in Czech Photography.* Prague: Kant, 2001.

———. *The Photographer František Drtikol.* Prague: Kant, 2000.

Birgus, Vladimír, ed. *Czech Photographic Avant-Garde 1918–1948.* Cambridge, MA: MIT Press, 2002.

Bois, Yve-Alain, and Rosalind E. Krauss. *Formless: A User's Guide.* New York: Zone, 1997.

Brabcová, Jana. *Luděk Marold.* Prague: Odeon, 1988.

Brandon, Ruth. *Surreal Lives: The Surrealists 1917–1945.* London: Macmillan, 1999.

Brod, Max. *Franz Kafka: A Biography.* New York: Schocken, 1963.

Brozová, Michaela, Anne Hebler, and Chantal Scaler. *Praha: průchody a pasáže.* Prague: Euro Art, 1997.

Brunhammer, Yvonne. *1925.* 2 volumes. Paris: Les Presses de la Connaissance, 1976.

Buben, Václav, ed. *Šest let okupace Prahy.* Prague: Orbis, 1946.

Buber-Neumann, Margarete. *Mistress to Kafka: The Life and Death of Milena.* London: Secker and Warburg, 1966.

Burkett, M. E. *Kurt Schwitters: Creator of Merz.* Kendal, UK: Abbot Hall Art Gallery, 1979.

Bydžovská, Lenka, and Karel Srp. *Jindřich Štyrský.* Prague: Argo, 2007.

———. *Knihy s Toyen.* Prague: Akropolis, 2003.

Calvocoressi, Richard. *Lee Miller: Portraits from a Life.* London: Thames and Hudson, 2002.

Canonne, Xavier. *Surrealism in Belgium: 1924–2000.* Brussels: Mercatorfonds, 2007.

Caws, Mary Ann. *Dora Maar with and without Picasso: A Biography.* London: Thames and Hudson, 2000.

Caws, Mary Ann, Rudolf Kuenzli, and Gwen Raaberg, eds. *Surrealism and Women.* Cambridge, MA: MIT Press, 1991.

Chadwick, Whitney. *Women Artists and the Surrealist Movement.* London: Thames and Hudson, 1985.

Chadwick, Whitney, ed. *Mirror Images: Women, Surrealism, and Self-Representation.* Cambridge, MA: MIT Press, 1998.

Cheek, Timothy. "Navždy (Forever) Kaprálová: Reevaluating Czech Composer

Vítězslava Kapralova through Her Thirty Songs." *Kapralova Society Journal*, Vol. 3, No. 2, 2005.

Cohen, Gary B. *The Politics of Ethnic Survival: Germans in Prague, 1861–1914*. Princeton, NJ: Princeton University Press, 1981.

Colomina, Beatriz. *Sexuality and Space*. Princeton, NJ: Princeton University Press, 1996.

Colville, Georgiana. *Scandaleusement d'elles: trente-quatre femmes surréalistes*. Paris: Jean-Michel Place, 1999.

Conley, Katharine. *Automatic Woman: The Representation of Woman in Surrealism*. Lincoln: University of Nebraska Press, 1996.

———. *Robert Desnos, Surrealism, and the Marvelous in Everyday Life*. Lincoln: University of Nebraska Press, 2003.

Cork, Richard. "Eye of the Beholder." *Tate Magazine*, No. 3, January–February 2003.

Daix, Pierre. *Aragon avant Elsa*. Paris: Éditions Tallandier, 2009.

Demetz, Peter. *Prague in Black and Gold*. London: Penguin, 1997.

Denton, Pennie. *Seaside Surrealism: Paul Nash in Swanage*. Swanage, UK: Peveril Press, 2002.

Derrida, Jacques. *Margins of Philosophy*. Trans. Alan Bass. Chicago: Chicago University Press, 1986.

———. *Positions*. Trans. Alan Bass. Chicago: Chicago University Press, 1982.

Dimanche, André, ed. *André Masson*. Paris: André Dimanche, 1993.

Dluhosch, Eric, and Rostislav Švácha, eds. *Karel Teige 1900–1951: The Enfant Terrible of the Prague Avant-Garde*. Cambridge, MA: MIT Press, 1999.

Durozoi, Gérard. *History of the Surrealist Movement*. Trans. Alison Anderson. Chicago: Chicago University Press, 2002.

Dvořáková, Zora. *Miroslav Tyrš: prohry a vítězství*. Prague: Olympia, 1989.

Eisner, Pavel. *Chrám i tvrz: kniha o češtině*. Photoreprint of 1946 edition. Prague: Lidové noviny, 1992.

Entwistle, Erik. "To je Julietta: Martinů, Kaprálová and Musical Symbolism." *Kapralova Society Newsletter*, Vol. 2, No. 2, 2004.

Evans, David. *John Heartfield; AIZ/VI*. New York: Kent Fine Arts, 1992.

Fanon, Franz. *Black Skin, White Masks*. New York: Grove Press, 1994.

Fárová, Anna. *František Drtikol: Art-Deco Photographer*. Munich and London: Schirmer Art Books, 1993.

———. *Josef Sudek*. Prague: Torst, 1995.

Farník, Jaromír, ed. *V + W = 100: Vždy s úsměvem. Pocta Jiřímu Voskovcovi a Janu Werichovi*. Prague: Lotos, 2005.

Foster, Hal, Rosalind Krauss, Yve-Alain Bois, and Benjamin H. D. Buchloh. *Art Since 1900: Modernism, Antimodernism, Postmodernism*. London: Thames and Hudson, 2004.

Foster, Norman. *Rebuilding the Reichstag*. London: Weidenfeld and Nicholson, 2001.

Foucault, Michel. *The History of Sexuality*. Vol. 1, *The Will to Know*. Trans. Robert Hurley. London: Penguin, 1998.

———. *The Order of Things: An Archaeology of the Human Sciences*. New York: Vintage, 1994.

Fukuyama, Francis. *The End of History and the Last Man*. London: Penguin, 1993.

Gehry, Frank, and Vlado Milunić. *The Dancing Building*. Ed. Irena Fialová. Prague: Zlatý Řez/Rotterdam: Prototype Editions, 2003.

Giddens, Anthony. *Conversations with Anthony Giddens: Making Sense of Modernity*. Stanford, CA: Stanford University Press, 1998.

Giroud, Francoise. *Alma Mahler: The Art of Being Loved*. Oxford, UK: Oxford University Press, 1991.

Gissing, Vera. *Nicholas Winton and the Rescued Generation*. London: Vallentine Mitchell, 2001.

Giustino, Cathleen M. "Rodin in Prague: Modern Art, Cultural Diplomacy, and National Display." *Slavic Review*, Vol. 69, No. 3, 2010.

Goldhagen, David J. *Hitler's Willing Executioners: Ordinary Germans and the Holocaust*. London: Abacus, 1997.

Greenberg, Clement. *The Collected Essays and Criticism*. Vol. 1, *Perceptions and Judgments, 1939–1944*. Ed. John O'Brian. Chicago: Chicago University Press, 1988.

Grunenberg, Christoph, and Max Hollein, eds. *Shopping: A Century of Art and Consumer Culture*. Frankfurt: Hatje Cantz, 2002.

Gruša, Jiří. *Franz Kafka of Prague*. Trans. Eric Mosbacher. New York: Schocken, 1983.

Hartl, Karla. "In Search of a Voice: Story of Vítězslava Kaprálová." *Kapralova Society Newsletter*, Vol. 1, No. 1, 2003.

———. "Vítězslava Kaprálová: A Life Chronology." *Kapralova Society Journal*, Vol. 2, No. 1, Vol. 3, No. 1, and Vol. 4, No. 1, 2004–6.

Havelock Ellis, Henry. *Studies in the Psychology of Sex*. Vol. 3. London: The Echo Library, 2007.

Hemus, Ruth. *Dada's Women*. New Haven, CT: Yale University Press, 2009.

Hobsbawm, Eric. *The Age of Extremes: The Short Twentieth Century 1914–1991*. London: Abacus, 1995.

Hockaday, Mary. *Kafka, Love and Courage: The Life of Milena Jesenská*. Woodstock, NY: Overlook Press, 1997.

Hojda, Zdeněk, and Jiří Pokorný. *Pomníky a zapomníky*. Prague: Peseka, 1997.

Hollier, Denis. *Against Architecture: The Writings of Georges Bataille*. Cambridge, MA: MIT Press, 1992.

Hollier, Denis, ed. "A Documents Dossier." *October*, No. 60, 1992, special issue.

Holub, Karel. *Velká Kavárna Slavia*. Prague: Jan Hovorka, 1998.

Horneková, Jana, Karel Ksandr, Maria Szadkowska, and Vladimír Šlapeta. *The Müller Villa in Prague*. Prague: City of Prague Museum, 2002.

Horská, Pavla. *Prague—Paris*. Prague: Orbis, 1990.

Houtchens, Alan. "Love's Labours Lost: Martinů, Kaprálová and Hitler." *Kapralova Society Journal*, Vol. 3, No. 1, 2006.

Huebner, Karla Tonine. "Eroticism, Identity, and Cultural Context: Toyen and the Prague Avant-Garde." PhD Thesis, University of Pittsburgh, 2008.

Irrigaray, Luce. *This Sex Which Is Not One*. Ithaca, NY: Cornell University Press, 1985.

Ivšić, Radovan. *Toyen*. Paris: Éditions Filipacchi, 1974.

Janeček, Gerald, ed. *The Eastern Dada Orbit: Russia, Georgia, Central Europe and Japan*. New York: G. K. Hall/Prentice International, 1998.

Jean, Marcel. *The History of Surrealist Painting*. Trans. Simon Watson Taylor. London: Weidenfeld and Nicolson, 1960.

Jean, Raymond. *Éluard*. Paris: Seuil, 1968.

Jentsch, Ralph. *George Grosz: Berlin—New York*. Milan: Skira, 2008.

Josef Sudek: Poet of Prague. New York: Aperture, 1990.

Josep Renau: catálogo razonado a cargo de Albert Forment. Ed. Albert Forment. Valencia, Spain: IVAM Institut Valencia d'Art Modern, 2003.

Jules-Rosette, Bennetta, and Njami Simon, eds. *Josephine Baker in Art and Life: The Icon and the Image*. Chicago: University of Illinois Press, 2007.

Kachur, Lewis. *Displaying the Marvelous: Marcel Duchamp, Salvador Dalí, and Surrealist Exhibition Installations*. Cambridge, MA: MIT Press, 2001.

Karas, Joza. *Music in Terezín 1941–1945*. 2d ed. Hillsdale, NY: Pendragon Press, 2008.

Keenan, Brigid. *The Women We Wanted to Look Like*. London: St. Martin's Press, 1977.

Klíma, Ivan. *Karel Čapek: Life and Work*. North Haven, CT: Catbird Press, 2002.

Klingan, Katrin, and Kirstin Gust, eds. *A Utopia of Modernity: Zlín. Revisiting Bat'a's Functional City*. Berlin: Jovis, 2009.

Koolhaas, Rem, and Bruce Mau. *S, M, L, XL: Small, Medium, Large, Extra-Large*. 2d ed. New York: The Monacelli Press, 1998.

Kopp, Robert, ed. *Album André Breton*. Paris: Gallimard, 2008.

Krauss, Rosalind E. *Bachelors*. Cambridge, MA: MIT Press, 2000.

Krejčí, Jaroslav, ed. *Zpráva o pohřbu básníka Jaroslava Seiferta*. Prague: Volvox Globator, 1995.

Kristeva, Julia. *Powers of Horror: An Essay on Abjection*. New York: Columbia University Press, 1982.

Kudělka, Zdeněk, and Jindřich Chatrný, eds. *For New Brno: The Architecture of Brno 1919–1939*. 2 volumes. Brno: Museum of the City of Brno, 2000.

Kudělka, Zdeněk, and Libor Teplý. *Villa Tugendhat*. Brno: FOTEP/Brno City Museum, 2001.

Lahoda, Vojtěch. *Český kubismus*. Prague: Brana, 1996.

Lamač, Miroslav. *Osma a Skupina výtvarných umělců 1907–1917*. Prague: Odeon, 1988.

Lang, Jaromír. *Neumannův Červen*. Prague: Orbis, 1957.

Langerová, Marie, Josef Vojvodík, Anja Tippnerová, and Josef Hrdlička. *Symboly obludnosti: mýty, jazyk a tabu české postavantgardy 40.–60. let*. Prague: Malvern 2009.

Laurence, Charles. *The Social Agent: A True Intrigue of Sex, Lies, and Heartbreak behind the Iron Curtain*. London: Ivan R. Dee, 2010.

Le Brun, Annie. *Lâcher tout*. Paris: Sagittaire, 1977.

———. *Sade: A Sudden Abyss*. San Francisco: City Lights, 2001.

———. "Toyen ou l'insurrection lyrique." *Nouvelle Revue Française*, No. 559, 2001.

L'Écotais, Emmanuelle de. *Man Ray Rayographies*. Paris: Editions Léo Scheer, 2002.

Lichtenstein, Therese. *Behind Closed Doors: The Art of Hans Bellmer.* Berkeley: University of California Press, 2001.

Lin, Maya. *Boundaries.* New York: Simon and Schuster, 2000.

Locke, Brian S. "Opera and Ideology in Prague: Polemics and Practice at the National Theater, 1900–1938." *Opera Quarterly,* Vol. 23, No. 1, 2007.

Lottman, Herbert R. *Man Ray's Montparnasse.* New York: Abrams, 2001.

Lukeš, Zdeněk, Petr Všetečka, Ivan Němec, and Jan Ludwig. *Vladimír Karfík: Building No. 21 in Zlín: A Monument of Czech Functionalism/Vladimí Karfík: Budova č. 21 ve Zlíně: Památka českého funkcionalismu.* Zlín: cfa nemec Ludwig, 2004.

Lyotard, Jean-François. *The Postmodern Condition: A Report on Knowledge.* Trans. Geoff Bennington and Brian Massumi. Manchester, UK: Manchester University Press, 1984.

Mahon, Alyce. *Surrealism and the Politics of Eros 1938–1968.* London: Thames and Hudson, 2005.

Mansbach, Steven A. *Modern Art in Eastern Europe: From the Baltic to the Balkans, ca. 1890–1939.* Cambridge, UK: Cambridge University Press, 1999.

Marcus, Greil. *Lipstick Traces: A Secret History of the Twentieth Century.* Cambridge, MA: Harvard University Press, 1999.

———. *The Old, Weird America: The World of Bob Dylan's Basement Tapes.* New York: Picador, 2001.

Marx, Karl. *The Civil War in France.* In Karl Marx and Friedrich Engels, *Collected Works,* Vol. 22. New York: International Publishers, 1987.

———. *The Eighteenth Brumaire of Louis Napoleon.* In his *Surveys from Exile.* London: Penguin, 1993.

Masák, Miroslav, Rostislav Švácha, and Jindřich Vybíral. *Veletržní palác v Praze.* Prague: Národní galerie, 1995.

McNab, Robert. *Ghost Ships: A Surrealist Love Triangle.* New Haven, CT: Yale University Press, 2004.

Mucha, Jiří. *Alphonse Maria Mucha: His Life and Art.* New York: Rizzoli, 1989.

Mumford, Eric. *The CIAM Discourse on Urbanism 1928–1960.* Cambridge, MA: MIT Press, 2002.

Nadeau, Maurice. *The History of Surrealism.* Cambridge, MA: Harvard University Press, 1999.

Nešlehová, Mahulena. *Bohumil Kubišta.* Prague: Odeon, 1984.

Nixon, Mignon. *Fantastic Reality: Louise Bourgeois and a Story of Modern Art.* Cambridge, MA: MIT Press, 2005.

Novotný, Miloslav. *Roky Aloisa Jiráska.* Prague: Melantrich, 1953.

Obecní dům hlavního města Prahy. Prague: Obecní dům, 2001.

Orlíková, Jana. *Max Švabinský: ráj a mýtus.* Prague: Gallery, 2001.

Paces, Cynthia. *Prague Panoramas: National Memory and Sacred Space in the Twentieth Century.* Pittsburgh: University of Pittsburgh Press, 2009.

Páleníček, Ludvík. *Max Švabinský: život a dílo na přelomu epochu.* Prague: Melantrich, 1984.

Páleníček, Ludvík, ed. *Švabinského český slavín.* Prague: Státní pedagogické nakladatelství, 1985.

Palmier, Jean-Michel. *Weimar in Exile: The Antifascist Emigration in Europe and America*. London: Verso, 2006.

Pečinková, Pavla. *Josef Lada*. Prague: Gallery, 1988.

Penrose, Antony. *The Lives of Lee Miller*. London: Thames and Hudson, 1988.

———. *The Surrealists in Cornwall: 'The Boat of Your Body.'* Falmouth, UK: Falmouth Art Gallery, 2004.

Penrose, Roland. *Man Ray*. London: Thames and Hudson, 1975.

Pfaff, Ivan. *Česká levice proti Moskvě 1936–1938*. Prague: Naše vojsko, 1993.

Polizzotti, Mark. *Revolution of the Mind: The Life of André Breton*. New York: Da Capo, 1997.

Potoček, Václav. *Vyšehradský hřbitov—Slavín*. Prague: Svatobor, 2005.

Ptáčková, Věra. *Česká scénografie xx. století*. Prague: Odeon, 1982.

Putík, Alexandr, ed. *Path of Life: Rabbi Judah Loew Ben Bezalel, 1525–1609*. Prague: Academia/The Jewish Museum, 2009.

Remy, Michel. *Surrealism in Britain*. Aldershot, UK: Ashgate Publishing, 1999

Le rêve d'une ville: Nantes et le surréalisme. Nantes: Musée des Beaux Arts, 1994.

Ripellino, Angelo Maria. *Magic Prague*. Ed. Michael Henry Heim, trans. David Newton Marinelli. Berkeley: University of California Press, 1994.

Robinson, Leonard. *Paul Nash. Winter Sea: The Development of an Image*. York, UK: William Sessions/The Ebor Press, 1997.

Roth, Andrew. *The Book of 101 Books: Seminal Photographic Books of the Twentieth Century*. New York: PPP Editions, 2001.

Rothenstein, Julian, and Mel Gooding, eds. *ABZ: More Alphabets and Other Signs*. London: Redstone, 2003.

Rubin, William S. *Dada and Surrealist Art*. New York: Abrams, n.d. [1968].

Sabatier, Thierry. *L'Origine du monde: histoire d'un tableau de Gustave Courbet*. 2d ed. Paris: Bartillat, 2006.

Sawin, Martica. *Surrealism in Exile and the Beginning of the New York School*. Cambridge, MA: MIT Press, 1997.

Sayer, Derek. "André Breton and the Magic Capital: An Agony in Six Fits." *Bohemia*, Vol. 52, No. 1, 2012.

———. *Capitalism and Modernity: An Excursus on Marx and Weber*. London: Routledge, 1991.

———. "Ceci n'est pas un con: Duchamp, Lacan, and *L'Origine du monde*." In *Marcel Duchamp and Eroticism*, ed. Mark Décimo. London: Cambridge Scholars Press, 2007.

———. *The Coasts of Bohemia: A Czech History*. Princeton, NJ: Princeton University Press, 1998. Abbreviated *Coasts*.

———. "Crossed Wires: On the Prague–Paris Surrealist Telephone." *Common Knowledge*, Vol. 18, No. 2, 2012.

———. "Everyday Forms of State Formation: Some Dissident Remarks on 'Hegemony.'" In *Everyday Forms of State Formation: Revolution and the Negotiation of Rule in Modern Mexico*, ed. Gilbert M. Joseph and Daniel Nugent. Durham, NC: Duke University Press, 1994.

———. *Going Down for Air: A Memoir in Search of a Subject*. Boulder, CO: Paradigm, 2004.

———. "Hypermodernism in the Boondocks." *Oxford Art Journal*, Vol. 33, No. 2, 2010.

———. "The Language of Nationality and the Nationality of Language: Prague 1780–1920." *Past and Present*, No. 153, 1996.

———. "A Quintessential Czechness." *Common Knowledge*, Vol. 7, No. 2, 1998.

———. "The Unbearable Lightness of Building—A Cautionary Tale." *The Grey Room*, No. 16, 2004.

Schaffner, Ingrid. *Salvador Dalí's Dream of Venus: The Surrealist Funhouse from the 1939 World's Fair*. New York: Princeton Architectural Press, 2002.

Schaffner, Ingrid, and Julien Lisa Jacobs. *Julien Levy: Portrait of an Art Gallery*. Cambridge, MA: MIT Press, 1998.

Šíp, Ladislav. *Česká opera a její tvůrci*. Prague: Supraphon, 1983.

Slavík, Antonín. *Josef Čapek*. Prague: Albatros, 1996.

Snyder, Timothy. *Bloodlands: Europe between Hitler and Stalin*. New York: Basic Books, 2010.

Solomon, Deborah. *Utopia Parkway: The Life and Work of Joseph Cornell*. New York: Farrar, Straus, and Giroux, 1997.

Spurný, Jan. *Karel Svolinský*. Prague: Nakladatelství československých výtvarných umělců, 1962.

Srp, Karel. *Jindřich Štyrský*. Prague: Torst, 2001.

Srp, Karel, and Jana Orlíková. *Jan Zrzavý*. Prague: Academia, 2003.

Srp, Karel, in cooperation with Polana Bregantová and Lenka Bydžovská. *Karel Teige a typografie: asymetrická harmonie*. Prague: Arbor/Akropolis, 2009.

Staněk, Tomáš. *Odsun Němců z Československa 1945–1947*. Prague: Academia/Naše vojsko, 1991.

Stargardt, Nicholas. *Witnesses of War: Children's Lives under the Nazis*. London: Pimlico, 2006.

Švácha, Rostislav. *The Architecture of New Prague 1895–1945*. Cambridge, MA: MIT Press, 1995.

Svoboda, Jan E., Zdeněk Lukeš, and Ester Havlová. *Praha 1891–1918: kapitoly o architectuře velkoměsta*. Prague: Libri, 1997.

Taussig, Michael. *Walter Benjamin's Grave*. Chicago: University of Chicago Press, 2006.

Taylor, A.J.P. *The Habsburg Monarchy*. London: Penguin, 1990.

Taylor, Sue. *Hans Bellmer: The Anatomy of Anxiety*. Cambridge, MA: MIT Press, 2002.

Templ, Stephan. *Baba: Die Werkbundsiedlung Prag/The Werkbund Housing Estate Prague*. Basel, Boston, and Berlin: Birkhäuser, 1999.

Terain, Gregory. "From La Bagarre: A Selective Dip into the Boston Symphony Orchestra Archives." *Bohuslav Martinu Newsletter*, Vol. 6, No. 2, 2006.

Tichá, Jana, ed. *Future Systems*. Prague: Zlatý řez, 2002.

Toman, Jindřich. "Émigré Traces: John Heartfield in Prague." *History of Photography*, No. 32, 2008.

———. *Foto/montáž v tiskem/Photo/Montage in Print*. Prague: Kant, 2009.

———. *Kniha v českém kubismu/Czech Cubism and the Book*. Prague: Kant, 2004.

Topinka, Miloslav. "The Dada Movement in Relation to the Czech Interwar Avant-

Garde." *Orientace*, 1970, trans. James Naughton for *Dada East*, 17th Prague Writers Festival, available at http://www.pwf.cz/rubriky/projects/dada-east/milo slav-topinka-the-dada-movement-in-relation-to-the-czech-inter-war-avant -garde_8057.html (accessed 4 May 2012).

Tyrrell, John. *Janáček: Years of a Life.* 2 volumes. Vol. 1, *The Lonely Blackbird.* Vol. 2, *Tsar of the Forests.* London: Faber, 2006, 2007.

Tyršová, Renata. *Miroslav Tyrš: jeho osobnost a dílo.* Prague: Český čtenář, 1932–34.

Vacek, Václav. "Praha—na hlavní evropské křižovatce." *Československo*, Vol. 1, No. 3, 1946.

Valette, Robert D., ed. *Éluard: livre d'identité.* Paris: Tchou, 1967.

Venturi, Robert. *Complexity and Contradiction in Architecture.* 2d ed. New York: Museum of Modern Art, 2002.

Vieuille, Chantal. *Nusch: portrait d'une muse du Surréalisme.* Paris: Le Livre à la carte, 2010.

Virilio, Paul. *Art and Fear.* Trans. Julie Rose. New York: Continuum, 2003.

Volavková, Hana. *Mikoláš Aleš: ilustrace české poezie a prózy.* Prague: Státní nakladatelství krásné literatury a umění, 1964.

Wagnerová, Alena. *Milena Jesenská.* Prague: Prostor, 1996.

Webb, Peter. *Leonor Fini: metamorphoses d'un art.* Paris: Éditions Imprimerie Nationale, 2009.

Weber, Max. *The Protestant Ethic and the Spirit of Capitalism.* Trans. Peter Baehr and Gordon C. Wells. London: Penguin, 2002.

———. "Science as a Vocation." In *From Max Weber*, ed. H. Gerth and C. Wright Mills. London: Routledge, 1974.

Whitford, Frank. *Oskar Kokoschka: A Life.* London: Weidenfeld and Nicolson, 1986.

Witkovsky, Matthew S. "Avant-Garde and Center: Devětsil in Czech Culture, 1918–1938." PhD dissertation, University of Pennsylvania, 2002.

———. "Surrealism in the Plural: Guillaume Apollinaire, Ivan Goll and Devětsil in the 1920s," *Papers of Surrealism*, No. 2, summer 2004, available at http://www.surrealismcentre.ac.uk/papersofsurrealism/journal2/index.htm (accessed 4 May 2012).

Wittgenstein, Ludwig. *Tractatus Logico-Philosophicus.* Trans. Brian McGuiness and David Pears. London: Routledge, 2001.

Zarecor, Kimberly Elman. *Manufacturing a Socialist Modernity: Housing in Czechoslovakia, 1945–1960.* Pittsburgh: University of Pittsburgh Press, 2011.

Index